MW00604356

TEACHING JEWISH VIRTUES

SACRED SOURCES AND ARTS ACTIVITIES

SUSAN FREEMAN

A.R.E. Publishing, Inc.
Denver, Colorado

The following publishers have generously given permission to use extended quotations from copyrighted works:

From *Jewish Spiritual Practices* by Yitzchak Buxbaum. Reprinted by permission of the publisher, Jason Aronson Inc., Northvale, NJ © 1990.

From *Tales of Hasidim: The Later Masters* by Martin Buber, translated by Olga Marx. Copyright © 1947, 1948 and renewed by Schocken Books, Inc. Reprinted by permission of Schocken Books, distributed by Pantheon Books, a division of Random House, Inc.

From *Likrat Shabbat* by Sidney Greenberg and Jonathan D. Levine, published and copyrighted by the Prayer Book Press of Media Judaica, 1363 Fairfield Ave., Bridgeport, CT 06605, Reprinted by permission of the publisher.

From *Abraham Isaac Kook, The Lights of Penitence, The Moral Principles, Lights of Holiness, Essays, Letters, and Poems,* translated by Ben Zion Bokser. Reprinted by permission of the publisher, Paulist Press, Ramsey, NJ © 1978.

Published by:
A.R.E. Publishing, Inc.

Library of Congress Catalog Number 99-72396
ISBN 0-86705-045-4

© A.R.E. Publishing, Inc. 1999

Printed in the United States of America
10 9 8 7 6 5 4 3 2 1

All rights reserved. No part of this book may be reproduced in any form or by any means without permission in writing from the publisher.

DEDICATION

This book is in honor of my parents Samuel and Joyce Freeman — my greatest teachers — whose dedication to virtue has been the most significant inspiration for my own efforts toward righteous living.

This book is dedicated to the memory of Marilyn Graubart — may her virtues live on in her children, grandchildren, and all those who loved her.

ACKNOWLEDGMENTS

Thank you, God, for giving me life, for renewing me, and for bringing me to this time.

The idea for this book originated in a workshop setting with the following individuals: Iris Berkman, Lisa Leizman, Linda Mondschein, Pamela Schwartz, and Abbie Steiner. They willingly took the plunge to explore, through unconventional means, ideas related to Jewish virtues. I give them my deepest thanks.

A major contribution to this book was made by Abbie Steiner, who served as art consultant, helping to set the tone for the Visual Art sections. She offered useful comments on the book's overall structure as well. For the chapters on *"Lo Levayesh"* and *"Hachnasat Orchim,"* she contributed many specific art exercises. In addition, she provided valuable suggestions for the Visual Art sections in several other chapters. She "tested" various projects with different age groups and explored, in a professional capacity, some of the more abstract ideas.

I am grateful to my husband, Rabbi Philip Graubart, who offered numerous suggestions on the book as a whole. He was particularly helpful in assisting me in locating and unraveling certain Text Study passages. Additionally, he was always willing to discuss concepts, and to listen supportively as I wrestled through various challenges presented by this project.

I thank Audrey Friedman Marcus and Rabbi Raymond A. Zwerin, the editors and publishers of A.R.E. Publishing, Inc. They provided insightful feedback on the drafts of this book. Besides their commitment to the detailed efforts of word by word editing, they provided helpful guidance in setting an appropriate overall tone and structure for the book.

Thanks to Rabbi Eugene B. Borowitz, scholar and professor at Hebrew Union College-Jewish Institute of Religion, for providing the Foreword to this book. Furthermore, my appreciation extends to him for being a wise teacher to me during my years at HUC-JIR. His influence has remained strong over time and permeates the pages of this book.

I am grateful, too, to my friends in the Congregation B'nai Israel community of Northampton, Massachusetts. And I am especially grateful to my family for giving me so much unconditional love and support.

CONTENTS

FOREWORD

When the twentieth century began, no one could have predicted how the focus of Jewish ethics would change over the coming 100 years. Back then, two things characterized discussions of contemporary Jewish morality. The first was Jewish social responsibility. Citizenship gave the Jewish community an equality it had long dearly wanted. Its reality challenged the community to create an active sense of duty to the non-Jewish world after the long period in which universalism had only been implicit in pre-Emancipation Jewish thinking. What was now required of Jews who no longer lived in or thought of themselves primarily as ghetto dwellers? And what ideals should they, as Jews, seek to realize in the great world of which they were now so happily a part? Social ethics so dominated the Jewish view of how one ought to live that even those who were now otherwise eager to be liberated from Jewish belief and practice made it the essence of their secular idealism. The happy result was that how Jews lived and, later, how often they voted for the common good, became a major source of pride to the Jewish community and a standard reason they advanced for Jewish continuity.

The second prominent aspect of Jewish ethics may have been of concern mostly to Jewish intellectuals, but through them it affected the ethos and self-image of much of the Jewish community. Jewish ethics, we proudly proclaimed, were in fact those duties mandated by human reason at its very best. They could easily be described by the philosophic kind of language that the increasing number of Jewish college graduates preferred to the dictates of revelation or the cryptic comments of the sages. Uniquely among nations and religions, we were the people of ethical monotheism (with special emphasis on ethical, to be sure). Thus one could take special pride in being a modern Jew for that meant thinking and acting to the highest standards of western civilization, those of universal rationality, and since Judaism laid claim to being the most rational, the most ethical of all human religions, it was, in its way, the very fulfillment of the hopes of modernity.

Ten decades later, it is not the substance of Jewish ethics that has radically changed — most of us still stand by the old social ideals — but the way in which we feel we must approach it. The intellectual underpinnings of the old view have largely collapsed. We have not seen that the more rational (or, if you wish, the smarter or the more logical) a person is, the more ethical a person will try to be. It turns out that one can think very carefully from one's assumptions to one's conclusions but never factor ethics into the argument; one can qualify to be one of the best and the brightest and not leave ethics out of one's critical thinking. Equally disturbing to the old assumptions is that people don't seem to be very rational, certainly not when something quite precious to them is at stake. Then all that mass of feeling, experience, social group, history, economic

interest, and the like that go to make up our "self" are far more likely to take over. From World War I to the atom bomb to the Holocaust to today's news, human nature is only partially dominated by our wonderful ability to think clearly.

While there is plenty of evidence of this in the lives of our neighbors, or relatives, or ourselves —particularly if we must face the revelations of motivation that therapy induces — it is on the social level, particularly the political, that we have seen how strongly even the best social ethics is dependent upon character. What kind of person one is cannot be separated from what ideals one claims one stands for. Neighborliness, relationships, citizenship are all predicated on our living with — not just thinking about — simple common decency. The best devised social programs need people of reasonably good character to carry them out or they will not succeed. And while we all, following Moses' example, may be sinners, Judaism insists that we are all free to be preponderantly decent, the classic Jewish measure of a *tzadik*.

These developments have made us return — like many caring souls in western civilization — to teaching about the virtues that go to make a good human being. We can no longer take it for granted that the institutions of our society will take care of that, as in the flush of our new freedom we naively thought a century ago. Our schools, our government, our commerce, our culture all need the help, even the grounding, that the biblical religions once explicitly provided and that we for so long neglected. Teaching about the virtues we commend will not mean that those who hear about them can be counted on to become virtuous. But ending the silence about them will do its part to encourage us to be good people if we will dedicate our freedom to choose life at its Jewish ideal best. When one peruses the variety of ways in which this book suggests that we open ourselves up to our traditional virtues, one can hope that far more than intellect will be affected by those who learn from these pages. The varied approaches so generously provided here seek to touch and influence the multifaceted nature of the human self. May they help us to become ever more effective allies of our *Yetzer Tov*, our urge to do good.

Eugene B. Borowitz
Sigmund L. Falk Distinguished Professor of Education and Jewish Religious Thought
Hebrew Union College-Jewish Institute of Religion

INTRODUCTION

Mastering *Middot* (Jewish virtues/values) is integral to becoming not only a good Jew, but a good person. It is essential for spiritual growth. The purpose of this book is to provide educators and other leaders with Jewish source materials, insights, perspectives, and suggested activities that will help them to teach and inspire personal character development.

Teaching Jewish Virtues: Sacred Sources and Arts Activities consists of the following: this Introduction, which first outlines the contents of the book, the organization and contents of the chapters, and makes suggestions as to how various audiences might use this book; Chapter 1, which introduces the concept of Jewish virtues and is entitled "About Middot"; Chapters 2-23, each one of which is about one or more individual *Middot* (these chapters are arranged in alphabetical order according to Hebrew transliteration[1]); Appendixes 1-6, which are lesson plans for various age groups, Appendix 7, which is a retreat schedule; Appendix 8, which is a complete list of *Middot* from *Pirke Avot* and *Orchot Tzaddikim*; and a Bibliography.

HOW THE CHAPTERS ARE ORGANIZED

The chapters in this book are organized in the following manner: Chapter 1 stands by itself

in that it introduces the concept of *Middot* — what they are, their origins, who is obligated to practice them, toward whom we must be virtuous, when we must practice *Middot,* and why. It concludes with an elucidation of the concepts *Halachta BiDrachav* (Walking in God's Ways) and *V'Dibarta Bam* (Speak These Words/ Spread the Word). Source material is included but, since this is an introductory chapter, there are no activities. All other chapters contain three sections: Overview, Text Study, and Activities. Here is an explanation of each of these sections.

Overview

The Overview is basically an orientation, allowing a leader or teacher to grasp the overall essence and implications of the virtue. Definition, background and historical development, interpretation, and perspective on the *Middah/Middot* under study are given here, along with some ramifications and challenges raised by the virtue. Advanced students may wish to read the Overview for themselves.

At the end of each Overview are three applications of the *Middah/Middot* to our lives. These are: *Bayn Adam L'Chavero* (how the *Middah/Middot* can enrich us in relationship to others), *Bayn Adam L'Atzmo* (how the *Middah/Middot* can enrich our

[1]The reason for arranging the chapters in this manner is that the English translations of the terms are approximations of their Hebrew meanings. Thus, there is a preference for framing the Hebrew term. The transliteration is used for the alphabetiz- ing, rather than the Hebrew, for easiest access to the widest variety of users (from those more familiar with the Hebrew to those who are less so).

day-to-day personal life as an individual), and *Bayn Adam L'Makom* (how the *Middah/Middot* can enrich us spiritually in terms of our relationship to God).

As each *Middah* is explored, the goal is to find its meaning in terms of each of these three levels. This gives depth and increased relevance to the process of mastering *Middot*. Take, for example, *Emet* (truthfulness). Being truthful to others is central. But what does it mean to be true to ourselves? What is it to be true before God? With regard to the *Middah* of *Yirah* (awe and reverence), plainly, we are to show awe and reverence before God, but should awe and reverence be a factor in how we relate to others, and should the *Middah* influence how we view and treat ourselves? Addressing these kinds of questions gives the study of *Middot* expanded layers of significance.

Text Study

Text Study (Talmud Torah) has been an integral part of Jewish religious life for centuries. The Rabbis assert that this *Mitzvah* (commandment) surpasses others in importance because it leads to them all. Likewise, it can be said that Talmud Torah leads to an understanding of virtues because our texts are values laden. A knowledgeable Jew practices *Middot*, living a life of righteousness, because their meaning and significance is woven tightly into our literary heritage.

Since our success in mastering *Middot* is enhanced as we absorb information and inspiration from Jewish source material, a number of texts that relate to a *Middah* are presented in each chapter. A text might explain the meaning of the virtue, offer an insight, or give an example of how to live by what the virtue purports. Some texts may be legalistic in tone, others might be anecdotal or story-like, and some texts are sayings or proverbs. Relevant prayers are included, too. By studying these texts, students will gain insight into the virtue. Text Study passages have been

culled from and are grouped according to the following categories: Tanach (Bible); Rabbinic sources (200 to 550 C.E. — Mishnah, Talmud, Midrash); and Post-Rabbinic documents (550 C.E. to the present — medieval philosophy, legalistic codes, mysticism, folk wisdom, the thoughts of Maimonides [1135-1204], sayings of Hasidic teachers [c. 1720-1850]; reflections of the first Chief Rabbi of Israel, Abraham Isaac Kook [1865-1935]; insights of the theologian, Abraham Joshua Heschel [1907-1972]; and others). Some of the chapters also include one or more excerpts of prayers under the heading Tefilah. Many of these prayers from the *Siddur* derive from the Tanach or from Post-Rabbinic sources.

Each text is preceded by a brief introductory sentence or so, and is followed by questions which help the reader put the text into perspective. For ease of recognition, each such text segment (introductory statement, text, questions) is "numbered" with a large capital letter and set in bold type. To make it even more accessible, the text itself is in bold type, indented, and set apart by a spacing before and after it. Since the Text Study material is extensive, a leader may wish to select just a few passages for in-depth study. However, according to our tradition, the more texts studied, the more well-rounded will be the perspective about a particular *Middah*.

Some of the translations of the texts quoted in this book have been adjusted from the original. The goal has been to preserve the meaning and essence of the text, make it gender inclusive, and avoid awkward language and sentence construction. Here are a few examples of how a text may have been changed: a text written in the third person masculine singular is usually translated in third person plural ("he" becomes "they"); the original text says "he," the translation reads "he/she"; "The Holy One, Blessed Be He," becomes "The Holy Blessed One"; the word "Lord" becomes "Eternal."

A number of questions follow each text. These are set off by an arrow. Of the many discussion

questions, some are more difficult than others. A leader may choose to address them all or only some of them. The intent of these questions is to help students grasp the basic meaning (*p'shat*) of the text, then to delve into its significance and intent, and finally to reshape it so as to apply its meaning to their lives.

Activities

Following the Text Study material, each chapter contains an extensive number of activity suggestions. These activities are intended to make the *Middot* more immediate and relevant to the student. All of the activities in this book are grouped into the following creative, artistic expressions: Language Arts, Visual Art, Drama, Movement, Music, and (in some chapters) Miscellaneous. The Miscellaneous activities are often experiential tasks which participants carry out on their own over the course of a given amount of time, e.g., recording progress in a journal concerning *Erech Apayim* (slowing down your anger).

Just as texts and prayers can foster religious growth and enhance the path to virtue, so, too, artistic expression can serve as a bridge to *Middot*. Creative interpretations of texts and events are not new to Jewish tradition, e.g., Aggadah, Midrash, commentaries, and storytelling. Artistic expression has also been around a long time, e.g., manuscript illumination, the making of beautiful ritual objects, Levitical choirs and the music of the Psalms, even the building of the Temple itself reflect creative artistic sensibility.

The activities in this book summon the use of creative energies, which open us to a deeper understanding of the *Middot*, lead to new discoveries about oneself, and thus increase our sense of ownership of the *Middah* under study. Actors and dancers physically embody (and thus become) the commentary. Visual artists and writers project their commentary onto a canvas, a sketch book, a sheet of paper, or the pages of a journal. Musicians declare their commentary through singing or instrumentation. The learning/experiencing/creating process can lead to new insights that are often surprising or invigorating or moving — even beautiful. An important adjunct to this process is the potential for coming to understand God as artist, Who has given to God's human creation the unique ability to appreciate beauty and be elevated by aesthetic experiences. Hopefully, as a result of such artistic "engagement," participants ("artists") will be inspired to pursue mastery of *Middot* with renewed vigor in all aspects of their lives![2]

Each activity is introduced with a sentence or two that raises one or more provocative questions, refers to a Text Study passage, provides context, and/or gives a rationale for the activity. One of the following symbols precedes each activity:

 This symbol stands for *Bayn Adam L'Chavero*. It precedes an activity which fosters understanding of that aspect of the *Middah* which is Between People.

 This symbol stands for *Bayn Adam L'Atzmo*. It precedes an activity which fosters understanding of that aspect of the *Middah* which is Between You and Yourself.

 This symbol stands for *Bayn Adam L'Makom*. It precedes an activity which fosters understanding of that aspect of the *Middah* which is Between You and God. Where there is more than one emphasis for the activity, more than one symbol is used. Using these symbols makes it easy to browse through the activities and hone in on the particular aspect you want to stress.

[2]Some of this section was drawn from ideas presented in "Creative, Artistic Responses To Jewish Tradition" by Susan Freeman, *CCAR Journal: A Reform Jewish Quarterly,* Summer, 1997.

Discussion questions follow most of the activities. These allow participants to do some or all of the following: share reactions, comment on each other's work, review what they experienced, evaluate, reconsider the meaning of a traditional text, reflect on how to apply what they learned to other contexts. Group discussion encourages participants to learn from each other's experiences, opinions, and insights. Many of the questions can be adapted for independent study, too.

Specific grade or age levels are not given for the activities, since it would be too subjective to determine these with precision. Instead, the activities are presented in terms of difficulty, from easiest or most basic (#1, #2) to most advanced or abstract (higher numbers). This gradation of difficulty is repeated for each section (Language Arts, Visual Art, Drama, and so on). The easiest exercises will be appropriate for younger children. But since these are also the most basic, they can be a good starting point for older children and adults as well. As the exercises grow in difficulty, they will be accessible to a continually narrower group of more and more advanced students. The last exercise(s) in each section will require the most amount of sophisticated thinking and/or abstract artistic expression. The gradation of difficulty is not an exact science. Different individuals and groups may find an activity presented at the beginning to be more challenging than one that comes later, and vice versa. Leaders are urged to read through the exercises and choose those that seem most appropriate for their particular situation and the abilities of their students or group members.

HOW TO USE THIS BOOK

Various individuals will find the material in this book applicable to their professional educational duties or to their personal quests. What follows is a description of how teachers, other leaders, and/or learners might use this book for their particular settings and circumstances. Included are Classroom Judaic Teachers (i.e., Religious School and Day School teachers); Adult Educators; Family and Mixed-Age Group Educators; Camp Counselors, Community Center Programmers, and Retreat Planners; Havurot Leaders; Artists and Teachers of the Arts; Individuals studying on their own; Rabbis and Other Prayer Leaders; Students (who may be guided by a teacher to read sections of the book for themselves before engaging in an activity); and planners and facilitators of Teacher Education.

Classroom Judaic Teachers

Religious School and Day School teachers will find the material in this book clearly relevant and applicable for use in their classrooms. The chapters can be adapted for groups of elementary school children through high school age.

For young children, a teacher will want to keep the approach to the material simple, i.e., first go over the basic thrust of the *Middah*, drawing on ideas presented in the Overview. Then present just a few of the most easily understood Text Study passages, and conclude with one or more activities. The teacher will want to select from those activities presented at the beginning of the categories. The teacher may decide not to cover all the discussion questions, sticking with only the most concrete ones.

For more advanced groups, adjust the lesson appropriately. Older students can handle more Text Study, including some passages that are more advanced. For the activities, the teacher may wish to begin with basic exercises, but can continue with intermediate and advanced ones as seems fitting. Discussion with older children and with teenagers can take place on an increasingly sophisticated level as well. See Appendixes 1-6 for examples of lesson plans for various age groups and situations.

Adult Educators

In addition to material geared to children, this book also contains a wealth of stimulating material appropriate for adult learners. Adult Educators can present a larger number of Text Study passages, including the most challenging ones. Adults will be able to address subtleties of a *Middah,* such as conflicting views of the sages, historical changes in attitudes toward the virtue, and contemporary ramifications and implications of the virtue. Adults can compare what they learn about a Jewish virtue to ideas familiar to them from other fields — psychology, philosophy, ethics, secular literature, other religions.

In teaching virtues to adults, it's acceptable to begin with familiar territory, such as Text Study and discussion. But Adult Educators should take the plunge and try one of the creative activities from a discipline unfamiliar to their students. Approaching learning through the arts may be new to some adults, or it may be something they haven't done for a long time. Some adults may need encouragement to grow and express through different modalities. Artistic expression can be a welcome, eye-opening experience for such learners. For groups of adults with little experience in a particular art discipline, it is advisable to start with one of the more basic (beginning) activities, and go from there to more advanced and abstract ones.

Family and Mixed-Age Group Educators

Mastering virtues is something which is relevant for all ages. Everyone has at least some "work" to do related to each *Middah.* (If there is someone who has mastered all virtues, that person can be an inspirational exemplar for the rest of us!) After introducing a virtue, the Family Educator may want to break a group into two for study, then have the group join together for an activity. Or, mixed age groups may wish to discuss a virtue

together; hearing viewpoints from different generations can be enlightening. From Text Study, the group can continue with an activity.

Many of the activities are appropriate for various abilities and age groups. For example, an adult may draw a picture or write a poem on a more sophisticated level, whereas a child will do the same on an elementary level. Another approach is to have adults and children do an activity together, such as write a prayer on a given theme. Drama and movement activities are some of the most easily adaptable to mixed-age groups working together.

Another approach to the activity part of a session might be to split the group for this part of the lesson. Each grouping might create a skit or choreograph a movement piece, then present their work for each other later. See Appendix 5 for a more elaborate example of a lesson plan for a Family Education Session.

Camp Counselors, Community Center Programmers, and Retreat Planners

Alternative setting educators can draw on the material in this book in any of the ways described above. Some other ideas: a camp may want to choose one of the virtues for a session theme, or there could be a virtue of the week. Retreat planners could choose one (or more) of the virtues as a theme for a Shabbat or weekend retreat, with appropriate study and activities included as part of the programming. See Appendix 7 for an example of a retreat with a Jewish virtues theme.

Havurot Leaders/Havurah Retreats

Members of Havurot can use material in this book as the basis for study and activity for their get-togethers. The material adapts well to such mixed-age groups. It will be helpful if one or two people plan the session ahead of time and act as the leaders for the session's activities (refer to

"Family Educators and Mixed-Age Group Educators" above). For Havurot made up mostly of adults, refer above to "Adult Educators." Appendix 7 provides an example of a retreat which could be adjusted for use by a Havurah.

Artists and Teachers of the Arts

The activity material in this book can be a valuable resource for artists and teachers of the arts. The exercises push participants to extend themselves creatively. Studying virtues through the arts ideally encourages personal, ethical, and spiritual growth. But the process also can provide new and stimulating avenues for experimenting and expressing oneself in a given artistic discipline. Oftentimes, especially in the Religious School setting, arts activities are representational in nature (e.g., making Shabbat candlesticks). Or, arts activities may stress mastery of specific skills (e.g., learning an Israeli folk dance or the words to a Hebrew song). But skill mastery is not the objective in these activities. Internalizing the message, value, and intent of a *Middah* is. By participating in more abstract activities, we bring to the surface intuitive knowledge and attitudes which we hold (and often didn't even realize). The process can have a profound effect in terms of eliciting our "gut" beliefs and values. From such an experience, we can begin to evaluate, to make conscious decisions, as to what behaviors we want to maintain and which we need to modify or even eliminate. From such activities, we can sometimes get to the core of what we are, where we stand, and how we want to evolve.

Individuals

While sharing experiences about the process of mastering virtues may be enjoyable and even valuable, in the final analysis, mastering virtues in an individual endeavor. The degree to which someone will integrate a particular *Middah* is up to each person. Every individual is responsible for his/her own behavior. Therefore, some students may wish to work on their own, learning about a *Middah* and exploring it through creative arts exercises. Some of the arts — writing and the visual arts especially — are more individualistic in nature. That is, people tend to write and create visual art on their own. The arts activities in this book can provide a framework for independent "virtue-work." Those interested in writing may want to go through each chapter, probing the meaning and implications of a virtue through completing all (or most) of the Language Arts exercises. Writers may or may not choose to share their writing with others. Artists may want to create a series of paintings on various virtues, then plan to have an exhibit of their work once they have accumulated enough of it. See Appendix 6 for an example of an Independent Study lesson plan.

Rabbis and Other Prayer Leaders

The Text Study material offered in each chapter can be helpful to a Rabbi or other speaker/teacher in preparing a sermon or *D'var Torah*. if the speaker chooses, after presenting and evaluating what our tradition has to say about a particular virtue, he/she can invite comments or questions from members of the congregation. The study of virtues could be used as part of a year's program — one *Middah* explored each Shabbat during the sermon. Perhaps a leader of "Junior Congregation" will wish to present a different virtue during each weekly service or as part of Torah study. The interaction among characters in the weekly Torah portion can suggest a certain *Middah*. Various virtues are referred to directly or indirectly in prayers recited in a worship service. A prayer leader may want to give a *D'var Tefilah* (a teaching about a prayer) relating the teaching to a particular virtue.

Students

This book is geared primarily toward classroom teachers and other leaders. Even so, it may be helpful for other children and adult students to read some of the written material for themselves. For example, teachers may think it beneficial for students to read, on their own, an Overview for one of the *Middot*. Or, members of a Havurah may find it worthwhile for everyone in the group to read the Overview, rather than having just one person summarize it for the group. Clearly, for extensive Text Study, students will benefit from having a version of the text in front of them to refer to.

Teacher Education

Modeling virtue is an integral part of our role as Jewish educators. Teaching our students *Middot* will make the greatest impact if we ourselves are exemplars of virtue. But just because we are Jewish educators doesn't mean we have attained perfect mastery of *Middot*. There is always learning and growing to do, even for teachers. Thus, virtues can be made a regular part of teacher education.

Perhaps teachers can spend some time learning about and discussing a different virtue at each staff meeting. Before we teach certain virtues to others, or *as* we do so, it is important to work on those traits in ourselves. As we become more aware, educated, and committed to virtues, we are more likely to incorporate them into our interactions with our students. Also, we will be more inclined to practice *Middot* in our places of learning and worship. As we teach and live virtue, others will hopefully do the same. What loftier goal is there for Jewish education than to inspire others to live lives of virtue?

And, now, we begin.

CHAPTER ONE
ABOUT MIDDOT (JEWISH VIRTUES)

מִידוֹת טוֹבוֹת

WHAT ARE MIDDOT?

The terms *"Middah"/"Middot"* (singular/plural) and "Jewish virtues" are used interchangeably throughout this book. Virtues are values — principles we consider to be of central importance. How we act; who we are; what we stand for; how we respond; how we view life and the world around us; our personal qualities, attributes, traits — all these reflect the degree to which we embrace Jewish virtues. While they have universal application, *Middot* are derived from Jewish tradition. Although their message was originally directed at the Jewish people, would that all people might adopt them and live by them. *Middot* challenge us to raise the level of our interactions with each other, with ourselves, and with God.

In striving for virtue, we define and prioritize what really matters in life. Torah and the codes of Jewish law, present us with the *Mitzvot* (commandments) and their applications to daily life. *Mitzvot* are about ritual observance and right conduct — the do's and don'ts of living a Jewish life within a social context. One might see *Mitzvot* as ritual and moral prescriptions — guidelines for *what* to do, *what not* to do, and when. *Middot,* on the other hand, might be considered as guidelines for *how* to carry out our deeds and how best to interact with others, with ourselves, and with God. They reflect the intentionality of our efforts and the caliber of our actions.

An example: To carry out a deed of loving kindness has great merit. But to carry out a deed of loving-kindness with *Ahavah* (love for others) raises the level of the interaction. Another example: *Hachnasat Orchim* literally means "bringing in guests." We can certainly fulfill this obligation by inviting people to our homes for Shabbat dinner. But how much richer our efforts become by developing in ourselves the traits of hospitality, warmth, and graciousness at all times.

Middot are an integral part of our tradition. Discussions of virtues and references to their importance appear in countless texts. Yet, it is difficult to measure virtues as we might measure other obligations. For instance, we can measure whether or not the *shofar* is sounded on Rosh HaShanah — it either is or it isn't. In contrast, how can we measure a pleasant demeanor or joy or attentiveness? Yet, without such virtues, can we say our lives are well-rounded, enriched, complete? *Middot* are a means by which we can increase our emotional, interpersonal, and spiritual fulfillment.

THE ORIGINS OF MIDDOT

We begin to learn about the importance of Jewish virtues from the accounts of early biblical interactions. Discussions of virtues continue throughout Rabbinic times, in medieval texts, in folk literature and Hasidic teachings, as well as in contemporary writings.

The first Rabbinic listing of Jewish virtues is found in *Pirke Avot* 6:6. There we are taught that Torah is acquired through 48 virtues. A number of the virtues listed there are covered in this book: *Anavah* (Humility), *Dibuk Chaverim* (cleaving to friends), *Erech Apayim* (slowness to anger), *Miyut Sichah* (minimizing small talk), *Samayach B'Chelko* (contentment with your lot) and *Makir et Mekomo* (knowing your place), *Shmiat HaOzen* (attentiveness/being a good listener), *Simchah* (joy), and *Yirah* (awe and reverence). *Emet* (truthfulness) and *Tochechah* (rebuking), along with several others, are referred to in *Pirke Avot* indirectly. (See Appendix 8 for a listing of the *Middot* cited in *Pirke Avot*.)

Orchot Tzaddikim: The Ways of the Righteous, a book about *Middot,* was published in Yiddish about 500 years ago and appeared in Hebrew in 1581. It has reappeared since then in more than 80 different editions. Many traits discussed therein are included in this book — humility, love, mercy, joy, generosity, truth, silence, and awe and reverence. (See Appendix 8 for a listing of the *Middot* from *Orchot Tzaddikim*.)

While we find explicit mention and discussion of *Middot* throughout Jewish literature, many Jewish virtues are discerned indirectly, e.g., through the actions of a biblical character. Joseph's restraint in dealing with his brothers despite the fact they had wronged him is one example. Interchanges between Joseph and his brothers reflect Joseph's efforts to reestablish *Sh'lom Bayit* (peace in the family). The virtue of *Sh'lom Bayit* is implied in that Torah account rather than stated directly.

Middot can also be derived from *Mitzvot*. When a *Mitzvah* is practiced on its loftiest level, a *Middah* often underlies it. For example, *Hachnasat Orchim* (bringing in guests) is a *Mitzvah*, but it points to a virtue as well — the *Middah* of hospitality. *Lo Tachmod* (not coveting) is one of the Ten Commandments, therefore, a *Mitzvah*. Yet, it is also a *Middah* associated with a specific attitude — how people perceive and treat the world around them.

WHO IS OBLIGED TO PRACTICE MIDDOT?

Some personality traits (being imaginative, witty, happy, optimistic, shy) we attribute to a natural proclivity. They are our style, the way in which we approach the challenges and the people we meet each day. Many would maintain that such traits are inborn. To use a computer analogy, this is our operating system — what we are when we boot up each morning.

Personal traits, such as being generous, peace loving, humble, friendly, courageous, even tempered (which also happen to be *Middot*) appear to be less natural to some people. Since they often run counter to egoism and materialism, they can require much effort to master. To illustrate: If we are not naturally generous, we need to strive to be more so. If we tend to lose our temper, we should work at slowing down our anger. In other words, if we do not naturally exhibit a particular virtue, we may have to work harder than someone else at developing it. And, likewise, what seems easy for us may be quite challenging for others. The point is, no one is let off the hook. Even if a *Middah* is difficult for us, we are encouraged to stick with it until we get it. In fact, some of our greatest sages had to persist for years before mastering a particular *Middah*. Here are a few examples:

About *Emet* (truth), the Ladier Rabbi said, "I have labored 21 years on truth: seven years to learn what truth is, seven years to drive out falsehood, and seven years to acquire the habit of truthfulness" (*Emet Keneh* published by A. Rosengarten; Piotrkov, 1907, p. 74).

In regard to *Nedivut* (generosity), Rabbi Yaakov Yitzhak of Pshischa said that people should train themselves to be good-hearted and giving:

"Start with something small. For example, accustom yourself to giving others a little of your snuff tobacco, then do a little more, such as letting them enjoy the use of your pipe, and so on by degrees, until gradually you are in the habit of being generous" (*Nifla-ot ha-Yehudi*, p. 58, as quoted by Yitzchak Buxbaum, *Jewish Spiritual Practices*, adapted, p. 461).

About *Sayver Panim Yafot* (a pleasant demeanor), Rabbi Aryeh Levin of Jerusalem said, "I was careful to receive everyone cheerfully until this became second nature to me. I was careful, too, to take the initiative in greeting everyone" (*A Tzaddik in Our Time* by Simcha Raz, Jerusalem and New York: Feldheim Publishers, 1976, p. 464). In sum, who is obligated to practice Jewish virtues? All Jews, even if doing so is at times difficult and challenging.

TOWARD WHOM MUST WE BE VIRTUOUS AND WHEN?

We are to strive to show virtue to all kinds of people. We are to avoid bias — being virtuous to some people, but not to others. Treating all people in ways influenced by *Middot* is a value. This value comes up in discussions of several virtues in this book. Some examples follow:

About *Anavah* (humility), it is said that we should be humble in Torah and good works; humble with our parents, teacher, and spouse; with our children; with our household; with our kinfolk near and far; even with the heathen in the street *(Tanna de Be Eliyahu* edited by M. Friedmann, Vienna, 1902, p. 197).

About *Emet* (truth), we are admonished not to lie to children (Sukkot 46b).

In relation to *Nedivut* (generosity), we are reminded to give presents to the poor according to our ability, and from time to time, send presents to the wealthy also *(Orchot Tzaddikim).*

About *Sayver Panim Yafot* (a pleasant demeanor), it was said that Rabbi Yohanan ben Zakkai was so quick to greet everyone that no one ever greeted him first, not even a gentile in the marketplace (*Brachot* 28a).

As we have learned, efforts to master *Middot* must be continual. While our persistence may be more intense at some times than at others, it takes consistent attention throughout our lives to make *Middot* second nature.

WHY PRACTICE MIDDOT?

Practicing *Middot* is a means by which to increase emotional, interpersonal, and spiritual fulfillment. Clearly, striving for virtue affects positively our interactions with other people. But there's more. Doing so helps us to understand ourselves — our strengths and our weaknesses — and it brings us closer to God. When we embrace *Middot*, we grow in righteousness and holiness. We grow as Jews.

When we act in virtuous ways, we will ideally see the results of increased goodwill among those in our community. Practicing *Middot* gives us an opportunity to enrich, inspire, and help improve the lives of others. *V'Dibarta Bam* means "speak these words." We can teach others by speaking words that are backed by exemplary deeds and behavior. Influencing others to good behavior, to merit favorable judgment *(Machrio L'Chaf Zechut)*, is considered a virtue in and of itself (*Pirke Avot* 6:6). It is a reflection of "loving our fellow creatures and attracting them to the study of Torah" (*Pirke Avot* 1:12).

Being on a spiritual path (discovering what God wants of us, relating to God, finding our place in the world) also requires efforts to master *Middot*. That is to say, when we learn the essence of *Halachta BiDrachav* (walking in God's ways), we then constantly strive to be like God, and to grow

in understanding of what God represents to us. This understanding leads to greater depth in our relationship with God.

Each person has a divine essence. When we live by *Middot*, we elevate that essence. Being created in the image of God makes each of us part child of, part partner with, and part agent for God. Realizing this and living in such a way as to promote this, we contribute to the ultimate betterment of the world . . . when good virtues will take precedence over evil. Mastering *Middot* is a way of participating in *Tikkun Olam* — repairing the brokenness of this world.

Following are texts related to the concepts of *Halachta BiDrachav* and *V'Dibarta Bam*, as well as discussion questions for each. Spending time learning about these ideas is an excellent way to begin the study and pursuit of *Middot,* which is the purview of this book.

HALACHTA BIDRACHAV (WALKING IN GOD'S WAYS/BE LIKE GOD!)

TEXT STUDY

Tanach

A The essence of who we are is godly.

> **In the image of God, did God make humankind. (Genesis 9:6)**

➤ In what ways do you believe human beings are like God? Do we have special obligations having been created in the image of God?

B When Abram is 99 years old, God appears to him and says:

> **Walk in My ways and be blameless (*tamim*) . . . (Genesis 17:1)**

Later, this injunction is reiterated by Moses to the Israelite people:

> **Walk in God's ways (*Halachta BiDrachav*). (Deuteronomy 28:9)**

➤ We have been created in the image of God. Since that is so, we need to behave in certain ways; we are to walk in God's ways. What do you think it means to walk in God's ways? What is suggested by being "blameless" or "pure" (*tamim*)? Do you believe if you walk in God's ways, if you follow a certain spiritual path, you can be blameless, pure? Explain.

Rabbinic

A God must love us dearly. Not only were we created in the image of God, but we have been given an awareness of who we are.

> **People are beloved, for they were created in the image of God. They are exceedingly beloved for it was made known to them that they were created in the Image, as it is written, "In the image of God, did God make humankind" (Genesis 9:6). (*Pirke Avot* 3:18)**

➤ Do you agree that being created in the image of God is an expression of God's love? Why, according to the *Pirke Avot* passage, must it be that people are "exceedingly beloved" by God? Why might knowing that there is something godly about each and every one of us be a gift of love from God? How might awareness of this gift of love impact on who you are, how you behave, decisions you make?

B Specific attributes are identified which we are supposed to emulate. How we should act in certain situations is made clear from God's example.

Rabbi Hama son of Rabbi Hanina further said: "What does this text mean: 'You shall walk after the Eternal your God' (Deuteronomy 8:5)? Is it, then, possible for a human being to walk after the *Shechinah* (the divine presence); for has it not been said: 'For the Eternal your God is a devouring fire' (Deuteronomy 4:24)? [And who can walk after a devouring fire?] But [the meaning is] to walk after the attributes of the Holy Blessed One. As God clothes the naked — for it is written: 'And the Eternal God made for Adam and for his wife coats of skin, and clothed them' (Genesis 3:21) — so you also clothe the naked. The Holy Blessed One visited the sick — for it is written: 'And the Eternal appeared unto [Abraham, while he was recovering following his circumcision] by the oaks of Mamre' (Genesis 18:1) — so you also visit the sick. The Holy Blessed One comforted mourners, for it is written: 'And it came to pass after the death of Abraham, that God blessed Isaac his son' (Genesis 25:11) — so you also comfort mourners. The Holy Blessed One buried the dead — for it is written: 'And God buried [Moses] in the valley' (Deuteronomy 34:6) — so you also bury the dead." (Sotah 14a)

➤ In the above passage, there are specific things God does, that we are to do, that we are to emulate. What are they? There are many other good actions and attributes we ascribe to God as well. Are there some that stand out in your mind as being things we should try to emulate?

C The previous passage (#B) referred to specific acts we are to carry out in emulation of God — clothe the naked, visit the sick, comfort

mourners, and bury the dead. The following passage speaks more of divine qualities we are to emulate.

> *Halachta BiDrachav* — walking in God's ways. (Deuteronomy 28:9). What are God's ways? Just as it is God's way to be merciful and forgiving to sinners, and to receive them in their repentance, so you be merciful one to another. Just as God is gracious, and gives gifts gratis both to those who know God and to those who do not, so you give gifts [freely] one to another. Just as God is patient with sinners, so you be patient with one another. (*Tanna de Be Eliyahu*, ed. M. Friedmann, Vienna, 1902, p. 135)

➤ What qualities are mentioned above that we are to try to emulate? Would you put these qualities at the top of your list? What might you add?

D In the two previous passages (#B and #C), we were urged to emulate God's deeds of loving-kindness as well as God's good traits. We could say that good deeds and good traits underscore a specific spiritual orientation; we do them because God exemplifies them, and by doing them we reach toward Godliness. The spiritual qualities of purity and holiness are also to be emulated. If we strive for purity and holiness, the desire to do good deeds and live by positive traits will follow naturally.

> For God said to Moses: Go and tell the Israelites, My children, as I am pure, so you be pure; as I am holy, so you be holy, as it is said, "Holy shall you be, for I, the Eternal your God, am Holy" (Leviticus 19:2). (*Leviticus Rabbah* 24:4)

➤ Do you think the desire to be holy motivates people to want to do good and master virtues? Does such a desire for holiness motivate you?

Post-Rabbinic

A We learned previously that we should act in certain ways toward others because we have been created in the image of God, and God acts in those ways. Here is a different perspective on that idea: act in such and such a way toward others because they, too, have been created in the image of God.

> **Honor every [person], whether poor or rich, and let your thought be that you are honoring them because they are created in the image of God, and when you honor them you are honoring [the Creator] who made them.** (*Derech Hayim* **6-48, as quoted in** *Jewish Spiritual Practices* **by Yitzchak Buxbaum, p. 214)**

➤ Why should you honor every person? Is the notion that each person has been created in the image of God enough to convince you that every person should be treated with honor, respect, and dignity? What is the relationship between honoring others and striving to master *Middot*, Jewish virtues?

V'DIBARTA BAM (SPEAK THESE WORDS)

TEXT STUDY

Tanach

A The words "*V'Dibarta Bam*" are in the "*V'Ahavta*," which is recited each day in the worship service. We are to speak these words no matter where we are or what we are doing. We are to teach them to the next generation. We are to use signs and symbols so as to remember them constantly. In that context, "these words" may refer to keeping the commandments, affirming

that God is One, and/or that God loves us. But interpreted more broadly, *V'Dibarta Bam* can include the breadth of Torah and Jewish tradition and certainly *Middot* as well. We should practice *Middot* because they are a part of speaking God's words. Mastering *Middot* helps us to become exemplars of righteous living. Ideally, through our example, others will be brought closer to Torah. The more virtue, the better the world is. Jewish tradition sees a better world as the forerunner to redemption. As people treat each other with dignity and honor, the world improves, and we draw closer to the messianic promise.

> **Take to heart these words with which I charge you this day. Impress them upon your children. Recite them (*V'Dibarta Bam*) when you stay at home and when you are away, when you lie down and when you get up. Bind them as a sign upon your hand and let them serve as a symbol on your forehead; inscribe them on the door posts of your house and on your gates.** (Deuteronomy 6:6-9)

➤ What is the meaning of "Speak These Words" — *V'Dibarta Bam*? Why should we speak such words? How is practicing *Middot* a reflection of *V'Dibarta Bam*?

Rabbinic

A "Speaking these words," teaching about and living lives of righteousness and virtue, can impact future generations; it can have a timeless effect.

> **Whoever teaches their children also teaches their children's children — and so on to the end of the generations of humankind.** (*Kiddushin* 30a)

➤ How might teaching ("speaking these words" to) the children of this generation affect those in generations to come? In what ways does a virtue you live by have an impact on others outside and beyond your immediate contact?

Summary

This chapter has provided insights concerning the significance of *Middot*, why Jewish virtues are so central to living a full and meaningful Jewish life. Now, armed with an orientation to this material and its rationale, you are ready to go and teach, to go and learn!

CHAPTER TWO
ANAVAH: HUMILITY

עֲנָוָה

OVERVIEW

Anavah, humility. We are impressed by great people who are seemingly self-effacing. Ah, if only we might be like they are, we tell ourselves. But what we really mean by that is, if only we were that great, then we wouldn't mind being humble. So if we aren't as great as they are, need we concern ourselves with this *Middah*? Perhaps before making a hasty assessment, we would do well to learn about this virtue and consider what it might mean for us, and what it requires of us.

Some *Middot* are more obvious. Welcome someone into your home and you are clearly practicing *Hachnasat Orchim* (hospitality). Pay a *shivah* call and your efforts reflect *Nichum Avaylim* (comforting mourners). To control or slow down your reaction to an infuriating situation is an example of *Erech Apayim*. And so forth. *Anavah* (humility) is harder to pin down and difficult to measure.

Who really thinks they need to work on *Anavah*? Most of us would probably rationalize: "I guess I'm pretty humble. Not to worry. Certainly, I'm humble enough. I don't go around tooting my own horn or bragging about what I have or how well I do. So, this virtue is a low priority issue. I think I can skip this one." The question is, who is humble enough to admit they need to be more humble? According to our Jewish sources, no one fully masters humility. You would be deceiving yourself to say, "I'm okay here. I've done this one. I'm ready to move on to other virtues." Becoming humble and/or sustaining humility is a lifelong process. We have to work on it continually.

In current popular culture, *Anavah* seems particularly elusive and difficult to appreciate. It's a marketplace out there, a selling mentality. We are bombarded constantly by signs, ads, and personalities hawking goods and services and extolling the virtues of material things. A competitive marketplace multiplies messages — "it's newer, it's supersized, it's better." On some level, this "it's better" message becomes "who's better." There is pressure to prove ourselves, show ourselves off. How difficult it becomes to work on ourselves, to admit our flaws when, at the same time, we feel we need to "sell" ourselves.

But we need to be humble in order to make room for growth. No one is perfect. Everyone has "work" to do. Admitting that we have areas in which we need to improve depends on humility. *Anavah* could be considered a foundation virtue. Before we can think about mastering other *Middot*, we have to have humility. Being clear about what we are *not* is the first step in moving toward who we want to become. Self-satisfaction is a dead end. It leaves no place to go. No place to grow.

Our Jewish sources bring up something that should shock us into humility — our origins, and our destiny. From dust we come, and to dust we go. What in the final analysis do our physical and material accomplishments really amount to? They can be devoid of significance. The "accomplishment" of humility, however, can lead to awesome rewards, rewards which touch on essential values — the ability to learn and to become righteous, to receive honor and respect from others, to grow in wisdom, to be beloved, to develop courage

and inner dignity, to attain grace before God. Not a bad payoff!

Our sources also balance the idea of being created from dust with the affirmation that in "God's image did God make humankind" (Genesis 9:6). We need to be humble, but we should also appreciate that something of the divine, a part of God, exists in every human being.

As is the case with all virtues, the merit of various *Middot* can become distorted. Rabbi Abraham Isaac Kook warns that if your humility becomes depression, it is defective. The meaning of humility can be confusing. How far does one go in the process of becoming humble? Most of us would agree that self-esteem is important. Without a sense of self-worth, a person can sink into depression. Rav Kook would argue that if you find yourself going down an emotionally paralyzing route, you're not on the path of *Anavah*. humility should lead to "joy, courage, and inner dignity" (see Text Study, Post-Rabbinic #B).

According to the Bible, Moses is the best exemplar of *Anavah*. And Moses was considered to be the greatest leader of the Jewish people. Joseph, too, in his later years becomes an exemplar of humility and greatness. A leader of Egypt, he humbles himself before his brothers, crediting God for his success and prestige. King David often expresses humility before God. Humility and greatness can go hand in hand.

In Rabbinic writings there is material about humility, as well as about a related concept, lowliness. That God loves and embraces the humble is clear. Humility is voluntary. We can choose to be humble or not. But the same is not necessarily true about lowliness. Most people don't *choose* lowliness. They don't strive for poor quality of life, low social and economic status, oppression, broken-heartedness, a broken spirit. Yet, lowliness does become entwined in discussions about humility. To hear that God is close to the downtrodden is comforting. It gives a boost to those who suffer. Knowing that God cares helps the downtrodden continue.

We assume a posture of humility in worship. In fact, this *Middah* is integral to prayer, to addressing God. Prayer requires us to diminish our sense of self, to deflate our ego, because if we are filled with our own selves, there can be no room for anything else. Humbling ourselves is like opening up space within. This openness allows us to be guided by God. When we are open, we are better able to experience God's presence, to be filled with non-ego, to be filled with a sense of the divine. Thus, meaningful prayer needs to be grounded in *Anavah*. We give ourselves reminders to maintain humility throughout worship. We bend the knee and bow several times during our recitation of prayers. We back away from the *Aron HaKodesh* on two occasions during the service, and on Yom Kippur there is even an occasion for prostration before the Ark. If we get distracted, if our egos take us away from prayer, a bend, a bow can bring us back to focus, to an attitude of praying sincerely.

Prayer isn't the only time when we are to be humble before God. Our tradition reminds us that God sees all things at all times. Before God, there are no secrets, there is no hiding. False pride and putting on "airs" may fool people, but not God, Who sees us as we truly are. We may as well be humble!

There are two additional concepts related to *Anavah* that are worth mentioning. These are complex ideas, from the realm of Jewish mysticism. (For more on the following Jewish mystical ideas, see Text Study, Post-Rabbinic #C, #D, and #E.) One concept is *Ayin*. The other is *Tzimtzum*. *Ayin* means nothingness. According to Jewish mystics, the humility we ultimately strive for should lead us to a state of *Ayin*. Humbling ourselves means emptying ourselves of any notion that we are separate beings. We focus on becoming nothing, no separate thing. When we are *Ayin*,

we can be suffused with God's essence. We become like a boundless vessel for the divine. In short, *Ayin* is less self, making room for more God.

Tzimtzum is God contracting within God's own self in order to make room for Creation. This is perhaps the ultimate act of humility — God making room for something else besides God's own essence. Is *Tzimtzum* something we can emulate? Does the concept teach us anything that can help us in our efforts to become humble? What would it mean to master *Anavah* as influenced by *Tzimtzum*? Perhaps it would mean making more room for other people — better listening skills, more compassion, more understanding, more willingness to help those in need. Pulling ourselves back, contracting our ego, would give us greater sensitivity — an openness to putting others' needs before our own. What else might it mean to master *Anavah* as influenced by *Tzimtzum*? Perhaps it would mean making more room for God.

The following summarizes how *Anavah* can be viewed in relation to other people, within our own selves, and in relation to God.

 BAYN ADAM L'CHAVERO, BETWEEN PEOPLE. *Anavah* before others is pulling back or diminishing our own ego concerns — less self-importance. Being humble allows one to be more sensitive toward others. We don't see ourselves as being better, more worthy than others.

Yet, humility is not a sacrifice. It does not make one less of a person. Great leadership (like that of Moses) requires humility. Being a beloved person depends on humility as well. The "rewards" for *Anavah* are numerous.

 BAYN ADAM L'ATZMO, BETWEEN YOU AND YOURSELF. *Anavah* on this level is about being honest with yourself. What's most important to you, status and material pos-

sessions, or loving relationships and personal growth? By seeing yourself as you are, your good qualities and your flaws, you will be able to take whatever steps necessary toward more virtuous living.

 BAYN ADAM L'MAKOM, BETWEEN YOU AND GOD. *Anavah* before God is key to our worship. Willingness to be guided by God means being less certain about our ability to control things. To be guided by God means being more open and humble. Allowing God to dwell within us often means quieting our own ego concerns. Self-importance blocks out God; humility lets God in.

God exemplifies humility through *Tzimtzum* — withdrawing some of God's essence to make room for creation. We can emulate God. We, too, can pull back to make room for others and for God.

TEXT STUDY

Tanach

A The very creation of humankind reminds us of our simple essence. Our origins are dust. When we get carried away with our own importance, we should remember where we came from. That should bring us down to earth!

The Eternal God formed man (Adam) from the dust of the earth. (Genesis 2:7)

➤ Do you think an awareness of our physical "ingredients" (dust, or in modern terms — water, chemicals, molecules) should influence our behavior? Should the idea of being formed from the dust of the earth make a person more humble? It says later in Genesis that "in God's image did God make humankind" (Genesis 9:6). Are we still required to be humble if we are created in God's

image? How does the statement from Genesis 9:6 fit into our understanding of Anavah?

B Abraham remembers his "dust and ashes" origins. In the following passage, he tries to convince God to abandon plans to destroy Sodom. Negotiating with God takes nerve. Even so, Abraham pleads his case while remaining humble.

> **Abraham spoke up, saying, "Here I venture to speak to my Eternal One, I who am but dust and ashes . . ."**
> **(Genesis 18:27)**

➤ Why does Abraham mention his "dust and ashes" origins while addressing God? Do you think Abraham's humility is sincere? How do you feel about yourself, your stature when you address God?

C Miriam and Aaron speak about Moses behind his back. They complain about his leadership role, saying, "Has the Eternal spoken only through Moses? Has God not spoken through us as well?" God hears the siblings bickering. Their words are particularly unjustified as Moses is a man of extreme humility:

> **Now Moses was a very humble man, more so than anyone on earth."**
> **(Numbers12:3)**

➤ Why is the humility of Moses mentioned in the context of this scene? How do we know Moses is humble according to Torah? Is Moses rewarded for his humility? Explain. Is there someone in our time you would describe as a very humble person, more so than anyone on earth?

D It is when life is good to us, when we feel powerful and successful, that we are most in danger of becoming overly proud. We must take extra care not to boast and take credit for our good fortune. It is a challenge to remain humble, to remember that it is God, and not us, who is the source of plentitude.

> **Take care lest you forget the Eternal your God . . . When you have eaten your fill, and have built fine houses to live in, and your herds and flocks have multiplied, and your silver and gold have increased . . . then your heart will grow haughty and you will forget the Eternal your God . . . And you will say in your heart, "My power and the might of my hand have won this wealth for me." Then you should remember the Eternal your God, for it is God who gives you the strength to amass wealth . . .**
> **(Deuteronomy 8:11-18)**

➤ Do you think the warning in this passage is fair, that wealth and success can make us more prone to becoming haughty and ungrateful? How might remembering God affect your attitude about wealth and success? How might remembering God affect what you *do* with your wealth and success?

E You might act proud. You can "puff yourself up" as much as you like. But God sees through you. God knows. God sees who you really are.

> **The hidden things are [known] to the Eternal our God . . . (Deuteronomy 29:28)**

➤ Should thinking that God sees all hidden things make one more humble? Why or why not? Has such a thought ever changed the course of your own behavior?

F *Anavah* is an entry point toward living a righteous life. To learn what God wants of us means being open, making room for God. We may have to subdue some of our own desires. Not every whim is worthy.

God guides the humble in the right path, and teaches the humble God's way. (Psalms 25:9)

➤ Why would one need *Anavah* in order to learn? Why is humility necessary in order to live a righteous, spiritual life? Think of your own experience — has humility been a factor in your ability to learn and to grow spiritually?

G Pride and arrogance lead to bad things. humility is the higher ideal.

Pride goes before ruin; arrogance, before failure. Better to be humble and among the lowly than to share spoils with the proud. (Proverbs 16:18-19)

➤ Do you agree with these pronouncements? Can you think of examples in which pride and arrogance could cause ruin or failure? How can you keep pride and arrogance in check?

H A summary of the rewards of *Anavah* is given.

The effect of humility is awe of the Eternal One, wealth, honor, and life. (Proverbs 22:4)

Are these "effects" accurate? Explain. Can you think of any other effects?

Rabbinic

A Our origins are dust, and we return to the ground when we die. Self-importance is an illusion. The meaning of life is less about attaining greatness, more about mastering humility.

Be exceedingly humble, for a mortal's hope is but the grave. (*Pirke Avot* 4:4)

➤ Why should knowing that our bodies return to the ground make us humble? What do you think is the point of the above comment — to depress us, to make us look realistically at our behavior and our values, to give information about what's to come?

B Those who are humble are the recipients of Torah's wisdom.

Rabbi Hanina ben Idi said: "Why are the words of the Torah likened to water, as it is written, 'Ho, everyone that thirsts, come to the waters' (Isaiah 55:1)? In order to indicate that just as water leaves high places and goes to low places, so the words of the Torah leave the one who is haughty, and stay with one who is humble." (*Ta'anit* 7a)

➤ How is the image of water used in this passage? Why does Torah "stay with one who is humble"? How are thirst and humility alike?

C To teach humility is the reason given for why human beings were created at the end of the six days of creation.

Why were human beings created on Friday: So that, if they become overbearing, one can say to them, "The gnat was created before you." (Sanhedrin 38a)

➤ Why should saying, "The gnat was created before you" make someone less overbearing? How often do you reflect on your place in the grand scheme of nature? Is it something you should do in order to become a more humble person?

D Concrete objects are used to illustrate what a person should/should not be like.

> Do not resemble a big door, which lets in the wind, or a small door, which makes the worthy bend down; but resemble the threshold on which all may tread, or a low peg on which all can hang their things. (*Derech Eretz Zuta* 1,3)

➤ What is the meaning of a "big door, which lets in the wind"? Why should you not make the "worthy bend down"? Why is it best to resemble a threshold or a low peg?

E Men and women who are humble in all that they study and do, in the ways they treat all people will be rewarded. Those who are humble are beloved. The following is said about a man. The same could be said for a woman.

> Ever let a man be humble in Torah and good works, humble with his parents, teacher, and wife, with his children, with his household, with his kinsfolk near and far, even with the heathen in the street, so that he become beloved on high and desired on earth. (*Tanna de Be Eliyahu*, p. 197)

➤ This passage makes it clear that one should be humble in all realms of life. Do you think humility is easier in some areas of life than others? In other words, is it easier to be humble with friends rather than with parents (or vice versa)? Is it easier to

be humble doing voluntary good works rather than while on the job? Is it easier to be humble while studying on your own rather than studying with a group? Explain your answers.

F Your stature can be affected by your attitude. It can be affected by whether or not you are humble. On the other hand, God's stature remains steady and sure. God's glory is not dependent on what people say and do.

> Elijah taught, "If people exalt the glory of God, and diminish their own glory, God's glory will be exalted and their own, too. However, if they diminish God's glory, and exalt their own, then God's glory remains what it was, but their glory is diminished." (*Numbers Rabbah* 4:20)

➤ What does it mean to exalt the glory of God? What does it mean to exalt the glory of yourself? What does it mean to diminish the glory of God? Of yourself? How can diminishing your own glory actually make you more exalted? How is God affected if you diminish God's glory?

Tefilah

A Our daily prayers include the recitation of the "*Alaynu*." Halfway through the prayer, we accompany our words with a deep bow. There are other instances, too, when we bow as we say certain words of prayer (see Movement #2 for other instances). Bending the knees and bowing is an expression of *Anavah*. In the "*Alaynu*" we pray, "*Va'anachnu korim u'mishtachavim u'modim . . .* " which means:

> We bend our knees and bow, and acknowledge our thanks before the Sovereign Who reigns over sovereigns — the Holy Blessed One.

➤ Why are certain sections of prayer accompanied by a bow? Do you feel more humble when you are bowing? If so, why do you think that is?

B During the *Yamim Nora'im* (High Holy Days), the *Chazzan* (Cantor) chants the *"Hineni."* This special prayer means, "Here I am!" God is asked to accept the *Chazzan's* prayers which are offered on behalf of the people. This request is made with extreme humility. Some excerpts:

> Here I am . . . I have come to stand and supplicate before You for Your people Israel, who have sent me, although I am unworthy and unqualified to do so . . . Please do not hold them to blame for my sins and do not find them guilty for my iniquities . . . May there be no stumbling block in my prayer . . .

➤ Why is humility an essential quality for a prayer leader? Are expressions of humility a way to get closer to God? Explain.

Post-Rabbinic

A According to Rav Kook, because of your negative qualities you should see yourself as lowly, but of high worth because of your good qualities.

> People can find in themselves exalted, great, and important qualities, as well as lowly and mean qualities. It is for them to see themselves as lowly because of their negative qualities, and as of high worth because of their good qualities. But they must not boast even of their good qualities. On the contrary, even their good qualities should fill them with endless humility, for it is [the good qualities] that challenge them to develop

their other qualities that are in an underdeveloped state. (Adapted from *Abraham Isaac Kook, The Lights of Penitence, The Moral Principles, Lights of Holiness, Essays, Letters, and Poems,* trans. by Ben Zion Bokser, 1978, p. 154-155)

➤ What should your attitude be toward negative qualities? toward positive qualities? How can humility help you to become the best person you can be?

B Rav Kook recognizes that humility can be misinterpreted. It does not mean low self-esteem. If trying to be humble is making you depressed, you're not on the right track.

> When humility brings about depression, it is defective; when it is genuine, it inspires joy, courage, and inner dignity. (ibid., p. 176)

➤ All good virtues can become distorted. Sometimes people go too far to the extreme with a virtue. Other times people misinterpret how they should go about trying to master the virtue. What dangers are there in efforts to become more humble?

C This quotation and #D and #E that follow are from Jewish mysticism. They are abstract, and are therefore meant for advanced study.

> Think of yourself as *Ayin* [nothingness] and forget yourself totally. Then you can transcend time, rising to the world of thought, where all is equal — life and death, ocean and dry land. This is not the case when you are attached to the material nature of this world. If you think of yourself as something, God cannot be clothed in you, for God is

infinite and no vessel can contain God — unless you think of yourself as Ayin." (Dov Baer, *Maggid Devarav le-Ya'akov,* Rivka Schatz-Uffenheimer, ed. Jerusalem: Magnes Press, 1976, p. 186)

➤ What is *Ayin,* and what does it have to do with *Anavah*? How might thinking of yourself as *Ayin* affect your relationship with God?

D God is everywhere. God's essence suffuses all things. There is no place where God is not. God is not separate from you. There is a place for God within you. God is as present inside as outside. Through humility, you begin to understand that you and everything else is a part of God.

> From one of Dov Baer's disciples: The essence of serving God and of all the *Mitzvot* is to attain the state of humility, to understand that all your physical and mental powers and your essential being depend on the divine elements within. You are simply a channel for the divine attributes. You attain this humility through the awe of God's vastness, through realizing that "there is no place empty of It." Then you come to the state of Ayin, the state of humility. You have no independent self and are contained in the Creator. This is the meaning of the verse [Exodus 3:6], "Moses hid his face, for he was in awe." Through his experience of awe, Moses attained the hiding of his face: He perceived no independent self. Everything was part of divinity. (Issachar Baer of Zlotshov, *Mevasser Tsedeq,* Berditchev, 1817, 9a-b)

➤ What does it mean that you are a channel for the divine attributes of God? What does humility teach you about the nature of God? Moses is called a most humble man. What would this passage say is the reason?

E According to Jewish mysticism, the creation of the universe began with an act of *Tzimtzum* — contraction. God withdrew into God's own self to make space for the world. This is perhaps the ultimate act of *Anavah.* It is divine humility. God pulls back in order to allow something else besides God to exist.

> Before the creation of the universe, *Ayn Sof* [the everlasting, never ending, Infinite God] withdrew Itself into Its essence, from Itself to Itself within Itself. Within Its essence, It left an empty space, in which It could emanate and create . . . (Shabbetai Sheftel Horowitz, *Shefa Tal,* Lemberg, 1859, 3:5, 57b)

➤ In what way is *Tzimtzum* an act of humility? What can we learn from God's act of withdrawing? Is there an underlying principle we can apply to our own lives , e.g., might *Tzimtzum* teach us that we, too, should pull back in order to allow others to exist, to make room for others to flourish?

ACTIVITIES

Language Arts

1 (10 minutes) Why is humility between people important? What are the consequences of boasting? Here is a way to introduce the *Middah* of *Anavah.*

Hold a discussion. Write on the top of a blackboard or oversized piece of paper taped to the wall these words: "I'm better than you are." Then ask what happens if a person goes around saying these words all the time. Write down responses.

Continue with some other discussion questions: Why do you think a person might brag about him or herself? When you feel proud of something, with whom might you want to share your accomplishment? What should you say? How should you say it? Is it possible to feel too proud? What would that mean?

 2 (15 minutes) Moses was considered the greatest Jewish leader of all time. Though he was the greatest, he also was most humble.

Talk about why Moses was considered such a great leader. How did he show humility? Complete Text Study, Tanach #C.

Now, write a job description for a great leader. Be sure to include humility as a necessary qualification, explaining why the leader must have this quality.

3 (15-25 minutes) We could say that being humble with ourselves means seeing ourselves as we truly are — both our good qualities and the traits that we need to work on. We all have areas in which we can improve. It is nothing to be ashamed about; yet, this knowledge should help keep us humble. Rabbi Abraham Isaac Kook points out that the good qualities can help us elevate negative ones (see Text Study, Post-Rabbinic #A).

Divide a page in half lengthwise — from top to bottom, making two columns. For the first column put the heading "Good Traits." For the second column use the heading "Traits to Work On." For each column number from 1 to 10. Now fill in the two lists.

Study your lists. Then spend a few minutes writing about how your good qualities can help you improve upon your negative traits or "under-developed qualities."

What is your reaction to this exercise? The object is not to make you feel depressed or ashamed. Rather, the point is to help you feel more clear about who you are and inspired to become the best person you can be. Ideally, you should feel dignity about who you are now, where you happen to be in your personal development. You should feel hopeful and optimistic. Do such feelings reflect your experience?

4 (15 minutes or more) There are things in nature, in the environment around us that can remind us to be humble. One vivid example comes from the Talmud (see Text Study, Rabbinic #C).

The gnat was created before human beings — that's one idea of something to remind us not to become overbearing. Now, try to put some of your own ideas on paper. Write about other things in our environment that can teach humility. For example: dew appears in the darkness, providing moisture for plants, then is absorbed and disappears as quietly as it came; a weeping willow tree can stand tall and exude greatness, though its branches bend humbly, arching toward the ground.

As you write, try to use a poetic style (such as detailed description, metaphor). In a group share what you wrote. Illustrate your ideas, too.

Some discussion questions: Is the world around you an effective teacher of *Middot*? How so? When the world around you is the teacher, are *you* an "effective" learner? Could you improve in any way?

 5 (15 minutes or more) This exercise is similar to the previous one. Rather than nature, material things become the

"teachers" of how to be and how not to be (see Text Study, Rabbinic #D). In that text, people are compared to concrete things — a door, a threshold, a low peg.

Now write some of your own instructional metaphors, using your own words, your own comparisons to illustrate how a person should be. Come up with what a person should not be like (and why), and what a person should be like (and why). You may want to write a few of these comparisons. Illustrating your ideas will add another dimension to this exercise!

Share your writing. What happens when you look at things in new ways? Can the world around you provide unexpected insights? How can you be more sensitive to what the world teaches about *Anavah?*

 6 (15 minutes or more) How should a person show humility before God? Is humility necessary for prayer? Are we humble when *we* pray?

Study the passages in Text Study, Tefilah. To go further everyone should riffle through a *Siddur* to find other passages that reflect humility. Which passages with *Anavah* themes do you find particularly inspiring or moving? Why?

Now create your own prayer on *Anavah.* You might ask God to help you cultivate this virtue. Or, you might write words on another subject that are expressed with humility. Or, you might confide in God about something that makes your feel humble. Another possibility is writing a prayer influenced by mystical ideas. If that's of interest, refer to Text Study, Post-Rabbinic #C, #D, and #E.

Was this *Anavah* prayer easy to write or difficult? Why? Do you think expressions of humility should be included as part of worship?

 7 (15-20 minutes) What does it mean to show humility toward yourself, to be humble with yourself? Is it seeing yourself for who you really are — your good points and your flaws? Does it mean being critical, yet gentle with yourself? Where will your ideas take you if you allow yourself to write down whatever comes to mind concerning *Anavah* (on the level of *Bayn Adam L'Atzmo* — between you and yourself)?

Use a stream-of-consciousness technique. That is, allow the words to flow from your pen without stopping or judging. Try to fill a pages or so, beginning with the words, "I show humility toward myself when . . . "

After you finish, you can go back and take a more critical look at what you wrote. What rings most true? What words are most compelling? Why? What can you do to become more humble with yourself?

 8 (10-20 minutes) In Jewish mystical circles, humility might be identified with *Ayin*, nothingness — making yourself like nothing so that there are no barriers or boundaries between you and God (see Text Study, Post-Rabbinic #C and #D).

Spend a few minutes writing about *Ayin*, "nothing" or "nothingness." What is it? To what can it be compared? What gets you to nothing? How does nothing look? feel? How is "nothing" like humility?

Share what you wrote. Do you think a state of *Ayin* is something (nothing!) you should strive for? Why or why not? If so, what is the best way to go about trying to experience it?

Visual Art

 1 (10 minutes) There are different ways we may show humility when we pray. Bowing is one way. Prostration is used much less frequently. We may close our eyes out of humility. What else?

Draw someone who is praying with *Anavah.* Include what you've seen others do, focus on

what you do, or imagine how humility should be reflected in prayer.

Share your drawings. Do you think you can "do" what you've drawn (pray in the manner depicted in your picture)? Why is humility considered important in prayer?

 2 (10 minutes or more) We know that greatness can be associated with humility. Moses, Joseph, King David are good examples of this (see the Overview).

Draw two figures (people or abstract shapes). The first is proud, arrogant, and boastful. The second is humble. Now, repeat the drawings. This time, somehow show that the humble figure is "greater" than the proud, arrogant, and boastful one. Whatever that means to you.

How did you depict greatness? What other ways might you have done so? What are the top reasons why you think a person should strive to be humble?

 3 (15 minutes or more) In Text Study, Rabbinic #B, Torah is likened to water. After studying the text, illustrate it. You can do one of the following:

a. Draw water leaving high places and going to low places. (Add a written explanation as to what the water stands for, or add the words of the text itself.)

b. Draw words of Torah leaving a haughty person and staying with one who is humble.

c. Mix the images together. Include both water and (words of) Torah.

How does your picture capture the idea of Torah leaving the haughty and staying with the humble? Do you think the water image is a good one? Why or why not? Water runs down because of gravity. How can gravity be a reminder to be humble? Do you think *you* could use the idea of gravity as a reminder to be more humble?!

 4 (20 minutes or more) In Language Arts #4 and #5, participants create metaphors that teach humility. Extend the writing exercises to art by illustrating some of the ideas, some of the metaphors. You could use the images from the Talmud itself or ones you invent, i.e., you could draw a person like a threshold or a low peg (Talmudic image), or draw a humble willow tree (a "new" image).

 5 (10 minutes) We can use color to convey a mood, a feeling. We might use white for purity, bright colors for happiness, grays and black for somber moods. What color or blend of colors is humility? Capturing the "color" of humility gives another angle from which to appreciate this virtue.

Using pastels, fill a sheet of paper with color that suggests humility. Try not to think too much about your choices. Just grab the color(s) that intuitively seem right and fill the page. With pastels you can soften edges with your fingertips, allowing borders between colors to blend into each other, if desired. The object is to give an impression of the virtue. A sense of it.

Share your work. Did others choose the same color or different ones? How do you account for the similarities? How do you account for the differences? How can examining your *impression* of something (a virtue) give you better understanding of it?

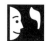 **6** (15 minutes or more) Review the concept of *Tzimtzum* (see the Overview and Text Study, Post-Rabbinic #E). If you were to humble yourself for something or someone, what would it be? What would you make room for? What would that look like?

Create a picture of yourself, a self-portrait in which you are pulling back or contracting in part

of your body. In this empty space, draw what you've made room for. What's happening in that newly formed space? Perhaps you've made room in your heart to hear people's pain. Therefore, in the empty heart-space, draw someone crying. Or, perhaps you've made room in your mind (your head) to be open-minded, less judgmental. Therefore, in the empty mind-space, draw a mini-version of yourself with each of your arms around someone who looks very different form you. Or, maybe you've made room somewhere in the center of your body to be more welcoming toward God. Therefore, you fill the empty space with light.

What did you make room for? Why? Does making room subtract or add to yourself as a person? How much room should you make? Is there anything else (besides what you drew) that you should make room for?

7 (15-20 minutes) Lowliness is often used as a synonym for humility. What does lowliness look like? What feelings does it arouse in us? The word "lowliness" may give us a negative feeling. But what happens if we try to strip away negative associations? What happens if we resist applying preconceived notions to lowliness? Lowliness is just being low. Thinking in new ways about lowliness may give us some insights on *Anavah*. Our artistic imaginations can assist us.

Create a visual composition that uses "low" images to hint at humility. What might you include? Possibilities: grass, worms, other small bugs, tunnels, streams in valleys, streams under bridges, shoe soles, sleeping figures, a gold mine, puddles, fish, coral reefs, figures going down stairs or down hills, digging, gardening.

In a group share your artistic creations. How did you go about making your art? How did you choose what to include in your picture? Did

your direction change in any way once you got involved in the project? If so, how? What do you like best about your picture? In what way does your work reflect or teach *Anavah*?

Drama

 1 (10 minutes or more) You could say that one way to show humility is by using good manners. Using the word "please" before a request means you don't assume you deserve something. Saying "excuse me" shows that you recognize that interrupting or disturbing another person may be bothersome. "Thank you" can be said in such a way that reflects humble appreciation. Saying "I'm sorry" is a way to admit you've done something wrong, to admit a flaw. Of course, for manners to reflect humility, they must be sincere. That is, saying "please" in a demanding voice doesn't count. Neither does saying "thank you" before greedily grabbing a requested item.

Hold a mock teaching session about manners and humility. One person is the teacher; the others are the students. The teacher describes what good manners are, and gives reasons why they reflect humility. Participants can take turns being the teacher. One good way to take turns is to give each "teacher" a different manner to teach. That is, one "teacher" can begin by saying: Our first lesson is on making a request using good manners — using the word "please."

After the first "lesson" is completed, a second "teacher" can have a turn, saying: Our next lesson is on expressing appreciation by using the words "thank you."

Continue with a few more "teachers." Then discuss the experience. Do you agree that working on good manners is a way to become more humble? What manner are you best at? Is there an area of manners you would like to work on?

 2 (10-20 minutes) The Talmud gives us some vivid, concrete images to associate with humility. These texts lend themselves well to dramatic interpretation.

Study Text Study, Rabbinic #C and #D. One text is about the gnat being created before human beings — to remind us not to become overbearing. The other text tells us not to become like a big door or a small door, but rather like a threshold or a low peg.

As extra preparation for creating a skit, students may want to practice some of the "parts." First, the group practices "acting" like a gnat. Then they can show with their bodies what the following look like: a big door, a small door, a threshold, and a low peg.

Participants divide into small groups. Each group is assigned one of the two texts. The texts will be used as scripts for short skits. The groups come up with a dramatic interpretation of their text. After practicing their skits a few times, the groups perform for each other (or for any other audience), teaching a virtue through dramatic presentation. After each performance, share reactions and comments.

 3 (15-20 minutes) Moses is considered one of the all-time humble people. In fact, it is said about him, "Now Moses was a very humble man, more so than anyone on earth" (Numbers 12:3). This statement is made when Miriam and Aaron speak behind Moses' back. They gossip about the woman their brother married and complain about his special leadership role. After Miriam is punished ("stricken with snow-white scales"), Aaron speaks words of regret and Moses says, "O God, pray heal her!"

Study the scene of Miriam and Aaron gossiping and bickering (see Numbers 12). It seems Miriam and Aaron were speaking spitefully. Yet, when God addresses the situation, God says, "Come out, you *three,* to the Tent of Meeting." There are three

people there! Was Moses present during the gossip session?! Let's assume he was. How would Moses have addressed his siblings? What would he have said to them? What would reflect an appropriate and dignified response, and also a humble one?

Reenact the scene from Numbers 12. Three actors — Aaron, Miriam, and Moses — imagine and recreate the conversation between the three siblings. They begin with Aaron and Miriam's negative comments about Moses. From there, they improvise how Moses may have participated in the conversation. Some considerations: When does Moses enter the scene? How much had he heard? How does Moses respond? What do Aaron and Miriam say in return? More than one trio can give this acting challenge a shot.

After the performances, discuss. What did the actors experience? What did the audience observe? Was Moses able to maintain his so-called humility? How was he able to do so? How did Miriam and Aaron react to Moses's humble manner? Can a person show anger or offer rebuke and still be considered humble? Explain.

4 (some time on one's own, plus group time) How do you act humbly? One way to learn how to do so is by closely observing someone who does act in such a way. Once these observations of humility are made, can they be transferred? Can the qualities of the humble person be adopted by you, the actor? Can you become as humble as the person you observed?

Preparation (on your own): Visit a crowded coffee shop or restaurant. Bring a journal. Spend a few minutes observing those around you. Decide which person, which "character," seems to be the most humble. (Yes, this is somewhat arbitrary, but that's not the point.) Then describe (in writing) what you see, with extra focus on details related to humility. Feel free to embellish what you exactly observe. Allow your imagination to provide more

details about this person and this person's humility. If observation "on location" is too ambitious, you could come up with a humble character "from scratch," completely from your imagination. Still, try to provide as many details as you can about this imaginary person.

Back to the group: Share your written descriptions of humble characters. Then each person takes on the character of the person he/she described. Everyone in the group should become their humble character.

Now study texts on humility for a half hour or so, staying in character as you study and participate. Speak as humbly, listen as humbly, be as kind and thoughtful as your character would, etc. You may wish to keep the characterizations going through a recess or break.

After the given time is up, reflect on the experience. How difficult was it to stay in humble character? Were you successful in doing so? Why or why not? What did you learn about humility as a result of this exercise? Will the experience change anything in you? Will it make a difference in terms of your efforts to be a more humble person?

5 (15 minutes) Rabbi Abraham Issac Kook maintains that humility depends on seeing yourself clearly — your good points and your flaws (see Text Study, Post-Rabbinic #A). He says that the good qualities can help elevate "underdeveloped" (or negative) ones. What does this improvement process look like? How do you put this process into action?

A group is divided into pairs. They choose two qualities — one good quality and one flaw. One person represents the good quality, the other represents the flaw. Have the two hold a dialogue. In the conversation the good quality tries to help the flaw improve. That is, the good quality tries to help "develop" the negative one. For example, patience may try to help hot temperedness. Or, generosity may try to influence greediness.

The good quality might use logical reasoning, mention "rewards," appeal to emotions, etc. The flaw might try to explain its behavior, may be a bit defensive, may have some clarifying questions, but finally should agree on some specific steps to take in order to become more "developed" (improved). After a few minutes, switch roles and choose another good quality and another flaw to represent.

Discuss. What was hardest about being the good quality? What was hardest about being the flaw? Do you think the flaw was convinced to make changes? Think of yourself — is there a good quality you have that could help you improve in another area of your life? How would you go about it?

 6 (20 minutes) The *"Hinayni"* prayer is an outpouring of humility during the *Yamim Nora'im* (High Holy Day) services. Throughout the worship, the *Chazzan* prays on behalf of the congregation. Doing so is quite a responsibility. In the *"Hinayni"* prayer, the *Chazzan* expresses humility about the role he or she plays. The essence of the prayer is that the *Chazzan* may not be worthy to pray for the community; yet, that should not stand in the way of the acceptability of the prayers before God. An excerpt of the *"Hinayni"* prayer is included in Text Study, *Tefilah* #B. It would be best for the following exercise to find the whole prayer text in a *Machzor* (High Holy Day prayer book).

The leader passes out copies of the *"Hinayni"* prayer and says: Imagine you are the *Chazzan* during the *Yamim Nora'im*. You have an awesome responsibility. You will be leading the whole congregation in prayer. Are you up to the task? Spend a few minutes studying the prayer with the whole group.

Now, in pairs, one person plays the *Chazzan*, the other represents the community. The *Chazzan* prays the *"Hinayni"* prayer before his/her com-

munity (as represented by the partner). The prayer should be expressed as humbly as possible. (This can be done in English.) Then switch roles, so that each person has a chance to "play" the *Chazzan.*

Discuss the experience with the whole group. How did you feel playing the *Chazzan*? What was it like being the community, listening to the words of the *Chazzan*? If you actually were the *Chazzan* of a community, would you be comfortable chanting the traditional text of the *"Hinayni"* prayer? Is there anything you would want to delete? Anything you would want to add?

Movement

1 (5 minutes) One way to show humility is through bowing. In some cultures a small bow is a part of an everyday greeting between two individuals.

Participants walk around the space, in no particular fashion or direction. When two people happen to come close to each other, they bow to each other in humble greeting.

Discuss. Is bowing a good way to show humility toward another person? In our culture bowing is not part of our usual greetings. What are other ways we can show humility to our friends when we see them?

2 (15 minutes) Bowing is a part of Jewish prayer. There are several times during our worship services in which bowing occurs. Review the following instances. (For more specifics on bowing in prayer, consult a book on Jewish prayer practice, such as *To Pray as a Jew* by Hayim Halevy Donin.)

 a. in the *"Barchu"*

 b. in the *"Kedushah,"* prior to saying *"Kadosh, Kadosh, Kadosh . . ."*

 c. several times during the *"Amidah"*: the first *"Baruch Atah . . ."*; the *"Baruch Atah"* at the end of the first paragraph; at the *"Modim Anachnu*

Lach" paragraph; at the end of the *"Amidah,"* when *"Oseh shalom"* is recited

 d. during the *"Alaynu"* prayer, at *"Va'anachnu korim . . ."*

 e. in the Full and the Mourner's *Kaddish,* at the end of *"Oseh Shalom"*

 f. at the end of *"L'cha Dodi"* — bowing to welcome the "Shabbat Queen"

Practice these bows. Combine the words and the bows in the appropriate places. Then think of as many ways of bowing as you can.

Now you are ready to choreograph your own prayer of humility. If you wrote a prayer of your own (see Language Arts #6), you can use that as an accompanying text. The prayer in movement should include bowing — all different kinds. Individuals or small groups can choreograph the prayers. When everyone is done, perform the prayers for each other.

Discuss. How did you feel as you performed your prayer? What did the audience observe? What other humble movement, besides bowing, did you come up with? Do you think bowing at regular intervals helps you to be more humble during prayer?

3 (10 minutes) In Genesis it is written that our physical origins are dust: "The Eternal God formed man (Adam) from the dust of the earth" (Genesis 2:7). At the end of our lives, our physical bodies return to the ground. This knowledge should help keep us humble. We come from the earth and return the earth.

Improvise freely for a few minutes, exploring movement that follows these guidelines: beginning on the ground, coming to full stature, returning to the ground. Repeat the cycle several times, finding different ways to do it.

What are your reactions to the exercise? Did the cycles feel natural? Why is the ground — being created from the ground and returning to the ground — associated with humility?

4 (10-15 minutes) Gravity serves as a constant reminder to be humble. Everything always goes down. We can only jump so high — we always return to the ground. Perhaps we can say that certain traits shouldn't "leave the ground" either. In this way, we can keep pride and self-importance down to a reasonable level.

"Play" with the idea of gravity. Imagine you are from outer space and are encountering the idea of gravity for the first time. Explore this weird phenomenon. Explore it with your body. Explore it with objects in the room. Show your fascination and amazement in your discoveries of this strange sensation.

After a few minutes, complete your exploration. Then, imagine you and the other participants are part of a panel reporting to your home citizens about this gravity thing. Explain what it is, what it feels like. But go further. Speculate about what gravity is supposed to teach. How might gravity indicate to people that they are supposed to be humble?

5 (15-20 minutes minimum) This activity is similar to Visual Art #7. In that activity humility and lowliness are compared through composing artwork that reflects low things — images from nature and our environment that are somehow low. In the following activity, we take visual images and explore them in movement.

Some low images and things: grass, worms and other small bugs, tunnels, streams in valleys, streams under bridges, shoe soles, sleeping figures, a gold mine, puddles, fish, coral reefs, figures going down stairs or down hills, digging, gardening. The leader calls out, one at a time, one of the items on this list. Participants respond to what they hear by putting the word, the image, in their bodies. For each word they improvise for about 30 seconds to a minute. You can end the activity here or continue with the following.

An extension: Choreograph a dance that uses movement motivated by low images, such as those on the list above. This dance is an abstract study on humility. The study portrays humility as something real and true — something we can notice in our immediate surroundings. The virtue is communicated to us through a myriad of ways, if only we would open our eyes and recognize it!

Perform the dances. Have audience members describe what they saw. How can we be more open to the "lessons" nature might have to teach us?

6 (15 minutes) Review the concept of *Tzimtzum* — God contracting part of God's self to make room for creation. See last two paragraphs of the Overview (before "*Bayn Adam L'Chavero*") and also Test Study, Post-Rabbinic #E. The image of contraction is very physical. Exercises in which a person contracts part of his/her body are often included in the study of modern dance. These exercises can be seen as a small taste of the meaning of *Tzimtzum*.

If possible, have someone familiar with modern dance lead some exercises which use contraction. Then spend a few minutes exploring contraction on your own — pulling back part of your body (then, gently allowing it to float back to place).

Now improvise more with the intention of understanding the notion of *Tzimtzum*. Some music for the improvisation may be desired. Here's the idea:

a. Begin by moving about the space freely. Completely fill the space with movement.

b. As you are moving, slowly notice that you want to make room for something else — something besides yourself, besides your own movement.

c. Start to pull back your movement — somehow, somewhere.

d. Once you've created space within the space, continue moving for a short time more. During this time, show through movement your

attitude toward the space within the space. Is the attitude loving, resentful, indifferent?

One group of dancers can improvise in the space at the same time. The others can watch, then take a turn later. Another possibility is for the "observers" to wait on the sidelines. Once "space" is created (that is, the performers pull back some of themselves), the observers can enter the improvisation. The original dancers (who initiated the *Tzimtzum*) and those who enter the scene (once there is room for them) can then interact together. What happens?

Share reactions to the improvisation. Do you think this exercise gave you a better understanding of *Tzimtzum*? Explain. How might you apply the concept of *Tzimtzum* to your every day life?

Music

 1 (10 minutes) How do we communicate with others in a humble way? How would that sound?

Have everyone sit in a circle. Pass out simple percussion instruments. Instruments might include triangles, drums, rhythm sticks, cymbals, etc. Go around the circle, allowing each person to improvise a short phrase of music, which seems to *sound* humble.

Now imagine the whole group is holding a conversation. But the discussion happens musically. Everyone must make extra efforts to use their "voice" (their instrument) in the most humble way possible. Let the flow of sounds continue for a couple of minutes. After you stop the musical conversation, the leader may wish to make some comments or ask participants for their comments. Then, taking into consideration the feedback, the group tries again.

Discuss the experience verbally. What is the sound of *Anavah*? What role do pauses and silence play in the sound of humility? What is the tempo of humility (slow, fast, moderate)? What is the pitch (high, low, alternating)?

 2 (10 minutes minimum) Music often can "say" things more directly than words. Music arouses feeling. Its impression is felt immediately. Can you communicate humility through music? humility before God? You may be able to come up with a prayer, with words that communicate humility before God (see Language Arts #6). But what would happen if you didn't use words at all? What would be the sound of a prayer of humility that was a melody only?

Compose a *niggun* — a wordless ("lai, lai, lai" or "da, da, dum" type) melody. This *niggun* should be like an *Anavah* prayer. The sound should reflect humility or inspire humility. Or, perhaps the sound will be like a humble confiding before God. Don't make the melody too long. You should be able to repeat it over a few times. Repetition allows you to experience the feeling of the melody more deeply. With each round, you become more immersed in the sense of humility the *niggun* inspires.

Each participant may want to teach his/her *niggun* to a group. Then everyone can learn and sing/hum each melody, repeating it a few times. If there is a melody that makes a special impression, try incorporating it into your worship service. Good places to insert a *niggun* might be: as an opening prayer, or after silent, individual prayer following the "*Amidah.*"

Miscellaneous

 1 (20-30 minutes) The mystical idea of *ayin*, nothingness is compelling. *Anavah*, humility, is associated with this concept. Go over Text Study, Post-Rabbinic #C.

Prepare to take an *ayin*-meditation nature walk. Go outside, to a park or other natural setting. Plan to walk for 20 minutes or more. Empty your mind. Don't think of yourself as separate from anything you see. Continue along your way, as if there are

no boundaries between you and your surroundings. Your *ayin*-humility should fill you with the sense that you are a part of something greater than yourself. You should begin to feel more connected with the greater world, with the universe — with God's flowing essence.

 2 (time on your own) Review the concept of *Tzimtzum* — God contracting part of God's self to make room for creation. See last two paragraphs of the Overview (before *"Bayn Adam L'Chavero"*) and also Text Study, Post-Rabbinic #E.

Consider: What or who do you need to make more room for in your own life? In what way do you need to be like God and pull part of yourself back? Then plan to make a concerted effort to do some actual follow-through. Give yourself a set amount of time — a week, two weeks? Record your "progress" in a journal. How have you pulled back? How have you made room? You also may wish to include thoughts in general about ways to apply the concept of *Tzimtzum* to your everyday life.

CHAPTER THREE

DAN L'CHAF ZECHUT: GIVE THE BENEFIT OF THE DOUBT

דן לכף זכות

OVERVIEW

The three words, *Dan L'Chaf Zechut,* mean "judge [others] according to a scale of merit." But, in order to capture the underlying idea of the Hebrew expression, a more accurate idiomatic meaning would be "give the benefit of the doubt."

There are some other phrases which expand upon the meaning of these words and help us get a clearer picture of the essence of this *Middah,* such as: judge others favorably (with the scale weighted in their favor); don't rush to judgment; don't jump to conclusions; don't immediately suspect others of wrongdoing (even if the situation seems to warrant it, even if it is easy to assume something improper is going on); be generous in judgment; give people a break; look for the good in others.

Such elaboration just to explain this one virtue! It might be said that if so many words are needed to explain the *Middah,* it can't be that significant. Or, if it were really that important, someone would have invented one strong Hebrew or English word for the virtue, right? After all, we have such succinct, to the point, one-word virtues as hospitality, generosity, mercy, and so on. Well, let's not rush to judgment on this *Middah. Dan L'Chaf Zechut* — give the virtue the benefit of the doubt!

This virtue is not obscure. Possibilities for violating it come up all the time. Indeed, how easy it is not to give the benefit of the doubt. Think about all the times in any given day we have the opportunity to make a judgment about someone? Do we leap at assumptions or jump to conclusions? How good are we at refraining from hasty judgment? Read through the following scenarios which highlight challenges to *Dan L'Chaf Zechut.*

1. You call a friend. The friend is not home, so you leave a message. A few days go by, and your friend doesn't call back. You call again. No answer. You leave another message. When the same thing happens a third time, you begin to feel . . . irritated. Your friend is . . . snubbing you . . . she is rude and inconsiderate . . . after all you've done for her. Sure she's busy; we're all busy. Just give me a call . . . is that too much to ask. Finally, after two weeks, the friend calls. She had been called away suddenly on a family emergency. She just now returned and got your message. She called immediately.

2. A classmate has been out with the flu for almost a week. When he returns to school on Friday, there is a test covering the material studied this week. The classmate goes ahead and takes the test, and gets the best grade in the class. You feel sure he must have cheated — after all, he missed the sessions covered by the test. Later, you find out that the classmate's brother had brought home study material from the teacher. The classmate had studied the material diligently, even while sick, and so was able to do well on the test.

3. Your friend borrows money from you, saying she will pay you back tomorrow or the next day. Tomorrow passes, the next day passes, a week goes by. No money. You assume your friend planned all along not to pay you back.

You suspect your friend is hoping you will just forget about the money. Days later, you're sweeping your front hall near your mail slot. You move the rug aside and find an envelope. It must have been dropped through the mail slot. It no doubt slid under the rug. Inside the envelope is the money from your friend with a note of thanks. Apparently, your friend had come by late in the evening of the day she had borrowed the money from you. She hadn't rung the doorbell because it was so late. She had wanted to repay her debt as soon as possible, so that you would have it back without delay.

4. You're driving a car. The car in front of you swerves for no apparent reason. You slam on your brakes, lean on your horn, shout angrily out the window, and make an insulting gesture toward the other driver. As you pass the car, you see that the driver had swerved because a child, chasing a wayward ball, had run into the street.

How might giving the benefit of the doubt have affected the above scenarios? Opportunities for rejecting or embracing the virtue are all around us. *Dan L'Chaf Zechut*, as a virtue, reflects a general attitude. We may or may not rush to judgment concerning a particular situation. But, more importantly, do we give the benefit of the doubt in general in our interactions with others? Isolated occasions of judging others favorably is not enough. We need to strive to make such mental generosity a regular part of our way of relating to people.

And the virtue isn't limited to relationships with other people. Giving *oneself* the benefit of the doubt, judging *oneself* on the scale of merit also applies. All of us have told ourselves things like: "Oh, I could never learn Chinese; I'm not smart enough." "I have no creative talent." "I don't make efforts socially because I don't think people are that interested in getting to know me." "I'd be a lousy parent." We may have amassed quite a list of such "judgments," all of which

violate the *Middah* of *Dan L'Chaf Zechut*. We need to give ourselves the benefit of the doubt. We might just be smarter, more talented, more likable, more competent than we give ourselves credit for. (Of course, we shouldn't give ourselves too much credit. *Anavah* [humility] is another important trait!)

We usually don't assume we are in the position of judging God on a scale of merit or on any other kind of scale, for that matter. God is beyond being weighed or measured. On the contrary, it is *we* who hope and pray that God will judge *us* on the scale of merit! We think of God as being in the position to judge us. But we do "give the benefit of the doubt" to God by having confidence in God, by having faith and trust in God's justice and mercy.

The concept of judgment is complex and the procedures to achieve it are very involved. This is so in modern society, and this has been the case for millennia. Jewish literature focuses on legal issues (judgment, justice, courts, law, punishment) more than on any other topic. *Dan L'Chaf Zechut* is like a commentary, an ethical gloss on the subject of judgment. The virtue helps temper the potential harshness of judgment, and reign in the temptation to judge too quickly.

Dan L'Chaf Zechut can be applied to complex issues related to judgment, and it can serve us well in our day-to-day lives. Making assumptions can harm us and can harm others; rushing to judgment can destroy reputations and relationships. Our success in mastering *Dan L'Chaf Zechut* is something we may need to check often, as each day places opportunity for judging others before us. How did we respond last time? How will we respond next time? Can we do better?

Not only do we need to master *Dan L'Chaf Zechut* in our relationships with others, we need to attend also to this *Middah* as it relates to ourselves and to God. All three of these focus areas for *Dan L'Chaf Zechut* are summarized below.

 BAYN ADAM L'CHAVERO, BETWEEN PEOPLE. Judging *people* on the scale of merit, giving *others* the benefit of the doubt, is the plain meaning of *Dan L'Chaf Zechut.* Are we generous in judgment? Do we tend to see others in the best possible light, judging them as favorably as possible? Do we wait until all the facts are in? Once we can answer yes to all those questions, we will be on our way to mastering the virtue.

 BAYN ADAM L'ATZMO, BETWEEN YOU AND YOURSELF. Every person has an enormous potential in many realms of life. Do we really give ourselves credit for our strengths and creativity? Humility may also be a good trait, but false modesty or making excuses for not living up to our best potential are not worthy traits. Judge ourselves favorably; look for the best in ourselves.

 BAYN ADAM L'MAKOM, BETWEEN YOU AND GOD. It is not within our purview to judge God. But there are times when we may have doubts about the nature of life and the "fairness" which we witness or experience. To employ this virtue with respect to God means that we reserve judgment, nurture a positive attitude toward life and the workings of nature, have confidence that all will be "fair" in the divine scheme of things, and cultivate trust and faith.

TEXT STUDY

Tanach

A Joseph gives his brothers the benefit of the doubt. Though they sold him into slavery, he takes a wider view of the situation. What the brothers did had a purpose that they could not have known.

Joseph . . . cried out . . . to his brothers. "Do not be worried or angry with yourselves because you sold me into slavery; the purpose was to save life . . . God sent me ahead of you to make sure you survived on earth and to save your lives in a remarkable deliverance." (Genesis 45:1-7)

➤ What is the benefit of the doubt Joseph gives his brothers? Do Joseph's brothers *deserve* this favorable judgment of their actions? Should you give others the benefit of the doubt even if they don't *deserve* it? Does it seem that Joseph is also giving the benefit of the doubt to God? Explain.

B Hannah is barren and prays to God of her anguish. Eli the priest assumes she is drunk. The Talmud explains that people who falsely suspect others, as Eli did, need to offer apologies, and even blessings. That is, they need to make amends for not giving the benefit of the doubt, for not carrying out *Dan L'Chaf Zechut.*

As [Hannah] kept on praying before the Eternal, Eli watched her mouth. Now Hannah was praying in her heart. Only her lips moved, but her voice could not be heard. So Eli thought she was drunk. Eli said to her, "How long will you make a drunken spectacle of yourself? Sober up!" And Hannah replied, "Oh no, my lord! I am a very unhappy woman. I have drunk no wine or other strong drink, but I have been pouring out my heart to the Eternal. Do not take your maidservant for a worthless woman; I have only been speaking all this time out of great anguish and distress." "Then go in peace," said Eli, "and may the God of Israel grant you what you have asked . . ." (I Samuel 1:12-17)

From this passage the Talmud posits a teaching which can be applied to daily living.

> Then Eli answered and said, "Go in Peace." Rabbi Eleazar said: From this we learn that those who suspect their neighbors of a fault which they have not committed must beg their pardon. And even more, they must bless them, as it says: "And may the God of Israel grant you what you have asked" (I Samuel 1:17). (*Brachot* 31b)

➤ What did Eli do that showed he was not giving Hannah the benefit of the doubt? How did Hannah react? What does Eli say when he realizes he'd been mistaken in his judgment of Hannah? What lesson does the Talmud see in the interchange between Eli and Hannah? Should Eli have behaved differently toward Hannah? What could Eli have done in order to give her the benefit of the doubt? If you had been in Eli's place, would you have "jumped to conclusions" as quickly?

Rabbinic

A The origin of the actual term *"Dan L'Chaf Zechut"* is from *Pirke Avot* 1:6.

> Joshua, son of Perachyah, said: Judge all people on the scale of merit.

➤ "Judge on the scale of merit" is a literal way of translating *Dan L'Chaf Zechut*. "Give the benefit of the doubt" is more idiomatic. Which translation do you like better, and why?

B There are ways in which we can heighten our willingness to give the benefit of the doubt. Hillel offers some relevant advice.

> Hillel said: Judge not your fellow until you have been in that person's place. (*Pirke Avot* 2:5)

➤ Say you followed Hillel's advice. Would you be more likely to judge others on the scale of merit, to give the benefit of the doubt? Do you yourself follow Hillel's advice? Should you try harder to do so? How might your relationships change with others if you refrained from judging others until you had been in their place? Can you ever really know what another person is going through? If not, how does that impact on the validity of judging others — is it ever fair to jump to conclusions, to make assumptions?

C Moses doubts that the Israelites would believe in God, and he is punished for his suspicions concerning them. Moses learns a lesson about giving the benefit of the doubt.

> Resh Lakish said: Those who are suspicious of innocent people will be smitten in their bodies. Thus, when Moses said, "But, behold, they will not believe me" (Exodus 4:1), the Holy One, to whom it was known that they would believe this, said to Moses: "They are believers, children of believers. It is you [Moses] who will end up not believing." And where is the proof that Moses was smitten? The verse "And the Eternal said furthermore unto him: 'Now, put your hand into your bosom.'" And he put his hand into his bosom. And when he took it out, behold, his hand was leprous, as white as snow (Exodus 4:6). (*Shabbat* 97a)

➤ What does Moses say that shows he was not giving the benefit of the doubt? How does God react? Have you ever expressed feelings of doubt similar to those Moses expressed, feelings which judged people unfavorably? What was the result?

D In this story one man is "set up" to be judged unfavorably by his companion. Despite the set-up, the man is judged by his companion with the scale weighted in his favor.

> There once was a young girl who had been taken captive. Two saintly individuals went after her to ransom her. One of the men entered a harlot's house [where the girl was being held]. When he came out, he asked his companion: "Did you suspect me of anything?" The other replied, "Of finding out perhaps for how much money she is being held." Said the first, "By the Temple service, so it was!" And he added, "Even as you judged me with the scale weighted in my favor, so may the Holy Blessed One judge you with the scale weighted in your favor." (*Avot d'Rabbi Natan*, chapter 8; also see *Shabbat* 127b for several stories of a similar nature.)

➤ What is it about the situation that could easily arouse suspicions of impropriety — that could make one think that improper behavior was going on? At the end of this story, why does the man tell his companion, "You judged me with the scale weighted in my favor"? What would you have said if you had been the companion in this story?

Post-Rabbinic

A The Baal Shem Tov makes a connection between a commandment and a virtue.

> Said the Besht (Baal Shem Tov): "From the biblical commandment to love your fellow person as yourself [*V'Ahavta le'rayachah kamocha*], we learn the Talmudic virtue to judge your fellow person on the scale of merit [*Dan L'Chaf Zechut*]. Since you always find excuses for your own misdeeds, make excuses

also for your fellow person." (*Derech Emunah Umaaseh Rav*, Warsaw, 1898, p. 59)

➤ Do you think judging your fellow person on the scale of merit is *required* in order to fulfill loving your fellow person as yourself? Consider what the Baal Shem Tov says about making excuses for people. Do you agree that making excuses for others should be part of the requirements of *Dan L'Chaf Zechut*?

B The tendency is to think that when you don't judge others on the scale of merit, you harm those individuals. You might assume such harm is the reason why you should refrain from weighing others' thoughts, motivations, actions, etc. A Hasidic saying gives us something else to consider.

> When you talk to people, do not weigh whether or not their thoughts are clinging steadfastly to God. A soul that weighs suffers harm. (Martin Buber, *Ten Rungs: Hasidic Sayings*, p. 101)

➤ What reason does this saying give for not weighing whether or not others' thoughts are clinging steadfastly to God? How might a soul that weighs suffer harm? Do you agree with this saying?

ACTIVITIES

Language Arts

1 (10 minutes) The Overview includes four examples of scenarios in which the benefit of the doubt is not given. Review those. Then, come up with examples of your own — either from actual experience or made up altogether. In terms of actual experience, you may want to think of the most recent occurrence

of when you did not give someone else the benefit of the doubt. Be sure to discuss how the situation might have been different had *Dan L'Chaf Zechut* been kept in mind.

 2 (10-15 minutes) When Eli wrongly suspects Hannah, he has to apologize to her, plus offer her a blessing (see Text Study, Tanach #B). Not giving the benefit of the doubt to someone may result in the need to offer an apology. Eli's apology is short and to the point: "Go in peace, and may the God of Israel grant you what you have asked." (I Samuel 1:17)

Imagine you have harmed someone by not giving the person the benefit of the doubt. Using one of the four scenarios in the Overview, imagine the person you suspected found out about your suspicions. Or, you can come up with your own scenario. Now write a letter of apology to the person for judging him/her unfavorably.

In a group share your letters with each other. Is there a letter you *really* need to write (or that you should have written a long time ago)? It's not too late — write and send that letter as homework!

 3 (10 minutes) When we think of *Dan L'Chaf Zechut*, we might get the picture in our mind of something that happens between two people. One person should judge another person favorably. But very often not giving a person the benefit of the doubt becomes contagious. It's called everyone picking on one person. A whole group can bully one individual. One person makes an unfavorable judgment of one other person, and then others join in.

Talk about the above experience. Is it something the group has witnessed? experienced or participated in? Is *Dan L'Chaf Zechut* something that operates in your classroom (or other place of meeting)? Do the people in your community give each other the benefit of the doubt? Come up with as many reasons as you can as to why *Dan L'Chaf Zechut* should be a rule in your classroom (or other relevant place).

 4 (15 minutes) Do we give our public figures the benefit of the doubt? Are they any less deserving of receiving the benefit of the doubt than anyone else? If we vote someone in as president, are we obliged to weigh his/her actions on the scale of merit? What about rich, famous, glamorous movie stars — should we judge them more harshly because of their privileged lifestyle?

Bring in a bunch of different newspapers and magazines. Assign one for each individual or small group to examine and report on. They are to look for how well the newspaper or magazine follows the principle of *Dan L'Chaf Zechut*. Rate the newspaper or magazine on a scale from one (lowest) to ten (highest) in terms of practicing the virtue. Then explain the rating you gave and why it deserves that particular rating.

Hold a discussion. In general, does our culture, through media, give people the benefit of the doubt? *Should* newspapers and magazines give people the benefit of the doubt? That is, should they tilt the scales one way or the other; or neither way (if that's possible)?

5 (10 minutes) It may be clear that giving the benefit of the doubt is a good thing. Even so, you are not supposed to deliberately do things that look suspicious, then trust and expect others will give *you* the benefit of the doubt. There's a Jewish concept called *meirat ayin* (inciting or alerting the eye — that is, other people's eyes). In English, we might say causing others to "raise their eyebrows." In other words, *meirat ayin* suggests avoiding doing things that easily arouse others' suspicions, that look bad. For example, if you claim to be a strictly

kosher person, you shouldn't be seen at the local hog roast, even if you plan to consume only a can of certified kosher Coke. Being seen there surely would raise an eyebrow or two. In Text Study, Rabbinic #D, the man entering the harlot's house knew it looked suspicious (*meirat ayin*). Luckily, for him, despite the fact that it didn't look good, the man's companion still gave him the benefit of the doubt.

Review the above mentioned examples of *meirat ayin*. You also may want to check out the extensive examples given in the Talmud, *Shabbat* 127b. Then, brainstorm examples of *meirat ayin*.

Meirat ayin and *Dan L'Chaf Zechut* are both important principles in Judaism. Do you tend to pay attention to one of these principles more than the other? What most do you need to work on concerning either *meirat ayin* or *Dan L'Chaf Zechut*?

 6 (15 minutes) Though Joseph's brothers had treated him wrongly, Joseph eventually is able to judge what happened in a favorable light (see Text Study, Tanach #A). Joseph also gives God the benefit of the doubt.

Everyone has doubts now and then. Even big doubts — concerning major decisions, life directions, relationships, and so on. Write about serious doubts you had at some point in your life. Why did you feel doubtful and how did you deal with the doubts? Then explore the meaning behind the path you eventually took. How did the way you resolved the doubts become revealed to you? Is the meaning of the path you chose (after doubting) still in the process of being revealed to you?

 7 (10 minutes) As a variation on #6 above, focus on self-doubts and how you overcame them. Are there ways in which you judge yourself more favorably than you

used to? What do you need to work on now in terms of giving yourself the benefit of the doubt?

 8 (15 minutes) Judging another's spiritual worthiness is misguided. It's not a good idea to weigh whether or not others' thoughts are clinging steadfastly enough to God. Doing so causes harm to your own soul. So we learn from a Hasidic saying (see Text Study, Post-Rabbinic #B). Have you experienced or witnessed harm that has come about because of religious conflicts — because one person judges the other unfavorably in terms of the other's religious observance or commitment?

Religious conflicts of this sort may take place in various contexts, e.g., within the realm of a large Jewish population, like Israel, or within the confines of the local synagogue. Invite a guest to class (or other setting). The person could be an Israeli who has good knowledge of religious conflicts in Israel, or the person could be a representative from your synagogue's Ritual Committee. Begin by sharing with your guest the passage about harm caused by judging others' religiosity (see Text Study, Post-Rabbinic #B). Then ask your guest some questions, such as:

a. What conflicts have you experienced or witnessed concerning religious issues?

b. What happens when the different parties try to discuss conflicting views?

c. Do people who are in disagreement give each other the benefit of the doubt? What results when they don't judge each other favorably?

d. Have you seen religious conflicts resolved peaceably? What were they, and how was it done?

e. Do you agree with the Hasidic saying?

Visual Art

1 (10 minutes or more) *Dan L'Chaf Zechut* literally means "judge on the scale of merit." What would such a "scale" look like?

Using clay, design and sculpt a scale that reflects the meaning of *Dan L'Chaf Zechut*. A few ideas: You may want to depict the scale as tipped to the side of merit, with one side of the balance (merit) larger than the other, and/or for the merit side, show an extra weight attached so that the side will be "favored."

Share your artwork. Artists can explain their artistic vision — how they decided to create what they did. Would you like to be judged on the kind of scale you created?

 2 (10 minutes or more) This exercise is similar to the previous one. It, too focuses on the image of the "scale of merit."

"On a scale of merit" is an abstract concept suggesting an approach for how to judge someone. Draw someone being judged on the scale of merit. The challenge is to depict this abstract concept more on a literal level, such as making a person standing on a scale. If you would rather, explore a different, related image. A few ideas are given below. These ideas come from idiomatic expressions. Again, any one of the concepts which follow can be depicted more literally.

a. Don't jump to conclusions.

b. Don't rush to judgment.

c. Let your first reaction to someone's actions be that his or her "heart is in the right place."

d. Hold your horses before you start raising your eyebrows! (A double-idiom!)

e. Give him/her a break.

f. Give the benefit of the doubt. (A couple of questions to get you started: What does a "benefit-of-the-doubt" look like? How could you show someone "giving" it?)

g. Make up your own idiom-like expression.

In a group show your artwork to others. Share comments and invite questions.

 3 (15 minutes) In the Overview four scenarios are given. They illustrate *not* giving the benefit of the doubt. The question is asked: How might the scenarios have been different had the benefit of the doubt been given? In this activity participants will show how so.

Choose one of the scenarios mentioned in the Overview, or else come up with your own. (An activity for coming up with scenarios is described in Language Arts #1.) Create split-scene drawings. One side should show the scenario when the benefit of the doubt was not given. The other side should show the same scenario — this time as if the benefit of the doubt had been given.

In a group share your artwork. Explain each side — why one shows not giving the benefit of the doubt; why the other side shows giving it. If you were present, as the judging person, in the scenario you depicted, on which side would you probably find yourself — side one or side two — giving or not giving the benefit of the doubt? Where would you *like* to be?

 4 (time will vary) This is a particularly advanced activity. The artistic process often involves seeing things in different ways, from different angles. When artists look at a subject to draw or paint, they may try to figure out what stands out most, what is special, how the subject or the scene can be captured in the best light or from the most interesting angle. They will attempt, in a certain artistic way, to give the benefit of the doubt, to "judge" and show their artistic subject favorably. Giving the benefit of the doubt may happen by looking for, seeing, and expressing beauty that exists in the seemingly ordinary. For example, take a street scene on a rainy, sloshy day. Typically, we may judge such a

scene as messy, cold, unpleasant, gray, and so on. But the artist may find something else. The artist might judge the scene on the scale of merit. The artist might see the glaze and shine of raindrops, the mystical feel of colors and images seemingly running together, the appeal of huge magenta outdoor café umbrellas brightly breaking up and surprising the feeling of grayness. Other examples: A crowded, dusty, bustling village might become a charming, colorful, intimate rural scene with the help of the artist's paintbrush. An ordinary country stable may be depicted to suggest the best of memories — the best of freedom and childhood, the love of animals.

Use the above ideas as inspiration for a drawing or painting. Find a scene, a subject you wish to draw or paint. Study it. What "merit" do you see? What stands out the most? What is most positive or inspirational? A poor, crowded village might be flooded with optimistic sunshine and lushly surrounded with a shelter of palm trees. The sunshine and the trees might be given an extra central role. They can be given an expanded, larger-than-life presence in the art piece. A portrait of a person could bring out his/her best features, all that is most beautiful about the person.

Share, explain, and display your artwork. What did the artistic process teach you about *Dan L'Chaf Zechut*, giving the benefit of the doubt? (Note: See Movement #5 below for a creative movement version of this activity.)

Drama

 1 (10 minutes) To understand *Dan L'Chaf Zechut*, you need to be clear about the difference between suspecting versus giving the benefit of the doubt. You can take the idea of suspecting to the smallest level in order to get the feel of what that attitude is all about. For example: Is that pen really a pen — or is it some kind of squirting ink trick? Is that orange really a delicious, nutritious piece of fruit — or has someone injected it with poison? Is that chair really safe to sit down in — or are those seemingly sturdy wooden legs simply brown-colored pieces of weak styrofoam?

Play a little drama game in which you pass ordinary objects around the circle of participants. As each participant takes the object, he/she looks at it, examines it with great suspicion. Gradually, the participant tries to overcome his/her suspicion and give the object the benefit of the doubt. (The pen is really a fine writing instrument, not a squirting-ink trick. The orange is not filled with poison after all. The chair is safe to sit in, etc.) In short, participants will show suspicion becoming favorable judgment.

After several objects have been passed around the circle, discuss the experience. How did you show suspicion? What did you do to show your attitude was changing, that you were making an effort to judge favorably? Was it hard to overcome your suspicion once you began with it? Do you tend to be someone who usually views people and situations favorably, or are you generally suspicious at first? Are there times when it may be desirable to "begin" with suspicion (as when a stranger offers you a ride home)? Overall, what do you need to work on most — being more trusting or more suspicious of others?

 2 (10 minutes) This activity is similar to #1 above. But rather than working with objects, people are the focus.

The group divides into pairs. Half of all pairs stand on one side of the space; half stand on the other. The pairs will practice greetings. Several pairs can do the greetings at the same time (so that the activity doesn't drag at too slow a pace). The basic format is this: Each person from a pair walks toward the center of the room toward his/her partner. The two greet each other, then continue on to the opposite side of the space. They repeat greetings four times, doing the following variations:

a. They walk as if they hold great suspicion for each other.

b. They walk as if one suspects and the other judges favorably — that is, one does not give the benefit of the doubt and the other does.

c. Same as above with reversed roles (the one who suspected now judges favorably, and the one who judged favorably now suspects).

d. The two walk as if they both are giving each other the benefit of the doubt; they both are judging each other favorably.

Discuss. Describe how you felt doing the different greetings. Did it seem more natural to suspect or to judge favorably? Which greeting is most representative of how you greet friends? strangers? acquaintances? family members? Should *everyone* be judged on the scale of merit, or just some people?

 3 (10 minutes or more for each dramatic reenactment) There are many examples presented in this chapter that show the benefit of the doubt being given or not being given. Any of those scenes can be reenacted on a dramatic level. A class might choose to reenact several scenarios. A number of such scenarios could be presented, one following the other, for a more full-length performance featuring the virtue of *Dan L'Chaf Zechut*. Here are some suggestions for scenarios to reenact:

a. One of the four scenarios described in the Overview. (See also Language Arts #1.)

b. One of the four scenarios described in the Overview, this time including what would happen if the person you suspected found out you had doubts about him or her. (See also Language Arts #2.)

c. Joseph giving the benefit of the doubt to his brothers; to God. (See Text Study, Tanach #A.)

d. Eli the priest being suspicious of Hannah, then backing off once she has explained herself. (See Text Study, Tanach #B.)

e. Moses suspecting that the Israelites would not believe in God. (See Text Study, Rabbinic #C.)

f. The man who goes into the harlot's house to ransom a young girl who had been taken captive there. His companion easily could have suspected something improper took place when he saw the man entering the harlot's house. Instead, the man is judged by his companion on the scale of merit. (See Text Study, Rabbinic #D.)

 4 (5-10 minutes) Do you ever make faces at yourself in the mirror? The expression on your face just may reveal whether or not you are judging yourself on the scale of merit.

Look in a mirror. Come up with five different facial expressions. These should be ones you might make while looking at yourself, but *not* judging yourself favorably. Then come up with five when you are judging yourself favorably. Share those facial expressions with a group if you like. You could have several people join together, making their faces. This group would become like a changing tableau, a slide show of different facial expressions. There would be five "slides" of non-*Dan L'Chaf Zechut* facial expressions, then five "slides" of pro-*Dan L'Chaf Zechut* facial expressions.

5 (10 minutes) Not judging favorably is similar to being negative. Judging favorably is similar to being positive. Participants will experience the difference between negating and affirming. They then will relate their experience to the *Middah* of *Dan L'Chaf Zechut*.

The group divides into pairs. The pairs can do the activity at the same time. Or, one pair at a time can perform (improvise) for everyone else. One person in the pair is the storyteller; the other is the reactor. The storyteller should relay a story about his or her life to the reactor. The

story can be as simple as describing what happened so far that day, what happened yesterday, what happened last weekend, plans for the summer, etc. As the storyteller talks, the reactor continually negates what the storyteller says. The reactor is suspicious, doubting, and unmerciful in judging the storyteller's actions. The reactor gives the "non-benefit" of the doubt. (Words the reactor might say: "No, no — you couldn't have done that . . . I don't believe that for a minute . . . You're full of hot air . . . No way . . . ") After a minute or two, a leader calls out for the reactor to switch to *Dan L'Chaf Zechut* — from negating to affirming, from reacting unfavorably to reacting favorably to what the storyteller says. Then change roles — the storyteller becomes the reactor, and the reactor becomes the storyteller.

Discuss. What did the storyteller feel when the reactor was negating everything he/she was saying? How did the storyteller feel when the reactor was affirming? How did the reactor feel about his/her role? If there was an audience, what did they observe? What lessons did this activity teach that can be applied to "real life?"

Movement

1 (10 minutes) Drama #2 fits into the category of movement as well. In this activity participants practice walks and greetings that reflect either suspicion or favorable judgment.

2 (10 minutes or more) There are different ways to express the concept of judging on the "scale of merit." There are expressions for related ideas as well. In Visual Art #2, participants are asked to depict through art an idiomatic phrase related to *Dan L'Chaf Zechut*. The same thing can be done through creative movement. Refer to the idiomatic expres-

sions listed under Visual Art #2, and come up with a movement interpretation for one or more of them. If you like, make a game of it: Have individuals or small groups make up an interpretation for one of the phrases. Then see if the others can guess what the phrase is after it is "performed" for them.

3 (15 minutes) Review Text Study, Tanach #B, which describes Hannah's experience being judged unfavorably by Eli the priest. Once Eli realizes he's mistaken, he reverses his opinion of Hannah. He makes amends and blesses her. It's not always easy to reverse the damage you can do by unfairly suspecting someone.

Everyone imagines they are Eli the priest. Each person comes up with a movement phrase that expresses Eli's suspicious attitude, plus his condemning words — "How long will you make a drunken spectacle of yourself?" (Perhaps some kind of stomping march forward with a couple of aggressive jumps, plus a spinning turn initiated by an arm and finger flinging out accusingly!) Once everyone has the phrase, they perform it a few times.

The leader coaches participants to express fully Eli's attitude and demeanor through their movement, then reminds them how Eli ended up being wrong in his assumptions about Hannah. Eli had to go back on his words; he had to make amends, apologize. Emphasize how difficult it is to take back what you did that was wrong, to reverse unfavorable judgments. Have participants experience a "reversal." Ask them to reverse the accusing movement phrase they made up for Eli. They are to do the exact same thing they made up — backwards!

An extension: Set the movement, and create a more fully choreographed piece about Eli. It will include three variations on the damning, accusing phrase of movement. First, the accusing phrase of

movement itself. Second, the movement phrase in reverse. And third, the movement phrase moving "forward" again, but completely revamped — reflecting apology, blessing, perhaps regret, as in the words, "Go in peace, and may the God of Israel grant you what you have asked . . . "

Share reactions to this exercise. What was easiest to do? What was most difficult? What did the reversal of movement teach you about "reversing" false suspicions of others?

 4 (10 minutes) When you do not give others the benefit of the doubt, it is as if you are negating them in some way — you are opposing them, you are favoring negativity. The opposite is true when you do give others the benefit of the doubt — you are affirming, you are favoring a positive response. Experience through movement what it is like to be negated as opposed to being affirmed, why it is preferable to give, and be given, the benefit of the doubt.

The group divides into pairs. The pairs can do the activity at the same time. Or, one pair at a time can perform (improvise) for everyone else. One person in the pair is the movement initiator; the other is the reactor. The reactor will echo the initiator. But the echo will have a "twist" to it. The initiator should do a simple movement, such as swinging a leg, or taking four steps around in a circle. After the initiator makes his/her movement, the reactor will echo it. The "twist" is that the echo is to somehow negate the initiator's movement. The reactor might distort the initiator's original movement — repeat it with a stomping, angry rhythm or repeat it with a slinky, suspicious air to it, etc. The initiator then will do his/her movement again. The second time the reactor repeats or "echoes" the movement, he/she is to do so in a way which affirms the initiator's movement. Perhaps the reactor will make the

movement bigger and more spirited, more refined and elegant, or repeated in an extra upbeat rhythm. After a few rounds, have pairs switch roles.

Discuss. What did the initiator feel when the reactor negated (negatively echoed) what the initiator was doing? How did the initiator feel when the reactor was affirming? How did the reactor (the "echo-er") feel about his/her role? If there was an audience, what did they observe? What lessons did this activity teach that can be applied to "real life"?

 5 (time will vary) Visual Art #4 shows how an artist may depict his/her subject by "giving the benefit of the doubt" to the object, scene, or model, thus showing his/her subject at its best. This activity can be adapted to movement. It becomes an even more abstract exercise, however.

Participants should try to experience this activity in an environment that has some variety and diversity to it — perhaps a playground, botanical garden, a preschool room, a special outdoor environment (by a lake or river, a courtyard, etc.), perhaps even a synagogue sanctuary. Echo or express some of the objects you see in the environment, using your body. That is, you move from one object to another. Your body becomes like a mini-painting. Whatever the objects are that you choose, you use your body to reflect the "best" about the objects, to highlight what is most favorable, most deserving of merit. You give the benefit of the doubt to any and every object you encounter, and show that in your physical response.

Share reactions to this improvisation. Was it hard to find, to uncover the best? Was it hard then to express that in your body? How did you do so? What did this improvisation teach you about *Dan L'Chaf Zechut*, giving the benefit of the doubt?

Music

 1 (15 minutes or more) Music is a great way to communicate an idea. Try coming up with a song that will explain *Dan L'Chaf Zechut*. For a "story-line" for your song, you may wish to use one of the four scenarios presented in the Overview. Here's an example of lyrics for a song based on the first scenario.

Say you call your friend, on the phone,
Trouble is — nobody's home.
You leave a message on the machine —
Say something nice, never something mean.

You give the benefit of the doubt —
Dan L'Chaf Zechut,
Give the benefit of the doubt.
Next day comes, you call another time,
Two days in a row — that's surely not a crime.
Once again you tell the machine —
"Hi, it's just me,"
But not one calls you back —
To call again would be number three.

Will you give the benefit of the doubt,
Dan L'Chaf Zechut,
Give the benefit of the doubt?

It's been two weeks now,
You're feeling quite distraught,
Your friend just has no manners,
Must never have been taught.

And you've lost it — that benefit of the doubt,
You've ditched it — *Dan L'Chaf Zechut*.

Then, suddenly, while you're sitting, slumped over, feeling mad,
Your friend phones —
"Sorry I didn't call back;
Guess what happened —
it's really bad."

But you never reveal how you could have —
Given the benefit of the doubt;
Should have — *Dan L'Chaf Zechut*,
Next time — will give the benefit of the doubt.

 2 (10 minutes) Movement #4 can be adapted for the category of music. Instead of using physical bodies to initiate and echo movement, use instruments to initiate and echo sounds.

CHAPTER FOUR

DIBUK CHAVERIM:
CLEAVING TO FRIENDS

דִּבּוּק חֲבֵרִים

OVERVIEW

Is friendship a virtue, a *Middah*? Friendship is a kind of relationship. Just having a friend doesn't necessarily make one virtuous. But cleaving to friends can. What is the significance of cleaving? This *Middah* isn't about having friends or spending time with friends. While those things might be included in cleaving, the meaning of *Dibuk Chaverim* seems to go deeper. Cleaving suggests how we treat friends, how we honor and respect friendship, to what degree we make friendship a priority, loving and appreciating friends, devotion. Cleaving to friends shows a valuing of a special relationship. Thus, it is the way we treat friendship that can be a virtue.

Dibuk Chaverim is counted among the 48 virtues listed in *Pirke Avot* as necessary for acquiring Torah. Because acquiring Torah is about learning and righteous living, this means that cleaving to friends is an important part of learning and righteous living. Friendship helps lead us to become the best person we can be.

We could go even further. Cleaving to friends doesn't only *help* us to learn and *help* us to become a righteous person, it is essential for both. Cleaving to friends *is* learning. And cleaving to friends *is* righteousness. We learn from, through, and with our friends. We can't excel in learning without friendship. As integral as books are to learning, so are friends. Rabbinic literature has always been studied by people in pairs. Such study is called *chevruta*, from the word *chaver*, friend. It is through such friendship partnerships that learning

increases, wisdom is passed down, and understanding becomes more profound.

In our tradition learning is linked to righteousness. Friendship teaches righteousness — how to be, how to grow, how to master *Middot*. We can't have righteousness without friendship. Friendship may not be *all* we need for righteousness, but it is significant. Consider the following: the kind of friend we cleave to helps us to reach our highest potential. A friend provokes ideas, helps us focus when we get off track (academically, socially, or emotionally), supports us, loves us, encourages us, corrects us . . . and, of course, enables us to reciprocate in kind. Through friendship we learn what it means to teach, to become a supportive person, to be loving, to be encouraging, to offer correction in a sensitive way. How can we become all that we can be without a friend? It hardly seems possible. To "acquire Torah" we need to cleave to friends. And, ideally, *Dibuk Chaverim* leads to other virtues as well.

It says in *Pirke Avot (1:6)*, "Acquire for yourself a friend." It is interesting that the singular is used here, not the plural. The kind of friendship that nurtures our best selves is something very rare. We can have many acquaintances, people with whom we enjoy spending time, but a true friend is unique. A true friend is a partner, one who shares our journey.

The value of partnership goes back to the beginning of Torah, to Creation. Man (Adam) is incomplete without a partner, someone with whom to share his life. God creates a companion for him (see Text Study, Tanach #A). Eve is a soul mate — she is created from Adam's very being.

Later in Tanach, we read about two special relationships, perhaps more identifiable as friendships. In each of these, individuals "cleave" to one another, capturing the essence of *Dibuk Chaverim.* They are David and Jonathan and Ruth and Naomi (see Text Study, Tanach #B and #C).

Then there is cleaving to God, *D'vaykut.* In Song of Songs, Jewish tradition identifies God as the beloved friend, *Dodi* and *Yedid,* to whom we should cleave. The idea of *D'vaykut,* which may have originated in the Bible, takes on particular significance in Jewish mysticism. Mystics consider this cleaving relationship of human beings with God to be central to their highest aspirations.

To sum up, the word "*dibuk*" suggests a deep bond or cleaving; it implies devotion, mutual support, communion, intimacy. The word for friends, *chaverim,* comes from the root meaning to "unite" or "blend together." Thus, *Dibuk Chaverim* means friends bonding and blending together. Giving something of ourselves to become something greater than we might be alone.

Such closeness requires tremendous trust and a willingness to be vulnerable. What else is "required" in cleaving to friends? What are the qualities of friendship to which we cleave? Focusing on how friendship operates in interpersonal relationships, in our relating to ourselves, and in our relationship with God will start us on the path to addressing those questions.

BAYN ADAM L'CHAVERO, BETWEEN PEOPLE. This category contains the word "*chaver.*" *Bayn Adam L'Chavero* is literally "between a person and his/her *chaver.*" When we cleave to a *chaver* (*Dibuk Chaverim*), we understand the friendship to be unique. But a *chaver* can also connote a broader relationship — a neighbor, a business partner, a social acquaintance. Our responsibilities for carrying out *Mitzvot* and *Middot* toward these more casual friends are non-

exclusive. Therefore, the word *chaver,* can suggest different degrees of relationship from very close and unique to occasional or casual and not necessarily close.

BAYN ADAM L'ATZMO, BETWEEN YOU AND YOURSELF. Friendship with others clearly is a value. But we can and should be our own friend as well. How do we befriend ourselves? By being true to ourselves, trusting ourselves, being supportive of ourselves. Can we spend time alone and truly enjoy the intimacy of our own companionship? We could if we were our own *chaver.*

BAYN ADAM L'MAKOM, BETWEEN YOU AND GOD. God is the ultimate friend to whom we are to cleave. The names we associate with God, in God's role as Beloved Friend, are *Dodi* and *Yedid.* In a well-known Kabbalat Shabbat poem/song, we address God as "*Yedid Nefesh*" (Beloved Soul Mate). A "beloved" is a most intimate friend.

Dibuk Chaverim, as it regards our relationship with God, directs us toward the concept of *D'vaykut. D'vaykut* is a word used to describe a profound awareness of and a loving attachment to God. When we cleave to God as ultimate friend, we experience *D'vaykut* — bonding with the divine.

TEXT STUDY

Tanach

A In the beginning, when humankind is created, God senses the need for companionship. God recognizes that to be alone is not good. Eve is created as a partner for Adam. While their relationship eventually resembles a marriage, its foundation is in companionship, which is a key element of friendship.

The Eternal God said, "It is not good for Adam/man to be alone; I will make a fitting helper for him." (Genesis 2:18)

➤ Who is the "man" and who is the "fitting helper"? Why would God say that it is not good for man to be alone? How is a friend like a "fitting helper"?

B *Chaver* comes from the root "to unite" or "blend together." David and Jonathan seem to capture the essence of friends who "unite," who cleave to one another. Their mutual concern for each other is so profound that Jonathan ends up saving David's life.

When [David] finished speaking with Saul, Jonathan's soul became bound up with the soul of David; Jonathan loved David as himself . . . Jonathan and David made a pact, because [Jonathan] loved him as himself. (I Samuel 18:1, 3)

➤ What does this passage tell us about David and Jonathan's relationship? What suggests that their relationship reflects *Dibuk Chaverim*? Jonathan protected David to the extent that he saved his life. Is protection something friends should expect of each other?

C In another example of friends who cleave to one another, Ruth physically and spiritually cleaves to Naomi.

Ruth replied [to Naomi], "Do not urge me to leave you, to turn back and not follow you. For wherever you go, I will go; wherever you lodge, I will lodge; your people shall be my people, and your God my God. Where you die, I will die, and there I will be buried . . ." (Ruth 1:16-17)

➤ Do you think all of the things Ruth promises Naomi are necessary for close friendship: living close to each other, sharing the same social circle ("your people shall be my people"), sharing the same religious beliefs, expressing the promise that you will feel the same about the friend for life? Explain.

D There are many benefits to be had when two people stick together.

Two are better off than one, in that they have greater benefit from their earnings. For should they fall, one can raise the other; but woe to the one who is alone and falls with no companion to raise that person up! Further, when two lie together they are warm; but how can one who is alone get warm? Also, if one attacks, two can stand up to the one . . . (Ecclesiastes 4:9-12)

➤ According to this passage, what are the four main benefits that derive from two people sticking together? Do you agree that these four things stand out the most? If not, what do you think are the main reasons two are better off than one?

E We can cleave to human friends. But we can cleave to God as well.

You, who held fast (cleaved) to the Eternal your God are all alive today. (Deuteronomy 4:4)

➤ What does it mean to cleave to God? How can God be a friend?

F In a pool of water, you can see a reflection of yourself. So, too, can you see your reflection (your true self, your heart) in the eyes of a friend.

As face answers to face in water, so does one person's heart to another. (Proverbs 27:19)

➤ In your own words, what is the verse from Proverbs saying? How can friendship be like looking at your face in the water? Do you think the image "works" — does it strike a chord with you? Explain.

Rabbinic

A Among the 48 virtues by which Torah is acquired, one of them is:

Dibuk Chaverim — Cleaving to friends. (*Pirke Avot* 6:6)

➤ How does *Dibuk Chaverim* help a person acquire Torah? Do you think friendship can make you wiser? more righteous? Explain.

B Nurturing a special friendship should be a top priority. The word "friend" is used rather than "friends" to stress that a close friendship is unique. It's not likely that you will have numerous friends to "cleave to"; having even one close friend is something to treasure.

Kenay l'cha chaver — Acquire for yourself a friend. (*Pirke Avot* 1:6)

A commentary on this passage underscores the unique nature of a close friendship.

And the Eternal said unto Moses: "Acquire for yourself Joshua the son of Nun." (Numbers 27:18) The word acquire implies acquisition at much cost, for a companion is acquired after difficulties upon difficulties. Hence, say the sages, people should acquire a companion for [everything]: for reading Scripture with

them, reciting Mishnah with them, eating with them, drinking with them, and disclosing all their secrets to them." (*Avot de Rabbi Natan* 8)

➤ What difficulties might be involved in acquiring a friend? Do you agree that you should be able to do everything with a friend? Why or why not? What are the most important things you should be able to do or share with a friend? What is gained from having a close friend?

C A friend should be held in high esteem. As you would like to be treated, so should you treat your friend. As you would like to be honored, so should you honor your friend.

Cherish your friend's honor as your own. (*Pirke Avot* 2:15)

➤ What does honor mean to you? What does honor mean to your friend? How do friends honor each other?

D Friendship doesn't necessarily mean that two people agree with each other all the time. Disagreements happen now and then, but friendship should not be defeated by them. Friends should honor higher principles, such as love, truth, and peace.

Come and hear: Although *Bayt Shammai* [The House of Shammai] and *Bayt Hillel* [The House of Hillel] are in disagreement on [numerous legalistic] questions . . . , *Bayt Shammai* did not, nevertheless, abstain from marrying women of the families of *Bayt Hillel*, nor did *Bayt Hillel* refrain from marrying those of *Bayt Shammai*. This is to teach you that they showed love and friendship toward one another, thus putting into practice the

Scriptural text, "Love truth and peace" (Zechariah 8:19). (*Yebamot* 14b)

➤ What does the relationship between *Bayt Shammai* and *Bayt Hillel* teach us about friendship? What kinds of disagreements can friendships tolerate? Are there disagreements that can overwhelm friendships? What might these be?

E The key line from this story is: "Either companionship or death." When Honi becomes isolated from those who should be his colleagues, he decides he would rather die than continue feeling hurt and alone.

Honi the Circle Drawer sat down to have a meal and sleep overcame him. As he slept, a rocky formation enclosed upon him which hid him from sight, and he continued to sleep for 70 years . . . [When he awoke] he said, "I am Honi the Circle Drawer," but no one would believe him. He then went to *Bayt HaMidrash* [the Study House] and there he overheard the scholars say, "The law is as clear to us as in the days of Honi the Circle Drawer," for whenever he came to *Bayt HaMidrash,* he would settle for the scholars any difficulty that they had. Whereupon [Honi] called out, "I am he," but the scholars would not believe him, nor did they give him the honor due to him. This hurt him greatly and he prayed [for death], and he died. Raba said: "Hence the saying, 'Either companionship or death.'" (*Ta'anit* 23a)

➤ What did Honi the Circle Drawer expect when he went to *Bayt HaMidrash* after 70 years had passed? What happened instead? Why did he pray for death? How would you feel if suddenly you had no friends?

F Just seeing a friend may feel like a blessing. When long periods of time have passed in which we haven't seen a friend, a special blessing expresses our gratitude for that person's presence in our lives.

When a person does not see a friend for a period of 30 days, the person is to say, "Blessed is the One who has kept us alive, preserved us, and brought us to this season." After 12 months, the person is to say, "Blessed be the One who revives the dead." (*Brachot* 58b)

➤ Why might a friendship inspire you to offer a blessing? Would the blessings above be the ones you would choose to offer upon seeing a friend you hadn't seen for a while? Why or why not?

Post-Rabbinic

A A close friend, with whom you can share religious ideas and feelings, is important for spiritual growth.

It is an important arrangement to make for your spiritual life, that you find a close religious friend, so that you can always take counsel with [that friend] on how to do the work of God in the right way. (*Derech Hayim,* 2-90, as quoted by Yitzchak Buxbaum in *Jewish Spiritual Practices,* p. 670)

➤ What are the qualities of a "close religious friend"? Why might you choose to share aspects of your spiritual yearnings with one friend over another? Is there someone in your life with whom you share religious ideas and feelings? If not, would you like to cultivate such a friendship?

B Here are some detailed ideas about the nature of a good friendship. These qualities seem to reflect the ideals of *Dibuk Chaverim*.

> **See that you have a good friend, someone who can be depended upon and who is able to keep a secret. You should talk with [the friend] half an hour every day about everything in your heart and innermost thoughts that [are] from the incitement of the evil inclination . . . And if you have worries, as the Rabbis teach, you should talk them out with a friend, and if something good happens to you, then you should share your happiness with [your friend]. (Rabbi Asher of Stolin, *Hanhagot Tzaddikim*, p. 9, #13, as quoted by Yitzchak Buxbaum in *Jewish Spiritual Practices*, p. 670)**

➤ Is there anything you would add to the above that should be included in a description of a good friendship? Does the passage suggest any adjustments to make in a good friendship you have?

C God can be considered the ultimate friend. The following defines what it means to cleave to God.

> ***D'vaykut* is the most intense love, such that you are not separated from God for even a moment. (*Sefer Haredim*, chapter 9, #10, as quoted by Yitzchak Buxbaum in *Jewish Spiritual Practices*, p. 3)**

➤ How is friendship with God similar to friendship with others? How is it different? How do we best cultivate closeness with God?

ACTIVITIES

Language Arts

 1 (10 minutes) Our traditional sources state or imply a number of qualities which reflect ideal friendship: love, loyalty, living in physical proximity, sharing the same social circle, sharing religious beliefs, learning together, confiding in each other, support, honor.

In groups or as individuals, brainstorm a list of the qualities of an ideal friendship. Perhaps you will include some of the qualities mentioned above; perhaps you will add a few others. Then read the lists. Write all the qualities on the board or a large piece of paper. Make a check mark for each word that appears more than once and additional check marks each time the word appears.

Which qualities of friendship seem most important? Are there qualities of ideal friendship on which everyone agrees? What qualities would you like to focus on in the friendships you have?

 2 (10 minutes) In #1 above, participants began with an abstract idea (ideal friendship), and then fleshed out the details. Now, let's begin with the concrete, rather than with the abstract.

For younger groups: Hold a discussion in which participants talk about close friendships and what makes them special.

For advanced groups: Everyone writes freely for several minutes without stopping, beginning with the words "My best friend is . . . " From there, everyone will flesh out his/her own stories. For example: My best friend is . . .

a. someone I met when I was four years old

b. someone who seems to be able to read my mind

c. really two people

d. someone with whom I had nothing in common, yet . . .

Members of a group may wish to share what they wrote. The leader should be sensitive to the possibility that mentioning names of best friends in a group may prove hurtful to some individuals (i.e., "*I* thought I was her best friend!"). If participants don't share exactly what they wrote, the leader at least can ask this: What do you value most about the friendship you wrote about? Do those qualities reflect the virtue of cleaving to friends — do they get to the heart of the meaning of *Dibuk Chaverim*?

 3 (10 minutes or more) Besides finding people with whom we can become close friends, it is also valuable to nurture friendship with God.

Write a prayer beginning with the words, "God, You are my friend." A group may wish to compose the prayer together. If desired, include the prayer(s) as part of a worship service.

 4 (10-30 minutes) A "prayer voice" and a "letter voice" bring out different things in us, because they reflect different styles of communication. In #3 above, participants wrote prayers. Letters (and perhaps e-mail) between friends seem to allow for intimate communication.

Write a letter to God, as if God were your closest, your best friend. Decide in advance whether the letters will be shared, as this might impact the contents.

Share reactions to this exercise. Did writing a letter help you to express yourself to God? When you "need a friend," might it be helpful to write a letter to God?

 5 (10 minutes) It's always a treat to see a friend. But seeing a friend who you haven't seen for a long time can be extra special.

Read Text Study, Rabbinic #F, about blessings said for a friend you haven't seen for a long time. Now write your own blessing.

In the next couple of weeks, make it a point to *use* the blessing at least once!

 6 (10 minutes) How can you be a friend to yourself? There may be things you can do for yourself. There may be ways you should treat yourself, honor yourself. There may be a way you might talk to yourself.

Number a piece of paper from 1 to 50 (for a more advanced group, 1 to 100). Quickly, make a list of ways you can be a friend to yourself. Write as much as possible without stopping or judging. It's okay if you list something more than once.

What patterns/themes do you see in your list? Does anything appear more than once? What significance might there be in any repetitions? Is there any action you want to take as a result of thinking about this list?

 7 (30-60 minutes of study and reflection/discussion; plus independent research time) Is friendship universal? Do you think there is cross-cultural agreement as to what makes for an ideal friendship?

Study some of the stories about friendship included in Text Study, Tanach #B and #C and Rabbinic #D and #E. Now, on your own, think about and find other references to stories about friendship. The passages don't have to come from Jewish tradition.

Discuss (or reflect on your own): What passages are most moving? Why? What qualities in friendship are idealized in the Jewish sources? in the other sources? Is there anything uniquely reflective of or required of friendship between Jews (studying together, living in the same community, sharing certain beliefs, etc.)?

 8 (10-15 minutes) For many of the *Middot*, one virtue leads to another. Generosity and graciousness (*Nedivut*) may lead to greeting others with a pleasant face (*Sayver Panim Yafot*); they may also lead to hospitality (*Hachnasat Orchim*). To what other virtues might friendship lead? To what might friendship with ourselves lead? Strengthening one part of ourselves helps our whole selves. Making an effort in one area can trigger improvements in other areas as well.

Make a web. On a piece of unlined paper, write "Friendship with Myself" in the middle of the page. Circle that phrase. Next draw lines from this circle (like sun rays). At the end of these lines, jot down a few words as to possible results of friendship with yourself (e.g., self-confidence, time alone, self-knowledge). Circle those words. From this second layer of the web, go further. For example, radiating from "self-confidence," make another line. Then write what it leads to — perhaps "friendliness toward others." (Circle it.) Then, continue: friendliness toward others leads (use a line) to hospitality (circle it), etc. Repeat with other circled ideas, extending them out.

What connections did you see? Reflect or discuss. Then, think about your personal value system (*Bayn Adam L'Atzmo*, Between You and Yourself). Are there other values, besides friendship with yourself, that you think deserve a central place? (For example, is not embarrassing yourself just as central? slowing down anger toward yourself? being generous toward yourself? etc.)

 9 (10-30 minutes each day, on one's own, for a week or so) Text Study, Post-Rabbinic #B refers to an actual person as a friend. Sometimes we can serve as our own friend, someone we can confide in, through keeping a journal.

For at least a week, spend ten minutes a day (longer, if possible) confiding in your journal as if it is your best friend. Don't hold anything back; let the words flow out of you freely, without judging.

Discuss reactions to the experience (without sharing actual journal entries). Is a journal a good confidante? How so? How not? Do you think you can become a better friend to yourself if you make journal-keeping a regular practice?

 10 (20 minutes) On the surface, the biblical book Song of Songs seems to be a love poem between a man and a woman. But there is a tradition that views it as a love poem between human beings and God.

Skim the book of Song of Songs, keeping in mind the interpretation that it is about the love between people and God. Find passages that lend themselves to this metaphorical interpretation. Which verses could be understood as reflecting God's role as beloved friend?

Visual Art

 1 (10-15 minutes) Capture friendship visually, through art. Ask everyone to paint a picture which celebrates a friend. Some ideas: Paint a picture of you and your friend having fun together, then give it to that friend. Paint a picture that would bring comfort to a friend in need, that would make a friend laugh. You might create an image of being a good friend or having a good friend — helping a friend solve a problem, comforting, hugging, laughing, sharing work, and so on.

Comment on each other's pictures. What is happening in the scenes? How does the artwork reflect or express friendship?

 2 (20 minutes) Talking to ourselves is a way of being a friend to ourselves. What kinds of things might you talk to yourself about when you are being a good friend to yourself?

Everyone creates a picture that could be titled "When I Am a Good Friend To Myself." The leader says: Draw a picture of yourself, showing how you feel when you are a good friend to yourself. Then, make a cartoon-like bubble from your mouth with words you might say to yourself at these times. (For example, you might say, "I sure look pretty/ handsome today," or "I'm a nice kid," etc.)

What did you do to show being a good friend to yourself? Why did you choose the example you did? In what ways can you be a better friend to yourself?

 3 (15-20 minutes) The Jewish calendar is filled with holidays and the many wonderful traditions and rituals that accompany them. There are secular holidays, too, such as Mother's Day, Father's Day, birthdays (which is *your own* day). In addition, some people celebrate Secretary's Day and Grandparent's Day.

Brainstorm ideas for a special, celebratory day called "Friendship Day."What would happen on this day? How might we celebrate and support the people we care about? Some ideas: Design a Friendship Day for the class (group) that celebrates and fosters good will toward one another. List environmental elements that encourage friendship — comfortable and inviting spaces, gardens, sunny days, shared fun activities. Share stories about our good friends. Everyone invites a special friend to a class party celebrating friendship.

Shape your ideas into a description of "How to Celebrate Friendship Day." Give the celebration a Jewish "flavor." Possibilities for a Jewish angle: friends are greeted with special blessings, people do skits about David/Jonathan or Ruth/Naomi, people spend time learning in *chevruta* (study pairs) following a festive meal, meditations on *D'vaykut* are added to worship services, at least a half hour is spent confiding in a friend, etc.

After a description of Friendship Day is formulated, everyone writes the description on a sheet

of paper, leaving room for illustration. For very young participants, the leader can prepare/photocopy the explanations on small pieces of paper. Participants can then glue these onto a larger sheet of paper, then illustrate the descriptions.

Would your group actually like to celebrate Friendship Day? When might you do this? What other guests should be invited?

 4 (short intervals of effort over the course of several days; time to develop film, plus 15 minutes for sharing/discussion) How would we be able to tell if two people were friends? were close friends? Can we become more aware of moments of friendship in our midst? Doing so may help us increase our appreciation of *Dibuk Chaverim*.

Try to capture friendship on film. For several days, photograph instances that capture friendship in at least three settings, such as a school playground, a Senior Center, Main Street downtown. Make a group display of the photos.

How did you decide which photos to take? What makes people seem like friends? Can friendship be faked? Is friendship necessarily visible, or might friends have ways of communicating that are not obvious to others? (For instance, without any outward signs, one good friend knows that the other is having a problem. These two individuals may be sharing tremendous caring and support for one another without visible communication.)

5 (20 minutes or more) Study Text Study, Rabbinic #F, about the blessing said upon seeing a friend after an absence. When you haven't "seen yourself" for the whole night, you say a blessing upon awakening, the "*Modeh Ani.*" The words are: "I am thankful before You, Eternal Sovereign, for mercifully returning my soul-breath to me [this day]."

Perhaps the frame of a mirror could remind you that you are seeing a friend you haven't "seen"

for a while. Design such a frame. Here are two versions of an art activity based on this idea.

Less ambitious: Purchase pocket mirrors for each participant. Everyone designs a border for the mirror that helps remind them that when they look into the mirror, they are seeing a friend. Beforehand, the leader should test whatever paint or markers will be used to decorate the frames, making sure the color won't rub off easily. Participants should create their designs on paper first, then copy them onto the actual mirrors.

More ambitious: Instead of pocket mirrors, attain larger plain-framed mirrors or attain plain, unpainted frames into which a mirror could be inserted. Decorate the actual frame so as to remind you that you are looking at a friend. Use appropriate paints — acrylic paint adheres well to plastic. Add glued-on materials if desired (making sure the glue adheres well to the frame material).

Use the mirror on a regular basis. Does it help remind you to be a friend to yourself? Does it help remind you, when you gaze in the mirror, to say to yourself, "You are looking at a friend"?

 6 (15-20 minutes) To see yourself as a friend means accepting all parts of the self. It means embracing the whole of who you are.

Create shapes symbolizing significant aspects of the self. These aspects may fall into various categories — physical, emotional, intellectual, spiritual, job, family, hobby. Perhaps one individual will have a collection of these shapes/aspects of the self: blue eyes, happy smile, *kipah,* Star of David, school book, soccer ball, home, and heart. After each has his/her own collection of shapes/aspects/character traits, create a supportive structure for the parts — a mandala, a chart, a geometric design, a web, etc.

Share your art. What did you choose for your structure for the parts, and why? Do you agree that to be a friend to yourself means accepting all parts of who you are? Explain.

 7 (10-30 minutes) Perhaps with a picture in mind, we can better understand what the concept of "cleaving together" means.

Divide a large piece of paper into six boxes. In the first box, make two distinct shapes. These shapes should be simple and easily replicated. In the next five boxes, repeat the shapes. With each repetition, explore different ways of relating, connecting, or attaching the two shapes. You can give the shapes some malleability, but they still should be recognizable. Some possibilities for putting the shapes together: as if with a zipper, with an eighth or so of each shape overlapping the other; as if the shapes have grown a few hands that clasp one another; as if the two shapes are embracing, with the shapes touching as much of each other's surface as possible.

Which version best reflects "cleaving together" as it relates to friends? That is, which best suggests the relationship of *"Dibuk"* as in *Dibuk Chaverim*? How so? If desired, create one more version of the shapes. This time, use a single sheet of paper and make an abstract version of *Dibuk Chaverim*. Base your creation on your favorite ideas gleaned from the first part of the exercise.

 8 (20 minutes minimum) This activity extends #7 above into the realm of our relationship with God. One could say that *D'vaykut*, cleaving to God, is an intense love in which we are not separated from God for even a moment. Here are some ways to explore and describe *D'vaykut*.

Brainstorm words that help illuminate the meaning of *D'vaykut*, such as connecting, linking, attaching, intertwining, binding, overlapping, meshing, harmonizing, uniting, clinging, cleaving, merging, clasping, twisting together, embracing, etc. Explore these words through art, doing one of the following:

a. Come up with two simple shapes (such as a red circle and a blue oval). Divide a page into

eight boxes. Label each box with a different *D'vaykut* word. Recreate the two shapes in each of the eight boxes, trying to capture the sense of the descriptive word.

b. With paint, pastels, or other drawing materials, explore more freely some or all of the *D'vaykut* words.

c. Make a collage of objects that capture some of the *D'vaykut* words. Glue these paired objects to a thick piece of paper (oak tag, poster board). Use imagination freely in collecting your objects — rubber bands, ribbon, sections of plants, paper clips, hooks, buckles, string, chain, toothpicks, popsicle sticks, noodles, wire, buttons, zippers, etc.

d. Use a vine and its counterpart (a wall, a tree, another vine) as a metaphor for *D'vaykut*. Paint or draw this metaphor. (See Movement #5 for more ideas on this.)

Discuss the artistic creations. In what ways does your artwork reflect the concept of *D'vaykut*? If it does not, how would you start over to make a piece of art that would better illustrate the idea? Do you think *D'vaykut* is the most positive way a person could relate to God? Explain.

Drama

 1 (5 minutes) This activity is especially good for young children. It introduces them to the idea of being a friend to yourself. A good friend is someone you may want to hug. What if that friend is yourself? See how many ways you can give yourself a hug. Can you come up with at least five?

Is it important to be a friend to yourself? What can you do to be a friend to yourself?

 2 (5 minutes) Can you recognize people who are friends just by how they stand next to one another?

Have one person take a pose in the center of the space. A second person is asked to go take a position next to the first, positioning him/herself

as if he/she is a close friend of the first. Repeat several times.

Discuss. How did you use your bodies to show the nature of your relationship with your partner? When you see two people together, how can you tell whether or not they are friends? Can you see trust, closeness, loyalty? How does it feel when you are standing next to a friend? Why might those feelings be ones you should nurture? What do those feelings teach you about why *Dibuk Chaverim* is considered a virtue?

 3 (15-20 minutes) Sometimes the devotion friends show for each other is beyond expectation. Such is the case with the inspirational story of Ruth and Naomi (see Text Study, Tanach #C).

The leader retells, simply, the story of Ruth, chapter one. At the point when Ruth insists on staying with Naomi, the leader says only, "Ruth really wanted, more than anything else, to stay with Naomi."

The listeners imagine the scene. Then the leader asks: What do you think Ruth said to try to convince Naomi to let her stay with her? Discuss some possibilities or list ideas on the board. For example:

a. For comfort: "We can comfort each other after all the sad things that have happened to us."

b. For help: "I could help you on the journey back which is long and hard."

c. Miss you: "I'll miss you too much if you go without me."

d. Too alone: "I have no one else I care deeply about in my life here. I don't want to remain alone."

Now the leader selects two actors to enact the scene as Ruth and Naomi. Begin the improvisation. Coach the Ruth-actor to give at least three distinct ideas or arguments that reflect her desire to go with Naomi. (In other words, you want the improvisation to be more interesting than Ruth

just saying, "Please, please, let me go with you, I really want to go, I want to so much.") The Naomi-actor responds to Ruth. Allow several pairs to enact the scene.

Now share what is written in the actual text of Ruth. Have two actors enact the words from the text, verses 1:16-17. (If necessary, create a version with simplified words beforehand.) The leader can act as coach (for beginning readers), whispering the words to the actor who repeats the words with feeling.

Compare the improvisations with the actual text. Were you surprised by what Ruth really said? Do you think Ruth's show of friendship was unusual? Would most friends act the way she did? In what ways would you like to be (or have a friend like) Ruth?

 4 (20-25 minutes) A good friend is someone you can depend on, someone you really talk with, confide in. You should be able to share your secrets, your innermost thoughts, what you feel in your heart, your worries, and also the good that happens to you, your happiness. (See Text Study, Post-Rabbinic #B.)

Two people imagine they are friends. Person A is to tell Person B about something in his/her life. (It can be made up.) Some possibilities: what happened at school that day, a project A is planning, weekend plans, etc. A tells his/her "story" twice. The first time, after every sentence or two, B makes a negative comment in response. The second time A repeats the story, B makes a positive or supportive comment in response. Here is an example of the first version:

A: I got up at about 7:00 this morning.

B: That's awfully late to get up for school.

A: And then, I couldn't even eat breakfast because I needed to finish my homework.

B: Not finishing your homework is irresponsible. And then you didn't even have time to eat breakfast — not a great way to begin your day.

A: Well, I did grab a doughnut which I ate on my way out.

B: If you'd gotten up earlier, done your homework the night before, you could have had a decent breakfast. So you ate this unhealthy doughnut breakfast on the way to school. Which means you obviously didn't brush your teeth this morning either.

The second version:

A: I got up at about 7:00 this morning.

B: You must have been tired.

A: Yes, we were out late helping my grandmother settle into her new apartment. And then, I couldn't even eat breakfast because I needed to finish my homework.

B: Well, that was nice of you to be helping your grandmother. But you must be hungry now. I think I have a granola bar in my coat pocket if you want me to get it for you.

A: Well, I did grab a doughnut which I ate on my way out.

B: That's good, at least you had something to eat. Did you ever get your homework done? I bet you could explain what happened to the teacher.

The leader should encourage short scenes, and coach actor A to try to keep the thread of his/her story the same in both versions. Allow several pairs of actors to improvise. Then discuss what this drama experience teaches about the role of friends. What are the best ways for friends to be supportive of each other? Are there ever times when friends should respond negatively to each others' words?

 5 (15-20 minutes) When a very close friend dies, the physical connection is severed. Yet, a spiritual connection remains.

A pair of actors takes on the roles of two close friends, one alive, the other dead, and improvises a conversation between these two friends. While both people were still alive, their

friendship was likely defined by many positive emotional and spiritual qualities. Try to remain true to what would have been the essence of the relationship. This activity can be done in one of two ways:

a. Pairs improvise on their own. They do the improvisation twice, switching roles. Then, have everyone share experiences as a whole group.

b. One pair at a time performs for the rest of the group. Then the group discusses reactions, observations.

Do you think there's an aspect of friendship that survives death? Explain.

Movement

 1 (10 minutes) Talk about how on Shabbat we make the time to think more about God and to pray. We especially are thankful for a time when we can be more aware of God's closeness.

Imagine that in the center of the space is someone you love very much. You've put aside some special time (such as Shabbat) to spend with this loved one. Everyone stand at the edge of the space and two or three people at a time improvise an approach to the center. They approach the center as if they are to meet with a most beloved friend.

How did your movement reflect that you were approaching someone very special? Now think about and compare God to a beloved friend. Do you need to make a particular effort to spend special time with this "Beloved One"? How would you approach God as a beloved friend?

2 (10 minutes) *D'vaykut* means cleaving to God. The experience of this loving attachment is constant, "such that you are not separated from God for even a moment" (see Text Study, Post-Rabbinic #C).

In pairs explore unison movement. Two people try to move, doing the exact same thing at the same time. Repeat three times:

a. With one person leading
b. With the other person leading
c. With no designated leader

Discuss. What was easy? What was difficult? What did you learn about moving in unison with another person? Can anything you learned be applied to an understanding of how to stay connected and close with God?

 3 (10-15 minutes) How could you show, in movement, a sense of feeling close to yourself, feeling an attachment toward yourself? The more you nurture your friendship with yourself, the more you have to draw upon in your friendships with others.

Come up with "movement metaphors" that seem to capture the experience of closeness with the self, i.e., attachment. These metaphors should help you explore what intimacy with yourself feels like. Examples:

a. Hold the palms of your hands together. (Your hands held closely together are the "metaphor.") Move through the space freely, allowing your hands held together to lead you.

b. One arm crossed over the chest with the palm on the heart. The other arm and rest of body are able to move freely.

c. Keep your head bent with eyes focused on the center of your body while the rest of your body moves freely.

d. Your own ideas!

Which movement metaphor worked best? Why? Do you think you can nurture a sense of intimacy or closeness with yourself? Do you believe that there is no friend closer to you than yourself? Explain.

4 (30 minutes) Close friends should be able to share with each other their deepest secrets (see Text Study, Rabbinic #B). Still, revealing secrets is not easy.

Begin by exploring concealing and revealing movements. Do this first, with "sculptures." One person takes a pose that reflects a sense of concealing. The next person comes and gently reshapes ("sculptures") the person to take on a sense of revealing. Repeat several times with different people. Next, improvise more freely, exploring concealing and revealing movement. Put on music if you like.

Next, ask each person to imagine a secret he/she holds. Spend a few minutes writing (or thinking) about this secret. Describe (or reflect on) what the secret is and how you feel about it. Now imagine holding this secret in your hands. Begin to explore this "handheld secret," as if it could take on a physical manifestation. Allow the secret to grow so that you can dance with it/ interact with it in movement.

Once everyone has a sense of the physical nature of their secrets, divide the group into pairs who are to imagine they are close friends. Friend A has a secret that he/she wants to share with friend B. Friend A begins moving, keeping his/her secret completely concealed. Friend B moves in response to A (maybe being curious, maybe trying to get A to share his/her secret, maybe not bothering A and giving A space to be secretive). Very gradually, A begins to reveal, through movement, his/her secret to B. A may go back and forth between concealing and revealing before the secret is completely exposed. Switch roles and repeat.

Share reactions. How did it feel to reveal a secret to another? Were you trusting, fearful, relieved? Do you think everyone needs someone in their lives with whom they can confide, to whom they can reveal secrets? How would your life be if you felt you didn't have anyone to talk with on a personal level? What did you learn from this improvisation that you can apply to real life?

 5 (20-30 minutes) Suppose that cleaving to God, *D'vaykut*, is like a vine clinging to its counterpart — a wall, a tree, another plant. (See Overview, *Bayn Adam L'Makom*, Between You and God, for more on *D'vaykut*.) Might there be clues in nature to help us understand God's role as the One to whom we cling? What things in our environment attach to one another? What can a vine and a wall teach us about *D'vaykut*? What else is out there that might hold some secret wisdom? Do the following exercises which prepare for a more developed improvisation.

a. Imagine you are a vine. Move across the floor as if you are growing in fast motion. (Two or three people can travel across the floor at the same time.)

b. The leader or a student calls out a variety of words that can be seen as counterparts for a vine. Participants strike a pose, based on what they hear, trying to capture the essence of the word. Some words to call out: wall, tree, trellis, pillar, fence, telephone pole, ground, ceiling. Repeat words several times in random order, giving everyone a chance to explore the possibilities more thoroughly.

Now begin a less structured improvisation. Everyone is a vine. They are to move through the space, cleaving/clinging to imagined vine counterparts. That means the dancer is like a vine and God is like the imagined counterpart. Allow several minutes for this improvisation, possibly having small groups at a time perform, while the others watch.

Discuss reactions. Was this difficult or easy? How so? What is God's role in *D'vaykut*? Do you think you now have a better understanding of a *D'vaykut* relationship (loving attachment between a person and God)?

Music

 1 (10 minutes) The connection between close friends is often so deep that it seems they almost have a language of their own. Yet, close friends don't always need language or words to communicate; they know what each other is feeling.

Two people imagine they are close friends. They are each given an instrument. With their instruments they will try to communicate their deepest thoughts and feelings to each other, as friends often do, without the need for actual words.

Discuss the experience. What did you hear? What are ways besides music to communicate without words? How can you be a good listener?

 2 (10-15 minutes) *"Yedid Nefesh"* (Beloved Soul Mate) is a song that seems to reflect on a *D'vaykut* relationship with God. (See Overview, *"Bayn Adam L'Makom,* Between You and God, for more on *D'vaykut.*)

Go over the words to the song. Learn a musical setting for it. Discuss how a Beloved Soul Mate is like a friend you cleave to.

 3 (5-10 minutes; an hour or more if extending the activity) Is there a song or melody you sing/hum/whistle to yourself sometimes? When do you do so? What is the song? In the group, sing or teach a couple of these songs. In what way is music a friend we can rely on even when we are by ourselves? Can music help us to feel close to ourselves?

An ambitious extension: Make a music compilation of the group's songs using either pre-recorded or "live" versions of the songs. Come up with a title and design a cover for the recording. Distribute copies of the tape.

Miscellaneous

 1 (time will vary) Actually celebrate "Friendship Day" (for ideas, see Visual Art #3).

 2 (20-30 minutes background activity, 10 minutes discussion) Try to hone in on an understanding of *D'vaykut.* Get the idea across by having participants experience being attached to another. (See Overview, *Bayn Adam L'Makom, Between You and God,* for more on *D'vaykut.*)

The leader instructs pairs to keep one part of each of their bodies attached to each other for a designated period of time (e.g., for all/part of a class session or during a recess). Pairs shouldn't use anything specific, such as string, to connect them together. Maintaining the connection should take conscious effort.

Afterward, discuss what it takes to maintain constant contact with another. Was it hard/easy? Can you apply what you learned to what it means to "cleave to God"?

 3 Something we constantly wear can help us understand *D'vaykut,* can remind us of God's presence. *D'vaykut* is a constant experience of God's closeness.

The leader asks how special clothing or accessories may serve as reminders of God's constant presence. Consider ritual items (*kipah* and *tallit/tzitzit*) and common items (necklace with a symbolic charm, a decorative pin, a special tie or scarf).

For a week or so, try wearing something you are not ordinarily accustomed to wearing. (The item can be as simple as a piece of yarn tied around the finger.) Designate that item as a special reminder that God, like the absolute best friend, is always near.

Discuss the experience. Did the item you wore help you to remember that God is near, that God is like a friend? Are there other things that remind you that God is near such as other people, certain situations? Is it possible to learn how to cleave more closely to God?

4 (1 hour, plus) A Hasidic source says you should talk with your friend half an hour every day about everything in your heart and innermost thoughts. (See Text Study, Post-Rabbinic #B.)

Put this piece of advice into action with a friend. Each friend takes a half hour each (shorter for younger children). During that time, each person talks about everything in his/her heart and his/her innermost thoughts.

Was it hard to talk for a half hour? Can you be a good listener without saying anything in response? Is this a practice you would like to do again? Explain. Are there any modifications you would want to make? (Some possible issues: Does the amount of time — a half hour each — feel right? Should each person speak without being interrupted, or can there be some response by the other? How often should you practice confiding in each other in a set manner — every day, once a week, once every two weeks?)

CHAPTER FIVE

DIN V'RACHAMIM: JUSTICE AND MERCY

דִּין וְרַחֲמִים

OVERVIEW

Justice and mercy, *Din V'Rachamim* — one without the other makes for a world that is out off balance, off-kilter. The call to integrate justice and mercy in our world, in our lives, permeates Jewish law and literature.

As for *Din* — Talmudic tractates and Codes of Jewish law elaborate on how to carry out justice. We are also reminded of our responsibility to effect justice through numerous ethical instructions. To name a few: *Lo Tirdah Befarech*, do not abuse power; *Hevay Metunim BaDin*, be cautious when rendering decisions; and when making judgments, *Dan L'Chaf Zechut*, give the benefit of the doubt.

The call for merciful action, *Rachamim*, also abounds. Some examples: We are to care for the poor, the widow, the orphan. We are to carry out deeds of loving-kindness — feeding the hungry, healing the sick, freeing the captive, welcoming strangers, comforting the bereaved, dowering the bride, burying the dead, and so on.

Our sacred literature portrays God as exemplar of one who balances justice and mercy, the One in whom those attributes coexist and are co-dependent. But what are *our* responsibilities? For one thing, we know that emulating God's qualities is a virtue. Therefore, justice and mercy should find balance in our lives, too.

While there is an ideal of balance, some would argue that the scales are not exactly equal. As much as we might strive to achieve the ideal, we can't or don't always apply to each judgment a strict formula — precisely one-half justice, one-half mercy. In fact, that kind of "measuring" is not necessarily best. There should be a leaning toward, a favoring, of mercy. Loving-kindness and compassion should take precedence whenever possible.

In our *Tefilah*, our worship, we say *"Emet VeEmunah"* (Truth and Faithfulness). Truth is like justice, pursuing what is right. Faithfulness is a softer word. Like mercy, it implies taking a risk, believing in the unknown. Certainly, we need justice, but the center still holds if we "tend toward" mercy and kindness. Justice is more objective; mercy is more subjective. Justice is more concrete; mercy is more ephemeral. Yet, the two coexist, are mutually dependent, and we need them both.

What follows is a summary of how *Din* and *Rachamim* factor into our relationships with others, with ourselves, and with God.

 BAYN ADAM L'CHAVERO, BETWEEN PEOPLE. In formal and informal settings, in the courts, in the community, and in the family, we are to strive to balance justice and mercy.

 BAYN ADAM L'ATZMO, BETWEEN YOU AND YOURSELF. Balance justice and mercy within yourself. On the justice side — be honest with yourself, analyze and be discriminating of your actions, take responsibility for your behavior. But on the mercy side — be kind and compassionate with yourself, don't judge yourself with undue harshness and criticism, accept that everyone makes mistakes and that mistakes are a part of learning and growing.

 BAYN ADAM L'MAKOM, BETWEEN YOU AND GOD. Are we in the position to show justice and mercy toward God? Perhaps this *Middah* tells us to contemplate and seek to understand God, Source of Justice and Source of Mercy and exemplar of both. In other words, the object isn't so much *to show* justice and mercy toward God. Rather, we are *to learn* justice and mercy by reflecting on God's nature.

According to Rabbinic tradition, two of the many names of God accentuate these attributes. *Elohim* is associated with *Din* — justice, and *Adonai* (*Yud-Hay-Vav-Hay*) is associated with *Rachamim* — mercy. In our blessings and in our prayers, both of these names or their variations are used side by side — *Baruch Atah Adonai Elohaynu* . . . as if to say, we praise You, *Adonai*, for Your mercy, and we praise You, *Elohim*, for Your judgments. May Your holy *Din* and *Rachamim* remain in divine balance, and may we learn from Your example.

TEXT STUDY

Tanach

A During Noah's lifetime, God sees the evil doings of humankind and decides to destroy all life on earth. Only Noah and his family and the animals aboard the ark survive the massive flood, which lasts 40 days and 40 nights. In its aftermath, God promises to temper the severity of future judgment and punishment.

> **Never again will I doom the earth because of humankind, since the devisings of people's minds are evil from their youth; nor will I ever again destroy every living being, as I have done. (Genesis 8:21)**

➤ What is God's promise? What is the role of mercy in this promise? Why is God influenced to act more mercifully in the future? In what other ways could God respond to groups of people who

had become evil — a response that would be both just and merciful?

B God is ready to exercise severe judgment against the people of Sodom and Gomorrah because of the sinful behavior of its citizens.

> **The outrage of Sodom and Gomorrah is so great, and their sin so grave! I will go down to see whether they have acted altogether according to the outcry that has reached Me; if not, I will take note. (Genesis 18:21)**

God is delayed by Abraham's argument:

> **Will You sweep away the innocent along with the guilty? (Genesis 18:23)**

After God and Abraham converse back and forth, God tempers the severity of the decree.

> **I will not destroy [the city] for the sake of ten innocent [people found in that place]. (Genesis 18:32)**

➤ Why was God ready to destroy Sodom and Gomorrah? How did Abraham convince God to soften the judgment, to deal more mercifully with the situation?

C At the end of his life, Moses experiences both judgment and mercy in his relationship with God. God will not allow him to enter the Promised Land because he hit the rock twice, instead of speaking to it as God had commanded. This action might be seen as reflecting a loss of faith. The punishment meted out by God reflects God's judging side, but it is tempered by mercy.

> **I have let you see [the Promised Land] with your own eyes, but you shall not**

cross there. And so, Moses, the servant of God died in the land of Moab . . . and he was buried [there]. . . and no one knows where until this day. (Deuteronomy 34:4-6)

➤ How does God show both judgment and mercy toward Moses at the end of his life? Are the two attributes of equal weight and significance? Is this last scene between God and Moses a fitting way to end the Torah? Why or why not?

D King David addresses God, recognizing that mercy and justice go hand-in-hand.

I will sing of kindness and justice; I will sing praises to You, O Eternal. (Psalms 101:1)

A *Midrash* explains that in this passage it is as if David says to God: "Sovereign of the Universe! If You show mercy to me, I will sing [and if you show justice to me, I will sing]. Be it this way or that, to the Eternal One, *I will sing praises.*" (*Leviticus Rabbah* 24:2)

➤ By praising God for both kindness and justice, how does David show integrity in his words to God? Is it more natural to pray for and praise God for kindness? Explain.

E God's attributes of justice and mercy are both expressed in this Psalm.

God surrounds you with kindness and mercy . . . God executes righteous acts and judgments for all who are wronged. (Psalms 103:4, 6)

➤ If God executes judgments against wrongdoers, how does that affect the one who is wronged? Can judgment toward one person be considered mercy toward another?

F Again, attributes of *Din* and *Rachamim*, ascribed to God, are found in the same passage.

I the Eternal act with kindness, justice, and equity in the world, for in these I delight — declares the Eternal. (Jeremiah 9:23)

Rabbinic

A An allegory is used to illustrate the need for both justice and mercy in the world. The king is like God, and the goblets are like God's world in the process of creation.

A king had some empty goblets. Said the king: "If I pour hot water into the goblets, they will burst, and if I pour cold water in them, they will crack." So what did the king do? He mixed hot and cold water together and poured the water into the goblets, and the goblets did not break. Similarly, said the Holy Blessed One: "If I create the world on the basis of mercy alone, it will be overwhelmed with sin; on the basis of justice alone, the world cannot exist. So I will create the world with both justice and mercy; that way it will endure!" (*Genesis Rabbah* 12:15, adapted)

➤ What do hot water and cold water represent in this *midrash*? What might happen to a vessel into which water of an extreme temperature is poured? Why did the king mix the hot and cold water before pouring it into the goblets? What would happen if the world were "ruled" by mercy alone? What would happen if the world were "ruled" by justice alone?

B In these two passages, mercy is the favored attribute.

Which attribute [*Middah*] is greater: the attribute of goodness [considered God's mercy] or the attribute of punishment? The attribute of goodness. (*Sifre Numbers*, Naso 8, 4b)

Happy are the righteous who turn the attribute of judgment into the attribute of mercy. (*Genesis Rabbah* 73:3)

➤ Why, in the second passage, is righteousness associated with mercy? Why might favoring mercy make a person happy? How can one attribute (justice) be "turned into" another attribute (mercy)?

C Especially during the *Yamim Nora'im*, the High Holy Days, we approach God through worship, charity, and repentance. God is moved then by our prayers for mercy. Note that God's name "*Elohim*" is associated with justice, and God's name "*Adonai*" (*Yud-Hay-Vav-Hay*) is associated with mercy.

Judah son of Rabbi Nachman opened his talk with the text, "*Elohim* ascends amidst shouting; Adonai (*Yud-Hay-Vav-Hay*) ascends to the blasts of the horn (*shofar*)" (Psalms 47: 6). When the Holy Blessed One ascends and sits upon the Throne of Judgment, the ascent is with intent to do [strict] judgment; thus, "*Elohim* ascends amidst shouting." But when Israel takes horns (*shofarot*) and blows them in the presence of the Holy Blessed One, the Holy One rises from the Throne of Judgment and sits upon the Throne of Mercy. For it is written, "*Adonai* ascends to the blasts of the horn, and God is filled with compassion for [Israel], taking pity upon them and changing for them the Attribute of Justice to Mercy." (*Leviticus Rabbah* 29:3)

➤ How is God's relationship with humankind special during the *Yamim Nora'im*? At what times might God's role be perceived as being more like that of Judge? more like the Source of Mercy?

D While some in our tradition may claim mercy as a more favored attribute, this passage emphasizes the notion that the two, held in balance, is not only ideal, but inevitable.

Rabbi Shimon ben Lakish says: "Those who are compassionate when hard-heartedness is called for will end up being hard-hearted when compassion is called for . . . Rabanan said that those who are compassionate when hard-heartedness is called for, *Middat HaDin* (justice) will eventually catch up with them." (*Kohelet Rabbah* 7)

➤ What might be the results of excessive compassion and leniency? What does it mean that justice will eventually catch up with them? Compare this passage to Text Study, Rabbinic #A, about the king and his goblets. Is the message the same?

Post-Rabbinic

A Justice and mercy must be inextricably tied together.

There is no justice unless mercy is part of it. (*Zohar*)

➤ How do these two concepts differ: (1) justice with mercy, and (2) justice and mercy?

B The essential core of God's Being is mercy, but this mercy must be somewhat concealed.

They asked Rabbi Zusya: "We pray, 'And bestow good mercy upon us,' and 'Who

bestows good mercy . . .' Is not every mercy good?" He explained: "Of course every mercy is good. But the truth of the matter is that all God does is mercy. Only that the world cannot bear the naked fill of God's mercy, and so God has sheathed it in garments. That is why we beg God that the garment, too, may be good." (Martin Buber, *Tales of the Hasidim: Early Masters*, p. 238)

➤ What might be meant by the "garments" of God's mercy? Are the "garments" justice? Why do you think that people cannot bear being exposed to the fullness of God's mercy?

ACTIVITIES

Language Arts

 1 (5-10 minutes) This introductory exercise helps to clarify the meanings of mercy and justice. On a blackboard, or individually on paper, write mercy words in one column and justice words in another. After you have exhausted the more precise similarities in meanings, move into word associations for both mercy and justice. Word associations will be more concrete for younger groups, more sophisticated for older groups. Here are some examples:

Mercy words: kindness, compassion, thoughtfulness, consideration
Words associated with mercy: softness, flexibility, suppleness, gentleness
Justice words: judgment, right, truth, fairness, consequences
Words associated with justice: rigidity, being unyielding, confidence, strength

Look at the two lists. What would it be like if we lived in a world defined by the words in the first column only? in the second column only? Why is it important to strive in our lives for a balance of concepts from both columns?

2 (5-15 minutes) Give examples of a few scenarios of troublesome behavior. Have the group come up with consequences that reflect both justice and mercy. Possible scenarios that would result in consequences include:

a. a child continually pulling the tail of a cat in a rough fashion

b. a child repeatedly dawdling before bedtime

c. siblings fighting and screaming in the car

d. a teenager "borrowing" money from his/her parents without asking

e. a worker missing work without explanation

It is from God that we learn the ideal of balancing justice and mercy. In what ways, in our own everyday interactions with others, are we challenged to do the same?

3 (10-15 minutes) It is clear from our tradition that we are meant to strive to be both just and merciful in our interactions with each other. Identifying situations in which both attributes are realized can help set a standard for what we should do in similar situations.

Small groups flip through several picture books, seeking pictures in which the characters experienced something that was fair but not unkind — that was merciful and just. (For younger students, stay in the larger group and discuss pictures pre-selected by the leader.) The groups imagine what happened to the characters based on the illustration, without consulting the actual text of the book. The groups then report back to the group as a whole.

 4 (10 minutes) Write about and/or discuss how the ideal parent combines qualities of justice and mercy in rearing children. Also, consider the ideal teacher.

Some points to make while directing the writing and discussion: Being a parent is sometimes described as the hardest job there is. Might this assessment have something to do with parents' unique challenge in balancing justice and mercy? What would family life be like if parents stressed justice above all else? mercy above all else? Judaism guides us to make room for both justice and mercy. Why is this so important in parenthood? Similar points can be raised for teachers, who often are likened to surrogate parents.

 5 (5-10 minutes) Our choice of words can reflect whether we are favoring mercy or justice.

Talk about names. Ask: What names do you use when calling your parents? "Mother"? "Mommy"? "Father"? "Daddy"? How do parents address their children? Do they use a child's full name? a diminutive of their names, or "Sweetie," "Honey," or "Darling"? Why the different usages of the names? Consider what names are used when parents are disciplining children (compare to justice) versus what names are used when comforting children (compare to mercy).

Explain how we understand God as having both the attributes of justice and mercy — how "*Elohim*," is associated with justice and "*Adonai*" (*Yud-Hay-Vav-Hay)* is associated with mercy.

To take the discussion a step further, ask if these two names of God are used in equal measure in our tradition. Does how the names are used reflect the Jewish value of balancing justice and mercy? One example of such balance is the Jewish blessing formula, "*Baruch Atah Adonai Elohaynu Melech HaOlam . . .*"

 6 (20 minutes) Refer to Text Study, Tanach #B, about the people of Sodom and Gomorrah. Write a portrait of the innocent people that needed to be found

in order for God to refrain from destroying the city. What qualities of these people might have inspired God to mercy?

A variation: Conduct imaginary interviews with the four innocent people (Lot and his family). Assign some in the group to be interviewed and others to be interviewers.

 7 (20-30 minutes) A major theme of the *Yamim Nora'im* has to do with *Din* and *Rachamim*, justice and mercy. As we seek forgiveness for any wrongdoing we may have committed, we also ask for mercy.

Look through a *Machzor* (High Holy Day prayer book) for themes of justice and mercy. Then, write your own prayer asking God to deal justly and mercifully with you.

Share your prayers with others in a group. You may want to assemble the creative prayers in a booklet. The booklet then can be photocopied, and copies made available to worshipers during High Holy Day services.

 8 (15-30 minutes) Participants look through newspapers in class or at home to identify stories in which a sense of mercy dominates, a sense of justice dominates, or both are in balance. Everyone explains and discusses their findings with the whole group.

Look at the articles again, this time with the Jewish perspective in mind — that it is incumbent to act both justly and mercifully. If someone who had mastered *Din V'Rachamim* were brought into the class, would he/she see the outcomes of any of the articles differently? The group may want to mount the articles and exhibit them in the classroom with explanatory legends.

A variation: Everyone watches TV shows looking for themes of justice and mercy. In law and police shows, these themes are explored explicitly. Discuss the findings.

9 (5-10 minutes) We are to balance justice and mercy in our dealings with other people. Is it also important to balance the two virtues in our dealings with ourselves?

Hold a discussion: In what ways are you merciful (or kind, nice, gentle) to yourself? tough (or hard, strict) on yourself? What if you were always merciful? What if you were always tough?

An extension: To increase awareness of how justice and mercy are reflected in our attitudes toward ourselves, do the following writing exercise: Write freely for several minutes, taking off from from each of these initial phrases: "I judge myself strictly when . . . " and "I am merciful toward myself when . . . " After you finish writing, you can evaluate.

If maintaining a balance between justice and mercy is the ideal, what attitudes toward ourselves must we hold so as to achieve that balance? Do we need to increase judgment, increase mercy, or just continue what we have been doing?

10 (10 minutes) A popular Hasidic comment says: In one pocket we should put a slip of paper containing the words: "For my sake was the world created," and in the other pocket, the paper should read: "I am but dust and ashes."

From this we learn that we are to keep in balance the two ideas of the dignity and import of each person and of humility. Like dignity and humility, justice and mercy must be in balance.

Write two slogans, one to remind you to be *merciful* toward yourself, and the other to remind you to be *just* toward yourself. Write the slogans on bumper sticker-sized pieces of paper. Then, the slogans can be displayed on two sides of a bulletin board under the headings "Justice" and "Mercy," or glued onto the back and front covers of students' notebooks.

11 (15 minutes) Review the story of Moses' punishment (see Text Study, Tanach #C). Do you think Moses suffered emotional or psychological consequences as a result of the punishment? How did he motivate himself to continue with his mission after he was told of his punishment?

Write about something you did wrong, a mistake you made, and how you were punished. Describe either the actual consequences or the psychological/emotional results of the punishment. How did you feel? What would you do so as to recover and move forward? Was there an act of mercy that helped you to get on with your life and return to a state of equilibrium?

If desired, discuss what you wrote with a group. What does Moses' experience teach us about balancing justice and mercy? Could there be a Jewish paradigm for balancing justice and mercy in our relationship and ourselves?

12 (10-20 minutes) Discuss which countries are good at balancing justice and mercy. Which countries are not? Explain. Are some forms of government more just and merciful than others? How so?

For the discussion consider: human rights records, behavior during war, attitudes toward immigrants, representative versus dictatorial government, welfare policies, charity toward other nations, response to local and international natural disasters, etc.

For an added challenge, analyze Jewish communities and governments throughout the ages. Consider biblical Israel, Rabbinic Jewry in Palestine, Rabbinic Jewry in Babylonia, Jewish communities in the Middle Ages, the Golden Age of Spain, Eastern Europe, contemporary Jewish communities in the Diaspora, and the modern State of Israel.

 13 (45 minutes minimum) See the beginning of Visual Art #8 below for a writing assignment that explores mercy and justice metaphorically. What is mercy like? What is justice like?

Visual Art

 1 (15 minutes to several hours) Who has experienced what it feels like to be merciful toward yourself? Make a facial expression that captures this. Look around the room and see what faces everyone else has made. Pass around a mirror so people can look at themselves. Discuss: Who has experienced what it feels like to be just toward yourself? Again, show it in your faces. Look around the room.

Draw or paint two self-portraits. One picture should show how you feel when you are experiencing mercy toward yourself, the other should show how you feel when you are experiencing justice or self-judgment.

Share your work. Which of the two pictures did you start with? Why? Was one self-portrait more difficult to do than the other? Why? What did this exercise teach you about how the virtues of *Din* and *Rachamim* operate in your life? What did you learn that can help guide you in your efforts to hold these *Middot* more in balance? For example, if your justice-portrait also looks sad, why is that? Why have you associated justice with sadness? Is there something you can do to improve your attitude toward the need for self-judgment (or self-analysis, honesty with yourself, etc.)?

 2 (15 minutes) The activity in #1 above has to do with you as you are now. This exercise focuses on how you want to be. (Due to the overlap in the two exercises, do one or the other, not both in the same session.)

In Language Arts #10, participants create slogans — one reminding them to be *just* toward themselves, the other reminding them to be *merciful* toward themselves. Rather than write two slogans, make two pictures, one a reminder to be merciful toward yourself, the other a reminder to be just.

Some ideas of what to draw:
a. Two differing situations
b. Faces reflecting different expressions
c. Images from nature
d. Other ideas

Post the pictures around the room and comment on each other's artwork.

 3 (10-15 minutes) Draw an old fashioned balancing scale in such a way that each side reflects the kind of object (quality) it will hold — one side justice, one side mercy. For example, the justice side might be blue and black, using very thick straight lines, with a square-shaped scale-plate. The mercy side might be purple and rose-colored, using curvy lines, with a circular scale-plate.

Explain the choices you made in designing your scales. Why is a scale a good symbol for the *Middot* of justice and mercy? Are there other symbols you might have chosen?

 4 (10 minutes) The leader finds two pieces of music — one that seems to express a feeling of mercy, the other a feeling of justice/judgment. (To do this, the leader will need to clarify some of his/her own notions about the "feel" of *Din* and *Rachamim*? Here are a few suggestions.

For *Din*, Beethoven's Fifth Symphony or the Overture to *Egmont*; Bach's Violin Concerto #2 in E Major, BWV 1042, first movement; the theme from *Black Orpheus*; John Coltrane's "Alabama"; band music by John Philip Sousa.

For *Rachamim*, Beethoven's Sixth Symphony (Pastoral), first movement; any Chopin Nocturne; John Coltrane's "Psalm" or "After the Rain."

First, play the "mercy music" while participants draw freely in response to what they hear. Then

play the "justice/judgment music" while participants again draw freely. Use the same piece of paper for drawing to both kinds of music. As they listen to the "justice/judgment music," they can draw in the open spaces of the paper, or they can overlap on what they drew previously to the "mercy music." The resulting artwork should reflect a mixture (a balance?) of merciful and just/judging images, colors, and textures.

A discussion will help you and other participants articulate intuitive beliefs about how justice and mercy "look." Some discussion questions: Why did you choose the colors, shapes, and textures that you did? Was it easier to draw to one piece of music than the other? Why? Are the results of the two drawing experiences in harmony with each other, reflecting the belief that justice and mercy work easily and naturally with each other? Do the justice images seem aggressive toward the mercy images, perhaps reflecting a belief that it is easy for mercy to be overwhelmed by the demands of justice? Explain.

Even though you listened to and drew to the two pieces of music for the same length of time, does one or the other style of drawing dominate? Why might that be?

 5 (20 minutes) Introduce Text Study, Rabbinic #C, about God being so moved as to shift from the "Throne of Justice" to the "Throne of Mercy."

Each half of the group is given a chair. One group decorates a chair as a "Throne of Mercy," the other decorates a chair as a "Throne of Justice." Remind participants that God doesn't really *sit* on a throne. Still, by allowing their imaginations to play out the metaphor, participants may discover subconscious attitudes they hold toward God as Judge and/or as Source of Mercy.

Discuss. Why did you make the choices you did in decorating your chair? What does your finished product reflect as to your feelings about

God in the role of Judge? as Source of Mercy? Are there other times when God might be moved to "switch thrones," to show mercy above justice? Consider other holidays or when certain *Mitzvot* are carried out.

 6 (20-40 minutes minimum) The following spontaneous, non-judgmental activity will help you capture intuitive ideas about the virtues of *Din* and *Rachamim* and help you to make these *Middot* more central in your life.

First, do the writing exercise in Language Arts #1 above, creating lists of synonyms and word associations for "mercy" and "justice." The leader calls out one of the words from this list. Using clay, participants quickly and freely create a shape that captures the sense of the word. The leader rotates between justice and mercy words.

Now sculpt more intentionally. Create a sculpture that expresses visually the virtue of balancing justice and mercy. Both qualities should be incorporated, balanced, and integrated in the sculpture.

In a group share and discuss your creations: How did you fulfill the task? What was most challenging?

 7 (20 minutes to several hours) Study the Hasidic passage in Text Study, Post-Rabbinic #B. Through drawing or painting or with costume materials (cloth, ribbon, buttons, embroidery thread, lace, etc.), design the "garment that sheathes God's mercy." As a result of this visual exploration and interpretation, the hope is to expand awareness (our "seeing") of God's merciful presence in our midst.

Some questions to guide choices in design: What color do you think the garment would be? what texture? Does it have an abstract pattern(s) that runs through it, or does it have recognizable images throughout? Is it above us like a canopy?

Is it below us like a carpet? Is it like an aura surrounding everything?

A variation: Each person designs a square for a quilt version of the "garment that shields God's mercy." Sew the pieces together. Display the garment. Then, if you wish, auction or donate the "garment" for a merciful cause.

After working on this assignment, as participants get ready to leave, the leader asks them to try to take an increased awareness or "vision" of God's merciful presence with them and hold onto it for as long as possible.

 8 (45 minutes to several hours) In this writing exercise, an attempt is made to "see" (metaphorically) mercy and justice in the world around us. In determining the nature of justice and mercy, we increase our understanding of these virtues in unexpected ways. Ideally, this will translate into action.

Complete Language Arts #1 above, creating lists of synonyms and word associations for "mercy" and "justice." Now, go one step further by creating more elaborate metaphors. That is, come up with comparisons for mercy and justice using *like* or *as*. What is mercy *like*? What is justice *like*? Here are some examples: mercy as gentle as a first spring rain . . . mercy as supple as a reed of tall grass . . . justice as confident as a soldier with medals . . . justice as rigid as a telephone pole.

Now begin to draw or paint on canvas a few of the metaphorical images, balancing an image(s) of justice with an image(s) of mercy.

Drama

 1 (15 minutes) Being merciful is particularly challenging when faced with someone who is a probable criminal. Those injured by a criminal's acts may think that person "deserves" the cruelest punishment imaginable. Can we exercise mercy even in the most challenging situations?

Each person imagines that he/she is accompanying a probable criminal to court. A leader might say: Imagine someone did something wrong. And you're the one who must take that person to the place he/she will be judged. The court will decide what punishment the suspected criminal will receive. If the jury decides that the suspect did do something wrong, punishment will be meted out. What might a punishment be (jail, community service, etc.)?

Everyone begins on one side of the room, standing next to his/her imaginary prisoner. Two or three such groups walk across the room at a time. (Everyone in the group should go across once before repeating this a second or third time.) In each crossing, imagine you are leading the suspect to court. First, cross to "court" as if the leader cares most that justice be done, and that the prisoner receive as hard a punishment as he/she deserves. Second, cross to "court" as if the leader cares most that the prisoner be dealt with mercifully. Third, cross to "court" as if the leader shows hope that both justice and mercy will be served.

How do you think the "prisoner" felt during the walks? How did the leader feel? Which walk was most difficult? Why? In Jewish tradition both justice and mercy are seen as necessary, even if at times we may be tempted to embrace one and abandon the other. What might we learn from this experience about the challenges of leaning toward mercy versus justice? Does one or the other come more naturally?

 2 (20-30 minutes) Study the *Genesis Rabbah* passage about the king and his goblets (see Text Study, Rabbinic #A). With the whole group or in a few smaller groups, create a dramatic retelling of this story. Parts for the skit are as follows:
1 actor: King
1 to 4 actors: Hot water

1 to 4 actors: Cold water
2 to 6 actors: Goblets
Voice offstage: God, the "Holy Blessed One"
Optional 2 to 4 actors: World (actors join hands to make a circular representation)

As preparation for the skit, the leader may want to give everyone a chance to try out all the parts, saying:

(For water) "Everyone stand up and show me how you can make your bodies look like water . . . Now make that water hot . . . and cold."

(For goblets) "Try standing as if you are a goblet . . . Show me what happens to you if you crack — start with a tiny crack at the top of your goblet-head that moves slowly, slowly to the bottom of your toes."

(For the world) "Now join hands with one or two people to make a circle. You are a mini-version of the world. Show me how, because of such horrible happenings in your world, you begin to fall apart . . . Now show that same world standing strong."

Smaller groups can perform the piece for each other. The whole group can perform their story for another audience (a school assembly, for parents, or for another class).

 3 (10-5 minutes) What is the tone of your inner dialogue? Does it sound merciful? just? both?

In pairs, one person plays him/herself, the other person plays the first person's inner voice. Use only intonation to communicate, that is, no words or gibberish (nonsense syllables), just a closed mouth that can express tone of voice. The "inner voice" person speaks to the "self" for a minute or two, intoning and balancing sounds that are merciful and sounds that are judging/just. Then, the "self" can respond (with intoned sounds only), and the two can "converse" for another minute or two, exploring the "inner voice" sound of mercy and judgment/justice toward self. Switch roles.

How successful were you in capturing the quality of what your inner dialogue really sounds like? Did the "self" and the "inner voice" feel they were responding effectively to each other during the "conversing"? Explain. Describe a time when the "self" didn't like what he/she was hearing from the "inner voice." In what ways will you be more careful in your efforts to balance Justice and Mercy in your inner dialogue as a result of this experience?

Movement

1 (20-25 minutes) Exploring the idea of balancing justice and mercy kinesthetically will lead to new cognitive insights. In other words, doing/experiencing affects thinking.

Complete Language Arts #1 above, listing synonyms and word associations for "justice" and "mercy." Then divide the group into pairs. As preparation for the core of the activity, first have the pairs practice counterbalances: For example:

a. Stand face to face holding hands. Each person leans back slightly, balancing each other's weight.

b. Stand back to back, leaning against each other. Gradually move slightly away (with tiny steps) from each other, maintaining contact between the backs so that the partners are mutually supporting each other.

c. Grab one hand of your partner. Each lean to the side in counterbalance.

d. Try other counterbalances: elbow to elbow, leg to hand/arm, etc.

The core of the activity: One person is the "mercy" words, the other person is the "justice" words. A leader calls out one word for each person. The person makes a pose, a sculpture, capturing the sense of their given word. When both people in the pairs have their words (their poses), they move closer together and try to figure out how they can hold onto the integrity of their poses

while somehow linking with the other person in a counterbalance. The new counterbalanced pose should reflect both an independent recognition of the words, plus an independent association (balance) between the two. Repeat a few times, allowing the pairs to switch roles (words).

A challenging extension: Once the pairs have their counterbalance, they gradually switch roles, taking on the pose of their partner, while still maintaining the sense of counterbalance.

What was easy/what was difficult about this exercise? What new insights do you have about the need to balance justice and mercy? How about the difficulty of balancing justice and mercy? Was one quality more dominant? If so, did that affect your ability to maintain balance with your partner?

 2 (5-10 minutes) Experiencing something in our bodies can deepen understanding. The spine is a metaphor for justice and mercy. Like justice, the spine can be sturdy, steady, rigid, straight, strong. Like mercy, the spine can be flexible, supple, yielding, adaptable, pliant. Spend a few minutes simply exploring what the spine can do. Then begin to experiment with movement you would associate with justice, and movement you would associate with mercy. Finally, the leader specifically calls out "justice" or "mercy" several times in random order. Participants respond to the words accordingly, with their bodies.

Discuss: Is it more natural for the spine to move one way rather than the other? Is it more natural to favor either justice or mercy in our day-to-day interactions with others? Do our outer selves (bodies) reflect our inner selves? In other words, do we have a bias to do justice over mercy, or vice versa? Did doing a physical exploration of justice and mercy teach you anything about mental attitude toward these virtues?

Extra challenge (add 10 minutes): For a more developed extension of this exercise, choose some

music with a variety of tempos and instruments. (Some suggestions: Mussorgsky's "Pictures at an Exhibition," orchestral version; Stravinsky's "The Soldier's Story.") Participants freely improvise a dance of balancing justice and mercy. They may wish to include one or more of the following:

a. Explore shapes and movement on their own.

b. Interact with others.

c. Include counterbalances (see Movement #2 above).

d. Allow their movement to respond to the music they hear.

e. Other ideas?

Discuss this extra challenge using guidelines, such as those outlined for the first section of this activity.

 3 (15-20 minutes) Through this exercise, participants will distinguish between the experiences of mercy and justice and explore the effect of these in their lives.

Imagine two large circles of equal size in the space. One is a place in which mercy is experienced; the other is a place in which justice/ judgment is experienced. Explore the two spaces through movement, going between the two as desired. Note the subtlety here: the circles are places in which you are *experiencing*, not expressing, mercy and justice/judgment.

Discuss reactions. Did it feel natural to experience exclusively one quality at a time? Are there physical places in which you experience justice/ judgment more intensely? mercy more intensely? What about internal places, that is, times when you experience one over the other? Are the qualities usually experienced separately (one *or* the other), or are both experienced together? Is there tension between mercy and justice, or not?

Repeat the improvisation, reimagining the circles to reflect different Jewish interpretations as to how justice and mercy *should* coexist. Refer to Text Study for ideas. For example, have the mercy circle much larger than the justice/judgment

circle, or have concentric circles with mercy as the inner core of justice/judgment.

 4 (15 minutes) Study the Hasidic passage in Text Study, Post-Rabbinic #B. Through participating in the following improvisation, the hope is to expand awareness of (our "sensing") God's merciful presence in our midst. After the session, participants should try to take the increased awareness with them and hold onto it for as long as possible.

In Visual Art #7, the "garment" that sheathes God's mercy is "created." Here, rather than fashioning the "garment" with art materials, participants simply *imagine* what it looks like (color, texture, design, degree of transparency), and what it feels like (light or heavy, soft or scratch, stretchy or unyielding). Everyone then imagines holding the unique "garment." Improvise movement with the imaginary garment, as if using it to "sheathe God's mercy." Playing appropriate music can give the improvisation more of a sense of structure.

Music

 1 (preparation time at home or 15 minutes) Paying attention to how notions of justice and mercy creep into popular culture can heighten our awareness of these virtues. And once we are more aware, the virtues have more of a chance of becoming a part of us.

The leader can prepare in advance a tape of some of the theme songs from the beginnings of law and police shows. Play them during a meeting or class time. Discuss: How are themes of mercy and justice captured in the music?

What other instances in popular culture might serve as reminders to work on our mastery of justice and mercy? Consider other forms of music, media, literature, art (both fine and commercial), etc.

2 (20 minutes) This activity is particularly appropriate for the *Yamin Nora'im*, the High Holy Day season. Study the passage in Text Study, Rabbinic #C, about God's role during the High Holy Days. When you attend services during the High Holy Days, pay special attention to the musical themes. What do you hear that suggests God changes from one "throne" to another during this time? What feelings does the music inspire?

When using this activity as preparation for, or during a time far from the High Holy Days, use a tape of music (such as *"Kol Nidre"*) to explore the ideas in this exercise.

Miscellaneous

1 (30-60 minutes) For this activity you will need either toy sets of building materials with mini-people, or participants will need to create materials of their own (out of clay, paper, etc.). First, study Text Study, Rabbinic #A.

Then, to prepare for the core of the activity, the leader says: Pretend there is a town in which justice is the bottom line; everything depends on justice, and no one is going to get away with anything! What might happen in the supermarket in such a town, say, if someone went to check out and discovered he/she didn't have enough money? What might happen in this town's factory if a worker arrived late one day? What would happen if a school child forgot his/her permission slip for a field trip? Tell me some other things that might happen in this town? The leader then offers a similar case study for a town ruled only by mercy, and for a town ruled equally by both justice and mercy.

Then, using either the toy or hand-made town materials, small groups create mini-towns: The Town of Justice, The Town of Mercy, and The

Town of Justice and Mercy. Each group can make three towns. (If the group is very large, divide into three smaller groups, with each group making one of the three towns.) Have each group explain their towns. Close the activity with a reinforcement of the moral from the story of the king and his goblets (see Text Study, Rabbinic #A).

CHAPTER SIX
EMET: TRUTHFULNESS

אֱמֶת

OVERVIEW

Be truthful, honest, straight; have integrity. Do not lie, fabricate, deceive, delude, manipulate, distort, or be false in any way. All of these are aspects of *Emet*.

Truth is an ideal to be sought in all aspects of life. We hope there is truth in advertising, truth in politics, truth in lending, integrity in friendships, true confessions, true love. We are alert to potential distortions of truth when we hear about yellow journalism or propaganda. There are positive concepts and personal traits which are built on being true, e.g., loyalty in friendship and fidelity in marriage. The foundation of trust is *Emet*, truthfulness.

Our tradition goes to great lengths to extol the virtue of truthfulness. That's fine and good when the truth is clear, when answers are straightforward. But truth is not always clear. Sometimes it is murky or slippery and hard to pin down. Sometimes we need to "soften" the truth. Yet, how far can we soften truth before it becomes less than the truth? We may think that *Emet* demands bluntness, complete honesty — the stark truth. But when some softening of the truth prevents shame or embarrassment, hurt or humiliation, that, too, is a virtue. Hillel and Shammai, for instance, had a fascinating debate concerning boundaries between truth and falsehood. They use the example of a bride who is unattractive and ungraceful. Does one tell her that she is so, or does one stretch the truth and not be totally honest? More on their debate can be found in Text Study, Rabbinic #F.

We say of God "*Adonai Elohaychem Emet*" (Your God is true). There are other traits we ascribe to God besides *Emet*. One of these is *Rachamim* (mercy). We know from the study of other *Middot* (see Chapter 5, Din V'Rachamim: Justice and Mercy) that God's *Din* (justice) is balanced with God's *Rachamim* (mercy). Human beings are to try to emulate the balancing of justice and mercy. Might such a delicate balancing apply to *Emet* as well? We are not to turn truths into lies, but it is valid and perhaps even worthy to temper truth with mercy. If there are ways we can be kind in our honesty, couching truth in kindness, we must do so.

While there are ambiguities in defining truth, there are blatant examples of falsehood. Distorting the truth for evil purposes or outright lying cannot be defended. In a book written in the 1500s about good and evil traits, the author writes of nine categories of falseness. He posits that it is important to understand falsehood, an evil trait, in order to be able to enter the "Gate of Truth." (*Orchot Tzaddikim: The Ways of the Righteous*, edited by Rabbi Gavriel Zaloshinsky, pp. 383-389.) Below, some modern examples of falsehoods have been added to the author's nine categories.

First category: False testimony, false denials concerning a neighbor's pledge or loan, and other falsehoods of this nature. There are two punishments for this type of falsehood — the first for the falsehood itself and the second for damage caused to others. (See Text Study, Tanach #B and #C.)

Second category: Deceiving others into trusting. The lie causes no direct injury to others,

but by believing, trusting, and not guarding themselves, they are exposed to harm. Jeremiah puts it succinctly, "There are those who speak peaceably to their neighbor, but in their hearts set a snare" (see Text Study, Tanach #D).

Third category: Being manipulative. We prey upon another through falsehood and deceit. Or we spout lies or false reports to another until that other person makes a gift. For example, Jacob pretends to be Esau. He deceives his father in order to receive the blessing meant for his brother (see Text Study, Tanach #A, the first part).

Fourth category: Lying just to lie. In recounting things we have heard, we deliberately distort them. We may even invent whole stories. There's no benefit from the lying, and the lies don't injure others. We perpetrate falsehood though it serves no purpose.

Fifth category: Saying one thing and thinking another. We tell of benefits, gifts, or assistance we will give. But while we are speaking, we think in our heart that we won't do as we have said. For example, we may say, "Sure, I'll help out. Just give me a call," knowing we have no intention of helping out. (Also, see Text Study, Tanach #D and Rabbinic #E.)

Sixth category: Building trust, then violating it; offering assurances and making promises, then breaking our word. For this, there is greater punishment than for the previous category in which the falsehoods were spoken more in general terms (see Text Study, Rabbinic #B). In the previous category, we spoke generally of our willingness to help out. In this sixth category, the offer made is more specific. Here, you might say to a friend with an awful job, "You can quit. I'll cover your rent for the next six months while you look for a new job." And then, you don't pay the rent.

Seventh category: Deluding or duping someone. We deceive others by telling them that we have done them a favor or spoken well of them, when in reality we have not done so.

Eighth category: Falseness about our own self. We praise ourselves for qualities we don't possess. Though we may give charity and gifts, these are not given for higher purposes ("for the sake of Heaven"), but for personal prestige and glorification. The Rabbis give an example: Say you are honored in a manner merited only by those who know two tractates of the Talmud, but you only know one. It is incumbent upon you to say, "I know only one" (Palestinian Talmud, *Shevi-it* 10:3).

Ninth category: Lying or "turning things around" because of your own needs. Injury isn't caused to others and there is no monetary gain. This violation is not as serious as the fourth category, in which lying is just for the sake of lying. There is a story from Talmud (*Yebamot* 63a) about Rav and his wife. When he would ask for lentils, she would make him peas, and when he would ask for peas, she would make him lentils. Chiya, their son, would reverse his father's words ("turn them around"). When Rav wanted peas, he told his mother, "Make lentils" and she would make peas. The son turned his father's words around out of honor for his father; he wanted him to have the food he liked. Nevertheless, Rav told him not to do so again. Doing so is lying. As it says, "They have taught their tongues to speak lies" (Jeremiah 9:4). A modern example of "turning things around": Lying about who initiated a romantic break-up — the other person didn't reject me (so you say), I rejected *him/her!* Here, we lie to save pride!

At times, it is easy to determine the truth, at other times, difficult. The main thing is to stay aware of the *Middah* of *Emet*. We must consider what truth is under all circumstances and conditions, so as to be able to judge how best to express it.

Some Remarks about Truth and the Arts

In this book we use the arts to explore virtues. The relationship between art and truth is particu-

larly thought provoking. What is "true art?" Do these words represent a contradiction? Once something is art, it is a representation. A representation is, by definition, not the real thing. We might say that photography is the truest art because it accurately reflects its subject — more so than a painting. (Unless the photo is manipulated, of course.)

When we talk about truth in art, we have to expand our thinking. Yes, an interpretation, a representation is not the same as a particular thing, but it can evoke "truths." Such truths are often deeper than what might come from a glance at the actual object. A painting might highlight color that is richer than its subject. A sculpture might exaggerate the expression of a certain feeling. A drawing of a town may depict people, buildings, and nature in an unusual scale to each other. Does that make these pieces of art lies? No. Art does not set out to replicate reality. It aims at essences. The experience of looking at a particular painting may make us notice and appreciate the "truly" amazing gift of color. Exaggerating the expression of a feeling shows that one emotion can be so intense that others seem less significant. What about a town not drawn in proper scale? By varying the proportions, an artist may show the degrees of value, the "true value," people ascribe to parts of their town — how residents "really" experience nature or urban development, etc. The portrayed essence of something may not be "real," as in tangible and representational, but it is no less "true." Bringing the essence of something into the foreground, as art does, provides its own lessons in "truth."

While these remarks have focused on visual art, the same ideas could be applied to other art forms as well. Writing, especially in a poetic style, goes beyond detailed descriptions. A typical poem is like a collage — verbal fragments, a collection of images and suggestions evoking different perspectives, deeper understandings. Drama tends

to be more "realistic" in its depiction of truths. Creative movement, like poetry, draws on images, suggestions, abstract expressions of feeling. The sound of composed music is far from the "real" sounds we hear in our environment. But music has a tremendous power to capture truths, to enhance ways of knowing our world. There are times when music may inspire us to do the right (truthful) thing; or raise us up to experience the full and true force of joy.

Art is an appropriate tool with which to explore our relationship with God. We don't point to an object and say, "This is God." We can't describe God. But we may use images, words, and ideas to remind us of God and to help us relate to God. Ideally, art and literature suggest truths — this is their spiritual aspect. The truths that art evokes are to draw us closer to the One Who is the God of Truth.

What follows are summaries as to the effect of *Emet* on our relationships with other people, with ourselves, and with God.

 BAYN ADAM L'CHAVERO, BETWEEN PEOPLE. Truthfulness is important in relationships, whether with strangers and acquaintances or with close friends and family. We need to avoid falseness, be it in business encounters or in promises to loved ones. When hurt or humiliation may result from stark and blatant honesty, softening the truth is acceptable so long as the softening is defensible. Softening truths shouldn't become so habitual that you are in danger of slipping into patterns of outright lying.

 BAYN ADAM L'ATZMO, BETWEEN YOU AND YOURSELF. You must be truthful with yourself. Be truthful whether people are "watching" or not. Don't lie to yourself about who you are. Do not portray yourself as someone you are not, claiming qualities for yourself that you don't possess. Also, be consistent in

what you say and how you feel. That is, don't say one thing and think something else in your heart.

 BAYN ADAM L'MAKOM, BETWEEN YOU AND GOD. God is *Emet*; God is true. Know this and live by it. Be truthful before God. God is close to all who call upon God in truth. God, who is "I Am Who I Am," wants you to be "you-are-who-you-are" — your truest self.

TEXT STUDY

Tanach

A There are many examples of deception in Genesis, and, for each, there are consequences. At the prompting of his mother Rebekah, Jacob tricks his father Isaac into giving him the blessing intended for Esau. Jacob must then flee his home. He is haunted by fear concerning Esau. Jacob's woes because of his deception, begin when he tells his father this lie:

> **I am Esau your firstborn . . . (Genesis 27:19)**

Jacob deceives and is deceived in return. He works for seven years in order to marry Rachel. But on his wedding night, her sister Leah is disguised and brought to him instead.

> **When morning came, there was Leah! So [Jacob] said to Laban, "What is this you have done to me? I was in your service for Rachel! Why did you deceive me?" (Genesis 29:25)**

Suffering as a result of deception doesn't end there. Jacob's own sons also deceive him. They sell their brother Joseph into servitude. They dip Joseph's tunic in blood, and let their father Jacob assume that Joseph was devoured by a beast.

> **[Jacob] recognized [the bloodied tunic], and said, "My son's tunic! A savage beast devoured him! Joseph was torn by a beast!" (Genesis 37:33)**

By the end of Jacob's life, deception is overturned. Jacob asks that he be buried in Canaan. Joseph promises to carry out his father's wishes and is "true" to his word. After Jacob dies, Joseph speaks to Pharaoh.

> **"Now, therefore, let me go up and bury my father; then I shall return." And Pharaoh said, "Go up and bury your father, as he made you promise on oath." So Joseph went up to bury his father . . . (Genesis 50:5-7)**

Deceptions cease with the death of Joseph. As he is about to die, he speaks with his brothers:

> **So Joseph made the sons of Israel swear, saying, "When God has taken notice of you, you shall carry up my bones from here." (Genesis 50:25)**

The Israelites are true to the promise made to Joseph. Once the Israelites abolish deception, they are ready to receive Torah. When they know what it means to keep promises, to follow through on commitments, they are ready to experience the God of truth at Sinai.

> **Now the Israelites went up armed out of the land of Egypt. And Moses took with him the bones of Joseph, who had exacted an oath from the children of Israel, saying, "God will be sure to take notice of you: then you shall carry up my bones from here with you." (Exodus 13:18-19)**

➤ Can you think of other instances of deception in the book of Genesis and the suffering that

resulted from them? What lessons can you learn concerning deception and truth from such stories?

B In Exodus, truth, especially in a court of law, is commanded.

You shall not bear false witness against your neighbor. (Exodus 20:13)

➤ What does not bearing false witness mean? To what kinds of situations does the commandment apply? That is, should it be interpreted broadly, meaning that any lie about any person is wrong? In Exodus 23:7, we are told to keep away from false charges, not to get involved in bribes, etc. Why do you suppose there is so much written in commentaries, legal texts, and stories about being true and about not perverting justice? Perhaps it is because truthfulness is not always clear — we need commentary, we need help. Do you agree or disagree?

C Much attention is given in Jewish sources to vows. Such solemn and emphatic promises to keep one's word have all kinds of legal ramifications. The underlying principle for discussion of vows comes back to truthfulness. Lying is intolerable.

One shall not break one's word. (Numbers 30:3)

➤ What is the relationship between vows and truthfulness? Why do you think vows are taken very seriously in Judaism?

D Judaism instructs us regarding our actions, but our tradition also teaches us to pay attention to our feelings and intentions, to strive for consistency between what we *do* and how we *feel*.

There are those who speak peaceably to their neighbor, but in their hearts set a snare. (Jeremiah 9:7)

➤ What might result from being false hearted? Is Jeremiah's concern one that troubles you as well? Explain. (See also Rabbinic #E.)

E The Prophet Jeremiah speaks about God and truth.

The Eternal God is *Emet* — truth. (Jeremiah 10:10)

➤ What do you think "God is truth" means? In what ways does falseness distance one from God? (See also Text Study, Tefilah #A, which describes how in our daily liturgy we affirm that God is truth.)

The Talmud underscores the link between truth and God's identity.

The Holy One's seal is truth (*Shabbat 55a*).

➤ What is meant by "The Holy One's seal"? Why is truth, as opposed to some other virtue, the Holy One's seal? Consider what Rabbi Bunam says: "Truth was selected as the Eternal's seal because any other virtue may be a clever imitation of the true form; whereas, any imitation of the truth is falsehood" (J.K.K. Rokotz, *Siach Sarfei Kodesh*, i, 53). Could there be other reasons to select Emet as The Holy One's seal?

F There is no room for deceit if we wish to lead a spiritual life.

Those who deal deceitfully shall not live in My house; those who speak untruth

shall not stand before My eyes. (Psalms 101:7)

➤ What does "those who deal deceitfully shall not live in My house" mean? What does "those who speak untruth shall not stand before My eyes" mean? Is a false person capable of having any significant spiritual life?

Rabbinic

A Deception, falseness, lack of truthfulness are like stealing.

There are seven types of thieves, but a "thought thief" (one who deceives another) is the worst of all. (*Mechilta, Mishpatim* 13, 135)

➤ Why is a "thought thief" the worst kind of thief? Do you agree that deceiving is equivalent to breaking the Commandment "Do not steal"? Should people be prosecuted for deception? Should punishments for "thought thievery" be the same as they are for stealing property?

B Many give little thought or concern when it comes to deceiving children.

Rabbi Zera said: "A person should not say to a child, 'I will give you something,' and then not give it to the child, because the child will be taught to lie, as in the denunciation, 'They teach their tongue to speak lies'" (Jeremiah 9:4). (*Sukkot* 46b)

➤ What is Rabbi Zera concerned about? Is his concern legitimate? Should you have the same standards for showing virtue to children as you have for adults? Do you think that people generally have the same standards for showing virtue

toward all people, whether they are more or less powerful? Are you consistent in the way you show virtue to people?

C In Text Study, Rabbinic #A, the question was asked whether or not untruthful people should be punished for their deception. Perhaps no explicit punishment is needed, as those who are false will get what they deserve.

Such is the punishment of the liar — even when speaking the truth, the person is not listened to by anyone. (*Sanhedrin* 89b)

➤ In this statement, how is the liar punished? Is the punishment fitting? Is the punishment enough, or should there be something more? In your experience, do you find the statement from the Talmud to be accurate, that people stop listening to liars? Explain and give examples.

D When we are asked a question, we often feel obliged to give an answer. The Rabbis disagree with this practice.

Teach your tongue to say, "I don't know," lest you be caught in a lie. (*Brachot* 4a)

➤ Why should you teach your tongue to say, "I don't know"? How far should a person go with this — should you say, "I don't know" every time you're asked a question? Do *you* say (or imply with a shrug or other gesture), "I don't know" as often as you should? How do you feel when a parent or a teacher says, "I don't know" in response to your question?

E The Talmud picks up on an idea expressed by Jeremiah (see Text Study, Tanach #C).

People should not say one thing with their mouths, and something else with their hearts. (*Baba Metziah* 49a)

Here is a specific story illustrating consistency between truthfulness in heart and truthfulness in deed.

It is told of Rabbi Safra that he had an article to sell. A certain man came to him while Rabbi was reciting the "*Shema*" and said, "Let me have the article for such and such a price." When Rabbi Safra didn't answer, the would-be purchaser, thinking Rabbi Safra was not willing to sell for the offered price, kept increasing the amount, saying, "Let me have it for more money." After Rabbi Safra finished saying the "*Shema*," he said, "Take the article at the price you mentioned first, for I was willing to sell it to you at that price." (*Makkot* 24a)

➤ Why doesn't Rabbi Safra answer immediately? What happens when Rabbi Safra doesn't answer the would-be purchaser? Why will Rabbi Safra sell the article for a price lower than the purchaser's higher offer? How does this exemplify the principle stated in *Baba Metziah* above?

F Should we be truthful all the time, under all circumstances, with all people? *Emet*, like so many virtues, needs to viewed with some moderation. There can be exceptions.

Our Rabbis taught: How does one dance before a bride? Bayt Shammai (the House or School of Shammai) says: "[Praise of] the bride should be as she is," and Bayt Hillel says: "What a beautiful and graceful bride!" (*Ketubot* 16b)

➤ Describe the different opinions of Bayt Hillel and Bayt Shammai. With which position do you agree, and why? Assuming that for the most part, the sages agree with Bayt Hillel, why do you think the opinion of Bayt Shammai is included in our records?

Tefilah

A In the daily liturgy, we affirm the connection between God and truth. The words below come at the end of the paragraphs that follow the "*Shema*."

Morning prayer version: *Adonai Elohay-chem Emet. Emet V'Yatziv . . .* (The Eternal your God is *true. True* and certain, established and enduring, fair and faithful, beloved and cherished, delightful and pleasant, awesome and powerful, correct and accepted, good and beautiful is this teaching for us forever and ever. True, the God of the Universe is our Sovereign, the Rock of Jacob, the Shield of our redemption . . .)

Evening prayer version: *Adonai Elohay-chem Emet. Emet V'Emunah . . .* (The Eternal your God is *true. True* and faithful is all this, and it is firmly established for us that God is our Eternal One, and there is none but God, and that we are God's people Israel.)

➤ Why is an affirmation of God's truth part of daily prayer? In what ways does the idea of God as truth "register" with you, influence you, make a difference to you in how you live your life and in how you see things on a daily basis?

B This verse, recited regularly in services, is part of the "*Ashray*."

God is close to all who call God, to all who call upon God in truth. (Psalms 145:18)

➤ Anyone can call on God. But for God to be close to the one who calls, something more is necessary. A person must call in *truth*. What exactly is the meaning of "in truth"? That is, is God close as long as (on condition that) the call is sincere, or *whenever* the call is sincere? In what ways does this line from Psalms make you feel more at ease/less at ease in terms of calling upon God?

Post-Rabbinic

A Truly mastering *Emet* can take years of practicing it before it becomes second nature, before we "own" the virtue.

> Said the Ladier: I have labored 21 years on truth: seven years to learn what truth is, seven years to drive out falsehood, and seven years to acquire the habit of truthfulness. (*Emet Keneh,* published by A. Rosengarten; Piotrkov, 1907, p. 74)

➤ Do you think the Ladier was exaggerating, or does it really take that long to acquire the habit of truth? Explain. How might one's understanding of truth change throughout the years? How have your views on truth changed with the passing of time?

B Which is worse, oral deception or monetary fraud? Maimonides taught:

> Oral deception is much worse than monetary fraud because restoration is possible in the latter (monetary fraud), while no restoration is possible in the former (oral deception), and [monetary fraud] concerns one's money while [oral deception] affects one's person. (*Mishnah*

Torah, Book Twelve, "Acquisitions," 14:18)

➤ Why does Maimonides consider oral deception to be worse than monetary fraud? Do you agree with Maimonides? Why or why not?

C This saying captures the concern of Maimonides about oral deception (see #B above):

> With lies you can go far, but not back again. (Yiddish Folk Saying in *The Word,* by Noah ben Shea, New York: Villard, 1995, p. 305)

➤ In your own words, what is this saying getting at? Can you think of examples of this saying — situations in which lies can lead a person to an unfortunate point of no return?

D In Rabbinic #F above, Bayt Hillel and Bayt Shammai argue about whether or not you have to be truthful concerning a bride. The thrust of tradition agrees with Bayt Hillel whose position can be summarized in these words:

> To avoid insulting someone, you are allowed to tell a white lie. (*Sefer Hasidim*)

➤ Do you agree with this statement? What "dangers" are there in putting forth a statement such as this one? Do you think the potential benefits outweigh the dangers? Explain.

E Whatever we say about truth — that one should never tell a falsehood, never deceive, or that occasionally it's okay to tell a white lie — the truth of the matter is that pure truthfulness may not exist in this world.

> Said the Kossover: "Pure truthfulness does not exist in this world. One person is far from falsehood, and another still

farther. But no one is altogether truth-ful." (*Emunat Tzaddikim*, published by A. Kahan; Warsaw, 1924, p. 64)

➤ Do you think the Kossover's opinion concerning truthfulness is accurate? Explain. Is he overly pessimistic? What does the Kossover's view of truth add to the discussion of the *Middah* of *Emet*?

ACTIVITIES

Language Arts

 1 (10-15 minutes for each debate or discussion) For a formal debate, choose one of the topics below, assigning opposite sides, or keep the debate informal, more of a discussion. Debate topics:

a. There are times when a white lie is called for. (See Text Study, Rabbinic #F.)

b. Oral deception is worse than monetary fraud. (See Text Study, Post-Rabbinic #B.)

If the debate has been formal, group members share what they really think afterward. Then discuss: Are there points others brought up that made you alter your initial feelings? What did the debate (or discussion) teach you about *Emet*? Will this exercise influence your future decisions concerning truthfulness?

 2 (5-15 minutes for each discussion) In the previous activity, truthfulness issues were discussed or debated using traditional sources as jumping-off points. Now participants again have an opportunity to discuss the nuances of *Emet*. The difference is they will discuss case studies reflecting more familiar kinds of circumstances. To root the discussions in Jewish sources, participants can refer to Text Study sources. Here are some case studies related to truth in friendship:

a. A friend is responsible for leaving spilled juice on the classroom floor, and the teacher wants to know who is responsible. Do you say?

b. A friend shoplifts a candy bar and pen. Later, the friend's mother sees her son/daughter has something she doesn't remember buying. She asks you if you know where the items came from. Do you tell the truth?

c. You are a friend of a couple who is dating. You see the girl out with another guy, flirting. Your one friend (the supposed boyfriend) asks if you think there's something strange going on with his girlfriend as she seems rather cool lately. Do you tell him the truth about the flirting incident?

Make up case studies for other situations. For example: In the news media, is it okay to report a news story before all the facts are in? Should political candidates who don't keep political promises, who aren't true to what they say, be allowed to run for office again? Or, is a punishment not necessary? (See Text Study, Rabbinic #C.)

Discuss: Are there points others brought up that made you alter your initial feelings? What did the debate (or discussion) teach you about *Emet*? Will this exercise influence your future decisions concerning truthfulness?

 3 (15-30 minutes; one exercise, plus two possible extensions) Review the nine categories of lying in the Overview. Now focus on the positive. Explore what is good and right about truthfulness. Make up nine categories of *Emet* (a few more or less is fine). What are the different shadings of truthfulness? A few ideas to get you thinking in this direction: witness stand reports, scientific facts, truth as faithfulness, and softening the truth in order not to hurt someone's feelings.

An extension: It can take years to master the trait of *Emet* (see Text Study, Post-Rabbinic #A). Imagine that the nine categories you listed are part of a progress report on *Emet*. Grade yourself

in each category from 1 (lowest) to 10 (highest). How well have you mastered each area of truth? If there's a good feeling of trust among group members, talk about why you gave yourself the grades you did. Discuss which areas of truth you find most challenging, and which you think you've mastered fairly well.

Another extension: For the nine categories of lying, certain punishments may apply. Instead of assigning punishments for degrees of lying, come up with rewards for telling the truth. Determine what the rewards should be for the various types of truthfulness on your truth list.

 4 (10 minutes) There's a relationship between *Emet* and *Emunah* (truth and faith). Having faith means believing in the truth of something. In our daily liturgy, we say, *"Adonai Elohaychem Emet"* (The Eternal your God is true). In our evening worship, we actually say the words, *"Emet V'Emunah."* (See Text Study, Tefilah #A.)

Think about these questions: What things in life give you faith? What gives you a sense that God is true (creation, love, Torah, the ability to grow and change, other things)? Elaborate.

Shape some of your thoughts and feelings into a prayer or poem.

 5 (10 minutes) Write freely, beginning with the words, "I am true to myself when . . . " After a few minutes, address the issue of truthfulness within yourself from the other side: "I am less than true to myself when . . . " Go back and forth, exploring when you are/ are not truthful.

If desired, share your writing with the group. What was predictable? surprising? Is there something you're uncomfortable with? If so, why? What are the priority areas of growth you would like to focus on concerning truthfulness within yourself? How does truthfulness (or the lack of it) affect your relationships with others? with God?

 6 (10-15 minutes) In the *"Ashray"* prayer, we say "God is close to all those who call upon God in truth" (see Text Study, Tefilah #B). What is the difference between calling upon God and calling upon God in truth? Reflect on this question and on the questions posed in Text Study, Tefilah #B. Now come up with examples of calling upon God in truth. In addition, or instead, create a prayer consisting of statements of true calls to God — calls that bring about God's closeness. Statements may be simple and straightforward or as complex as you wish.

A few examples of simple statements: Thank God!, Comfort me!, Give me courage to face the future.

Here's a more elaborate example: When I lie awake at night, troubled and ill at ease, I turn my heart toward you. I am reassured by Your presence, for You take shattered feelings, exchanging them for peace.

If desired, turn the statement into more of a prayer: This night, I lie awake, troubled and ill at ease. As I turn to You, You turn to me; my heart awaits You. Reassure me by Your enveloping presence. Eternal God, take these shattered feelings; You who are the Source of Peace, allow Your gift of peace to descend on me.

Share your statements or prayers. How and why do these statements or prayers reflect God as truth? You may want to arrange the writings in a booklet. If you wish, add illustrations.

 7 (15-30 minutes) The prophet Jeremiah speaks about inconsistency between what we say and how we feel (see Text Study, Tanach #D). The Talmud also addresses this troubling issue (see Text Study, Rabbinic #E).

Reflect on the issue of dissonance (lack of harmony) between heart and word/deed. Write either about a personal experience in this matter or about something imagined. A review of the

story of Rabbi Safra may give you some ideas (the second passage in Text Study, Rabbinic #E). Here are a few questions to get you started:

a. Who are the main players/characters in the story?

b. Where and when is the story taking place?

c. What is happening on the level of action and word?

d. What are the characters really thinking or feeling ("in their hearts")?

e. Who is being deceived? How?

f. What responses are there to any deceptions?

g. How does everything turn out in the end?

h. What lessons can be learned about truth from the story?

If desired, share your stories with others.

Visual Arts

 1 (10 minutes or more for each picture) In lying, you may hide what you're thinking, but not what you feel.

Draw or paint a picture. Show how someone might feel who has told a lie. How would their face look? How would they be standing (or sitting)? What would they be doing with their hands? Then show that same person after he/she has told the truth.

Draw someone who is known to lie all the time, who is no longer listened to by anyone (see Text Study, Rabbinic #C). Place the person in the midst of peers and acquaintances. The liar is trying to tell them something important. How are the others responding (with their backs turned, walking away, covering their ears, ignoring the person who usually lies)?

Share drawings. Discuss how the various people are feeling, and why? Would you feel the same as the figures in pictures you drew? Do the figures in the first picture you drew show how *you* would feel if you told a lie and then told the truth? Would you treat someone who tended to lie the same as the people in the second picture

are treating him/her? If you always told lies, would people stop paying attention to you, even when you said something truthful? Explain.

 2 (15 minutes or more) Jacob deceives and is deceived (see Text Study, Tanach #1).

Using several feet of butcher paper, depict a few scenes from Jacob's life. Focus on the theme of deception. The format will resemble an over-sized comic strip. Individuals work on their own "strip" (series of scenes), or groups can create one "strip" together.

A more advanced group can illustrate a turning point in Jacob's understanding or experience of the meaning of truth. Choose an actual event from Genesis (wrestling with a man/angel?), or come up with your own *midrashic* idea.

Discuss. What does Jacob's life teach us about truth? The Jewish people are closely identified with him. We dwell in the "tents of Jacob." We are the "Children of Israel" (Israel is another name for Jacob). Jacob struggled with deception and truth. What does Jacob's life teach us about falsehood? In what ways do Jews today wrestle with deception and truth? When do you yourself wrestle with deception and truth?

 3 (15 minutes) Advertisements often distort the truth. Food appears more wholesome, colorful, or juicy on a carton than the actual product. We are so much as told that we will be richer and more alluring if we buy certain cars, shampoo, toothpaste.

Look through popular magazines for advertisements which are less than truthful. Create a collage (individuals by themselves or groups together) of ads that do not pass the Jewish truth test.

Discuss: If there was a Jewish standard for advertising, how would it change the ads on TV? What advertisement represents the worst distortion of truth, and why? Are violations of truth in advertising too common? Explain.

 4 (15 minutes or more) Lies can lead to trouble. Using one of the following expressions, create a picture showing the trouble that lying can lead to: you can get "trapped in a web of lies," "tangled up in lies," "caught in a lie." (Also see Text Study, Post-Rabbinic #3.)

Share your pictures with a group. Why do we use words such as "trapped," "web," "tangled," and "caught" in conjunction with lying? Are there other words, other images, you associate with the trouble that lying can lead to? Why are the words "crystal clear," "pure," "stark" associated with truth? What other images would you choose for depicting truth?

 5 (15 minutes or more) Jeremiah associated lying with the image of a snare, a trap. Illustrate his words in Text Study, Tanach #D. Create a person with a snare for a heart. Then use a comic strip bubble to show peaceable words coming from the person's mouth.

Discuss. What are the peaceable words you showed? Why are these words untruthful? What is really going on inside of the person? What is the problem when there is a difference between what is said and what is felt? Have you personally experienced this problem?

6 (15 minutes or more) Use optical illusions, mirages, dreams during sleep, and/or daydream visions as the starting point for a painting or other artwork exploring the meaning of *Emet*. Such things as these can alter preconceived notions of what's true, what's real. (It may be helpful to review the section in the Overview, "Some Remarks about Truth and the Arts.")

Share your artwork. Exchange comments, questions, and explanations.

7 (time will vary, depending on whether a trip is taken or art books are used) In this activity, the relationship between art and truth is explored in an abstract way. (See the section in the Overview, "Some Remarks about Truth and the Arts.")

Look at various pieces of art from the perspective of truth. Consider: What is "true" about a specific piece of art — is there an underlying essence? (Does it have to do with color, realness, feeling, value?) Is the art *trying* to express a truth? How does the artist want the viewer to feel? What does the artist want the viewer to learn or to know?

In a room full of art pieces (or within several pages of an art book), which piece of art communicates the most profound truth, in your opinion, and why? (Discuss this question in several different rooms or repeat with several book sections.) How can art be an effective communicator of truth?

Drama

 1 (10 minutes or more for each skit) Several of the Text Study passages lend themselves to dramatic interpretation. Also, stories in the Language Arts activities or those made up by participants can be used for short dramatic pieces. Create skits based on one or more of the following:

a. Scenes from Jacob's life related to deception (see Text Study, Tanach #A)

b. Making a promise to a child, but then not fulfilling it (see Text Study, Rabbinic #B)

c. The punishment of the liar who, even when speaking the truth, is not listened to by anyone (see Text Study, Rabbinic #C)

d. Rabbi Safra's story about consistency between heart and deed/word (see Text Study, Rabbinic #E, second passage)

e. Your own Rabbi Safra-type story, as created in Language Arts #7

f. (the easiest option) The case studies presented in Language Arts #2 (concern over whether or not you should tell the truth when it likely will get a friend into trouble)

Use the discussion questions in each Text Study (or Language Arts activity).

 2 (20 minutes) The Overview discusses nine categories of lying. The leader hands out summaries of the nine categories of lying to each participant, then assigns one or more of the categories to pairs or small groups. (Participants should not know what categories others have.) Each pair or small group makes up a short skit exemplifying the type of lying assigned. When everyone is ready, the groups perform for each other. Audience members try to guess which category of lying is being shown.

You can also use nine categories of truth. You will need to make up these categories. Refer to Language Arts #3 above (the first part), for guidelines.

Discuss. Are there really levels of lying, or levels of truth? In other words, can some lying be worse than other lying? Can some kinds of truth be better than others? Explain. Is there a type of lying you find particularly hard to avoid? What can you do to prevent yourself from lying in this way? Is there an area of truth you're particularly strong in, that you've definitely mastered? Describe and explain.

 3 (10 minutes) In our morning prayers, the words following "*Adonai Elo-haychem Emet*" (Your God is true) describe the nature of God's teaching. In addition to being "true," God's teaching is "certain, established, enduring, fair, faithful, beloved, cherished, delightful, pleasant, awesome, powerful, correct,

accepted, good, and beautiful." That's 16 adjectives altogether! (See Text Study, Tefilah #A.)

Participants create something like a human slide show prayer of the above mentioned adjectives. Have the group take one adjective at a time and come up with a facade-like statue that expresses the word. Do the same for all the adjectives, gradually making a transition from one word to the next. The group will need to keep reviewing so as to remember the sequence.

"Pray" this version just for the group, or share it at a worship service.

 4 (10 minutes) Diaries are a source of true confessions. They give us a window into how a person wrestles with truth. How have Jews throughout the ages wrestled with truth in the privacy of their own diaries?

In a Judaica library, find a diary or autobiography that interests you. Find a passage in which the author reveals a personal truth or perception of the world. The passage should be a few paragraphs long, up to a couple of pages.

Practice your passage as a monologue. Work to make your delivery of the words as sincere as the sentiment that went into writing them. Members of a group can perform their monologues for each other.

Discuss: Why did you choose the passage you did? How is the passage a reflection of truth? What did you do in order to deliver (perform) your chosen passage with conviction? Of all the performances, which words and ideas presented do you find particularly inspirational? Why?

Movement

 1 (10 minutes) In movement terms, truth requires precision, accuracy, and clarity. Movements for falsehood would be movements that distort precision and clarity. They are blurry, murky, stumbling.

Begin with a simple warm-up. Move one body part at a time in each of two ways. For example, start with an arm:

a. Move your arm in a clean, precise way — perhaps by keeping your arm perfectly straight, and moving it as if you are drawing a huge circle with your fingertips.

b. Now, move your arm in an imprecise, not so clear and crisp way (perhaps you will jiggle your arm and/or fling it about randomly).

Repeat with other body parts. Ask participants to make suggestions. (Hip? Shoulders? Legs? Torso? Head and neck?) For a short, basic activity or for younger groups, you can stop here. Otherwise, continue.

Now extend the improvisation to the whole body and to the whole movement space. You will explore truth and falsehood more deeply, using the descriptions in the introductory paragraph for this activity. Divide the space in two. One side is truth; the other is falsehood. Move freely in each side, back and forth as you like, experiencing and expressing the essence of these two qualities. Interact with others as desired.

What did you experience in the two sides of the space? What did you do? Did you notice what others were doing? Was it more challenging to move on one side as opposed to the other? If so, why? Was it difficult to move *between* truth and falsehood — to make transitions? Can any lessons learned here be applied to "real life"?

 2 (10 minutes) If deception were made physical, how would it look? In order to understand what truth is, it can be helpful to look at its opposite.

Explore sneaky movement. Break it down as follows:

a. Do a sneaky walk from one side of the room to the other — restricting the sneakiness to your legs only. Keep your upper body neutral.

b. Do another sneaky walk across the room. This time include your upper body in the sneakiness.

c. The third walk should add facial expression — perhaps furtive glances, biting your lip, a sly smile.

d. Take a couple of minutes for free improvisation exploring sneakiness. You can interact with others or simply slink around the edges on your own. Add sneaky background music if you like — slow, deep toned sounds.

e. Optional: choreograph a short sneaking/ sneaky dance.

Discuss. What did you experience? What did you observe? How was your movement like deception or lying? What would happen if interactions based on sneakiness were the norm? Would you prefer to live in a world in which truth between people is the expectation? Why or why not?

 3 (10 minutes) In Visual Art #4 above, participants created pictures based on phrases associated with lying.

Have individuals or small groups create a short dance expressing the words of one of these phrases. The images — being trapped, a web, getting tangled up, getting caught, getting so far away that you can't return (which is similar to losing your way) — should provide plenty of inspiration. Perform your dance pieces for others in a group, sharing reactions and comments. Also, draw on the discussion questions given for Visual Art #4.

 4 (10 minutes) What does it mean to be true before God? Can we see God as a recipient of our confessions? Can we confide in God as we might confide in a diary?

Imagine the floor is like your diary. But this diary is between you and God. The floor diary represents God's receptiveness. Through move-

ment, pour your true self, your true nature into your diary. You are confiding and revealing who you are, as well as your deepest feelings and concerns. Gradually, you can allow your diary to become three-dimensional. This is like standing in God's house (see Text Study, Tanach #F).

Any reactions? new insights? What did you experience? In what ways did the image of the "diary" work or not work for you? What do you believe it takes in order truly to live in God's house, to stand with integrity before God's eyes?

 5 (15 minutes or more) In Visual Art #6 above, participants explore optical illusions, mirages, dreams during sleep, and/ or daydream visions through art forms. Here, the challenge is to create a movement piece, a dance, based on one of those experiences. Follow the outline given in the Visual Art activity, then adapt it as appropriate for movement. Note: This activity, too, refers indirectly to the section of the Overview, "Some Remarks about Truth and the Arts."

Music

 1 (variable time) Hold a discussion based on the idea that music can express feelings more truly than words. Then play selections of emotionally expressive music. The leader can choose selections on his/her own, or the leader can assign emotions to the participants who then find their own music.

Some emotions you may want to include are: happy, sad, exciting, silly, serious, peaceful. After listening to the selections, discuss whether the music expresses truth more accurately than words do. Or, does music just express feelings differently? (You may want to refer to some of the issues brought up in "Some Remarks about Truth and the Arts" in the Overview.)

 2 (10 minutes) After we pray the words *"Adonai Elohaychem Emet"* (Your God is true), we go through a list of adjectives which we believe describes the nature of God's teaching. (See Text Study, Tefilah #A.)

Participants create short sound phrases for each adjective. Strung together, these adjectives will be a musical version of a prayer. Keep going over the phrases as you come up with them, so that you will be able to remember all 16.

Pray your version of the prayer just for yourselves, or share your interpretation at a worship service. (Note: This activity is similar to Drama #4.)

 3 (15 minutes or more) This exercise involves challenging, abstract thinking. Create music phrases expressing a few of the nine categories of lying from the Overview. Another option is to follow the guidelines in Language Arts #3 and create short music phrases expressing some of the nine categories of lying (see the Overview). Following are examples of music ideas for category 1 and category 3.

Category 1: False testimony – A music idea: Use two instruments. One is the "true" instrument, the other the "false testimony." The true instrument keeps a slow, steady beat. The false testimony instrument plays in a contrasting, inconsistent, random rhythm and tone.

Category 3: Being manipulative – A music idea: Use two instruments. Instrument A keeps a steady beat. Instrument B plays in a contrasting rhythm. B plays louder and louder, beginning to drown out A until, finally, A begins to sound like B. That is, A has become "manipulated" by B and begins to play in the same rhythm as B. A does what B "wants."

An extra challenge: Assign participants various categories. After each person performs his/her idea, the others can try to guess which category is being expressed.

 4 (time will vary) Music can add a rich dimension to dance experiences. The activities listed in the Movement section could be accompanied by music in very effective ways. Consider composing music for one or more of them. A simpler alternative would be to do some music research and find recordings that could be used to accompany one or more of the movement activities.

Miscellaneous

 1 (intermittent time over a day or more) Do you say the words "I don't know" as often as you should? The Talmud says we should practice saying those words (see Text Study, Rabbinic #D).

For a day, a week, two weeks, whatever it takes, make it a practice to answer people with the words "I don't know." Now and then, throughout the given period, reflect on these "I don't know" efforts. Is it difficult to say "I don't know"? What effect does saying "I don't know" have on you? upon others? To what degree should you adapt as your norm saying "I don't know"?

CHAPTER SEVEN

ERECH APAYIM:
SLOW TO ANGER

אֶרֶךְ אַפַּיִם

OVERVIEW

Anger seems to have a life of its own — like a demon that inhabits us and changes our normal composure. Is anger an automatic response, or do we have some control over it? What to do about anger?

Some pop psychology encourages us to express our anger as if there is danger in "holding everything in." Still, from experience and observation, we may have discovered that giving free reign to anger can lead to unpleasant results. Venting anger without restraint can alienate and hurt others. Furthermore, if we give in to explosive anger, we may become alienated or hurt ourselves. Clearly, it is far better to master our anger than the other way around — having anger master us. Working on the *Middah* of *Erech Apayim* (slow to anger) is a good place to begin taking charge of our anger.

The concept of *Erech Apayim* seems reasonable enough. We are not asked to deny our *feeling* anger. We need not assume that anger is necessarily always wrong, or that expressing anger is forbidden. Rather we are taught to be less reactive, to slow anger down. Raging, "flying off the handle," "going ballistic," bursting out with hurtful accusations or put-downs, exploding — those responses are inappropriate. Slow to anger means slow down, think about it, try to be patient, stretch out the reaction time. Is your anger justified? Determine the most appropriate way to express it.

In Torah this *Middah* is first mentioned as one of the attributes of God: "*Adonai! Adonai!* a God compassionate and gracious, *slow to anger,* abounding in kindness and faithfulness, extending kindness to the thousandth generation, forgiving iniquity, transgression, and sin . . . " (Exodus 34:6).

What is the context of this passage that calls for this listing of God's attributes? The story is about something that could have provoked divine anger, but God held back.

God asks Moses to carve two more stone tablets, because Moses had shattered the first set when he saw the people worshiping the Golden Calf. God instructs Moses about the tablet carving, and Moses completes the task. Afterward, God speaks to Moses on the top of the mountain, saying, in effect, that despite the people's idol worship and the shattering of the first set of tablets, I will restrain Myself. God resists full-blown, irreconcilable anger, and is merciful.

Still, what's the point of listing the attributes in connection with this story? The essence of life is that we can make choices. Torah is given as a guide to help us make moral and cultural choices that elevate, ennoble, and lend dignity to life. We can choose who we will be and how we will behave. We can even choose whether or not to enter into a covenant with God. We can decide freely as to whether or not we are going to live according to the teachings of Torah. So, the divine attributes are listed here to make the point that God, too, had a choice. God could have been cruel, angry, and unforgiving, but instead God chose to be compassionate and gracious, slow to anger. God chose (and continues to choose) the path of positive attributes. Therefore, we must also choose to live by such positive attributes.

God's slowness to anger is referred to throughout the Tanach. But we also hear about another

side — the God who "vents fury" and "pours out blazing wrath" (see Lamentations 2:5 and elsewhere). What do we do with this apparent contradiction? Is God truly slow to anger or does God rage now and then? Can we reconcile this apparent contradiction? Could there be divine attributes we are supposed to emulate, and also attributes we are to avoid?

Here's one thought: both restraint and fury are ascribed to God, but with important distinctions. Slowness to anger is a positive attribute, a quality that God has. It is a trait we indeed should try to emulate. The fury? Sometimes the Bible is descriptive, rather than prescriptive. That means the text describes what people are experiencing, what they are feeling, what they perceive. The fury is their perception, not God's act; it is in them, not in God.

There are times when we cannot understand what is happening to us, to our world, times when it seems as if everything is falling apart around us, our center is not holding. There are times when, due to frustration or perplexity or personal hurt, we need to cry out . . . often in anger. It is appropriate to direct our crying out toward God. Our anguish is safe with God. By dealing with our feelings on a spiritual level, we can express and work through a range of emotions and frustrations. This may help deflect anger away from social situations. It can help us resist becoming outwardly reactive. It can enable us to become *Erech Apayim* — slow to anger.

The following summarizes how this *Middah* applies to our dealing with others, with ourselves, and with God.

 BAYN ADAM L'CHAVERO, BETWEEN PEOPLE. Slow down anger in relationships with others — with friends, relatives, co-workers, team members, etc. Take the advice passed down from one generation to the next: before reacting, count to ten.

 BAYN ADAM L'ATZMO, BETWEEN YOU AND YOURSELF. This is anger within. Sometimes we say, "I'm angry at myself because . . . " Where does this kind of anger come from? What do we do with it? To begin with, we need to slow down the anger so that we can more easily come to grips with it and diffuse it.

 BAYN ADAM L'MAKOM, BETWEEN YOU AND GOD. *Erech Apayim,* slow to anger, is a trait ascribed to God, one that we should emulate. Yet, in other biblical references we read about God's anger toward human beings. These descriptions of anger may reflect human projection onto God so as to explain what people experienced. What we *cry out* against is not necessarily what God *is* or what God *does*. However, it is understandable that in the face of tragedy, in times of illness or grieving, our anger toward God can be quite powerful. We plead and we blame. We express our frustration. Even in such circumstances, perhaps especially then, we must strive to be slow to anger.

TEXT STUDY

Tanach

A In the following verse, the attribute of *Erech Apayim* appears. This listing of God's attributes is recited before taking Torah from the Ark on the High Holy Days and Festivals. If we are created in the image of God, and God is slow to anger, then we, too, should strive to be slow to anger. (See Overview for fuller discussion.)

> *Adonai! Adonai!* — a God compassionate and gracious, slow to anger, abounding in kindness and faithfulness, extending kindness to the thousandth generation, forgiving iniquity, transgression, and sin. (Exodus 34:6, also see Numbers 14:18.)

➤ The words *Erech Apayim* are "sandwiched" between the words "compassionate and gracious" and "abounding in kindness and faithfulness." What is the relationship between being slow to anger and compassion, graciousness, kindness, and faithfulness? Is there another term you think would address a good way to handle anger? Is there an attribute you should try to master (such as "be calm" or "hide anger")? Or, does "slow to anger" say it best?

B Moses loses control of his anger. The Israelite community is without water, and they lash out at Moses and Aaron.

> **Why did you make us leave Egypt to bring us to this wretched place, a place with no grain or figs or vines or pomegranates? There is not even water to drink . . . (Numbers 20:5)**

Moses reacts to the complaints with anger.

> **"Listen, you rebels, shall we get water for you out of this rock?" And Moses raised his hand and struck the rock twice with his rod . . . (Numbers 20:10)**

➤ For his explosive reaction, Moses is punished. He will not be allowed to enter the Promised Land. Why did Moses give vent to such anger? Did his anger warrant the punishment he received? What might Moses have done differently had he been slow to anger? Why was it so difficult for him to remain calm? Have your plans or expectations ever been messed up because of an angry outburst?

C Here is some pithy advice on the subject of anger.

> **Slowness to anger results in much understanding; impatience brings about folly. (Proverbs 14:17)**

➤ Do you agree/disagree with the statement from Proverbs? Why? In what ways are anger and impatience alike? How can slowing down your reaction time, slowing down anger, make you a more understanding person?

D Mastering *Middot* is better than mastering material things. Who you are is more important than what you accomplish.

> **Better to be slow to anger than mighty, to have self-control than to conquer a city. (Proverbs 16:32)**

➤ Do you think most people would agree with this statement? Why or why not? In what ways has your desire for things or status been a factor in your ability to control your feelings?

E The following verses from Lamentations infer God's anger. Does God get angry, or do we project this emotion on God? What we experience — what we think God does and what God actually does — are not necessarily the same things. Addressing God provides a safe outlet to express very real, very powerful feelings, and it is preferable to, and less damaging than, exploding at other people. (See Overview for more discussion on this subject.)

> **Look about and see: Is there any agony like mine, which was dealt out to me when God afflicted me on the day of God's wrath? (Lamentations 1:12)**

> **In blazing anger, God has cut down all the might of Israel. (Lamentations 2:3)**

> **The Eternal has acted like a foe. (Lamentations 2:5)**

> **God vented all of God's fury, pouring out blazing wrath. (Lamentations 4:11)**

Take us back, O Eternal, to Yourself,
And let us come back;
Renew our days as of old!
For truly, You have rejected us;
Bitterly raged against us.
Take us back, O Eternal, to Yourself,
And let us come back;
Renew our days as of old! (Lamentations
5:21-22)

➤ What feelings pour forth in the above passages?
Do you think expressing such anger is a good
thing? Is it helpful in any way? Is God really
angry? How would you know? God is said to be
slow to anger. That being so, what do you make
of these comments about God's anger?

Rabbinic

A Hillel had a reputation for being able to
control his anger, for mastering *Erech Apayim.*

Our Rabbis taught: A person should
always be gentle like Hillel, and not
impatient like Shammai. It once
happened that two men made a wager
with each other, saying, "He who goes
and makes Hillel angry shall receive 400
zuz." Said one, "I will go and incense
him." It was *erev* Shabbat, and Hillel
was washing his head. The one passed
by the door of Hillel's house, and called
out, "Is Hillel here, is Hillel here?" There-
upon Hillel robed and went out to him,
saying, "My son, what do you require?"
"I have a question to ask," said he. "Ask,
my son," Hillel prompted. Thereupon
he asked: "Why are the heads of the
Babylonians round?" "My son, you have
asked a great question," replied Hillel.
"It is because they have no skillful
midwives." The man departed, tarried
a while, returned, and called out again

for Hillel. Hillel robed and went out to
him, saying, "My son, what do you
require?" "I have a question to ask,"
said he. "Ask, my son," Hillel prompted.
Thereupon he asked: "Why are the
Palmyreans bleary-eyed?" "My son, you
have asked a great question," he replied.
"It is because they live in sandy places."
The man departed, tarried a while,
returned, and called out again for Hillel.
Hillel robed and [the man] asked, "Why
are the feet of the Africans wide?" "My
son, you have asked a great question,"
said he. "It is because they live in watery
marshes." "I have many questions to
ask," said the man, "But I fear that you
may become angry." Thereupon Hillel
sat before the man and said, "Ask all the
questions you have to ask." "Are you the
Hillel who is called the *Nasi* (prince) of
Israel?" "Yes," Hillel replied. "If that is
you," the man retorted, "may there not
be many like you in Israel." "Why, my
son?" asked Hillel. "Because of you I have
lost 400 *zuz*," the man complained. "Be
careful of your moods," Hillel answered.
"Better that you lose 400 *zuz* and yet
another 400 *zuz* [on account of Hillel's
self-control], than that Hillel should lose
his temper." (Shabbat 31a)

➤ What did the man in the story do to try to
make Hillel angry? How did Hillel react to these
attempts to make him angry? Do you think he
reacted appropriately? Would you have reacted the
same way? If not, what would you have done
differently — would your response be better or
worse than Hillel's? What lesson can be learned
from this story about *Erech Apayim*?

B People differ in personality and tendencies.
The question is, can one's temperament be
altered?

There are four types of temperaments:
Easy to anger and easy to appease —
the loss is canceled by the reward.
Hard to anger and hard to appease —
the reward is canceled by the loss.
Easy to anger and hard to appease —
a wicked person.
Hard to anger and easy to appease —
a saint (*hasid*). (*Pirke Avot* 5:13)

➤ Which of the above categories is more natural to people than the others, and why? Does one of the temperaments describe you? Is it the temperament category you would like to be in? If not, what do you need to do to change? How might this passage inspire someone to make changes?

C For many of the *Middot* we find advice like the following: You shouldn't have one set of attributes for some people, and another set for others. You should be consistent in your traits. In the case of *Erech Apayim*, you should be slow to anger toward all people, not just toward the righteous or those you like. The speaker uses a grammatical point to prove his reasoning.

Rabbi Haggai (some say Rabbi Samuel ben Nahmani) stated: What [was the purpose] when Scripture wrote: "Slow to anger" [*apayim*, in the plural] where the singular [*af*] might well have been used? But [this is the reasoning]: Slow to anger toward the righteous *and* slow to anger also toward the wicked. (*Eruvin* 22a)

➤ Do you need to be equally slow to anger with all kinds of people? What about with someone who, repeatedly, intentionally irritates you? Do you treat that person with the same slowness to anger as you do someone who is usually kind and considerate? Why is consistency in personal attributes important?

D If you can't control your anger, your life will suffer for it.

The Sage has said: Those whose anger comes upon them with thought, upon them you will see composure and grace, and those whose anger comes upon them with thoughtlessness, upon them you will see folly. The Sage has said further: Those whose anger is strong and their wrath intense are not far from the demented. And those who are given to anger, their life is no life. (*Pesachim* 113b)

➤ How does lack of self-control affect quality of life? In what ways are the lives of angry people less fulfilling? In what ways do periodic, out of control outbursts cause significant or lasting damage?

Post-Rabbinic

A Rabbi Pinchas has some interesting ideas about anger.

Rabbi Pinchas once said to a Hasid: "If people wish to guide others in the right way, they must not grow angry at them. For anger not only makes one's soul impure, it transfers impurity to the souls of those with whom one is angry." Another time he said: "Since I have tamed my anger, I keep it in my pocket. When I need it, I take it out." (Adapted from Martin Buber, *Tales of the Hasidim: The Early Masters*, p. 128)

➤ The damage anger can cause concerns Rabbi Pinchas. Do you share his concerns? Why or why not? What do you think it means to transfer impurity to another's soul? From what Rabbi Pinchas said, would you agree that he has mastered *Erech Apayim*? Is the image of carrying your anger in your pocket one that appeals to you? Why or why not?

B The Gastiner Rebbe had an interesting way of dealing with anger.

> The Gastiner Rebbe followed this policy: Whenever he was offended or took offense at something someone said to him, on that day he would never say anything to that person about how he felt. Instead, he would let his emotions sleep on the matter, and on the next day approach the offender, saying, "I was not happy with you yesterday." (The Gastiner Rebbe, quoted by Noah ben Shea in *The Word: A Spiritual Source-book*, p. 109)

➤ What was the Gastiner Rebbe's policy concerning anger? Do you think it is a good one? Explain. Do you do anything similar? If not, would it be worthwhile to try to use his approach as a model for handling your anger?

C Here's another concrete piece of advice about handling anger with silence.

> If someone you are with is provoking you to anger, be silent; if you have to speak to [that person], make it a point to speak in a low and gentle voice as this will keep anger from overcoming you. This is a good device to see that an argument that starts does not continue and get bigger. (Rabbi Hayim Yosef David Azulai, *Hanhagot Tzaddikim*, p. 67, #16; as quoted by Yitzchak Buxbaum, *Jewish Spiritual Practices*, p. 634)

➤ What advice is given here about slowing down anger? Do you think the advice is realistic? Helpful? Would you be willing to try to follow this advice?

Activities

Language Arts

 1 (10 minutes) This is a good opening exercise for learning about *Erech Apayim*. Participants make a conscious effort to think through how anger can be slowed down in their own lives.

Either individually or as a group, Make two lists. One list starts, "I feel angry when . . . " The other begins, "I can stop (or slow down) my anger by . . . "

Did this exercise suggest any new ideas about how to handle anger? How is this exercise itself like "slowing down"? Which strategy for slowing down anger do you think works the best? Why?

 2 (10-15 minutes) This exercise is a good starting point for exploring *Erech Apayim* as it relates to the category of *Bayn Adam L'Makom*: Between You and God. It will be helpful to refer to the Overview for background.

Write about or discuss: Have you ever felt very angry toward God? What did you say, or what went through your mind? How did you move beyond those feelings?

 3 (20-30 minutes) You could argue that much of the tragedy in the world stems from anger getting out of control, exploding (see Text Study, Rabbinic #D). Can folly or tragedy be averted with a slowing down of anger?

Look through a newspaper and find an article that shows a tragic result of anger. Rewrite/revise the article showing what could have happened if there had been a slowing down of anger.

In a group, share the original and the revised articles. What various approaches did participants use to show how the (revised) person/people in the article slowed down anger? Should newspapers

(and news shows) have more stories of tragedy being averted because people controlled feelings of rage? Think of other possible stories about models of *Erech Apayim* (such as a modern day Gandhi or Martin Luther King) that newspapers or news shows should carry.

 4 (Blocks of time over several days; 5-10 minute discussion). How does anger come across in our popular media? Does the media provide a forum for justified complaints that will result in positive, needed response and action? Or, does media stir up anger and rage thoughtlessly and carelessly, leaving people wound up, despairing? What can media do to use anger as an "agent" of *Tikkun* (repair)?

Individually, over the course of a few days, tune into a few talk shows on TV and radio. Pay attention to how anger is used by the presenters.

Discuss observations. Refer back to some of the questions at the start of this activity. How might the use of anger in the media be rethought, reshaped?

 5 (10-20 minutes) We learn from our sages that *Erech Apayim* doesn't mean never feeling anger at all. It means to have control over anger. Being in control requires self-discipline, a good practice to master. But, like most attributes, if self-discipline becomes punishing and unproductive, it goes too far. Are we clear about the difference between self-discipline and self-punishment?

Make two lists: "Self-discipline" and "Self-punishment." List examples under each heading. These examples don't have to be about *you* in particular. The idea is to brainstorm, and through that process to gain increased understanding. Under Self-discipline, you might list such things as practicing an instrument each day, eating dessert not more than once a day, saying prayers at regular times. Under Self-punishment, you might list

putting yourself down, making yourself do an extreme amount of physical exercise, smashing a piece of art you made, tearing up something you wrote because it "wasn't good enough," or deliberately breaking one of your possessions.

Discuss the relationship between self-esteem/self-discipline versus anger/self-punishment. When does anger, between you and yourself, go too far? Is this a concern you have? If so, what can you do to help turn punishing self-anger into something helpful and positive?

 6 (15-60 minutes) This discussion is for parents. Teach your children ("*V'Shinantam L'Vanecha*"), says our tradition. But teaching/learning involves disciplining/ discipline. Unfortunately, anger, even rage, can get mixed up with the process of disciplining. Children cannot be expected to have mastered *Erech Apayim*; therefore, it is up to the parents to exemplify this *Middah*.

Hold a discussion on how to discipline children without being manipulated by feelings of anger (yours or theirs!). It may be worthwhile to invite a guest expert from the mental health or child development field to help facilitate the discussion.

 7 (10-15 minutes) Study some of the emotional outpourings in Lamentations (see Text Study, Tanach #E). Notice that these involve both wrath and mercy. The speaker cries out concerning God's wrath, but faith in God's mercy also echoes throughout the text. The anger and the mercy exist side by side, going back and forth. This exercise explores some of the complex feelings we may have toward God. Ideally, our feelings would reflect the sense that God is merciful. But like the writer of Lamentations, we may sometimes have feelings of anger as well.

Using your words and perhaps your personal experiences, write an internal dialogue inspired

by the style of Lamentations. Have your words go back and forth between despairing, overwhelming feelings of anger, and reaffirmation. End with reaffirmation. (Look at Psalms, too. Many have a similar pattern of despair and reconciliation.)

 8 (15 minutes) Use Text Study, Tanach #D as a starting point. Notice the pattern: "Better to be X than to be Y." Or, "Better to do [this], than to do [that]." Use this same pattern to develop further ideas about self-control and anger.

Using the pattern described above, come up with images that remind you of being in control of anger versus out of control. Here's an example: "Better to breathe deeply" (that's what you do when you're in control) "than to pant wildly" (that's what you do when you're out of control). "Better to swim in a clear river than to kick dust." If desired, shape these images, including the phrase from Proverbs, into a complete writing piece.

Visual Art

 1 (10 minutes minimum) How do we feel when we are angry? Do those feelings come across in the expressions on our faces? In the way we hold our bodies?

Draw two versions of yourself — one angry, one calm. What did you do to show the differences? How does being slow to anger affect who you are on the inside? on the outside?

 2 (15 minutes minimum) Throughout the ages, there have been times when Jews have felt God was angry with them or felt anger toward God. In addition, Jews have felt reconciled with God — blessed. (See Lamentations 5:22 in Text Study, Tanach #E.)

Draw two pictures of yourself (self-portraits) or two pictures of an imaginary person. The first picture should reflect how it felt (or might feel)

to be angry with God. The second should show how it would look to feel reconciled and at peace with God.

What is your gut response when you look at the portraits? Explain how you decided what to draw?

 3 (10 minutes minimum) According to the story in Text Study, Post-Rabbinic #B, the Gastiner Rebbe would "sleep on the matter" before reacting to an offense.

Study the Gastiner Rebbe's policy. Then, make an illustration of him "sleeping on his emotions," or an abstract picture of the concept of "sleeping on emotions."

Share and explain the drawings. How is "sleeping on the matter" like "slowing down"? As a result of doing this exercise, in what ways are you more likely to try to give yourself some extra time before reacting to an offense?

 4 (30-45 minutes) What does anger "look" like? What is the physical sensation of anger spreading and over-whelming a person? It might begin with a tensing up of the chest and move to the arms and hands, which lash out in all directions. Everyone shows what that spreading of anger looks like — from chest to arms and hands. Experiment for a minute or two making angry gestures, especially with hands and arms. Imagine you are holding long paintbrushes in your hands, almost like extensions of your arms. Make the angry gestures again. Then, imagine there is paint on the brushes and the floor is the recipient of the bursting anger. Imagine brushing paint angrily on the floor. (Keep it on the floor; don't let it fly around the room!) Then, slow it down. Do the same gestures, but in extreme slow motion. Practice brushing the imaginary paint in a controlled, intentional way.

Now, use real paint and large paintbrushes. (If the potential mess seems overwhelming, the

leader could adapt the exercise and use markers or crayons.) First, completely cover the painting space with newspapers. Tape butcher paper to the floor. The leader should think through the logistics beforehand — where the painting will take place, how many painters can paint at a time, if an extra helper is needed (parent or teenager) to supervise the project, what those who are not painting will be doing while waiting for their turn, etc.

For the first painting, use angry brush strokes to fill the canvas with paint. Painters use their whole arms to recall the angry sensations they practiced earlier. Then continue with a second painting. Do similar gestures, but slow them down. Focus on controlling the brush and controlling where you put the paint.

A variation: Mix both styles of painting (angry and slowed down anger) together on the same canvas.

After the paintings dry, arrange them in a place where the whole group can look at them. Discuss. What are your reactions? What do you see? Is the difference between anger and slowed-down anger clear? How did you feel doing the two styles of painting? Which was more appealing and what can you learn from "seeing" your anger? Are there other ways you can express emotions (even the fiery ones) safely? (See Text Study, Tanach #E, in which the author of Lamentations expresses feelings of anger through poetic verses directed at God.)

 5 (10-15 minutes) In this variation on the above exercise, the artwork is a community effort; everyone draws/paints on the same canvases. Participants will go back and forth between anger and calm, resulting in new insights. Participants experience self-control through expressing various states of being. They will also learn how it feels to be surrounded by anger (angry painters) versus how it feels to be surrounded by calm (calm painters).

Lay out two large canvases (use several feet of butcher paper) on the floor. One canvas will reflect out of control anger, rage. The other canvas will reflect calmness, serenity, being in control. The artists go back and forth between the two parts, expressing the designated sentiment through colored drawing or painting.

Continue with discussion as outlined at the end of the previous activity.

 6 (30 minutes minimum, plus time for clay to dry) Ideally, we should show on the outside what we feel on the inside. Even so, according to Jewish traditions, we are not blamed or punished for what we *feel*. But how we *act* is another thing — we are all responsible for our actions. Therefore, we should act with self-control, be slow to anger. Try sculpting this idea.

Out of clay, sculpt an abstract form that depicts "anger." What is going through your mind as you shape the clay? Allow your sculpture to dry. Now paint the clay with colors and patterns that you consider opposite to anger. The goal is this: Through your decoration (what you put on the outside), you are somehow buffering or insulating the inner rage.

In popular psychology we may hear that suppressing anger can be dangerous, self-destructive. But raging isn't so good either. How do we strike the right balance between working through anger, and keeping anger under control? Does your sculpture express that balance?

 7 (15 minutes minimum) Metaphor is a way of tapping into intuitive notions about an idea. Knowing what something is "like" or "not like" can help clarify dimensions, nuances, of a value we hold.

Work with two sets of metaphor: The first set begins, "When I am angry, I feel like . . . " (a dog who's had it's bone taken away, a robot whose

program has gone haywire, etc.). The other set begins, "When I feel calm, I feel like . . . " (a giant elm tree rooted deeply and securely in the ground, a lily pad floating easily and lazily on a pond, etc.). Illustrate some of the images, juxtaposing them on your paper/canvas. Include the actual words of your metaphors, too.

Share and explain the artwork. What do you like best about your artistic creation, and why? Do you have a favorite metaphor you illustrated? How does metaphor and illustrating metaphor add to your understanding of the *Middah* slow to anger?

 8 (10-15 minutes) If you could visualize anger between two people, what would it look like — like darts of fire? a long, thin razor? a chaotically twisted rope? How could these images be tamed, softened? If you can see the possibilities (for "taming") with your creative eye, you can draw on those images in actual situations to slow down anger.

Draw (or paint) two figures (realistic or abstract) on opposite sides of a piece of paper. Make the figures tall, so that they stretch from the top to the bottom of the page. Then, imagine the color and texture of angry energy. Draw the pathway of that energy between the two figures. This energy should go gradually from anger to forbearance, self-control, patience, gentleness. Perhaps the pathway will make a zig-zag pattern that starts at the top of the page and crosses back and forth, top to bottom. Or, maybe the pathway will begin at one's hand, go to the other's head, cross back to the first figure's heart, and finally (in a changed, gentle form and energy) wrap behind the other's back and fade to the ground.

Share your artwork, explaining what you did and why. What one image from someone's drawing will stick most in your mind? Why? In what ways does visualizing the path from anger to slow to anger add to your understanding of the *Middah*?

 9 (30 minutes) Many, if not most of us, feel anger toward God at some point. To move forward, we must eventually work through this anger. While we need to express it, we must strive to rule the anger and not let the anger rule us. One way to do this is to envision what it would look like to slow down anger with, say, an "injection" of mercy, grace, and calm. What would that look like? How could gentler emotions soften the jagged edges of raw anger? Visualize this slowing down or softening, then capture your vision artistically on paper.

Following are the materials and instructions needed for this activity.
1 smaller piece of paper (8½" x 11") for each participant
1 piece of paper roughly double the size of the smaller piece for each participant
scraps of paper that can be torn to make shapes for a collage for each participant
glue
paint, markers, or crayons

a. As if you are angry with God, tear pieces of paper into rough, angry shapes. Now make an angry arrangement of the torn paper pieces, collage-style on the smaller piece of paper. Glue down the pieces and let dry.

b. When it is completely dry, cut the whole collage (including the background paper) into five to ten random, jagged pieces. These jagged shapes will be like puzzle pieces.

c. Spread the jagged shapes on the larger sheet of paper. Space out the pieces so that you can see the relationship between the cuts, but with "alleys" between the edges. It will look like a puzzle with channels of space between the pieces. Glue everything down again, on this larger piece of paper.

d. With paint, markers, or crayons fill in — "inject" — the spaces that are like curving alleyways between the jagged, puzzle-like pieces with the color and texture of mercy, grace, and calm. The complete work should somehow capture

"breaking down anger toward God." Does it succeed/fail? Is there another way you might visually capture that sentiment? Try it.

Drama

 1 (5 minutes) Our face is often a mirror of how we are feeling and how we are likely to act. We have all caught ourselves at one time or another with an angry grimace.

Relaxing facial muscles and releasing the tight expression may be a helpful first step in slowing down anger. Practice this. Make a horribly angry face, hold it tight for about ten seconds, then gradually release. Repeat five to ten times with different angry expressions.

Over the course of the next week or so, try to "catch yourself" with an angry face, then purposefully release your expression. Report back to the group about this experience. Will this relaxation practice have a lasting effect? Explain.

 2 (15-20 minutes) Study and discuss the story of Moses striking the rock for water (see Text Study, Tanach #B). Consider how the situation could have been different if Moses had slowed down his anger.

Now stage two versions of the scenario in which Moses strikes the rock. The first version remains true to the actual text. The second version explores what might have happened if Moses had been slow to anger. Here are all the possible parts for actors:
Moses
God (a voice offstage)
Israelites
Aaron
Miriam (in spirit, as she actually dies just before this incident)

Compare the experience of performing both versions. Which did you like better? Why? Can you think of other situations in history which might have had different outcomes if a key person had slowed down his/her anger?

 3 (20 minutes, at least) Hillel's example of being slow to anger is inspiring. Study Text Study, Rabbinic #A. Then stage a dramatic reenactment of the scenario. There are three parts:
Hillel
One man – a partner in the bet to make Hillel angry (a minor part)
A second man – the one who actually approaches Hillel

Perform this skit for another group or at an assembly.

 4 (10-15 minutes) Our tradition emphasizes that we have free will. But it takes a lot of hard work to become who we want to be, who we think God wants us to be. This exercise provides an opportunity to decide how we will act when anger is brewing.

One actor at a time can do a solo performance, or several actors can do "solos" simultaneously. The rest of the group is the audience.

Imagine that beyond the door of an adjacent room is a situation that may make you very angry, but you must enter and react. (Sample situations: So-called friends are going through your private diary, laughing and making fun of you; classmates are in the classroom messing up your science fair project on which you worked extremely hard; co-workers have entered your computer and are taking notes on valuable research you did for the company; some kids are picking on another kid, making racist or anti-Semitic remarks.) Talk to yourself (out loud) as you struggle with your feelings before you go through the door. When you finally push the door open, react verbally to the situation, then freeze until other actors finish their "solos." Here are some possible feelings to express as you approach the door:

a. anticipatory anger

b. efforts to try to get yourself calm and collected

c. nervousness and trepidation

d. denial

e. tension in your face and body

f. other ideas

Discuss. What are your reactions to this exercise? Did your actor-self act in the same way you yourself would have? Explain. In this exercise you were able to choose deliberately how you would handle anger in yourself. Do you think people really are capable of making such kinds of choices in the heat of the moment? Why or why not? How did your deliberations before you opened the door influence what you said after you entered the room?

 5 (10 minutes) Feeling anger toward God is not uncommon. Those who are sick or grieving may experience despairing anger, or even rage. In crying out, people often use powerful words, such as: "How could this happen?!" "Why me?!" "What do you want from me, God?!" "Why are You making me suffer?" How do you handle such anger? Improvising (using an imaginary scenario) can trigger intuitive, spiritual wisdom.

Two people role play — one person visiting a mourner (or sick person). The mourner expresses anger at God. Improvise the ensuing conversation.

Discuss. Were you surprised at anything you said? Do you think your response would have been different if you had "planned" the script? There are those who say that God is present in intimate moments of deep caring. Do you agree/disagree? Explain your answer.

 6 (15-25 minutes; 1 hour with additional challenge) One way to handle anger is to react with silence to someone who is provoking you. If that won't do, at least use a low and gentle voice to respond (see Text

Study, Post-Rabbinic #C). Practice this advice through dramatic presentations.

Write a monologue in which angry words are expressed toward another. (Because this is creative exploration, not therapy, it is probably best to do this exercise for the first time, at least, using an imagined scenario and imaginary characters instead of based on personal experience.)

Perform the same monologue twice, the first time quickly in a high-pitched voice, the second time slowly and calmly. Compare the two monologues. Describe the differences in how the performer felt and reacted in each one. Is it or is it not realistic for a person to choose intentionally how to "deliver" his/her anger? Explain.

Additional challenge: This time, slow down the anger through word choice. Rewrite the monologue, communicating strong sentiments using less hurtful or emotionally charged words. Compare the performance of the original monologue with the performance of the revised version.

 7 (15-30 minutes) Many of our sages point out that we have choices in how we express emotions. We don't have to rage; we can express anger thoughtfully and gently. One sage warns that anger makes the soul impure (see Text Study, Post-Rabbinic #A). This exercise shows how anger can affect or "tarnish" us in a lingering way.

Pretend you are about to engage in a simple activity or chore such as cleaning the kitchen, doing yard work, playing outside with the neighborhood kids. Imagine that right before you entered into this place of activity, your anger was provoked. (Some examples of anger-provoking situations are included in Drama #4.) Play the scene twice, the first time without an attempt at controlling your lingering anger, the second time with such an effort. If you like, have the audience guess what the actor imagined happened before the performed scene.

After trying this exercise doing solos, you can come up with variations — adding other

actors to the scene, elaborating on what the situation was that made you so angry beforehand, etc. If other actors are included in the scene, make sure everyone understands that physical contact is not permitted.

In what ways is lingering anger damaging? Can it make your own "soul impure"? Explain. How is it possible to contain the effects of anger — to choose what you will do with any lingering, simmering feelings?

 8 (20 minutes) In this more challenging variation on Drama #7, decide on the simple activity or chore the actors will carry out. Also, decide on what maddening thing happened beforehand. This time have two actors play two parts of the same person. As actor A performs the activity or chore in an angry style, actor B shadows A. But the shadowing is in a different style. B portrays (shadows) the same actions, and echoes the same words as A, but does so as if he/she (actor B) were the calmer, more controlled side of A. Reverse roles.

Extend the scene by doing the following: Have the actors remain in character — two sides of the same person. Then have them improvise a discussion about their performance. Here's an example. The "simple activity" is cooking dinner; the "maddening thing that happened beforehand" is getting a phone call in which someone told you that you didn't get the job promotion you wanted and felt you deserved. An example of the dialogue:

B (the calm shadow) to A (the one who's very angry): You didn't have to react so angrily. Is smashing the phone against the wall and banging pots and pans going to solve your problems?

A to B: Banging pots and pans is a safe way to express my anger. At least I didn't hit anybody.

B to A: Etc.

Share reactions to this exercise. Do people really have such a range of responses (to agitating situations) within themselves? Explain. How did the actors reflect potential attitudes that might exist in one and the same person?

Movement

 1 (10 minutes) Seeing and feeling the slowing down of anger on a physical level makes a strong impression. What we learn on one level (physically) can provide insights as to what we strive to do on another level (emotionally).

Make sure each person has plenty of space around himself/herself. Practice what might be considered angry, aggressive movements. Once everyone has spent a couple of minutes exploring such movement, split the group into pairs. The pairs recall some of their solo movements and do them toward each other in extreme slow motion, never touching each other. The movement can still be angry, but the explosiveness is controlled, deflated by being slowed down.

As a variation, the pairs can limit the aggressive movement by keeping feet and legs still, planted in one place, and by keeping the arms still as well. The angry interchange is allowed to happen using the torsos only.

Compare the experience of doing the solo angry movement full force versus slowing down angry movement in pairs. Was one easier? When you were moving in pairs, what were you doing or thinking to try to get yourself to slow down? Could some of these thoughts be translated to an actual heated, emotional situation? What did you learn from moving slowly that you might use during times when you really are angry?

 2 (5 minutes) The *Middah* of *Erech Apayim* teaches that fierce anger can and should be tamed. In this exercise partners help each other experience the physical sensation of slowing down anger by reshaping it.

In pairs, one person takes a very angry position and holds it still. The second person "sculpts" the first, reshaping the anger in such a way that preserves the essence of what might need to be expressed, but "softens the blow." Repeat a few times and switch roles.

Discuss. Describe the sensation of having someone "reshape" you. Did you welcome their "help," or did the reshaping feel unwelcome, intrusive? What does the experience of physically "softening" teach you about emotionally "softening"?

 3 (5-10 minutes) This "call and response" exercise takes Movement #2 a step further. Participants repeat another's angry movement. But they do so in a revised way. They reshape the anger using thoughtfulness and gentleness. (Refer to Music #3 for more details.)

 4 (5 minutes) We need to think about slowing down anger before we find ourselves in a situation that riles us up. Can we tame our anger the way Rabbi Pinchas tamed his — by putting it in his pocket (see Text Study, Post-Rabbinic #A). This exercise provides an opportunity to practice the taming of your anger.

Give each person plenty of space. Think about feeling angry inside. Let that feeling grow until it compels you, seems to make you burst out with an angry movement (a punch, kick, elbow jab). Now repeat the movement you just did, this time concentrating on slowing down the experience from the growing feeling inside to the actual movement. Try doing several "rounds."

Were you successful in slowing down anger? Were others in the group? What else can you do on your own to practice the ability to control anger?

 5 (5-10 minutes) According to directions called out by a leader, participants move quickly between anger, slowing down anger, and stopping. As you respond immediately, you learn control. Could you have the same degree of control as Rabbi Pinchas (see Text Study, Post-Rabbinic #A)?

A leader calls out various movement commands to a group (e.g., walk, swing arms, jump, circle the head, etc.) and asks the group to do each movement in an angry way when he/she says "Go." The leader can also say, "Slow it down," or "Freeze," going back and forth and adding changes of movement.

Here is an example of a leader's directions: Begin walking (angrily) — Go! . . . Slow it down . . . Go! . . . Freeze! . . . Swing your arms — slow it down . . . Go! . . . Freeze! . . . Etc.

Discuss how hard or easy it was to go between anger and ceasing anger. Do you have the same ability to control your anger as you do your physical movement? If not, what can you do to increase your level of control?

A variation: Imagine two large circles on the floor. One is associated with anger, with aggressive explosiveness. The other conveys calmness, being in control, evenness. Go back and forth between the two circles, expressing and experiencing the appropriate movement. Discuss how hard or easy it was to go between the two circles. Continue with the discussion, as above.

 6 (10-15 minutes) In Drama #4 participants expect to confront an anger-provoking situation behind a closed door. They move toward the door, exploring possibilities for managing their internal state of being. Refer to the structure outlined in the Drama activity, but allow freer more abstract dance-like movement. That is, dance the anticipatory anger, dance the nervousness and trepidation, etc.

 7 (10-15 minutes) In Lamentations (see Text Study, Tanach #E), the speaker deplores and despairs of God's wrath, but also affirms faith in God's enduring mercy. We sometimes experience both of these sentiments, too.

Divide the space in two, one side where feelings of anger toward God are intense, the other side where there are feelings of reconciliation. Using movement to reflect the moods, move between the two spaces. Pay particular attention to how you transition between the two areas.

Share reactions and observations. In which side of the space did you prefer to move? Why? In what ways was it difficult to make transitions between the two sides? How much control do we have in how we experience God? How much control do we have in what we express toward God? Is such expression different from real-life experience?

 8 (20-30 minutes) Complete Language Arts #8, in which images of being in control of anger are contrasted with images of being out of control. Use the images as the basis of a short dance.

Music

 1 (10-30 minutes) Our tradition offers many suggestions for slowing down anger. One technique is through the use of music. Music is integral to our heritage. We use it to create an atmosphere, to change the feeling in a room. Music can transform an ordinary room into a worship space. Music can elevate, evoke spiritual connections. It might be just the thing to help us move from anger to a sense of peace.

Imagine it is late Friday afternoon, right before Shabbat, after a hectic and aggravating week. You enter a place of worship, sit down, and try to unwind, readying yourself for prayer. What piece of music would help you to slow down feelings of accumulated anger from the week so that you can turn yourself to God in prayer? Would a *niggun,* a wordless melody, have the desired effect? What other piece of music would you choose? Listen to each others' music choices and share reactions. Put this technique to the test on a late Friday afternoon.

 2 (10-15 minutes) This exercise is similar to Movement #5. What does anger sound like? Are there different levels of loudness and intensity to anger? How do you distinguish what decibel level is acceptable? Explore these questions by using musical instruments.

Use a crescendo/decrescendo pattern: Play on percussion instruments these sounds: neutrality, building to anger, burning anger, slowing down anger, return to neutrality.

A variation: A leader calls out instructions for the musicians, using hand signals, too, in order to be heard over loud instruments. "Go!" means play your instrument angrily. "Slow it down" means slower rhythm, quieter volume. "Rest!" means stop playing, be silent.

The leader can mix up the "symphony" by calling out (and signaling with hands), "Drums, go! Triangles, slow it down. Bells, go! Drums, rest! Triangles, go!" etc.

Discuss: In what ways did the crescendo/decrescendo pattern reflect the sound of anger building, then slowing down? Was it hard/easy to follow the leader's commands? Explain. Can you control your anger as well as you do your instruments? If not, what can you do to improve your ability to master *Erech Apayim*?

3 (5-10 minutes) This activity can be done through music, movement, or both. It takes practice to be able to control your temper (see Text Study, Post-Rabbinic #C). In the following exercise, practice turning heated anger into something more acceptable, more thoughtful.

In pairs, have one person do an angry movement or make an angry sound on an instrument. The other person responds by repeating what was seen or heard, but refashions it to a more gentle version or interpretation. Switch roles and repeat several times.

What was your first reaction to seeing your partner do such an angry movement or make such an angry sound? Did it take extra thought, extra thoughtfulness, to react the way you were supposed to, according to the instructions you were given? Why is it worthwhile to practice taming anger? Are there other ways you could practice (besides doing this exercise)?

Miscellaneous

 1 (10-15 minutes) Various pieces of wisdom concerning *Erech Apayim* have come down to us. Here are some: *Erech Apayim* leads to understanding. We should show the trait equally to the righteous and to the wicked alike. Anger is something we can learn to tame by slowing it down. We should wait before responding to an agitating situation, even sleep on a matter. We should be silent or use a low and gentle voice when anger begins to build. We should be thoughtful.

What other strategies can we glean from our tradition for handling anger? One sage says that anger can make our souls impure (see Text Study, Rabbinic #A). We say in our liturgy, "*Elohai, neshamah sheh-natata bi, tehorah he*" (My God, the soul-breath you have given me is pure). There is something pure about breath. We can use breath as a tool to reorient us, to help us return to a state of calm, to a state of purity.

First, experience the following guided visualization (elaborating on it is fine). The leader says: Close your eyes and imagine yourself in a situation which made you angry . . . What was it that made you so angry? . . . How did you feel inside yourself? . . . How did your body feel? . . . Spend a few moments remembering . . . Now focus on your breath. Imagine that in ten slow, deep breaths you will calm the feelings of anger . . . Your anger will lighten . . . Now, do it — breathe slowly and deeply, ten times.

After the ten breaths, discuss, reflect, or write about the experience. Does slowing down the rate of breathing help slow down anger? Over the next couple of weeks, experiment with using breath as a calming down tool. Then evaluate. Is it a good strategy to use in helping master *Erech Apayim*?

 2 (15-30 minutes preparation time, plus a few minutes or more every once in a while) The Gastiner Rebbe would "sleep on the matter" before reacting to an offense (see Text Study, Post-Rabbinic #B). Retreating to a special place at a particular time can be helpful for regrouping. Perhaps we need such a "time-out" space which calms us down, slows us down, and helps us to be thoughtful about how we should handle our anger.

Design a refuge to escape to when very angry. What kind of chair or pillows should be there? What kind of artwork or verbal posters/reminders? What other objects? books? music? After it is arranged, make it a point to "send yourself" to the time-out space a few times over the course of a few days. Why is it helpful to spend time there? What does this special space provide?

 3 (A few minutes every day on your own) Our sages teach that mastering *Erech Apayim* requires understanding and thoughtfulness, composure and grace, which in turn require introspection — looking inside of yourself. Writing provides a helpful framework, a structure, for such self-reflection.

For a week or so, track your feelings of anger in a journal. Write a short passage recording each time you feel or express anger. At the end of the week, look through your notes.

What have you learned from your journal? Is there any pattern to your anger? Do you always react the same way when you feel provoked? Perhaps you act differently, depending on the situation. If that's the case, what is it about various situations that provoke different responses? Does writing about anger help you focus on changes you might want to make — changes in how you want to handle anger? What are these changes?

CHAPTER EIGHT

HACHNASAT ORCHIM: HOSPITALITY

הַכְנָסַת אוֹרְחִים

OVERVIEW

A surprising amount of attention is given to *Hachnasat Orchim* in our tradition. It is actually a *Mitzvah,* a commandment, an obligation.

The root of *hachnasah* (*ch-n-s*) means "enter," but since the form is in a causative tense, *hachnasah* means to "bring in." In other words, there is a deeper nuance to the kind of hospitality we are supposed to offer. The virtue is not about standing at the door and welcoming those who choose to enter; rather, one is to go outside and bring in the guest or stranger. "Inviting" is a good thing, but "bringing in" is an even higher level of fulfilling this mandate. The *Mitzvah* "to bring guests in" compels us to develop the *Middah* of hospitality.

Living a Jewish life requires community. A *minyan* (quorum) is needed for the recitation of certain prayers and for celebrating most life cycle events and holidays. It has been essential for Jews to depend on each other, to support each other, and to be united as a group. To maintain this standard requires inclusiveness, and inclusiveness means "inviting people in."

Hachnasat Orchim, mentioned frequently in Rabbinic literature, is rooted in the pre-Exodus experience of the Jewish people. Stories, prayers, commandments, ethics, and holidays remind us that since "we were strangers in Egypt," we should know what it is like to be outsiders. Therefore, we have a special obligation to reach out to others.

Hachnasat Orchim involves risk. When we bring in guests, we can't count on the predictable patterns and conversations of our household. We open ourselves to encounter something new, which can at once be exciting and intimidating. Yet, we grow and learn by our exposure to such new experiences.

Implicit in *Hachnasat Orchim* is that we are expected to develop a welcoming, gracious demeanor along with a hospitable home. A hospitable personality accompanied by acts of hospitality — that is the ideal!

Below are summaries on how *Hachnasat Orchim* plays a role in our relationships with others, with ourselves, and with God.

 BAYN ADAM L'CHAVERO, BETWEEN PEOPLE: Bring in guests, invite guests, show hospitality toward others. There are two specific actions here: bring guests in and be a welcoming, gracious person.

 BAYN ADAM L'ATZMO, BETWEEN YOU AND YOURSELF: Show hospitality toward yourself. This can mean be gracious and accepting of various traits you might have, such as, being disciplined, shy, or artistic. It can also mean welcoming possibilities within yourself (such as, "I could be an electrical engineer or a travel writer or a marine biologist"). Hillel calls the soul a guest in the body (see Text Study, Rabbinic #G). We know we are supposed to show hospitality to guests. Thus, if the soul is a guest, it deserves hospitality, no less than any other guest.

 BAYN ADAM L'MAKOM, BETWEEN YOU AND GOD: How do we invite God into our lives? Do we invite God as a guest?

We may hope that God is always present, that God knows God is always welcome. No special invitations should be necessary. But we must admit, there are times and ways we block out God. How might we maintain a posture of graciousness toward God?

(Note: See Chapter 16, "Sayver Panim Yafot: A Pleasant Demeanor" for related ideas.)

TEXT STUDY

Tanach

A The first explicit instance of hospitality in our tradition concerns Abraham. Often quoted and referred to later in Jewish literature, it is a foundation story for this virtue. The fact that God's presence is part of the following greeting of guests lends hospitality an extra air of significance.

> **The Eternal One appeared to [Abraham] by the terebinths of Mamre; he was sitting at the entrance of the tent as the day grew hot. Looking up, he saw three men standing near him. As soon as he saw them, he ran from the entrance of the tent to greet them and, bowing to the ground, he said, "My lords, if it please you, do not go on past your servant. Let a little water be brought. Bathe your feet and recline under the tree. And let me fetch a morsel of bread that you may refresh yourselves; then go on — seeing that you have come your servant's way." They replied, "Do as you have said." (Genesis 18:1-5)**

➤ What was Abraham's act of hospitality? What is the role of the Eternal One in the scenario? It says that Abraham "*ran* from the entrance." Why did he *run*? What guest(s) would inspire such a hospitable response in your own life?

B The guests in the following scenario are at first reluctant to accept Lot's offer of hospitality. Nevertheless, Lot urges them strongly, and they change their minds:

> **The two angels arrived in Sodom in the evening, as Lot was sitting in the gate of Sodom. When Lot saw them, he rose to greet them and, bowing low with his face to the ground, he said, "Please, my lords, turn aside to your servant's house to spend the night, and bathe your feet; then you may be on your way early." But they said, "No, we will spend the night in the square." But he urged them strongly, so they turned his way and entered his house. He prepared a feast for them and baked unleavened bread, and they ate. (Genesis 19:1-3)**

➤ Lot responds enthusiastically toward the angels. Did he know they were angels? Would he have welcomed *any* strangers at the gate? At first, the guests decline Lot's offer. How strongly should we urge reluctant guests to accept our hospitality?

C Because of Rebekah's kindness and hospitality, she is seen as a suitable marriage partner for Isaac. After Rebekah fetches water for Abraham's servant and his camels, the servant asks:

> **"Is there room at your father's house for us to spend the night?" She replies, "There is plenty of straw and feed at home, and also room to spend the night." (Genesis 24:23, 24)**

➤ What does Rebekah do that is considered hospitable? Elaborate on the qualities Rebekah has that we can infer from her actions. Why are these qualities important for a marriage partnership? In our day, many of us have concerns about

inviting strangers into our homes to spend the night. What options do we have for helping a stranger in need if we ourselves did not feel comfortable putting him/her up for the night?

Rabbinic

A Rabbi Huna is extraordinary in his hospitality, at each meal inviting in the hungry. The record of his attitude became so inspirational as to be included in the Pesach *Haggadah*. While Rabbi Huna may have practiced hospitality on a regular basis, we at least are to intensify, during Pesach, our efforts at hospitality. Rabbi Huna's words are a good reminder of the extra efforts we should make at Pesach and at others times as well.

> When [Rabbi Huna] had a meal, he would open the door wide and declare, whosoever is hungry let [that person] come and eat. (*Ta'anit* 20b)

> Let all who are hungry come and eat . . . (*Passover Haggadah*)

➤ Why do you think Rabbi Huna's statement is included in the *Haggadah*? It seems that he invited in the hungry every day, while the words in the *Haggadah* are stated only during Pesach. At what other times should we repeat the words, "Let all who are hungry come and eat"? How should we proffer our invitations?

B The following passage is similar in nature to Rabbi Huna's statement in #A above. To openness and a welcoming attitude are added a few more details that emphasize a reaching out toward the poor.

> Let your house be open; let the poor be members of your household. Let a person's house be open to the north and to the south and to the east and to the west, even as Job's house was, for Job made four doors to his house, that the poor might not be troubled to go round the house, but that each would find they faced a door as they approached . . . (*Avot de Rabbi Natan*, 7:17a,b)

➤ What was particularly welcoming about Job's house? Why is it mentioned here? Why is there special concern mentioned about the poor in terms of them finding entrance easily? Is (are) the entrance(s) to your house welcoming and easily accessible? If not, how could you make it (them) more so?

C A village gets its reputation, its nickname, solely based on its attitude toward hospitality:

> *Kefar Bish* [an evil village] was called so because they never gave hospitality to strangers. (*Gittin* 57a)

➤ How did a town come to deserve the nickname "evil village"? How would you rate your town or community in terms of hospitality to strangers? What can you and others do to make it more open and welcoming to newcomers? to the homeless? to visitors?

D According to Rabbi Simeon bar Yohai, both the host and the guest have roles and responsibilities.

> Rabbi Simeon bar Yohai: The host breaks bread and the guest says grace. The host breaks bread so that [the host] should do so generously, and the guest says grace so that [the guest] should bless the host. How does [the guest] bless [the host]? "May it be God's will that our host should never be ashamed in this world nor disgraced in the next

world." Rabbi [Judah HaNasi] added some further items: "May [our host] be very prosperous with all his/her estates, and may his/her possessions and ours be prosperous and near a town, and may the Accuser have no influence either over the works of his/her hands or of ours, and may neither our host nor we be confronted with any evil thought or sin or transgression or iniquity from now and for all time." (*Brachot* 46a)

➤ Why does the host break the bread? Why should the guest bless the host? What is the nature of this guest's blessing? What are its main points? Would you bless your host in the same way? If not, how would you do so?

E In this passage more details are given as to what a good guest should say. To make clear a good guest's appropriate words, the words of a "bad guest" are also given.

What does a good guest say? "How much trouble my host has taken for me! How much meat he has set before me! How much wine he has set before me! How many cakes he has set before me! And all the trouble he has taken was only for my sake!" But what does a bad guest say? "How much after all has my host put himself out? I have eaten one piece of bread, I have eaten one slice of meat, I have drunk one cup of wine. All the trouble which my host has taken was only for the sake of his wife and his children!" (*Brachot* 58a)

➤ What is emphasized in the words of the good guest? the bad guest? In your experience have you come across both types of people? How did you respond to or feel about the different individuals? In what ways are you a good guest?

F The tone of this passage is in stark contrast to that of the preceding ones. Whereas hospitality is praised exceedingly in most of our tradition, here is a warning to not let our efforts get out of hand.

Rabbi says, people should not invite too many friends to their house, as it is written, "There are friends that people have to their own hurt" (Proverbs 18:24). (*Brachot* 63a)

➤ What does this passage advise? In the previous texts, it is clear that hospitality is of the utmost value. But this passage forces us to take a more critical look at the *Middah*. How does the passage fit in? Can you carry hospitality too far? What consequences could there be in inviting too many people in, in being overly hospitable? Have you ever been hurt by taking the *Middah* of hospitality too far? If so, what limitations might be considered worthy in carrying out *Hachnasat Orchim*?

Often the Rabbis resisted assigning absolute value to even the most lofty practices. Why would that be? Can you think of other *Middot* in which it might be worth warning people not to go too far? Consider *Nedivut* (generosity), *Tochechah* (rebuking), *Anavah* (humility), *Malachah* (industriousness). Other ideas?

G Is it a value to show hospitality toward ourselves? Hillel responds to that question.

"Those who are merciful do good to their own souls" (Proverbs 11:17) applies to Hillel the Elder. Once, when he had concluded his studies with his disciples, he walked along with them. His disciples said to him: "Master, where are you going?" He replied: "To bestow kindness upon a guest in the house." They asked: "Have you a guest every day?" He replied: "Is not the poor soul a guest in the body?" (*Leviticus Rabbah* 34:3)

➤ Who is the "guest in the house" here? Where do you think Hillel was going or what specifically might he have been about to do? What might it mean to treat yourself as if you are the vessel for an important guest? How do you bestow kindness, or show compassion toward yourself? Do you treat your soul as a guest?

More challenging issues for discussion: According to other Rabbinic texts, guests and hosts have obligations toward one another. One obligation is that the guest is to praise the host. Also, there are definitions of a good guest and a bad guest. Keeping in mind Hillel's metaphor of the soul being the guest and the body being the host, consider what obligations, praises, and definitions should be ascribed to the soul-guest, and to the body-host?

H Some interpret Genesis 18:3 as an account of Abraham speaking to God, begging God to remain while Abraham leaves to attend to guests. For Abraham, serving guests is a top priority.

> **Hospitality to wayfarers is greater than welcoming the presence of the Shechinah, for it is written, "And [Abraham] said, 'My God, if now I have found favor in Your sight, turn not away . . .'" [i.e., while I go to attend to my guests] (Genesis 18:3). (*Shabbat* 127a)**

➤ What does Abraham ask of God? Does he have his priorities straight? Why might hospitality to wayfarers be more commendable than welcoming the *Shechinah*?

I Shabbat is a gift from God. When we welcome Shabbat, inviting this special time into our lives and homes, we are appreciative of God. On Shabbat, we make special efforts to heighten our awareness of God as we "invite in" the Sabbath Bride/Queen.

> **Rabbi Hanina robed himself and stood at sunset of Shabbat eve, exclaiming, "Come and let us go forth to welcome the queen Shabbat." Rabbi Jannai donned his robes on Shabbat eve and exclaimed, "Come, O bride, Come O bride!" (*Shabbat* 119a)**

➤ Who is being welcomed in this passage? In what ways is welcoming Shabbat a welcoming of God? Observing Shabbat makes the day feel different from other days. How much of that different feeling has to do with Shabbat being experienced as a special guest? In what ways have you experienced Shabbat as a guest in your life and home?

J Prayer and Torah study are associated with welcoming God.

> **Rabbi Levi ben Hiyya said: "One who, on leaving the synagogue, goes into the House of Study and studies the Torah is deemed worthy to welcome the Divine Presence, as it says, 'They go from strength to strength, every one of them appears before God in Zion'" (Psalms 84:8). (*Brachot* 64a)**

➤ What activities are seen here as being particularly welcoming of the divine presence? Are there other activities which you think invite in the divine? Are there particular attributes? If so, which ones?

Post-Rabbinic

A It is a Sukkot *minhag* (custom) to invite *Ushpizin*, ancestral guests, into the *sukkah*. There is a formula for inviting in these special guests, one for each night of the holiday.

I invite sublime guests to dinner —
Abraham, Isaac, Jacob, Joseph, Moses,
Aaron, David.
[First day of Sukkot add:] "O Abraham,
my exalted guest, may it please you to
have all the exalted guests dwell with us
— Isaac, Jacob, Joseph, Moses, Aaron,
and David . . . "
[Second day of Sukkot add:] "O Isaac,
my exalted guest, may it please you . . . "
(and so on, with the rest of the guests).

The *Zohar* takes this practice a step further —
inviting the poor:

When one sits in the *sukkah* . . . Abraham
and six righteous men come to share
his company . . . Everyone should try to
invite an equal number of poor people
to share meals in the *sukkah* . . . (Zohar,
Emor)

➤ What Sukkot *minhag* reflects the virtue of
Hospitality? How would the *Zohar* suggest we
enhance the tradition of *Ushpizin*? On Pesach, we
are to say, "Let all who are hungry come and eat."
On Sukkot, we are to invite biblical guests and
"poor people." Are there other holidays that have
messages of hospitality?

B The wording of a verse in Genesis concerning
Abraham's hospitality is puzzling. To explain
its meaning, a clever slant on hospitality is offered
— that hosts acquire the virtues of their guests.

This is what the Yehudi said concerning
the verse in the Scriptures that tells
about Abraham being visited by angels:
"And [Abraham] stood over [the guests]
and they ate" (Genesis 18:3). Why is this
said in the Scriptures? It is not customary
for the host who does not eat with his
guests to stand over them while they
eat. Now this is what is meant by these

words in the Scriptures: The angels have
their virtues and flaws, and people have
their virtues and flaws. The virtue of
angels is that they cannot deteriorate,
and their flaw is that they cannot
improve. People's flaw is that they can
deteriorate, and their virtue that they
can improve. But a person who practices
hospitality in the true sense of the word,
acquires the virtues of that person's
guests. Thus Abraham acquired the
virtue of angels, that of not being able
to deteriorate. And so he was over and
above them. (Martin Buber, *Tales of the
Hasidim: The Later Masters*, Volume II,
p. 231)

➤ According to this passage, what special benefit
comes to those who practice hospitality in the
true sense of the word? What virtue of the angels
did Abraham acquire that allowed him to "stand
over and above them"? To what extent do you
think it's true that hosts acquire the virtues of
their guests? Are there interactions you have had
with guests that have made you more virtuous?

ACTIVITIES

Language Arts

 1 (5-10 minutes) *Hachnasat Orchim*
isn't limited to inviting others for a
meal. The *Middah* suggests a certain
attitude — being an inviting person. This trait can
affect a broad range of circumstances. For example,
Rebekah shows kindness by drawing water for the
stranger and his camels, and inviting him to lodge
at her father's house. Her attitude, her whole
demeanor reflects warmth, generosity, and gra-
ciousness. (See Text Study, Tanach #C.)

For a class of children: First, the leader reviews
with them the story of Rebekah, explaining how
she is a model of *Hachnasat Orchim*. Then, children

reflect on the value of *Hachnasat Orchim* in a context more familiar to them — a new child in their class. Discuss what they could do to welcome and show hospitality toward that child. What can they learn from Rebekah in terms of being an inviting person?

 2 (10-15 minutes) We have an old teaching about how a host should be blessed and what a good guest should say. Could we take old ideas and make them work for us now?

Study the blessing of the host, and what the good guest should say, according to the Talmud (see Text Study, Rabbinic #D and #E). Then write your own blessing of a host or your own blueprint for what a good guest should say.

How is what you wrote similar to/different from the ideas of the Rabbis? For a special challenge, use what you wrote in an actual situation. Then report the results.

Optional extension: Participants make thank-you cards using what they wrote as the cover design. If desired, they may decorate the card, too.

 3 (10-15 minutes) This exercise involves using words to communicate hospitality. *Practicing* hospitality is a good way to start *being* hospitable.

In a small group or individually, write a letter to an imaginary Israeli cousin, inviting him/her for a visit. Then imagine it is months later, and the cousin writes, recalling the visit he/she had with you, and inviting you to come to Israel to visit. Write this letter, too.

Share and compare the letters. List on a board all the ways the letters communicated hospitality. Have you ever used any of the strategies in your personal experience?

 4 (10-30 minutes) When we invite people in (even when we are reluctant hosts), we open ourselves to opportunities for learning and growth.

Write about a special guest, beginning with one of the following phrases or one of your own:
A most unusual guest visited.
A special visitor taught me something new.
When I was feeling low, a surprise visitor lifted my spirits.
It was difficult to invite _____, but in the end I'm glad I did.

If you like, share what you wrote with a group. To extend this activity, create dramatic interpretations of one or more of the visits.

 5 (5-10 minutes) Hillel wants us to show kindness to our soul as if it were a guest in the body (see Text Study, Rabbinic #G). Do we show kindness to ourselves in a way that is similar to what is expected of a good host toward a guest? Are we gracious?

Write freely for a few minutes without stopping, beginning with "I am gracious toward myself when . . ."

Did you write anything that surprised you? Explain. Think of a follow-up to this exercise for each person in the group to do.

 6 (15 minutes or more) As mentioned in #5 above, Hillel said the soul is a guest in the body and that we should show kindness to it. Perhaps we could see and understand our own soul more clearly if we could determine its enduring nature, its essence. Not an easy task! What is it about us that transcends time and place? Who/what might we be in a different era and locale? What insights might come from having our souls do some time travel?

Imagine inviting yourself into a different time, place, and culture. Assume your "soul" is the same. Write about a typical day, keeping your same "soul-voice," your same inner nature, but changing the circumstances.

Did you feel welcome in the imaginary time and place? How so or how not? Does projecting

yourself into a new situation make you more sensitive as to how a stranger might feel? What does this exercise teach you about being more gracious to yourself? to others?

 7 (10-15 minutes) Write freely for a few minutes on each of these two topics: How I Block God Out, and How I Invite God In. Do not pause to shape your words, evaluate, or polish.

Members of a group may wish to share all or part of what they wrote. If you were to highlight an idea or two under each of the topics, what would stand out and why?

 8 (10 minutes preparation time; time on your own; plus one 20-60 minute group study period) Study Text Study, Rabbinic #J, which is about how one who studies the Torah is deemed worthy to welcome the divine presence. In a group, discuss the meaning of this passage.

Then, on your own, between sessions, find a Jewish text that is worthy of study because it is equivalent to welcoming the divine presence.

When the group reconvenes, everyone brings in their text. Study the chosen texts together. Save a few minutes before parting to reflect on whether the divine presence is/was present at the study session.

Visual Art

 1 (20 minutes) Exaggerating can clarify an idea, help us to "see" more. In this exercise we try to see more clearly the "look" of hospitality, the expression of graciousness.

Divide into pairs. Using face paints, partners paint a welcoming demeanor on each other. (Take photographs if you like!)

Discuss. How did you decide on the facial "design"? Besides the facial design you chose, what

other "looks" would count as welcoming? How do you feel when you come across a person who shows a welcoming demeanor?

 2 (10-15 minutes minimum) As in #1 above, participants explore the "look" of hospitality. What does a welcoming face look like? How does a face that is not welcoming look?

Draw or paint two sets of portraits, one a welcoming face and one with a non-welcoming face. You could depict an imaginary person or do a self-portrait.

In a group share your creations. What distinguishes the two sets of portraits? How can you make your face (and other body language) "look" more hospitable? Will trying to look more hospitable actually make you a more hospitable person (or a phoney)?

 3 (15-30 minutes) Job showed hospitality by having four doors to his house (see Text Study, Rabbinic #B). Without remodeling our homes, we can probably think of more modest, extra touches we can make to help guests feel particularly welcome. Here's one idea:

Create a special, welcoming guest place mat out of fabric or paper that is laminated. For fabric, have participants plan their design on paper before using the fabric paints. For paper, after drawing their design, laminate or seal the place mat between sheets of Contact paper. Use the place mat when you have a guest to your home.

How else might you add extra measures of hospitality to your home?

 4 (20-40 minutes) Hospitality is not limited to the home. This virtue can and should be present in other venues as well. Efforts should be made to make others feel welcome in communities and in special interest

groups. Certainly our Jewish institutions should be welcoming, especially synagogues. How are people welcomed into your synagogue? You may wish to invite a representative from the Membership Committee to share what the committee does. The following activity will be most meaningful if it is aimed at an actual gathering.

For a new member Shabbat service or other gathering, design special, welcoming announcements and invitations for the special guests. Also, decorate the room with welcoming place mats, posters, brochures, etc.

 5 In #3 above, participants designed special place mats for their guests. What special touch could we provide that would express our eagerness to welcome God as a guest?

Choose a clear day for this outdoor activity. Divide into small groups. Using colored chalk on the sidewalk, each group works to make its own version of a huge "welcome mat" for God.

When everyone is done, groups explain to each other why they designed their welcome mat as they did.

 6 (10 minutes) In this activity we respond to music using the tool of another nonverbal art, drawing. The two together inspire unique responses, bringing to the surface intuitive notions about our relationship with God.

Find a few pieces of music that capture the sense of welcoming God. It could be a prayer or Psalms melody, a *niggun* (wordless melody), or the like. The music should lift your spirits and enable you to "tune in" to God's nearness. Draw freely to the music.

Share the drawings with a group. Can you articulate what you experienced as you listened and drew? What inspired you to put down on paper what you did? What effect can music have on a person bringing God in, drawing God near? Did the intention of welcoming God make God more present?

 7 (15 minutes minimum) This exercise builds on and assumes the completion of Miscellaneous #6 below. Make a "still life" painting. "Invite in" various, perhaps disparate, objects to share a canvas. When you invite people, you can learn and grow, but inviting on other levels can also change your way of looking at things. When you stand back and look at the canvas, you may feel moved and inspired by what beauty and harmony exists.

Sketch or paint a collection of objects, striving to create a sense of gathering that communicates something of interest — surprising, meaningful, or beautiful, etc.

What feelings are inspired by looking at your artwork? Are any of these feelings similar to what you might feel when you carry out the *Middah* of inviting in guests? How would you say a "still life" reflects (in an abstract way) the value of *Hachnasat Orchim*?

 8 (10 minutes to several hours) By capturing an idea in an abstract form, we gain new insights as to its implications. Sometimes the insights are easy to articulate; other times they are more subtle, giving a feeling of inspiration or touching our spirit:

Spend some time studying Hillel's words in Text Study, Rabbinic #G. Then, paint (or draw) a canvas, reflecting the words "The Soul Is a Guest in the Body." Pay special attention to the use of color, shading, shapes, and real versus abstract figures and images.

What was most difficult/easiest about this assignment? What do you feel when you stand back and look at your painting? How does artistic interpretation of an idea enhance our understanding of it?

9 (15 minutes minimum) One way to welcome blessings into our lives is by giving them tangible, multi-dimensional properties — concrete forms that we can look at and touch. This allows us to explore and share blessings in new ways, perhaps bringing more sanctified moments into our world.

Everyone in a group imagines a blessing, and assigns to it its own unique set of properties. It's as if the blessing has an existence in and of itself. What color would it be? Would it be bursting with energy or more delicate? Would it be large or small? Would it be opaquely solid or almost transparent? For instance, what would be the color, energy, size, etc., of the blessing over a rainbow?

After imagining the blessing, begin to draw or paint it. Don't draw someone "doing" the blessing (lighting candles, looking at a rainbow, etc.). Rather, ascribe to it more abstract qualities in terms of shape, color, texture, how much of the page it fills up, broad strokes or finely detailed drawing, and so on. A special touch would be to give your "work of art blessing" to someone.

What aspect of your artwork stands out to you? Why? Does trying to see, touch, feel a blessing make it more a part of you? In what ways is engaging in this artistic activity a way of welcoming God?

Drama

 1 (5-10 minutes) The light, fun activity included in Drama #1 in Chapter 16, Sayver Panim Yafot: A Pleasant Demeanor works well for this *Middah*, too. Each person, in turn, enters the room. Everyone else calls out welcoming phrases and gives the person a standing ovation.

 2 (10-15 minutes) Note: This could also be a Movement activity. Hospitality involves bringing in new dimensions of experience. In this playful activity the self invites in an unusual guest.

Invite a guest animal. What animal do you particularly like? What is it about the animal that you like (a lion's courage, a deer's gracefulness, a dog's loyalty, a snake's flexibility)? How can you put the quality of that animal into movement? Try it.

Now a leader calls out, "Be yourself," and everyone walks around the space as they usually move. After a short while, the leader calls out, "Invite in your animal guest," and everyone becomes their chosen animal. The leader switches between the two instructions several times.

A variation: Rather than having participants simply "become their chosen animal," have them imagine they are meeting, greeting, having some sort of interchange back and forth with the imaginary animal before incorporating the animal's qualities into their movement, into themselves.

Discuss. What did you enjoy about this activity? Do animals have something to teach us? Is it valuable to invite their qualities into our lives? What other parts of nature or the environment around us would we do well to open ourselves to?

 3 (5-10 minutes) Can we visualize what welcoming God means? Can we put the intention to do so into our bodies, our expressions? Such an effort can help us to feel more ownership of *Hachnasat Orchim* as it relates to God.

Make a human tableau. One person takes a pose that reflects a welcoming attitude toward God. The next person adds onto the pose. Everyone continues adding on until a welcome tableau is created. Repeat the process a few times.

Which was your favorite pose? Were there any "themes," similar shapes, that were repeated in the taking of poses? If so, is that significant? Might there be a shared sense of what it means to welcome God, even if this topic had not been discussed previously?

 4 (20 minutes or more) Complete Language Arts #4, in which visits by special guests are described. Now, create dramatic performances of one or more of the visits.

 5 (15-20 minutes) Inviting imaginary, ancestral guests, as we do to the *sukkah,* underscores the value of *Hachnasat Orchim.* It is hoped that by inviting imaginary guests, we will be inspired to welcome live guests as well.

Practice welcoming *Ushpizin* on Sukkot (see Text Study, Post-Rabbinic #A). You also could invite in another special ancestor each day. If it's not Sukkot, study and practice the *minhag,* reciting the words of the daily invitations. Then improvise a scenario of meeting, greeting, and inviting one or more of the guests. For each scene you will need:

1 actor to play him/herself
1 or more actors to play ancestor(s)

In the improvisation try to capture some of the awkward feelings that might be present in a meeting, as well as efforts by the host to put his/her guests at ease. An improvised scenario with Abraham and Sarah might begin like this:

You: Oh, how wonderful! Abraham and Sarah have come to share a meal in our *sukkah.*

Sarah: I hope we're not late. We weren't sure how long it would take to get here. We didn't exactly know where [this city] was. It's rather far from our home town.

You: Well, glad you made it, and welcome! I hope you're hungry — there's plenty here to eat.

Abraham: You know we flew here, and we didn't realize we had to order kosher meals in advance. So we haven't had a thing to eat all day.

Discuss the experience. Was the host welcoming? By what standards? For those who played hosts: Are you actually as gracious as the person you portrayed as yourself? How can you become more gracious and attain increased mastery of this *Middah?*

 6 (the duration of a meal) While especially appropriate for Sukkot, you could do this activity for Shabbat: Invite a special imaginary guest to a Shabbat meal (see Text Study, Post-Rabbinic #A). But go further — everyone invites his/her own guest, but the guest doesn't simply sit at the table invisibly. The host "becomes" his/her guest during the course of the evening. Everyone participates in the meal "in character" so that you might have Moses, Golda Meir, Beruria, Maimonides, Chagall, Deborah, and Leo Baeck all interacting at the same time.

Did you like playing "host" to a prominent individual (that is, being/acting as the person)? Was it difficult to stay in character? What did you learn by "inviting" the person in?

 7 (10-15 minutes) This activity encourages participants to explore the more subtle ramifications of this *Middah* — the differences between "inviting" and "bringing in."

Draw on Rabbi Huna's phrase "Whosoever is hungry come and eat!" (see Text Study, Rabbinic #A). One or more people become Rabbi Huna and stand in the middle of a large space, the imagined home to which the others will be invited. Everyone else stands around the perimeter of the space.

First, have "Rabbi Huna" verbally invite those on the perimeter to "come and eat." "Rabbi Huna" stays in place in the middle of the space and calls out. Keep repeating, "Whoever is hungry come and eat!" When and if those on the periphery are comfortable and ready to go toward "Rabbi Huna's home" (the center spot), they go to the middle of the space. Those playing Rabbi Huna really want everyone to come and may use other words to try to convince those who are reluctant. What might Rabbi Huna say to be extra convincing? Perhaps

he might say, "There's great food here" or "It won't cost you a cent" or "A lot of your friends are already here, having a good time."

Second, repeat the exercise, this time allowing those playing Rabbi Huna to move toward the periphery, where the potential guests are standing. Those playing Rabbi Huna can say, "Whoever is hungry come and eat" and other words, too, to encourage their guests, but they can also do more. They physically go out to the periphery and welcome the guests. They "bring in" the guests toward "home." They do this by walking next to the guest, taking the guest by the hand, and leading him/her, or by gently putting an arm around the guest and directing him/her back to the middle of the space.

Discuss the difference between the first and second experiences. Which experience best captures the ideal of hospitality? How so? Have you observed or practiced both kinds of hospitality? Which has worked better, and why?

 8 (10 minutes) Some messages of welcome are clear and direct. Consider Rabbi Huna's call, communicated straight out: "Let all who are hungry come and eat!" There are also nonverbal signs of welcome. Job had doors on all four sides of his home, so that it would be open to guests from all sides (see Text Study, Rabbinic #A and #B). Do we use all the potential opportunities we have to communicate hospitality?

Members of a group imagine that each has a telephone answering machine. Assign everyone adjectives (the leader whispers them directly or hands them out as individual notes). Keep the adjectives secret, for now. These words will determine the tone of the message participants will create for their imaginary message machines. Besides hospitable, other adjectives could be intimidating, irritable, anxious, disinterested, coolly professional, etc. Give the group a few

minutes to work on their messages. Then, have everyone perform what they came up with. See if the group can guess whose message was hospitable. What about the other messages — can they guess the tone the performer tried to convey?

Discuss. How was the hospitable message successful in getting across its tone? What did you learn about the sound of hospitality? Besides message machines, what other "hidden" opportunities might there be for expressing *Hachnasat Orchim*? Are there improvements you could make in boosting the hospitality level in some of these?

 9 (15 minutes) This exercise gives participants an awareness of the essential process underlying *Hachnasat Orchim* — a bringing in that opens our eyes to new understandings. We focus here on bringing in different aspects of yourself, depending on the imaginary object being passed around or carried across the room. Participants either gather in a circle or plan to travel across the room (one or more people at a time). One (imaginary) item is chosen. Here are a few ideas:

a. A crying infant bringing out your gentle, but frantic self

b. A large fragment of broken glass requiring your careful self

c. A heavy piece of furniture requiring your strong self

d. A dead animal bringing out reverence? anxiety? sadness?

e. Other ideas?

Everyone takes a turn with the object before passing it to the next person. Repeat with a few items, trying to be as true as you can to what is required of a person coming into contact with such an object.

Were you able to call on the various ways of being at will? How much control do you have over the aspects of self you "invite in"?

Movement

 1 (10-15 minutes; 5-10 minutes) See Drama #2 and #3 for additional activities. Both involve creative movement.

 2 (10-15 minutes) Experiencing hospitality on a physical level makes *Hachnasat Orchim* more tangible, giving us more awareness of our abilities to impart hospitality. Thus, we get closer to "owning" the *Middah*.

Have all but one or two people create an inviting space, a group sculpture, with their bodies. In this part of the exercise, the majority of the participants "become" hospitality. Then have the one or two other people enter into the inviting space, walk/move around it, through it, and exit. In this part of the exercise, selected participants experience or receive hospitality. Repeat a few times, giving others the opportunity to experience the welcoming energy.

Share reactions. Have those who entered the group sculpture describe what it was like. What was it like "being" hospitality, being the welcoming sculpture?

Now contrast the first experience with its opposite. Have a group make a non-welcoming group sculpture, an uninviting space. Then, have one or two people enter, walk/move around, and exit. Repeat a few times, taking turns with different people creating the sculpture and entering the space.

An advanced extension: Allow the "sculptures" to move with their upper bodies and arms only, keeping their feet planted in place, or with complete freedom to move (but not touch those entering).

Discuss. Do you have new insights about *Hashnasat Orchim* as a result of this experience? For those who entered into the sculptures, what was the best moment? What was the weakest? Why? Can you apply anything you learned through this movement exercise to life situations?

 3 (5-10 minutes) Is welcoming God something we can sense physically? Is it an internal stirring of emotion? Taking a walk often clears the mind and allows new perceptions to enter into our realm of experience.

Walk freely through the space without thinking about anything. After a minute or so, continue walking, but with the intention of *not allowing God in*. Then very gradually, change the nature of your walking, your moving to reflect a changing orientation *toward inviting God in*.

Discuss reactions. How was your walk changed as a result of what you were intending? Did any part of your moving feel awkward? If so, why do you think that was? Outside the realm of a movement activity, are there ways you move through your day that reflect greater and lesser degrees of welcome toward God? Explain.

 4 (10-15 minutes) As in Visual Art #9, everyone in a group imagines a blessing. They assign to the blessing its own unique set of properties (e.g., what color would it be, would it move quickly, slowly, or how, would it be large and hard to grasp or would it be something you could hold easily in hand, does it suggest angular movement or curving, flowing movement?). After everyone has some image of their chosen blessing, begin to move — inviting the blessing in, gathering it in, reaching it toward you, pulling it, dancing with it. Once you "have" it securely, share it with someone else. Bless someone else with that imagined blessing.

What moment of the improvisation stands out to you? Why? Does trying to see, touch, feel a blessing make it more a part of yourself? Did you feel God was more welcome as you were moving? Does blessing someone else make God more welcome? If so, why?

 5 (10-20 minutes) How might you be different than you are? Exploring the possibilities could be a kind of inviting in.

Imagine and jot down something about a different self, a "guest self" you'd like to welcome in. You might say, "I'd like to invite the self that became a doctor or the self that became a travel writer." Or you might say, "I'd like to invite in the self who is bold, eccentric, and funny."

Everyone starts on one side of the space. Two or three people at a time will cross the space, doing the following: Walk normally toward the center of the space, imagining that from the other side, one of your chosen "guest selves" is moving toward the center as well, toward you. You are to meet, greet, interact with the imagined "guest self" before incorporating that self into who you normally are. Then, you, as your guest-implanted self, continue crossing to the other side of the space.

Variations: Do the improvisation in a freer form, with everyone moving about the space as their normal selves, then greeting, interacting, and incorporating and un-incorporating their guest-self spontaneously. Or, the group could split in half, with pairs improvising — one person is him/herself and the other is the physical embodiment of the first person's designated, imagined guest.

Discuss. Did you welcome the "guest self"? Besides (or instead of) welcoming, what else did you experience as you encountered the "guest self"? Are you as open as you might be in terms of welcoming all aspects of who you are, who you could be? How can you become more gracious in your attitude toward yourself?

 6 (10-15 minutes) Kabbalists in sixteenth century Safed would to go to the hills on *erev* Shabbat to greet the Sabbath Bride. Today, we maintain that tradition by singing *"L'cha Dodi"* (Come My Beloved) before Shabbat Services (see Text Study, Rabbinic #I). As we come to the last verse of that song, we rise, turn toward the door of our worship place, and bow as we sing *"Bo-ee Kallah, Bo-ee Kallah"* (Enter Bride, Enter Bride).

Go outside and move or simply walk about freely for a few minutes. Focus on inviting God's presence into your midst. Keep wandering about, and when you feel inspired, bow deeply. This bow is a welcoming gesture in response to a heightened sense of awareness of God's presence. Continue in this outdoor movement "meditation" for a few minutes.

Discuss reactions. Was this exercise prayerful, effective in invoking a sense of inviting God in? In what ways is the experience of welcoming Shabbat spiritually meaningful? At what other times do you feel as if you are bringing in holiness, times of especial closeness with God?

 7 (15-20 minutes) This exercise builds on and assumes the completion of Miscellaneous #6. The underlying energy of inviting is gathering in and arranging, reaching and pulling.

As a preliminary, everyone starts on one side of the room and in groups of two or three, crosses the room six times, practicing the following:

a. Gathering and arranging movement

b. Reaching and pulling

c. Reaching and pulling using different speeds (slowly, quickly, in between the two)

d. Reaching and pulling using different forces (aggressively, gently)

e. Reaching and pulling from different directions (in front, at the side, from the back)

f. In pairs, one person reaches and pulls in the direction of the partner (without touching). The partner is like a magnet that gets urged along to the other side of the room.

For the core of the activity, one to three people as the "hosts" will draw on their "reaching and pulling" repertoire of movement. The others will each take on the properties of a different object in one of the object collections chosen by the hosts (as arranged in the Miscellaneous #6 activity). For example, an object collection might include a balloon (do rounded, light, and airy kinds of movement); a fork (use stiff, pointy, maybe threatening kinds of movement). For the improvisation, the "hosts" (the "reaching and pulling" folks) gather in their "guests" (representatives of objects from one of the collections). The guests may interact as desired. Everyone simply allows the gathering to happen — in movement!

Follow up with a discussion. What was easy/difficult about the improvisation? What new level of insight concerning this *Middah* resulted from this experience? Will you now think differently about *Hachnasat Orchim*? Explain.

Music

 1 (10-20 minutes minimum) *"L'cha Dodi"* (see Text Study, Rabbinic #I) is a traditional song of welcoming the Shabbat Bride, welcoming God into our midst.

Compose or recall other songs or melodies which capture this sense of welcoming God. String together the melodies chosen by each person for a complete service of welcoming and inviting God in.

 2 (10 minutes) We know that Rabbi Huna used to call out, "Let all who are hungry come and eat" (see Text Study, Rabbinic #A). Today, our doorbell or knocker tells us that someone is at our door. How do your guests feel as they approach your door? Do they hear a welcoming, hospitable sound?

Compose a very short phrase of music that could be used as your "doorbell" — something

that would sound as welcoming as possible. Play your sound for the group. Which "doorbell" is the closest in feel to Rabbi Huna's words? Why?

Miscellaneous

 1 (15-20 minutes) Guests can bridge distances between individuals. As common interests and backgrounds are discovered, a stronger community can result. (This game often is used as an icebreaker at gatherings.)

Each person is given a list of things they are supposed to find in others. Examples include: Find someone who has buttons on his/her shirt; has a brother and a sister; has lived in this city for less than two years; was born in the same month as you; whose favorite color is blue; who plays a team sport; who knows how to juggle three or more items; who has been to Israel. A list of 20 items is a good number to start with. When you find a match, have the other person sign his/her initials next to the listing. See how many items you can match up in a given time period (with perhaps a prize for the most matched).

As a result of completing this activity, do you feel "the guests" know each other better? How does learning about each other help build the kind of community in which *Hachnasat Orchim* is practiced diligently?

 2 (time required to visit places of worship) Take a field trip to a variety of sanctuaries, some that are not Jewish, to determine what makes a space more or less inviting. Or, simply visit your own sanctuary and look at it afresh from the point of view of how inviting it is to worshipers and to God.

As a follow-up, have the group imagine they are remodeling consultants for the *Hachnasat Orchim* Building Company. How would they redesign some of the worship spaces you visited to make them more consistent with the *Middah* of hospitality?

 3 (time on your own) Hospitality involves graciousness. Experiencing graciousness can motivate you to make graciousness more a part of your life.

We are hospitable toward ourselves when we give ourselves a special indulgence. Think of an indulgence that feels respectable, even if frivolous. In the next few days, allow yourself this pleasure. (Examples: Going out to a pancake breakfast before school or work, swinging on a playground swing set, going skiing at night, watching a video of a stand-up comic, etc.)

A variation: Invite yourself to a special meal. Prepare your favorite foods, set the table beautifully, put on music you like, sit down and enjoy yourself! When you are the host and you are the guest, you can extend a special kind of hospitality.

What was the best thing about each of these experiences? Are there ways you can and should be more gracious to yourself? Are there limits? What are they? By being more gracious toward yourself, are you more likely to be a more gracious person in general?

 4 (time on your own, from a few minutes to a few hours) In this exercise, you will explore new possibilities or other dimensions in yourself. Hillel said the soul is a guest in the body (see Text Study, Rabbinic #G). How do we nurture that guest?

For a week or so, invite in a new dimension of experience or expression. Try something you haven't done before, whatever grabs your fancy, spending some time on the activity every day for the set period. A few possibilities: praying/meditating each night before bed, Torah study, beach volleyball, knitting, journal writing, volunteering at the local animal shelter, building a model rocket ship.

Did you welcome the experience? How so? What did it teach you about yourself? Is this a kind of invitation you would like to extend again? What new experience would you next invite in?

 5 (15 minutes or more) This exercise, which focuses on professions, builds on #4 above, but it is more concrete. What might you do if you could do anything? "Invite in" the possibility.

List ten professions you could imagine you would enjoy. If possible, apprentice for a part of a day in one or more of them. If you can't serve an apprenticeship, interview one or two people in these professions about what they do and how they feel about it. Do you still think that you would enjoy these professions? Explain.

 6 (time at home, plus a 10-15 minute group discussion) *Hachnasat Orchim* enriches life in general. Its significance goes beyond making strangers feel welcome. The essence of the *Middah* is bringing together, and that might lead to bringing more beauty and understanding into the world.

Over the course of a week or so, collect and arrange an assortment of objects and images. These should include diverse but complementary items that when combined together result in something more beautiful. Flowers of different colors and shapes result in a more beautiful bouquet. Squares for a quilt are another example. (Note how this collecting and assembling of things parallels the "assembling of guests" — varied personalities brought together often result in a synergy more interesting than the individuals alone.)

Share collections with the group by displaying/ viewing, explaining/exchanging reactions. "Invite" one display to join another. Do they work together or not? Why? Note what different properties of an object(s) are brought out, depending on what surrounds them. One aspect of an object may be highlighted when in the presence of another object, such as color, function, feeling, sense of safety or threat, etc. Here's an example: Someone displays a collection of brightly colored

balloons. Another person displays a beautiful place setting. Now "invite" the fork from the place setting, and put it next to the balloons, and the feel of the newly assembled objects takes on a different quality altogether.

What new insights are gained by exploring *Hachnasat Orchim* on this more abstract level? In what ways do you now feel you have a better grasp of what it means to master this *Middah* ? In other words, how does abstract understanding (knowing) translate into action (doing)? To what extent does knowing have to translate into doing?

CHAPTER NINE

LO LEVAYESH: NOT EMBARRASSING

לֹא לְבַיֵּשׁ

OVERVIEW

Our tradition reflects clearly the importance of not embarrassing others, *Lo Levayesh*. In talking about this *Middah,* the Rabbis often use hyperbole or exaggeration to catch our attention. They want us to know just how seriously we need to take this virtue. For example (see Text Study, Rabbinic #B and #C), the claim is made that those who shame a person in public lose their share in the World to Come, and that the destruction of Jerusalem was the result of one person being humiliated!

"Not embarrassing" is similar to one of the Ten Commandments, "Do not steal." When we embarrass, what is it we steal? It might be another's self-esteem, private information about them, or their dignity; it might be someone's confidence, their pride, their zest for living, or their willingness to take risks. However, embarrassing isn't always as clear as stealing. While we usually know if we're stealing, we might have to think twice about whether or not we're embarrassing someone. Extra thought and care must be given so as not to cross the boundaries of this *Middah.*

We begin to apply *Lo Levayesh* by stopping ourselves when we know we are making embarrassing comments or doing things that embarrass others. But causing shame, even if unintentionally, has serious consequences. Making ourselves more aware of this *Middah* will help us lessen the chances of causing *either* deliberate or unintentional harm, both of which must be avoided.

What about feeling shame toward ourselves — feeling shame about some of our actions, our thoughts? There are hints about Jewish attitudes on the matter, but there are few, if any, definite guidelines. One hint is in a very early story about shame. In the third chapter of Genesis, when after tasting the forbidden fruit in the Garden of Eden, Adam and Eve experience shame. To "cover" their shame, they sew fig leaves for their naked bodies. The shame they feel likely has to do with something more than just shyness about their bodies; shame about their actions is also involved.

The Adam and Eve story can give us direction about how we should see self-shame. Perhaps their experience demonstrates the beginning of shame as it pertains to one's own actions. This kind of shame may not be all bad. It seems fitting that Adam and Eve felt shame for what they did — going against the command of God. Still, there are limits to the kind of shame that one might internalize. Shame that is self-destructive should be avoided. In other words, what does *Lo Levayesh* mean as it relates to ourselves? To ascertain the limits we need to look deeper into our tradition, and perhaps into our own experiences and ideas as well.

More is written about *Teshuvah* or repentance than about self-shame. But *Teshuvah* is more active than self-shame. Repentance or making restitution implies going from one state-of-being to another. It implies making improvements and changes. Self-shame, however, can leave us adrift, stuck in a certain attitude. If shame overwhelms us, we may not be able to make the changes needed. It

takes a conscious effort not to stay in a state of shame. Thus, in this context (of self-shame), we can understand *Lo Levayesh* as "don't *overwhelm* ourselves with shame."

For thoughts on *Lo Levayesh* as it relates to our relationships with others, with ourselves, and with God, see below.

 BAYN ADAM L'CHAVERO, BETWEEN PEOPLE. We usually associate *Lo Levayesh* with refraining from behavior that could result in the social/psychological hurt and/or humiliation of another person. We know when we deliberately cause embarrassment, and we must avoid doing that. But we must also be aware of the unintentional ways that we might cause embarrassment. We must become sensitive to what we say and do vis-a-vis others in public.

 BAYN ADAM L'ATZMO, BETWEEN YOU AND YOURSELF. A personal sense of shame which results from our wrong actions may lead to regret and repentance, to a change of behavior which can be a positive thing. If, however, we overwhelm ourselves with shame, we may become unable to make such changes.

In the context of self, *Lo Levayesh* is related to self put-downs, self-deprecation. Do not force yourself to be what you are not, presenting a facade, a false self that is really not you. This can turn out to be embarrassing, a shaming of your true nature.

 BAYN ADAM L'MAKOM, BETWEEN YOU AND GOD. Embarrassing God might mean acting in ways that cause shameful words to be cried out toward God. Not embarrassing is asking questions without the expectation or insistence that they be answered. It means reflecting each day on the expression *"Mi Chamocha"* (Who is like You). *Lo Levayesh* as it relates to God

means standing in awe, humbly appreciating moments in God's presence.

In the *"Ahavah Rabbah"* prayer, we ask God to enlighten us with Torah and help our hearts to cleave to a life of *Mitzvot*; thus, we will come to love and revere God's name, and *never be brought to shame*. Loving God, feeling close to God, bolsters our confidence and our clarity of purpose. We become less vulnerable to feelings of shame.

TEXT STUDY
Tanach

 At first, in the Garden of Eden, shame was an unfamiliar concern.

The two of them were naked, the man and his wife [Adam and Eve]; yet, they felt no shame. (Genesis 2:25)

Before long, Adam and Eve disobeyed God. They tasted the fruit from the tree forbidden to them. Then their eyes "were opened" to shame.

When the woman [Eve] saw that the tree was good for eating and a delight to the eyes, and that the tree was desirable as a source of wisdom, she took of its fruit and ate. She also gave some to her husband [Adam], and he ate. Then the eyes of both of them were opened and they perceived that they were naked; and they sewed together fig leaves and made themselves loincloths. (Genesis 3:6-7)

➤ Before eating of the forbidden fruit, the text says Adam and Eve "felt no shame." What might this comment mean? Later, Adam and Eve's eyes "were opened" — to what? Why did they sew coverings for their bodies? Is it possible they were trying to

cover shame that went beyond their physical nakedness? Were Adam and Eve embarrassed more in front of each other or more as a result of God's admonishment? Have you ever been embarrassed before God? What did you/could you do to move beyond these feelings of shame?

B The next passage teaches that we should avoid doing things that could make us feel embarrassed before God. Ezra's embarrassment and discomfort in God's presence causes a certain struggle in his relationship with God.

> I got down on my knees and spread out my hands to the Eternal my God, and said, "O my God, I am too ashamed and mortified to lift my face to You, O my God, for our iniquities are overwhelming and our guilt has grown high as heaven." (Ezra 9:5-6)

➤ Why did Ezra feel he could not lift his face to God? Ezra says, "*I* am ashamed . . . for *our* iniquities . . . " He seems to take personal responsibility for guilt that goes beyond himself. Does it seem reasonable to express shame for wrongdoing that involves many others? If Ezra's community had refrained from wrongdoing in the first place, perhaps they would have avoided being embarrassed before God. How much control do we have over the embarrassment we may or may not feel before God?

Rabbinic

A Though the following passage (for mature students) is from the Tanach, it serves as a foundation for the development of significant Rabbinic ideas related to embarrassment.

> If two men get into a fight with each other, and the wife of one comes up to save her husband from his antagonist and puts out her hand and seizes him by his genitals [literally, "*mevushav,*" embarrassed places"], you shall cut off her hand; show no pity. (Deuteronomy 25:11-12)

One Rabbinic comment on the passage focuses on intention. That is, does it matter if she meant to embarrass the antagonist or not?

> Even though she didn't intend to embarrass him, she is still liable for causing him shame. (*Baba Kama* 27a)

The tradition is not unanimous, however, about the role of intention. Some argue that if you *did* intend embarrassment, you are liable; if you did not, you are not liable. Others argue that whether you *did or did not* intend embarrassment, you are liable. The next Rabbinic comment gives an opinion on the matter. The opinion asserts that the woman who seized the antagonist's genitals (in the Deuteronomy passage) did indeed intend to do harm. According to this opinion, not intending embarrassment releases the harm-doer from liability for the embarrassment (though not from other damage).

> If a person falls from a roof, and that person causes damage to and embarrasses another person, the person who fell is liable for the damage, but is exempt from the embarrassment he/she caused. As [the Torah text] says, "She [intentionally] puts out her hand and [then] seizes him." The person who fell is not liable for the embarrassment unless that person specifically intended harm. (Palestinian Talmud, *Baba Kama* 8:3)

➤ Summarize how the passages view the role of intention in terms of a person's liability for embarrassing another. Why did the Rabbis see

the question of intention as significant? Can you think of contemporary examples in which knowing whether or not someone *intended* embarrassment made a difference? Did knowledge of the intention (to do harm or not) change anything? If the harm was unintentional, was there less anger, fewer bitter accusations?

B According to the following statements, the consequence of embarrassing another is drastic.

> A Tanna (sage during Mishnaic times) recited before Rabbi Nachman ben Isaac: One who publicly shames a neighbor is as though that person shed blood . . . One who whitens a friend's face (puts a friend to shame) in public has no share in the World to Come. (*Baba Metziah* 58b-59a)

➤ How and why is hyperbole used in these comments? What is the significance of "in public"?

A comment on this Talmudic attitude on shame adds the following.

> Therefore, one must take great care not to do anything which may cause shame to anyone in the world. This also applies to Torah study. If in the course of discussion you hear your friend err, you should not tell the friend, "You have erred" or "You don't understand what you are saying," or the like, so that the friend will not be ashamed. But you should say to the friend, "I received it thus from my teacher," or, you should give the impression of not having heard the error. Similarly, you should not call your friend by a nickname, so the friend will not be ashamed. (*Orchot Tzaddikim: The Ways of the Righteous*, p. 93)

➤ *Orchot Tzaddikim* elaborates on the Talmudic passage, which focuses on Torah study. Elaborate on other realms to which the Talmudic attitude could be applied, such as certain special occasions, places of employment, or athletic events.

C Even one person being shamed can have dire results.

The destruction of Jerusalem resulted from the humiliation of Bar Kamtza. (*Gittin* 55b-56a)

➤ What does a statement such as the above reveal about the Rabbis' attitudes toward embarrassing (humiliating, shaming) another? The significance of just one person's experience holds great weight here. Is the dignity of the individual still such a significant value in our present Jewish community? our general culture? Explain.

D A specific instance is given in which several individuals join together in a deliberate effort to prevent the public embarrassment of another person.

> It once happened that while Rabbi [Judah the Prince] was delivering a lecture, he noticed a smell of garlic. Thereupon he said: "Let him who has eaten garlic go out." Hiyya arose and left; then all the other disciples rose in turn and went out. (*Sanhedrin* 11a)

➤ Why was the statement of Rabbi Judah the Prince cause for embarrassment? How did the group of disciples respond? Was their response the most effective way of sparing anyone embarrassment? Might Rabbi Judah have been embarrassed by the actions of the Rabbis? Is there a lesser/greater of two embarrassments here?

E In this next passage, similar in tone to #D above, one individual assures the protection of another's dignity. In the previous passage, some damage may have been done before there was an adequate response (the whole group getting up and leaving). The context for the following is the setting of the calendar's months and festivals, a process in which only designated scholars participated.

> Once Rabban Gamliel II said: "Send seven scholars to the upper chamber early in the morning [to set the calendar]." When [Rabban Gamliel] came in the morning, he found eight. "Whoever came without permission must leave," he announced. Samuel the Little got up and said, "I am the one who came without permission. But I didn't come to take part in setting the calendar; I came because I wanted to learn the law." "Sit down, my son, sit down," said Rabban Gamliel. "You are certainly worthy of setting the calendar, but the Rabbis decreed that only those specifically appointed for that purpose may do so." In reality, it was not Samuel the Little who had not been invited, but another scholar. Samuel had taken the blame upon himself to save the other from embarrassment. (*Sanhedrin* 11a)

➤ Summarize what the potentially embarrassing situation was. How was embarrassment avoided? Did Samuel the Little do the right thing?

F Our tradition does not disregard all forms of self-focused embarrassment as negative. Sometimes we direct shame toward ourselves as a result of wrongdoings (transgressions) we may have committed. The following comment says that this kind of shame should be rewarded.

> All who commit a transgression and are ashamed of it are forgiven for all their sins. (*Brachot* 12b)

➤ Are there times when self-imposed shame might be appropriate? The comment says that *all* sins are forgiven as a result of shame over *one* transgression. Is this an exaggeration? What might be the reason for making this kind of extreme comment? Could self-directed shame over something you did that was wrong ever go too far? Should there be limits to what's acceptable in embarrassing the self?

Tefilah

A From the "*Ahavah Rabbah*" prayer, we learn that a certain way of life protects us from experiencing shame. In fact, we pray to God to help us cleave to Torah, *Mitzvot*, love, and reverence — safeguards for a life of dignity.

> Open our eyes to Your Torah, help our hearts to cleave to Your *Mitzvot*. Unite all our thoughts to love and revere You. Then shall we never be brought to shame (*v'lo nayvosh l'olam va'ed*). (*Siddur*)

➤ How might Torah and *Mitzvot*, and love and reverence for God save us from shame? What else might a person pray for to protect him/herself from experiencing shame?

Post-Rabbinic

A The following Hasidic story is a good complement to the stories cited above from the Talmud (Rabbinic #D and #E). In all of the stories, the central characters purposefully try to deflect an awkward situation and spare hurt feelings:

> On a business trip to Leipzig, Rabbi Bunam, together with a number of

merchants who had accompanied him, stopped at the house of a Jew in order to say the Afternoon Prayer. But the moment he entered he realized that he had come to an ill-smelling house; never had he prayed in such a room. He gave the others a sign and they left. The Rabbi turned to go to the next house. But after a few steps he stopped. We must go back!" he cried. "The walls are summoning me to judgment because I scorned and put them to shame." (Martin Buber, *Tales of the Hasidim: The Later Masters*, p. 240)

➤ Why did Rabbi Bunam and the worshipers accompanying him leave an ill-smelling house, and then return to it? What do the "walls" represent? Does restraining ourselves from causing embarrassment come naturally? Explain.

ACTIVITIES

Language Arts

 1 (10 minutes) Discuss stealing and its similarities to not embarrassing. Is stealing wrong? Why? What happens if you are caught stealing? What might you think of yourself if you became a thief? What do we know about God's attitude toward stealing?

Brainstorm examples of the commandment "Do not steal" (such as stealing something from a store, stealing someone's seat at lunch, stealing change from your mother's purse). Then brainstorm examples of the *Middah* of *Lo Levayesh* (such as calling someone by a silly nickname, making fun of someone's new haircut, spotting a low grade on someone else's paper and announcing it to others). How are the examples similar? (For instance, stealing someone's seat at lunch could embarrass the person, calling someone by a silly nickname is like stealing the person's good name

or dignity, making fun of a new haircut is like stealing someone's confidence in how they look.) If desired, come up with a dictionary-style definition for "embarrass." Include the word "steal" as part of the definition.

To close the discussion, consider whether embarrassing is as bad as stealing. Should there be punishments for embarrassing someone, just as there are punishments for stealing? What would an appropriate punishment be?

 2 (10 minutes) Write a prayer in which you ask God for forgiveness for embarrassing another person. (In Jewish tradition an effective prayer of this type must be preceded by requesting forgiveness directly from the harmed individual.) If desired, include this prayer in a worship service. Or, pray your composed prayer every day for a week. Share reactions to this experience at the next class session.

 3 (15 minutes) Just as shame had no place in the study rooms of our scholars in centuries past, it should not have a place in our modern classrooms. Our places of study should reflect the virtues that are as important now as they were a long time ago.

Study the comment from *Orchot Tzaddikim: The Ways of the Righteous* in Text Study, Rabbinic #B, about not embarrassing someone engaged in Torah study. Now, think of classrooms in our own time. How might embarrassment happen in the classroom setting? How can such embarrassment be prevented? Come up with a list of classroom rules based on *Lo Levayesh*.

Once in a while (perhaps every few sessions), the group may want to do a "self-check," by asking, "How are we doing in following the rules we set up for ourselves concerning *Lo Levayesh*?"

 4 (10-15 minutes) The rules created in #3 above are meant to ensure that embarrassing others is avoided in the

classroom. But what about outside the formal settings of classrooms — during play, in school administrative policies? Are we consistently able to uphold the virtue of not embarrassing? In the following two debates, examine some practices that many groups take for granted as acceptable.

For younger groups: Stage a debate using the question: "Does picking teams (e.g., for sports games) violate *Lo Levayesh*? To prepare, divide a group into two. One group defends the picking of teams and the other opposes it. Each group comes up with points to support their positions before setting up ground rules for the actual debate.

Afterward, ask if anyone's opinion was changed as a result of the debate. When confronted with a situation in the future involving the picking of teams, what can be done to ensure that no one is embarrassed in the process?

For older groups: Jewish sources tell us that friends studying together must be extremely sensitive about not embarrassing each other. If that's the case, all the more so should we make sure administrative policies don't violate the virtue of *Lo Levayesh*. (See Text Study, Rabbinic #B, about not embarrassing someone engaged in Torah study. See also Text Study, Rabbinic #D.)

Stage a debate, using this scenario: Hold a mock parent-teacher meeting. The divisive issue is "tracking" for different academic levels. Some say this is embarrassing and humiliating for some kids; others say it is necessary for academic excellence and to keep motivated kids interested. The side opposing "tracking" obviously can draw on the implications of the *Middah Lo Levayesh*. What other arguments are there? The side defending "tracking" should be able to come up with reasons consistent with Jewish tradition as well. (For example, there is much written about the value of scholarship, wisdom, industriousness, respecting all creatures — including perhaps their talents, etc.)

Afterward, discuss: Were any opinions changed as a result of hearing the arguments presented in the debate? If a school does rely on "tracking," what can be done to maintain the self-esteem of all students? Consider other issues that reflect general school policies. Should any policies be adjusted to provide a more hospitable environment for the virtue of *Lo Levayesh*?

 5 (20-40 minutes) Just as people in ancient times needed to be alert to potentially embarrassing someone, so, too, must we be on guard.

Refer to the stories from *Sanhedrin* 11a in Text Study, Rabbinic #D and #E. Rewrite one of the stories in a way that reflects a modern situation. For example, instead of Rabbi Judah the Prince, Hiyya, and other disciples in a house of study, write a parallel scene in a contemporary classroom. Or, instead of a group of scholars gathering to set the calendar, write about a situation at a modern-day professional conference.

To extend this activity: Have small groups perform dramatic interpretations of the stories.

 6 (10 minutes) The *"Ahavah Rabbah"* prayer states that if we cleave to a life of *Mitzvot*, we will "never be brought to shame." How might the following *Mitzvot* help us to grow in our ability to refrain from embarrassing others? (For example, honoring father and mother will result in them being upset with us less often. Less anger can save us from shame.)

 a. Honor your father and your mother.
 b. Do not steal.
 c. Do not covet.
 d. No gossiping
 e. Studying Torah
 f. Leaving the gleanings (of your harvest for the poor) — *Peah, Leket,* and *Shich'chah*
 g. Not placing a stumbling block before the blind

h. Honoring the elderly

i. Others?

 7 (10 minutes) An opinion in our tradition says it's worthy to feel shame over things you did that were wrong (see Text Study, Rabbinic #F). But, can shame go too far, causing harm? In this exercise participants give embarrassing subjects a more positive spin.

List examples of self put-downs in one column. In the next column turn the put-downs into positive statements. (If thinking about your own personal situation feels threatening, try creating statements for an imaginary person.) For example:

I'm a lousy student. // I know how to study hard.

I'm so unpopular. // The people I care about, care about me.

I'm clumsy. // I have a clever mind.

What can you do to avoid shaming yourself unfairly? How can you be true to your own nature, embracing the positive?

 8 (5 minutes; plus 10-15 minutes for extra challenge) Hold a discussion about what it might mean to embarrass God. Write ideas down on a blackboard if you like. Consider the following possibilities:

a. Acting in ways that might cause shameful words (curses) to be cried out toward God. (Shameful words could "embarrass" God.)

b. Arrogance – refusing to accept the mysterious nature of God's Creation. In simple language, this is like saying you are better than God.

c. Mimicking God – using an evil voice

d. Showing disrespect to holy objects, to the Torah

e. Showing disrespect to God's Creation — nature or people

Do you agree that the above ideas reflect good examples of what it means to embarrass God? Explain. What can you add?

Extra challenge: If we say that God has provided humankind with enough resources so that no one has to go hungry, we must also acknowledge that people *do* go hungry. The angry cry of those who are hungry would be "embarrassing" to God.

Write a lament in God's imagined voice about how human beings have embarrassed God, e.g., You have embarrassed Me by [allowing so many to go hungry], and so on. Then, write God's imagined plea for people to change their ways so that God is not shamed (*kivayachol*). It may be appropriate to incorporate one or more of the prayers into a worship service, especially for the High Holy Days or for Tishah B'Av. (Note: See Media and Popular Culture #4 below for a related activity.)

 9 (10 minutes) How might a child feel if she attends school on Jewish holidays and all the other children do not? Or, she does not attend school on Jewish holidays and all the other children do? How might an adult feel if at a dinner meeting at a restaurant with other Jews, he orders something *treif* (unkosher), and everyone after him orders vegetarian food?

Discuss varieties of Jewish religious practices. How might a person feel self-respect in a community where there is a variety of Jewish religious observances? Under what circumstances might a person feel embarrassed? If no one blatantly points out reasons for another to be embarrassed, might a person still feel embarrassment initiated by his/her own self? When might it be valid to feel shame over personal religious observance? When not?

 10 (5-15 minutes) This activity complements #9 above. Hypocrisy is a loaded word, particularly when applied to religion.

Hold a discussion about religious hypocrisy. (Examples: regular attendance at worship, but cheating in business; keeping kosher, but not taking good care of pets.) Would you call religious hypocrisy embarrassing or shameful toward God? What dangers might there be in judging or accusing others of religious hypocrisy? Might such accusations be embarrassing? Since embarrassing others is considered wrong (and perhaps shameful in God's "eyes" as well), should you "call" someone on religious hypocrisy or not?

 11 (15-20 minutes) For mature groups: Study the passages from Genesis about Adam and Eve (see Text Study, Tanach #A). Discuss troubles people may experience because of embarrassment related to their physical bodies (e.g., eating disorders, "sleeping around," abusing drugs or alcohol). As a private journal assignment, write about your attitudes toward your body. Are these healthy attitudes? How can shame or discomfort about the body be transformed into a more positive attitude?

12 (10-15 minutes) In Text Study, Rabbinic #F, we learn that those who commit a transgression and are ashamed of it are forgiven for all their sins. Write freely for a few minutes on the relationship between shame and forgiveness. This exercise is particularly appropriate for the High Holy Day season.

Discuss. How do you intuitively treat shame? How do you process wrongdoing? Does the line from *Brachot* 12b ring true — more or less — after completing this exercise? Is shame toward self a good thing? How so and/or how not?

13 (10-15 minutes) Trespassing means going where you are not supposed to go. When someone is being embar-

rassed, it is as if they are experiencing a trespassing of boundaries. They are exposed, made to feel vulnerable.

Think about boundaries in general — fences, road signs, private areas, etc. These are more obvious to identify than are personal boundaries. After getting a handle on physical boundaries, participants explore what it means to cross "boundaries" in a more personal way. By clarifying the essence of this *Middah* — "going where you're not supposed to" in a concrete way — the hope is to become more aware of how we can restrain ourselves from "trespassing" on the level of other people's feelings.

Make a list or bring in photographs of different kinds of boundaries (for example, fence, wall, frown, stop sign, barbed wire, hands shielding face, locked doors, an *Eruv*). Discuss how crossing a boundary without permission can be compared to embarrassing someone. Is the exploration of boundaries an effective metaphor for getting at the heart of the meaning of this *Middah*?

 14 (5-10 minutes) What is the underlying essence of embarrassing? It is as if a protective layer is forcibly removed from another, leading to involuntary exposure. An example is the embarrassment of Adam and Eve at their nakedness (see Text Study, Tanach #A). Sometimes we can gain new understanding on an issue by looking at it from an abstract, unexpected angle.

Make a list of objects or concepts that have two layers (such as turtles, clothing on skin, book cover and contents, ice on sidewalk, paint on canvas, etc.). Compare to embarrassment — how the integrity of an object changes once one layer is "removed" and another exposed.

Media and Popular Culture

 1 (15-20 minutes, or homework, plus 5-10 minutes group time) We are constantly exposed to situations in which individuals are embarrassed publically through our media. Very possibly, we are so accustomed to seeing people embarrassed in newspapers, magazines, and on TV that we become numb to the effect on the "victims."

In what ways are people shamed in the media? (Examples include publicizing problems in the private life of a public figure, showing someone crying or mourning who may not have wished to be photographed, presenting photographs of scantily clad individuals, publishing secrets of people revealed by former friends, etc.) We cannot master the *Middah* of *Lo Levayesh* without becoming aware of how prevalent (even acceptable) embarrassing others is in our secular culture.

From tabloids and entertainment-type magazines, cut out articles and photographs that are embarrassing to their subject. Talk about how the subject may have felt, and the responsibility of the media in so far as embarrassing goes. Discuss: How did you feel about sorting through the newspapers and magazines looking for instances in which someone was embarrassed? What effect will this exercise have on you? Should there be any censorship in regard to publishing embarrassing material about people? What can be done to help alleviate the potential hurt people might feel after being publically embarrassed in our media? What should you do when you come across material that would embarrass its subjects?

 2 (10-15 minutes) Comedy often relies on embarrassment for its humor, making fun of the presenters themselves or mocking other individuals and groups. Can you think of examples of this? They might include a comedian making fun of his own clumsiness, sarcastically describing her own social life, mimicking a politician, stereotyping an ethnic group, or ridiculing an audience member.

Watch a tape of a stand-up comedian. How is embarrassment used? Does the comedian embarrass his/her own self? family members? only others? What standards are reasonable for a comedian to follow in terms of not embarrassing?

In your view, is embarrassment a valid, acceptable way to entertain? Explain. If embarrassment is generally accepted in media and the entertainment business, how can we make sure it doesn't interfere with our own striving to master *Lo Levayesh*?

 3 (15-20 minutes) Some law enforcement agencies rely on the controversial act of shaming wrongdoers into reforming. Arguments against doing this include the claim that public embarrassment is a violation of individual's civil liberties. Consider the situations below and judge whether or not public shaming is justified. Integrate what you know about the values of modern secular society with Jewish values. Are the two approaches (modern secular and Jewish) in harmony, or do they clash? How do you reconcile conflict if you discover contradictory values?

Situation 1: Single mothers in a community are having difficulty collecting child support from their ex-husbands ("deadbeat Dads"). They turn to local political officials who give the go-ahead to publish the names of these men in the local paper. It doesn't take long for a dramatic increase in compliance with paying child support.

Situation 2: (For mature students) A certain section of town has become a "red light district." Citizens are distraught about the decline in their neighborhood. Law enforcement patrols have not been successful in curbing the activity. Hidden cameras are installed to photograph men in the process of soliciting "favors" from prostitutes. The photos are then published in the local paper (or

put on TV). After just a couple of weeks of "shaming," the neighborhood is turned around — prostitution, along with petty crime, disappears.

4 (10-15 minutes, plus time at home) Before doing this activity, do Language Arts #8. Afterward, complete this "homework" assignment:

During the course of a week or so, listen to music on popular radio stations. What music would you describe as respectful to God? What is embarrassing or shameful toward God?

In the follow-up discussion, reflect on your "homework." Would you say there are many examples of ways God might be "embarrassed" by our popular culture? How, in general, do people respond to such things? Are these "embarrassments" (toward God) considered perfectly acceptable, nothing extraordinary? In what ways are you now more alert as to how God might be "embarrassed" by what is considered acceptable in popular culture? Does simply being more alert make you a more virtuous person (in terms of mastery of this *Middah*)? Explain.

Visual Arts

1 (10-15 minutes) In order to get across a sense of why it is important to avoid embarrassing someone, it is necessary to teach empathy, e.g., how might someone feel who becomes embarrassed. Use imagination and art as tools for increasing empathy.

Draw a face of someone who feels embarrassed. Next, draw a face of someone who is feeling safe and trusting of his/her company.

Discuss the images. Was it easier to draw one or the other image? Which drawing effort did you enjoy creating more? Why do you think that might be? What new insights do you have about how an embarrassed person feels? Why should

we try to curb words and actions that can cause embarrassment?

2 (10-15 minutes) As an extension of the previous exercise, participants draw several versions of a face in which the expression gradually shifts from neutral to embarrassed as the person experiences teasing or an ethnic joke.

What does concretizing the images on paper teach? One person looks at another's drawings and imagines the internal state of the person depicted. That one person, then, improvises a narrative of what might be happening that is causing the "face" to look more and more embarrassed (plus, possibly distraught, uncomfortable, hurt, or angry, etc.). The artist can respond to the interpretation — did the "art critic" capture what the artist was trying to communicate? After repeating this interpretation exercise with several or all of the drawings, discuss what variety was depicted. What different ways might embarrassment be experienced? In what ways did the exercise make you more sensitive to why embarrassing someone is seriously admonished in our tradition?

3 (15-20 minutes) In this activity participants are encouraged to be more alert to potentially hurtful situations in their day-to-day interactions with others.

Create an imaginary scene in which one or two people are being embarrassed by others. Create another picture of the same scene, altering the situation so that everyone can leave feeling good about themselves and others.

Have participants comment on their art work. What is happening in the first scene you drew? What did you do to alter the scene? Are there other ways you could have altered the scene that would have been equally successful? Will you remember what you learned here today when situations arise in the future? How can you help yourself remember?

 4 (5-10 minutes) Some people say that when we become embarrassed or are ashamed, we blush or our face turns red. Growing pale is another possibility (see Text Study, Rabbinic #B).

Draw two mini-versions of yourself in outline form. Color in the first outline the shade of embarrassment, and color in the second the shade of color you prefer to be.

Discuss. For the first outline — who chose red? Who chose white? Who chose another color altogether? Why?

 5 (5-10 minutes minimum) Use the interpretation of "not embarrassing God" as respecting, accepting. Draw an image of a person not embarrassing God. It can be a simple line drawing, a face, whatever. Share your drawings and explain what you did.

 6 (10 minutes to several hours) It could be argued that the ways in which human beings treat the environment are shameful from the perspective of God, that our abuse of nature is disrespectful to God.

Think of environmental damage caused by human beings that you would call "an embarrassment to God." Use watercolor washes to show one example of a way humankind has hurt the earth. Here are a few possibilities: a dissolved ozone layer, a chopped down rain forest, a brown cloud of pollution, a devastating oil spill, etc.

What are our responsibilities in helping to prevent the shameful abuse of the earth? What are ways we can publicize the issue? (One way is to display the paintings created in this activity.)

 7 (10-15 minutes) People are often embarrassed when falseness within themselves is revealed by themselves or others. If we want to understand and accept truth in ourselves and others, we must learn to be astute observers.

Draw a picture of a daisy and of yourself without looking at either. Afterward, look at the real daisy and look at yourself in a mirror.

Discuss: How did your drawing compare to the real thing? How might astute observation enhance our knowledge of our true selves? Will such knowledge help us to avoid falseness (and its corresponding embarrassment)? Explain.

 8 (15 minutes) Here's a way to make an abstract picture of the process of embarrassment. The activity broadens our vision and understanding of the value of *Lo Levayesh*.

Divide a large paper into eight boxes. Draw or paint a shape or object that is complete, has integrity (such as, an apple, rock, face, geometrical shape, abstract image). In the next three boxes, gradually strip it of its integrity. It is a shape which is losing its sense of itself; it is being embarrassed. In the next three boxes, help it regain its form. In box 8 the object may be identical to what it was in box 1, or it may have been altered by its experience. You decide.

Discuss: What did you draw? Why did you choose that particular object? Did the object regain its form in the end? Why or why not? How does the "experience" of the object reflect human experience?

 9 (10-30 minutes) The *Middah* of *Lo Levayesh* concerns not embarrassing. Yet, we begin to comprehend its meaning only by entertaining the opposite — embarrassing. Once we create an image of embarrassment, we understand what prevents it. Follow these instructions in order, without reading ahead. Respond to the directions quickly and with spontaneity.

a. Spend a minute or two coloring a rectangle the color of embarrassment. Try more than once if you like. Did you orient the rectangle vertically or horizontally? Why?

b. Make an embarrassed shape with paint or charcoal. Make a few if need be, in five minutes or less.

c. Make two shapes, one embarrassing the other. Is the "embarrassee" shaped differently when the "embarrasser" is present?

d. Create an abstract or figurative image of respect.

How did you distill this concept to make it workable? Did you make an image of a respectable person? of someone behaving respectably toward another? toward God and/or nature?

What did you learn by completing the above tasks? Any new insights about this *Middah*? Was there one task that appealed to you above the others? Why?

 10 (30 minutes to several hours) Complete Language Arts #14, in which participants imagine two-layered things and images, then explore how, when one layer is removed, the integrity of something is altered.

Now, draw or paint a composition of one or more two-layered images, with and without both its layers. The goal is to create a canvas that communicates something of the power of embarrassment. Make a work that could be titled something like "Why Shaming Is Forbidden," "Forced Exposure," "Embarrassment and the Deterioration of Integrity," etc.

Drama

 1 (10-15 minutes) We know that, try as we may, we are likely at some point(s) in our lives to embarrass someone. Hopefully, any embarrassment we cause will be done unintentionally. Still, for causing harm even when we didn't mean to, we are obliged to seek forgiveness. We need to repent and apologize.

Role play a scenario in which one person apologizes to the other for embarrassing him/her. For what other reasons might we apologize to another person? Is it easier/more difficult to apologize for embarrassing someone or to apologize for other wrongs? How might a relationship be affected in which one person embarrasses the other, but never apologizes for doing so?

 2 (5-10 minutes in a group; plus 5-10 minutes at home) In this exercise, begin with an embarrassing situation that happens among people in public. Then use that experience as a foundation to pursue the more complex issue of what it means to experience personal embarrassment within or toward yourself.

Why do kids often laugh when another kid trips and falls? Have one actor pretend to trip in the most ridiculous way possible. See if the audience can restrain itself from laughing. Ask for the actor's reactions — embarrassed/not embarrassed. When do you think it's okay to laugh at another's mishaps? When is it not okay?

Now for the exploration having to do with one's own self. As "homework," ask everyone to practice tripping in private. Think about (perhaps jotting down some notes) about how the embarrassment factor is affected when no one else is around. Are you embarrassed around yourself? Why or why not? What does cause you embarrassment toward yourself? When the whole group reconvenes, share your discoveries.

 3 (10-15 minutes) As preparation for this drama exercise, ask participants to write or think about embarrassment:

For writing: Write for five minutes (without stopping) on *Lo Levayesh*. That is, write about moments you embarrassed someone, or moments when you yourself became embarrassed.

For thinking: Think for a minute about moments you embarrassed someone. Then, think about moments you yourself became embarrassed.

Now, without talking about the specific situation, create one pose/statue that captures the most pertinent (climactic) moment — the "height" of the embarrassment. People add onto the pose, with statues that respond in some way to the starting person's statue, creating a tableau.

Was it hard or easy to come up with a way to respond to the initial pose? How does one person's attitude to an embarrassing moment "cue" others in how to react? Can there be a "domino effect" in exacerbating embarrassment — making the situation worse? If so, what do we know about the significance and repercussions of even one person's response? (See Text Study, Rabbinic #D, in which Hiyya's response in an embarrassing situation triggered others to follow his example.)

 4 (5-10 minutes) In order to uphold the *Middah* of not embarrassing someone, it is helpful to identify specific instances in which embarrassment may occur. Projecting how a shamed person might feel in such cases will encourage potential "embarrassers" to empathize and restrain themselves.

Ask how teasing might cause embarrassment. For older groups talk about ethnic jokes — what makes them funny versus what makes them cross over into being embarrassing in a hurtful way? Have a group imagine they are hearing teasing (or an embarrassing joke). Show facial expressions that gradually change as a result of what is heard.

 5 (15-60 minutes) Study one or more of the stories cited in Text Study, Rabbinic #D and #E and Post-Rabbinic #A. In these stories, individuals, alert to the potential embarrassment of others, take action to try to prevent hurt.

To prepare, discuss what could have happened if some effort were not made to lessen or avoid embarrassment. Then act out one or more of the stories up to the potentially embarrassing climax. Next provide two alternate endings — the first (made up) as if the most embarrassing possibility did occur, and the second (as the story actually is told).

A narrator can introduce the story, then say at the moment for potential embarrassment, "This is what could have happened . . . " After the imagined scene (either planned or improvised), he/she can say, "But this is what really happened . . . " The narrator may also close the skit, underscoring the lessons that can be learned.

For Rabbinic #D, about one who eats garlic, these are the parts: Rabbi Judah the Prince, Hiyya, Disciples (other students in the room with Hiyya), Narrator (optional).

Parts for Rabbinic #E, about appointed scholars setting the calendar: Rabban Gamliel II, Samuel the Little, 7 Scholars, Narrator (optional).

Parts for Post-Rabbinic #A, about praying in an ill-smelling house: Rabbi Bunam, the owner of the ill-smelling house, 8 or more Merchants (ready to pray), 3 or more actors as Walls, Narrator (optional).

The group may also want to make up their own story, with two alternate endings. Consider performing one or more of the scenarios for an assembly, parents, or other class/group.

 6 (15 minutes) How and why might two people, content and comfortable in each others' presence, suddenly feel embarrassment?

Study the passages from Genesis about Adam and Eve (see Text Study, Tanach #A). Have two people improvise, elaborating on what they imagine the details were of Adam and Eve's dialogue.

Then, come up with a contemporary scenario, in which two people who are comfortable with each other become embarrassed. Improvise details of that scene, too.

 7 (5-10 minutes) Sometimes we don't even realize that what we do might be interpreted as being embarrassing toward God. In the following exercise, the focus is just on tone of voice. This narrow focus will help sensitize participants to ways and instances in which they indeed may transgress this *Middah*.

Divide group into pairs. Using gibberish (nonsense syllables that use intonations similar to recognizable speech), one person speaks in a way that could be called embarrassing toward God. (For example, the person might use mock cursing, mock accusing, whining in a self-righteous way, etc.). The second person tries to convince the "embarrasser" — again through gibberish — to calm down and refrain from such shameful behavior.

Afterward, discuss what the participants experienced and what insights they discovered.

 8 (15-20 minutes) Study the citation in Text Study, Tanach #B, about shame and guilt before God. We all face shame in our lives, but how do we handle it when it becomes overpowering? Rehearse the experience of turning shame that overwhelms us into something that we can face with dignity. Do the following twice — first individually (not interacting) and second as a group.

Imagine shame as having an independent existence, like a tangible energy force. This force has "grown high as heaven." Try to tame this high-reaching force, bringing it down, reshaping it down to a more manageable size. Once that is accomplished, you are relieved of your burdensome task and can lift your face honorably to God.

What was most challenging about the improvisation? What was the difference in performing the exercise individually versus as a group? In what ways will you handle shame, especially before God, more resourcefully in the future as a result of this experience?

Movement

 1 (5-10 minutes) In order to become aware of our "gut" sense of a value, it is often helpful to express the idea through our bodies.

Improvise for a couple of minutes trying to capture the sense of the words "Do Not Embarrass." Perhaps you will experiment with hiding-type movements; shuffling backwards; ducking, trying to stand straight, then ducking again; moving with your head bowed down, etc. Then actually choreograph a short dance phrase on "do not embarrass." Draw on the material you improvised beforehand.

In a group share the dance phrases with each other. How did you go about creating your phrase? How are the various interpretations similar/different? What is something new you learned about embarrassment as a result of this activity?

 2 (15-20 minutes) Complete Language Arts #3 as an introduction to this movement experience. By exploring ideas on a physical level, especially deep impressions are made as one more sense (kinesthetic) joins the other senses (especially sight and hearing). The physical reinforces the cognitive. In this exercise participants will practice disrespecting versus respecting boundaries and relate that to embarrassing versus not embarrassing.

Identify a line, real or imaginary, that stretches across the space. In small groups, taking turns, participants do the following:

a. Approach the boundary (line), respect it, and turn away.

b. Approach the boundary, disrespect it, and invade the space.

c. Try invading using different energies or leading with different parts of the body.

d. Repeat the above, using a person as a boundary rather than a physical delineation.

Discuss the experience. Were you able to imagine effectively the so-called boundaries? Do you think you completed each task convincingly? Explain. How are physical boundaries like personal boundaries? What new thing did you learn about crossing boundaries without permission? How can doing so be compared to embarrassing someone?

3 (10-15 minutes) Complete Language Arts #14. This movement activity is designed to allow participants to begin to identify how "removing" a layer might parallel the exposure felt by being embarrassed. Use scarves:

a. "Remove" the scarf from one area to another.

b. "Remove" it surreptitiously, as if you are not supposed to.

c. "Remove" it in a malicious way that reflects the intention of leaving damage in the action's wake.

d. Repeat (steps 1-3 above) this time with the scarf being worn by or in the possession of another person.

Share new insights gained about the characteristics of embarrassment. In what ways does the image of "removing" capture part of what's involved in an understanding of this *Middah*?

4 (15 minutes) This exercise guides participants to explore on a physical level the experience of vulnerability associated with embarrassment.

a. Roll across the space (on your side). Note different experiences — how you feel when face up versus face down.

b. Repeat with awareness and intention — when face up, feel vulnerability; when face down, feel protection.

c. Repeat again. In the process of rolling, bring to (private) awareness something you may not want to reveal that is hurtful or embarrassing to you.

d. Repeat a final time. Have one other person look at you while you roll, then more than one person. While you do this, think about something you could reveal that would cause embarrassment. Communicate what that something is, with your eyes only (for example, "When I'm alone with my family, I often lose my temper").

Have participants share their experiences. Did you/did you not gradually feel more vulnerable or embarrassed as you progressed through the steps in the exercise? Explain. What physical sensations are associated with the experience of embarrassment? Can you recognize them in yourselves? in others? How is your awareness of this *Middah* heightened, particularly as it relates to your internal state, as a result of completing this activity?

5 (15-20 minutes) Drama #8, about taming shame "grown high as heaven," can be performed in a more dance-like way.

6 (15 minutes or more) How does deepening our relationship with God, such as in living a life of Torah, help us to rise above shame? Refer to the line from the "*Ahavah Rabbah*" prayer — "Enlighten us with Your Torah; we will come to love and revere Your name, and never be shamed." In this activity the goal is to inspire a poetic and profound ownership of this line through creative interpretation and expression.

Work with the metaphor of God as light. A narrator will improvise verbally, describing different types of light (sunrise, dawn, sun on a winter afternoon, dusk, etc.). Dancers (one or more at a time) will respond in movement. After each "encounter" with a scene of light, the speaker and

dancer(s) will pause, standing still and straight for a few moments, focusing on experiencing a quiet respect ("we will never be shamed"). Then, the narrator will continue with another description, repeating several times. Take turns being narrator and respondents.

Discuss what participants experienced (and viewers observed). Evaluate differences in reactions to the various descriptions of light.

A variation: Rather than improvising verbally, spend time creating more intentionally crafted poems on light. Use those as accompaniment to the movement improvisations.

Music

 1 (5-10 minutes) In this exercise music becomes the means by which we express our feelings of embarrassment and deepen our knowledge of what is at the heart of the virtue of *Lo Levayesh*.

On a percussion instrument (triangle, drum, cymbals, etc.), improvise music phrases. Imagine yourself going about your business, becoming embarrassed, returning to a non-embarrassed state.

Play with variations, such as:

a. Slowly versus suddenly becoming embarrassed

b. Returning to a non-embarrassed state that is markedly different from the initial part of the phrase

c. Contrasting a phrase of experiencing embarrassment instigated by another person versus embarrassment instigated by yourself

d. Your own idea

How did it go — expressing embarrassment through music? Were you surprised to discover something new about a value you thought was familiar? What new understanding did you gain? How much of what you learned was because you used a nonverbal medium?

2 (5 minutes for improvisation up to several hours for composition) This exercise is a musical adaptation of Drama #8. Improvise or compose a piece of music that reflects shame growing as "high as heaven." Then try to bring down the pitch, the energy, the force of the sound so that it reflects shame brought down to a more manageable level.

CHAPTER TEN
MALACHAH: WORK/INDUSTRIOUSNESS

מְלָאכָה

OVERVIEW

Work as an ethic has its roots in biblical times. It is valued in our Jewish tradition even though it brings challenges. While work is a means to providing the necessities of life and even some extras, non-stop toil can be overdone and work related stress can be overwhelming.

From the very beginning, the positive aspects and the challenges of *Malachah* are mentioned together. In Genesis 3:19, one of the very first edicts given humankind has to do with "tilling and tending the land for food." The first punishment is also related to work: "By the sweat of your brow shall you get bread to eat" (see Text Study, Tanach #A and #B). On the positive side, work can be enjoyable and rewarding. But on the negative side, work can be unpleasant — fighting the elements, sweating and aching, just to eat. Industriousness is necessary, but we need to figure out how to make it a satisfying part of our lives.

The Rabbis in Talmudic times expressed basic attitudes toward work. A person should not allow him/herself to become needlessly dependent on others because of laziness or a bad attitude about working. Parents must make sure their children are equipped to support themselves with appropriate skills or a trade. But the Rabbis go beyond the basics of survival: *Malachah* seems also to contribute to a person's character. Work makes us better by helping us avoid sin. It helps us develop a sense of pride and dignity. Still, with all the wonderful character development that happens because of *Malachah*, the Rabbis urge us to have

balance in our lives — some work, some rest, some Torah study.

Two major Jewish events in recent history depended on a strong work ethic. One was the settling of the State of Israel. The *chalutzim* (pioneers) reclaimed the land through hard work. The Hula Valley in the Upper Galilee was a malaria infested marsh that had to be drained so that it could become arable land. The desert needed to be irrigated in order to make it bloom. Consistent, strenuous work was called for.

Another event was the mass emigration of Jews from Eastern Europe to America (and other places), especially in the early part of the twentieth century. Looking at the American immigrant experience, it is clear that hard work was valued. Industriousness was the route to survival, prosperity, and even more — well-being.

As important a value as *Malachah* is, it is not the be-all and end-all of attributes. There are limits even to a good thing. The most obvious counter-balance to work is Shabbat. What is valued and worthy of praise (work) is forbidden in the context of Shabbat. Work — a practice that is advocated — must be abandoned once each week.

Besides Shabbat (and Festival) rest, there is another way the tradition keeps the value of *Malachah* in perspective — through Torah study. Torah study requires thought and reflection which might be neglected in the rush and stress of work. Torah sets standards, ethical and spiritual goals by which we can better judge the merits of our work, making changes or adjustments if necessary. To work without focusing some energy on the

questions of how one should live and what it all means leads to a shallow, robot-like, non-creative existence.

A most profound perspective on *Malachah* comes from this comment: "All are proud of their craft. God speaks of God's work (Genesis 2:2); how much more should people" (*Avot de Rabbi Natan* 21, 23a). The work God "speaks of" is Creation. Through our *Malachah*, we have the opportunity to live up to our creative potential. God is in charge of Creation (with a capital "C"), but we're in charge of our own creativity. There may be tasks we need to carry out in order to make a living, to ensure our physical survival. Enjoying the achievement of our work, as God did of God's own work, affirms our creativity. We should take pride in being part of a dynamic process. Our efforts help guide the unfolding process of the creation of the universe.

Though usually translated as "work," the virtue *Malachah* goes beyond toil and bringing home a paycheck. Thus, to convey the idea that *Malachah* is an attribute, the term is also translated as "Industriousness." The *Middah* addresses how we keep busy, whether we are occupied meaningfully. Industriousness can include other activities as well — artistic creativity, housekeeping, parenting, volunteering, social action works, etc.

What role does *Malachah* play in our relationship with others, with ourselves, and with God? Some ideas are included below.

 BAYN ADAM L'CHAVERO, BETWEEN PEOPLE. Industriousness encompasses a range of activities from caring for family members to being involved in the general society. Working with others can make us more aware of problems people face in the world and the steps needed for *Tikkun* (repairing the world).

 BAYN ADAM L'ATZMO, BETWEEN YOU AND YOURSELF. What is meaningful about industriousness in terms of our own personal growth and self-image? Satisfaction and pride in our achievements make us feel good about ourselves. This *Middah* can inspire us to develop important habits of self-discipline and diligence. It also directs us to nourish our inner resources of creativity.

 BAYN ADAM L'MAKOM, BETWEEN YOU AND GOD. In our relationship with God, industriousness means sharing the burden with God to take care of creation. We are not to be a "drain" on the world; we are to contribute positively to it. Created in the image of God the Creator, we, too, should explore and express our creative abilities. Being creative connects us more deeply to God. That indeed is a blessing!

TEXT STUDY

Tanach

A Even from the very beginning, human beings had "jobs." The first job is associated with taking care of the Garden of Eden.

> **The Eternal God took the man, and put him into the Garden of Eden to till it and tend it. (Genesis 2:15)**

➤ The first interaction God has with Adam is to put him to work. Why might that be?

B Adam and Eve disobey God by partaking of fruit from a forbidden tree, and are punished by God.

Cursed be the ground because of you; in anguish shall you eat of it all the days of your life. Thorns and thistles shall it bring forth for you, and you shall feed on the grains of the field. By the sweat of your brow shall you get bread to eat, until you return to the ground. (Genesis 3:17-19)

➤ What can Adam expect in his work life following his disobedience? What curses of work are hinted at? what rewards? Is work usually a "mixed bag"? Give a few examples.

C Isaac immersed himself in work; he got busy from the beginning.

Isaac sowed in that land and reaped a hundredfold the same year. The Eternal blessed him, and the man grew richer and richer until he was very wealthy. (Genesis 26:12)

A later comment:

[Isaac explained], No blessing rests on persons except by the work of their hands. (*Tosefta Brachot* 7, 8)

➤ Some people refer to their work as a "calling." This has the implication that God wants them to pursue their occupation. Is such a theory consistent with Isaac's experience? Why or why not? Is it difficult to pursue work without the confirmation that you will receive blessing as a result? If so, what blessings do you seek?

D Industriousness is essential, but it is not meant to be an obsessive constant. There must be time for other things as well. One of those is Shabbat. Taking a break is not just a good idea, it is a *Mitzvah,* a commanded observance, a

central value. There is a time and place for work, and there is a time and place and a need for rest as well.

Six days shall you labor and do all your work, but the seventh day is a Sabbath of the Eternal your God — you shall not do any work . . . (Exodus 20:9)

➤ What most distinguishes the six days of labor from the seventh day? If industriousness is a significant value, what is the purpose of a day in which you are forbidden to do what normally is expected, and even praised? Would the world be a better place if everyone were synchronized in a rhythm of six days of labor, one day of rest?

E An ant becomes a metaphor for industriousness in the following passage. The result of laziness is poverty and want.

Lazybones, go to the ant;
Study its ways and learn.
Without leaders, officers, or rulers,
It lays up its stores during the summer,
Gathers in its food at the harvest.
How long will you lie there, lazybones;
When will you wake from your sleep?
A bit more sleep, a bit more slumber,
A bit more hugging yourself in bed,
And poverty will come calling upon you,
And want, like an armed man. (Proverbs 6:6-12)

➤ What can you learn from the ant about industriousness? Are there other animals that can teach us about maintaining good work habits? What is the result of indolence?

Rabbinic

A One of the reasons work is so important is that a person should not become dependent on others.

Hire yourself out to a work which is strange to you rather than become dependent on others. (Palestinian Talmud, *Sanhedrin* 11:7, 30b, line 68)

➤ What happens if you become dependent on others (because you don't work even though you are able)? In what ways might dependency compromise one's personal dignity, self-esteem, and self-motivation? How far should you go in securing employment — should you take a job that is "beneath you," one that requires much training in order to perform, or one that you don't enjoy very much?

B One of the responsibilities parents have toward their children is to teach them a trade, to lay the foundation for their secure future.

Parents are obliged to teach their children a trade, and whoever does not teach their children a trade teaches them to become robbers. (*Tosefta Kiddushin* 1, 11)

➤ How do parents who do not teach their children a trade teach them to become robbers? Are educating children and teaching them a trade the same thing? How so and/or how not? Do you agree with the comment from the *Tosefta*?

C According to the Rabbis, there must be balance, even for praiseworthy practices.

The study of Torah is commendable when combined with worldly occupation, for toil in them both drives sin out of mind. But study alone, not combined with work, leads to idleness, and ultimately to sin. (*Pirke Avot* 2:2)

➤ According to this passage, what happens when Torah study is divorced from worldly occupation? What examples are there of idleness turning to sin?

D These excerpts from *Pirke Avot* imply that you can't have the richness of learning and growth (Torah) without the practical infrastructure provided through making a living.

No Torah, no worldly occupation; No worldly occupation, no Torah. No sustenance, no Torah; No Torah, no sustenance. (*Pirke Avot* 3:21)

➤ How are Torah and worldly occupation, and Torah and sustenance interdependent? Say that Torah study represents meaningful existence. Is having meaning in your life a "basic need"?

E This text gives a specific formula for what could be considered a decent balance between learning and work.

If people learn two paragraphs of the Torah in the morning and two in the evening, and are occupied with their work the rest of the day, it is as though they fulfilled the entire Torah. (*Tanchuma* on Exodus, *Beshallach*, paragraph 20)

➤ What does this comment suggest in terms of how a person should balance study and work? In what ways is this suggestion reasonable? Is it exaggerated to say that a person fulfills "the entire Torah" by doing the above? Explain.

F Balance in worldly occupation is important. Pride in what you do also defines industriousness at its best.

Rabbi Elazar ben Azariah said: Great is work, for every craftsperson walks out with the implements of their calling, and is proud of them. Thus, weavers walk out with a shuttle in their ear. Dyers walk out with wool in their ears. Scribes walk out with their pen behind their ear. All are proud of their craft. God speaks of God's work (Genesis 2:2); how much more should people. (*Avot de Rabbi Natan* 21, 23a)

➤ How is the pride of craftspeople reflected? Is pride in work considered a positive thing? What examples of pride in work do you see in your own community?

G Workers should give themselves credit for their accomplishments, but those who don't work should not deceive themselves into thinking they have achieved.

If a person says to you, "I have worked and have not achieved," do not believe the person. If the person says, "I have not worked, but still I have achieved," do not believe the person. But if the person says, "I have worked and I have achieved," you may believe the person. (*Megillah* 6a)

➤ What claims about working should you not believe? Why? Why can we believe people who say they worked and they achieved? It could be asserted that work not only changes a situation, but changes the worker him/herself. What do you think?

H Being industrious is worthy of God's blessing; idleness is not.

It is written, "The Eternal will bless you in all the work of your hands"

(Deuteronomy 2:7). Rabbi Jacob said: "One might think that God will bless us even if we are idle; therefore it says, 'in all the *work* of your hands.' If a person works, that person is blessed; if not, the person is not blessed." (*Midrash Psalms* on 23:1)

➤ Why is a working person blessed? What kinds of blessings might an idle person miss out on?

I Work comes first, then come rewards. Even in Eden Adam had chores.

Rabbi Simeon ben Elazar said: "Even Adam did not taste food until he had done work, as it is said, 'The Eternal God took the man, and put him into the Garden of Eden to till it and keep it' (Genesis 2:15), after which God said, 'Of every tree of the garden you may eat.'" (Genesis 2:16) Rabbi Tarfon said: "Even the Holy One Who Is Blessed did not cause the Shechinah to rest upon Israel until they had done work, as it is said, 'Let them make for me a sanctuary, and then I will dwell among them (Exodus 25:8).'" (Avot de Rabbi Natan 11, 23a)

➤ For Adam, what key reward comes from working the land? What reward do the Israelites receive for completing the sanctuary? Is there work today that has spiritual rewards? Explain.

J This quotation asserts the importance of taking a balanced view of *Malachah* in a most succinct and compelling way.

You are not obliged to finish the task (*Malachah*); neither are you free to desist from working at it. (*Pirke Avot* 2:21)

➤ What should be our attitude toward work according to this passage? If we define *Malachah* most broadly, how might the value of moderation apply not only in terms of our professional/career lives, but in parenthood/family responsibilities? in academic life? in terms of communal/civic responsibility? in religious life?

Post-Rabbinic

A During the pioneering days of modern Israel, work, especially on the land, was seen as key to building the Homeland, establishing the Zionist dream. The work ethic is captured in this simple song of the *chalutzim*.

> *Zum gali gali gali zum gali gali . . .*
> *He-chalutz l'ma-an avodah; avodah*
> *l'ma-an he-chalutz . . .*
> **(The pioneer is for work; work is for the pioneer.)**

➤ How essential is reaching toward a goal to make work meaningful? What would motivate you to work your hardest? Would the Zionist pioneer life have appealed to you? Why or why not?

B The following Zionist slogan continues to serve as inspiration. It reminds us to persevere in our efforts, to do what it takes to get the job done. For the Zionists, the dream is for the Jews to live as a free people in the land of Israel.

> *Im tirtzu ayn zo aggadah.*
> **(If you will it, it is no dream.)**
> **(Theodor Herzl, 1860-1904)**

➤ What is the relationship between "willing it" and *Malachah*? In what ways does fulfilling our dreams require work?

ACTIVITIES

Language Arts

 1 (5-10 minutes) Review Text Study, Tanach #A and #B. Then make two lists. On one list, brainstorm all the positive aspects of work and its results. On the second, write down some of the challenges.

Discuss the two lists. Are the positive aspects of work enough to keep a person motivated to be industrious? How might a person deal with some of the challenges listed? Do you think you need to be more industrious in your life? Explain. If you answered yes, how might you go about accomplishing this?

 2 (5-10 minutes) Industriousness can mean a job that produces a paycheck, but it can be much more — child-rearing, volunteer work, housecleaning, maybe even exercise. To appreciate fully the scope of this *Middah*, brainstorm its many possible meanings.

Number a piece of paper from 1 to 100 (to 50 if you don't want to work so hard!). Now, as quickly as you can, fill the page with as many ways of being industrious as you can. Don't worry if you write the same thing twice, or three times — repetition tells us something, too. The more we flesh out the meaning of *Malachah*, the more opportunity we have to enjoy its promised blessing!

Now, look over your list. Any surprises? Any themes or words that kept coming up? Do you see industriousness any differently as a result of doing this exercise? Explain.

 3 (10 minutes) Rabbi Elazar ben Azariah speaks of pride in work (see Text Study, Rabbinic #F).

Reflect (or help a younger child reflect) on the past 24 hours or so. Think about all you accomplished. On one side of a page, make a list under the heading "Accomplishments" (completed homework, helped with dishes, wrote get well card, took attendance for teacher, finished computer assignment, etc.). Title the other side of the page "Why I Am Proud." Give a reason for feeling pride about each one of the accomplishments listed. Small illustrations can be used instead of, or in conjunction with, the writing.

Why is it helpful to look on our accomplishments with pride? In what ways will you make more of an effort to value your achievements as a result of this exercise?

 4 (10-20 minutes) Refer to Text Study, Post-Rabbinic #A and #B. Imagine you are a pioneer in the Land of Israel a few years before statehood. Write a letter to a friend in Eastern Europe, encouraging him/her to come to help work the land. Try to be convincing as to why the work is essential and meaningful.

A variation: Imagine you are a new immigrant in America. Write to a friend or relative still in Eastern Europe, encouraging him/her to come and help you in your new business. Give reasons as to why coming over to work is a good thing.

 5 (15-20 minutes) This exercise makes the point that one person's industriousness can help to sustain the wider world for good.

On a piece of paper, list ten jobs or so, spacing out the entries so that they fill up one half (vertically) of the page completely. (An art alternative is to make small sketches of an individual engaged in various jobs on one side of the page.) On the other half of the page, in a different order from the jobs listed, write or draw how the various jobs affect others (even if indirectly, after a number of in-between jobs).

At the top of one side, the occupation listed might be a writer; the other side (halfway down the page) might have children engaged in story hour at a library. Or, one side might have a painter engaged in art; the other side might have people enjoying an art exhibit at a museum. There might be a farmer on one side, and people eating a meal around a table on the other. Draw lines connecting the jobs with the results. The mixing up of the order of jobs on one side, and results on the other, will give the effect of lines crossing each other. This look of lines crossing should give the sense that jobs are interconnected, that each has its particular and important place.

Discuss the merit and significance of everyone fulfilling a job for the efficiency and betterment of the world. How are *Malachah* and *Tikkun* (repairing or fixing the world) interrelated?

 6 (10-15 minutes) Our sources state that work comes first and then comes blessing (see Text Study, Tanach #A and #B, and Rabbinic #H and #I). Through prayer, we can become more aware that God is present and supports us in our work efforts.

Write two prayers along the theme of work — one of which is to be said prior to engaging in work, the other to be said following the work.

 7 (15-30 minutes) Work is essential for encouraging independence (see Text Study, Rabbinic #A). Explore the role of independence in your personal growth.

Pick three scenarios from your life reflecting gains in independence. Describe them and comment on their significance. Examples can range from learning how to walk to getting on the school bus by yourself to landing your first job.

In a group you may wish to share what you wrote. Why is striving toward independence important? Are there times when dependence is appropriate? How can you be sure you are nurtur-

ing independence to a degree that supports your own well-being?

 8 (10-15 minutes) Write freely, without stopping or censoring, on the topic of work. By allowing yourself to record what comes into your mind, without judging the content, underlying beliefs and attitudes are made clearer. Thus, you increase the likelihood of incorporating industriousness more consciously (and hopefully satisfactorily) into your life.

 9 (a few minutes a day for a week or two) This exercise is similar to the previous one, but involves more ongoing reflection, not just about work in general, but about your work (or accomplishments at school). One of the great things about work should be the feelings of pride it can give us (see Text Study, Rabbinic #F). On a day-to-day basis, how do we feel about our work? In what ways does it sustain us — financially, socially, emotionally, spiritually?

Over a set period of time, keep a record concerning your work (this could mean school work) — the degree of satisfaction it gives, the sense of achievement it inspires, the pride you feel. Spend a few minutes at the end of each day reflecting on the above questions and jotting down your thoughts.

What do your notes tell you about the role of work in your life — is it a source of satisfaction and pride? Why or why not? Are there any changes you should make in order to make your work/school more meaningful?

 10 (10-20 minutes) (For a related activity, see Movement #3.) Idleness or "wasting time" can lead to sin (see Text Study, Rabbinic #C and #H). But we also know that stillness, silence, and meditation are valued. (See Chapter 11: *Miyut Sichah: Minimizing Small Talk.*)

Can you describe the difference between a person purposefully being still versus a person being idle? Write a portrait of the same person engaged in each state of being. You might begin with a phrase such as, "So-and-so is sitting on a park bench . . . " Develop the scene in two ways. A first version may reflect a positive stillness, contemplation perhaps, appreciation of the natural world. A second version may reflect boredom, restlessness, an indifference to nature.

How did you flesh out the descriptions of the two ways of being? Are the differences subtle, or are you able to identify them decisively? How much agreement do you think there is among people in general about what defines worthwhile stillness and what defines idleness?

Visual Art

 1 (15-30 minutes) We can learn from the animal world about the importance of industriousness (see Text Study, Tanach #E). Unlike many *Middot,* industriousness is an attribute that we share with creatures. One of the key benefits of industriousness is basic survival — something all creatures need to master. Some might argue that animals are more proficient in this than are humans.

Spend some time observing ants, noticing their industriousness. You may want to observe other animals, too (or instead). A film of animals (or a mental recall of their habits) may have to substitute for direct observation.

On the top half of a piece of paper, illustrate the *Middah* of industriousness by drawing a scene from the animal world. Label this half "[name of animal, such as Ants] Engaged in *Malachah.*" On the bottom half, make a second illustration, connecting the industriousness of the animal you chose to the world of human beings. Label this second half: "What We Learn from the World of Animals."

Share the illustrations in a group. What animals did participants draw? What ideas did they come up with concerning what we can learn about the *Middah* from the world of animals? Are animals more accomplished than human beings in certain aspects of industriousness? Defend your position.

 2 (15 minutes) This activity is similar to #1 above. Illustrate the passage from Proverbs 6:6-12, presented in Text Study, Tanach #E, about the efficiency of ants as compared to lazy human beings.

 3 (5-10 minutes) See Music #1 for an exercise in drawing to the sound of "industrious" music.

 4 (10-15 minutes minimum) Working is worthy of blessing (see Text Study, Tanach #A and #C, Rabbinic #H and #I).

Create a drawing or painting of a person engaged in work. Surround that person with a background that communicates blessing. What is the color, the texture, the "feel" of blessing? You may wish to come up with a worker from your imagination, or you could use Adam or Isaac as a "model" (see Text Study, Tanach #A or #C).

 5 (15 minutes or more) Learning cooperation may be one of the reasons engaging in *Malachah* is beneficial. Cooperation is a necessary attribute in interactions at home, as well as in negotiations between governments. Capture the value of cooperation through the use of color and shapes on a canvas.

Begin by making one simple shape or image. Then add another, placing it in cooperative juxtaposition with the first. Continue adding shapes until the page is filled. The result should be a canvas that "exclaims" cooperation.

Discuss. What colors and shapes did you use on the canvas? How did you juxtapose the shapes in order to address the assigned task? How can our observations of cooperation in nature and the general environment remind us to nurture this attribute in ourselves?

 6 (15 minutes minimum) Reflect on the value of trying to achieve balance in the way time is spent between *Malachah* (work), *Menuchah* (rest), and *Talmud Torah* (study). (See Text Study, Tanach #D and Rabbinic #C and #D.)

This activity begins similarly to Movement #2 below. Refer to that exercise and complete the opening discussion described there, creating "graphs" with pie-shaped sections showing the relative amount of time a person should/could be occupied in various activities.

Now, through art, express what you believe to be the ideal. You might make a more realistic picture, using human figures. Or, you might take a more abstract approach, using non-specific shapes and images. These are the kinds of questions you will need to ask yourself: What is the color of rest? What is the shape of study? How much space does work cover? The more abstract approach captures subtle shades of mood and feeling which bring to the surface intuitive attitudes on the subject.

To do a more abstract study, you may wish to begin with a few smaller, rough drawings that explore options (shapes and images) in expressing the three subjects of work, rest, and Torah study. Then, move onto a larger canvas for the more developed work. Pay attention to color, texture, light versus heavy strokes, use of overlapping, etc. Once you are working on the canvas, spend some time developing the space in between the themes — how do they connect, how do they relate?

When everyone finishes, share and discuss the works of art. How is creative activity related to

work? to rest? to Torah study? What did you do in the space between images? Why?

Drama

 1 (15 minutes) Complete the first part of Visual Art #1, studying the work habits of ants and other creatures. Make two groups. Both halves then choose a group of animals and decide how to portray a central aspect of their industriousness. Each half then performs their animal scene for each other. The audience should watch each other's scene carefully, as they will need to use the material they see for the next part of the exercise.

Each half of the group then builds on the material presented in the other's animal scene. They are to create a short skit drawing on and elaborating on the aspect(s) of industriousness they observed, translating the animal industriousness into a human scenario. A "beaver scene" may get turned into a skit showing workers cooperating at a construction site. An "ant scene" may become highway workers clearing out a tunnel. Perform the skits for each other. Is work part of the "natural order of things" for animals? What are the positive aspects of emulating animal industriousness? What are the limits? Where do and should humans differ?

 2 (10-15 minutes) Work in a group involves cooperation. It could be argued that one of the reasons *Malachah* is worthy of praise is that it can teach important lessons about cooperation.

Play *Machine Charades*. Small groups decide on some kind of machine they will enact together — a vacuum cleaner, a popcorn maker, a washing machine, etc. Each group "performs" their machine for the others, who try to guess what they are.

Discuss. What kind of cooperation was necessary just to complete the assignment? How is a

machine like a workplace? Would you say that work is important because it teaches cooperation? Is getting along with others necessary for those who work alone? Explain.

3 (15 minutes) Part of the justification for valuing work is that it is a source for supporting oneself and one's family, and also that it can have an impact on improving the world. Explore the connection between industriousness and *Tikkun* (fixing or repairing the world).

In pairs, one person is the owner of items that need repair, and the other is the worker who will fix the item and return it. Several pairs can complete this assignment simultaneously, or one pair at a time can perform (improvise) for the rest of the group.

At first, the "owner" brings a small item that is broken, such as a coffeemaker or a toy, to the "worker." The two improvise a scene of repair. This scenario is repeated several times with bigger and more complex items being brought to the "worker." Eventually, more abstract things are brought to the "worker" — physical ailments, interpersonal problems, etc. The "worker" must strive to repair these problems of "brokenness" as well.

Discuss. Were there differences in the way the actors played the scene, depending on what was brought in? How do you account for these differences? Were the responses to brokenness consistently appropriate? Can work be sacred? How so? How can seemingly mundane work be suffused with a higher degree of meaning or satisfaction?

 4 (10 minutes) Look over the entries in the Text Study section above. Imagine that you are to give the commencement speech to a graduating Jewish high school or to a college class. String together a few Text Study passages which you think would be

pertinent and then "perform" them as if you are an accomplished, inspiring orator.

Movement

1 (10 minutes) Read Visual Art #5. Then, rather than drawing shapes to add on to each other, participants themselves become the shapes. Begin with one person becoming a shape. The next person creates another shape, then juxtaposes him/herself in a cooperative relationship with the first. Everyone in the group, one by one, adds on to this human sculpture of cooperation.

Discuss. What shapes did you create with your bodies? How did you juxtapose the shapes in ways that suggested cooperation? By experiencing and thinking about cooperation in this exercise, are you, in the future, more likely to be cooperative? Explain.

2 (10-20 minutes) One notable way of achieving balance in the way a person spends time is to complement *Malachah* (work) with *Menuchah* (rest) and *Talmud Torah* (study). (See Text Study, Tanach #D and Rabbinic #C and #D.)

First, discuss how much time should be spent in the various activities of work, rest, and Torah study. Then have everyone make a pie-shaped graph showing the relative amount of time they think a person should devote to each. In addition to this graph, have them make another graph that seems unworkable or undesirable.

Now come up with three short phrases of movement — one capturing the sense of *Malachah*, one of *Menuchah*, and one of *Talmud Torah*. A leader then calls out one of expressions, and participants repeat their appropriate movement phrase over and over until the leader calls out another direction. The leader changes his/her direction based on the percentages suggested in

one of the graphs created earlier. Repeat with a few of the time-percentages suggested in various circle graphs. Pause to make a transition between each "circle."

To make the activity more complex, try incorporating other types of activity into the balance (the pie-shaped graph) as well, such as socializing with friends, exercise, occupational work versus volunteer work, etc.

Was it difficult to master balance in this exercise? How does what you experienced here compare with what happens in actual day-to-day living? Do you think you need to make any adjustments in how you balance activities? If so, how and why?

 3 (10-20 minutes) We are warned in our tradition that idleness can lead to sin (see Text Study, Rabbinic #C and #H). On the other hand, there are numerous references to the value of stillness, silence, meditation (see Chapter 11, Miyut Sichah: Minimizing Small Talk). How to resolve the seeming dichotomy may in part have to do with your mental attitude, as well as with how you spend your time. If you're busy most of the time, then stopping activity may be more like taking a break, reflecting — stillness in its best sense. But if you are rarely engaged in work, then being inactive is nothing new. This second kind of inactivity does not contribute to growth and reflection; rather, it makes you stagnant. Stillness consists of meaningful pauses; idleness is wasting time.

Indicate the boundaries of two large imaginary circles in the space. Designate one circle idleness, the other stillness. All the other space in the room is "busyness" — activity, *Malachah*. Participants are to explore the three spaces at their own pace, moving back and forth through "busyness" into stillness and idleness.

Brainstorm movement ideas beforehand. Or, just let the improvisation happen. Some move-

ment ideas: "busyness" might be characterized by quicker, even frantic movement; the visual focus might be more narrow. Stillness might show a person allowing his/her focus or vision to extend beyond the immediate space — perhaps it will include slow, meditative walking. Idleness might include some toe tapping and pacing.

Discuss the experience. What was easy about it? What was difficult? Did you discover anything new about the difference between stillness and idleness? How would you characterize the nature of your own periods of inactivity?

Music

 1 (5-10 minutes) Our environment can affect how industrious we might be. To focus on the effect of what surrounds you, especially sound, try the following.

Play some "industrious" sounding music — marches work well. How does the music make you feel? Freely draw or paint, getting down on paper whatever inspires you as you listen.

Does the result "look" industrious? How so? What if other sounds were playing, such as water dripping, screeching, creaking, or jack hammers drilling pavement — would those noises affect your industriousness? What else in our work environment, besides sound, might affect our ability to be industrious?

 2 (15 minutes minimum) In Movement #2 participants created short movement phrases for work, rest, and Torah study. Here, compose short musical themes for work, rest, and Torah study. Then, arrange these themes into a balanced musical composition. (See also Visual Art #6.)

Miscellaneous

 1 (10-20 minutes on your own) We should be proud of what we create (see Text Study, Rabbinic #F). God has all of Creation on display. Do you have your achievements displayed? Do you appreciate your creativity?

Look around your room — in drawers, under the bed, in the closet, in the attic or basement or garage — wherever you (or your parent) may have stashed away some of your creations, awards, certificates, articles, etc. Make a corner of your room into a display of your creations and accomplishments. After collecting some mementos, set up a display that honors your creativity and achievements — your growing mastery of *Malachah*.

 2 (20 minutes or more) Explore and experience industriousness through "cleaning up." The leader designates several areas of jobs that could use some cleaning up — desks, art supplies, windowsill and radiator, playground, etc. Assign various slants on industriousness for each of the tasks, especially drawing on values highlighted in the Text Study sources. Examples are: giving too much time to complete the task, giving too little time, mixing in some Torah study with the work, making lots of comments during the task to reinforce feelings of achievement and pride, giving jobs that may be considered "beneath" participants, etc. The group works in one area at a time, incorporating the given "slant," before moving on to the next area.

Discuss the experience. Did being engaged in work feel satisfying? Consider the alternative and compare (that is, would you be happier if you never had to work, never accomplished anything)?

Which work environment (and "slant") was preferable? Why? Is industriousness something you practice in other parts of your life? How so and how not?

 3 (blocks of time over set period) Work should be supplemented by learning (Torah study) — the two go hand in hand. Learning and work take effort, diligence, and self-discipline. Are those qualities very much a part of you?

Commit yourself to learning something new. Set aside a block of time each day (or so) to practice or study. Some possibilities for skills to learn — karate, juggling, watercolor, ethnic cooking, dancing the tango, playing the penny whistle or harmonica, writing haiku, planting a terrarium, establishing a fish tank, beading, learning a foreign language, building or painting furniture, playing golf, etc.

As you put effort into mastering a new skill, be conscious of how you learn: What comes easy? Where do you get stuck? In what ways is self-discipline natural/unnatural for you? Does learning make your life richer? Are there lessons in general about learning that you would like to take back to your occupation (work or school)? Why might it be important to keep "a pot of learning" going at all times?

 4 (blocks of time over set period) This exercise is similar to #3 above, but focuses on learning to be creative. Read through #3. Focus on learning a creative art, such as making pottery, oil painting, doing modern dance or jazz, playing an instrument, acting, or writing poetry.

By participating in the creative process, do you feel closer to or more connected with God, Who is the Creator of all? Is creative expression equivalent to spiritual experience? Explain.

 5 (15 minutes) What is the opposite of *Malachah*? Is the opposite necessarily a bad thing? Is the opposite of *Malachah* always idleness (which, according to Text Study, Rabbinic #C, can lead to sin), or can there be a break from activity that is beneficial?

Spend ten minutes (clock it) sitting in front of a canvas or a blank piece of writing paper (open journal), or in an empty dance/theater space. Do nothing; just sit there and see what goes through your mind.

Discuss the experience. Would you describe the ten minutes as idle time? Or, was it worthwhile in some way? Define work, idleness, and stillness, taking into account any new insights gained in this exercise.

CHAPTER ELEVEN

MIYUT SICHAH: MINIMIZING SMALL TALK

מִיעֹוּט שִׂיחָה

OVERVIEW

In *Pirke Avot* we learn that Torah is acquired through 48 virtues. *Miyut Sichah* (minimizing small talk) is one of them. What do Torah and small talk have in common? Why do we need to minimize small talk in order to become more Torah-wise?

It is difficult to learn and contemplate righteousness if one is chattering away. It's not that talking and conversation are wrong, it's just that getting caught up in trivialities causes one to lose focus on what is truly important. An excess of small talk takes away focus from learning and personal improvement.

In Jewish tradition/Jewish Law, there are many instances when certain types of speech are considered *Lashon HaRa* (evil speech). These include talking about others behind their backs, gossip, slander, and spreading rumors. Other speech transgressions are: orally shaming someone in public, cursing God's name, giving false testimony, and making insincere vows. Small talk does not fall into the category of "transgression," that is, small talk it is not something clearly bad and worthy of vigorous condemnation. Yet, if we are to master *Middot* (become as virtuous as we possibly can), we need to give the matter of *Miyut Sichah* our attention. Failing to practice *Miyut Sichah* can lead to a shallowness that diminishes us.

Interestingly enough, no clear-cut definitions of small talk are provided by our sages. Silence, solitude, attentiveness, meditation are cited here and there as worthy practices. Small talk, then, must fall somewhere between silence and transgressions. Not a big help. Yet, perhaps that's the point. The sages don't want to define small talk, they just want to raise the issue. How we use language should be intentional, something we control. Falling absentmindedly into habits and patterns of idle chatter is not ideal. Consciousness and conscientiousness should both factor in. The goal is to choose deliberately how we speak and what we speak about.

While there are no clear-cut definitions of small talk, we may elicit some hints from the extension of *Miyut Sichah* — stillness, quiet, silence, and meditation. It is safe to say that sages, Rebbes, gurus, and spiritual geniuses wouldn't spend their time in constant, shallow chattering. Thoughtfulness, deep reflection, meditation, penetrating conversation, counseling, inspiring sermons or speeches would be more characteristic of such spiritually accomplished souls. While most of us will not become religious masters, we can nevertheless learn something from the traits of the wise. No doubt such masters have acquired control over their speech, which is part of spiritual mastery. If we also want to move in the direction of spiritual mastery, awareness of our use of speech must be part of our game plan.

Perhaps those who have greater mastery over *Middot* think about the question, "What does God want from me?" before they act, before words come tumbling out of their mouths. We, on the other hand, may be able to assert that God wants us to help the poor, to do deeds of loving-kindness, to respect parents and elders and teachers, even to eat in a certain way, but we may have devoted little time to thinking about what God wants us

to say. This issue is significant, as what we say filters into many — if not most — things we do. That is, what do we say while helping the poor, while doing deeds of loving-kindness, in our conversations with elders, parents, and teachers? Are we as circumspect as we could and should be? Do our words reflect how God would want us to use them?

We are currently experiencing a "revolution" in mass communication. Computers, television, telephones, message machines/services, cell phones, beepers, a plethora of media coverage all maximize talk. There are many wonderful things about instantaneous access to information, to world conversation. Still, what would happen if we were to give equal weight to the virtue of *Miyut Sichah*? How would that affect the way we communicate as individuals? as a society? More isn't necessarily better, as far as communication goes.

Let's see how this *Middah* applies on the following three levels of relationships.

 BAYN ADAM L'CHAVERO, BETWEEN PEOPLE. This is the most obvious level on which to interpret *Miyut Sichah*. People — friends, colleagues, acquaintances, relatives — can minimize small talk. At times, just being with another person in silence, or saying little, may be appropriate or desirable.

 BAYN ADAM L'ATZMO, BETWEEN YOU AND YOURSELF. It is possible that we overwhelm ourselves with internal conversations focusing on matters of little consequence. Consider: obsessing over something, not letting a matter go, reviewing an incident over and over in your mind, "replaying" a conversation to your disadvantage, thinking vengeful thoughts. What kind of inner dialogue counts as "small talk"? Where is the line between what is acceptable and what is detrimental? What benefit might there be in spending more time in silence

on a regular basis, perhaps in meditation, walking alone, or in another quiet activity?

 BAYN ADAM L'MAKOM, BETWEEN YOU AND GOD. The *Middah*, on this level, means minimizing small talk with God. It is difficult to imagine God engaging in chatty conversation. We should first be conscious of how we want to communicate with God, what we want to say, how often we try to say it, when we might want to focus silently on simply being in the presence of God.

TEXT STUDY

Tanach

A In the face of tragedy, there is often nothing you can say. Concerning Aaron, the High Priest, after his two sons were killed in the Tabernacle, we read:

And Aaron was silent. (Leviticus 10:3)

➤ Why do you think Aaron was silent? Was his response appropriate? Did Aaron just *become* speechless or did he *choose to be* silent? Have you ever *become* speechless after witnessing (or hearing about) tragedy? Have you ever *chosen* to be silent after tragedy? What's the difference? (For traditional commentary, see Rabbinic #B below.)

B To Elijah, God is not associated with the fierce rumblings of nature — the great and mighty wind . . . the earthquake . . . or the fire. Rather, Elijah recognizes God's presence in:

A still, small voice — *kol demamah dakah*. (I Kings 19:12)

➤ After Elijah hears the voice, he goes outside to the entrance of his cave where God addresses

him further. Was the *"kol demamah dakah"* coming from within Elijah or from the outside? Should you listen for God's "voice" to emanate from within yourself or from outside of yourself? Explain.

C Intelligence and wisdom are associated with what comes out of your mouth.

> **Wisdom is to be found on the lips of the intelligent. (Proverbs 10:13)**

➤ If you work on increasing your intelligence, will you become more wise? If you become more wise, are you more likely to use speech in meaningful ways? Is increasing your intelligence a value? Why or why not?

D The following includes comments about talking. Righteousness is associated with those who are thoughtful in speech. Wickedness and foolishness are associated with those who use speech for harmful purposes.

> **Those who conceal hatred have lying lips,**
> **While those who speak slander are dullards.**
> **Where there is much talking, there is no lack of transgressing,**
> **But those who curb their tongues show sense.**
> **The tongue of a righteous person is choice silver,**
> **But the mind of the wicked is of little worth.**
> **The lips of the righteous sustain many,**
> **But fools die for lack of sense. (Proverbs 10:18-21)**

➤ Can the way you use speech reflect how righteous a person you are? Can it reflect whether or not you are foolish? wicked?

E Minimizing small talk doesn't mean no talk at all. Certain kinds of talk can be worthwhile, even beautiful and sweet.

> **Let me hear your voice for your voice is sweet. (Song of Songs 2:1)**

> **Pleasant words are like a honeycomb, sweet to the palate and a cure for the body. (Proverbs 16:24)**

➤ When do voices sound sweet? How does "sweet talk" differ from "small talk"? When is your voice sweet/not sweet?

F There's a time and a place for both silence and speech. The challenge is to figure out the time and the place, as well as what words are appropriate.

> **A season is set for everything, a time for every experience under heaven . . .**
> **A time for silence and a time for speaking . . . (Ecclesiastes 3:1 and 3:7)**

➤ What are "times for silence"? What are "times for speaking"? What guidelines should you use to decide just what "time" it is?

Rabbinic

A According to a Mishnah, Torah is acquired through 48 virtues, including:

> **By a minimum of small talk — *B'Miyut Sichah. (Pirke Avot 6:6)***

➤ What does it mean that Torah is "acquired"? Would you agree that minimizing small talk is necessary for "acquiring Torah"? If so, why?

B This is a commentary on the line from Torah, "And Aaron was silent." (See Tanach #A.)

Aaron was rewarded for his silence. How do we know that he received a reward for his silence? From the fact that he was privileged to have the divine utterance addressed to him alone, as it is said, "And the Eternal spoke to Aaron" (Leviticus 10:8). (*Leviticus Rabbah* 12:2)

➤ What was Aaron's reward for silence? In what ways was it a reward? Under what circumstances do you think silence is worthy of reward? Does God speak only when we are silent? Explain.

C Comparative worth is assigned to silence and to words.

Rabbi Joshua ben Levi said: "A word is worth a sela [a small coin], but silence is worth two [*sela'im*], even as we have learned in the Mishnah: Simeon his son used to say: 'All my life I grew up among the wise, and I found nothing better for a person than silence.'" (*Leviticus Rabbah* 16:5)

➤ What did Simeon learn from the wise? Why might silence be good for a person? Overall, do you agree with this passage? Why or why not?

D The commentary on the following passage from *Pirke Avot* gives us some insight into acceptable, even praiseworthy, speech.

Rabbi Akiva taught,
Jesting and levity lead a person to lewdness;
Tradition is a protection for Torah;
Tithing is a protection for wealth;
Vows are a protection for abstinence;
Silence is a protection for wisdom.
(*Pirke Avot* 3:17)

Following is commentary on the above passage from *Pirke Avot*.

[That last line] is not talking about silence with respect to speaking of Torah — it has been written that one *should* speak words of Torah. And the silence being referred to isn't about gossip, *Lashon HaRa* (evil speech), or slander. The Torah instructs about [those transgressions]. What [this line about silence] must be referring to is elective, permitted conversation that takes place between two people. A person should minimize that kind of talk as much as possible. Solomon in Proverbs said about these matters: "Even fools, if they keep silent, are deemed wise." (Bartenura)

➤ How is silence a protection for wisdom? What kind of talk does Bartenura think is acceptable? What kind should be minimized? Do you agree/disagree with him? Why or why not? Do you think the ability to be silent is a characteristic of a wise person?

E More details are offered concerning how a wise person uses speech.

There are seven characteristics which typify the clod, and seven the wise person:
Wise people do not speak in the presence of those who are wiser than they are;
They do not interrupt their friend's words;
They do not reply in haste;
They ask what is relevant, they answer to the point;
They reply to questions in orderly sequence;
Of what they have not heard, they say, "I have not heard";
They admit to the truth.
The opposite of these typify the clod.
(*Pirke Avot* 5:9)

Rank the characteristics in this passage from the easiest to the hardest. Then explain your ranking.

F The tradition to keep silent in a house of mourning goes back to ancient times.

> "A time for silence and a time for speaking" (Ecclesiastes 3:7): The wife of Rabbi Mana died in Sepphoris. Rabbi Abun went up to visit [Rabbi Mana] and said to him, "Would the master care to expound something of the Torah to us?" He replied, "Behold the time mentioned by the Scriptures has come when one should keep silent and give preference to silence." (*Ecclesiastes Rabbah* 3:10)

➤ Do you think Rabbi Abun is a "clod"? Why or why not? There is a tradition that when visiting a house of mourning, one shouldn't initiate conversation. Instead, one simply responds when a mourner wishes to talk. Do you think this is a good practice? Why or why not?

G When the world was completely silent, God's voice was heard.

> When God gave the Torah, no bird twittered, no fowl flew, no ox lowed, none of the *Ophanim* [angels] stirred a wing, the world was hushed into breathless silence and the voice went forth: I AM THE ETERNAL YOUR GOD. (*Exodus Rabbah* 29:9)

➤ Are silence and stillness necessary in order for us to "hear" God? Explain. Describe a time when opening your ears to silence allowed you to "hear" in a new way, on another level.

H In the book of Lamentations, the speaker mourns the destruction of the Temple, the disintegration of the community — a tragic time for the Jewish people. This passage is very poignant as silence and weeping have replaced the former joy.

> What did people used to say when in the Temple Court? "Let everything that has breath praise the Eternal" (Psalms 150:6). But now, "I will silence them" (Psalms 42:5): in silence I go up and in silence I come down. "These things I remember": In the past I used to go up with songs and Psalms before the Holy One, Who Is Blessed, as it is stated, "With the voice of joy and praise" (Psalms 42:5). Now I go up with weeping and come down with weeping. "These things I remember": In the past I used to go up in crowds of holidaymakers, as it is stated, "A multitude keeping holy-day" (Psalms 42:5). Rabbi Levi said: "They were like a [river's] cataract which stops neither day nor night. But now I go up in silence and come down in silence: 'These things I remember, and pour out my soul within me.'" (*Lamentations Rabbah* 1:52)

➤ What is the mood of the *Lamentations Rabbah* passage — regretful, nostalgic, mournful? Is silence something positive or negative in this passage? What does the line mean: "I pour out my soul within me"?

I Speech can be used for good purposes or for bad. The following gives a strong impression of what such speech "looks like."

> "Death and life are in the power of the tongue" (Proverbs 18:21). Akila the Translator defined the tongue as a tool having a knife at one end and a spoon at the other — death at one end and life

at the other. Even so, Ben Sira said, "Blow on a coal to make it glow, or spit on it to put it out; both results come from the same mouth" (Eccesiasticus 28:12). (*Leviticus Rabbah* 33:7)

➤ Why is death likened to a knife? Why is life likened to a spoon? What is Ben Sira's point? Are there any other images that you can think of that capture the "two sides" of speech?

Post-Rabbinic

A When it is silent, you can sometimes "hear" more.

Rabbi Mendel's Hasidim once sat at his table in silence. The silence was so profound that one could hear the fly on the wall. After grace the Rabbi of Biala said to his neighbor: "What a table we had today! I was probed so deeply that I thought my veins would burst, but I managed to hold out and answer every question I was asked." (Martin Buber, *Tales of the Hasidim: The Later Masters*, p. 301)

➤ Was there silence or conversation at Rabbi Mendel's table? Assuming it actually was silent, how would you explain the statement by the Rabbi of Biala that he was probed and that he answered questions?

B Rabbi Mendel teaches his art (silence) by practicing it.

When Mendel was in Kotzk, the Rabbi of that town asked him, "Where did you learn the art of silence?" He was on the verge of answering the question, but then he changed his mind, and practiced his art. (Martin Buber, *Tales of the Hasidim: The Later Masters*, p. 301)

➤ How did Rabbi Mendel answer the question addressed to him by the Rabbi of Kotzk? Was it a good answer? Do you think Rabbi Mendel was trying to be funny? Was he being rude? Explain. Can you think of times when it might be acceptable to respond to a question with silence?

C It seems that everyone in our society is on the go. The Rabbi of Berditchev offers some wise counsel in this regard.

The Rabbi of Berditchev saw a man hurrying along the street, looking neither right nor left. "Why are you rushing so?" he asked him. "I am pursuing my livelihood," the man replied. "And how do you know," continued the Rabbi, "that your livelihood is running on before you, so that you have to rush after it? Perhaps it is behind you, and all you need do to encounter it is to stand still, but you are running away from it!" (Martin Buber, *Tales of the Hasidim: The Later Masters*, p. 226)

➤ Why was the man in this story rushing? What advice did the Rabbi of Berditchev offer him? Is this advice something that might apply to you? to your friends? to your parents? How so? Is it fair to say that a logical extension of *Miyut Sichah* is an appreciation for stillness? Explain.

D Music consists of sounds and silences. Pauses and rests are part of what makes a piece of music beautiful or moving.

It is the silence between the notes that makes the music. (Noah ben Shea, *The Word: A Spiritual Source book*, p. 333)

➤ Silence (in music or drama), stillness (in dance), empty space (on a canvas) can be essential parts of art. Explain why.

E Sometimes we have to be alone, to be in a quiet place, in order to figure out what it is we want to say. This may be especially true in our relationship with God. In a quiet place where we can appreciate God's Creation, our words may flow from us in more meaningful ways. We can minimize small talk with God, and speak from our hearts of our deepest feelings.

> Master of the Universe,
> Grant me the ability to be alone;
> may it be my custom
> to go outdoors each day among the
> trees and grasses,
> and there may I be alone,
> and enter into prayer
> to talk with the One
> to whom I belong.
> (Rabbi Nachman of Bratzlav)

➤ How is the content of your prayer affected by your environment? Compare being in a bustling, buzzing crowd versus being outdoors, alone in nature. Why might it be important to spend time in both environments? In which place are you more likely to minimize small talk with God? Explain.

ACTIVITIES

Language Arts

 1 (10 minutes) This activity involves both discussion and drama (role play). The value of *Miyut Sichah* is associated with learning, since small talk can distract us from learning (see Rabbinic #A).

Discuss: What rules are there about talking in the classroom? What reasons might be given for having such rules? Then role play a teacher trying to present a lesson. The "students" break a rule about talking.

Share reactions. What is the effect of breaking rules about talking in the classroom? Why is the *Middah Miyut Sichah* important to follow in order for students to learn?

Now, consider worship services. What is the protocol concerning talking during services? How does small talk affect worshipers? Role play. Then discuss.

 2 (20-40 minutes) We need to feel free to pray to God, to say what is in our hearts. Yet, on the other hand, we may spew nonsense, spout off, complain constantly, act petty, and sound bitter. That kind of communication is probably not the best way to cultivate a close, loving relationship with God.

Discuss or write responses to this question: What prayer does God like best to hear from you, and why?

Continue by creating a community collage of prayers. Everyone copies (and possibly illustrates or illuminates) his/her chosen prayer or writes an original one. Compile the prayers on a large piece of paper, collage-style. Ideally, hang the collage in an area where worship takes place.

A variation: Create a booklet of prayers made up of those copied by participants. Use the booklet for a worship service.

 3 (the time it takes to go on more or less ambitious field trips; plus 15 minutes or so in each place.) Refer to Visual Art #2. In that exercise participants visit different "sacred places" and then draw whatever comes to mind. Here, you will write about your impressions, keeping in mind the necessity for stillness and quiet in these spaces.

4 (10-20 minutes) Everyone elaborates on the phrase: "A wise person is . . ." When everyone has completed the task, read the passage in Text Study, Rabbinic #E.

Compare what participants wrote with how the sages describe a wise person. What similarities/ differences are there?

 5 (15-30 minutes) If we can clarify what is good and meaningful about some of our conversations, perhaps we will be able to elevate the level of more of them.

Write a letter to an imaginary special person in your life. Begin with the words, "I love our conversations because . . . " As an alternative, this exercise could be done in the past tense — remembering conversations you had with someone special in your life. If you feel like it, go ahead and send the letter.

Did this exercise clarify your views of meaningful conversation? How much of your usual conversation time could be described as meaningful? Are you satisfied with the amount of time? If not, how can you "elevate" more moments of conversation?

 6 (15-20 minutes) Rabbi Mana reminds Rabbi Abun of the "preference for silence" in a house of mourning (see Text Study, Rabbinic #F).

Discuss experiences of visiting houses of mourning or visiting people who are sick. What role did talk and silence play? What is appropriate? Study what Jewish tradition has to say along these lines. (Refer to books on *Mitzvot* or Jewish practices.)

 7 (15-25 minutes) Spending time in silence can be a positive experience. But there's another side of silence. Silence can be used as a weapon. "The silent treatment" is a way for people to avoid communication or to punish. Refusing to communicate can be used in order to hurt another. Or, silence can be strained, as when two people who were once in love, have nothing to

say to one another. These examples fall in the category of *Bayn Adam L'Chavero* (Between People).

Similarly, there's a side to *Bayn Adam L'tzmo* (Between You and Yourself) silence which has to do with reflection and personal growth nor with anger. Silence, when you are by yourself, can be unnerving or depressing or lonely. Silence can even be frightening, such as when a young teenager is staying at home by him/herself at night. Or, silence can be sad, as when all the visitors have left a *shivah* house and the mourner is alone for the first time. The silent absence of a loved one becomes accentuated.

Begin with the words, "It was silent . . . " and go on to describe the unique nature of your chosen scenario of silence. Be sure to develop detail — the environment, the time of day, the internal state of the person. Begin with a *Bayn Adam L'Chavero* (Between People) scenario. Then repeat the exercise with one that is *Bayn Adam L'Atzmo (Between You and Yourself)*.

Discuss. If you totally minimize small talk, you could wind up with silence. Do you think you now have a better handle on what it might mean to face up to silence — both the good and the not-so-good variety? Do you have the right amount of silence in your life now? the right kind? Are there any adjustments you need to make? If so, how can you go about making them?

 8 (10 minutes) We learn about words that are welcome, beautiful, and sweet (see Text Study, Tanach #E). What words should we use when we address God?

On a piece of paper, write, "God, what do you want to hear from me?" Then answer the question, imagining God's answers. Perhaps you'll begin writing something like this:
I want to hear kindness, only kind words from your lips;
Words of blessing, not just when it is "required,"
But whenever, however, for no reason at all, and for every reason.

I want to hear silence,
The silence that means trust,
The trust that means love . . .

Was what you wrote expected/unexpected? Do you "believe" what you wrote — that there really are certain things God wants to hear from you? Explain.

 9 (5-15 minutes) The biblical phrase "the still, small voice" has captured the attention and imagination of generations. Is the voice of God outside of us? Is it inside of us? There is something significant and profound about these words, yet, it is hard to pin down exactly what they mean. One way to loosen the mystery is to try to allow our intuitive reactions, our own wise commentary, to come to the surface.

Study the passage in the Bible about Elijah hearing a *"kol demamah dakah"* — still, small voice (see Text Study, Tanach #B). Then write freely for a few minutes, beginning with, "The still, small voice . . . " Let the words flow. Don't stop to evaluate, reason, or shape your writing.

Do you think you have a clearer notion of "the still, small voice" after writing about it? Is this voice always consistent, always the same thing? Or does it change at different times, under different circumstances? Is the voice something only a great prophet can hear, or can you and others hear it, too? When can you hear it? When can they hear it?

 10 (20-30 minutes) As we work toward using words meaningfully with others, we need to be conscious of our own inner conversations, too.

Write two versions of an inner dialogue. The first should capture more of a "small talk" version. Perhaps the dialogue goes around in circles, is self-effacing, or is petty. The second version should be more constructive, helpful, self-encouraging. Possible topics:

a. Attending a new school
b. Starting a new job
c. Beginning a friendship
d. Anticipating an exam
e. Participating in a sport
f. Planning a family reunion
g. Inviting a guest to your home

Discuss. What makes inner dialogue a lower versus a higher quality? How much control do we have over what goes on in our own minds? Which is better, trying to have control and impose limits on what you will allow yourself to mull over, or giving free reign to your mind, your inner voice?

Visual Art

 1 (10-15 minutes) Art can be a means to converse (back and forth, between two people). This exercise challenges us to examine the way we communicate and to explore the richness of expressing ourselves through art.

In pairs, create a painting in silence. One person draws something (concrete or abstract), then hands the paper to a partner who adds to the artwork. They pass the painting back and forth until they both agree (without using words) that the picture is complete. Try this activity with clay, too.

Afterward, discuss. How would the process have been different had the partners used words? How did the partners know/agree they had completed their joint piece of art? How does art communicate ideas as compared to how words do?

 2 (the time it takes to go on more or less ambitious field trips; plus 15 minutes or so in each place) Different places can inspire feelings of closeness with God. Such feelings develop when we are in the right frame of mind and we have calm, quiet time.

Visit some sites that you consider to be "sacred places" — a sanctuary, places in nature, a special spot in your home, etc. In each place spend a few moments listening to the silence as you turn your thoughts toward God. Then draw whatever comes to mind.

Are stillness and quiet necessary for the appreciation of sacred places? How does the spirituality you feel in an energetic, enthusiastic crowd compare with the spirituality you feel when surrounded with silence? Is a feeling of sacredness more dependent on what surrounds you or on who surrounds you? Explain.

 3 (10 minutes) Complete Music #4, in which participants make a "sound collage," capturing sounds on a tape recorder that are worthwhile, positive, pleasant. Then try drawing to the sound. Listen and let whatever artistic images strike you flow from your wrist to the paper.

 4 (10-20 minutes) In Text Study, Rabbinic #I, the tongue seems to hold the power of death and life.

Review and discuss the Text Study passage. Then make pictures of either or both of the following:

a. A "two-edged" tongue

b. A person whose mouth can blow on coal to make it glow, as well as spit on it to put it out

In a group share and discuss your artwork.

 5 (15 minutes minimum) Our worship services include a time for silent prayer after the "Amidah." Of course, we are encouraged to pray our own prayers at other times as well. This individual prayer is valued in our tradition (see Text Study, Post-Rabbinic #E).

When you think of a Jew deeply immersed in personal prayer, what is the first thing you

picture? Someone with eyes closed, perhaps wrapped in a *tallit*? Someone sitting, bent over with face in hands? Someone with eyes covered blessing the Shabbat candles? We do not often think of someone deep in prayer with their eyes wide open. One prayer custom uses a visual aide — a picture, a design — to help people go deeper into prayer. Some cultures use a mandala. In Judaism we use a decoration featuring the word "Shiviti" (I set myself before God). Often this is a beautiful wall hanging or paper art showing hands in blessing.

If possible, bring in examples of *Shiviti,* designs. Examine them and share reactions. Make your own "Shiviti." Draw a picture that would help people focus their thoughts appropriately for "silent prayer."

Explain how you came up with your particular design. Compile the designs into a "Shiviti book." If pictures are black and white, you can photocopy them for everyone. You might also display the "Shiviti" works in the sanctuary or other worship space.

 6 (10-15 minutes) Through art, we can capture the essence of talk and explore its "texture."

Divide a piece of paper into nine boxes. Label the boxes: Silence, Chatter, Prayer, Quiet, Gossip, Explosive Anger, Words That Embarrass, Wise Words, Sweet Words (see Text Study, Tanach #E). Then do quick line drawings capturing the essence of each of the talk words.

In your drawings, can you "see" why some kinds of speech are more praiseworthy than others? Which drawing reflects the most dangerous or detrimental use of words? Why? Was this expected/unexpected? Which drawing do you think reflects the most favorable way to use speech? Why?

 7 (the time needed to photograph and develop a number of pictures) What suggests silence, stillness, quiet in the environment around us (a tall tree on a cloudless day, a mother nursing her baby on a park bench, a deserted downtown street at night)? Part of minimizing small talk is an appreciation of the more quiet, peaceful moments of life.

Over the course of a given period of time, take photographs that capture stillness, quiet, silence. What is it about the photos that suggests these qualities? Which photo is your favorite? Why? To take this activity a step further, use one of the photos as the basis/inspiration for a drawing or painting.

 8 (30 minutes minimum) In art, a form that explores objects at rest is called a "still life."

Examine examples of still life paintings. What "still" moods are captured in the various works? Gather objects that reflect your vision of stillness and quietude and arrange them.

Create a piece of art based on the arrangement of the objects. Your art can be representational or abstract (capturing impressions of shapes, textures, and colors rather than fine details).

Another approach is to begin with the objects themselves (rather than with a preconceived, abstract notion or definition of stillness). When arranged together, the objects should suggest the message of their stillness. You may want to try various arrangements. What is communicated by arranging the objects in various ways? Choose the arrangement you find most "quietly" compelling.

 9 (30 minutes) In talk between people, it can be argued that "less is more." Some modern artists, intrigued with the "less is more" idea, developed a style known as "Minimalism." Some examples of this genre: a painting that consists only of two thick, black,

vertical lines on an enormous canvas; a symphony in which there are long periods of silence or long pauses between the notes of a single instrument; a dance in which the dancers remain still for more time than they move, or in which the dancers move very slowly, in a barely visible manner.

Try this art experiment. Choose a subject to draw — a house, a building, a river, a street scene, a playground, a garden, etc. You will draw the subject twice, taking exactly ten minutes for each version.

a. Draw or paint the subject, making it as detailed as possible. When the allotted ten minutes is up, stop working.

b. On another sheet of paper, draw or paint the same subject. This time, ignore detail. Be as thoughtful as possible with every stroke of paint, pen, or pastel. Don't try to recreate the subject; try to communicate its nature using fewer, but more meaningful canvas strokes. Here, less is more. Every mark on the canvas should count, should "say something," not just "represent" something.

Compare the two drawings. Analyze and explain which picture more "accurately" reflects its subject. Why might practicing the art of doing less be a good exercise? Can anything you learned in this art assignment be applied to the "art" of speaking? Explain.

Drama

 1 (10 minutes) The context, the tone of voice, the volume, the intention behind the words — all of these characterize the nature of conversation. We can become more sensitive to how we use speech by being conscious of all of its components. (Is our small talk higher pitched, whispered, spoken in a giggly or sarcastic voice, etc.?) The point is to notice what we're saying, and increase our awareness of how we sound when we say it.

Gibberish consists of nonsense, made-up, improvised, language-like syllables. Pairs or

small groups improvise a conversation using gibberish. No recognizable words should be spoken. Begin with "small talk" gibberish, then gradually have the "conversation" become more thoughtful, less frivolous.

Discuss the experience. What made the conversation sound more like small talk? What made the conversation sound more thoughtful? In what ways can *how* we talk help clue us in to the worth of what we're saying?

 2 (10-15 minutes) This activity is similar to #1 above in that it also highlights *how* something is said. To become more sensitive to how we use speech, we need to become more conscious of the associated components of speech — gestures, facial expressions, movement, and other body language.

Watch a dramatic film or TV show, but turn the sound off. What is lost when you can't hear the actors' voices? What is gained? Was it obvious when the actors were engaged in "small talk"? in more meaningful conversation? How could you tell the difference? Try improvising your own silent scene.

 3 We usually associate spending time in silence with being alone. But spending time in silence with a friend can be a rich experience.

In pairs (or trios), pantomime a shared silent activity or two. Flesh out the scene with some specific details in order to give the presentation some depth.

Perform the scenes for each other, then discuss them. How is an activity done in silence with another person different from other types of activities? Are you comfortable or uncomfortable spending time in silence with another person? Explain. In what ways can spending quiet time with another person strengthen a friendship?

 4 (15-20 minutes) Language Arts #7 explored all sides of silence through writing. In this Drama variation, the participants act out the scene. You can add a game element to the drama by having an audience guess the situation being responded to by the silent actor(s). Before beginning the acting, the actor(s) should have noted (at least mentally) many specific details about the scenario.

5 (10 minutes) In the "*V'Ahavta*" prayer, we read "*V'Dibarta Bam*" (You shall speak of [these words]). These words are God's love for us, our love for God, our commitment to a life of Torah. We are supposed to speak of these all the time, when sitting in our homes, walking along the way, lying down, and rising up.

Choose a mundane scene, such as waking up and getting ready for school, cooking dinner, or running a particular errand. One person describes the scenario to a partner in a straightforward fashion, as if in conversation. For example: "The alarm clock went off, I hurried out of bed, threw my clothes on, grabbed a bowl of cereal and a glass of orange juice, yelled 'good-bye,' and ran out the door to the bus stop."

The second person takes the scenario and repeats it in such a way that God is included in the conversation, through blessings, exclamations of gratitude, and/or expressions acknowledging an awareness of God's presence. The second person might revise the first person's words to something like this: "The alarm clock went off. Thank God for ears that hear a wide range of sound. I hurried out of bed and thanked God for returning my soul-breath to my body, for giving me strength each day. I threw on my clothes while thinking about the *Mitzvah* of *Malbish Arumim* (clothing the naked). How might I help provide clothes for the needy? I offered blessings before gobbling

down my cereal and orange juice, and thought about the miracle of sun, water, soil, and seed coming together to make an orange. I almost left without saying good-bye to my parents. Then I remembered 'Honor your father and your mother.' So I shouted 'good-bye' as I ran out the door to the bus stop."

Discuss. Was it difficult to include God in your stories? Did it feel natural/unnatural? How might you increase your awareness of God through your day-to-day talk?

 6 (30 minutes) In Language Arts #10, participants wrote versions of an inner dialogue. The experience of talking to oneself is likely familiar to most of us. We might even say to ourselves something like, "I need to talk to myself about . . . " It's almost as if we have two parts to ourselves — the "I" and the "Myself."

Have two people represent two "halves" of one person. Decide on a topic for inner dialogue. One person is one part of the self; the other is another part. The two parts of the self begin a dialogue together. They begin with "small talk" and gradually move to more substantial, meaningful "inner dialogue."

Movement

 1 (10 minutes) Sincere prayer is a high quality use of words. What about prayer without words? Prayer communicated nonverbally, with our bodies, offers a new angle to the *Middah* of *Miyut Sichah*. Show the prayer, become the prayer. In other words, "With every limb, praise" (from the Shabbat morning liturgy).

What is your favorite prayer? Say it or sing it out loud (by yourself or in a group). Then pray the same prayer wordlessly, through movement. What is different about the two experiences?

 2 (15 minutes) *Miyut Sichah* reminds us that there are many ways in which we can communicate with others. Sometimes the absence of words can communicate better than words spoken out loud.

Divide the group into pairs. One partner in each pair verbally describes movement he/she wants the other person to do. The one giving instructions should be as specific as possible, giving plenty of details, such as "Raise your right arm over your head, with your palm facing out. Then leading with your elbow, quickly make a large, clockwise circle."

After a few minutes, switch to nonverbal mirroring. The partners face each other. The first person guides the second nonverbally in movement. The second person follows as closely as possible, so that it is hard to tell who is leading and who is following. Switch leadership roles, repeating the exercise both verbally and nonverbally.

Pairs discuss the experience, then share their insights with the group as a whole. Some questions: Which was more difficult in this situation, verbal or nonverbal guidance? List some situations in which teaching through doing and by example is more effective than teaching through talking.

 3 (5-10 minutes) How do external voices and noises influence our own inner conversation?

Play a piece of music for a short while, then turn it off. Participants try to continue the feel of the music in their bodies, moving in silence according to the remembered sound.

Take this idea a step further. The leader asks: If you listen to arguing all day, how might that make you feel and think? Put that in movement. What about if you listen all day to the sound of ocean waves on the shore? Put that in movement. What about sirens? a baby crying? silence?

How much control do we have in shaping our own inner dialogue? What can we do to get away from stress, to find the quiet, peaceful place inside of ourselves? In what ways can we improve the quality of our inner talk?

 4 (15-20 minutes minimum) Choreograph a dance to the words of Nachman of Bratzlav's prayer (see Text Study, Post-Rabbinic #E).

 5 (15 minutes or more) We communicate our prayer not just with our words, but with our whole beings — our bodies, the expression on our faces, from our hearts, and with our souls. In this exercise, we focus through movement on the nonverbal dimensions of worship.

Collect photographs that show people of different cultures worshiping. Put the sentiment of the photo into your body and dance what is being expressed. To create a fuller sacred dance, string a few of these interpretations together.

What did you discover about the merit of nonverbal prayer? What would it mean to become a "prayerful person"?

 6 (15 minutes or more) This is another photo-to-movement activity. Complete the photography assignment listed in Visual Art #7, or bring in pictures from magazines and/or books that communicate stillness, quiet, silence.

Choose five or so of the images. Then as individuals, pairs, or in small groups, create a physical shape or a short phrase of movement based on each. Choreograph a movement piece by linking the photo/movement images together. Move slowly, precisely, and intentionally between each image or sub-phrase.

Everyone performs their short movement pieces for the rest of the group. Then the per-

formers share what they experienced and the observers share what they saw.

 7 (10 minutes) This activity is similar to Music #3. In most movement improvisations, we begin with a movement idea. The focus is on performing, responding to a given instruction about what we're supposed to *do*. If we start with the opposite premise, the focus is on not doing, but on stillness. If and when movement happens, it becomes secondary. Movement actually is "minimized." Why dance less? In order to allow the wisdom of stillness to be expressed.

Use stillness as the dominant theme in a movement improvisation. Begin in stillness, limiting movement to what seems most intentional, essential, vital, significant. Then return to stillness, initiating movement only when it truly seems "ripe."

Discuss the experience. Was it difficult to have such a minimal instruction for the improvisation — almost a non-instruction? What did you learn about stillness? You were asked to think before you moved, to feel really inspired or motivated to move. Are there any lessons you can apply from this experience to the world of conversation (the world of *Sichah)*?

Music

 1 (15 minutes or more) Through music, we express ideas and feelings. A minute or two of music can provoke deep responses. If we minimize small talk, perhaps we will make more room for music, for song.

Learn/teach a *niggun* (a wordless melody). Repeat the melody for a long time, allowing it to "take possession of you." Vary the speed and volume if you like.

Compare singing with words and singing without words. Was there a point when the melody seemed to take on a life of its own, when

you became the receptacle for song? When you're immersed in song, what happens to inner dialogue, to internal chit-chat? If it is silenced, with what is it replaced?

 2 (15 minutes or more) After learning and singing a previously composed *niggun* (see #1 above), compose one or more of your own. Have the *niggun* communicate some kind of mood, e.g., joyful or contemplative. Notice how singing the same melody in different ways can cast shades of different moods — singing quickly may give a more exalted nuance; singing slowly may evoke a more reverent feeling. Discuss the questions in #1.

 3 (10 minutes) This activity is similar to Movement #7. When you think of composing music, you think of creating sound. But how might you go about creating music centered around silence?

Use silence as the dominant sound-theme in an improvised piece of music. In pairs or small groups, everyone takes an instrument. (Singing voices could be used in addition or used instead.) Players (or singers) are to favor, be attentive to, and highlight silence.

Begin in silence, making sound only when you have something really significant, really inspired to play (sing). The notes should be intentional, essential, vital. Then return to silence until it seems truly "right" to play (sing) sound once again.

You may want to try the above using a different angle. Players use sound more specifically, as if they are participating in a dialogue. Two people use their instruments to communicate directly with each other, back and forth, in a call and response style. Again, the notes they play should be meaningful. Pauses in the musical conversation can be just as important as the sounds.

Discuss the experience. Was it easy/difficult to pay more attention to silence than sound? What

did you learn about silence? You gave some thought to playing your instrument in order to be certain that your notes would be significant, meaningful. What lessons can you apply from this to the *Middah* of *Miyut Sichah*?

 4 (short amounts of time spent over a few days; plus time for group sharing) In Text Study, Tanach #E, we read about a sweet voice and pleasant words that are like a honeycomb. As we minimize small talk, what do we want to hear in its place?

Over the course of several days, use a tape recorder to make a "collage" of sounds that are worthwhile, positive, pleasant, sweet.

Listen quietly to the collection you've put together. What feelings does it evoke? Discuss why each person chose the sounds he/she did. If desired, borrow each other's tapes.

An extension: Draw freely to the sounds on these special tapes which you made (see Visual Art #3).

 5 (5-10 minutes) Can we become more aware of the nature of our internal dialogue by ascribing a sound to it? Abstract sound can reflect mood and feeling.

In a group come up with an emotional tone of inner talk (anger, sadness, elation, anxiety, jealousy). With your eyes closed, imagine (through listening with your "inner ear") a melody line that expresses the given mood.

Everyone opens eyes. At a signal from the leader, everyone begins to hum, improvising the sound of the inner conversation. Try to remain true to the sound of your interpretation, while at the same time listening to the communal "chorus."

Describe your reaction to giving a tangible quality (sound) to a mood or emotion. In what way was it helpful to hear what you are feeling?

What did you learn from listening to the interpretations of others?

Miscellaneous

 1 (10 minutes, plus time on your own) You can prepare for this assignment either by yourself or with a group. Take *Miyut Sichah* out of the realm of the theoretical, and think about how nice it might be to spend more time in quiet or silent activities. Change the thinking into doing.

List ways you practice silence, things you do silently, quiet activities. Choose one of your favorites on the list. Then elaborate (orally or in writing) on why you think the activity or practice is important, meaningful. Next, make another list — silent or quiet activities or practices you would like to try.

Now everyone looks at his/her second list and chooses something that is new to them to do over the course of a week or so. Report back to the group about your experiences after an agreed upon amount of time. (Individuals doing this exercise on their own may write about their experiences.)

CHAPTER TWELVE
NEDIVUT: GENEROSITY
נְדִיבוּת

OVERVIEW

Examples of generosity and bringing gifts abound in our tradition. Rebekah shows generosity toward Isaac's servant Eliezer at the well. Jacob sends presents to his brother Esau, before they reunite after 20 years of separation. The reunion of Joseph with his father and brothers involves gift giving.

Reference to the actual virtue of *Nedivut (Generosity)* appears in Exodus 25 (see Text Study, Tanach #D). There, God asks Moses to tell the Israelite people to bring gifts from all whose hearts so move them (*Yidvenu libo*). These are not obligatory taxes; they are voluntary gifts reflecting generosity. From these gifts, "let them make Me a *Mishkan* (sanctuary) that I may dwell among them." The *Mishkan* denotes a place where God's presence is especially felt. In addition, it is ideally a nurturing place for the highest standards of virtue. God draws close to virtue, and virtues motivated out of desire, not obligation, reflect the highest human standards. Thus, God asks for the *Mishkan* to be built from gifts given freely, gifts motivated by a sense of voluntary generosity.

Generosity is also expressed in our holiday customs: *Mishloach Manot* ("sending portions/gifts") is a Purim tradition which involves giving *hamentashen,* coins, and other treats to neighbors and friends. On Purim and Pesach, we are to make special efforts to provide food and *Tzedakah* to the poor (*Matanot L'Evyonim/Ma'ot Chitim*). Giving gifts on Chanukah has become popular with many families. Birthdays also inspire gift giving, as do life cycle milestones, such as birth, Bar/Bat Mitzvah, Confirmation, graduations, marriage.

Tzedakah and *Gemilut Chasadim* are more familiar terms than *Nedivut. Tzedakah* is associated with monetary charity and good deeds. *Gemilut Chasadim* refers to acts of loving-kindness. *Tzedakah* and *Gemilut Chasadim* can stem from generosity, but are not dependent on it, for they are *Mitzvot,* required actions.

So, if *Tzedakah* does not depend on *Nedivut,* why develop this attribute? Because *Nedivut* indicates more of an attitude than a deed. Here are a few reasons why this attitude is important: If we cultivate the quality of generosity, we are more likely to do generous deeds, including *Tzedakah* and *Gemilut Chasadim.* Generosity can motivate us to go beyond "the letter of the law," which means more support for those in distress. Generosity promotes a sense of goodwill among people in general, no matter what their financial state or personal circumstances.

There may be necessary, basic, loving deeds that have to be carried out just to alleviate a modicum of suffering in the world. But we can reach higher than that. Everyone's spirits are lifted in an atmosphere of generosity, not just the poor, the suffering, or the downtrodden.

It is clear, then, that generosity is a good thing. But how do we become more generous? Some people just naturally seem generous. Others seem stingy by nature. Is generosity something we can work on? And will such work make a difference?

To start, we might try to discover a sense of abundance from which to draw. What signifies abundance? From many a five-year-old's point of view, the answer may be a basket of candy, a

"Charlie and the Chocolate Factory" kind of abundance. Food is definitely associated with abundance — *hamentashen,* chocolate *gelt,* and the Pesach exhortation "Let all who are hungry come and eat!" What else — a warm home, special knowledge or skills that can be shared, compliments (verbal "gifts"), the ability to find humor in situations (an openness toward human foibles)? As we uncover what abundance means to us, we may surprise ourselves in finding we have more resources, more to give than we thought.

What follows is a summary of how *Nedivut* can factor into our relationships with other people, with ourselves, and with God.

 BAYN ADAM L'CHAVERO, BETWEEN PEOPLE. Showing generosity to others probably comes to mind first when thinking of the quality of *Nedivut.* Some acts of generosity may occur in day-to-day interactions; others may be associated with special events.

 BAYN ADAM L'ATZMO, BETWEEN YOU AND YOURSELF. Being generous to yourself might mean discovering a sense of inner abundance, being able to smile at your failings, treating yourself to generous helpings of exercise and rest, giving yourself permission to be creative and to take calculated risks, encouraging yourself to grow in knowledge and faith. Other ideas?

 BAYN ADAM L'MAKOM, BETWEEN YOU AND GOD. From God's generosity we learn the meaning of this virtue. Creation or even life itself might be deemed gifts. Torah could be considered God's greatest gift to the Jewish people, a reflection of God's love ("*Ahavah rabbah ahavtanu . . .* With *abundant* love You have loved us"). Knowledge is a gift; love in abundance is the source of that gift. The gift of knowledge includes the ability to learn, to grow,

and to have a conscience. (See Text Study, Tefilah #B.)

To be like God means that we, too, are to give gifts. What are we "required" to give? God has loved us with abundant love, and we in turn are to love God. In Jewish tradition living a life of *Mitzvot* is a fulfillment of that love. Such a way of life reflects our Covenant with God. Striving to master *Middot* is another way to show appreciation for the gifts God has given us.

TEXT STUDY

Tanach

A Abraham instructs Eliezer, his servant, to go to Haran and obtain a wife for Isaac. At a well he meets Rebekah, who responds graciously to him. She draws water for him and his camels. Then she takes him to her family's home where he is offered kind hospitality.

> **We have both straw and food enough and room to lodge in. (Genesis 24:25)**

During the visit, it is agreed that Rebekah will wed Isaac. The agreement is celebrated with gifts.

> **And the servant [of Abraham] brought forth objects of silver and gold, and garments for Rebekah, and he gave presents also to her brother and her mother. (Genesis 24:53)**

➤ How did Rebekah show generosity? What gifts did the servant give? Does one person's generosity inspire generosity in others?

B After receiving a blessing from his father that had been meant for his brother Esau, Jacob runs away from home. After 20 years, when the brothers are to meet again, Jacob is fearful. He therefore sends many presents ahead:

200 she-goats and 20 he-goats, 200 ewes and 20 rams, 30 milch camels and their colts, 40 cows and ten bulls, 20 she-asses and ten he-asses. Jacob instructs his servants to tell Esau that these animals are:

> A gift sent to my lord Esau, and [Jacob] himself is right behind us. (Genesis 32:14-20)

➤ What was Jacob's special motive in sending gifts to Esau? If there is a motive behind a gift, can the giving still be considered an act of generosity? How so or how not? Was Jacob's offering to Esau an example of generosity?

C Joseph brothers are about to go down to Egypt for food. This is the second time they will stand before "the man" (Joseph) who controls the food supply. To prepare for the meeting, Jacob tells his sons:

> Take some of the choice products of the land in your baggage, and carry them down as a gift for "the man" — some balm and some honey, gum, ladanum, pistachio nuts, and almonds . . . (Genesis 43:11)

Later, after Joseph's identity is revealed, the brothers plan to return to Canaan and bring their father and their households back to Egypt. Joseph gives them wagons and provisions for their journey, plus a change of clothing.

> But to Benjamin he gave 300 pieces of silver and several changes of clothing. And to his father he sent the following: ten he-asses laden with the best things of Egypt, and ten she-asses laden with grain, bread, and provisions for his father on the journey. (Genesis 45:21-23)

➤ Reading the whole Joseph story will put the giving of the gifts in context. Nonetheless, there are some insights we can gain from reading just the above excerpts. What gifts are given in these citations from the Joseph story? Do these seem generous? What kinds of gifts between family members reflect generosity?

D (This passage is also discussed in the Overview.) The concept of *Nedivut* derives from the passage in which God asks Moses to tell the Israelite people to bring gifts for the building of the *Mishkan*. Gifts from the willing heart will draw God's presence near.

> The Eternal spoke to Moses, saying: Tell the Israelite people to bring Me gifts; you shall accept gifts for Me from all whose hearts so move them. And these are the gifts that you shall accept from them: gold, silver, and copper; blue, purple, and crimson yarn, fine linen, goat hair; tanned ram skins, dolphin skins, and acacia wood; oil for lighting, spices for the anointing oil and for the aromatic incense; lapis lazuli and other stones for setting for the *ephod* and for the breast-piece. And let them make Me a sanctuary that I may dwell among them. (Exodus 25:1-8)

➤ What kind of gifts does God want? Are gifts from the heart and gifts not from the heart equally valid? equally acceptable to God? In what ways does generosity bring God's presence near? Explain.

E Sacrifices may be understood as gifts. Several types of sacrifices are mentioned in Torah, including burnt offerings made to atone for sins committed in error by individuals, by leaders, and by the community as a whole, as well as guilt offerings, thanksgiving offerings, and offerings of grain. (See Leviticus 1-7.)

➤ In what ways is a sacrifice a gift? Is it a "gift from the heart"? Are there sacrifices we make in our own day that reflect generosity? Explain.

F Aphorisms from the Book of Proverbs can be most thought provoking. For instance:

> **Giving gifts eases a person's way, and gives that person access to the great. (Proverbs 18:16)**

➤ How can giving gifts improve the quality of life? Do you have any personal experience with this? What would you advise someone who tells you he/she is planning to give a gift and hopes to be rewarded for it (with a job promotion, with acceptance to a special learning program, to win affection, etc.)?

G One of the arguments in favor of generosity is that "what goes around comes around." There's a saying "*Mitzvah goreret Mitzvah*" (one good deed brings about another). Perhaps we could also infer that "*Middah goreret Middah*" (virtue inspires more virtue). If you are generous, others will show generosity as well. You, yourself may be the one who benefits! What you give away will come back to you. Ecclesiastes says it more poetically:

> **Cast your bread upon the waters, for after many days you will find it. (Ecclesiastes 11:1)**

➤ Do you agree with this premise from Ecclesiastes? Why or why not? Does it make it easier to be generous if you know you will eventually get back what you give? Is this thought a motivation for the gifts you give? What can you rightfully expect in return for "gifts from the heart"?

H If we were to think of a visual image for Generosity, perhaps it would be an outstretched arm. This image is included in a description about one of God's most generous actions — the freeing of the Israelites from slavery.

> **The Eternal freed us from Egypt by a mighty hand, with an outstretched arm, and awesome power, and by signs and portents. (Deuteronomy 26:8)**

➤ How does the image of an outstretched arm capture the idea of generosity? In what situations do people stretch out their arms in generosity?

Rabbinic

A *Tzedakah* (doing charitable deeds) is a *Mitzvah*, something we are supposed to do. How we fulfill this *Mitzvah* may or may not reflect the virtue of *Nedivut*, generosity.

> **Among those who give *Tzedakah*, there are four types of people:**
> **Those who want to give, but do not want others to give — they begrudge the *Mitzvah* to fellow human beings.**
> **Those who want others to give, but do not themselves give — they begrudge the *Mitzvah* to themselves.**
> **Those who want to give and want others to give — they are saintly people. Those who do not want others to give and do not themselves give — they are scoundrels. (*Pirke Avot* 5:15)**

➤ Reflecting upon these four types of givers, would you say the majority of people fall into one category over the others? Do you think saintly people can be "made," or are they born that way? What about scoundrels?

B Rabbi Jose argues that Torah was given to Moses and his descendants only. He makes his case by appealing to grammar.

> **Rabbi Jose son of Rabbi Hanina said: "The Torah was given only to Moses and his seed, for it is written, *you* [Moses] carve two tablets and I [God] will inscribe them (Exodus 34:1). Just as the tablets are yours, so is the writing yours. But Moses in his generosity gave [the Torah] to Israel, and concerning him it is said, 'The generous person is blessed'"** (Proverbs 22:9). (*Nedarim* 38a)

➤ Why is Moses considered particularly generous? How would the world be different had Moses not been so generous? To what extent can one act of generosity make a difference? Can you think of any other act of generosity that may have changed the course of history? What about one act of generosity that changed something significant within your own community?

C The following is simply a record of gift giving. The exchange of gifts may have been for political reasons, out of friendship, or simply because the givers were generous people.

> **Any king who had no regent in *Eretz Yisrael* would regard his sovereignty as of no value. The regent of the king of Babylon had his seat in Jericho, and the former would send dates to the latter, while the latter would reciprocate with gifts.** (*Genesis Rabbah* 85:14)

➤ For what reasons do our heads of state, our political figures, exchange gifts? Perhaps gift giving has benefits that go beyond the gifts themselves, enhancing a general sense of goodwill. What gifts, exchanged between nations, promote such goodwill, even peace?

Tefilah

A The *"Ahavah Rabbah"* prayer lists the following requests of God. Having any or all of these requests fulfilled could be considered a divine gift.

> *Rachaym alaynu ve'tayn b'libaynu lehavin, u'lehaskil, lishmoa, lilmod, u'le-lamayd, lishmor, ve'la-asot, u'lekayaym et kol divray talmud toratecha, be'ahavah.* **(To understand, to have insight, to hear, to learn, to teach, to observe, and to have the ability to do and to fulfill the teachings God revealed to us in love.)**

➤ Would you agree or disagree that it is gift giving when God fulfills the requests listed? What other gifts has God given us? Can we learn abundant love from God's example? If we learn abundant love, how might it affect our generosity toward others?

B We thank God for the gift of knowledge in our daily recitations of the *"Amidah."* The word used for "giving" is *"chonen,"* which signifies a gracious granting of something.

> **You graciously have granted mortals intelligence, teaching wisdom and understanding. Grant us knowledge, discernment, and wisdom. Praised are You, Eternal One, who graciously grants intelligence.**

➤ Is the gift of knowledge something we need to thank God for every day (in fact, three times a day according to tradition)? Are there other gifts for which we should give thanks so frequently? If you made a sincere effort to spend a few moments three times a day being thankful to God for the gift of knowledge and intelligence, how might that affect you?

Post-Rabbinic

AAccording to one Hasidic Rabbi, cultivating generosity is something you have to work on. The best way to work on it is to do so gradually.

> The Holy Jew [Rabbi Yaakov Yitzhak of Pshischa] said that people should train themselves to be good-hearted and giving. Start with something small. For example, accustom yourself to giving others a little of your snuff tobacco. Then do a little more, like letting them enjoy the use of your pipe, and so on by degrees, until gradually you are in the habit of being generous." (*Niflaot ha-Yehudi*, p. 58, as quoted by Yitzchak Buxbaum, *Jewish Spiritual Practices*, p. 461)

➤ Do you agree that becoming a generous person is something you have to train yourself to do? Is a gradual training process the best way? How so or how not? To follow Rabbi Yaakov Yitzhak's advice to start gradually, what next step should you take in becoming a more generous person?

ACTIVITIES

Language Arts

 1(15 minutes) You can expand thinking about the definition of *Nedivut* by imagining how different people would define it. A scholar once taught that we should give presents to the poor according to our ability and, from time to time, send presents to the wealthy also.

Make two lists of desired presents, from the perspective of various recipients, such as a parent, sibling, friend, co-worker. One list of ten or so things should be material objects that the person would like to receive. The other list should be non-material gifts. Also make two lists of presents you desire.

Discuss. What differences are there in the lists? Is one list *better*? To develop the *Middah* of generosity, how important is it to take into account giving from both kinds of lists? Explain. (For an extension of this exercise, see Drama #1.)

 2(15 minutes) In Text Study, Tanach #F, gifts are said to ease a person's way. In what ways has this been the case in your experience? What do the high points of gift giving in your life teach you about the significance of *Nedivut*?

Write for at least five minutes, beginning with the sentence, "The best gift I ever gave was . . ." Try to put in as much detail as possible, describing the gift and describing the responses to the gift. Repeat, beginning with the sentence, "The best gift I ever received was . . ." An alternative is to discuss these gifts.

What made the gifts the "best"? Which did you enjoy more, reflecting upon the best gift given, or about the best gift received? Any reason why? Is there something you can learn about generosity by reflecting on these high points in gift giving and receiving?

 3(10-30 minutes) Study Text Study, Tanach #B, concerning Jacob about to see his estranged brother Esau, and Text Study, Tanach #C, about Joseph reuniting with his brothers. Pay careful attention to the role of gifts.

Now reflect on your own situation. What gifts would you bring your sibling if you had become estranged from him/her? Develop this exercise into a whole story orally or in writing. Include details about how the siblings became estranged, the circumstances that led to them meeting again, and, of course, the role of gifts in easing the reconciliation. Illustrate if you wish.

In a group, share the stories. Some more advanced questions: Does giving gifts, in the situation of estranged siblings, "ease a person's way" (see Text Study, Tanach #F)? Or, is gift giving in this kind of situation more like making a sacrifice (see Text Study, Tanach #E)? Explain.

 4 (10 minutes) According to the "*Ahavah Rabbah*" prayer, God has loved us with an abundant love. (See Text Study, Tefilah #A.) Following the "*Ahavah Rabbah*," we say the "*V'Ahavta*," the first words of which are an expression of our love for God. Elaborate on what God wants from us besides the "gift" of our love. What is this love like? How is our love actualized? Are there other things we can do, ways we should act, that could be considered gifts to God?

Go around the room and have everyone mention something that could be on an imaginary gift list from the perspective of God. What gifts would God want from human beings in general? from you? (An alternative is for each person to write down such a list.) For an extension of this exercise, see Drama #5.

 5 (10 minutes) What do you consider to be gifts from God? What would the world be like without these gifts? In this exercise, use your imagination to explore what it would mean to do without some of the gifts you take for granted. By doing so, perhaps your appreciation of the presence (presents!) of those gifts will increase.

Improvise a speech beginning with the words, "If God hadn't given us (me) the gift of . . . " (Alternatively, starting with the sentence above, write for several minutes, jotting down whatever comes to mind.) After everyone finishes recounting God's gifts, bring in copies of the Pesach song "*Dayenu*," a recounting of a myriad of gifts from God.

Ask everyone to choose one favorite line from what they said (or wrote). Then talk about the nature of gifts from God — what exactly is "necessary"? What would life be like if it were devoid of gifts from God?

 6 (10 minutes) In biblical times, people offered *korbanot* (sacrifices) to God. The Hebrew root of that word is *k-r-v*, which means "to bring near." What do we/you do today in order to feel nearer to God?

Write freely beginning with the phrase, "I feel close to God when . . . " In what you wrote, do you see a connection in general between gift giving and feeling close? How about in connection with God?

 7 (20 minutes) Refer to the texts listed under Tanach #A through #D. Do these instances of gift giving equally reflect generosity? How do gifts given out of fear or with expectation of something in return compare with gifts from those whose "hearts so move them"? How are *Nedivut* and *Tzedakah* the same? How different? Compare also *Nedivut* and social action/activism.

 8 (20-30 minutes) *Pirke Avot* gives us four short sketches of givers — more and less admirable (see Text Study, Rabbinic #A).

As individuals or in pairs, come up with descriptions of people who are givers. Try to come up with four "portraits" altogether. Organize these portraits by describing for each:

a. Things they give (time, money, smiles)

b. How they give (thoughtfully, carefully, joyfully, manipulatively)

c. To whom they give (friends, strangers, all living creatures, a great pool of ideas)

How much diversity is there among people you would consider to be generous? What limits

are there in defining *Nedivut*? (Does generosity toward animals count as part of the definition? What about giving out hugs and kisses "generously"? Is smiling a lot considered a generous activity? Etc.)

 9 (15 minutes or more) This exercise is similar to Miscellaneous #2. Create poems of abundance. Come up with images, descriptions that could complete the phrase, "Abundance is . . ." Shape these images into a poem.

 10 (10 minutes minimum) Besides giving gifts, we can learn generosity by thinking about those gifts we have received. Spiritual guidance can be such a gift. It can nourish us emotionally, socially, intellectually, and in our relationship with God. Discuss as a group or write individually on the following: What spiritual "character" or teacher has given the most to you? Why? How?

Visual Art

 1 (15-30 minutes) This activity is especially appropriate for Chanukah or another gift giving celebration.

Generosity, to some extent, is about packaging, about attitude. *How* you carry out an act matters, as in the expression, "It's the thought that counts." If there is significance in the packaging, then why not create some packaging that communicates the value of *Nedivut*?

Create wrapping paper using butcher paper or paper bags cut open and turned inside out. Then decorate the paper, using themes and ideas from Text Study. Use writing, drawing, painting, stamping, sponge or potato prints, or other medium. Here are a few specific ideas:

a. On the paper, write phrases from various texts that strike you as meaningful.

b. Make hand prints (suggestive of "the outstretched arm").

c. Use a repeating theme of bread loaves on water (from Ecclesiastes).

d. Decorate with drawings of jewels; bits of gold, silver, and copper; and strings of blue, purple, and crimson yarn. Or, glue collage materials suggestive of those items on the paper. (This design represents items brought for the building of the *Mishkan*.)

e. Make a repeating pattern of tablets (representing the gift of Torah).

Wrap a gift in this special handmade paper. Then give the gift away.

 2 (30-45 minutes) How does generosity "look"? Could we capture on paper the energy, the momentum, the impulse to be generous?

The "flow" of generosity, you might say, begins in the heart and moves to the arms and hands. Ask everyone to show what that "flow" looks like. Have them try making some generous gestures with their hands and arms. Now have them imagine they are holding long paintbrushes in their hands, almost like extensions of their arms. Make the generous gestures again. And then, imagine there is paint on the brushes and the floor is the recipient of the generosity. Imagine splattering paint generously all over the floor. Practice splattering the imaginary paint in a more controlled (but still generous) way, too, as if aiming it at one particular canvas on the floor.

Now actually do the above! This is a potentially messy project, so cover the painting space with lots of newspaper. You will need large paintbrushes and plenty of paint. Tape sections of butcher paper to the (newspaper covered) floor. Use splattering, generous dripping, large paintbrush strokes to fill the canvas with paint. The leader needs to think through the logistics ahead of time — where the painting will take place, how

many painters can paint at a time, if you need an extra helper (parent or teenager) to supervise the project, what those who are not painting will be doing while waiting for their turn, etc.

When all the paintings have dried, set them out where the whole group can look at them. What do you like about the paintings? In what ways do they give a feeling of generosity? Group members imagine their work as a "prop." They refer to it while explaining generosity.

 3 (short amounts of time at home over the course of a few days; plus 15-30 minutes to complete the project) Messages about generosity in the media can teach us something about pursuing ethical growth, about cultivating *Nedivut*.

For about a week, cut out any article, picture, or headline from the newspapers that strikes you as good news. Assemble some of the texts, and add any drawings or words to create a collage to be used for an artistic promotional poster for *Nedivut*.

How did you choose which newspaper clippings to include? In what ways does the secular world have something worthwhile to teach us about *Nedivut*?

 4 (10-15 minutes minimum) Explore the image of the outstretched arm as a symbol of generosity (see Text Study, Tanach #H).

Draw or paint generosity, using the image of an outstretched arm. You can interpret this assignment in a variety of ways:

a. Make a person with an outstretched arm(s).

b. Make one large outstretched arm.

c. Make several outstretched arms in a collage-style in different sizes and colors, crossing over each other, stretching in different directions, etc.

d. Focus more on the idea of outstretched and make abstract images that give a "feel" of outstretching.

e. Other ideas?

What are the different interpretations of the assignment? How did you decide what to paint/draw? What makes the image of an outstretched arm a powerful reminder of *Nedivut*?

 5 (time at home; plus 30 minutes) Create a basket or bouquet of abundance as in Miscellaneous #2 below. After some sharing, give everyone a piece of butcher paper that is a bit longer than their height. Also give out drawing or painting supplies. Divide into pairs and draw the outline of each other's body on the paper. Working individually, create a portrait of yourself as the physical embodiment of abundance, filling in your body outline with the colors, textures, and visual rhythms suggested by the items in your basket/bouquet of abundance.

 6 (15-20 minutes minimum) Choose something that you would consider to be a gift from God — food, a park, the ocean, animals, etc. Think of some of the elements or components central to that something's existence or appeal. For food, you might say moisture, color, taste, and smell. For the ocean, you might say swirly lines, sand, the color blue. Create a title for your art work, using words of appreciation for one of its elements (one that you can capture visually) — "Thank God for the Gift of Colorful Foods" or "Thank God for the Gift of Ocean Swirls."

Now, paint (or draw) two versions of the same thing. For the first example mentioned above, you might paint a colorful basket or banquet table of foods on one half of the paper. Continue by painting the same thing, devoid of color, on the other half of the page. For the second example, you might paint a version of the ocean emphasizing the swirly lines, then juxtapose a version devoid of pattern, ripple, waves.

In a group, explain your paintings to each other. How did you fulfill the assignment? Why are you so grateful for the gift depicted in your painting? Are gifts really "extras" or are they as necessary as anything else? Explain.

Drama

 1 (10-15 minutes) First, complete the writing exercise in Language Arts #1 by making lists of gifts. Then, for each gift recipient, check off which is the most desirable of the ten things on each of the two lists.

Now have two people improvise a scene. One person is the recipient, the other the gift giver. The two should stand on opposite sides of the room. The giver should use all of his/her senses to capture the essence of the gift (what it looks, sounds, smells, tastes, feels like), and bring it slowly and thoughtfully to the recipient. The recipient improvises receiving the gift. The giver should repeat the gift giving with the non-material item as well. If desired, the giver can be instructed not to reveal orally what the item is. The audience can then guess what was brought.

Discuss the differences in acting out the giving of material versus non-material gifts. How did the giver feel about giving each type? How did the recipient feel about receiving each type? In what ways does this exercise help you to see the giving of gifts in a different way?

 2 (10 minutes) *Tzedakah* is something we are to do, regardless of how we *feel* about it. In contrast, *Nedivut* is more of a trait, something desirable, but not commanded. People might be more generous if given reasons to be so.

In pairs improvise this scene: One person tries to convince the other to participate in the giving of Purim gifts, *Mishloach Manot*, stating reasons why this is a good practice. The other person at first resists, then finally agrees. Reverse roles. If you like, some pairs can perform in front of the rest of the group.

What reasoning was used to make the case for the value of giving gifts? Which reasons were most effective? Why? How did the person listening to the reasoning feel about the techniques used to persuade him/her?

In *Pirke Avot*, those who want to give and want others to give are called saintly people (see Text Study, Rabbinic #A). How might you "spread the message" of generosity?

3 (10-15 minutes) Refer to the previous exercise. This time, however, the pairs come up with their own scenario. Experiment with scenes reflecting more intangible gifts, such as:

a. One friend tries to convince the other to offer to baby-sit the children of a mutual friend who is a single parent. The single parent just lost her job and needs someone to watch her children while she's out interviewing.

b. A parent tries to convince a son to show extra kindness toward his brother on the playground because the brother has been experiencing some unpleasant teasing during recess.

c. Other possibilities?

Continue with discussion as outlined in Drama #2.

4 (5-10 minutes) Sometimes it's not what we do, but how we do it that makes an act "feel" generous. If the content is generous, but the "delivery" is not, what is said (or done) hardly counts as being generous at all.

Experiment with tone of voice and intent. Use the same phrase to reflect a generous self and an ungenerous self. Try to come up with four or so distinct versions of each phrase (emphasizing different words will give different nuances).

The group can decide which version is most generous and explain why. Some phrases to try are: May I help you? Do you need anything? Life's been hard on you lately. I've come to be with you.

This exercise can be taken one step further by having a second person improvise a phrase or two in response to the various versions of the initial phrase. Evaluate how a person's tone and intent can shape another's response. Are there ways you can "sound" more generous? How does your voice give clues to your intentions? In terms of being generous, are what you say and how you say it equally important? Similarly, are what you do and how you do it equally important?

 5 (10-15 minutes) Language Arts #4 is a good preparation for this exercise. We say that some of the most amazing gifts we receive from God are a result of God's love. Knowledge, insight, understanding, intelligence — all are wonderful gifts. We could certainly elaborate on this list and add all the things that we have generously received from God (such as our world, the ability to love, physical bodies, breath, etc.). In return, God wants our love — "V'Ahavta." But what else? An improvisation may lead to an insight.

Improvise a dialogue between a modern person and God's imagined voice. The first few lines might sound like this:
Modern Person: So God, care for any new gifts?
God: You might think the thing I'd like most would be world peace. True that would be nice, but what I really would like these days is a little more respect.
Modern Person: People pray to You, don't they? Doesn't that count as respect?
God: No, it's more than that.
Modern Person: So, what is it?
Etc.

In what ways did this exercise add to your ideas of what gifts God would want from us? Were you surprised by anything you or somebody else said? Explain.

Movement

 1 (5 minutes) This short exercise is a good way to introduce the concept of *Nedivut*.

In pairs, "sculpt" one another. One partner takes a "stingy" but malleable shape. The other partner reshapes the stingy pose to a generous one. Switch roles. Repeat a few times. Switch partners.

A variation: Designate a large circle of the space as the place for stinginess. Designate another large circle as the place for generosity. Participants explore both circles — moving back and forth as desired, experimenting with movement that seems appropriate to each.

Some questions: Was it difficult to move between one trait and the other? Did you enjoy doing one kind of pose/movement as opposed to the other? Why do you think that might be? In the "sculpting" exercise, how did you feel about being manipulated by your partner? What can influence changes from stinginess to generosity? How much control do we have over this process?

2 (5-10 minutes) This exercise is a variation on the preceding one. It's also a good jumping-off point for learning about *Nedivut*.

Be stingy in movement. Begin with isolated body parts, barely moving, then gradually becoming more generous in the movement. Try moving more than one body part at a time (leg and head, or fingers and hips) from stingy movement to generous movement. Try moving just the lower body, then just the upper body, etc.

How did it feel to be stingy versus being generous? Was it hard to make the movement toward generosity gradual? Do you think it is a

more natural tendency to move "stingily" or move "generously"? Explain. What about character — do you think it is more natural to be stingy (have a stingy character) or to be generous?

 3 (10-15 minutes) What is the underlying path of generosity? What is its essence? Perhaps abundance exudes from and extends out of one person; then another receives the abundance, gathers it in. As we experience this flow of generosity in the classroom, we become more familiar with the *Middah* and gain confidence to take that trait out into the real world.

In pairs, practice giving and receiving movement in a "call and response" sequence. Persons A and B face each other. Person A does an "opening out" movement toward person B. Person B responds with a "gathering in" movement. B then continues with an "opening out" movement (toward A), and A responds with "gathering in." Go back and forth several times.

This activity also can happen in a circle. A "opens out" to B, B "gathers in," B "opens out" to C, C "gathers in," and so on around the circle.

Once everyone is comfortable with the basics of "opening out" and "gathering in," go one step further. To some upbeat music, improvise a "Gift Dance." Participants spontaneously give and receive, "open out" and "gather in" toward each other as they are inspired. An especially motivated group can perform a dance in this style, either improvised or set, for one of the holidays with a particular gift giving theme (i.e., Purim, Pesach, or Chanukah).

Share reactions to the exercise. Which did you like better, the "opening out" or the "gathering in" movement? With which were you more comfortable? Explain. How will the "practicing" of generosity in the movement exercise give you a boost in your efforts to be a generous person in "real life"?

 4 (5-10 minutes) Perhaps we can learn something about abundance from becoming aware of our breathing.

Bring abundance/generosity toward your self through breath. Breathe with the awareness of expanding, then bring the breath back to self. Imagine breath as energizing, healing, nourishing. Add the arms, allowing them to "breathe," too. Experiment with adding other body parts as well.

If you feel you have a source of abundance within yourself, are you more likely to act generously? How did this exercise make you more aware of a source of abundance within yourself? How might a few moments spent doing this breathing exercise, on a regular basis, enhance your efforts to become a more generous person?

An extension: Experiment with allowing the breath, the awareness of its constancy and abundance, to be the motivation for freely improvised movement. Also, see the following activity.

 5 (10 minutes) The previous exercise is a good warm-up for this one. It is assumed that a feeling of abundance gives a sense of resourcefulness on which to build the trait of *Nedivut*. One of our most abundant resources is air or space.

Improvise gathering to yourself the most air/space you possibly can. Then, once you are completely "sated," imagine that abundance flowing, exploding, billowing from you. If desired, use appropriate music for accompaniment.

Once you discover a sense of abundance within yourself, you are ready to go further. Return to identifying that source of abundance within yourself. Start small, then allow this source to expand, to move beyond the immediate space around you, eventually to touch/reach others. Improvise freely for a few minutes. Then, when you are ready to stop, just remain still while the others complete their movement explorations and come to a rest.

Share reactions. Did any moment stand out? In what ways did the image of air/space as a source of abundance work for you? How was moving by yourself different from moving when you were allowed to interact with others? Do you feel more connected with your own resources of abundance as a result of completing this exercise? What specifically do you feel you possess in abundance? What is the most natural way for you to be generous? On what do you need to work to become more generous?

 6 (15-20 minutes) Refer to the *"Ahavah Rabbah"* and *"V'Ahavta"* prayers in the prayer book. Out of God's abundant love, we receive Torah. In return, we are to give love. In maintaining this special relationship, we are privileged to experience Torah's treasures — insight, discernment, knowledge.

Explore abundance in God's creation, in nature. What might you find in abundance — grass, clouds, sand, waves, mountain peaks, water, snow. Come up with a rhythm that captures the essence of one of those things; clap it out, then add movement in the same rhythm. You should be able to repeat the rhythmic pattern over and over, maintaining it in a "state of constancy."

In pairs, one partner tells the other what the abundant object is and begins moving in the rhythm of that object. The second person improvises verbally, sharing insights and knowledge (*"l'havin u'lhaskil . . . "*) that he/she has about the named object. For example, one person improvises in the imagined rhythm of grass, while the other improvises accompanying words (slowly and with pauses), such as:
Grass is green,
Stretches across the land.
Needs water and sunshine.
Don't trample too often over its velvet surface.
Cows grow fat because of it.

Children run happily because of it. Tombstones stand peacefully surrounded by it. It can be everywhere or confined to one small patch . . .

Each person should have the opportunity to be both the performer and the verbal accompanist. Discuss what performers experienced and what observers observed. Did the ideas of abundance and constancy come across in the improvisations? How did these performances reflect *Nedivut*?

 7 (10 minutes) See Music #2 below, in which the rhythm of "abundant love" is explored. Complete that activity through movement.

Music

 1 (10-15 minutes) What does *Nedivut* sound like? The more senses we use to get a handle on the meaning of this *Middah*, the more success we will have in incorporating it into our lives.

Use decrescendo and crescendo as a parallel to stinginess and generosity. Hand out percussion instruments (skilled musicians can play their own instruments). In solos or small groups, improvise a musical sketch of a stingy person who becomes more generous, then returns to stinginess again.

What improvisations are most convincing? What makes the improvisations successful, that is, effective in conveying the "stingy-generous-stingy" scenario?

A variation: Improvise the sound of generosity in its ideal form. One person can start, others can join in one at a time until a symphony of generosity is created.

What was different about the "symphony of generosity" task as compared with the "stingy-generous-stingy" scenario? What sounds do you identify with generosity in the "real world"?

 2 (10 minutes) "With abundant love You have loved us . . . " it says in the "*Ahavah Rabbah*" prayer. From this abundance numerous gifts have flowed. (See the Overview, *Bayn Adam L'Makom*.)

Start with the question: What is the rhythm of abundant love? Each participant figures out an appropriate rhythm and begins clapping, playing an instrument, or moving in their rhythm. Everyone continues to improvise in their made-up rhythm while one person reads or chants the "*Ahavah Rabbah*" prayer in Hebrew and/or English.

Share reactions. How did you come up with your rhythms? What was the effect of playing (or moving in) your rhythms while hearing the words of the "*Ahavah Rabbah*" prayer in the background? In what ways might you "listen" more for the sounds of abundant love in day-to-day life?

Miscellaneous

1 Do something generous, something you've never done before.

 For another person. To get yourself started, make a list of ideas — new ways to show generosity. Choose one or more things from the list, and within the next few days, do them.

 For yourself. List ways you could be nice to yourself, show generosity toward yourself. Choose one or more things from the list, and within the next few days do

them. Could you do ten things from your list? How would you feel if you did?

 For God. What would it mean to do something that shows generosity toward God? Maybe it would mean a concerted effort to be more loving in a particular situation. Or, it might mean being more aware of God's gifts, and giving blessings for those on a regular basis. Maybe it would mean studying something new — using the gift of intelligence and knowledge God has granted us. Whatever it is, try it, do it!

If desired, share with a group the experiences and insights you had in completing the above exercises.

 2 (time at home; plus 10-15 minutes discussion time) You can nurture awareness of abundance — within yourself and within your immediate environment. A sense of abundance can inspire generosity, which is a foundation for building the *Middah* of *Nedivut*.

This exercise requires "homework." Create a basket of "abundance" out of a group of collected items. Don't limit yourself to food, but imagine what kind of collection would "exclaim" abundance (a huge bouquet of flowers, a large basket filled with richly colored fabrics, a box filled with photos and family heirlooms, a mixture of various riches and delicacies and treasures)? On a designated day, everyone brings in their creations and presents them to the rest of the group. Discuss the relationship of discovering a sense of abundance and being a generous person.

CHAPTER THIRTEEN

OHEV ZEH ET ZEH/MECHABAYD ZEH ET ZEH: LOVING AND HONORING ONE ANOTHER

אוֹהֵב זֶה אֶת זֶה / מְכַבֵּד זֶה אֶת זֶה

OVERVIEW

Ohev Zeh et Zeh and *Mechabayd Zeh et Zeh* — we are to love one another and honor one another. Perhaps these above all else are what God wants of us (see Text Study, Rabbinic #A). Intuitively, we know that loving and honoring are integral to what it is to be human. These virtues are also emphasized in our sacred texts.

"*Love* your fellow person as yourself . . . " (see Text Study, Tanach #A). "Let the *honor* of your fellow person be as dear to you as your own . . . " (see Text Study, Rabbinic #C). It is instructive to note that in each of these teachings, *you* are the measure and the standard of love and of honor. You must love and honor the other as much as you do yourself. *Your* experience counts for a great deal in these virtues. You cannot live without love for yourself and honor (respect, a sense of dignity) for yourself. This understanding should give you empathy for, and identification with, the feelings of others. This empathy should in turn prompt you to cultivate *Ahavah* and *Kavod* — love and honor.

Our own experiences are significant, but our obligations to love and honor become much more compelling when we bring God into the picture. "God loves us with an abundant love," we affirm, as an introduction to the "*Shema*" in our daily worship. And shortly thereafter, we recite: "You shall love the Eternal your God" (see Text Study, Tanach #C). There's a mutuality in our relationship with God (sometimes explicit, sometimes implicit) that God loves us and will honor us, as we love and honor God (see Text Study, Tanach #D).

This so-called covenant of love and honor becomes a model for our relationships with other people. Love *one another;* honor *one another.* Showing love and honor begets love and honor; respect begets respect. Everyone benefits from a world being filled with shared expressions of *Ahavah* and *Kavod.*

What does it mean to love and to honor others? What are we supposed to *do*? To whom are we obligated — to everybody? Are there any limits? For answers we turn to two respected sages, Maimonides and Rabbi Abraham Isaac Kook. To Maimonides, "love" may be an abstract concept, but deeds of love are concrete. He explains that the commandment to "love your fellow person as yourself" is the basis for carrying out specific deeds. Such deeds include visiting the sick, comforting mourners, caring for the dead, and so on (see Text Study, Tanach #A). We could add that doing deeds of loving-kindness also honors and affirms the dignity of others.

Rav Kook says that love for others is to be "expressed in practical action, by pursuing the welfare of those we are bidden to love, and to seek their advancement." Who are we "bidden to love"? Created beings, humanity, other Jews. And the highest love is the love of God (see Text Study, Post-Rabbinic #A).

Practical action, carrying out specific deeds of loving-kindness — we can't be doing these acts for all people, all the time. We can't be visiting the sick 24 hours a day. We can't invite in any and every person to be our guest. We can't personally be responsible for preparing each dead body for burial. True, we can try to be active and

to maximize efforts to give love and honor, but there are limits to how much one person can *do*.

There is, however, an open-ended aspect to these virtues. This is the love and honor in our hearts — the feeling of *Ahavah* and *Kavod*. In Leviticus, before we are instructed to love (interpreted by Maimonides as meaning to *do* loving deeds), we are told not to have hatred in our hearts (Leviticus 19:17). *Having* hatred in our hearts is like *feeling* hatred in our hearts. Push away feelings of hatred — it leads to destruction. Groundless hatred (*sinat chinam*) is the reason given for the fall of the Second Temple. It is more serious than even the worst of sins — idolatry, harlotry, and murder. Removing our inner hatred toward anyone takes a continual effort. There aren't practical limits to removing hatred. We can't say we don't have enough time to remove hatred, or that we only have enough energy to remove heartfelt hatred for some people, not all people. "The heart must be filled with love *for all*," says Rav Kook. When it comes to "the heart," who we love and when we love should not be restricted.

There's another important point about heartfelt loving and honoring. Part of having a loving heart is appreciating the preciousness of all creatures. In addition, valuing each creature's uniqueness shows honor.

Give love, give honor — to give so much is a lot to ask. Further, there is the effort required to *feel* in our hearts love and honor for all! Can we expect anything in return? Certainly, in relationship to God, reciprocity is assured. In our worship service, the *Ahavah Rabbah* (God loving us) is followed by the *V'Ahavta* (us loving God). We can find that kind of reciprocity in terms of honor as well. As we honor God, we can expect to receive honor. Rav Kook says that love of God "spells humankind's greatest happiness" (see Text Study, Post-Rabbinic #A). So, happiness is a by-product of loving and honoring God.

But, concerning people, can we expect anything in return for loving and honoring them? It may be nice to receive positive "returns" for our efforts, but such an expectation can't be the *reason* for loving and honoring. A loving parent doesn't say to a child, "I'll love you only if you promise to love me when I am old." A respectful student doesn't say to a teacher, "I'll give you the honor you deserve, but you must vow always to speak honorably about my work, and to treat me respectfully in front of my peers." Attaching such conditions misses the point. To fill the world with love and honor means persisting in our efforts. We are to do so regardless of reciprocity.

Perhaps there are no measurable gains for the love and honor we give. Still, there are general rewards. For one thing, in embracing *Ahavah* and *Kavod*, we can be assured that we are on a path of righteousness. Loving and honoring can be said to be what God requires of us above and beyond all else. For another thing, while we can't *expect*, when we give love and honor, to receive the exact equivalent in return, we can trust that, in the bigger picture, as we love others, we become more beloved. As we honor others, we become more honorable.

What is the role of love and honor between people, between you and yourself, between you and God? These categories are looked at specifically below.

 BAYN ADAM L'CHAVERO, BETWEEN PEOPLE. *Ohev Zeh et Zeh* means loving one another; *Mechabayd Zeh et Zeh* means honoring one another. In the way they're worded, these virtues clearly point to something that is expected to transpire between people. The virtues are fulfilled by doing deeds of loving-kindness, concerning yourself with the welfare of others, appreciating the uniqueness and precious qualities of others, not hating in your heart, treating all people with dignity.

 BAYN ADAM L'ATZMO, BETWEEN YOU AND YOURSELF. Your own personal experience can give you a sense of the importance of *Ahavah* and *Kavod.* To develop empathy, it helps to identify with the feelings of others (see Text Study, Tanach #A and Rabbinic #C). What you know about yourself should inform you of the significance others would attach to love and honor. In other words, love and honor yourself — thus will you understand the call to love and honor others.

 BAYN ADAM L'MAKOM, BETWEEN YOU AND GOD. God loves you, and you are to love God. You are to honor God, and God will honor you. *Ahavah* and *Kavod* are covenanted. Ideally, this God-human pattern will be applied to our relationships with others.

Another point: loving and honoring shows respect and appreciation for God's creation. To love God is to love God's creatures. To honor God is to honor God's creatures.

TEXT STUDY

Tanach

A The following words are to inspire us (and require us!) to carry out certain *Mitzvot,* especially deeds of loving-kindness.

> Love your fellow person as yourself . . . (Leviticus 19:18)

In his *Mishnah Torah,* Maimonides says that the biblical commandment "love your fellow person as yourself" is the basis for many *Mitzvot* described by the Rabbis. These Rabbinic laws include visiting the sick, comforting mourners, caring for the dead, providing a dowry for the bride, escorting guests, performing burial rites, rejoicing with bride and groom and helping support them with necessary provisions (*Hilchot Avel* 4:1).

The verse which precedes Leviticus 19:18 also includes an important point related to love.

> **Do not hate your fellow person in your heart . . . (Leviticus 19:17)**

A Rabbinic comment on this verse:

> **You might think this means, "I must not strike or beat or curse the person." Therefore it says "in your heart" to urge you not to have hatred in your heart. (*Arachin* 16b)**

➤ Why does Leviticus 19:18 say to "love your fellow person as yourself"? What does yourself have to do with loving others? Maimonides attaches all kinds of laws to this statement. How can he justify doing so? "Love your neighbor as yourself" is a positive commandment — do love! "Do not hate your fellow person in your heart" is a negative commandment — do not hate! Efforts to love should go all the way from not hating in your heart to actively loving others. What do you think?

B God and creation are intimately tied together. To love God fully, we must strive to love God's creation, God's creatures. Here is the commandment.

> **Love the Eternal your God with all your heart, with all your soul, and with all your might. (Deuteronomy 6:6)**

➤ Do you agree that to love God we must love God's creatures? The verse continues by saying we should teach these words to our children, that we should speak of these words as often as we can. Is it love (more than anything else) that we should teach? Is it love (more than anything else)

that we should "speak about"? Explain. It is noteworthy that we are commanded in the Torah to honor parents, but not commanded to love them. Why do you think this is?

C Ideally, love involves giving and receiving. God loves us; we are to love God. Reciprocity is the ideal in human relationships, too. The experience of mutual love is perhaps the peak experience in *Ohev Zeh et Zeh.*

I am my beloved's, and my beloved is mine. (Song of Songs 6:3)

➤ Which is the highest level of love — loving others freely and unconditionally without expectation of receiving love in return, or being involved in a relationship of mutual love? Explain.

D Ben Zoma asks (*Pirke Avot* 4:1), "Who is honored?" He answers his own question — "Those who honor their fellow person." He bases his teaching on a passage from the Tanach. The verse implies that we can learn about honoring others by understanding what God expects of us.

Those who honor Me, I will honor, but those who scorn Me will be despised. (I Samuel 2:30)

➤ Is Ben Zoma's interpretation of the verse from Samuel reasonable? That is, do you agree that if you honor others, you are more likely to experience honor in return? Explain. Should you honor others only if you receive honor from them? Why or why not? Does mastering the virtue of *Mechabayd Zeh et Zeh* mean you always have to be willing to "go first" in giving honor?

E Even for an enemy, you are to find some residue within yourself of love and respect. You are not to ridicule enemies, nor rejoice over their suffering. True, you may not personally feel affection for someone, but that is irrelevant in terms of *Ohev Zeh et Zeh* and *Mechabayd Zeh et Zeh.* Each person deserves to be treated with dignity.

When your enemy falls, do not rejoice. (Proverbs 24:17)

➤ Why is there a need for this statement from Proverbs? Do people tend to rejoice when enemies fall? How do you usually react when someone you dislike runs into trouble? How might you work to change such reactions?

Rabbinic

A Where do these terms *Ohev Zeh et Zeh* (loving one another) and *Mechabayd Zeh et Zeh* (honoring one another) come from? The following passage claims loving and honoring others to be the most important virtues. Another virtue is mentioned as well — *Yirah.* (See Chapter 23 in this book.)

This is what the Holy One said to Israel: My children, what do I seek from you? I seek no more than that you love one another and honor one another; and that you have *Yirah* (awe and reverence) for one another. (*Tanna de Bei Eliyahu Rabbah* 26:6)

A Prophetic verse is structured in a similar way:

God has told you, O people, what is good, and what the Eternal requires of you: Only to do justice, and to love goodness, and to walk humbly with your God. (Micah 6:8)

➤ If you were to sum up what you believe God wants from us, which text would you use — the Rabbinic one, from *Tanna de Bei Eliyahu,* or the

biblical one, from Micah? Why? The section from *Tanna de Bei Eliyahu* continues by referring to Micah's words, as if the Rabbinic text is an explanation of the biblical one, as if the two texts are saying the same thing. The suggestion is that both texts describe what it means "to walk humbly with your God." Or, as *Tanna de Bei Eliyahu* words it, "be humble and your God will walk with you." Perhaps the virtue of *Anavah* (humility) supersedes all other virtues — even loving, honoring, and revering others, even doing justice and loving goodness. State and defend your opinion.

B The Rabbinic sage Hillel looks to Aaron as an exemplar of many good traits. One of those is loving one's fellow creatures (*Ohev et HaBriyot*).

> **Hillel taught: Be a disciple of Aaron: loving peace and pursuing peace, loving your fellow creatures, and attracting them to the study of Torah. (*Pirke Avot* 1:12)**

➤ Is there a connection between loving your fellow creatures, and loving and pursuing peace? between loving your fellow creatures and attracting them to the study of Torah?

C One of the ways we can identify with a *Middah* is by looking at its effect upon our own selves. If we know how we feel about a *Middah*, we will better understand why it may be important to others. "Love your fellow person as *yourself*" is one example. It suggests that our own experiences of love and honor should teach us how we should behave toward others. Examining our own experience can make us more aware and sensitive. Other people should be no less deserving of virtuous attitudes than we expect and desire for ourselves.

> **Rabbi Eliezer said: "Let the honor of your fellow person be as dear to you as your own . . . " (*Pirke Avot* 2:15)**

Another text directly applies this idea to the realm of study. It expands on the requirements for giving honor.

> **Rabbi Elazar ben Shamua taught: The dignity of your student should be as precious to you as your own. The dignity of your colleague should be as precious to you as your reverence for your teacher. The reverence for your teacher should be as great as your reverence for God. (*Pirke Avot* 4:15)**

➤ Do you agree with Rabbi Eliezer's statement? Why does Rabbi Elazar ben Shamua go to such extremes when speaking about honoring others within a learning environment? In what ways is honoring others a value upheld within the places in which you study (classrooms or elsewhere)?

D Loving others is essential for the health of a community.

> **People must love their fellow creatures, and not hate them. The people of the generation which was dispersed over the earth (the tower of Babel generation, Genesis 11:1-9) loved one another, and so God did not destroy them, but only scattered them. But the people of Sodom hated one another, and so God destroyed them from this world and from the World to Come. (*Avot de Rabbi Natan* 12, 26b)**

➤ What is the difference between the tower of Babel generation and the people of Sodom,

according to this passage? Why was one community destroyed and not the other?

E All kinds of evil sins are committed by members of a community. Such sins can severely damage a community. But groundless hatred (*sinat chinam*) is on a par with the worst sins.

> The first Temple was destroyed because of the sins of idolatry, harlotry, and murder. The second — in spite of Torah studies, *Mitzvot*, and deeds of love executed during its existence — fell because of groundless hatred. This teaches us that groundless hatred is a sin that weighs as heavily as idolatry, harlotry, and murder. (*Yoma* 9b) Rabbi Yochanan ben Torta said: "The destruction of the Second Temple came about because people loved money and hated one another." (*Tosefta, Menachot* 13:22)

➤ Studying Torah, following commandments, and carrying out deeds of loving-kindness are not enough. People have to love one another in order for a community to be healthy and strong. Do you agree? Groundless hatred is obviously not love. Is it also "not honor" — is it disrespectful to hate? Explain. How might loving money more than people lead to violations of people's dignity?

F An aspect of fulfilling *Ohev Zeh et Zeh* and *Mechabayd Zeh et Zeh* means recognizing the fact that every person is unique. We are to accept, honor, and be sensitive to the special characteristics of each individual. According to tradition, this is something Moses tried to do. We, in our own day, should strive to do so as well.

> If you see a great crowd of people, say: "Blessed are You, O Eternal our God, Ruler of the universe, who knows people's innermost secrets." For, as their faces are not like each other, so are their temperaments not like each other, every individual having a temperament of his/her own. So when Moses was about to die, he called out to the Holy One: "Sovereign of the universe! The mind of every individual is revealed and known to You. The temperaments of Your children are unlike one another. Now that I am taking leave of them [when I die], appoint over them, I pray You, a leader who may bear with each one according to each one's temperament." (*Numbers Rabbah* 21:2)

➤ If you believe a person needs to make some significant changes to improve bad habits, to work on bad behaviors (such as, lying, rudeness, aggressiveness, cheating, stealing, etc), what do you "owe" such a person in terms of love and honor? (Also see Chapter 22, Tochechah: Rebuking.)

G Perhaps we need a *Middah* that tells us to love others because doing so is not always our natural inclination. Studying and thinking about the *Middah* helps make us more aware of its importance. Prayer also can heighten our awareness. We can ask God to help us in distancing ourselves from hatred.

> May it be Your will, O Eternal our God and God of our ancestors, that no hatred against any person come into our hearts, and no hatred against us come into the hearts of any person, and may none be jealous of us, and may we not be jealous of any; and may Your law be our labor all the days of our lives, and may our words be as supplications before You. (Palestinian Talmud, *Brachot* 8:6)

➤ Is this a prayer you would choose to include in your worship services? Why or why not? What about in your own personal prayer? Do you think love is as strong a theme as it should be in Jewish worship? Explain.

Post-Rabbinic

A Rav Abraham Isaac Kook explores the meaning of loving others and the different ways of grouping the people we are to love.

> The heart must be filled with love for all . . . The love of all creation comes first, then comes love for all humankind, and then follows the love for the Jewish people, in which all other loves are included, since it is the destiny of the Jews to serve toward the perfection of all things. All these loves are to be expressed in practical action, by pursuing the welfare of those we are bidden to love, and to seek their advancement. But the highest of all loves is the love of God, which is love in its fullest maturing. This love is not intended for any derivative ends; when it fills the human heart, this itself spells humankind's greatest happiness. (*Abraham Isaac Kook, The Lights of Penitence, The Moral Principles, Lights of Holiness, Essays, Letters, and Poems,* p. 135)

➤ Who are we to love, according to Rav Kook? How should we show our love? Is there anything we can expect in return for the love we give? Can we expect happiness?

B When you honor other human beings, you honor God.

> Be careful of the honor of all human beings and honor them as they should be, with the thought that you are thereby giving honor to God's own Self, Who is Blessed — because they are the work of God's hands and God's creatures. (*Derech Hayim,* 7-7, with translation adapted from *Jewish Spiritual Practices* by Yitzchak Buxbaum, p. 214)

➤ Do you think people deserve honor just because they are part of God's creation? Why or why not? Describe a time when this thought influenced you in a practical sense? That is, a time when you gave respect to someone just because that person was a human being created by God, even though your natural inclination may have been otherwise.

C Any creature deserves honor. Being respectful toward other creatures should be reflected not only in our deeds, but also in our speech.

> Never speak derogatorily of any creature of God, not even a cow or a wild animal or birds. (Derech Hayim, 7-44, Yitzchak Buxbaum in Jewish Spiritual Practices, p. 473)

➤ Why is it important not to *speak* derogatorily about animals even though they can't understand human speech? Is there any part of creation you think people tend to overlook as being worthy of honor? Is there a part of creation toward which you should show more honor?

D Moses recognized and appreciated the uniqueness of each individual, according to a *midrash* (see Rabbinic #F). A Hasidic saying teaches something similar, but more directly and explicitly.

> In every person there is something precious, which is in no one else. And so we should honor each for what is hidden within him/ her, for what only that person has, and none of his/her comrades. (Adapted from Martin Buber, *Ten Rungs: Hasidic Sayings,* p. 80)

➤ Do you believe that each person has something precious and unique hidden within? In what ways do you treat others as if you believe this is so? In what ways do you honor and appreciate what is precious and unique about *you*?!

ACTIVITIES

Language Arts

 1 (10-15 minutes) Maimonides interprets the biblical commandment "Love your fellow person as yourself" (Leviticus 19:18) in terms of specific loving deeds we are supposed to carry out. Review this list of loving deeds (see Text Study, Tanach #A). Then make your own list of deeds you think people are meant to do because of the biblical injunction to love your fellow person as yourself.

Discuss. How do the deeds you chose reflect loving others? In what ways does carrying out deeds of loving-kindness show honor (or respect, dignity) toward others, as well? Do you think Maimonides is right to interpret "Love your fellow person as yourself" as he does? Explain. Is there an interpretation you prefer?

 2 (10 minutes) There are Jewish schools that choose not to celebrate Valentine's Day, a secular holiday with Christian roots. One Jewish preschool explains to families that, "We celebrate love every day."

Does your school celebrate love every day? Discuss ways in which love is part of your school, community, or culture. Is love "celebrated" as much as it should be? could be? Explain. How might love be increased?

 3 (10 minutes) Review Text Study, Tanach #A and Rabbinic #C. Is it from your own experience that you will

grasp the significance of what it means to love and honor others?

Make two lists, one entitled "Loving Myself," the other entitled "Honoring Myself." Now write underneath each heading short descriptions of how you show yourself love and honor.

Share parts of what you wrote in a group. What did you learn overall from this exercise? Was it difficult to create the lists? Did anything surprising emerge as you did the exercise? Why do you think it's so important to love and honor yourself?

 4 (10 minutes) A variation on the above. Make two lists: "Loving God" and "Honoring God." Continue as described in the previous exercise.

 5 (10 minutes) A Hasidic source teaches that we must never speak derogatorily of any creature of God (see Text Study, Post-Rabbinic #C). Turn that comment into the positive, i.e., speak *positively* of every creature of God, whether cow, wild animal, or bird.

Make a list of creatures. Then go back and add a positive comment about each. Some examples: Cows . . . give such sweet milk. Wild bighorn sheep . . . have good balance, knowing how to live on steep cliffs of mountain slopes. Birds . . . have an amazing sense of direction.

Discuss. Why is it a good idea to reflect now and then on the positive qualities of all kinds of creatures? What effect does thinking about the good in others have on *you*? How can you make thinking and speaking lovingly and honorably about all creatures more of a regular practice for yourself?

 6 (10 minutes) This exercise is similar to the above. But instead of focusing on animal creatures, it focuses on people.

Write down the names of five to ten people in your life. Then, for each one, write something loving and honoring you could say to that person. Talk with the group about what you learned from the writing exercise, sharing bits of what you wrote as appropriate. As "homework," try practicing the loving, honoring things you wrote. Report back to the group about this experience, too.

 7 (10 minutes) Ridding ourselves of hatred is not always easy. To find support in our efforts we may look to God. A sample of a prayer asking God to remove hatred from us is included in Text Study, Rabbinic #G.

Write your own prayer asking God to remove hatred from your heart. Add anything else you think naturally follows from that. Share your prayers with a group. If desired, include them in a worship setting, too.

 8 (Variable amounts of time) In every crowd of people, each person is unique. Each has his/her own story, secrets, heartaches, successes, personality traits and temperament, etc. (See Text Study, Rabbinic #F and Post-Rabbinic #D.)

With a notebook, go out to a crowded place — a baseball park, a carnival or amusement park, a large and busy restaurant, a school playground at recess, etc. Use your imagination to describe the unique characteristics of several different people you observe. Make up stories about them, filling in details about their lives and personalities, even revealing their innermost "secrets." Imagine what is most precious about each person.

Share these written portraits with a group. Did you enjoy doing them? How did you come up with the imagined details of the people's lives? In what ways did the exercise make you appreciate more the uniqueness of each person? What unique qualities would you highlight if you wrote about yourself in the crowd?

 9 (15 minutes) There is a tradition that the Second Temple fell because of groundless hatred (*sinat chinam*). (See Text Study, Rabbinic #E.) Rabbi Eleazar gives an example of hatred during First Temple times: people who eat and drink together and then thrust each other through with daggers (*Yoma* 9b).

Hold a discussion or have participants write short essays on the specific things that might be happening in a society in which groundless hatred exists and grows. How could such things lead to the society destroying itself? Include in your examples hateful things you have witnessed or heard about, plus things you can imagine. Then begin to explore these important questions: Where does hatred come from? What can be done to prevent it? What can be done about hatred once it already exists?

Visual Arts

 1 (15 minutes or more) Discuss the assertion by Maimonides (in Text Study, Tanach #A) that loving your fellow person as yourself means carrying out deeds of loving-kindness. Then draw a picture of someone doing a deed you think reflects loving others — picking up groceries for someone who is sick, giving your parents a vase of flowers, baking extra *challah* to share with new Jewish neighbors, etc. Share your drawings with a group, describing the deed you chose to depict and why you chose it.

2 (15 minutes or more) In a large crowd, each person is unique and has his/her own particular temperament (see Text Study, Rabbinic #F).

Draw a large crowd of people. Make each face unique — as distinguished as possible from any other face. There can be differences in color of hair, eyes, and skin; facial expressions; head shape; texture and length of hair; and so on. These dif-

ferent faces reflect the fact that various people's "outsides" are as unique as their "insides."

Share your drawings with a small group. What did you do to distinguish one face from another? As you were doing so, did you think of how the person would be unique on the inside as well? In what ways are people as different on the "inside" as they are on the "outside"? Does each person deserve respect just because he or she is a unique individual? Explain.

 3 (10 minutes or more) Love is often communicated through letters. A common way of ending a letter is "Love, So-and-So." The "Love" stamp is one of the most popular issued by the U.S. Postal Service. Loving one another — by mail or otherwise — is an esteemed value. Do one or both of the following:

a. Design your own *"Ahavah"* postal stamp. It will need to be a simple design that says a lot in a tiny space. See if you can come up with an inspiring idea that keeps in mind what Judaism says about *Ohev Zeh et Zeh*, loving one another. Reduce larger pen and ink drawings to the appropriate size using a photocopy machine. If desired, make rows of stamps that can be cut apart and glued on the backs of envelopes of actual letters.

b. Some people make X's and O's to denote "kisses and hugs." Others draw a tiny heart or two. Design your own unique symbol of love for the end of a letter.

4 We are enjoined to love others as ourselves (see Text Study, Tanach #A). The American Jewish Committee distributes an anti-hate button. It is a simple white button with a red rim. The word "Hate" in black is crossed through with a red line. Design your own anti-hate button. Make it out of cardboard and decorate it with felt, sequins, etc. (or use an actual button-making machine). Wear your

button for a few days, then write up the reactions of people.

 5 (15 minutes or more; plus time to collect materials) When you think of love, what images come to mind? What images do you associate with honor?

Create two collages, using one large piece of paper or board as the "canvas" for both of them. The topic for the whole work is "Loving and Honoring One Another." But one collage will be dedicated to love, and the other to honor. Collect things that you associate with each. Then assemble the items, collage-style, on each half of your paper or board. For love, you might collect lace, satin ribbon, drops of blood (red paint), twigs and grass (that is, fragile materials used to make nests), etc. For honor, you might collect purple velvet, drawings and photographs of open hands, strands of different people's hair (showing uniqueness, bringing to mind individual DNA), sections of honor certificates or awards, etc. You may want to add something that ties the two collages (love and honor) together. For example, around both collages, you might draw or glue on cut-outs of a circle of people holding hands.

In a group share your finished pieces. What do you see in each other's work? What did the artist intend? What were your first impulses concerning materials to choose for the collages? Why those materials? Did the artistic process give you any insights concerning the nature of *Ahavah* and *Kavod*?

 6 (15-20 minutes) It is difficult to feel honor for criminals, yet people who break laws, who hurt others, also deserve to be treated with dignity. How should a prison be designed so that at least minimal parameters of *Mechabayd Zeh et Zeh* are observed? What is the "bottom line" acceptability in terms of honoring others within a prison setting?

On paper, design a prison. Keep in mind the issues raised in the preceding paragraph. How big should the cell be? What should there be in the cell? Are there windows? Is there an outdoor area? A place for physical activity? Areas for study, education, rehabilitation? A health clinic? A place for worship? A communal dining area? Describe the amount of time the prisoner is expected to spend in each space, i.e., give an example of a prisoner's typical daily schedule/routine.

Discuss. How does your prison design show respect for justice (certainly also a Jewish value), plus respect for an individual's dignity? What did you find to be most challenging about this exercise, and why? Are you satisfied with your design, or are there areas you still feel are problematic? Explain. Should there be different kinds of prisons for different kinds of criminals? As an extension to this exercise, invite a law enforcement person and/or a former prisoner to discuss issues related to respect for human dignity within the prison system.

7 (15 minutes or more) You may know people who seem to exude love, *tzadikim* who capture in their very beings the ideal of "let your love shine through." Certain individuals are said to have an aura "shining through" around them. While most of us cannot "see" auras of love, we can perhaps envision such an aura in our mind's eye.

Draw or paint a picture of a person who you believe exudes love, who is an exemplar of a loving person. Then, give substance to the love that surrounds the person. Color that emanation of love. Give it a texture, a quality. Make its essence visible to the naked eye.

Discuss your artwork. Who did you choose for your model of a loving person, and why? How did you show the essence of love which surrounds the person? Did you consider other ideas? What ways stand out most in terms of your sensing another's loving essence? That is, do you sense another's love visually (by looking at the person), aurally (in hearing the person), by feeling something special (physically and/or emotionally)?

Drama

1 (10 minutes) In the Overview the circular nature of loving and honoring is discussed. The more *you* love and honor, the more love and honor is increased in the world. Eventually, love and honor should circle round — back to you!

Play a game in which a gesture travels around a circle. One person "passes" the gesture to the next person until it makes it back to the originator. The gestures that "circle round" should be ones that suggest loving and/or honoring. Here are some suggestions:

a. Hand squeeze: Everyone holds hands and passes a gentle, loving hand squeeze around the circle.

b. Tipping a hat: Use an imaginary or real one.

c. A curtsy

d. A head nod: This can be a lovingly affirming nod or one that expresses honor.

e. A handshake: The initiator can make it extra loving by covering a second hand over the whole handshake.

f. A smile

g. A loving pat on the back

h. A vase of flowers

i. A compliment

j. Your own idea

When you finish passing love and honor around the circle, ask a few questions: Do you believe that if you give love and honor you will receive love and honor in return? When you yourself have experienced love, has that made you want to give love to others? When you have experienced honor, has that made you more likely to honor others?

2 (15 minutes) Maimonides teaches us that loving your fellow person as yourself involves carrying out deeds of loving-kindness (see Text Study, Tanach #A).

Small groups choose one of the *Mitzvot* mentioned by Maimonides: visiting the sick, comforting mourners, caring for the dead, providing a dowry for the bride, escorting guests, performing burial rites, rejoicing with bride and groom, or helping to support a new couple with necessary provisions. If desired, a different deed of loving-kindness can be chosen. Reenact the deed of your choice twice, the first time in a perfunctory, halfhearted, even disrespectful manner, the second time in a way that reflects the virtues of *Ohev Zeh et Zeh* and *Mechabayd Zeh et Zeh* (being loving and honoring as you carry out the act).

Discuss. What differences did performers experience and audience members observe in the two versions of the same scenario? Is it enough just to *do* a deed of kindness in order to fulfill the requirements of the commandment to love your fellow person as yourself? Or, must you also be loving in your *manner*? Consider when you've been the recipient of deeds of kindness. Compare how it feels when someone does something for you lovingly and respectfully, as opposed to out of obligation.

3 (10 minutes) This exercise is similar to Language Arts #5. One teacher tells us not to say anything derogatory about any of God's creatures — not even a cow or wild animals or birds (see Text Study, Post-Rabbinic #C). Put in the positive, perhaps it is worthy to speak favorably concerning all God's creatures.

Half the group plays animals of their own choosing and half play themselves. The object is to meet up with various "animals" as you mill about the room. When you meet a particular animal, act in a loving and honoring manner, perhaps saying a few positive, favorable things

to the creature. After a short interaction, go on to "meet" another one of God's creatures. Do this activity for a few minutes, then switch roles.

Discuss. Do you believe we have an obligation to be loving and honoring to all of God's creatures? Explain your point of view. Is it enough to *refrain* from being derogatory and disrespectful toward God's creatures (i.e., just don't hurt them)? Or, must we make *active* efforts to love and honor them (i.e., actively protect them)? How can you be loving and honoring toward animals? (For example, feed pets before you yourself eat, do what you can to "escort" creatures out of your house rather than swat them, eat a vegetarian diet, contribute to wildlife funds, etc.)

4 (10 minutes) Movement #3 below, which is about a community removing groundless hatred from its midst, is also appropriate as a drama activity.

5 (15 minutes) A couple of the passages in Text Study (see Rabbinic #F and Post-Rabbinic #D) relate to appreciating the uniqueness of others. This is part of loving and honoring.

One half of the group becomes a crowd of unique human beings. The other half will be aliens. The crowd of human beings lies on the floor, as if asleep. They are sleeping so soundly that commotion won't disturb them. The aliens enter. They are encountering human beings for the first time. They walk around the group of sleeping humans, discovering and noting the uniqueness of the individuals they observe. They comment out loud to each other. One of the amazing talents these aliens have is the ability to "see" people on the inside, too. They can discern temperaments, and can detect the most secret and precious parts of every individual. That means that as they observe and comment on the group of sleeping humans, they can note the unique personality traits they discover.

After a few minutes, have the humans beings and aliens switch roles, and repeat the improvisation. Discuss the experience. How did it feel to be an alien? Is there anything you learned as an "alien" that is worth integrating into your real, day-to-day human existence?

 6 (15-30 minutes) A major reason given for the fall of the Second Temple is that people hated each other without reason. One Rabbinic source adds that it came to a point where people loved money more than they did other people (see Text Study, Rabbinic #E).

Keep the group together or break up into smaller groups. Make up skits with story lines that show people who love money more than they love other people. Some companies, for instance, love potential profits more than the welfare of consumers and/or employees. Some examples:

a. At a board meeting of a tobacco company, the executives decide to go ahead with a subtle advertising campaign that actually targets youngsters. They know tobacco will be addictive and damaging to these youths . . . but sales will be profitable.

b. Members of a company's overseas publicity staff distort the benefits of baby formula, promoting their product in very convincing ways to impoverished, uneducated women with new babies. These women live in unsanitary conditions without clean water for mixing a safe formula. Because of their poverty, they water down the formula so that it is unhealthful and weak. Most of the women would be capable of and better off breast-feeding, and their babies would be better nourished. The baby formula company is more interested in profits than in the welfare of poor women and their babies.

c. Factory leaders agree to allow unsafe or unhealthy work conditions for their employees. It costs money to improve lighting, provide better ventilation, etc.

d. Investors in a nursing home ignore the overcrowding of residents. Such crowding compromises the basic needs of the residents (bathing, eating, administering medications, assisting them in whatever physical activity is possible). Dignity and loving care are neglected, but the more residents, the more money.

After skits are presented, share reactions. How were love and honor being disregarded in each of the scenarios? How would you feel if you were subject to the kind of "hatefulness" that prefers money over your dignity and welfare? Should we be concerned about groundless hatred in our society today? What can we do about it?

Movement

 1 (10 minutes) Have you ever watched someone communicating through sign language? Signing looks almost like dance. Invite someone to teach the group how to sign various phrases from Jewish sources related to loving and honoring. Use several of the quotations from Text Study.

Working individually, in pairs, or in small groups, participants choose one signed phrase, and expand on it so that it involves the whole body. For example, a hand that makes a circular motion (in sign language) can become a full run along a circular path (in the expanded phrase). They should allow the sign language to trigger ideas for additional, related movements. Such movements can be incorporated into the original phrase. Continuing with the example previously mentioned, the hand that makes a circular motion (in sign language) becomes a circular run, a spin in place, then a jump straight into the air. Participants can perform their expanded sign language phrases for each other.

2 (10 minutes) In Drama #1 above, participants passed around the circle a gesture of (or item suggesting)

love or honor. Return to the list of ten suggestions. A leader calls out one idea at a time, and participants improvise a response. They expand on the idea, using it as the initiator to a phrase of movement. For example: "a hand squeeze" might lead to a series of reaches — first with the hands and arms, then with other parts of the body. "Tipping a hat" might lead to a head tilting to the side and around back, until you are stepping in a circle around the back. You might begin to communicate "a compliment" with your hand, then see where that leads you. If you wish, develop some of your phrases into a choreographed piece.

Share reactions. Which phrase of movement that you improvised did you particularly like? Why did you choose to extend the movement the way you did, and how did you feel in performing it? Does the movement phrase suggest a real-life possibility for "expanding" on love and/or honor?

3 (10 minutes) In Text Study, Tanach #A, we are commanded to rid ourselves of hatred. Hatred was said to be the cause of the destruction of the Second Temple, not to mention many other destructive events in history. The term in Hebrew for groundless, undeserved hatred is *sinat chinam*. The word "*chinam*" also suggests "for free." *Sinat chinam* is like hatred that takes on an existence of its own.

Have a group imagine hatred has taken on an existence of its own. It exists in the performance space. While invisible, it seems to have a tangible, almost physical essence. The goal of the group is to remove this free reining, groundless hatred from their presence. Begin by deciding as a group where the hatred exists, its shape and boundaries. For example, it is a huge 20 foot by 20 foot blob hovering right above your heads. Begin improvising. Work at getting rid of the hatred, perhaps by trying to shrink it; by pulling it apart into smaller, more manageable pieces — burying some pieces, flinging others away; by transforming it.

After the *sinat chinam* has been "removed," discuss the improvisation. Did people seem to have different ideas about how to get rid of the hatred, or was there more of an unspoken shared intuition? How did you feel in the presence of such daunting hatred? How did you relate to your fellow participants? Are there any lessons learned in this exercise that can be applied to "real life"?

4 (10 minutes) The sentiments in Text Study, Tanach #A and Rabbinic #C are key to an understanding of the virtues of loving one another and honoring one another. It is as if there are two focus points — on yourself and on others.

Use the idea of two focal points as motivators of movement. One focal point is yourself — an inward focus. The other focal point is out into the immediate space, particularly toward other dancers. Spend a minute or two improvising — going between inner focus and outer focus. Then, begin to associate love and honor with the different focus points. That is, when your focus is inward, think of love and honor toward yourself, and when your focus is outward, think of love and honor toward others. Finally, add a third focus — outward beyond the limits of the physical space. This is the dimension associated with the limitless God. The third focus stretches toward the horizon — to the sky, moon, stars, and to the center of the earth and out the other side. This third focus follows love and honor out into the universe. A leader may want to call out when participants should add the various dimensions to their improvising.

Discuss. What did you like best about doing this improvisation? What was most challenging? What insights did this experience give you regarding why you are to love and honor others as *yourself*?

 5 (5-10 minutes) In Visual Art #6, participants draw an aura of love around a loving person.

As a variation on this activity, do a movement improvisation. One person is the loving individual. Surrounding that individual is a so-called aura of love. Everyone else (or even just a partner if you choose to do duets) moves freely throughout the space. The others are attracted to the loving essence surrounding the loving individual. They move in and out of the loving individual's "aura" of love. Their movement reflects the nature of the space in which they are moving.

Discuss reactions to this exercise. Describe the difference between moving within versus moving outside of the loving aura. In what ways was it hard to express distinctions between the areas? How did the loving person feel having people darting in and out of his/her personal space? How would you define what it is that loving people actually emanate — something comforting, emotional warmth, physical warmth, optimism?

 6 (5-10 minutes) This is a variation on #5 above. Instead of moving within the aura of an individual's loving presence, participants imagine the space is suffused with God's love. They move appropriately, expressing what it's like to be in God's loving "aura." Metaphorical associations may be helpful. For example — concerning God's love, consider:

a. the color

b. the texture (thin or thick, smooth or bumpy)

c. the volume (is it constant or does it change? Is it everywhere or more concentrated in places?)

d. the rhythm (does God's love suffuse a space like one constant sustained note, is it repetitive like a steady heartbeat, or is the rhythm of love unpredictable?)

Participants use the intuited, metaphorical images (as defined above) to motivate what they feel to be appropriate movement responses. After

a few minutes, bring the improvisation to a close. Ask for reactions. Some questions: What images did you have in mind to motivate your movement? In what ways will the experience of doing this exercise make you more aware of God's loving presence within your midst?

Music

 1 (20 minutes) The topic of love is a popular one for songs. How many songs do you know that include the word "love"?

With a large group (a whole school, camp, or *Havurah*), hold a "sing down." Divide participants into several groups of mixed ages. Each group prepares a list of songs which contains the word "love" or *"Ahavah"* in its lyrics. Then, in turn, the groups must sing the song until they come to this word. After all groups have sung a song, the first group begins round two. A group not able to come up with a song in its turn is eliminated. The last remaining group is the winner.

If desired, repeat the sing-down with other words related to the topic of this chapter. Here are some ideas:

a. Give/giving/gift (the gift of love)

b. Please (a word used when honoring, being respectful)

c. Heart or *Layv*

d. True/truth or *Emet* (respect a person's true, unique, and precious nature)

e. Peace or *Shalom* (see Text Study, Rabbinic #B about the necessity to love peace and pursue it to be a disciple of Aaron)

f. Any kind of animal (love and honor *all* of God's creatures)

2 (5-10 minutes) In the *"Kedushah"* prayer, we chant the words, *"Kevodo malay olam"* (God's *Kavod* fills the universe). *Kavod* becomes something bigger and greater when connected with God — more like "glory."

Have everyone choose an instrument. One person begins improvising the sound of *Kavod* — God's glory. The leader (conductor) points to one person at a time to add the sound of his/her instrument to the improvisation. The idea is to fill the space with *Kavod* through music. Improvise for a few minutes. Then share reactions. Describe what you heard. What feelings were aroused within you by the sounds?

 3 (time will vary) Music can inspire feelings of *love*. Music is also associated with *honoring* people. A song might be written in one's honor.

Everyone does the following "homework." Find a piece of music you associate with love and another piece you associate with honor. Bring recordings of these pieces back to the group on a specified date. Play excerpts of the music you chose. Each person explains the significance the pieces hold for them related to love and honor.

Miscellaneous

1 (preparation time for a celebration; the celebration itself) To love and honor God means loving all creatures, honoring the work of "God's hand." We set aside

special days for showing love and honor to certain people — Mother's day, Father's day, Secretary's Day, birthdays, anniversaries, etc. But how about something more general, an All Creatures Day? Luckily, we have blueprints for such a celebration — Rosh HaShanah ("Birthday of the World") and Shabbat (a day to appreciate creation).

Choose a special time for your All Creatures Day. You may want to make a connection with Rosh HaShanah (perhaps following *Tashlich*) or with Shabbat. Decide what you will do for this special celebration. There's plenty of study material in this chapter for a learning session; drama and movement activities could work well, too. You may want to prepare special banners or murals beforehand to decorate the space.

One activity could be a visit to a pond to feed ducks. Give out gift bags that include copies of poems or prayers on honoring and/or loving others, information about organizations looking for volunteers to assist in deeds of loving-kindness, a couple of sweet treats (one to keep, one to give), duck food (see above), etc. Plan a few non-competitive, cooperative games for large groups (books with these kinds of games are available at libraries and bookstores).

CHAPTER FOURTEEN
OMETZ LAYV: COURAGE

אוֹמֶץ לֵב

OVERVIEW

There's a subtlety to the meaning of *Ometz Layv*. *"Ometz"* means "strength" and *"Layv"* means "heart." Heart indicates an internal quality, a trait. *Ometz Layv*, therefore, is less about *acts* of courage — displays of power, might, and bravery — than it is about who we are in our heart, what we believe in.

It's easy to confuse soldier-type bravery with *Ometz Layv*-type courage. The ancient Israelites needed both fighting skills and the belief that God was on their side to succeed in battle against hostile peoples. David showed bravery when he faced the giant Goliath. In our day, the State of Israel needs a powerful army and brave soldiers to defend the country and ensure the safety of its populace. Soldier-type bravery is necessary at times; displays of power may be justified. There are all kinds of ethical issues to consider in going to war, maintaining military security, etc., but soldier-type bravery (might and power) are not virtues in and of themselves. Courage, however, is.

Already, during the time of the prophets, a distinction is made between might/power and courage. God says, "Not by might, nor by power, but by My spirit . . . " (Zechariah 4:6). Ironically, or perhaps prophetically, these words are read each year during Chanukah, which celebrates military victory. What does it mean to live by God's spirit? "God's spirit" means something different from might and power. Certain wars (such as those involving self-defense) may be justified, but "holy wars" — forcing religious beliefs and practices on others — should be foreign to Jewish spiritual goals. Such activity does not equate to "living by God's spirit."

The ideal kind of strength and courage we are to strive for can be divided into two categories. The first is related to not being fearful. We don't fear because we are willing to turn to God in trust and faith. There are times when we may be afraid, as when we are down in the dumps, as if "walking through a valley of darkness" (Psalm 23). We may feel fear when we are faced with immediate danger — hostile enemies or a pack of wild dogs. And we may feel fear in our everyday life in facing work or domestic problems, financial concerns, ethical dilemmas, chronic health issues. Each day we may need to "renew our strength" (Isaiah 40:31) and find courage. And how to get courage? By keeping our heart (*Layv*) turned toward God's spirit, trusting that we can make it through. Mustering faith is *Ometz Layv* courage.

The second category has to do with living a life of *Middot,* with self-mastery (see Text Study, Rabbinic #A). This theme appears in many guises throughout Rabbinic literature. We may mistakenly associate courage with might and power. But the kind of might and power that really matter have nothing to do with physical prowess, with pushing enemies around, throwing stones, bullying people, sabotaging another's career or personal life. Real might and power means the incredible endurance, persistence, and strength it takes to be a good person. That's *Ometz Layv*, too!

There's one other subject worth looking at here. The modern State of Israel is an important part of the Jewish story of courage. Earlier, it was

mentioned that soldier-type bravery is something the citizens of Israel have displayed and relied upon. But the State of Israel exists because of a tremendous amount of *Ometz Layv* as well. During its short history, Israel has faced many threats. Its citizens have shown courage in the belief that Israel will continue to flourish and that peace will ultimately reign.

Such courage was displayed by the Zionist pioneers. They expressed faith in the mission to make Israel once again the homeland of the Jews. Without any guarantees for the future, they used their strength to plant and to build. And the Jews who came from the Diaspora after World War II, most of them Holocaust survivors, showed courage in their desire to rebuild the land. Jews who came from Arab lands, Soviet Jews, Ethiopian Jews, Yemenite Jews, and others also showed courage. They left familiar cultures, learned a new language and new customs. Often, these immigrants had to leave family members behind.

Abraham may have been the first Jew to go from the land of his birth, to have the courage to go to a place that God would show him. But there have been many Jews who have followed his example, many who have bravely faced radical change, the unknown, a new beginning. It takes courage to go to "a place which God shows us" — physical places, moral places, and spiritual places.

How courage plays a role in our relationships with other people, with ourselves, and with God is summarized below.

 BAYN ADAM L'CHAVERO, BETWEEN PEOPLE. Part of courage between people has to do with not being afraid of others. In addition, being courageous is about using our strength to pull others up, not push or keep them down. A mighty person is one who is able to conquer evil impulses (*Pirke Avot*). When you use your strength to control negative impulses and master positive traits, that can have the effect of

better relations with other people. Friends can nurture courage, too. By *encouraging* one another, they inspire strength.

 BAYN ADAM L'ATZMO, BETWEEN YOU AND YOURSELF. This is the strength to conquer negative behavior, the power to control yourself.

 BAYN ADAM L'MAKOM, BETWEEN YOU AND GOD. God is the ultimate Source of strength. Through faith we overcome fear and live each day with courage. To a large extent, courage is supported by trust and faith in God. These are "pillars of strength." Joy in your relationship with God and a commitment to live righteously ("to walk in God's ways") can fortify you as well.

TEXT STUDY

Tanach

A The giving of the Ten Commandments at Mount Sinai was surely an awesome experience, but it may also have been frightening. There was thunder and lightening, blaring horns, smoke. The Israelites backed away, stood at a distance from the mountain, fearing they would die if God actually spoke to them. Moses offered reassurance.

Moses answered the people, "Be not afraid; for God has come only in order to test you, and in order that the awe of God may ever be with you, so that you do not go astray." (Exodus 20:17)

➤ Why do you think the Israelites were fearful? How did Moses address their fear, and what did he say to reassure them? How would you have felt had you been standing at the foot of Mount Sinai (or how *did* you feel, since tradition says

that all Jews were there!)? In what ways would you have found Moses' words helpful, and in what ways would they have given you courage?

B As the Israelites journeyed toward the land that had been promised to them by God, they were concerned about encountering hostile peoples along the way.

I said to you [as we journeyed], "Have no fear of [hostile peoples]. None other than the Eternal your God, who goes before you, will fight for you, just as God did for you in Egypt before your very eyes, and in the wilderness, where you saw how the Eternal your God carried you, as a parent carries a child, all the way that you traveled until you came to this place." (Deuteronomy 1:29-31)

➤ The idea that God is with us on our journeys and is a source of courage has remained strong throughout the centuries, but it is not a Jewish belief that God actually participates in battles. Why do you think that is? A powerful image is mentioned in the passage above — that God is like a parent carrying a child. How does a parent's practice to carry his/her child when the child feels vulnerable help build that child's sense of courage? Should knowing that God "carried us" back then help us feel courage as we face challenges today? When has this "knowledge" been important to Jews throughout the years?

C Friends can give courage to one another. David is encouraged by his friend Jonathan. Later on, Jonathan's son is reassured by David.

He [Jonathan] said to him [David], "Do not be afraid — the hand of my father Saul will never touch you. You are going to be king over Israel and I shall

be second to you; even my father Saul knows this is so." (I Samuel 23:17)

David said to [Mephibosheth], "Don't be afraid, for I will keep faith with you for the sake of your father Jonathan. I will give you back all the land of your grandfather Saul; moreover, you shall always eat at my table." (II Samuel 9:7)

➤ What is the "path" of reassurance that takes place in these two passages? Do you think David felt more courage because of what Jonathan said to him? How so? Do you think Mephibosheth felt more courage by what David said to him? Explain. To what extent can friends give courage to one another?

D Faith in God can help give us courage and diminish fear. When we're down, and things are going badly, we may need extra courage to climb out of the "low places." At those times, we may be especially open to God as source of strength.

Though I walk through a valley of deepest darkness, I fear no harm, for you are with me; Your rod and Your staff — they comfort me. (Psalms 23:4)

The Eternal gives courage to the lowly . . . (Psalms 147:6)

➤ Describe the fear you might feel when you are down. Why might you especially need courage then? How do you call upon God as source of strength during difficult times?

E Sometimes danger stares us in the face and we have every reason to be afraid. But even at the moment of immediate threat, God can be a source of courage and can help us cope.

Should an army besiege me, my heart would have no fear; should war beset me, still would I be confident . . . Look to the Eternal; be strong and of good courage! O look to the Eternal! (Psalms 27:3, 14)

➤ How is courage in present danger different from the courage you need when you're already down (see Text Study, Tanach #D)? Which kind of courage is harder to muster? Why might it be important to nurture faith during times when you feel confident and at ease?

F Text Study, Tanach #D is about finding courage during especially troubled times. Tanach #E discussed courage when facing present and immediate danger. But we also need to build courage that has to do with abiding trust — even during ordinary times. We often need courage day in and day out as we deal with people, face challenging issues, and confront problems. Courage needs to be an enduring, rather than a "special occasion," *Middah*.

Fear no person, for judgment is God's. (Deuteronomy 1:17)

Those who trust in the Eternal will renew their strength. (Isaiah 40:31)

When I am afraid, I trust in You, in God, whose word I praise, in God I trust; I am not afraid; what can mortals do to me? (Psalms 56:4-5)

➤ Why might a person need courage to cope with everyday life? At what times have you felt the greatest need for courage — when you were down in the dumps, when you faced an immediate threat, or just in day-to-day life? Has the courage been there when you've looked for it? For what kinds of circumstances do you need to build more courage?

G The following verse is included in the *Haftarah* read each year during Chanukah. (See also the Overview for this chapter.)

Not by might, nor by power, but by My spirit . . . (Zechariah 4:6)

➤ In your own words, what point is the prophet trying to make? How does physical might differ from spiritual might? Are they of equal importance?

H Joy fortifies you, builds character, builds strength.

The joy of the Eternal is your strength. (Nehemiah 8:10)

➤ Do you agree with the words from Nehemiah? Why or why not? What about happiness in general — do you need to master the *Middah* of *Simchah* (happiness) in order to master the *Middah* of *Ometz Layv* (courage)? In other words, do you need to be happy in order to be strong?

Rabbinic

A True might is not physical power on the battlefield, conquering others. Rather, a mighty person is someone who can "conquer" him/herself — impulses, traits, and spirit.

Ben Zoma taught: Who is mighty? Those who conquer their evil impulse. As it is written: "Those who are slow to anger are better than the mighty, and those who rule over their spirit than those who conquer a city" [Proverbs 16:32]. (*Pirke Avot* 4:1)

➤ According to Ben Zoma, who should be called mighty? Who do you think should be called mighty? In what ways would you most like to be mighty, and why?

B This passage has a similar underlying message to #A above. We need strength, most of all, in order to live a righteous life.

> Yehudah ben Tema taught: Be bold as the leopard, swift as the eagle, quick as the deer, mighty as the lion, to perform the will of your Heavenly parent. (*Pirke Avot* 5:22)

➤ We may admire characteristics of certain animals. But unlike animals, we have the ability to choose how we apply our characteristics and talents. According to Yehudah ben Tema, for what should we use our qualities? Would he agree that there may be times when we feel war is necessary, when we will want certain animal-like qualities?

C We can become weakened — emotionally, physically, or spiritually.

> Three things deplete a person's strength: fear, travel, and sin. (*Gittin* 70a)

➤ How can fear, travel, and sin deplete a person's strength? Are there other major strength-depleting factors that come to mind?

D It can be difficult to feel courage when we stop "seeing clearly." Sometimes we need to approach our fears from new angles, to "turn a light" on our fear and examine it rationally from a different perspective.

> A man saw an insect that looked like a live coal [a firefly] and it terrified him. He was asked, "Is this what terrifies you? At night it is a fiery, blazing thing, but when morning comes, you can see it is nothing more than a worm." (*Pesikta Rabbati* 33:4)

➤ Of what was the man terrified, and why? What is this passage trying to teach about fear? Are the situations (or people) you fear ever truly worthy of the emotion you "devote" to them? Explain.

E This passage has to do with confronting fear resulting from danger.

> A man walking on a road saw a pack of dogs and felt afraid of them, so he sat down in their midst. (*Genesis Rabbah* 84:5)

➤ Why does the man sit down among the dogs? How might you apply any lessons you learned from the man's reaction to danger?

F *Ometz Layv* could be translated as "courageous of heart" or "strong hearted." The following passage shows what the *"Layv"* in *"Ometz Layv"* can signify. Truly brave people have heart — they use their strength to help others.

> "Why do you boast yourself of evil, mighty fellow?" (Psalms 52:3). David asked Doeg: "Is this really might, for one who sees another at the edge of a pit to push the other into it? Or, seeing someone on top of a roof, to push the person off? Is this might? When can someone truly be called a 'mighty person'? When there's an individual who is about to fall into a pit, and that someone seizes the individual's hand so that he/she does not fall in. Or, when that someone sees another fallen into a pit and lifts the other out of it." (*Midrash Tehillim* 52:6)

➤ True might is not about "pushing someone into a pit." Rather, it's about "lifting a person out." What's the difference? How is your might best shown — in "pushing down," or in "hand-holding" and "lifting"? Explain.

G Joining forces with others can be a source of strength. We can feel strength in community, greater courage in the company of friends. (This text is similar to an idea in Ecclesiastes 4:12: "A three-fold cord is not readily broken!")

> Separate reeds are weak and easily broken; but bound together they are strong and hard to tear apart. (*Tanchuma, Nitzavim* 1)

➤ What is this passage getting at, and what does it teach about strength? Can you think of examples of how courage might grow when people "pull together"?

Post-Rabbinic

A The following words set to a melody, have become a popular song. (See *"Kol HaOlam Kulo"* in *Kol HaNeshama: Songs, Blessings and Rituals for the Home,* Federation of Reconstructionist Congregations and Havurot, Church Road and Greenwood Avenue #300, Wyncote, PA 19095-1898. In other collections, the song may be titled *"Gesher Tzar Me'od."*)

> *Kol ha-olam kulo gesher tzar me-od, v'ha-ikar lo l'fachayd klal.*
> All the world is . . . is a very narrow bridge. The most important thing is not to be afraid. (Rabbi Nachman of Bratzlav)

➤ Why is the world compared to a very narrow bridge? For what reasons might being on a very narrow bridge make us afraid? Why should we not be afraid?

B When we're at our lowest, courage doesn't have to disappear. As long as we live, we have some reserves of strength even if finding them and drawing upon them become challenging.

The Wounded Lion
At times of distress, strengthen your heart,
Even if you stand at death's door.
The lamp has light before it is extinguished.
The wounded lion still knows how to roar.
(Samuel Ha-Nagid, in *Masterpieces of Hebrew Literature,* ed. by Curt Leviant, New York: KTAV Publishing House, Inc., 1969, p. 179)

➤ Explain the last two lines of this poem in your own words. Do you find this poem encouraging? Do you think it's important for a person in distress to persist in efforts to be strong hearted?

C Sometimes fear takes on a life of its own. We become fearful of new things, because they remind us of our fear of the initial thing. When such a situation happens, we need to readjust, reevaluate, rethink our fear. Is the fear rational? How can we tame it?

Whoever Has a Lurking Enemy Shall Tremble Morning and Evening
An ox saw a lion and ran away, for the lion roared and bellowed and trumpeted after him. The ox hid himself in a certain pit beneath thick flaxen branches. There a ram also was hidden. The ox's heart was in terror; it made him tremble in fear of the ram. The ram said to the ox: "Why are you afraid? Surely you and I belong to the same herd." The ox answered: "Every animal I see alive is in my eyes a mighty lion. If I had found you alone, I would not have feared you. But now, because of the lion, I am flustered and shaky."

The parable is for those who have an enemy whom they fear always, morning and evening, walking and sitting, rising and lying down. They imagine every person to be their enemy. They say, 'Now shall I be pursued!' But it is the sound of a driven leaf that pursues them. (*Berechiah ha-Nakdan, Fox Fables,* adapted from *Masterpieces of Hebrew Literature,* ed. by Curt Leviant, New York: KTAV Publishing House, Inc., 1969, p. 436)

➤ Why, in the parable, does the ox become so flustered and shaky? In the explanation of the parable, it says "it is the sound of the driven leaf that pursues them." What does that line mean? What should we do when fear gets out of hand, when a particular situation creates in us a generalized feeling of fear?

D If you become overwhelmed by fear, it is a sign that you're seeing only part of the picture. "Fear is foolishness," says Abraham Isaac Kook. It causes a distorted way of looking at life. But "evil fantasies" and "terrifying ghosts" can be transformed. Life sapping fear can be overcome. It can be replaced by "supportive forces, which gladden and satisfy the mind."

There is no reason for [people] to be afraid. All the frightening images are only the fragmented colors of a great vision that needs to be completed. (*Abraham Isaac Kook, The Lights of Penitence, The Moral Principles, Lights of Holiness, Essays, Letters, and Poems,* p. 179)

➤ What do "frightening images" and "fragmented colors" have to do with one another? Do you agree with Rav Kook's assessment of fear?

ACTIVITIES

Language Arts

 1 (10-15 minutes) Ideally, strength should be used for good, not for bad. You should show your strength by helping people up — lifting them, supporting them, protecting them. It is better to use your might those ways than to use it to push people down (see Text Study, Rabbinic #F).

Either orally as a whole group, or by independent writing, make two lists. Entitle one "How to Use Strength for Good" and the other "How Strength May Be Used for Bad." Then brainstorm ideas to put under each topic — the good and the bad. Extend this activity by acting out some of the items on the list. (See Drama #1.)

Discuss. Which items listed would you call the best examples of *Ometz Layv*, and why? Is it more natural to do the things on one list versus the other? How can we make sure that we steer our strength toward the "good list"?

 2 (20 minutes) Friends can encourage each other — give each other courage. Examples of this are included in Text Study, Tanach #C, in which Jonathan encourages David, and then later on, David encourages Jonathan's son. Another good example of people providing strength for each other is in Text Study, Rabbinic #G, which states that reeds (like people) bound together are stronger than they are individually. What are the ways your friends and members of your community give strength to others?

Write a dialogue, an imaginary conversation between friends. One friend is feeling weak and discouraged. What is the reason? (That's the writer's job to imagine and decide.) The other friend offers encouragement. What does the encouraging friend say? What does the discouraged friend then say in response? And so on, back and forth. The dis-

couraged friend should eventually feel increased courage as a result of the conversation with his/her friend.

Are there similarities in the words of encouragement the various writers imagined? What kinds of words of encouragement "work best" on your friends? on you? Do you look to friends and community to help provide you with courage? Are there limitations to how much another person can encourage you? What is the best source of courage? (Note: This exercise is also appropriate for study of the *Middah* in Chapter 21, *Somaych Noflim, V'Rofay Cholim*: Supporting and Healing.)

 3 (15-20 minutes) There are many times when you may feel the need for courage. In our tradition people often look to God as a source of strength. Situations calling for courage are discussed in the Overview and in Text Study, *Tanach* #D, #E, #F. Look at those references, then continue with the following.

At what times do you (or people in general) look to God for courage? Give specific examples. You may want to divide your lists into these areas:

a. Difficult, depressing, down-in-the-dumps, "walking in the valley of darkness" times (for example, after the death of a loved one, after being fired from a job, getting divorced)

b. Times of immediate danger or threat (for example, during a flood or earthquake, being confronted by bullies, facing a dangerous animal)

c. Everyday situations (for example, needing to confront a hostile classmate about stealing from you, persisting in learning a challenging academic subject, living with a physical disability)

How might trust and faith in God help you to find courage in dealing with various kinds of challenges? In what situations are you more likely to look to God for courage? In what situations are you less likely? Why? Are trust and faith qualities you would like to develop more in yourself? How might you do so?

 4 (10-15 minutes) In order to face your fear, you need to know what it is about. You even may need to confront your fear straight on. (See Text Study, Rabbinic #D and #E, plus Post-Rabbinic #C.)

One way to see your fears clearly is to make an intentional effort to examine them. Do this through a stream of consciousness exercise. Write freely, without stopping or judging. Begin with the words, "I feel afraid when . . . " After a few minutes, start a new topic beginning with the words, "I feel courage when . . . "

Now, look back on what you wrote. Is it what you expected? Any surprises? Of what are you most afraid? Where do you find courage? Are there areas in which you need to make a concerted effort to work on courage? How can you become stronger?

 5 (interview time; plus 15-20 minutes to write up or discuss) Someone who has been a soldier in a war has likely faced terrifying experiences and probably has some theories about courage and about how to cope with fear.

Interview a war veteran about his/her beliefs on courage. Make your list of interview questions beforehand. Ask what was frightening, why things were frightening, how the veteran dealt with fear, how others dealt with fear, a specific example of someone who showed admirable courage, etc. Individuals may go out on their own for interviews, or invite a special guest to class.

After the interview(s), discuss what you heard. Compare the interview subject's views on courage with what you know about the *Middah* of *Ometz Layv*. How are the ideas similar/different? What are some of the characteristics of a Jewish soldier who has mastered *Ometz Layv*?

 6 (15 minutes at least) Abraham left his home and his native land when God instructed him to do so. Leaving familiar places and building a new life takes

courage. Making changes in general takes courage. It means leaving behind what you're accustomed to, being willing to face the unknown. The modern State of Israel was built on such courage (see the Overview).

Write a story from your imagination about leaving the familiar and going toward the unknown. The story should explore *Ometz Layv*, the kind of courage needed in order to make changes. The most obvious subject for a story would be a physical leaving, a journey from one land to another, such as immigrants going to Israel. But you might consider writing about a young child leaving home to go to school for the first time, or about someone who "leaves" an abusive (though familiar) relationship and ventures into "unknown territory" (life on one's own).

In a group share your stories. Give reactions and comments. Which journeys take the most *Ometz Layv*? Is there a journey you have taken which required a great deal of courage? How did you acquire the necessary courage?

 7 (15-20 minutes) When we speak about characters in the Bible, we sometimes use the term "Bible heroes/ heroines." What makes a person a hero/ heroine? We often lionize someone who shows courage.

Choose one or more biblical characters. Discuss or write about how they were courageous. For example:

a. Abraham (goes to the place that God would show him)

b. Jacob (wrestles with an man/angel)

c. Rachel (childless, has to face Leah)

d. Moses (overcomes a speech impediment to engineer the Exodus)

e. Esther (goes before the king even though she hadn't been called)

f. Your own ideas . . .

 8 (15 minutes or more) In Text Study, Rabbinic #A, a sage asserts that a mighty person is one who conquers his/ her evil impulses (see Text Study, Rabbinic #A). Suppose we soften this idea just a bit. A mighty person is someone who turns a weakness into a strength.

Write a portrait of someone who turned a weakness into a strength — selfishness into generosity, envy into contentment, or being hot tempered into having self-control. (You may want to disguise the person's identity and situation if the writing is to be shared with a group.)

 9 (20 minutes or more) A parable presented in Text Study, Post-Rabbinic #C talks about fears becoming distorted and out of hand — "monsters." Study the literary style of the parable. By drawing on an imaginary circumstance, the author of a parable is able to drive home a particular point in an effective, even powerful way.

Now, come up with your own parable — a story about fear, about a "monster" of some sort. You may want to begin with the point of the "lesson," then write the parable itself. Parables often use animals or kings and queens and subjects. Take your parable to the next step, showing how fear was turned into courage.

As you share your parables with the group, see if the listeners can explain it — do they get the point? In what ways was writing a parable difficult? Did you enjoy the exercise? What did you learn? (Note: this exercise could also fit into the categories of *Bayn Adam L'Atzmo* and *Bayn Adam L'Makom*, depending on the content of the parable.)

Visual Art

 1 (15 minutes or more) We are reminded that real strength is about helping people up, not pushing people down. (See Text Study, Rabbinic #F.)

Create two pictures that illustrate how physical strength can be used. Divide a piece of paper in two. On one half of the page, depict someone using strength for the wrong reasons (such as, pushing someone "into a pit" or "off the top of a roof"). On the second half, show someone using strength for the right reasons (such as rescuing someone). Title the pictures: "Using Strength for the Wrong Reasons" and "Using Strength for the Right Reasons."

Analyze the different ideas people came up with. Did you decide what to draw based on real-life experiences? In what ways will you now be more aware of how you use your strength?

 2 (10-15 minutes) Review Text Study, Rabbinic #D about the person who mistook a firefly for a live coal.

Create a before and after picture. In the before picture (on one side of the page), fear is distorted — like the blazing, fiery, terrifying coal. In the after picture, a "mere worm" is what's seen in the morning after a "light" is turned onto the fear. You can base your drawing on the text mentioned above or you can come up with your own idea.

In a group, share your drawings. What did you do to make the before picture look frightening? How did you alter the before picture for the second version? Have you ever been afraid of something, then overcome your fear because you looked at it differently? Explain.

 3 (20 minutes or more) A simple poem by Samuel HaNagid is included in Text Study, Post-Rabbinic #B. Create a short booklet that illustrates the poem. Make a cover page and an illustration for each of the lines.

Share your booklets, offering comments and explanations, then display them.

 4 (10 minutes at least) In Text Study, Tanach #D, the writer of Psalm 23 walks through the valley of darkness and does not fear. According to the Psalm, fear is blunted by faith that God is with us.

Make a drawing or painting of someone walking bravely through "a valley of deepest darkness." You can make a simple line drawing, or an elaborate painting.

Share your artwork and discuss. How did you depict "a valley of deepest darkness"? Why did you settle on your interpretation? Did you consider other possibilities? Did your impression of the "valley" change as you immersed yourself in the artistic process? If so, how? How did you show courage on the part of the person walking through the valley? In what ways is the person in the picture like/unlike you? (Note: A creative movement version of this activity can be found in Movement #4.)

5 (10 minutes at least) There's a simple way in which we might experience a taste of courage in the realm of art. It takes courage to try something new, to take risks. It may also take courage to do an art exercise if art is an unfamiliar medium. We may be afraid of failure. Even experienced artists may feel fear, choosing to work primarily with familiar tools and materials and in a familiar style. The point here is to experiment with new art materials and art forms.

Have the courage to try a new art technique — oil painting; working with silver (the actual metal); making a painting out of "clashing colors" — orange, black, and purple; making huge finger paint banners. Push yourself to do an artistic something that is "gutsy." Such gutsiness may just spill over into your approach and attitude toward life in general.

Discuss the experience. Did you feel courageous? Did you enjoy taking a risk, exploring an unknown? Can you nurture *Ometz Layv* in situations that don't pose a serious threat or when you aren't feeling low or depressed? In what ways do modest experiments and explorations in *Ometz Layv* help you build up the courage you may need when you face truly difficult circumstances?

 6 (15 minutes or more) Rabbi Nachman of Bratzlav compares the world to a very narrow bridge, and advises us not to be afraid (see Text Study, Post-Rabbinic #A). This analogy can stimulate our imagination. For example, where does the bridge begin? Where does it go? Is it narrow because this world is fleeting? Is its narrowness a mark of it being flimsy or rickety? Must we remain tightly focused because our journey across the "bridge" may feel wobbly and tenuous?

Imagine the bridge. Then draw or paint it, addressing some of the questions above. Also consider: How sturdy is the bridge? Does it even look like a bridge? Is it a suspension-type bridge, or is it supported from underneath (and with what, to what)? Who is on the bridge? Is there more than one bridge?

A variation: Make a three-dimensional bridge. Use clay or other construction materials (wood scraps, toothpicks, cord, etc.).

Explain your interpretation of the bridge to others. To what extent do you believe your artwork reflects truth — what people really experience? (Note: A related activity can be found in Movement #5.)

 7 (10 minutes) Ideally, we may want to show courage under all conditions. Most likely, however, our courage wavers. In order for our courage to be there when we really need it, we must nurture trust in a consistent way. Trusting helps us to renew our strength each day (see Text Study, Tanach #F).

In this exercise you will explore the wavering tendency of strength. But instead of simply allowing the strength to waver wherever it wants, you will guide it. You will lead weakness back to strength; you will renew courage.

Make a three part series of quick charcoal drawings. For each one, do the following:

a. Make a strong shape ("strength").

b. Repeat the shape in such a way that it looks somehow depleted.

c. Repeat the shape one last time, this time with renewed strength.

Make four or five of these three-part "renewal of strength" drawings. What makes something look/seem strong? How does strength become depleted? How is strength renewed? Did you get any special insights from doing this exercise?

 8 (15 minutes) In Text Study, Rabbinic #A, we learn that a strong person is one who "conquers" evil impulses. What does this kind of conquering look like?

Draw an evil impulse. Whatever it is, make it simple and small, something you can recreate easily, such as a thorn or hot ember. On a large piece of paper, make several copies of the evil impulse. Spread the drawings out, making about eight of them.

Then, draw different ways of "conquering" each evil impulse. A few ideas: Jail one. Zap one with a lightning bolt. Squash one under a foot. Bury one in a ditch. Pull one apart into tiny, harmless bits. Burn one. Have someone swallow one.

Share your artistic "conquering" ideas. Which image do you like best? Are any of the images realistic? How so?

 9 (15-20 minutes minimum) Abraham Isaac Kook says that there's no reason to be afraid because all the frightening images are only the fragmented colors of a great vision that needs to be completed (see Text Study, Post-Rabbinic #D).

Interpret Rav Kook's words using paint. Consider that in a kaleidoscope the bits of color you look at actually make up a whole, integrated picture. Consider also the artist Jackson Pollack, who used random splatters of paint across a canvas, creating paintings that reflect whole, integrated visions. He captured randomness and wholeness on one and the same canvas.

For your painting you will need to reflect on what are "fragmented colors." Are they like shards of glass, spraying in all kinds of directions? indistinct blobs of color running into each other? multitudes of colored wafers jaggedly snapped in half? random splatters of paint (similar to a technique used by Jackson Pollack)? pulled apart, puzzle-like pieces of color? Other ideas?

You also will need to imagine "a great vision that needs to be completed." How do the "fragmented colors" fit in? That is, how will the colors eventually fit into the whole picture, into the "great vision"? There must be various stages in the process of completing the "great vision." What is the stage you wish to depict — less complete or moving closer toward completion?

Share your paintings. Ask viewers to comment on what they see in your work. Give explanations if you wish. What insights about courage did you learn in this exercise?

Drama

 1 (10-15 minutes) Strength can be used for good or for bad. It takes strength to help people; it also takes strength to push people down. Better to use strength for good! That's the message of Text Study, Rabbinic #F and Language Arts #1. Have small groups complete the Language Arts activity by making two lists: "How to Use Strength for Good" and "How Strength May Be Used for Bad."

Now, have the groups come up with dramatic renditions of a few items on each of their two lists. (That is, act out someone pulling someone else out of a pit, etc.) Have each group perform, *Charades*-style, a few of their "good strength" and "bad strength" examples. After a group finishes acting out an example, the audience tries to guess what it was and offers an opinion on whether the strength was good or bad.

Discuss the experience. Which was harder — coming up with examples of using strength for good or of using strength for bad? What do you think is more natural for people? Are there ways you can guard your strength, making sure to direct it toward good, toward positive things?

 2 (10 minutes) The poem about the wounded lion, included in Text Study, Post-Rabbinic #B, lends itself well to dramatic interpretation.

A student or the teacher recites the poem out loud slowly while actors improvise a dramatic interpretation of the words. Repeat the reading several times so that everyone has a chance to perform (three or four actors can improvise at the same time).

Ask the actors: When did you feel fearful or least courageous during your improvising? When did you feel most courageous? What do you think the poem is trying to teach about courage? Have you ever felt like the "wounded lion"? What did you do to muster your strength?

 3 (5-10 minutes for each dramatic interpretation; preparation time is additional) Several other Text Study passages about *Ometz Layv* lend themselves to dramatic interpretation. You may want to string several of these together into a performance. Here are additional ideas for various skits:

a. Text Study, Rabbinic #G (creating a three-fold cord). Three people are separate reeds — weak, fragile, easily broken. They join together, binding themselves as one, becoming "strong and hard to tear apart."

b. Text Study, Rabbinic #E (facing fear). One actor portrays the man or woman, five or more actors are the dogs. The person walks amidst the pack of dogs. At first, the person is afraid, and then he/she decides to face the fear. He/she sits down in the midst of the "dogs."

c. Text Study, Post-Rabbinic #C (the parable of the ox fearing the lion). Minimally, you will need four actors, but parts easily can be assigned to eight or more people. One person is the ox, one is the lion, and one is the ram. You also will need a narrator and/or another three or more actors to act out the explanation of the parable. Perhaps someone can play "a driven leaf" as well.

d. Text Study, Tanach #C (the dialogue that takes place between Jonathan and David, and the one between David and Jonathan's son). You will need three actors: David, Jonathan, and Mephibosheth. You may want to flesh out the dialogue, using your imagination. Another idea is to act out a made-up dialogue in which one friend encourages another (see Language Arts #2).

e. Language Arts #7 (about Bible heroes showing courage). Choose to depict one or more of these through a short dramatic piece (that you make up).

Create your skits. Rehearse them. And (if you like), perform them! If you choose to make a "big deal" performance, you may want to open up the theater to questions from audience members afterward. Focus the discussion on *Ometz Layv*. The actors can comment on what their skits teach about this *Middah*. Audience members may have thoughts to add as well. Appropriate refreshments might be strong coffee (or lemonade), powerful mints, spicy dips, braided ("three-fold cord") *challah*.

 4 (10-15 minutes) A person who is able to "conquer" his/her evil impulse is considered truly mighty (see Text Study, Rabbinic #A).

Stage a mock battle. The battle is between the actor and his/her evil impulse. You can do this as a solo, imagining the "enemy" (evil impulse) or with two actors, one playing him/herself, the other playing the "enemy" (evil impulse).

Create a short, dramatic piece in which a person "battles" and "conquers" his/her evil impulse. If you choose the second option, don't make the battle so real that someone could get hurt. You may want to make a no touching rule for the battle scenes.

Discuss. What do you think of using the idea of battling and conquering as a metaphor for overcoming your evil impulse — is it effective? Describe the kind of courage you need in order to engage in the "battle" against your evil impulse. (Note: This activity also works well as a Movement activity.)

Movement

 1 (5 minutes) It's difficult to sustain a sense of courage. Strength needs to be renewed. We can renew wavering strength by turning to God, by trusting: "Those who trust in the Eternal will renew their strength" (Isaiah 40:31; see also Text Study, Tanach #E). Renewing is like taking sagging courage and redirecting it, "re-sculpting" it.

Express with your bodies the above idea of renewing strength. Divide into pairs (or choose one pair for everyone else to watch). One person makes a pose that suggests someone whose strength is sagging, failing, weakened, depleted. The second person is the "sculptor." The sculptor gently reshapes the "discouraged" individual. The sculptor's adjustments revitalize and "renew strength." Repeat a few times, switching roles.

Discuss. How did the first person show lack of strength? How did the sculptor help renew strength? How is God like the sculptor? What can we do to allow ourselves to experience renewed strength?

An advanced variation: Base the sculpting exercise around the words of Zechariah in Text Study, Tanach #G. One person takes a pose based

on might and/or power. The other reshapes the pose so that it reflects God's spirit, or opens up to God's spirit. Switch roles, and repeat a few times. Then, share thoughts and reactions. What did you do to show commitment to "God's spirit"?

 2 (5 minutes) We can look to God as a source of strength, for help in getting out of "low places," for providing the courage we need to go on. Put "into your bodies" the line from Text Study, Tanach #D and/or the following line from Psalm 145:14 (part of the "*Ashray*" prayer), "The Eternal makes all who are bent over stand straight once again."

Begin on the ground as "low" as possible. Imagine yourself to be discouraged, weakened, depleted of strength. Slowly, imagine the words from one of the citations taking effect. You begin to feel strength and your courage grows.

Discuss. How did you feel as you rose from the ground to stand straight and strong? Were you focused on the line(s) from Psalms? To what extent do you look to God as a source of strength/source of courage?

 3 (10-15 minutes) Follow the general guidelines and discussion questions for Drama #4. In that exercise participants stage a mock battle in which they conquer their evil impulse. Adapt this exercise to Movement by allowing interchanges to be more expressive through freer use of the whole body. Short dramatic movements can be developed that become fuller dance phrases. For example, one realistic-type kick might become a series of kicks with turns and percussive jumps.

 4 (5-10 minutes) Faith that God accompanies you can provide the courage you need to "walk through" fearful times and places (see Text Study, Tanach #D).

Imagine walking through "a valley of deepest darkness." What would it look like? How would you feel standing in its midst? The whole group starts on one side of the room. You will cross the space, two or three people at a time. (Each subsequent pair or trio can begin once the previous group is halfway across the space.) Build up to a walk through "a valley of deepest darkness" by doing the following in order. (You will end up crossing the space a total of five times.)

a. Simply walk across the space, in no particular way.

b. Walk across the space as if you are frightened.

c. Walk as if you are moving through a deep, dark valley, but are emotionally neutral about the experience.

d. Walk through "a valley of deepest darkness" as if very frightened.

e. Again, walk through "a valley of deepest darkness." There's the potential for fear — it may linger here and there, in some hidden crevices, but this time you are not frightened. You know God is with you; you trust and feel God's comforting presence.

Discuss. How did the experience change for you as the walks developed? What was easiest/most difficult about this exercise? Have you drawn courage from God when you've walked through "valleys of deepest darkness"? Did this movement experience remind you of those times? (Note: A similar activity can be found in Visual Art #4.)

 5 (5-10 minutes) This is a variation on #4 above. Rather than walking through "a valley of deepest darkness," walk across "a very narrow bridge" (see Text Study, Post-Rabbinic #A). Follow the guidelines as outlined in the previous exercise. Also, refer to Visual Art #9 above for some clarifying questions and ideas.

 6 (15 minutes) You need strength in order to live a righteous life. Some animals can provide wonderful lessons concerning courageous qualities we ought to develop (see Text Study, Rabbinic #B).

For this activity individuals can work on their own, in pairs, or in small groups. Choreograph a short dance based on the words of the above text. Begin by creating four short phrases of movement, based on being:

a. Bold as a leopard
b. Swift as an eagle
c. Quick as a deer
d. Mighty as the lion

String the phrases together. The tricky part will be the last phrase, interpreting the final line in movement: "to perform the will of your Heavenly Parent." You may wish to express these words by showing someone at prayer, by having someone expressing loving-kindness to another person, or with your own idea.

Perform your choreographed pieces for other members of the group. What did the performers experience? What did the observers observe? What was the most challenging part of this exercise? Are there other lessons about courage in our midst; other lessons we should notice and take stock of (from animals, other parts of nature, etc.)?

 7 (30 minutes or more) To experience life's journeys takes courage. (Such journeys are mentioned in the Overview.) In Language Arts #6, participants imagined and wrote their own stories of courageous journeys.

For this movement activity, choreograph a journey of courage. Group members may wish to collaborate, creating one piece together. First, decide the content and nature of the journey. Next, you may want to create a floor pattern. That is, draw on a piece of paper the pathway of the journey you will choreograph (a zig-zag, a spiral, a pattern that continually crisscrosses the same

point, etc.). Make marks on this simple line pathway to indicate events that will take place (in dance) along the way. These events will require courage in confronting them, then moving on to continue the journey.

Some questions to consider as you choreograph: What are the most difficult "journeys" — which journeys, and parts of journeys, take the most *Ometz Layv*? Should your choreography include confrontations with the most difficult challenges? Is there a particular journey *you* have taken which required a great deal of courage? How have you acquired the courage necessary to take difficult steps along your own pathway? Do you want your choreography to reflect your own experiences?

Plan to perform your dance for friends, parents, other family, and/or community members. Share it at an assembly, as part of a Jewish arts series, or at a worship service. For a worship service, the piece can be performed as a *D'var Torah* (like a sermon). Schedule your *D'var Torah* dance when a section of Torah is being read that concerns a journey.

Music

 1 (5-10 minutes) Refer to Text Study, Post-Rabbinic #A, in which Rabbi Nachman of Bratzlav compares the world to a very narrow bridge. Then learn the melody that has been set to the Hebrew words. (The source for one recording of this song is cited in that Text Study.)

 2 (5 minutes) God can be a source of strength, helping us to emerge from "low places" (see Text Study, Tanach #D). God can help us find courage when we feel our strength has given out.

Use simple percussion instruments for this exercise. Put the line from Psalms 147:6 into the sound your instrument makes. Begin by making

"low" sounds. If you are using only percussion instruments, you will need to explore how "low-ness" can be expressed in ways other than tone. Slow, dull, non-precise sounds might suggest being low. You are trying to capture, through sound, feelings of being discouraged, weakened, depleted of strength. Then gradually imagine the words "The Eternal gives courage to the lowly" taking effect. That is, express growing strength and courage through your instrument.

Discuss. How did you begin playing your instrument? What changed as you gradually altered your playing to make the "sound" of courage? Do you look to God as a source of strength/source of courage? If so, when?

3 (10-15 minutes) Throughout the ages, music (often in the form of marches) has been composed to help inspire and support courage. Courage building music usually will use repetitive sounds with a strong underlying beat. Likely, it will escalate in pace and volume. Such music can help arouse savage bravery, aggressive power, and might. (For example, Wagner's music was played to help motivate the evil doings of the Nazis.) On the other hand, such music may support the best of courage.

Use music as the center of a discussion on soldier-type bravery versus *Ometz Layv*. Listen to marches and other music that could inspire bravery or courage (e.g., John Philip Sousa's band music or Beethoven's Fifth Symphony).

Then discuss: How did the music make you feel? If you were a soldier in an army, what effect would the music have? What effect would the music have on you at a time when you had been feeling low, frightened, or discouraged? In what ways can our listening to music inspire good behavior (as in *Ometz Layv*)? When could it motivate us to do wrong (as in savage aggressiveness)?

CHAPTER FIFTEEN

SAMAYACH B' CHELKO: CONTENTMENT WITH YOUR LOT
MAKIR ET MEKOMO: KNOWING YOUR PLACE
LO TACHMOD: NOT COVETING

שָׂמֵחַ בְּחֶלְקוֹ / מַכִּיר אֶת מְקוֹמוּ / לֹא תַחְמֹד

OVERVIEW

Samayach B'Chelko, Makir et Mekomo, and *Lo Tachmod* are listed together because all three *Middot* contain similar underlying principles: Don't pretend to be someone you are not, don't envy what belongs to others, be content with what you have, be happy with your own talents and accomplishments, live in the present moment, accept who you are.

You may say: If one is so happy and content with who one is now, why would one be motivated to improve oneself, to grow? Shouldn't we desire to improve our living conditions, our marital relationship, other relationships, our health, our knowledge base, and so forth? Isn't improving oneself a value? Isn't this whole book about mastering virtues, after all?!

To find the Jewish answer to this, let's look more closely at the three *Middot* and flesh out what they really mean. *Samayach B'Chelko* literally means "happy or content with one's lot." *Makir et Mekomo* literally means "knowing one's place." Torah, in its broadest sense is heritage, culture, religion, stories, laws, traditions, history, and values. When we study Torah, we begin to clarify values. The line between what's okay and what goes too far becomes more distinct. The list for acquiring Torah includes 48 virtues (in *Pirke Avot*). *Samayach B'Chelko* and *Makir et Mekomo* are just two of these. As we work on the other 46, and as we study the laws and stories related to those, we grow in understanding of what contentment and knowing our place means.

Lo Tachmod (do not covet) is actually the last of the Ten Commandments. Coveting is a profound envy that can prove destructive both to oneself and to others. Breaking this commandment can lead to breaking the preceding nine — killing, stealing, committing adultery, dishonoring parents, taking God's name in vain, devaluing Shabbat, worshiping idols — ultimately, denying God. Coveting usually implies not only wanting what another has or is, but also wanting others not to continue having or doing.

It is difficult to define precisely when acceptable ambition becomes coveting. Yet, consider this: Striving for something and being content with your lot do not have to be contradictory. Part of "your lot" can be striving. Part of knowing who you are, knowing what your "place" is, can be knowing who and what you want to become. That may take envisioning yourself in another "place." You may need to strive to become the person you want to become. As long as your striving is not mean spirited, as long as your motivation is not greed, as long as in your striving you do not hurt others and destroy relationships, as long as your efforts are directed toward acquiring Torah, then your ambitions and intentions may be considered acceptable, even worthy.

The following paragraphs show how these three *Middot* apply in our relationships with others, with ourselves, and with God.

 BAYN ADAM L'CHAVERO, BETWEEN PEOPLE. Coveting happens between people. Extreme envy of others can

have negative, even disastrous results. Coveting can damage friendships and other relationships by leading to distrust, estrangement, awkwardness, resentment. Worse still, coveting can result in stealing, killing, or committing adultery.

When content, you don't feel threatened by the success and good fortune of others. You can rejoice in what they have while appreciating what is yours. How you feel about yourself can have an impact on your attitude toward others.

 BAYN ADAM L'ATZMO, BETWEEN YOU AND YOURSELF. Envy of others can result in dissatisfaction with your own life (even with what is good about it). Coveting can cause an obsession with material things. Coveting can mean that you become *overly* focused on "how I should be" or "how I wish I would be." You reject who you are — your essence, your soul. Such a rejection is neither a step toward self-improvement nor about making a few changes for the better; it is like desiring falseness. It is as if you want to be someone other than yourself.

When envy propels you to further yourself in learning, good deeds, and good traits, it is acceptable.

 BAYN ADAM L'MAKOM, BETWEEN YOU AND GOD. You are created in the image of God. That is a good "self-image" to have. Be content with that. If you live a life of constant dissatisfaction, it is, on some level, a rejection of the Creator. It lessens appreciation of the life God has given you, including the ability to enjoy all the richness and beauty of Creation.

In the Torah we are given some special guidelines for living — the Ten Commandments. One of these, "Don't Covet," reminds us that if we are living for what others have, we distance ourselves from what we have and what we can be. As if to serve as a reminder, this tenth Commandment is

placed opposite the fifth Commandment, "Honor your father and your mother," i.e., do not covet another set of parents, do not reject those who created you.

You might so covet a spiritual path, a certain way of living, that you ignore the present. You disregard the godly grace that is inherent in each moment. You might covet spiritual practice in such a way as to become fanatic, extremist in worldview and behavior, intolerant. To "covet" God while discounting others (faiths or people) can ultimately mean discounting God as well.

TEXT STUDY

Tanach

A The first man and woman, Adam and Eve, were warned not to take the fruit from a certain tree, but they were tempted. Not satisfied with their lot, their desire to have more, to "taste" more, got the best of them. They went against God's word and took what was not theirs to take, thus losing Eden.

> **When the woman saw that the tree was good for eating and a delight to the eyes, and that the tree was desirable as a source of wisdom, she took of its fruit and ate. She also gave some to her husband, and he ate. (Genesis 3:6)**

➤ What did Adam and Eve do wrong? Would you agree that according to the Torah, coveting is the first sin? Let's say it is. What is the significance of it being the first sin? In what ways are uncontrolled desire and greed for what is someone else's at the root of the problems in the world?

B The tenth Commandment is *LoTachmod* — do not covet.

You shall not covet anything that is your neighbor's. (Exodus 20:14)

➤ Why do you think not coveting is included in the Ten Commandments? Our Rabbinic tradition says that even though not coveting is the tenth Commandment, it is of primary significance. Do you agree that coveting can lead to breaking the preceding Commandments?

C Ahab's desire for Naboth's vineyard begins innocently enough. But Naboth is not interested in parting with his vineyard. Ahab's desire for the vineyard grows. He complains and pouts. His wife Jezebel gets involved. Things get out of hand. Eventually, Naboth is murdered. God considers the whole episode an abomination.

> Ahab said to Naboth, "Give me your vineyard, so that I may have it as a vegetable garden, since it is right next to my palace. I will give you a better vineyard in exchange; or, if you prefer, I will pay you the price in money." (I Kings 21:2)

➤ Is there anything wrong with what Ahab says to Naboth at first? How might a simple desire begin to turn into something unacceptable? What would make a desire actually become evil? There are innocent (maybe even healthy) desires, and there are desires which can become obsessive and destructive. Do you have a sense of the distinction between them? Explain.

D We use money in exchange for food, shelter, and basic needs. Money can also allow us to enjoy some special treats and indulgences. But the desire for treats and indulgences can get the better of us.

> Those who love money never have their fill of money, nor do those who love wealth have their fill of income. (Ecclesiastes 5:9)

➤ Some people might say that loving money is like idol worship. Do you agree? What is the difference between enjoying money and loving money? Is it okay to enjoy money? What role does money play in being *Samayach B'Chelko* content with your lot?

E It can be tempting to envy someone who sins. The wrong might seem thrilling or pleasurable. We might be curious about what a lawless life would be like. Thus, we are given a specific warning.

> Do not envy a lawless person, or choose any of that person's ways . . . Do not envy sinners in your heart, but only those who are in awe of God, at all times. (Proverbs 3:31; 23:17)

Ben Sirach (*Ecclesiasticus* 9:11) would add:

> You shouldn't envy a sinner, "because you don't know what awaits that person."

➤ Why might someone envy a sinner? What could be the results of being envious of someone who does wrong? Have you ever been envious of someone who sins — someone who clearly behaves immorally?

F Envy is destructive and it eats away at you, affecting the very core of who you are.

> Envy is rottenness in the bones. (Proverbs 14:30)

The Talmud adds:

When people have envy in their heart, their bones rot, but when they have no envy in their heart, their bones do not rot. (*Shabbat* 152b)

➤ Why is envy associated with rotten bones? How can you rise above envy? Once something becomes rotten, is the effect permanent? Explain.

G It seems that we human beings will always see something else that we want.

The eyes of a person cannot be satisfied. (Proverbs 27:20)

➤ Are greed and dissatisfaction just facts of human nature? If so, what can be done about this?

Rabbinic

A Knowing your place and being satisfied with your lot are both included in a list of 48 virtues.

Torah is acquired through 48 virtues: . . . [including] by knowing one's place (*Makir et Mekomo*) and by contentment with one's lot (*Samayach B'Chelko*) . . . (*Pirke Avot* 6:6)

➤ Why are these two virtues necessary for "acquiring Torah"? How might these virtues be important for acquiring peace, for acquiring love of God, for practicing deeds of loving-kindness, for Shabbat and holiday observance? Anything else?

B Richness is not measured by how much money we have, but by how we feel about it.

Ben Zoma taught: Who is rich? Those who are happy with their portion [*Samayach B'Chelko*]. As it is written, "When you eat from the labor of your

hands, happy will you be and all will be well with you" (Psalms 128:2). (*Pirke Avot* 4:1)

➤ How does Ben Zoma define wealth? If someone were to ask *you* to define wealth, what would come to mind first? How important are money and riches for contentment?

C It is easy to become arrogant and judgmental about the world around you and to look down on some people. But the knowledge that all people and things have their place can help you be a more contented person.

Ben Azzai said: Do not despise anyone. Do not underrate the importance of anything, for there is no one that does not have his/her hour, and there is no thing that does not have its place. (*Pirke Avot* 4:3)

➤ What is Ben Azzai's reasoning for not despising anyone and not underrating the importance of anything? Why would he say that it is a virtue to know that things have their place? Would you say the same thing? Do you feel more content when you have a sense that all things have their place?

D All things have their place. Even the smallest creature, an irritating bug, or a dangerous reptile is worthy of existing in God's Universe.

Among all the things which God created in God's Universe, God created nothing that is useless. God created the snail as a cure for a wound, the fly as a cure for the sting of the wasp, the gnat as a cure for the bite of the serpent, the serpent as a cure for a sore, and the spider as a cure for the sting of a scorpion. (*Shabbat* 77b)

➤ Every creature has its place — including us. Do you know your place? Do you feel you have a purpose? In what ways does knowing your place make you happy?

E Rabbi Akiva indicates that present satisfaction influences the future. To guarantee contentment tomorrow, and the next day, and the day after that, we need to work on being content with our today.

> **Rabbi Akiva used to say: If people are satisfied with what is theirs, it is a good sign for them. If they are not satisfied with what is theirs, it is a bad sign for them. (*Tosafot Brachot* 3:3)**

➤ Why is being satisfied a "good sign"? Why is not being satisfied a "bad sign"? Do you agree or disagree that how you feel now about your life is a good indicator of how you will feel in the future? Explain.

F In #E above, Rabbi Akiva calls not being satisfied a "bad sign." Envy is one way a person shows dissatisfaction. There are other "bad signs" that reflect discontentment.

> **Rabbi Elazar HaKappar taught: Envy, lust, and pursuit of honor will ruin a person's life. (*Pirke Avot* 4:28)**

➤ A ruined life . . . isn't that a bit harsh? How might envy ruin life? How might lust ruin life? How might pursuit of honor ruin life? Is it possible to really work on being content? Is contentment an emotion people can control? Explain.

G Take a look at #F above. Then look at the following quotation. It appears as though the camel kind of ruined its life.

> **When the camel demanded horns, they cut off its ears. (*Sanhedrin* 106a)**

➤ Why do you think the camel demanded horns? Was it envious? Was it pursuing honor (jealous of the honor horned animals receive)?

H There are always exceptions. For example, if you envy another's wisdom, that can be a good thing. It may inspire you to increase your own wisdom.

> **The envy of the scribes increases wisdom. (*Baba Batra* 21a)**

A later commentary adds that the same can be said for good deeds and good traits. Being envious of these in another person can help you to improve yourself.

> **A person who sees another learning should generate envy in the heart and say: "That person learns a whole day; I will do likewise." The same applies to all *Mitzvot* and good traits — everyone should envy their neighbors and seize upon their good deeds. (*Orchot Tzaddikim*, in a version edited by Rabbi Gavriel Zaloshinsky, Jerusalem: Feldheim Publishers, 1995, p. 277)**

➤ Do you agree that envy can have positive results? Some say that envy of the wisdom of others, of *Mitzvot* carried out by others, and/or of the good traits which others exemplify can be worthy. Can you add other things that are acceptable to envy? In what ways does what you do with the envy make a difference? Even here, with envying so-called good things, might the envy have negative results? What precautions need to be taken?

The gist of this prayer is: no hatred, no jealousy, follow the Law, and serve God. That seems to be a good formula for contentment.

> May it be Your will, O Eternal my God and God of my ancestors, that no hatred against any person come into our hearts, and no hatred against us come into the hearts of any person, and may no one be jealous of us, and may we not be jealous of any; and may Your Law be our labor all the days of our lives, and may our words be as supplications before You." (Palestinian Talmud, *Brachot* 4:2)

➤ Do you find this prayer meaningful to include as part of your regular worship? What would you add or adjust? Do you think someone whose life reflects the essence of this prayer would be *Samayach B'Chelko* — content?

Post-Rabbinic

A In just a few words, these folk sayings capture the meaning of envy.

> Don't count the teeth in someone else's mouth.
> He is less upset by his poverty than by your wealth.
> Envy turns into hate.
> Envy destroys contentment.
> (Folk Sayings, Leo Rosten, *Treasury of Jewish Quotations*, New York: Bantam Books, 1972, pp. 181-182, o.p.)

➤ Elaborate on what each of these sayings mean. Sometimes a very complex issue can be nailed down in a few brief words. Do you think these sayings are successful in doing so for envy? Explain.

B When you are satisfied with what you have, you will have more time and more energy for

pursuing righteous living and spiritual growth. Get your priorities straight!

> Too many people are worried about their own stomachs and other people's souls, when they should be worried about their own souls and other people's stomachs. (Based on advice from The Kotzker Rebbe, *Fun Unzer Alten Otzar* by B. Jeuszsohn; Warsaw, 1924, ii, 82)

➤ In your own words, what does this mean? In what ways does doing the opposite (worrying about your own "stomach" and other people's souls) tend to make a person less content?

C Envy of friends can be particularly distressing. Such jealousy can be damaging to a friendship, and tends to be self-destructive as well.

> There are some people so foolish that when they see a friend in luck they begin to brood and are so upset and distressed that even the good things they themselves possess no longer afford them pleasure, such is the effect that their friend's good fortune has on them. Of them the wise Solomon said: "Envy is the rottenness of the bones" (Proverbs 14:30). (Moses Hayyim Luzzatto, *The Path of the Upright,* transl. by Mordecai Kaplan, Philadelphia: Jewish Publication Society, 1948, pp. 109f)

➤ How do you feel when a friend is very lucky or successful? How do you handle feelings of jealousy toward a friend? Can jealousy destroy "true" friendships? When friendships unravel because of jealousy, how do the two people involved feel?

ACTIVITIES

Language Arts

 1 (5-10 minutes) According to Text Study, Rabbinic #C and #D, every creature has its place. You can be confident that you, too, have an important place in God's universe! In Text Study, Rabbinic #D, we learn that each creature has a special role, a special place.

As a group or individually, make a list of other animals not mentioned in Rabbinic #D. For each creature listed, describe something unique about it — something special it does, a special role it plays, or a special quality it has (dogs are loyal, sheep have thick fur that can be turned into warm wool, cheetahs are extraordinarily fast, etc.). The last "creature" should be you! What is unique about you, and what is your very special place in God's universe?

 2 (15 minutes) According to Text Study, Tanach #G, our eyes can never be satisfied. Is this really the case?

Without censoring yourself, cut out of catalogues and magazines everything you see that you want. Make a pile of all the items you cut out.

Then read and discuss the verse from Text Study. Could such a thing be said about *you*? Suppose you actually had all the things you cut out. What about you would be the same (even with all your new things)? What would be different? What is most important to you, the things you have or the kind of person you are?

 3 (15 minutes) This sentence completion exercise is a good introduction to the three *Middot* under discussion.

First option: Do this exercise *before* any formal studying takes place. That way initial thoughts are captured. Then participants can see what the tradition says and compare it with their own first impressions. Afterward, look back and see if, after study, any of your thoughts have changed.

Second option: Use the exercise as review and clarification *after* studying what the tradition says. Perhaps you or other participants will answer the questions in ways influenced by what you learned. Or, you may not have been convinced by what the tradition says. You may write something that contradicts what was studied. Create your own commentary by answering the questions.

Complete the following sentences. (Note: Depending on the age group, some questions will be more appropriate and will make more sense than others. Also, limit the length of answers to just a sentence or two.)

To know your place is to . . .
To be content with your lot is . . .
Envy causes discontent by . . .
Envy causes hatred because . . .
Envy is like rottenness in the bones because . . .
Envy in the heart is . . .
A little envy can be good when . . .
Being satisfied is a good sign because . . .
Being dissatisfied is a bad sign because . . .
A person's eyes can never be satisfied in that . . .
A rich person is . . .
Coveting is offensive to God because . . .

An extension: Everyone in the group comes up with one more question related to *Samayach B'Chelko*, *Makir et Mekomo*, or *Lo Tachmod*. The leader collects the questions and photocopies them or writes them on the board. Everyone writes answers to these new questions and shares their responses (or some of them) with the whole group.

 4 (15-20 minutes) The leader hands out copies of the Ten Commandments (Exodus 20) or writes them on

the board. Go through each one and discuss how coveting might lead you to go against one or more of the Commandments. For example, how might coveting cause you to steal or murder? After completing this task, come up with another five or more potential consequences of envy. These consequences could reflect breaking with other commandments (*Mitzvot*) or virtues (*Middot*). For example, you might want something so much that you pressure someone in a way that causes him/her public embarrassment (thus transgressing *Lo Levayesh*). Or, because you covet a fancy new house, you hoard your money, and don't give *Tzedakah*.

Now you are ready to make a list of what could be acceptable envy. Text Study, Rabbinic #H speaks about appropriate envy — envy of wisdom, good deeds, and/or good traits. Give examples of acceptable envy of wisdom (envying another's reading habit, class attendance, getting homework in on time, etc.). Give examples for good deeds (envying another's charitable disposition, frequent visits to the sick, observance of holidays — creating a Pesach *Seder* or building a *sukkah*). Give examples of good traits (envying another's modesty, generosity). Is anything else acceptable to envy?

You now have two lists. The first is clear coveting, the second is (possibly) acceptable envy. Do you feel you have a better understanding of what coveting is? of when envy may be acceptable — or not? From now on, in what ways will you handle these feelings of envy and jealousy? Do you think that someone who knows how to deal with envy is a happier person? Explain.

 5 (20 minutes) In Drama #4, participants rewrite the story from I Kings 21, then act it out. Here participants will do the rewriting, but without the dramatization. When stories are complete, share them and continue with the suggested discussion.

 6 (10-15 minutes) Read over Text Study, Post-Rabbinic #A, which includes several sayings related to envy. Then come up with a few of your own sayings. Make them short and to the point. Cleverness and humor help make a saying "catchy." In a group, share what you wrote.

 7 (15 minutes) Text Study, Rabbinic #I is a prayer. If your life reflects the words in the prayer, you are likely content. We ask God to keep hatred out of our own hearts and the hearts of others, keep us from jealousy, help us live according to God's laws, and accept our prayers.

Now write your own prayer asking for contentment. Are there issues you want to ask God to help you work on? qualities you want to develop? What might you want to thank God for?

Compile the prayers into a class book. Photocopy the book for each student. If you wish, include the prayers in an actual worship service.

 8 (10-15 minutes) Once you recognize what your goals, dreams, and desires are, you can decide how best to shape them into a righteous and meaningful life.

Respond to these questions as quickly as you can to uncover your "gut" attitudes and desires.

a. What are the top 20 things you currently strive for in your life? (Examples: love from family members, job recognition, academic achievement, athletic achievement, solitude, friendship, etc.)

b. What are the top 20 material things you would like to have that you don't have already?

In your lists, with what are you comfortable/ uncomfortable? Why? Is there anything you put down that could cause you to covet? How so? Is this a concern? What do these lists teach about your own personal contentment? Are there changes you think you should make in your life

based on these lists? How can you honor these lists, but still be a person who has control over envy? If desired, compare your list with those of other participants.

An alternative approach to the underlying goal of this exercise is to respond to the following question on three levels. What would make you content/happy:

a. In terms of yourself (physically, intellectually, emotionally, professionally)?

b. In your relationships with others (family, friends, classmates, coworkers, community members)?

c. Spiritually — in your relationship with God?

Let your imagination fly without censorship. Once you have your thoughts on paper, then you can evaluate them.

 9 (15-25 minutes) A variation on #8 above is to write about ways, situations, and places in which you are filled with contentment. Use as much detail as possible — how things look, smell, sound, taste, feel. Try to include at least three scenes: one which takes place by yourself, one with others, and one with God.

In a group, share your writing if you wish. What did this exercise teach you about your attitude toward contentment? Are there any recurring themes? Do you think, overall, you are content with your lot?

 10 (15 minutes) This writing exercise also explores who you are and where you stand.

Write about knowing your place. Where do you feel comfortable? Where do you "belong"? What "belongs" to you? Use as much detail as you like:

a. What physical locations are "your place"? (Outside: a certain spot under a tree? a rock by the river? Inside: the aisle seat in the third row from the front of the sanctuary?)

b. Emotional "places"? (Centered, calm, and collected? Enthusiastic and sensitive?)

c. Intellectual and creative "places"? (Areas of expertise, talents?)

d. Spiritual "places"? (Singing *Shabbat* songs after Friday night meals? Walking in a particular natural setting? Teaching Torah?)

In a group, discuss. Do you know your place? Does knowing your place make you a less envious type of person? Does knowing your place make you more content?

 11 (5-10 minutes) In #10 above, you reflected on your "place." Text Study, Rabbinic #C and #D point out that even tiny or irritating creatures have their place. Here's a lighter way to approach what it means to know your place.

The artist Andy Warhol said that everyone has their 15 minutes of fame. Would it likely have to do with what your "place" is in the world? What is the core of what you stand for? What makes you unique?

Discuss, using questions similar to those at the end of #10 above.

Visual Art

 1 (15-20 minutes minimum) Study the Adam and Eve story (Genesis 2-3). Focus on their temptation to eat the forbidden fruit and on when they do so.

Answer the following: At what point did the desire become so overwhelming that they were ready to disobey God? (That moment may have been different for each of them.)

Now draw the moment that coveting was most intense. Share your artistic interpretations. Try to justify why you chose the moment you did.

More advanced questions: What "voices" cause us to feel the most temptation? Which are hardest

to ignore — our internal desires, curiosity? the voices of others, as in peer pressure? Which "voices" help us to stay on track, to be content with our lot — our inner voice? voices of others (friends, family, coworkers, fellow students)? God's "voice" (guidance we receive from our tradition and from spiritual experience)?

 2 (20 minutes) First, complete Language Arts #7, in which participants created their own sayings related to envy. Then add illustrations.

 3 (10-20 minutes) Being "green with envy" is an abstract idea. There must be a reason why such an abstraction takes hold, why such an expression becomes common. Perhaps the reason is that coveting/envy is more of an internal experience, that it's hard to measure or even identify. If you could begin anew, creating a common image for envy — would it be a color, size, shape?

Start with the idea that envy begins inside of a person. When we imagine feelings — the origin of emotions, we think of the heart. When someone is envious, how do you picture that person's heart? Is the heart "turning green"?

One option: In an encyclopedia or anatomy book, find a picture of a human heart. Divide a piece of paper in half. Copy or draw an outline of the heart on each side. Everyone will have one piece of paper with two outlines of a heart shape. Label the outlines "Envy" and "Contentment." The leader may wish to prepare this beforehand (photocopying the outline shapes is fine).

Now, you are ready to color in the hearts. Color the first one the color of envy. It doesn't have to be just one color. Make it appear as envious, jealous, coveting as possible. Then, color the second heart. Make it the color(s) of contentment.

Simpler option: Instead of two heart outlines, make two simple whole body outlines. As above, fill one in with the color(s) of envy. The person is turning . . . what color(s) . . . with envy? Fill the second with the color(s) of contentment.

Share your drawings and discuss. What color(s) did you choose for your hearts (or bodies), and why? Do you like the saying "green with envy" — does it ring true? In actuality, our hearts are pinkish red. But what if you were to assign the *idea* of color to your heart, the abstract association? If someone was said to have a "black heart," what would you take that to mean? How about a "white heart"? A "bright red heart"? What color(s) is your own heart most of the time?

4 (15 minutes or more) The above activity focused on the saying "green with envy." There's another fairly common image associated with envy. In a story, as a conflict is being set up, the narrator might say, "And the seed of jealousy was planted . . ." Anyone reading those words knows that trouble lies ahead — it's a seed now, a strangling plant down the road!

Draw a "seed of jealousy" on a piece of paper. Then, on the same piece of paper, draw other versions of it as it develops. Create three to five pictures of this "jealous seed" as it grows into a full-sized plant (or creature or contraption). What exactly will come of this jealousy seed? In order to decide how to shape it, you may want to think of the situation causing the jealous seed to appear in the first place. A seed of jealousy planted over money may "grow" differently from one planted over love.

As each group member shares what he/she made, others can comment on what they see. The artist can then explain his/her vision and inspiration. What makes a "jealousy seed" grow? What makes a "jealousy seed" stay just as it is — a seed?

 5 (15 minutes minimum) Envy is so destructive that it is associated with "rottenness in the bones" (see Text Study, Tanach #F).

Make a picture that depicts rottenness. The picture acts as a metaphor for envy. Possible subject material: a bowl of rotten fruit, moldy cheeses, rotting bones, a refrigerator full of rotten food, flowers rotting on a grave.

Yes, the subject material can be rather disgusting, but that's the point of the metaphor. Even the ancient image of rotting bones, from Proverbs, is blatant and off-putting. If depicting something in art causes an unsettling reaction, perhaps that is its lesson for us. Shouldn't we react to envy with an equal amount of disquiet? Putting the image in front of our faces makes us "see" just how "rotten" envy is.

Discuss reactions to this exercise. Should you try to make art "pretty"? For what reasons can you justify drawing or painting disturbing subject matter? How well do you think the paintings serve as "lessons" on envy?

 6 (10 minutes or more) Activity #5 above focused on one verse about envy from Proverbs. Consider also Text Study, Tanach #G.

Draw or paint these dissatisfied "eyes." What do they look like? Are they very big? Do they take up most of a face, even "spill over" the edges or surface of the face? Do the tiny red veins stretch out beyond the eye, like little grabbing fingers and hands? Is the pupil like an endless tunnel, a never ending black hole, a vacuum?

Continue with discussion along the lines of the one at the end of #5 above.

 7 (20 minutes or more) When we are overwhelmed with envy and discontented with our lives because of jealousy eating away at us, everything becomes

"all out of proportion." This jealousy distorts our vision, preventing us from "seeing straight." In this exercise, we explore on an artistic level what distortion means and what it looks like.

There are two parts to this exercise: a general exploration of distortion, and the creation of a specific scene.

First: On a large sheet of paper, experiment freely with distortion. Make a number of small drawings (5 to 10), filling the page. Start with a simple shape of a recognizable object. Then, draw another version of the same shape — a distorted version. Somehow change the shape so that it becomes "out of proportion." Some simple shapes to try: a pear, balloon, stop sign, wheel, flower, leaf, cup, shirt, hat, guitar, ladybug, ice cream cone, moon, sun, kite, hand.

Second: Create a more composed scene. Draw or paint a picture of someone wanting, coveting a specific item(s). Make the human figure and object(s) you draw recognizable, yet distorted somehow. The human figure desires something (or someone). That extreme, covetous desire has created the sense of "things being out of proportion." That sense will affect the way you depict your subject material.

In a group, share your artwork. How did you explore the idea of distortion? What various ways of distorting did different participants come up with? Which way seems best to capture "out of proportion" as it relates to envy (really big or oversized; lopsided; sharp, frayed, or ragged edges)? Explain. What does it mean to "see straight"? What does "seeing straight" have to do with being content?

Drama

 1 (10 minutes) Coveting is internal. We feel envy inside. Mental attitude and feelings help define what is envy and what is not. Even so, envious feelings can leak out. An underlying attitude of jealousy just might be detected.

In this exercise participants act out what coveting looks like. This attitude of coveting is contrasted with one which reflects contentment — someone who is *Samayach B'Chelko*.

Everyone sits in a circle. The leader imagines a large box is behind him/her filled with all kinds of wonderful treasures. He/she takes one thing at a time out of the box to pass around the circle. Here are some suggestions for imaginary items to pass around: a diamond necklace, a trophy, a bar of gold, the autograph of an admired person, a photo of someone you love, a new puppy, a crown. Solicit ideas from the group, as well. The leader announces what the object is before passing it around. The imaginary item will take two "trips" around the circle. The first time, participants should receive the item as if they covet it — as if they really, really want it. They do this nonverbally. They should look and touch the imaginary item with aching desire and envy.

When the item gets back to the leader, the leader changes the mode of passing. For the second "trip" around the circle, participants are to receive, look, touch, and pass the item as if it is *not* coveted. It is seen through the eyes of someone who is content with their lot. Does that mean the item can't be admired? Does that mean there can't be interest in the item? Experiment with what it means to look at items in a variety of ways that are not covetous, envious, or overwhelmed with desire.

Discuss the experience. In what ways did the exercise help you understand the meaning of coveting? How does someone who is basically content look at desirable items? Can you control feelings of envy and desire? Assuming you *can* control these feelings, how do you go about doing so?

2 (10 minutes) How you really feel about your personal circumstances may show in the way you walk, talk, and carry out tasks. When you are discontent, you may think you can keep your feelings hidden, and perhaps sometimes you can. But, most likely, if you are unhappy and dissatisfied, those feelings do come out on some level. You might be brusque or apathetic. You might overcompensate for your feelings and be falsely enthusiastic, even hyper. You might move slowly and be prone to tearfulness.

Come up with a few short scenes. Each one will include an entrance and a small task. Some examples:

a. Enter the classroom. Take your seat. Open your desk, and take out paper and pencil.

b. Enter your home. Hang up your coat in the closet. Go into the kitchen and pour yourself a glass of water.

c. Enter your high-rise office building. Go up the elevator to your floor. Get out. Stop by your mail slot and collect your mail. Go to your desk and sit down.

d. Your ideas . . .

Now choose an actor who is to complete a given scene twice. The first time the scene is done as if the actor is not *Samayach B'Chelko* (content with his/her lot) and/or does not *Makir et Mekomo* (know his/her place). The second time the actor *does* show contentment and clarity of purpose.

Give several actors the opportunity to perform. Each actor should try to come up with distinct ways of portraying the scenes. The performances should reflect different and new interpretations.

Discuss. What are all the ways observers saw discontentment being portrayed? What about contentment? What are some strategies for handling feelings of discontentment? Which are the best? Sometimes feelings of discontentment indicate that you need to make a change. How do you figure out when you should strive to feel more content in your current situation versus when you should make changes? Do you have a process for evaluation that works for you?

3 (15-20 minutes) Study Genesis 3, in which Adam and Eve eat fruit from the forbidden tree. Was coveting the reason for their banishment? (For further discussion questions, see Text Study, Tanach #A.)

Have two actors portray Adam and Eve following their banishment from the Garden of Eden. They improvise a conversation (an argument?) about whether or not coveting was the reason they were banished from the Garden of Eden. After a few minutes of improvising, open the scene to audience questions. Adam and Eve remain in character. Audience members can ask anything they want. For example, they may ask Adam or Eve a clarifying question, challenge them on one of their points, make a comment for one or the other to respond to, etc. Repeat the experience a couple of times, giving a few individuals an opportunity to play the scene.

Share reactions. Any new thoughts or conclusions about Adam and Eve? Any new thoughts or conclusions about coveting?

 4 (30 minutes) Refer to Text Study, Tanach #C, the story of Ahab's desire for Naboth's vineyard. His desire becomes overwhelming and tragedy follows.

Read over the whole story from I Kings 21. Rewrite it as a script, changing the setting to a modern one. (Individuals can work alone or in a small group.) Base it on a real situation (perhaps a political one) or on an idea you come up with from your own imagination. A few examples of possible settings:

a. In an area of prime real estate, one neighbor wants and seeks to purchase the land adjacent to his/her property. But the other landowner does not wish to sell.

b. One country wants a certain strip of land that belongs to the adjacent country.

c. One teenager wishes to date a classmate's girlfriend/boyfriend.

After the scripts are complete, stage and rehearse the skits. Groups can work on their own or under the direction of a leader. Perform the skits and share reactions. Discuss: Do you think that what happened in Ahab and Naboth's time could happen just as easily today? Why or why not?

Movement

1 (20 minutes) We have needs, and it is natural to want certain things. But the spectrum of wanting is wide. It stretches from wanting the basics to being attracted to some comfortable extras, desiring, envying, and coveting. We have a variety of words for wanting that conveys differences in meaning. But the differences aren't so clear-cut. What one might call "being attracted to a few comfortable extras," another might call "coveting." Thus, another level of exploring differences in meaning might be helpful — a nonverbal level.

Think of the spectrum from merely wanting all the way to coveting. It is like being drawn toward something with varying degrees of intensity. As a warm-up, experiment along these lines. Start on one side of the space. Imagine something you want is on the opposite side. Move across the room as if you are being drawn toward the desired object. (Two or three people can move across the space at a time.) Do this several times, choosing some of the following variations:

a. With various degrees of intensity/speed (slowly, quickly, strongly, weakly)

b. With various parts of your body (hands, head, heart, hips)

c. Being pulled while maintaining self-control

d. Being pulled and losing control

e. Being pulled intentionally

f. Being pulled, caught by surprise.

Younger groups can end now after this warm-up, and discuss what the differences are in wanting things, what's acceptable and what's

not. More advanced groups can go further. Imagine one side of the room is the object of coveting, the other side is the opposite. Define these in your own mind. Then experiment with being pulled to one side and the other. You are exploring feelings of coveting, of wanting very much, versus resisting and controlling impulsive desires.

A variation: Change this improvisation from a solo to an ensemble experience. Have two dancers be the "sides" — one portrays the coveted object, the other portrays the opposite. These will need to be defined for them. In other words, what is the coveted object and what is the opposite? The third dancer is "pulled" between the other two dancers, who are representing the sides. That is, the third dancer goes back and forth between wanting one "side" (dancer) so badly versus resisting and controlling impulsive desires toward the other "side" (dancer).

Discuss. What did you experience? Are there different ways of being "pulled" by desire. Can you define some of the ways? What new insights did you discover as you moved? When does simple wanting or innocent desiring turn into something that is unacceptable, more ominous?

 2 (5-10 minutes) You can dwell overly much on "how I should be/how I wish I were," causing you to become distant from your true nature. That doesn't mean you shouldn't strive to improve, to fulfill *Mitzvot* and master *Middot*. Rather, it means that everyone has a soul, a God-given essence that is worthy of honor. You can reach for things and strive for improvement, but if and when you get "thrown" off center, you've gone too far. In movement terms — don't lose your center.

Experience what it means to maintain your center. Contrast that with reaching in such a way that it throws you off center:

a. Walk normally throughout the space.

b. Walk reaching. Start by reaching with just one part of the body at a time. Then reach with all parts of your body at the same time.

c. Walk and exaggerate the reaching.

d. Walk and exaggerate the reaching to such a degree that it pulls you off center.

Discuss. Define the differences you felt in the various walks. How can you "reach" and still be self-accepting at the same time? When does "reaching" become coveting? Which kind of walk is the best metaphor for living a life that combines contentment and growth? Explain.

 3 (5-10 minutes) As in #2 above, this exercise explores what it means to be pulled off center.

Divide the group into pairs. Person A plays him/herself. He/she takes a statue-like pose. This statue should be stable, grounded, centered, sturdy. Person B is like a magnet to which Person A must respond. Person B is imagined to be some sort of attractive quality that Person A desires (being infinitely beautiful? infinitely patient? very popular and beloved?). Person B tries to destabilize Person A — tries to influence him/her, pull him/her off center. Person B experiments with destabilizing his/her partner by using (imaginary) magnetic pull of various strengths. The "pull" might be steady or percussive. The technique might include pacing around the "statue," stomping around it, pausing and staring. (The leader should decide beforehand whether the group is mature/advanced enough to use touching.) Improvise for a couple of minutes. Then switch roles and repeat the activity.

Discuss. How did you feel in the presence of your "destabilizer"? How did you deal with your conflicting emotions — on one side your desire for the attractive quality, and on the other side your belief that you are a person centered in your own right, just fine the way you are? What do you think is the best way to deal with these con-

flicting emotions? Did you learn anything about what it means to be true to yourself? Is this the same thing as "knowing your place"?

 4 (10 minutes) What does it mean not to covet, in relationship to God? One possibility is that it means being in the present moment, appreciating the here and now, being content with your lot. You feel gratitude for all that God has given you — the enjoyment of creation, opportunities to love, learn, and grow.

The most obvious way to appreciate the wonder of the present moment is to begin with ourselves, with our very bodies. (A similar exercise is found in Movement #4 in Chapter 19, Shmirat HaGuf: Taking Care of Your Body.) Here's a modern translation of a morning prayer in which we thank God for our bodies.

Blessed is our Eternal God, Sovereign of the Universe, who has made our bodies with wisdom, combining openings and closings — arteries, glands and organs — into a finely balanced network. Should but one of them, by being blocked or opened, fail to function, it would be impossible to exist (to stand before you). Wondrous Fashioner and Sustainer of life, Source of our health and our strength, we give You thanks and praise.

Improvise as if you're discovering for the first time the essence of this prayer:

a. All the connections and all the openings and closings of the body.

b. If some part of us were open that shouldn't be, or closed that shouldn't be, we wouldn't be alive — be able to "stand before You."

c. We are a finely balanced network.

Share reactions. Appreciating what your body can do is one way of being in the present moment.

What are other ways? What do you think it means not to be covetous in your relationship with God?

 5 (10 minutes) Envy can destroy relationships. In a folk saying, we are warned that envy can become hate (see Text Study, Post-Rabbinic #A). The Jewish thinker Moses Hayyim Luzzatto speaks about our reactions toward friends in luck (see Text Study, Post-Rabbinic #C).

Do this loosely structured improvisation in pairs. The pairs can all improvise at the same time, or some can watch while others perform. Here are the general guidelines:

a. Begin by moving together as if you are good friends.

b. Very slowly, envy begins to creep into the relationship. One friend wants something of the other. (Or, the friends *both* want something of each other.) The wanting grows, and the envy becomes more and more hateful.

c. The improvisation must work itself to a conclusion. This is for the pairs to discover. Can trust be rebuilt? If so, how? Does the hate become so deep, so destructive that a return to close friendship is impossible? Any chance for reconciliation? How about a cool truce?

Discuss the improvisations. How did you conclude yours? What did you do with the envy that had entered the friendship? How destructive is envy — is there a point when you can no longer turn it around, when you can no longer return to trust and closeness? Any lessons to be applied to "real life"?

Music

 1 (10 minutes) Everyone has his/her hour, everything has its place (see Text Study, Rabbinic #C). Here's a light way to explore what it means *not* to know your place — perhaps not even to have a place! For

the most part, when you don't know your place, you lose.

Play *Musical Chairs*. Set chairs in a circle facing out rather than in. Set up one less chair than there are participants. Begin playing music while participants walk in a circle around the chairs. After a short while, stop the music. Everyone tries to take a seat. One person will be out. Remove another chair from the circle and repeat the game until just one person is left.

Talk about the game from a Jewish perspective. What happens when people don't know their places? Why is it a Jewish value to know one's place, *Makir et Mekomo*?

 2 (5-10 minutes) There are sayings and images associated with envy. These sayings can be given a musical interpretation using simple percussion instruments. Improvise for a minute or two on Text Study, Post-Rabbinic #A, Tanach #G, or one (or more) of the following:

a. He (or she) turned green with envy.

b. A seed of jealousy was planted.

c. Those who love money never have their fill of it . . . (Ecclesiastes 5:9)

Contrast sounds of the above quotations with the two below. Improvise interpretations of:

a. "Who is rich? One who is happy with his/her portion." (*Pirke Avot* 4:1)

b. "There is no thing that does not have its place." (*Pirke Avot* 4:3)

Discuss. What distinguishes the sound of envy? of contentment? What did looking at envy and contentment through the "window" of music contribute to your understanding of these feelings?

 3 (5-10 minutes) There's such a range of music available to us. But more, there are all kinds of noises, all kinds of distractions. Are we able to

focus enough to listen for the voice of God in the midst of our surroundings? Are we able to sing out in prayer? Can we maintain a relationship with God despite the "noise"? Or, will we be tempted to abandon a disciplined focus? Will we covet other "sounds," covet other voices?

Choose a simple *niggun*, a wordless melody. One person will begin singing this *niggun*, repeating it over and over. This singing of a *niggun* represents focusing on a relationship with God. Singing the *niggun* reflects following a Jewish way of life.

A second person gets into the act. This person is going to try to throw the *niggun* singer off. This second person can make whatever noises he/she wants to distract the singer. The distractor might use conflicting rhythms, sounds of laughter, loud singing of popular songs, etc.

Repeat the whole exercise a few times with different singers/noise makers.

Discuss. Was it difficult to keep singing the *niggun* when someone was trying to throw you off? Did you feel tempted to join in with your distractor? Did you envy your distractor? Why or why not? What did those watching observe? Describe some of the challenges you have in being content with who you are and with your relationship with God. What temptations tend to throw you off, making you feel discontent? What is the best way to respond to such temptations?

Miscellaneous

 1 (10-15 minutes, includes a bit of preparation on one's own beforehand) Even though this is the last exercise in this chapter, it presents a beginning way to address the question of what coveting is. It draws on our own personal experience as the starting point for discussion. How have we dealt with our wants and desires in the past?

There are things we may want that we need in order to survive. There are things that can make

our life more comfortable. Fantasizing or dreaming can be a healthy way to motivate, experiment, and inspire creativity. But coveting is forbidden. How do you define the difference between coveting versus legitimate wanting, fantasizing, or dreaming?

As preparation, bring to the next session (or make a mental note of) something you acquired out of a desire so strong that you're a little uncomfortable about it. You may have gotten obsessive about possessing that item. Or, you may feel that the acquisition reflects an unsettling amount of frivolity or greed.

Also as preparation, make a mental note of something you could justify acquiring, but that you haven't acquired because you feel it would be overly frivolous or greedy.

When the group reconvenes, share what you prepared. Explain your feelings about the acquired and non-acquired objects. Then discuss the difference between coveting versus legitimate wanting, fantasizing, or dreaming. Take a look at what Jewish sources say about coveting, too. Remember that "Do not covet" is the last of the Ten Commandments. The first is "I am the Eternal your God . . . " Consider: Coveting is the kind of wanting that leads you away from God, from the good way of living. (See also the section in the Overview on *Bayn Adam L'Makom.*) When does wanting or desiring begin to lead you away from God? Can fantasizing and dreaming lead you away from God?

SAYVER PANIM YAFOT: A PLEASANT DEMEANOR

סֵבֶר פָּנִים יָפוֹת

OVERVIEW

A demeanor is an attitude, one's apparent mood. "A pleasant demeanor" is a succinct (though not literal) way to explain *Sayver Panim Yafot*. The essence of this virtue is to greet every person cheerfully, to be warmhearted in the company of others, to show friendliness. And those qualities could be extended: be a nice person, try not to be grumpy or grouchy or sour or bitter, don't snap at people. Let your best inner spirit shine through.

"*Sayver*" means "brighten," "*Panim*" means "face," and "*Yafot*" means "lovely." One could say that *Sayver Panim Yafot* means "put on a happy face." Yet, showing a superficial pleasantness is only a start. Ultimately, what is wanted is for pleasantness to become second nature — a pleasant face should reflect sincere and inner warmth. Our outsides should reflect our insides; what we display should emanate from how we feel.

There's an element of eagerness to this virtue. Don't wait for others to be pleasant first; take the initiative in extending warmth. We have all heard (or made) the complaint: "I went to such and such a place, but no one was very friendly to me." According to tradition, the onus is on us. As nice as it might be for others to greet us, our obligation is to be willing to make the first move. Accusing others of not being friendly misses the point. Worry about yourself. Make sure you nurture and demonstrate your own personal attitude of warmth and friendliness.

We read about cheerful greetings in stories as old as the book of Genesis. Abraham, Esau, and Laban all *run* to offer greetings. They take the initiative. They don't wait around for others to be pleasant first. Being pleasant is not something to turn on and off. Warmth and cheerfulness come naturally to many in the ancient world. So, too, should we strive to make these qualities part of ourselves.

The sages, during Rabbinic times, encourage the practice of *Sayver Panim Yafot*. "Greet every person with a pleasant face," they say. "Receive every person in a cheerful manner . . . be the first to extend greetings to every human being." (*Pirke Avot* 1:15; 3:16; 4:20)

There is a difficulty with this virtue. Should we "put on a happy face" even if we're feeling low and out of sorts? Are we asked to "fake it," even though many psychologists and therapists tell us not to suppress things, not to hide how we're really feeling? Aren't we supposed to be honest about our thoughts and feelings?

All that may be so. But those concerns don't necessarily have to conflict with the virtue of *Sayver Panim Yafot*. This *Middah* does not demand that we deny our feelings, that we never become sad or distraught. It tells us that even at low ebb, there are boundaries. Be sad, grieve, mope, do what you have to do, but don't allow your low times to dominate you so much that your interactions with others become poisoned.

How about anger? Should you never be angry, pretending that nothing is wrong when something really is? Should you hold it all in, and just smile? No. That's not what *Sayver Panim Yafot* is about either. There's another virtue that helps us know

what to do with anger. When we neutralize anger with *Sayver Panim Yafot*, with a pleasant demeanor, the result is *Erech Apayim* — slow to anger (see Chapter 7). Anger can be real, strongly felt. But a dose of pleasantness can help keep it under control, slow it down. It can help make anger a tool for improving things, rather than a prelude to violence.

In our sacred literature, we come across the expression "God's face." The image conjures up light. In the Priestly Benediction, the expression is "May God's face shine on you . . . " (Numbers 6:24). We know about human shining faces. We may have seen people whose faces seem to radiate as if an inner light came through in their smiles, a twinkle in their eyes, an easy expression of kindness and gentleness. We may say that such a light is the light of the soul — the divine spark within us. The soul can reflect God's light. So, what is *Sayver Panim Yafot* on the highest level? It is a divine reflection — an aura of sorts. Our face can reflect "God's face."

Below is a succinct presentation as to how this *Middah* applies in our relationships to other people, to ourselves, and to God.

 BAYN ADAM L'CHAVERO, BETWEEN PEOPLE. A pleasant demeanor suggests a certain attitude toward people. Ideally, it involves greeting every person cheerfully, being warmhearted in the company of others, showing friendliness, being a nice person, trying not to be grumpy or grouchy, sour or bitter, or short with people. When this *Middah* becomes a way of being, second nature, it is as if one's spirit shines through.

 BAYN ADAM L'ATZMO, BETWEEN YOU AND YOURSELF. Showing pleasantness to yourself. Don't be overly self-critical. Be nice to yourself. Enjoy your own company.

Also, when you strive to be pleasant toward others, it can change your mood, your demeanor.

Efforts to be overtly cheerful and friendly can have an influence on the inner you.

 BAYN ADAM L'MAKOM, BETWEEN YOU AND GOD. What is it to have a pleasant demeanor toward God? Does this mean you can't be yourself — confiding, complaining, crying out to God? No, expressing yourself honestly doesn't have to conflict with *Sayver Panim Yafot*. The point is that you can make heartfelt communications with God more meaningful by being present before God with a pleasant demeanor. You can relax. Soften your face, ease the tense expression in your eyes, your mouth, your jaw. When you are pleasant before God, it is like an openness. You aren't entrenched and unmovable. You open up your face to the "face of God." Such openness readies you for God's warmth and God's light.

TEXT STUDY

Tanach

A An underlying message in the story of Cain is the necessity to master our "face" — the expression, the feelings behind it.

> **Cain was much distressed and his face fell. And the Eternal said to Cain, "Why are you so distressed, and why is your face fallen? Surely, if you do right, there is uplift. But if you do not do right, sin crouches at the door. Its urge is toward you, yet you can be its master." (Genesis 4:5-7)**

➤ What does Cain's face reveal? What is God's advice concerning a "fallen face"? How can Cain keep his face "uplifted"? What is the connection between mastering your face (its expression, the

feelings underneath) and mastering sin? Is God's advice for Cain as relevant today as it was back then?

B Some of our biblical ancestors knew what it means to greet another with warmth. There's a value these individuals seem to understand that is recorded in *Pirke Avot* (many hundreds of years later) — the merit of being "the first to extend greetings to every human being." (*Pirke Avot* 4:20)

> Looking up, [Abraham] saw three men standing near him. As soon as he saw them he ran from the entrance of the tent to greet them . . . (Genesis 18:2)

> When Lot saw [the two angels], he rose to greet them. (Genesis 19:1)

> Rachel came with her father's flock [to the well], for she was a shepherdess. And when Jacob saw Rachel, the daughter of his uncle Laban, and the flock of his uncle Laban, Jacob went up and rolled the stone off the mouth of the well, and watered the flock of his uncle Laban. Then Jacob kissed Rachel, and broke into tears. (Genesis 29:9-11)

> On hearing the news of his sister's son [Jacob's arrival], Laban ran to greet him; he embraced him and kissed him, and took him into his house. (Genesis 29:13)

> Esau ran to greet [his brother Jacob]. He embraced him and, falling on his neck, he kissed him; and they wept. (Genesis 33:4)

➤ What is the style of the greetings these characters give? Why did several of them "run" to make their greeting? What do these greetings reflect about the characters' personalities/dispositions?

C When a person presents pleasantness and warmth, it can be like seeing the face of God.

> Jacob says to his brother Esau: "To see your face is like seeing the face of God . . . you have received me favorably." (Genesis 33:10)

➤ Why does Jacob say to his brother that seeing his face is like seeing the face of God? (More insight will be gained by looking at the story in its fuller context in Genesis 33:1-17.) What is meant by the "face of God"? Do you think it is possible to see the "face of God" in another human being?

D Moses had a very close relationship with God. After he presented himself before God, his face became radiant. It shone so brightly that he had to wear a veil in front of other people. Perhaps when we are deeply connected with God, others can see it in our face. They can see God when we greet them. The need, however, to wear an actual veil is unique to Moses. For most people, God's glow in a person's face is more subtle, more gentle.

> Whenever Moses went in to speak before the Eternal God, he would leave the veil off until he came out, and when he came out and told the Israelites what he had been commanded, the Israelites would see how radiant the skin of Moses' face was. Moses would then put the veil back over his face until he went in to speak with God. (Exodus 34:34-35)

➤ Why was it necessary for Moses to wear a veil over his face? What kinds of experiences make your own face shine?

Psalms asserts that we can experience God's radiance as well.

People look to God and are radiant; let their faces not be downcast. (Psalms 34:6)

➤ Have you ever experienced God's radiance? Explain.

E In the Priestly Blessing, the word "face" is mentioned in connection with God. Just as God's "face" shines upon us and is gracious toward us, so should we greet others with shining faces and show graciousness. As God lifts God's face toward us, granting us peace, so should we show our godly best and be messengers of peace.

May God bless you and protect you. May God make God's face shine upon you and be gracious to you. May God lift God's face toward you and grant you peace. (Numbers 6:24-26)

➤ Is God's face actually a face as we understand the word, or does God's face indicate a more general sense of God's presence? What part does "God's face" play in the Priestly Blessing? In what ways should we make our faces like "God's face"?

F You can actually see wickedness in a person's face.

The wicked person is brazen-faced . . . (Proverbs 21:29)

➤ What kind of facial expressions are associated with someone who is wicked? Have you ever seen wickedness in a person's face? Describe the situation.

G A face reflects a person's intelligence and disposition.

Wisdom lights up a person's face, replacing the face of deep discontent. (Ecclesiastes 8:1)

➤ Have you ever seen wisdom in a person's face? discontent? Describe these situations. How might wisdom change feelings of discontent?

Rabbinic

A These words from *Pirke Avot* get directly to the point:

Greet every person with a pleasant face . . . Receive every person in a cheerful manner. (*Pirke Avot* 1:15; 3:16)

➤ Why is it said that every person should be greeted in a pleasant, cheerful manner? Is that realistic? How diligent are you about giving such warm and friendly greetings?

A comment on the above verses takes the idea of pleasantness even further.

If you give your fellow person all the best gifts in the world with a grumpy face, Scripture regards it as if you had given the person nothing. But when you receive your fellow person with a cheerful face, Scripture credits you as though you had given the person all the best gifts in the world. (*Avot de Rabbi Natan* 13, 29a)

➤ What does the commentary say to emphasize the importance of a cheerful face? We speak about the "gift of a smile" or the "gift of laughter." Do you consider these gifts? Would Rabbi Natan (the author of the above commentary passage) consider these gifts?

B *Sayver Panim Yafot* should not be simply a reaction you give to another person.

Be the first to extend greetings to every human being. (*Pirke Avot* 4:20)

➤ Why be "the first"? Do you know people who are usually the first? Do you consider their manner to be praiseworthy? Are you the type who goes "first"? If not, how might you try to be?

A comment on the virtue of being first to extend greetings:

> Rabbi Helbo said in the name of Rabbi Huna: "When you know that your friend is in the habit of greeting you [saying, 'Peace be to you'], you should greet the friend first, for it is said, 'Seek peace and pursue it'" (Psalms 34:15). (*Brachot* 6b)

➤ Two ideas are mentioned: be the first to extend greetings, and seek peace and pursue it. What do the two ideas have in common?

Another comment that highlights the accomplishment of one sage in the area of enthusiastic greetings:

> It is said of Rabbi Yohanan ben Zakkai that no one ever greeted him first, not even a non-Jew in the market place. (*Brachot* 17a)

C You may think that if you're always trying to be pleasant, you're bound to become a phoney. Rabban Gamliel II has a response for you — the pleasantness on the outside must reflect who you are on the inside.

> Rabban Gamliel II used to say: "No pupil whose 'inside' is not the same as the pupil's 'outside' may enter the house of study." (*Brachot* 28a)

> Rabban Gamliel used to say: "Act in secret as you act in public." (*Avot de Rabbi Natan* 32, 36a)

➤ What is the point of such sayings? To what extent should you try to act pleasant, even if you're not feeling pleasant? If you're feeling grouchy, might an effort to behave pleasantly on the outside help you to feel more positive on the inside?

D A Rabbinic work views Joseph as an exemplar of *Sayver Panim Yafot*. He greets those who despise him, and he greets fellow citizens even after he rises to a position of prominence. God considers such behavior most worthy.

> And [Joseph's brethren] hated him and would not return his greeting [literally, could not speak peaceably to him] (Genesis 37:4). Joseph used to greet them, but they would not respond. It was always his custom to greet them. There are folk who, before rising to greatness, will always greet other people, but when they attain to greatness, their spirit becomes haughty, and they pay no heed to greet fellow citizens. Joseph was different. After he had risen, he still greeted others (Genesis 43:27). God said to him, "Joseph, because you took the initiative in greeting your brethren in this world even though they hated you, I will reconcile you in the world to come, and remove hatred from among you, and settle you in amity," as it is said, "How good it is when brethren dwell peacefully together" (Psalms 133:1). (*Tanchuma*, Buber edition, *Vayeshev* 90b)

➤ What does Joseph do that is considered so worthy? Should prominent people have an extra obligation to greet their fellow citizens? Why or why not? Is greeting people who hate you a good thing to do? Why or why not? To what extent can warmth, pleasantness, and friendliness dissolve hatred?

Post-Rabbinic

Rabbi Arye Levin of Jerusalem took seriously some Rabbinic advice — to receive each person cheerfully and to be the first to greet everyone (see Text Study, Rabbinic #A and #B).

I was careful to receive everyone cheerfully, until this became second nature to me. I was careful, too, to take the initiative in greeting everyone. (*A Tzaddik in Our Time*, p. 464, as quoted in *Jewish Spiritual Practices* by Yitzchak Buxbaum, p. 216)

A comment on the above:

When he greeted someone, Reb Arye would take that person's hands in his own and hold them in a loving, caressing way that would be electric with holiness, sending God's energy directly into [the person's] heart. There are many other *tzadikim* who have taught by their example, too, how in a greeting, we should focus lovingly on the person we are with. (Yitzchak Buxbaum in *Jewish Spiritual Practices*, p. 216)

➤ How can receiving others cheerfully be a holy act? If a virtue doesn't feel natural to you, how long should you persist in going through the motions? How well do you focus lovingly on the people with whom you spend time? What lesson(s) can be learned from Reb Arye?

ACTIVITIES

Note: Many activities in Chapter 16, "Hachnasat Orchim: Hospitality," can be adapted effectively for this chapter as well.

Language Arts

 1 (5 minutes) Make a list of all the ways you can think of to offer a greeting. First, list as many words and phrases as you can think of (Hello, Hi, Good Morning, How's it going, etc.), and second, list gestures or actions (waving, smiling, nodding your head, etc.).

Discuss how such greetings usually reflect a pleasant demeanor, which is a virtue. Could a person say the same words or make the same gestures in ways that are not especially pleasant? Can making an effort to give warm and cheerful greetings help you become a more pleasant person in general? Can "practice" make *Sayver Panim Yafot* begin to feel more and more natural?

 2 (10-15 minutes) It's difficult to be pleasant all the time, but most of us probably could increase the number of minutes in a day when we present a pleasant demeanor. To do this, we must recognize patterns in our behavior — when we are grouchy and when we feel pleasant.

Write without stopping, for a few minutes on each of these two topics. First: "I get grouchy when . . . " Second: "It's easiest for me to be pleasant when . . . "

An easier variation: Simply hold a discussion using the above questions.

Identify any patterns or themes in your writing. Are there any surprises? What stands out most as the thing that inhibits pleasantness? What stands out most as the thing that increases your desire or ability to be pleasant? Write a contract with yourself, specifying how you will incorporate the virtue *Sayver Panim Yafot* into your life.

3 (15 minutes or more, not including travel time) How do we greet others warmly? How do we receive others cheerfully? A crash course in greetings can be found at an airport, train, or bus station, or in a coffee shop. Relying on your own observation skills, watch meetings and greetings closely in order to learn about different nuances and varieties. Record in a journal what people say verbally, as well as their nonverbal expressions and body language. How do the greetings of children compare with those of adults? How do the greetings of people who seem to be related compare to those of people who are not related?

Which greetings were your favorite/least favorite, and why? What did you learn from watching a variety of greetings? Did you have any insights that increase understanding of the virtue *Sayver Panim Yafot*?

4 (10-20 minutes) You probably know many people who exhibit the virtue of *Sayver Panim Yafot*. Perhaps there's someone who always makes it a point to greet newcomers at worship services. Maybe you have a teacher who stands by the door in the morning, warmly welcoming each student, a bus driver who greets his/her passengers as if their arrival on the bus makes the whole profession of driving a bus worthwhile.

Hold a discussion based on these individuals, or write portraits of people who exhibit the best in *Sayver Panim Yafot*. Try to be specific. What do these *Sayver Panim Yafot* "champions" do? How do they make other people feel? How do they make you feel? Why is what they do important, worthy? How do you think these people feel about themselves? What one thing does that "champion" do that you would like to begin doing?

5 (10 minutes) A difficulty is raised in the Overview. Should you try to be pleasant, or warm and cheerful even if you're feeling low? Hold a discussion or debate on this issue. Refer to the Overview for some ideas.

6 (15-20 minutes) In Text Study, Tanach #C and #D, we learn that Jacob compares seeing Esau's face to seeing the face of God. Moses' face also shines after being on Mount Sinai.

Look through photography books that feature portraits of people. Find a portrait that somehow reflects the "face of God." Once everyone locates a photo, begin writing. Imagine an experience, a life behind the face. What makes the face shine? What makes the person seem to reflect God's light? Write a story that builds up to the moment in the photograph.

Share the photographs and your writings. Explain why you wrote the story you did.

Visual Art

1 (5-10 minutes) A face can change with wisdom (see Text Study, Tanach #7).

Go over the passage from Ecclesiastes. Then everyone takes a flat circle of easily malleable clay. Experiment for a few minutes, moving the clay between wise expressions and expressions of "deep discontent."

A variation: A leader or other participant models expressions of wisdom and expressions of discontent for the rest of the group to capture in clay. Do each "round" of shaping quickly. Look around at others' clay circles before going on to the next "round." Do three or four expressions each of wisdom and discontent.

Have a short discussion. How did you show wisdom/discontent? Was it difficult to make clear distinctions between the two? How well do you think you can see such differences on a real live person?

 2 (20 minutes or more) In Language Arts #3, participants watch the faces and the greetings at an airport, bus or train station, or coffee shop. For this activity, make charcoal sketches. Draw faces and greetings, capturing both pleasant and less than pleasant interchanges.

Reflect on the exercise. What did you see? What do you learn about greetings and faces? Is there a sketch you would like to develop into a more refined drawing or painting? What sparks your interest concerning that particular sketch (the tilt of the head, the twinkle in the eyes, the expression of the mouth)?

 3 (10-15 minutes for preparation, plus 10 minutes minimum for each drawing) In Drama #4 below, participants act out various kinds of greetings (recorded and imagined) given by biblical characters. This time, draw the greetings. Make at least one drawing from each of the following three categories (see Drama #4 for specific examples).

a. Actual greetings – positive, admirable interchanges

b. Scenes – may include positive as well as negative/less admirable greetings

c. Imagined greetings (unrecorded) – imagined interchanges between various characters. You decide their nature — positive/pleasant or negative/unpleasant.

Group members can share and comment on their work. Then, continue with the discussion questions in Drama #4.

 4 (15 minutes minimum) This exercise involves illustrating a greeting.

Read through the whole Text Study, Post Rabbinic section, then continue with the following exercise. Draw a picture of Reb Arye greeting someone. To go one step further, draw another

picture, this time of someone you know who has qualities similar to Reb Arye.

In a group, share your artwork. What similarities/differences are there in various participants' pictures? What difficulties did you encounter in showing how a person *feels*? How did you overcome these difficulties? In what ways did this experience make you more aware or sensitive to what happens in a real-life interchange — a Reb Arye type interchange?

 5 (20-30 minutes minimum) Some things arouse pleasant feelings; others make us feel less than pleasant. Sometimes we may catch ourselves showing our reactions in our faces — grinning or frowning, and the like. Art can be a powerful tool to help us to become more aware of our reactions, to gain control, to "choose our face."

Go to an art museum or look at paintings in books. Shake off any prior feelings of happiness, sadness, or anger, and be open to what you see in the present moment. As you look at each picture (or sculpture), note your feelings. Look at 20 to 30 pieces of art using this approach.

Then reflect on your reactions. Was there art that inspired *Panim Yafot*, a "pleasant face"? What brought such feelings to the surface most of all — abstract paintings with bright colors and harmonious, well-balanced images? rich oil paintings of domestic scenes? sculptures that highlight the rounded curves of the human body?

Now create your own piece of art, a picture or sculpture that inspires a warm response, "a pleasant demeanor." Display the artwork.

Drama

 1 (5 minutes) Study the passage about wisdom in Text Study, Tanach #G.

Discuss the questions. Then practice such a face. Begin by showing deep discontent in your face. Slowly, imagine you are becoming

increasingly wise. Let the wisdom, that new look, be reflected in your face.

2 (5-10 minutes) To experience, in an intensified way, the (presumably) uplifting effect of being received warmly and enthusiastically, exaggerate and extend the greeting time at the beginning of a class.

After the group settles into the room, have each person, in turn, reenter the room and go to the front. Everyone calls out welcoming phrases (All right! So-and-so is here! Come on in! Glad to have you here! Great to see you again!), and gives the person a standing ovation. As a variation, rather than call out welcoming phrases, the group could accompany their standing ovation with the enthusiastic singing of "*Hevaynu Shalom Alaychem!*"

Discuss. What was it like to have everyone greet you so enthusiastically as you came into the room? What was it like to be one of the enthusiastic greeters? What is the relationship between friendliness and *Sayver Panim Yafot*? What are some ways you can apply what you learned in this exercise to other situations in your life (e.g., welcoming others to a club meeting or sports team practice, welcoming strangers or friends in your home, welcoming family members when they return home after a long day, welcoming people at the synagogue).

(Note: Because this activity fits well in two categories, *Hachnasat Orchim* and *Sayver Panim Yafot*, it is mentioned in both chapters.)

3 (10-15 minutes) Complete Language Arts #1. You should have two lists: one of words of greeting, the other of gestures and actions of greeting. At first glance, such words and gestures should seem favorable — good things to say and do. But for the *Middah* of *Sayver Panim Yafot*, it's less about what you do and more about how you do it.

To get a clearer sense of the proper attitude for *Sayver Panim Yafot*, do the following. Assign one person to take the first list and to be the word person (Person A). Another person takes the second list, becoming the gesture person (Person B). Person A says a word (the first on the list); Person B does a gesture (the first on the other list). Person A says the next word; Person B does the next gesture, and so on. The scene will be a "responsive reading" of sorts such as the following:
Person A: "Hello."
Person B: Waves.
Person A: "Hi."
Person B: Nods the head.
Person A: "How's it going."
Person B: Smiles.
And so on . . .

Each pair will go through the lists twice. The first go-through will be done *without* a pleasant demeanor (no warmth, cheerfulness, friendliness, but with grumpiness, grouchiness, bitterness, a sour face). The second go-through will be done *with* a pleasant demeanor. Actors will express the difference using tone of voice and body posture. A few acting pairs should perform the lists.

Discuss. What did the actors do to distinguish between the two styles of performance? Were the distinctions clear? Have you ever witnessed discrepancies, gaps between *what* a person says or does, and how the person says or does it? Can you tell when a pleasant demeanor is not genuine? What did this activity teach you about the best way to carry out *Sayver Panim Yafot*?

4 (10 minutes to do just the first part, using improvisation; up to 30 minutes to do the whole activity) Participants reenact instances of greetings recorded, hinted at, or imagined in the Bible. The leader assigns small groups a few scenes each to rehearse (one from each of the following three categories). Or, you can use improvisation. These are the scenes:

First Category: Recorded greetings — positive, admirable interchanges. Refer to Text Study, Tanach #B and #C for several instances of greetings. Consult the Bible for more details.

Second Category: Recorded scenes, but actual greetings must be imagined. Such greetings may include negative/less admirable greetings, as well as positive ones. Refer again to Text Study, Tanach #B and #C.

Third Category: Unrecorded greetings — imagined interchanges between various characters. Again, refer to Text Study, Tanach #B and #C. Imagine scenes with greetings that were never recorded. You decide their nature — positive/ pleasant or negative/unpleasant. Actors will need to fill in the blanks.

Discuss the experience. Who among our biblical ancestors are the best exemplars of *Sayver Panim Yafot*? Is there any lesson you can apply to your own life — something you would like to try to emulate, to copy? Explain.

 5 (15-20 minutes) The Overview addresses the issue of presenting a pleasant demeanor even when things are going wrong.

Select two actors to improvise a scene. Actor A has just had a terrible day and is going home (or to a friend's house). Actor A enters the house, and tells Actor B about his/her awful day. The content of what happened is improvised. Actor A may reveal his/her feelings in nonverbal ways as well. The two actors will play the scene twice. The first time, Actor A will have no regard for pleasantness — he/she will be grumpy, grouchy, snappy, sour, and bitter. Stomping, huffing, large sighs are all appropriate. The second time, he/she demonstrates *Sayver Panim Yafot*. Actor A communicates to Actor B what happened, why his/her day was so terrible, but this time, he/she tries to maintain some pleasantness in his/her demeanor. Actor A expresses true feelings. But he/she controls

him/herself to the degree necessary to resist taking out negative feelings on Actor B.

Discuss after several pairs have tried this improvisation. What did the actors experience? What did audience members observe? When things are not going well, is it still reasonable to expect some control concerning our demeanor? How much? How well do you do in mastering your demeanor in a variety of circumstances? What "work" do you need to do in terms of *Sayver Panim Yafot*?

Movement

 1 (5 minutes for each warm-up) *Sayver Panim Yafot* refers specifically to the face, but a pleasant demeanor can be reflected in your whole body — the way you stand, walk, talk (use your voice), arm gestures you make.

Do these simple exercises as "warm-ups" to the *Middah* of *Sayver Panim Yafot*:

a. The leader calls out various things to do — with a pleasant demeanor. For each instruction, allow 15-30 seconds for participants to respond. A leader might say: Walk in a pleasant manner . . . Keep walking and add a pleasant facial expression . . . Stop, but keep your pleasant face. Make some pleasant arm gestures, while standing in place . . . Add pleasant words . . . Keep the pleasant words going, but stop moving your arms . . . Stop talking, and begin walking again in a pleasant manner . . . Stop, and stand still in a pleasant posture . . .

b. "Sculpt" pleasantness. Everyone stands in a circle. One person is chosen to go into the center, and makes him/herself into an unpleasant shape and posture, and holds it. A second person is chosen to reposition the unpleasant person, to "sculpt" him or her to pleasantness. Repeat several times with different people going to the center of the circle.

c. Practice greetings. Divide the group in two. Half stand on one side of the space, half on the

other. Two people at a time, one from each side, walk toward the center of the room, as if they are going to greet each other. The first time should be *without* warmth, friendliness, or cheerfulness. The second time should be *with* warmth, friendliness, and cheerfulness.

Share reactions. Is it hard to be pleasant, to express pleasantness? What stands out most (a movement, feeling, expression) as a way to show pleasantness/the opposite of pleasantness?

 2 (10 minutes to do just the first part; up to 30 minutes to do the whole activity) In Drama #4 above, participants act out greetings given by biblical characters. Follow the same guidelines, but instead of focusing on words and more realistic physical action, use movement more freely. Your bodies can express, in an abstract way, actions and feelings. Through movement, participants can elaborate on the interaction, creating a short improvisation between characters.

 3 (15-20 minutes) Drama #5 could also be carried out with an emphasis on creative movement rather than on words and more realistic action.

 4 (10 minutes) Text Study, Tanach #G asserts that wisdom can change the look on a face. Study the passage and discuss the questions. Then define two concentric circles in the space. The inner circle is small; it is the circle of wisdom. The outer circle (the circle of deep discontent) is much larger. As participants move in each circle, back and forth as they wish, exploring and expressing what they experience, they imagine they are trying to make the wisdom-circle grow and slowly overtake the discontent-circle. At the end of the improvisation, only the faintest rim of discontent remains. When they have completed the task, participants move out

of the circle area and wait on the side until everyone is finished.

Discuss. What kind of movement did you do in each circle? How did you feel in each of the spaces? Were you aware of what others were doing, and did that influence your own movement? Was it difficult to push wider the border of wisdom? How did you do it? If you felt conflicted emotions, what were they? What did you learn from this experience about the relationship between wisdom and a pleasant demeanor?

 5 (10 minutes) *Sayver Panim Yafot* should reflect not only who you are on the outside, but who you are on the inside. Study the passages and questions in Text Study, Rabbinic #C. Divide the space in half. Keeping in mind Rabban Gamliel's first statement, participants on one side improvise as if their "insides" match their "outsides," as if the two are in harmony with each other. Participants on the other side improvise as if their "insides" do not match their "outsides," as if the two are in disharmony. Improvise freely, going back and forth between the two sides, trying to understand the different nuances of each.

Discuss. Overall, was this exercise easy or difficult? What was most easy/difficult? Do you have any new insights as to what it means to have your "inside" not the same as your "outside"? Do you agree that consistency between "inside" and "outside" is a value? Defend your view.

 6 (5 minutes) Recall the idea of God's face — how we use the image of God's face shining on us (see Text Study, Tanach #E). We can also see the light of God's face in the face of another person (see Text Study, Tanach #C and #D).

Walk around the room for a minute or two, feeling God's light streaming on your face, radi-

ating through you. If you like, improvise any other movements that seem appropriate.

Discuss the experience. In what ways can you intentionally bring God's light/God's face into your own?

Music

 1 (10 minutes, at least) Song lyrics, like poetry, have to get right to the point.

After studying *Sayver Panim Yafot*, write a song about this *Middah* with a small group. The verses might talk about situations in which you need a dose of *Sayver Panim Yafot*. The chorus, the most essential part, could describe what you've got to do to get it. Perform the songs for each other.

 2 (10 minutes to do the first part, using improvisation; up to 30 minutes to do the whole activity, longer if using composed music) Refer to Drama #4. Add musical accom*panim*ent, either improvised or composed, to the greetings.

 3 (15 minutes) Most people use words as the central part of their greetings. In classical music, the composer doesn't use greetings exactly, but there are rather clear openings, introductions, and overtures.

Listen to the opening bars of several symphonies. The composer is very deliberate in setting the "first impression." What is he/she trying to communicate in the initial "greeting" to the listener? Through listening, what can you learn about the significance of openings, of greetings, of setting the proper tone? Can we exert the same amount of control as a composer when monitoring what comes forth from our own instrument (our bodies and voices)?

Miscellaneous

 1 (activity takes place during other scheduled programs or situations) Put the *Middah* of *Sayver Panim Yafot* into action in an organized way. Do one or more of the following:

a. On a rotating basis, assign greeters at worship services — someone who greets people as they come in, and someone who greets people following services. Perhaps one person can be assigned a special task — seeking out new faces and introducing them to others in the congregation.

b. Do the same thing as in #1a for special holiday events or social occasions.

c. Assign a classroom greeter. Students will take turns being the one to officially greet classmates as they enter the building or classroom. This responsibility can even be included on a classroom duty chart or a job wheel.

d. Assign people to take a *Sayver Panim Yafot* shift in the library, cafeteria, playground, etc. These people are goodwill ambassadors who make special efforts to show pleasantness. For a certain period of time, a "shift," they have the official responsibility to receive visitors in a warm and friendly manner.

After a few opportunities to greet others, meet to see how it's going. Is *Sayver Panim Yafot* a virtue that comes naturally? Does it get easier the more you do it? Ideally, everyone would be cheerful and warm at all times and always greet others in a friendly manner. Since that is not always the case, is assigning official greeters a good idea? Explain.

 2 (On your own, over the course of a week or two) Refer to Text Study, Rabbinic #B for statements on greeting

others first. Then, as in the previous activity, put this idea into practice.

Over the course of a week or two, make a special effort to "be first to extend greetings." Take the initiative in being warm, friendly, and pleasant toward others. Keep notes of your efforts in a journal. After the assigned amount of time, you may wish to continue making such an effort.

A variation: Monitor your demeanor. How often and under what circumstances do you stray from pleasantness? Record how you did at the end of each day. Is your demeanor where it should be? Are you satisfied with where you are in the mastery of *Sayver Panim Yafot*? How might you improve?

CHAPTER SEVENTEEN

SH'LOM BAYIT: PEACE IN THE HOME/PEACE IN THE FAMILY

שלום בית

OVERVIEW

We translate the words *Sh'lom Bayit* as "peace in the home," but the words suggest more. The root of the word *"shalom"* is *sh-l-m*, meaning completeness or wholeness. *Bayit* literally means house or home, but can imply family, too. Hence, this *Middah* projects a home that feels complete, a family in which members are connected with one another, a home in which fractures are healed and brokenness is made whole (*shalaym*), family harmony.

All of this begs the question, what is a family? "Family" here means something beyond mother, father, and children. There are families in which children live with grandparents, with one parent, or with adopted parents. There are families which are headed by two men or two women. Two unrelated roommates might constitute a "family." There are homes in which there has been a divorce or in which a widow or widower lives alone. There are homes in which lives a single person who may connect with extended family that lives in different physical locations. Perhaps what distinguishes families is a sense of connectedness that exists among the individuals that together make a whole. Families/households/homes are comprised of individuals who come together to create their own sanctuary of peace.

Peace is not passive; it doesn't just happen. We need to go after it, chase it, become *Rodefay Shalom* — pursuers of peace. Peace requires action. Whether in the marketplace, the synagogue, international arenas, or even in the living room, pursuing peace must be an active, consistent process.

Trust, respect, affection, honesty, humility, good manners, humor, sensitivity, and the ability to listen are qualities that are needed to attain and to maintain *Sh'lom Bayit*. In fact, all the virtues should inform our demeanor at home, as well as on the street.

Peace begins with each individual affecting positively his/her own environment at every moment. Such efforts are the foundation for peace that extends to the world and into the future. Additionally and ultimately, peace transcends human efforts. Therefore, we look to God.

One of the names of God is *Oseh Shalom* (Maker of Peace). These words which conclude the *Kaddish* and therefore every Jewish worship service are as poignant and as pertinent to our lives as any we may recite: "May the Maker of Peace, who makes peace in the High Places, make peace among us and among all of Israel. And let us say, Amen." "Among us" are the words that suggest peace here and now, beginning with myself, my family, my own *bayit*. Thus, we look to God and we draw on God's guidance to nurture peace close to home. Doing so is the starting point for bringing peace to "all of Israel" and to the wider world. How do we know God's guidance points to peace? Because we say of Torah: "Its ways are ways of pleasantness and all its paths are *peace*."

Pursuing peace and maintaining peace are lofty aims in Jewish life. We are urged to work for peace in the community and in the world. Ideal peace may be the workings of God from the High Places (*Bimromav*), but practically speaking,

the real work of *Shalom* on earth begins in our most immediate and intimate surroundings — with *Sh'lom Bayit*.

What follows are summaries of how this *Middah* can play a part in our relationships with others, with ourselves, and with God.

 BAYN ADAM L'CHAVERO, BETWEEN PEOPLE. The ethic of peace in the home can be explained easily enough. Mastering *Sh'lom Bayit*, however, is not simple; it requires consistent, even persistent effort. What brings about peace at one period of development may need to be adjusted as family members grow and change.

Peace comes with work. This work includes striving to master a number of other *Middot*, such as *Ohev Zeh et Zeh* and *Mechabayd Zeh et Zeh* (loving and respecting others), *Anavah* (humility), *Simchah* (joy), *Malachah* (work/industriousness), *Sayver Panim Yafot* (a pleasant demeanor), *Shmiat HaOzen* (attentiveness/being a good listener), *Erech Apayim* (slowing down anger), among others.

 BAYN ADAM L'ATZMO, BETWEEN YOU AND YOURSELF. In this rubric, *Sh'lom Bayit* is understood symbolically. *Bayit*, literally meaning house or home, is given a more personal definition. Home becomes self, thus, *Sh'lom Bayit* in this context means maintaining peace within your own person, being centered and moving surely on a personally fulfilling path.

 BAYN ADAM L'MAKOM, BETWEEN YOU AND GOD. In the "*Hashkivaynu*" prayer, we ask God to spread over us the "*sukkah* [shelter] of Your peace." Understanding *Sh'lom Bayit* in this category means growing in awareness that peace is available to us as we put ourselves in relationship with God. We bolster our sense of peace by seeing ourselves as belonging to "God's home" — a sanctuary, a *Bayit* of *Shalom*.

We might also include in this category learning from God, who is called Maker of Peace. God guides us in our pursuit of peace, teaching and exemplifying what the attribute means. From God's gift of Torah, we gain insights on how to realize a sense of peace in our immediate environment. The closest environment to us is the home and family. From God in "the High Places" (*Bimromav*), we learn what's required of us to live peacefully in the "lower places."

TEXT STUDY

Tanach

A When God told her she will have a child, Sarah laughs because she says Abraham is so old. In repeating the conversation to Abraham, God changes the story for the sake of *Sh'lom Bayit*.

Sarah laughed to herself, saying, "Now that I am withered, am I to have enjoyment — with my husband so old?" Then the Eternal said to Abraham, "Why did Sarah laugh, saying, 'Shall I in truth bear a child, old as I am?'" (Genesis 18: 13-14)

➤ How does the white lie told by God help preserve *Sh'lom Bayit*? Did this circumstance justify dishonesty? Why or why not? In this situation the white lie was ascribed to God. Do you think people, family members, should risk telling such lies?

B The brothers lead their father Jacob to make a false assumption about what happened to Joseph. While suspect, the brothers may be justified in doing so because the truth would destroy all semblance of peace within the household.

Then [the brothers] took Joseph's tunic, slaughtered a kid, and dipped the tunic

in the blood. They had the ornamented tunic taken to their father, and they said, "We found this. Please examine it; is it your son's tunic or not?" He recognized it, and said, "My son's tunic! A savage beast devoured him! Joseph was torn by a beast!" Jacob rent his clothes, put sackcloth on his loins, and observed mourning for his son many days. (Genesis 37:31-34.)

➤ Why did the brothers trick their father into assuming Joseph dead? Were they justified in doing so? What other options may they have had in preserving peace in the household? What better ways are there in handling jealousy of siblings (besides trying to kill them or sell them into slavery!).

C After many years, Joseph and his brothers are reunited. At first, Joseph doesn't let on to his brothers his true identity. Finally, Joseph cannot bear the charade any longer and reveals himself.

Then Joseph said to his brothers, "Come forward to me." And when they came forward, he said, "I am your brother Joseph, he whom you sold into Egypt. Now, do not be worried or angry with yourselves because you sold me into slavery; it was to save life that God sent me ahead of you. It is two years that there has been famine in the land, and there are still five years to come in which there shall be no yield from tilling. God has sent me ahead of you to ensure your survival on earth and to save your lives in an extraordinary deliverance." (Genesis 45:4-7)

➤ How many lies can you think of that are told in the story of Joseph? How do these various lies

affect *Sh'lom Bayit*? Joseph, instead of taking revenge on his brothers, is very generous toward them and forgiving of them. After Joseph revealed his identity, do you think there was *Sh'lom Bayit* in his family? Is the range of emotions and actions in the Joseph story (jealousy, vengeance, lies, and physical separations, as well as forgiveness and generosity) typical of families? If so, how can families tame the negative and enhance the positive so that *Sh'lom Bayit* reigns?

D God will send Elijah ahead of utter destruction to initiate a very important task.

He shall reconcile parents with their children and children with their parents. (Malachi 3: 24)

➤ Why must all families reconcile in order that God not carry out "utter destruction"? In what ways could reconciliation between parents and children have repercussions that go beyond their own individual homes?

E Without peace in the home, it is difficult to enjoy life's pleasures.

Better a morsel of dry bread, with peace, than a house full of feasting, with strife. (Proverbs 17:1)

➤ Do you agree with this saying? What would you be willing to "give up" in order to be assured of peace in the home?

F Peace within your dwelling places is a blessing — a prerequisite for prosperity.

Peace be within your walls, and prosperity within your palaces. (Psalms 122:7)

➤ In what ways is peace within your home a prerequisite for prosperity? Does peace have to exist

within homes before it can exist in the general society?

G This line from Psalms makes us think of inner peace — our own selves as "homes" for peace. God's role can be significant in terms of the peace we feel inside.

> **I will both lie down and sleep in peace, for You alone, Eternal God, keep me secure. (Psalms 4:9)**

➤ What part does God play in how peaceful you feel inside of yourself? What is the relationship between feeling secure and feeling at peace? Traditionally, certain prayers are to be said just before going to sleep, and others upon waking up. Do you think such a practice enhances feelings of inner peace?

Rabbinic

A We grow from Torah's teachings when we are willing to plunge in, to study Torah *lishmah,* (for its own sake.) Ideally, Torah study leads to more virtuous living (practicing *Mitzvot* and *Middot*), and thus to peace.

> **Rabbi Alexandri said: "Those who study Torah for its own sake make peace in the Upper Family and the Lower Family [humankind]." (*Sanhedrin* 99b)**

➤ Is studying Torah "for its own sake" the same as studying Torah for the sake of peace? Explain. Do you believe efforts you make in working toward peace have an effect that stretches beyond your own life, beyond your immediate circumstances? In other words, do efforts for peace have a cosmic effect — do they make an impact on God, on unseen forces in the universe?

B Although the statement below contains a specific instruction, it also indicates a general attitude.

> **If your wife is short, bend over to hear her whisper. (*Baba Metzia*, 59a)**

➤ What is the significance of this instruction? What general principle might it illustrate? Can you come up with more illustrations, similar in style to the one in the quote?

C *Sh'lom Bayit* suggests a sense of completeness and wholeness in the home and family. But sometimes, there are painful, irreparable "cracks" when family members feel they can no longer live peacefully with one another. Divorce, for instance, can be devastating.

> **If a man divorces his first wife, even the altar [in the Temple in Jerusalem] sheds tears. (*Gittin* 90b)**

➤ Why does the "altar" shed tears? What is the significance of the altar? How might the hopes, the dreams, the expectations people have on their wedding day lead a couple to *Sh'lom Bayit*? How might such thoughts and feelings eventually lead to the breakup of a marriage? Are "tears" the best way to describe how people feel about divorce? Explain.

D The Talmud gives some guidelines on how to have peace in your home. (In this case, home is a tent.)

> **Concerning a man who loves his wife as himself, who honors her more than himself, who guides his sons and daughters in the right path and arranges for them to be married near the period of**

their puberty, Scripture says, "And you shall know that your tent is in peace" (Job 5:24). (*Yebamot* 62b)

➤ According to this passage, what should a husband's attitude be toward his wife? Should a wife have a similar attitude toward her husband? What would be the effect if both had such an attitude? Is this enough to ensure peace in the marriage? Explain. What does the passage suggest concerning children to help ensure *Sh'lom Bayit*? What would you add to the passage?

E After leaving their homes in anger, people often long for reunification, to return to *Sh'lom Bayit*. Does this happen also with *Shechinah* (God's in-dwelling presence)?

> Rabbi Aha said: "The *Shechinah* may be likened to a king who left his palace in anger. After going out, he came back and embraced and kissed the walls of the palace and its pillars, weeping and exclaiming, 'O the peace of my palace, O the peace of my royal residence, O the peace of my beloved house! O peace, from now onward let there be peace!' Similarly, when the *Shechinah* went forth from the Temple, it returned and embraced and kissed its walls and pillars, and wept and said, 'O the peace of the Temple, O the peace of My royal residence, O the peace of My beloved house! O peace, from now onward let there be peace!'" (*Lamentations Rabbah* Prologue 25)

➤ Why does the king leave his palace? What makes him want to return? What is the king's attitude toward peace? Why would the *Shechinah* go from the Temple? What would make the Shechinah want to return? Are there times when we alienate (or distance) God from our homes? from our houses of worship? For what reasons might God's presence be experienced as distant? What role does peace have in making God's presence felt in our midst?

F Losing our temper greatly disrupts *Sh'lom Bayit*.

> When his disciples asked Rabbi Adda bar Ahavah, "To what do you attribute your long life?" He replied, "I never lost my temper in the midst of my family." (*Ta'anit* 20b)

➤ Why is it important to be even tempered for there to be peace in the family? What long-term effects might losing your temper have on family relationships?

Tefilah

A In our worship service, peace is associated with a *sukkah* — a shelter. We strive for *Sh'lom Bayit* in our personal shelter, our home, and in the world ("God's house") as well.

> *Ufros alaynu sukkat shlomecha.*
> (Spread over us a shelter of Your peace.) ("*Hashkivaynu*" prayer)

➤ What comes to mind when you think of a "shelter of peace"? What is the significance of praying these words in the evening service? At what times of day do we especially long for peace?

B The Memorial Prayer, "*Ayl Malay Rachamim*" (God Full of Mercy), is recited during a Jewish funeral service.

> Exalted, compassionate God, grant perfect peace in Your sheltering presence, among the holy and the pure who shine

with the splendor of the firmament, to the soul of our dear _____ who has gone to his/her eternal home. Master of mercy, remember all his/her worthy deeds in the land of the living. May his/her soul be bound up in the bond of life. The Eternal is his/her portion. May he/she rest in peace. And let us say: Amen.

➤ What references are there to peace in this prayer? In the prayer, what is meant by "home"? Which of the following phrases are associated with *Sh'lom Bayit* (in terms of God's eternal house of peace): *she'halach l'olamo* (going to your eternal home), *b'Gan Eden tehay menuchato* (experiencing repose in Gan Eden), *Adonai, Hu nachalato* (accepting that God is your inheritance), and *ve'yanu'ach b'shalom al mishkavo* (lying down, in restful peace)? In what ways is death a kind of *Sh'lom Bayit*?

Post-Rabbinic

A Peace in the world begins with peace in the home. This passage takes that idea further.

> Rabbi Bunam taught: "Our sages say: 'Seek peace in your own place.' You cannot find peace anywhere save in your own self. In the psalm we read: 'There is no peace in my bones because of my sin.' When people have made peace within themselves, they will be able to make peace in the whole world." (Martin Buber, *Tales of the Hasidim: The Later Masters*, p. 264)

➤ Where does peace in the world begin? You might say families nurture a sense of peace among its individual members. Because of family support, individuals learn to feel peace within themselves. Or, as individuals strive for peace within themselves, they are able to contribute to peace in the family. Does this process begin with family or with individuals? Is it from family that individuals gain peace, or from individual efforts that the family gains peace? Explain.

ACTIVITIES

Language Arts

 1 (15 minutes) Simply saying that families should strive for peace is not enough; there needs to be more direction. This exercise allows participants to discover the "recipe" for making peace.

Create a recipe for *Sh'lom Bayit*. Examples of "ingredients" include respect, affection, good manners, humor. Determine the relative value of the ingredients by deciding how much of everything to put in — in teaspoons, tablespoons, cups, pinches, etc. Some questions to get you started: What is the most important ingredient? What other ingredients do you need? What ingredients are like spices (only a small amount is needed)? What do you need to *do* with the ingredients once you've gathered them together?

A variation: Put a big pot (or picture of a pot) in the middle of the space. Allow participants, one at a time, to add their special ingredient to the group "recipe." Each "chef" can explain and defend his/her ingredient.

In a group compare recipes. Were there any major differences between how the "chefs" suggested *Sh'lom Bayit* be created? Do you think family recipes for *Sh'lom Bayit* change at various times? If so, how?

 2 (10-15 minutes) We say there are seven rules (the Noachide Laws) which all nations must follow for there to be a basic level of morality in the world. In our tradition, of the 613 commandments in Torah, ten are singled out. These are called *Aseret HaDibrot*, the Ten Commandments.

Create a list of a family's "ten commandments" for *Sh'lom Bayit*. Participants can do this exercise by themselves or at home with their families.

Compare the lists. Are the "commandments" mostly the same? Are there any significant differences? Is there anything in the ten required specifically of Jewish families? Would your list look different if you had composed it on your own, as opposed to working on the list with the members of your family?

 3 (10 minutes) The Talmud has some ideas as to what makes for peace in the family (see Text Study, Rabbinic #D). Do you think the members of your family would define *Sh'lom Bayit* in different ways?

Define peace for yourself. Do the same thing for each member of your family, trying to capture their point of view. (Adults can use their present family or the family in which they grew up.)

Did the writing process evoke any surprises? How accurate do you think you are in "guessing" the perspectives of family members? Why might it be worthwhile to figure out how family members actually do define *shalom*? Ask them!

 4 How a family establishes and maintains *Sh'lom Bayit* may depend in part on the make-up of a family. Abraham and Sarah work toward peace in a way different from Joseph and his brothers (see Text Study, Tanach #A, #B, and #C). And the millions of families after them work toward peace in still other ways.

Brainstorm the compositions of eight to ten imaginary families. Write these on a board or large piece of paper for everyone to see. Some examples:

a. Father, mother, identical twins boys

b. Grandmother, mother, granddaughter

c. Father, mother, child adopted from foreign country

d. Two adult men, two girls, and a boy

e. Family with 12 children

Discuss the similarities and differences in terms of establishing and maintaining *Sh'lom Bayit* in the various households. If it seems appropriate, discuss more personal issues. What is unique about your household? What makes its personality one of a kind?

 5 (5-10 minutes) Refer to Text Study, Tefilah #A. Then discuss the materials used in a *sukkah*. What kind of fabric suggests protection? Compare the roof of the Sukkot holiday *sukkah* with the "materials" of an idealized shelter of God's peace. What "shelter" do we experience in life? What shelter do we long for?

For an extension of this exercise, see Movement #7 below.

 6 (10-20 minutes) Refer to the two stories from Torah in Text Study, Tanach #A, #B, and #C. Compare and contrast the family of Abraham and Sarah with the family of Jacob, Joseph, and the brothers. What different strategies did they use to maintain *Sh'lom Bayit*? Which of these strategies would you want to adopt for use in your family, and why?

 7 (15-20 minutes) Using a stream-of-consciousness style, write freely on the theme *"Gan Eden"* (the Garden of Eden.) Include descriptions of a place, descriptions of feelings, ancient associations, modern notions, etc.

Afterward, study with the group the *"Ayl Malay Rachamim"* prayer, in which *Gan Eden* is associated with an eternal resting place — a "house" of peace (see Text Study, Tefilah #B). Reflect on this definition: *Sh'lom Bayit* means existing in peaceful harmony with God. What is the relationship between *Gan Eden* and *Sh'lom Bayit*?

For an extension of this exercise, see Visual Art #8 below.

Visual Art

 1 (20 minutes) When we talk about peace in the family, we are challenged to figure out the meaning of both "peace" and "family." Despite the surface differences in families, peace in the home is a value toward which all families work.

Cut out pictures of various kinds of people from magazines. Imagine that together these people make a large family. Next, take a large piece of poster board and have participants arrange the "paper dolls" in a collage that reflects a sense of *Sh'lom Bayit*.

A variation: Make two collages (or one collage divided in half). Have one part reflect *Sh'lom Bayit*, and the other reflect lack of *Sh'lom Bayit*.

Discuss. How did you make the "characters" in your collage show *Sh'lom Bayit*? What other arrangements could you have made that would have been equally as effective? How did you decide certain figures, assembled together, would make a good definition of "family?" Do you think peace is a value all families share? Explain.

 2 (10 minutes) What does it feel like to experience a sense of inner peace? Can you see this peace in others? How do you look when *you* feel peace?

Draw the faces of someone who feels at peace and someone who doesn't. Then, share the pictures with other participants in a group. Discuss: What did you do to make the two faces different from each other? In what ways does a person's face reflect the peace he/she feels inside?

An extension (or introduction): Look through photographs and paintings/drawings of faces that reflect inner peace. What factors keep coming up? Does knowing how *shalom* "looks" make it

any easier to emulate "the look" — to learn how to become more peaceful inside? In short, can changing your facial expression change how you feel?

 3 (10 minutes minimum) Some Rabbinic statements related to *Sh'lom Bayit* give strong visual impressions. Hearing the words and "seeing" the picture is an effective combination for making a lasting point.

Discuss the statements from Text Study, Rabbinic #B and #C. Then choose one and illustrate it.

An extension: If you like, come up with your own statement about *Sh'lom Bayit*. The statement should reflect something you can picture and should make a strong visual impression. Then illustrate your idea.

Post the illustrations around the room. The group walks around, commenting on each.

4 (15-20 minutes minimum) We say in our liturgy, "*Ufros alaynu sukkat shlomecha*" (Spread over us the shelter of Your peace). How would we design a space in order to enhance our sense that "God's house" is a shelter of peace (*sukkat shalom*)?

Describe orally or in writing those places in God's world where you most feel a sense of peace and closeness to God. Then, as a group or as individuals, design a special garden or park in which the experience of being in "God's house of peace" is most highlighted and underscored for visitors. A more specific idea: The group imagines it is the Landscape Committee whose task it is to adapt their garden or park design for the space surrounding the synagogue (money is no object).

Take field trips to gardens, parks, and grounds of places of worship. Which places best capture the feeling of being at home and at peace in God's Creation?

A variation: Focus on "Houses of Worship," physical buildings, in addition to or instead of outdoor grounds and parks.

5 (10 minutes minimum) Family harmony is in our hands. We say that everyone has an inclination to do evil (*Yetzer HaRa*) and an inclination to do good (*Yetzer HaTov*). Similarly, we can "incline" toward *Sh'lom Bayit*, or we can "incline" toward conflict and negative feeling. The same "raw materials" — personality traits and tendencies — can be used to nurture harmony or disharmony. In this exercise the "raw materials" are represented by colors. These can create either harmony or disharmony.

Begin by choosing which colors you will use in your paintings. Put a little of each color along an imaginary (inch or so) border at the top of the page. Those colors are your "raw materials." Draw a line under the color palette to separate it from the rest of the paper. This palette represents potential — the fact that "raw materials," like inclinations, can create different results.

Next, divide the rest of the paper in half, horizontally. The top half is "Disharmony," the bottom half is "Harmony." Use the same colors, the same "raw materials," to illustrate each idea. In "Disharmony," the blue might make a swirl like a violent tornado. In the "Harmony" half, the blue might make soft, wavy lines like gentle ocean waves.

Discuss. How are the colors like personality traits and tendencies? How much control do we have over these? Consider the idea that the potential to create harmony or disharmony resides in each of us. Do the paintings succeed in expressing this idea visually?

6 (10-15 minutes) Metaphors give us new ways of thinking about what something or someone is *like*.

This project will involve some homework in terms of collecting appropriate materials. Build a structure (like a three-dimensional collage), a "house," out of a variety of items. Each item should represent a member of your present family or family of origin. Perhaps your structure will include colorful Lego (your mother), a pen (your father) a cup (you), a thin stick (your sister), and a small bouncing ball (your baby brother). Arrange the items in a way that reflects the overriding dynamic in your family.

Explain your structures to others in the group. How did creating concrete metaphors shed light on how you see your family? Did you feel "stuck" at any time as you worked on the exercise? If so, is there any particular significance to that? Are there any "adjustments" your structure could use in order to enhance *Sh'lom Bayit*?

7 (10-15 minutes minimum) When we think of shelter, we think of something over our heads. When this shelter is God's, we imagine a very expansive canopy stretching over the sky, through the universe. We might be able to see only part of this shelter — the sky. Looking at the sky can help us to begin to imagine the color, "fabric," and feel of God's shelter.

To prepare for this session, spend time during the preceding days paying particular attention to the sky. Look at it at various times of the day — sunrise, mid-day, dusk, sunset, dark. Notice the colors, the shapes of the clouds, the stars and the moon.

Use watercolors and watercolor paper (which keeps moisture from soaking through to the surface underneath). Make several paintings of the sky, each one different. Several small paintings on one page is fine. Make rectangular boxes to separate them. Use plenty of water to make the paintings — you can paint plain water across the page, then gently add color. Or, you can make thick lines of color, then use plain water to

"soften" the sky and give it more subtlety. If you don't want colors to bleed, let them dry between applications.

Now you are ready to apply what you have learned to imagining "God's shelter." Paint "*Sukkat Sh'lomecha*" (the "shelter of your peace"). What does this canopy look like? Using whatever colors you like, make a few small paintings. By freely experimenting, making several versions, you are likely to find one that really captures your sense of what God's shelter suggests.

In a group, share your paintings. Explain why you made the choices of colors you did, how you allowed (or didn't allow) sections to blend into one another, any highlights you added (dots, dashes, smudges, etc.). In what ways do you think people experience a shelter, such as the one you created?

(Note: A similar activity to this one can be found in Chapter 23, "Yirah: Awe and Reverence.")

 8 (30 minutes minimum) Complete Language Arts #7 above before doing this one. Then choose several lines or images from your writing that inspire or jump out at you. For each line, ascribe a color(s) and a texture or quality, and possibly a mood. For example, a line might be assigned "blue, curvy, tranquil." After you have done this for five or more lines, you are ready to approach the canvas (with watercolors, acrylics, pastels, etc.). Using the guidelines of the written material, create a painting/picture that could be titled "*Gan Eden, Sh'lom Bayit*: God's Eternal House of Peace."

What was most challenging about this exercise? What came easily? In what ways are you pleased with the results of your efforts to write and paint? What did you learn in the process?

 9 (25 minutes minimum) In each of us, disparate parts exist "peacefully." We are fractured and whole at the same time. Figuring out how to resolve this paradox gets us closer to understanding inner *Sh'lom Bayit*. In an artistic creation, two (or more) conflicting images can exist peacefully together on one and the same canvas.

Bring in pictures or slides of Cubist artists, such as Picasso or Braque. Discuss how the artists created a unified work even though parts and sections of recognized wholes were rearranged in unexpected ways.

Write down a series of images (related to each other or not) that capture some aspect of yourself. Some examples: playing the flute, late fall, late afternoon; watching myself brush my hair in the mirror; talking on the telephone while sipping chocolate milk.

As you refer to your written image, create Cubist-style self-portraits that reflect the theme of inner *Sh'lom Bayit*. Juxtapose objects and images to reflect both diversity and unity, division and harmony. The written images can be shaped into a poem and included as an accompanying text to the portrait.

Drama

 1 (15 minutes) It's not always *what* is said, but *how* something is said that makes the difference in how a person responds. Increased awareness of this will improve our efforts to contribute to our family's mastery of *Sh'lom Bayit*.

As a group, write a short outline of a typical dinner table discussion (e.g., "How was your day at school," "Pass the salt," "What shall we do this weekend?"). Make two circles of students, an inner circle and an outer circle. Using your outline as a rough guide, the inner circle role plays the family. Repeat the improvisation twice, the first time reflecting a family that does not demonstrate *Sh'lom Bayit*, the second time reflecting a family that does. Those in the outer circle act as observers. Experiment doing the role play in loud (and

maybe fast) voices, then again using softer and calmer voices. Experiment also with the *tone* of voice.

The observers comment on the role plays, noting how something is said impacts peace in the home. Observers also consider what an individual person can do to take more control over the *how* (volume, tone of voice, pace, etc.). If desired, switch roles.

 2 (5-10 minutes) We sometimes telegraph whether or not we feel inner peace. With practice, we can become sensitive to these signals, which will help us in our own pursuit of peace.

Two people stand on opposite sides of the room, imagining they are about to meet for the first time. They go to the center, shake hands, and introduce themselves. The first time, they act this out as if they *are not* experiencing inner peace, but rather anxiety, uncertainty, nervousness, etc. The next time the two greet each other as if they *are* experiencing inner peace.

In what ways did watching others help you to learn how to *act* more peacefully?

Movement

 1 (5-10 minutes) Refer to Text Study, Post-Rabbinic #A, which speaks of finding peace within. Is there a specific physical sensation associated with peace in your own self? Sometimes we may think we are at peace, and don't even realize that our shoulders are tensed up, our stomach is tight, or our jaw is clenched. Our bodies can give us feedback as to how well we're doing in maintaining inner peace. It works the other way, too — relaxing our bodies can stimulate or support our efforts to be more peaceful emotionally.

The leader calls out one body part at a time for participants to tense. Continue until the whole body is completely tense. Everyone then releases

the tension and relaxes. Compare the feeling of release to feeling inner peace. Take the exercise one step further by creating knotted, tangled poses, then relaxing into calm positions. Compare the two types. Then move from one to the other, back and forth.

Discuss. What did you like about the relaxation exercise? How did it feel to make the knotted, tangled poses? How about the relaxed, calm ones? Does having a relaxed body have anything to do with inner *Sh'lom Bayit*? Can you be tense physically, but still at peace (i.e., peaceful emotionally)? If you are relaxed, are you more likely to be at peace? Why is it worthwhile to make *deliberate* efforts to be more physically relaxed? How might you go about doing so?

 2 (5-10 minutes) The harmony of the family depends on the individual family members. Sensitivity is needed by family members in order to adjust to the changing, growing, and shifting that happens in everyone's lives at various times. This short, kinesthetic experience drives the point home.

Stand in a circle, everyone holding hands. Without planning it, people at various times shift their weight. As the structure changes, the others must adjust, shift, and compensate in order to maintain a balanced, supportive whole.

A simpler variation: In pairs, face each other and hold hands. Each person leans and shifts in such a way that they are off balance and would fall without receiving the support of their partner. Explore the nuances of independence and interdependence by playing with a variety of counterbalances (e.g., two people holding on to one of each other's hands, then leaning back or sideways in counterbalance hand to foot, back to back, linking elbows, etc.).

What did you have to do to maintain balance when one person shifted? Was it difficult to readjust? Were you happy to do so? Did you feel

imposed upon? What parallels can you make between this exercise and family harmony?

 3 (10 minutes) In the *"Hashkivaynu"* prayer, peace is a shelter, something that is spread (see Text Study, Tanach #A). In this exercise, participants access what it means to feel protection, refining impressions of the nature of "God's shelter of peace."

One person takes a pose. Another person complements that pose with one that suggests protection. Others join the person who is providing protection so that the pose grows, "spreads" a larger sense of protection, of peace around the original pose-taker. The larger protective "quilt" of people can add movement that suggests spreading protection more broadly (rather than remaining in the statue-like sculpture). Several (or all) participants should have the chance to initiate the exercise.

Discuss. Describe the experience of being the center of protection spreading around you. Describe the experience of providing protection. How was what you experienced in this exercise similar to feeling God's peaceful, protective presence? Explain.

 4 (20-25 minutes) Complete Visual Art #6 above, in which participants build three-dimensional collages representing their families. In this exercise, participants physically build *Sh'lom Bayit* through collages of people.

Capture what the items people brought for building their three-dimensional family collages suggest in physical body terms. (For example, a cup would suggest an open, wide, rounded shape; a stick might suggest a lanky, almost straight, slightly fragile shape.) It's probably best to have one director at a time "placing" the physical bodies, creating the three-dimensional human collage.

A director's instructions might sound something like this: "You be the cup and stand over here, making your arms into an open circle in front of you; then, squat low, more like a mug than a tall glass. And you be a stick and lie down, as straight as you can; but let your arm bend enough so you can balance it on the edge of the cup." Be sure to give several (or all) participants the chance to be the director, to create their collages in physical form.

Discuss: How did you feel about seeing your family depicted in this way? Did you "see" anything new? Did the experience make you feel more accepting/less accepting/neither about the quirks in individual families?

 5 (15 minutes) Text Study, Tanach #F is about "peace within your walls." But how to get to that peace?

The leader prepares a list of ways of communicating in a home — negotiation, stewing, attentiveness, affection, explosiveness, passivity, silliness, secrecy, etc. Write these words on slips of paper, enough so that each person can have four (there can be repeats). Each person draws four words, then creates a string of four short phrases of movement that reflect each of the four styles of communication. (An alternative is for each person to come up with the four words and to create the phrases of movement based on those.)

These phrases are then presented in duets, trios, or quartets. A sample duet would have each person dancing a phrase of four short segments. One performer might express affection, anger, stillness, silliness, and the other attentiveness, explosiveness, calm, enthusiasm. The phrases are repeated several times, during which the dancers are to become aware of and respond to each other. Will the dancers try to influence or overpower each other? Will they pause and be attentive to

the others' movements for a few moments? Will they improvise new movement, or adjust their phrases as a result of what they see in their partner(s)? Will they try to maintain their own "perspective" while integrating the others?

Pairs (or trios or quartets) discuss the experience. How did you respond to each other? Was it difficult to keep dancing your own phrase while your partner did something completely different? In what ways did the dance improvisation reflect in any way what happens in real families? How can a family attain a sense of *Sh'lom Bayit* when family members are in different moods and feel emotions that clash with each other?

 6 (15-20 minutes) Each person chooses three to five of their photos (or drawings) done in Miscellaneous #2 below. For each of the photos (or drawings), they are to create a short movement phrase that captures the feel of, or an element reflected in, each picture. Then they string the short phrases together and take turns presenting them to the rest of the group.

Those observing can be directors, suggesting variations on the original phrase that lead the performer to a more refined portrait of, or a specific journey toward, *Sh'lom Bayit* as it exists within. A director might say: Do the first phrase ("photo") timidly. Do the second phrase extra slowly. Do the third in a way that integrates segments of the first and second phrase.

How was the experience for the performers? For the directors? What new thing(s) did the performers learn by following the directors' instructions? In what ways, if any, has *Sh'lom Bayit* (as it exists inside) become clearer from doing this exercise?

 7 (10-15 minutes) Carry out a discussion as outlined in Language Arts #5 above, comparing a Sukkot holiday *sukkah* with a *sukkat shalom* — a shelter of peace.

Then try the following: Two people hold a blanket. A third person approaches the blanket as if it is a metaphor for God's peace as prayed for in the "*Hashkivaynu.*" They improvise for a short time with the "shelter," exploring its properties of protection and the sense of security it gives.

Try other shelters and fabrics, more flimsy ones (a wet paper towel, a dishrag, gauze-like material), and more solid ones (a sheet of clear plastic, a wide board like a tabletop). Also, give everyone a chance to experience all the roles (those protecting/holding the shelter, the one approaching the shelter, and any observers).

Review the various "fabrics" with which participants danced. Which fabric best captures the sense of God's nature as shelter, God's protecting presence? Describe an image of shelter you most would like to have in mind when praying.

Music

 1 (5 minutes) In this light activity, participants do physically what they may strive to do emotionally. That is, they harmonize *rhythms* within themselves, just as they try to harmonize *feelings* within themselves.

The leader directs participants: Using one part of your body, create a rhythm. Using another part of your body, create a different rhythm. Try "playing" the rhythms at the same time. Gradually, bring the two rhythms into synchronization. Repeat with other parts of the body, other rhythms. You are literally creating harmony with and within your body.

Discuss. Was it hard to harmonize the rhythms, to bring them into synchronization? Think about the challenges of bringing physical rhythms into harmony. Are such challenges at all similar to the challenges of bringing different (perhaps conflicting) parts of yourself into harmony (into peace)?

 2 (5-15 minutes) It is helpful to analyze and reason. New insights can be gained by exploring an idea from our more intuitive, artistic instincts.

Hand out five or so percussion-type instruments at a time. One person begins by making up and repeating over and over a phrase of music. The next person creates a phrase or rhythm that complements the first in a harmonious way. The next people continue in the same pattern.

Discuss the experience. What might musical harmony teach about family harmony?

A variation: Begin in pairs. One partner creates a repeating musical pattern as above. The second person "enters" with a sound that is cacophonous, but very gradually becomes harmonious.

Another variation: Come up with a simple family interaction scenario and improvise it on instruments. For example, two members of a family carry out a task together when an argument breaks out. They disagree, but eventually work things out and are at peace again.

 3 (5-10 minutes) *Sh'lom Bayit* is family harmony. Can musical harmony teach us anything about family harmony?

Pick a song that everyone in the group knows. Sing it one time through, instructing everyone to express his/her own voice as fully as possible. Sing the song again with the intent of blending harmoniously by trying to "sound like" the voices of the individuals sitting next to you. Try other variations in harmony (and disharmony), too.

Discuss. Was it easy or hard to experiment with musical harmonies? What similarities/differences are there between musical harmony and family harmony?

Miscellaneous

 1 (10-15 minutes discussion; plus a few minutes, at least, every day for about a week) We need to work con-

stantly at seeking peace (see Text Study, Rabbinic #A). It is therefore important to explore new methods for developing and sustaining it.

Brainstorm activities people pursue in order to increase a sense of inner peace. Examples include prayer, meditation, physical activities (such as biking or hiking), writing, drawing, talking with a counselor, etc. The leader asks everyone to spend a few minutes or more a day pursuing inner peace, experiencing the process in a way they haven't tried before. After a week, they report back to the group.

Did you enjoy pursuing inner peace in a new way? Was it helpful, insightful? Do you think a person should try new ways of working toward inner *Sh'lom Bayit* or, once you have a way that seems to work well enough, just stick with that? Explain.

 2 (10-15 minutes group time; plus time at home) Analyzing old photos of yourself can be instructive in your continuing pursuit of peace.

Participants bring in five or so photos of themselves. In small groups each person explains which photo best captures a sense of peace within him/herself (within his/her own personal "house"). Also discuss which photo best captures *Sh'lom Bayit* in its more straightforward meaning — peace in the home, peace in the family. Are the choices the same? different? Why?

As a follow-up, take photos at home that capture the meaning of *Sh'lom Bayit* — both as between people (*Bayn Adam L'Chavero*) and within oneself (*Bayn Adam L'Atzmo*).

A variation: Participants draw or paint self-portraits instead of using photos.

CHAPTER EIGHTEEN

SHMIAT HAOZEN: ATTENTIVENESS/ BEING A GOOD LISTENER

שְׁמִיעַת הָאֹזֶן

OVERVIEW

The Hebrew root of "Shmiat" comes from sh-m-a (listen, hear), while "Ozen" is Hebrew for "ear." Shmiat HaOzen literally means "a listening of the ear." Listening goes beyond the level of physical hearing. Hearing is not a virtue, per se; it is physiological. Listening is mental, emotional, and social. Listening involves understanding, processing, evaluating, giving consideration, heeding, obeying, accepting, and being willing. Any or all of these acts and attitudes may be part of Shmiat HaOzen.

The expression "Shmiat HaOzen" appears in the Rabbinic writing Pirke Avot. That tractate of the Mishnah focuses on ways we should behave, how to be a good person, how to acquire Torah, and emphasizes study as the method for achieving these goals. Merge the virtue of Shmiat HaOzen with study and we get one kind of listening — the type of attentiveness we need in order to learn. Paying attention to the teacher, listening to what other students say, absorbing the lessons in text study, being alert to our own insights, being willing to act on what we learn, may all be part of the pshat (the straightforward) meaning of Shmiat HaOzen, as it appears in Pirke Avot. Yet, as important as classroom attentiveness may be, a still broader understanding of this Middah is in order. For this, there is a range of other Jewish sources on listening.

In the Bible the word "hear" is used when various characters communicate. In such interchanges, paying attention to what is being said is all that is called for. But when God is the Other in a communication, the word is not a request

for attention, but a command. God's call to listen means more than letting sound fall on ear drums; some follow-through is expected. Hearing God involves heeding, obeying, accepting, being willing. God's voice lingers. When God says, "Shema Yisrael" (Hear, O Israel), the hearing is not meant to be a onetime event. We are not meant to hear, to process information, and then simply to move on to the next thing. There's an expectation that hearing God should influence one's activity, our identity. Hearing God calls for a commitment to accept a specific spiritual path — to live by and continue to live by it. The voice of God may first have resounded "back then" — long ago, in the days of the Bible — yet, God's words continue to reverberate through the centuries. We are the listeners of our day! And our children, too, are to heed the injunction, "Hear, O Israel . . . "

Furthermore, God's voice is not only "out there" — pre-recorded to be played aloud from time to time — rather, God's voice is to resonate within us, renewed each day. The voice is ancient, but it is also new. We call it the "kol demamah dakah" — "the still small voice." It is heard with the "inner ear." We open our inner ears to God's voice when examining our hearts, through meditation, through turning inward.

Ideally, what is required in listening to others (Bayn Adam L'Chavero) in day-to-day conversations? Although obedience and heeding are not necessarily implied in being a good listener to other people, still, we can learn from certain listening qualities we ascribe to God. We call God a compassionate listener. So, too, should we be compassionate listeners. We say that God listens

equally to all people. That is, God doesn't favor the rich over the poor, the powerful over the weak, adults over children, men over women, etc. Likewise, in our relationships with people, we should try to be unbiased and open-minded when we listen. We say that God understands that people range in their capacity to listen. This teaches that we should understand there may be limits to how much we ourselves can "hear" at any particular moment (or comprehend, process, accept, respond to). Likewise, we should understand there may be limits to how much others can "hear" us.

Our capacity to listen can change. A "listening ear" can become sharper and more highly tuned through a lifetime of trying to make it so.

How a "listening ear" functions in our relationships with other people, with ourselves, and with God is summarized below.

 BAYN ADAM L'CHAVERO, BETWEEN PEOPLE. Being compassionate and understanding, being open-minded and unbiased — these are key in the mastery of this *Middah*. In order to be a good student, a good learner, listening to others (teachers, colleagues, students) is necessary. Growing in wisdom and self-understanding can be enhanced by listening to counsel others give.

 BAYN ADAM L'ATZMO, BETWEEN YOU AND YOURSELF. Listening to yourself, being attentive to yourself, hearing your own inner voice — these are what is involved in mastering *Shmiat HaOzen* as it relates to yourself.

 BAYN ADAM L'MAKOM, BETWEEN YOU AND GOD. Listening to God assumes more than attentiveness. God may be asking for obedience, acceptance, and/or willingness. To be a good listener in the presence of God involves listening to your still, small inner voice as well.

Good listening qualities are ascribed to God. That is, God is said to be a compassionate, unbiased, understanding listener. Try to emulate compassion, open-mindedness, and understanding as you work to master the virtue of listening that transcends mere hearing.

TEXT STUDY

Tanach

A In the Bible there is a connection between hearing and obeying. Hearing *"shema"* or *"nishmah"* in the context of a religious experience makes an impact on a deeper level. It summons one to act in a certain way, to heed a certain lifestyle.

> **Then [Moses] took the record of the covenant and read it aloud to the people. And they said, "All that the Eternal has spoken we will do (*na'aseh*) and we will hear (*v'nishma*)." (Exodus 24:7)**

➤ What does hearing mean in the context of this verse? How would it change the meaning of the verse to translate *nishmah* as "obey" or "understand"? You might think that the final two phrases should be reversed — that is, first you would "hear" and then, you would "do." Why do you think the verse is worded the way it is ("doing," and then "hearing")?

B We recite the *"Shema"* several times a day in prayer. The word *"shema"* is sometimes translated as "Hear!" and sometimes as "Listen"!

> **Hear, O Israel! The Eternal is our God, the Eternal alone. (Deuteronomy 6:4)**

➤ Elaborate on what you think it means to "hear" in the context of this verse. Why have

these words become so central in our worship? What is the relationship between "hearing" and leading a spiritual life?

C See Rabbinic #2 for explanations of some different styles of listening. These explanations are drawn from the lives of biblical characters.

D Being a good, attentive listener can enhance wisdom.

The one who listens to counsel is wise. (Proverbs 12:15)

➤ How can listening to counsel make a person wise? When you have listened to counsel, has doing so made you wiser? Explain.

E The prophet Isaiah makes an important point when he says that listening is not passive. The listening that nourishes the soul demands a high level of attentiveness.

Incline your ears and go to Me; listen and your souls will live. (Isaiah 55:3)

➤ In your own words, explain the first phrase of this verse, then the second phrase. The verse speaks about listening to God. In what ways might the ability to listen well to other people bring you closer to God?

Rabbinic

A One of the clear implications of *Shmiat HaOzen* is attentiveness in learning.

Torah is acquired through 48 virtues . . . [Included among them is] *Shmiat HaOzen* . . . (*Pirke Avot* 6:6)

➤ Why do you need *Shmiat HaOzen* in order "to acquire Torah"? Can a "listening ear" help you

to acquire specific virtues? That is, how might *Shmiat HaOzen* contribute to your ability to be merciful? to be just? to be supportive (support the falling)? to comfort mourners? to have *Sh'lom Bayit* — peace in the home/family? Other ideas?

B This complex Rabbinic text draws on biblical examples to explain styles of listening. These examples direct us toward clarifying the best in listening. Some lessons that can be drawn from this passage are: use discretion in listening, listening should be accompanied by evaluating, think about what you hear.

There are four types of listening: Listening and losing, listening and gaining, not listening and losing, and not listening and gaining.

Listening and losing: as in the case of Adam, about whom it is written: And to Adam God said: "Because you listened to the voice of your wife . . . " (Genesis 3:17). And what did he lose? "Because you are dust and to dust will you return." (Genesis 3:19)

Listening and gaining: as in the case of our father Abraham, who was told: "All that Sarah tells you, listen to her voice" (Genesis 21:12). And what did he gain? "For in Isaac shall your seed be called to you" (*ibid.*)

Not listening and gaining: as in the case of Joseph, concerning whom it is written: "And he did not listen to [Potiphar's wife], to lie by her, to be with her" (Genesis 39:10). And what did he gain? "And Joseph was the ruler over the land." (Genesis 42:6)

Not listening and losing — as in the case of the Jews, concerning whom it is written: "And they did not listen to Me, and they did not incline their ears" (Jeremiah 7:26). And what did they lose? "Such as are for death, to death; and such as are for the sword, to the sword" (Jeremiah 15:2). (*Yalkut Shimoni*, Genesis 32, quoted in *Orchot Tzaddikim*, p. 255)

➤ Each of the four types of listening in this passage includes two citations from the Bible. For each type of listening, explain how the biblical citations support or "prove" that type of "listening." In other words, for each type, why is the first phrase cited as proof of "listening" (or "not listening"), and then why is the second phrase used to prove the "losing" (or "gaining")? Who would you consider to be good listeners in these passages? What are these passages trying to teach, overall, about listening?

C It is difficult to listen equally to all people. We often listen or pay attention to some and brush off others. Such bias may be common, but it is not God's way. To emulate God, we should try to be good listeners to all people.

Rabbi Judah ben Shalom said: If a poor person comes, and pleads before another, that other does not listen to the poor one. If someone who is rich comes, the person listens to and receives the rich one at once. God does not act in such a manner. All are equal before God — women, slaves, rich and poor. (*Exodus Rabbah* 21:4)

➤ What is the difference between the human listener in this passage and God? In your experience are people more likely to hear what is being said by those in positions of power? those who are wealthy? those who have social status? Are you biased in your listening? If so, what can you do to rid yourself of undesirable bias?

D There's some similarity between this passage and the previous one. An underlying message of both is that we should open our ears a little wider, in order to hear more from all kinds of people. Listening to those who are less powerful, less learned, and/or younger is important in a community.

Happy the generation whose great [leaders] listen to the small, for then it follows obviously that in such a generation, the small will listen to the great. (*Rosh HaShanah* 25b)

➤ Why does this passage call the generation happy? Do you agree/disagree with the use of that word? Explain. How might the passage apply in families? in schools? in the work place? in the synagogue? in politics?

E We are told that each person hears according to his/her own ability. But the hearing is more than the physical experience of sound registering in the brain. Hearing in these texts seems to include such experiences as understanding, processing, acceptance, and willingness.

The eye is shown only what it is capable of seeing, and the ear is given to hear only what it is capable of hearing. (*Avot d'Rabbi Natan* 1:2)

God's voice went forth to everyone in Israel according to their powers of obedience. The elders heard the voice according to their capacity; the adolescents, the youths, the children, the

babies, each according to their capacity;
the women, too, according to their
capacity, and also Moses according to
his capacity, for it says, "As Moses spoke,
God would answer him with the voice."
(Exodus 19:19) That is, [God would
answer Moses] with a voice that Moses
was able to hear. (*Tanchuma, Shemot,*
25, 90b)

➤ What does it mean to hear according to your
own capacity? What situations or experiences
could make people change or grow in their
capacity to hear? Has your ability to hear been
the same your whole life, or has it changed? If it
has changed, why and how has it done so? (See
also Post-Rabbinic #A.)

Tefilah

A The words of the "*Shema*" come from the
Torah. (For a more complete explanation,
see Tanach #B.) The following is a prayer-poem
built around the meaning of listening, as inspired
by the words in the "*Shema*."

<div align="center">Listen!</div>

Judaism begins with the commandment:
Hear, O Israel!
But what does it really mean to "hear"?
 The person who attends a concert
 With a mind on business,
 Hears — but does not really hear.
The person who walks amid the songs
of birds
And thinks only of what will be served
for dinner,
Hears — but does not really hear.
 The one who listens to the words of
 a friend,
 Or spouse or child,
 And does not catch the note of
 urgency:

"Notice me, help me, care about me,"
Hears — but does not really hear.
The person who listens to the news
And thinks only of how it will affect
business,
Hears — but does not really hear.
 The person who stifles the sound of
 conscience
 And thinks "I have done enough
 already,"
 Hears — but does not really hear.
The person who hears the Hazzan pray
And does not feel the call to join in
prayer,
Hears — but does not really hear.
 The person who listens to the rabbi's
 sermon
 And thinks that someone else is being
 addressed,
 Hears — but does not really hear.
On this Shabbat, O Lord,
Sharpen our ability to hear.
 May we hear the music of the world,
 And the infant's cry, and the lover's
 sigh.
May we hear the call for help of the
lonely soul,
And the sound of the breaking heart.
 May we hear the words of our friends,
 And also their unspoken pleas and
 dreams.
May we hear within ourselves the
yearnings
That are struggling for expression.
 May we hear You, O God.
For only if we hear You
Do we have the right to hope
That you will hear us.
 Hear the prayers we offer to you this
 day, O God,
 And may we hear them too.

("Listen" by Jack Riemer and Harold Kushner. Reprinted with permission from *Likrat Shabbat* by Sidney Greenberg and Jonathan D. Levine, published and copyrighted by The Prayer Book Press of Media Judaica, 1363 Fairfield Ave., Bridgeport, CT 06605, pp. 74-75)

➤ How do the authors of this prayer expand on the idea of listening? Do you agree that the command to listen involves all the things included in this prayer? Is this prayer a good summary of the virtue of *Shmiat HaOzen*?

B This passage is included in the daily prayer, the *"Amidah,"* in which we ask God to listen to us.

> Hear our voice, Eternal our God, have pity on us and be compassionate, and accept our prayer with loving favor, for You are God who listens to prayer and supplications. Do not turn us away unanswered, our Sovereign, for You hear the prayer of your people Israel with compassion. Blessed are You, Eternal One, Who hears prayer.

➤ When you pray, you expect that God will listen. If this is so, why would the above passage be included each time we recite the *Amidah*? Is it necessary? Give reasons why it might not be superfluous.

C There's a special *"Shema Kolaynu"* or "Hear Our Voice" prayer chanted during the *Yamim Nora'im*, the High Holy Days. It begins with the same words as the section from the *"Amidah"* quoted above, and then goes on:

> Give ear to our sayings, God, understand our thoughts.

> May the words of our mouth and the thoughts of our heart
> be acceptable to You, God, our Rock and our Redeemer.
> Do not cast us away from Yourself, and do not take away from us Your holy spirit.
> Do not cast us away in old age, when our strength fades, do not forsake us.
> Do not forsake us, Eternal, our God, do not be distant from us.
> Make us as a sign for good, so that our enemies may see it and be ashamed, for You, Eternal, will have helped and comforted us.
> Because for You, God, we waited, You, my Eternal One, our God will answer.

➤ Why do you think this prayer is recited during the *Yamim Nora'im*? Is it said more for God's benefit or for our own? Explain.

Post-Rabbinic

A Like the passages in Rabbinic #E, the following quotation asserts that people hear according to varying capacities.

> Once a great throng of people collected about the Rabbi of Apt to hear his teachings. "That won't help you," he cried to them. "Those who are to hear will hear even at a distance; those who are not to hear will not hear no matter how near they come." (Martin Buber, *Tales of the Hasidim: The Later Masters*, p. 115)

➤ What does hearing mean in this passage? Why does the Rabbi of Apt say that there are those who will not hear no matter how near they come? What is the relationship between hearing and

willingness? How would the Rabbi of Apt describe the connection between the two?

B When you listen most intently, you may discover hidden lessons beneath the surface. Such is what happened with the brothers Reb Elimelech of Lizensk and Reb Zusya.

> [Once the brothers] arrived in a certain village, and though the head of the village wasn't in his house, his wife took them in as guests. When her husband came home in the middle of the night, he lit a candle on the table as he worked to mend a rip in his fur coat.
>
> The two brothers who were in bed (but awake), heard how his wife called to him saying, "Hurry up and fix the coat while the candle is still burning." And one brother said to the other, "Did you hear what the lady of the house is saying to her husband?"
>
> This is a great teaching, to fix yourself quickly and repent while your soul is still within you. (*Siah Sarfei Kodesh*, II, p. 80, #260, Yitzchak Buxbaum in *Jewish Spiritual Practices*, p. 470)

➤ What did the wife in this story say to her husband? How did the brothers Reb Elimelech and Reb Zusya "hear" what was said? Describe the different levels of hearing.

C Listening to God involves listening to the inner voice.

> The Besht (Baal Shem Tov): When people listen well to the inner voice which is within the material voice and sound that their ears hear, they will not hear anything other than the voice of God. The voice of God enlivens and

brings into being that very minute, the sound they hear." (Hadrachot ha-Besht, end of Divrei Shmuel, as quoted by Yitzchak Buxbaum in Jewish Spiritual Practices, adapted, p. 469)

➤ Do you think God can be heard by listening well to the inner voice? Explain. What, according to this passage, is the relationship between your "out loud voice" (or "material voice") and the voice of God? Do you agree with what the passage says? If you want to hear the "voice of God," where do you believe it's best to direct your attention?

ACTIVITIES

Language Arts

 1 (5 minutes; plus you may want to repeat the activity several times) The virtue of being a good listener involves more than the physical experience of hearing. Nevertheless, tuning up our sense of hearing can be a good beginning for enhancing the virtue of listening.

The leaders says: Stop everything you're doing right now and listen! Listen all around you — above, below, on all sides. Listen to close-up sounds. Listen to what's far away. How much can you hear?

Have participants write down everything they hear for a minute or two. Compare notes, then put the pages aside. Every once in a while, during the session, repeat the exercise. A younger group can do this activity without writing. After listening for a minute or so with eyes closed, they can discuss or dictate what they heard. A more advanced group could do this exercise on their own (i.e., as "homework"). This group would be told to listen at certain times (when they first wake up, while they're walking to school/work, during

lunch, late afternoon at home, and before going to sleep), and write down what they hear.

Share reactions. In what ways did your ability to hear change when you repeated the exercise? What new things did you hear because you made a special effort to listen? What might you discover or learn by paying more attention to sound?

 2 (5 minutes, repeated at various intervals) Being a good listener involves paying attention to inner sounds, your inner voice, in addition to the sounds and voices of the world around you.

Complete #1 above, then do this variation of it. As you listen, stop at given intervals and write for a minute or two everything you "hear" inside yourself, all the inner dialogue. As you write, don't stop or evaluate. After five to ten of these writing intervals, look at what you've written.

What is the nature of inner dialogue when you "catch it" by surprise? How does it differ from premeditated, more composed writing? How is your inner dialogue influenced by what you hear on the "outside" — in the world around you?

 3 (15 minutes) *Shmiat HaOzen* includes being a good listener within the context of study.

Go over the related material in the second paragraph of the Overview and in Text Study, Rabbinic #A. Then create a list of ten (or so) rules for the classroom derived from the virtue of *Shmiat HaOzen*. For example: listening to the teacher, listening to other students, not interrupting others, evaluating and thinking before you talk, giving equal attention to all members of the class, etc.

Post the rules where everyone can see them. Now and then return to the list and conduct a group check to determine how well the class has been carrying out the virtue of *Shmiat HaOzen*.

 4 (10 minutes at least) Our liturgy includes prayers about hearing, about listening. The spiritual power of listening has been of inspiration for centuries. Here are some examples:

a. The *"Shema"* is a statement that has been called "the watchword of our faith."

b. The *"Shema"* has been the stimulus for new, creative prayers on listening.

c. A section in the *"Amidah"* is about hearing prayer.

d. Asking God to hear our voice (*Shema Kolaynu*) is an important liturgical theme during the *Yamim Nora'im* (High Holy Days). See Text Study, Tefilah #A, #B, and #C for more on these prayers.

Study some or all of the various prayers mentioned above. Then write your own prayer about listening. If desired share your prayers with each other, perhaps including them in an actual worship service.

 5 (15 minutes) Text Study, Rabbinic #B uses the Bible to provide examples of listening and not listening.

Study the text and, in small groups or individually, come up with modern examples for the categories of listening/not listening. This can be done as a discussion or in writing. Here is one modern example for "listening and losing": Your classmate tells you to write a few answers to the upcoming spelling test on your hand. You "listen" and do so. But you end up "losing" out because later, you feel awful about cheating. Not only that, you get caught. You receive a flunking grade for the test, plus your parents are called and informed about what you did. You "listened," but you "lost."

What does this activity teach you about listening? What can you do to bring about more "gains" than "losses" in listening?

 6 (15 minutes) There is a relationship between hearing and obeying. In fact, in the Bible, when we are told by God to listen, it is clear that more is expected, that obeying or heeding is part of the equation as well. The phrase *"na'aseh v'nishma"* can be translated as "do and *hear*" or as "do and *obey*" (see Text Study, Tanach #A). This exercise explores the extent of this kind of obedient/willing hearing in our lives.

Number a blank page (or two) from 1 to 100. Quickly, fill in your responses to the question, "What do I obey?" You might write down "Torah" and also "my heart." Or, you might write down such diverse things as "red traffic lights" or "red light facial expressions" (the latter being the signals others give you when they don't want to talk about something).

Were there any surprises in what you wrote? any words or themes that come up again and again? Is there significance to such repetition? Are you obeying what you think you should be obeying? How might you need to reorient or readjust your "listening"?

Visual Art

 1 (5 minutes; plus you may want to repeat the activity several times) This activity is similar to Language Arts #1 above, during which participants listened every once in a while to all the sounds in their midst, then wrote down everything they were hearing. Here, though, rather than writing, participants draw or paint everything they hear. The activity can be repeated several times, at various intervals.

2 (15 minutes) The virtue of *Shmiat HaOzen* includes the attentive listening we must do in order to be good students (see the second paragraph of the Overview and Text Study, Rabbinic #A). It is also true that people hear in different ways, or according to their "own capacity" (see Text Study, Rabbinic #E). This activity combines these two ideas.

The leader chooses an object without others seeing what it is. For an elementary group, this can be something simple, such as a mug or a small shovel; for a more advanced group, it can be a more complex object. The leader describes the object with as much detail as he/she can without actually naming it. Participants listen and try to depict the object visually.

Discuss how this exercise underscored that idea that attentive listening is necessary in order to learn. Does the variety of art created by group members support the view that people hear differently (according to their "own capacity")? Is the fact that people "hear differently" a good thing, not a good thing, or neither good nor bad? Explain.

 3 (10 minutes or more for each picture) What does a person look like who is listening? Does it show in their posture — how the person sits or stands? Does it show in their facial expression or the direction of the person's eyes? How does the listener's appearance change depending on whom the listener is listening to?

Draw a picture of one or more of the following:

a. Someone who is listening to another person
b. Someone who is listening to him/herself
c. Someone who is listening to God

What do the various pictures have in common? What essentials of listening can you discover by looking at the drawings? If you did all three drawings, what similarities and what differences are there between them?

 4 (15 minutes) This variation of #3 above focuses on the listening that takes place between people. The artistic process will show the experience of meaningful listening.

Keeping in mind that a good listener is compassionate and open-minded, draw two small shapes (such as two small circles) on opposite sides of a page. Imagine these shapes are listening to each other, carrying on a "conversation." Each exchange in the conversation is "recorded" by adding to the shapes, first one and then the other, back and forth. The shapes will take on layers or sub-shapes as the conversation develops. Consider what colors compassion and openness are.

Share your artwork with a group. Describe how the artistic process worked for you — what you began with, and how and why the work developed the way it did. What do you find most striking about your piece? What do others find most striking? What new things did you discover about the meaning of listening through this exercise?

 5 (15 minutes or more) The passage from Isaiah 55:3 quoted in Text Study, Tanach #E lends itself to artistic interpretation.

Illustrate this verse in an imaginative and abstract way. For example, you might make the ears bigger than normal life-size. "Going to Me" might be shown by footprints traversing an earth shape, with the earth shape encased in the folds of a partially unrolled Torah.

Share and display your artwork if you like. Artists may wish to comment on how they came up with their various artistic interpretations of the verse. They may have questions they want to ask about each others' work.

Drama

 1 (5-10 minutes) This exercise, which provides practice in active listening, is a good, short opening to the topic of *Shmiat HaOzen*. It demonstrates that a good listener doesn't just hear, but absorbs, processes, and integrates what he/she hears.

Pairs spread out around the room (so that they will not distract one another), then "mirror" each other's sounds. The pairs decide who goes first. That person makes whatever sounds he/she wants — words, humming, sighs, grunts, loud sounds, soft sounds. The follower will try to "mirror" (or echo) the initiator's sounds as closely as possible. Do this for a couple of minutes, then switch roles back and forth a few times.

Discuss. Was this exercise easy or difficult? Was there anything special about the listening you did in this exercise — did you or did you not pay more attention to what you were hearing than you usually do? Explain. Did you need extra concentration or need to look especially closely at your partner? Anything else special about the listening?

 2 (5-10 minutes) Attentiveness involves not only the ears, but the whole body. In this exercise, you will listen with your whole self.

First, address *Shmiat HaOzen* as the listening and the attentiveness required to be a good student. Together with a small group, think of five ways of sitting (or standing) that show you are not really listening. Then think of five ways that show you are truly listening with your whole self. Participants share or "perform" their poses for each other.

Second, address the kind of listening in Text Study, Tanach #D — one who listens to counsel is wise. In pairs, one person is the counselor, one the listener. The listener acts out five postures showing he/she is not really listening to the counselor and five showing he/she truly is. Then the pairs switch roles.

Discuss the various ways people demonstrated listening and not listening. What did it feel like not to be listened to? Compare this feeling to being listened to. What else is required for being a good, attentive listener besides "opening your ears"? What body language shows active listening?

 3 (5-10 minutes minimum; less time for spontaneous improvisation to the words of prayer, more time for planned and rehearsed interpretation) The prayer "Listen" in Text Study, Tefilah #A lends itself well to dramatic interpretation in one of two ways:

As an improvisation: One person is the reader, perhaps the teacher or leader. Some people are chosen to be the performers or a whole group could perform together. The reader recites the prayer very slowly and the performers act out what they hear.

As a planned and rehearsed interpretation: One large or several smaller groups create a dramatic version of the prayer. They act out the words, and "set" what they come up with.

After rehearsing, the dramatic interpretation(s) can be shared with others — in the classroom, at a worship service, or at an assembly.

 4 (5-15 minutes for each exercise) Following are three other texts that lend themselves to dramatic interpretation.

a. Text Study, Tanach #B, the "*Shema.*" Imagine you are Moses addressing the Israelite people, then take turns calling out the words of the "*Shema*" (in Hebrew or English) as you believe Moses would have. Did he call out forcefully? with a strong and confident voice? with a quavering voice? Did he draw out the words slowly and intently, or did the words rush out of his mouth with a quick urgency? Did he raise his arms as he called out the words, or were his arms folded across his chest, or were they hanging loosely at his sides?

b. Text Study, Rabbinic #B, which is about listening and losing, listening and gaining, not listening and gaining, and not listening and losing. You may want to do both a dramatic interpretation of the traditional text and a modern version of the passage. (Modern versions are discussed in Language Arts #5.)

c. Text Study, Post Rabbinic #B, which is about two brothers who hear a deeper message in a seemingly straightforward interchange.

5 (15 minutes) Are you more likely to listen to someone who is rich than someone who is poor? Would you tend to pay more attention to a "popular" person (someone of high social status), over someone who is "unpopular"? Rabbi Judah ben Shalom reminds us of our biases and states that God does not show such biases (see Text Study, Rabbinic #C).

Study the text, then set up three chairs in a line, facing the audience. Three actors chosen to improvise a scene sit in the chairs. The middle person is the listener. On one side is a poor person, on the other a rich person. These two begin talking to the listener at the same time to get his/ her attention. The poor person and the rich person stay in character, improvising their words in ways that reflect their poverty or richness. The listener tries to be the best listener he/she can. To whom does the listener listen? Here is an example of the beginning of such a dialogue:

Poor person: I've come to you out of desperation. I've just lost my job. My children are sick, and I need to have them seen by a doctor. We haven't been able to pay for health insurance for many months now, and I know we can't afford the medicines the children will need.

Rich person: I have to tell you about a fantastic moneymaking opportunity that has come my way. There's a new condominium development going up on the east side of town — very elegant, very exclusive. These places will sell fast. I'm inviting you to be one of the partners in the investment.

After a few minutes, give other trios the opportunity to improvise. Then discuss. What did the performers experience? What did the audience members observe? In what ways is it difficult to listen to all people equally — rich and poor alike? How do we become more like God through listening to all equally? How can we become better, "equal opportunity" listeners?

Movement

1 (10 minutes for each improvisation) In the first part of Drama #4, participants imagined they were Moses calling out to the Israelites to listen. In #a below, both sides of the "Shema" communication are represented — Moses on one side, and the Israelites on the other. In #b below, the focus is on a traditional *midrash* on the "Shema."

a. Dancers take turns being Moses, while the rest are Israelites. Moses repeats the "Shema" several times over (in Hebrew or English) in a voice he/she feels carries the sense of the command. The Israelites respond in movement in ways that reflect how they hear Moses' voice.

b. A *midrash* suggests that the words of the "Shema" were spoken to Jacob (or Israel) by his sons as he was about to die — "Listen, Israel, we affirm and will carry on the belief in one God." Dancers take turns being Jacob (Israel) while the rest are his sons. The sons recite the "Shema" accompanied by improvised movement, as if they are at the side of the dying Jacob. Jacob responds in a way which reflects spiritual strength coupled with physical frailty.
(Note: These two activities appear in *Torah in Motion: Creating Dance Midrash* by JoAnne Tucker and Susan Freeman, p. 200.)

Share how you felt when you played Moses. How about when you were an Israelite hearing Moses' words? Compare that experience to the scene with Jacob and his sons. What was it like to be Jacob hearing his sons' words (the "Shema")? How did the sons feel as they told their dying father to "listen"? What do you yourself feel when you pray the words of the "Shema"?

2 (5-10 minutes minimum) This activity is a movement adaptation of Drama #3. Here, participants improvise or choreograph a dance to the words of the poetic prayer "Listen."

(Note: A similar activity is found in *Torah in Motion: Creating Dance Midrash*, p. 201.)

3 (15 minutes) Using Drama #5 as a guide, introduce the following adaptations. Instead of having three performers sitting on chairs facing the audience, have the poor person stand on one side of the performing space and the rich person stand on the other. The listener stands in between. As in the drama exercise, the poor and rich person "plead their cases" loudly to the listener. The listener responds to the two in movement — going back and forth between the two individuals as he/she feels compelled to do. To make the exercise even more challenging, the speakers (the poor and the rich person) can move while they talk and plead their cases. "Speakers" could also plead their cases with their bodies only, without using their voices.

4 (10 minutes) Take a deeper look at Isaiah's words in Text Study, Tanach #E, which tells us that ears can take the lead in bringing us closer to God. Begin with the following three "warm-ups." Then continue with the more developed improvisation that follows.

a. Experience what it means to use one body part as the initiator of movement. For example, use your hands to initiate a turn, to lead you to a forward fall, to lift you in a jump off the ground, etc. Repeat with a few different body parts (an elbow, a hip, a knee, etc.). Finally, come to your ears. Spend extra time on the ears, using them as the initiators of movement. Allow your ears to lead you into a turn around your back, a run, a side fall to the ground, a marionette-like bounce, etc. What else can your ears lead you to do?!

b. Play a variety of sounds — a quick clapping or drumming rhythm, bells, samples of different music styles (classical, jazz, loud rock, children's nursery rhymes), the sound of a small appliance

(blender, can opener, electric beater, etc.). With each sound, respond to what you hear in movement, "inclining" your ears toward the sound.

c. Listen to sounds in the environment and respond to those sounds. Respond first with your ears, with the rest of your body following.

The more developed improvisation: Focusing on the actual verse from Isaiah, incline your ears to God. Improvise freely for a few minutes, taking inspiration from the words from Isaiah. The listening that takes place in the second half of the verse is invigorating, awakening, energizing. Something is revealed, something is learned in the process of listening. Participants may use a combination of moving individually and interacting with others, as desired.

Discuss reactions to the experience of using your ears as your first sense in responding to what's around you. Did it feel natural/unnatural? What would you like to change about how you use your ears to listen in "real life" to the world around you? to other people? to God?

 5 (5-10 minutes) What does it mean to do, and then to hear? In the Bible the Israelites respond to Moses' reading of the covenant in this way by agreeing to do and to hear (see Text Study, Tanach #A). There's a powerful sense of willingness in this response. A *midrash* speaks highly of a man named Nachshon, an exemplar of willingness, who was the first to step forward and plunge into the Reed Sea. Nachshon takes the plunge; he is willing to "go for it." He has the confidence "to do," and he has the trust that the "hearing" or understanding will follow.

Choreograph a dance based on hearing, defined as "willingness." If desired, use Nachshon's experience as inspiration. The piece should include a going forward with confidence and should convey a trust that understanding will eventually come. Share what you discovered and learned from the creative process. If you can, find an opportunity to perform your choreography.

Music

 1 (5 minutes for each time you repeat the activity) So much about music involves good listening skills! See Language Arts #1 and #2 for activities which sharpen our hearing. While those activities are not exactly music exercises, they can help us become more sensitive.

 2 (5-10 minutes) Drama #1, in which participants "mirror" (closely echo) each others' sounds, is also appropriate as a music activity.

 3 (10 minutes or more) Find various melodies for the "*Shema*" (see Text Study, Tefilah #A). Then sing, play, and/or teach some of the melodies. Which melody best conveys the sense and power of the words of the "*Shema*"? Try using a different melody for this prayer in a worship setting over the course of several services. Then question worshipers as to their reactions to the new melody. Were they comfortable/uncomfortable at first? How long did it take to get used to the new melody? Which melody do they prefer, and why?

Find different melodies for "*Shema Kolaynu*" (Hear Our Voice), which is sung during the *Yamim Nora'im* (see Text Study, Tefilah #C).

An advanced challenge: First play or sing your congregation's melody for the following prayers. Then compose and perform your own compositions based on the prayers.

a. The "*Shema*" (Text Study, Tefilah #A)

b. "*Shema Kolaynu*," part of the "*Amidah*" (Text Study, Tefilah #B)

c. "*Shema Kolaynu*" as sung on the *Yamim Nora'im* (Text Study, Tefilah #C)

Note: A Cantor or music specialist may be of help in finding music for the activities in this section. Also see *Gates of Song,* ed. By Charles Davidson (New York: Transcontinental Music Publications, 1987), #33 and #34, and listen to *"Shema"* on the album *Sing Unto God* by Debbie Friedman (distributed by A.R.E. Publishing, Inc.).

CHAPTER NINETEEN

SHMIRAT HAGUF: TAKING CARE OF YOUR BODY

שְׁמִירַת הַגּוּף

OVERVIEW

Our tradition teaches that we are created in the image of God. Being like God carries responsibilities — comporting ourselves in such a way as to emulate God's positive qualities. Be merciful, for God is merciful. Be generous, for God is generous. Be just, for God is just. And so on.

But our being is more than a matter of character. Our physical selves, on some level, also reflect the Creator. Our bodies are more than atoms, chemicals, skin, and bones. There is something holy about us. Some would say our bodies are holy because they house the soul. And the soul is like a breath from God, a whisper of God's being.

We say that the body is a gift from God, and as such must be treated with utmost care and respect. Yet, though it is a gift, we also say the body belongs to God. It is as if we're given the gift on loan. We must take good care of our gift for we are responsible for it. And our responsibility has some conditions. We cannot do whatever we want with our bodies.

This principle has implications with regard to some specific issues. One is suicide. If your body does not belong to you, and you are not free to do whatever you wish with it, suicide is not permitted. A person is not supposed to bring on death purposefully, by unnatural means.

Another specific issue is caring for a dead body. Jewish law prohibits cremation. Again, a key reason given is that the body belongs to God. Burial is seen as a natural process. Thus, cremation thwarts the process of the body returning to the earth. Embalming also disturbs the natural process, and

it involves cutting into the body. It is therefore not allowed unless burial is delayed for a legitimate reason. Autopsies are also discouraged (unless mandated by the judicial system or in order to save another's life).

The Torah forbids gashing (intentionally injuring) yourself, which was an ancient mourning practice. The body is not ours to injure. In modern times, smoking, tattoos, and body-piercing are questioned. These practices are like "gashing" and cause damage to the gift you are simply "borrowing."

In our daily worship, there is a prayer that speaks of God's gift of the body. In this prayer we express thanks for our bodies and express marvel at how each person is "crafted." We stand before God to utter this prayer, but our ability to stand comes from God.

We've established that God has given us the responsibility of *Shmirat HaGuf* (taking care of our bodies). On a practical level, this includes eating, bathing, sleeping, and exercising. At the more subtle level, this includes not endangering ourselves unnecessarily and treating our ailments in proper fashion, getting help from such sources as physicians when necessary.

A general guideline would be all things in moderation. Moderation is about "not too much" and "not too little." It's about not going overboard. We can eat too much, we can become neurotic about cleanliness, we can sleep too much, and we can over exercise. The same goes for mental health. Mental stimulation is good; unrelenting stress is not. Acknowledging our sexuality is part of taking care of ourselves, too. Sex is encouraged

in the context of certain loving relationships. But obsessiveness about sex and undiscriminating behavior is "too much." Physical desires, expressed in sanctified ways, ennoble and lend dignity and pleasure to life.

Judaism does give us opportunities to sample some extremes. On Purim, we are allowed to drink, even to an excessive degree. On Yom Kippur and other specified days, fasting is practiced. On Shavuot, people deprive themselves of sleep, staying up all night studying. And how about eating lots of fried foods on Chanukah?! Still, where extremes are concerned, there are limits. What you are allowed to do (beyond the "norm"), and when, is limited to certain things and to certain times. There is moderation even in experiencing the extremes.

We may think that *Shmirat HaGuf* is not really a *Middah* or virtue. We may believe it is more mechanical. Wash the body, feed it, let it get enough sleep. But *Shmirat HaGuf* does involve a combination of identifiable virtues. It requires responsibility, appreciation, and loving care. The body is an amazing creation. It is ours to tend for a lifetime. We ought to take care of it in the best way possible!

How does the *Middah* of *Shmirat HaGuf* apply in relation to others, to ourselves, and to God? Some overall ideas are summarized below.

 BAYN ADAM L'CHAVERO, BETWEEN PEOPLE. *Shmirat HaGuf* is associated with taking care of *your own* self, your own body. There are other terms associated with taking care of others. These include *Rofay Cholim* (healing the sick) and *Pikuach Nefesh* (saving a life).

There are times when taking care of your own body may require the involvement of other people. You may need to consult someone else, to seek help. In such a case, the doctor or the therapist may be practicing *Rofay Cholim* (healing). But you are practicing *Shmirat HaGuf* by seeking their help.

Unfortunately, when you don't care for your body (through drug or alcohol abuse, fasting that makes you sick, not practicing "safe sex," etc.), you affect others. The community may have to suffer, pay, or toil for your behavior.

 BAYN ADAM L'ATZMO, BETWEEN YOU AND YOURSELF. This is the area in which *Shmirat HaGuf* seems to apply most clearly. Taking care of your body is usually carried out "between you and yourself." No one can eat for you. No one can sleep for you. You may wish someone could exercise for you! *Shmirat HaGuf* requires you to show respect, responsibility, and loving care toward your body.

 BAYN ADAM L'MAKOM, BETWEEN YOU AND GOD. We are created in the image of God, who breathed life, a soul, into us. Taking care of our bodies honors God.

God has given us the gift of our bodies; yet, we cannot do with our bodies whatever we wish. The body belongs to God. It is "on loan" to us. We express gratitude to God for allowing us to borrow, for however long our lifetime is, such an amazing, complex "house for our soul."

TEXT STUDY

Tanach

A Taking care of ourselves is a way of respecting and honoring God. Therefore, we need to treat our whole selves, including our bodies, with care and dignity. (see also Rabbinic #A for a related text.)

For in the image of God, did God make humankind. (Genesis 9:6)

➤ What does being created in the image of God have to do with Shmirat HaGuf (taking care of

your body)? What are a few of the ways in which taking care of your body shows respect for God?

B In the ancient world, there was a custom for mourners to gash their flesh. This practice of deliberate mutilation, however, is forbidden in the Torah.

> **They shall not make gashes in their flesh . . . (Leviticus 21:5)**

> **You shalt not . . . make any tattoo marks upon you . . . (Leviticus 19:28)**

➤ Why do you think some people would make gashes or tattoo marks in their flesh? Why do you think the Torah forbids this practice? Some people argue that body piercing is like purposeful gashing. They say inserting body rings and pins goes against Jewish belief. Do you agree? Tattooing is certainly against Jewish law. Why do you think that is?

C Keeping yourself out of danger is part of *Shmirat HaGuf.* The following statement concerns passing through another people's territory (that of the descendants of Esau). The statement basically is a warning, meaning "Watch out!"

> **. . . Take good care of yourselves. (Deuteronomy 2:4)**

➤ How does being careful relate to *Shmirat HaGuf?* What are some examples of *unavoidable* danger? of *avoidable* danger?

D We appreciate the awesomeness of God just by taking a look at something we know very well — our own bodies. Here's an exultant expression of thanks for the wonder and amazing intricacy of the body.

> **I praise You, for I am awesomely, wondrously made. Your work is wonderful; I know it very well. (Psalms 139:14)**

➤ Why should the body fill you with a sense of wonder? How does awareness and appreciation of the body help you to master another *Middah* — *Yirah* (awe and reverence)?

E Overdoing in any area of life can be harmful to the body. You can overdo it with medicine, exercise, mental stress, food, or drink. Or you could get too little sleep. The following addresses moderation in eating special treats.

> **If you find honey, eat only what you need. Otherwise, you'll overdo it, and throw it up. (Proverbs 25:16)**

➤ What specific warning is given concerning overdoing it? What are the more general implications — that is, is there a greater principle hinted at?

F Part of taking care of yourself includes doing what it takes to be fit and strong. But regardless of any amount of effort you may put into fitness, you shouldn't take all the credit for the endurance and stamina you might build. You should acknowledge God, who is the source of strength.

> **The Eternal . . . will make your bones strong. (Isaiah 58:11)**

➤ What is your role in keeping your body strong? What is God's role? Should exercise be considered a *religious* duty?

Rabbinic

A Being created in the image of God should remind you to take care of your body. Hillel

says he keeps this idea in mind even for such practices as bathing.

> Once when the sage Hillel had finished a lesson with his pupils, he proceeded to walk along with them. "Master," they asked, "where are you going?" To perform a religious duty (a *Mitzvah*)," he answered. "Which duty is that?" "To bathe in the bathhouse." "Is that a religious duty?" they asked. "Yes! Somebody, appointed to scour and wash the statues of the king that stand in the theaters and circuses, is paid for the work, and is even associated with the nobility," he answered. "Since that is so, how much more should I, who am created in the image and likeness of God, scour and wash myself? As it is written, 'In the image of God, did God make humankind'" (Genesis 9:6). (*Leviticus Rabbah* 34:3)

➤ According to Hillel, why can bathing be considered a religious duty? Do you agree with his reasoning? Are there other things that the concept of being created in the image of God should remind you to do? What are they?

B Some specific pointers reflect a more general principle. The general principle is *Shmirat HaGuf*, take care of yourself. Look at this text and also #C below.

> Rav said to his son Hiyya: "Don't get into the habit of taking drugs, don't leap over a sewer, don't have your teeth pulled [wait until they get better], don't provoke serpents." (*Pesachim* 113a)

C Here is some practical advice to avoid getting sick or hurt.

> Rabbi Ammi said: "One should be cautious about things that people are cautious about: for example, one should not put small coins into the mouth or a dish of food under the bed . . . ; nor should one thrust a knife into a radish or an etrog [i.e., one should avoid getting cut]." (Palestinian Talmud, *Terumot* 8:3)

➤ Review the specifics mentioned in both #B and #C above. What is the reasoning behind each piece of advice? How does each piece of advice reflect the more general principle of *Shmirat HaGuf*? What advice would you add from your own experience (give a few examples)?

D Access to fresh, healthy produce is necessary for good health.

> It is forbidden to live in a city that does not have a vegetable garden. (Palestinian Talmud, *Kiddushin* 4:12, 66d)

➤ What is the Jewish argument for eating your vegetables? According to the Talmud, besides having a vegetable garden, the city in which you choose to live should have a physician. What else do you think a city should have to be considered one that supports good health (i.e., a decent hospital, good air quality, parks, places for physical recreation, bike paths, health education)?

E Taking care of yourself requires moderation. You need the proper amount of food, sleep, work, and recreation. The Talmud offers some thoughts on the topic of moderation.

> Eight things are harmful in large quantities but beneficial in small ones: travel and sexual intercourse, riches and trade, wine and sleep, hot baths and bloodletting. (*Gittin* 70a)

➤ Bloodletting is not practiced any longer. Do you agree that moderation is in order for the other seven things listed? Is there anything else you would add to this list?

F For most of us, we can manage our physical needs on our own. But there are times when we may need someone else's help. Taking care of ourselves includes recognizing or admitting when we should consult with another person, an "expert". Some health issues — both physical and emotional — require professional advice. Seeking that advice may require extra humility on our part.

> When a person has a pain, that person should visit a physician. (*Baba Kama* 46b)

➤ How might allowing someone else to take care of you count as taking care of *yourself*? Under what circumstances should you seek help?

G Another piece of advice about caring for yourself involves being responsible, not taking unnecessary risks.

> When injury is likely, one should not rely on a miracle. (*Kiddushin* 39b)

➤ What is the view in this statement toward putting yourself in physical danger? Are there risks you take that perhaps you shouldn't?

H If you put your health at risk, it is not your concern alone; others may be affected as well.

> Rabbi Yose said: "People may not mortify themselves by fasting, lest they [fall ill and] become a charge on the community, which will then have to maintain them." Rabbi Judah said in

the name of Rav: "What is Rabbi Yose's reason? Because in saying, 'And let man become a live soul' (Genesis 2:7), Scripture means: Keep alive the soul I gave you." (*Ta'anit* 22b, *Tosafot Ta'anit* 2:12)

➤ How could endangering your own health harm others as well? What are some examples, besides excessive fasting (smoking, not following traffic safety precautions, driving a car after drinking alcoholic beverages, etc.)? How does God want us to treat our souls?

Tefilah

A Our bodies are complex, intricate, marvelous! In one particular prayer, we give thanks to God for this amazing gift. The prayer reminds us to do our part, to make sure we take good care of our bodies.

> Blessed is our Eternal God, Sovereign of the Universe, who has made our bodies with wisdom, combining openings and closings — arteries, glands and organs — into a finely balanced network. Should but one of them, by being blocked or opened, fail to function, it would be impossible to exist. Wondrous Fashioner and Sustainer of life, Source of our health and our strength, we give You thanks and praise.

➤ Why do we give thanks for our bodies? In what ways might giving thanks make a difference in how we treat our bodies?

Post-Rabbinic

A One reason the body should be treated with respect is that it houses the soul.

The body is the soul's house. Therefore, shouldn't we take care of our house so that it does not fall into ruin? (Philo Judaeus, *The Worse Attacks the Better*, section 10)

➤ Do you think about your body as being the house for your soul? Does this idea influence any of your practices, any of your personal habits?

B Physical exercise can benefit our mental health. When we are feeling healthy psychologically, we are more relaxed and alert. We can pursue more earnestly efforts to live a righteous life.

If your custom is to take walks, you should intend it for the sake of heaven — in order to be healthy for the service of God [Who is blessed]. Your thought should be that you are exercising so that your mind will be relaxed and vigorous, so that you will see how to act in all your affairs as is proper. (*Avodat ha-Kodesh, Moreh b'Etzba*, 3-123; as quoted by Yitzchak Buxbaum in *Jewish Spiritual Practices*, p. 654)

➤ What physical, mental, spiritual benefits are there to exercise? Are you satisfied with your exercise habits? Are there any adjustments you think you should make?

C Judaism teaches that physical needs and desires are natural.

Judaism does not despise the carnal. It does not urge us to desert the flesh but to control and to counsel it; to please the natural needs of the flesh so that the spirit should not be molested by unnatural frustrations . . . Judaism teaches us how even the gratification of animal needs can be an act of sanctification. (Abraham Joshua Heschel, *Man Is Not Alone: A Philosophy of Religion*, New York: Farrar, Straus and Giroux, 1972, p. 263)

➤ What is the Jewish attitude toward the body? Why might we need "control" and "counsel" regarding our physical selves? How can the "gratification of animal needs" be "an act of sanctification?"

ACTIVITIES

Language Arts

 1 (10-15 minutes) When we think of taking care of our body, we probably think first of the mechanical things — eating, washing, sleeping. But we also need to have an attitude toward the body that is respectful, responsible, and appreciative.

Make two lists. For the first list, brainstorm all the physical ways people need to take care of their bodies, the mechanical things. Then make a second list which includes the qualities people need for *Shmirat HaGuf* (respect, responsibility, appreciation).

In your view, does *Shmirat HaGuf* require both mechanical things and a certain attitude toward the body, or is one of those things enough? Defend your answer.

 2 (20 minutes or more) It is unclear whether or not some practices should be permitted according to the *Middah* of caring for our bodies. Physical risk, danger, and injury may be a threat, and certain practices might be considered disrespectful to God.

Stage a debate on one or more of the following practices. From a Jewish standpoint, are we allowed

to do it (one side of the debate) or not (the other side)?

a. Participate in a Super-Triathlon (26 mile run, one mile swim, and 30 mile bike ride)

b. Climb Mt. Everest (danger includes avalanches, fatal storms, hypothermia, oxygen deprivation)

c. Complete a five day "health fast"

d. Smoke

e. Take sleeping pills regularly

f. Get tattoos or have body piercing

g. Permit an autopsy — when there's only a slight chance that the information obtained would help solve a non-violent crime (such as shoplifting)

h. Hold a very stressful job

Here are some points debaters may want to consider in their arguments:

a. The body is a gift

b. The body belongs to God

c. We are responsible for taking care of our body

d. Gashing (or otherwise injuring) ourselves is forbidden

e. We shouldn't endanger ourselves unnecessarily

f. Putting ourselves at risk may have negative consequences for other people as well

g. Judaism teaches that we should enjoy the body; physical pleasure is not a sin

h. Moderation is an important guideline in *Shmirat HaGuf*

i. The body is the "house of the soul"

j. Our bodies come from "the dust of the earth" and eventually return to the ground

After the debate(s), evaluate the experience. What is clear-cut in terms of taking care of the body? What is harder to figure out? (Perhaps it's harder to figure out what counts as "unnecessary risk" or how to define "moderation.") In what ways will this debate influence your thinking on any of the issues involved?

 3 (15-20 minutes) *Shmirat HaGuf* calls for appreciation for our bodies and gratitude to God. In one traditional prayer, we thank God for the miracle of our bodies, for its intricate design, for all the openings and closings (see Text Study, Tefilah #A).

Write a prayer which thanks God for our bodies. Choose some specific body parts (eyes, ears, hands, taste buds, joints, muscles, brain, lungs) and express why you are thankful for these. What is the function of these body parts? What would life be like without them?

Share your prayers. If desired, include one or more of the prayers as part of a worship service and/or assemble the prayers in a pamphlet. (Make this pamphlet available to those attending the "Jewish Center for *Shmirat HaGuf*" in the following activity.)

 4 (15-20 minutes) Passages quoted in Text Study make it clear that taking care of our bodies can be considered a sacred task. But is this concept carried out in our society?

Describe the attitudes toward health and beauty in our popular culture. Give a few specific examples (a particular ad you saw, the title of a new best-selling book, etc). What seems consistent with Jewish values? What seems inconsistent?

Now, imagine you own a body center called something like "The Jewish Center for *Shmirat HaGuf*." Write a brochure for your center. What does the center stand for? What do people do there? How much time should a member of your center plan to spend there? And so on.

In addition (or as an alternative), design the regimen for taking care of the body that your center recommends.

 5 (a one or two-day retreat) Read through #4 above. In this activity, you will design a one or two-day retreat

that you, and perhaps a few friends, actually could do at the Jewish Center for *Shmirat HaGuf*. The retreat will be a Jewish version of a spa getaway. Write out the activities and the menu. Additionally, describe the contents of any Jewish and health education study sessions you will hold.

 6 (10-15 minutes) In this journal writing exercise, write for several minutes, beginning with the words: "I am caring/not caring for my body when . . . " Write freely without censoring and from your own experience. You might start with more obvious things such as, "I am caring for my body when I shower each morning." But you can get into more subtle issues, such as " . . . when I take long walks on Shabbat afternoons." And even deeper issues: "I am *not* caring when I make myself sick with worry . . . when rage causes my heart to pound . . . when I drink to alleviate stress . . . when I take chances and court danger because I'm feeling depressed."

Look over what you wrote. Are there any new insights? surprises? lessons? changes you want to make?

 7 (20-30 minutes) Text Study, Rabbinic #H is about people willingly endangering their health and thus the well-being of their community.

The group imagines it is the Board of Directors of a major nonprofit health insurance company. These Board members are like the "community" in Text Study, Rabbinic #H. (Assume that individual greed does not come into play when the company makes decisions.) The company is deciding whether or not to cover certain health problems. It could be argued that certain of these problems are caused by careless health practices because people don't take care of their bodies, don't follow *Shmirat HaGuf*.

Stage a debate. Half the group represents Board members in favor of the coverage; the other half

is opposed. Choose one at a time from the following list of possible health problems.

 a. Problems resulting from smoking

 b. Problems due to alcohol or drug abuse

 c. Problems caused by taking risks in sport (skiing in avalanche/closed territories, sailing in stormy weather)

 d. Problems resulting from a hunger strike

 e. Problems due to not taking prescribed medicine (or not following a doctor's advice)

The debate points listed in the second part of Language Arts #2 above may be helpful here. There are other Jewish principles to keep in mind, too:

 a. *Kol Yisrael Arayvin Zeh BaZeh* (Jews are responsible for each other)

 b. *Ahavat HaGer* (respect and care should be given to non-Jews, all the more so for those in need)

 c. *Ohev Zeh et Zeh* and *Mechabayd Zeh et Zeh* (loving and honoring fellow creatures)

 d. *Rachamim* (mercy)

 e. *Din* (justice)

 f. *Dan L'Chaf Zechut* (give the benefit of the doubt)

 g. *Hochayach Tochiach* (you shall surely rebuke)

 h. *Pikuach Nefesh* (saving life is a priority)

After the debate, evaluate the experience. Do you think the community has a right to question which health problems it will tend to? In what ways will this debate change your thinking on health care and the community's responsibility?

 8 (15 minutes) This activity focuses on *Shmirat HaGuf* as it relates to appreciating the body, and is appropriate for mature groups in which members know each other well, and in which there is a strong feeling of trust. In this unusual approach, another person helps you "take care of your body" by voicing the gratitude and praise that would be appropriate for you to give yourself.

The group divides into pairs, which sit facing one another. Partner A begins by observing and

praising partner B's body for several minutes, calling attention to all the amazing things partner B's body can do, all of its intricacy and beauty, etc. Then partners switch roles.

Discuss reactions. How did you feel receiving praise, about hearing appreciation for your body? How did you feel giving praise and appreciation? Is your understanding of *Shmirat HaGuf* any different as a result of doing this exercise? What did you learn that will inspire you to make changes related to this *Middah*?

Visual Art

 1 (10-20 minutes) The leader asks: What specifically does taking care of your body involve? Brainstorm and write responses on the board. Examples might include bathing, eating nutritious foods, exercise, brushing your teeth, avoiding smoking and drugs, eight hours sleep each night, wearing a seat belt in the car, making time for mental relaxation, and so on.

Then group members imagine they are participating in a "Take Care of Your Body" campaign. Each person (or pairs) chooses a topic from the list created on the board and designs a poster for the campaign based on that topic.

Display the posters around the room or in another more public area (such as the hall of the school).

If you could take one poster home as a reminder to improve one of *your* health habits, which would it be, and why?

 2 (20 minutes) Text Study, Rabbinic #D suggests that the city in which you choose to live should have a vegetable garden. Review that text, and answer the questions which follow it. One of these questions asks for other components of a city that supports good health. By yourself or with a partner, draw a picture of such an ideal city.

Consider: What kinds of health facilities would the city have (hospital, nursing home, gym, recreation paths)? What ways would the city try to limit pollution (having public transportation, using solar energy)? How would you make your city safe for people with disabilities (wheelchair accessibility, traffic lights that set off a noise when they change so that blind pedestrians know when it is safe to cross a street)? How would the produce look at a vegetable stand or in the supermarket? And so on.

Share the pictures and offer comments. What things are in other's pictures that you hadn't thought of? What radically new ideas were expressed? Are there some improvements your actual city should adopt? What can you do to promote such adoption?

 3 (10-20 minutes) While our tradition values moderation when it comes to the body (see Text Study, Rabbinic #E), some people still overdo it. The quotation from Proverbs 25:16 gives us a clue as to what happens in this instance.

Create a picture of overdoing it related to a specific instance (e.g., sleep, exercise, exposure to mental or emotional stress, bathing, etc.). The picture should help remind a person why moderation is a good policy. Come up with a title for your picture and write it across the top.

Why is moderation important in the "mastery" of *Shmirat HaGuf*? What is most natural for people — moderation, excess, or self-deprivation? On certain occasions, Judaism allows for excess and self-deprivation (e.g., on Purim we are allowed to drink, even "excessively," and on Yom Kippur we are supposed to deprive ourselves of food through fasting). Are these practices sound? Why or why not?

 4 (10-20 minutes) Text Study, Rabbinic #B and #C refer to some practices that invite accidents or injury (such as putting small coins in the mouth or using a kitchen

knife carelessly). Even in our own homes, we probably can use some safety reminders.

Design signs (mini-posters) for at least four rooms in your house that could serve as safety reminders. For example:

a. For the bathroom: A reminder to put the rubber mat in the bathtub before showering, to avoid dangerous slips. (Or, a reminder for grown women to do a monthly breast check.)

b. For the kitchen: Don't draw a knife toward yourself when slicing something (like a bagel!).

c. For the bedroom: Before you go to sleep, lock the doors to your house.

d. For the family room/living room: Check regularly that the smoke detector is working.

If family members prefer not to have your signs up all the time, have a safety week — a special *Shmirat HaGuf* week — during which the signs are displayed.

How are safety reminders around the house a way of practicing *Shmirat HaGuf*? What signs would you include for other locations — a school, a hospital, a factory, etc.?

 5 (15-20 minutes minimum) The word *"shmirah"* in *Shmirat Haguf* can be translated as "watching" or "observing closely." As we thank God for the amazing intricacy of the body in one of our daily prayers, we observe the body's complexity and magnificence. Through science, too, we observe closely just how remarkable our bodies are.

Find books that have magnified pictures of parts of the human body. What colors, textures, and patterns are found within the human body? What do taste buds look like when they are blown up in size? the iris of the eye? bone marrow? skin cells? a hair follicle? lung tissue? Then express your fascination and appreciation for the body through your art.

Basing your work on a photograph or your imagination, draw or paint a detailed magnifica-tion of a body part. Notice. Observe. Visualize all the tiny components that go into a limb, organ, or muscle.

How does your art reflect an appreciation of the human body? In what ways does such appreci-ation enhance *Shmirat HaGuf*? Why, in particular, are you fascinated with this particular body part?

Drama

 1 (15 minutes) Even if you are fighting an illness or have a disability, you can be taking care of your body. Examples include having a cast put on a broken arm, resting and drinking tea or chicken soup if you have a cold.

Write definitions of *Shmirat HaGuf* on the board. In groups of six to eight, create imaginary ads extolling *Shmirat HaGuf*. Each group creates three different tableaux of people who take care of their bodies. They should think divergently about what taking care of the body might mean — it's not just standing straight, sticking out chests, flexing muscles. Each group then shows their tableaux to the other groups.

Allow participants to comment on their expe-rience as audience members and as performers. How did you come up with your various tableaux? Define *Shmirat HaGuf* based on what you experi-enced and saw in this exercise. Are the definitions different from/more expansive than those on the board?

 2 (10-20 minutes) Study Text Study, Rabbinic #B and #C, which refer to some practices that invite accidents or injury (e.g., putting small coins in the mouth or using a kitchen knife carelessly).

Then, in small groups, play a version of *Charades*. Each group comes up with three to five fairly common, yet dangerous practices, such as crossing the street when the light is red, leaving

lit candles unattended, leaning over a ledge in a high-rise apartment while cleaning the outside of a window. Without words, the groups act out the scenes for each other. Those watching try to guess what the danger is, then explain why what they observed is dangerous.

Discuss. If you were to do some of the dangerous things in the skits, in what ways would you be going against *Shmirat HaGuf*? If you were to write a modern Talmud, which examples of danger would you include, and why?

 3 (10-20 minutes) In this exercise, which is similar to #2 above, the focus is on moderation in taking care of our bodies (see Text Study, Tanach #E and Rabbinic #E, about what happens when we eat too much). You can overdo it in other areas, too, such as with sleep, exercise, exposure to mental or emotional stress, bathing, etc.

In two or three small groups, play a version of *Charades*. Each group comes up with three specific ideas of how a person might do "too much" or "too little" in regard to taking care of the body. Groups then perform their scenes for each other without words. Those watching guess what is happening in the scene and why what they observed is doing too much or too little.

Discuss. In what ways do the things you observed/performed go against *Shmirat HaGuf*? Is it prohibited to overdo it/under-do it at all times? What do you believe are the biggest concerns today related to overdoing or under-doing, to lack of moderation (e.g., too much dependence on drugs or alcohol, overeating, too much TV, too much mental stress)?

 4 (15 minutes) We are responsible for taking care of our own body on a day-to-day basis (when there's no special illness or disability). Thus, for the most part, *Shmirat HaGuf* is something that

happens "between you and yourself" — *Bayn Adam L'Atzmo*. But, when we learn from others how to take care of ourselves in better ways, *Shmirat HaGuf* also happens "between people" — *Bayn Adam L'Chavero*.

Pairs of actors act out one or more of the following scenes. One actor tries to convince the other to take better care of him/herself, to make changes necessary for improving health. After a few minutes of improvising, choose another scenario and reverse roles.

a. A grandfather dying of lung cancer tries to convince his teenage granddaughter to give up smoking.

b. One teenager tries to convince the other to stop drinking (or doing drugs).

c. One spouse tries to convince the other to not work so hard, or to quit a job that is endangering physical and/or mental health.

d. One worker tells a co-worker that the perfume or cologne he/she wears might be causing health problems.

e. Your own idea

Discuss. How did you feel as the person offering advice? as the person receiving advice? What did the audience observe? Is it appropriate to offer unsolicited advice about another's health? Have you ever received valuable advice concerning the taking care of your body?

You may want to bring in the idea of *Tochechah* (rebuking), a *Middah* discussed in Chapter 22. When are you obliged to rebuke another? In this case, the rebuke would relate to criticizing another's health practices.

 5 (20 minutes) Knowing our body is a gift from God can inspire us to take better care of it. A prayer included in daily worship stresses appreciation of our bodies as a perfect system of "openings and closings." Appreciating these is part of watching or closely observing all that our bodies do — the *"shmirah"* in *Shmirat HaGuf*.

Partners face each other at opposite sides of the room. The leader says to those on one side: Everyone on this side of the room imagine you are unformed matter, a "blob" without arms, legs, head. Get yourselves into a "blob" position on the floor.

To the other side of the room, the leader says: Everyone on this side of the room imagine you are a messenger from God. One at a time, you are bringing to the "blob" the body parts it needs in order to become a human being. Pay very close attention to each body part, to how special it is. The "blobs" receive the body part graciously, appreciating each "gift" from God and showing how it adds shape to their physical selves.

The leader calls out one body part at a time that the "messengers from God" are to bring: hands, arms, shoulders, head and neck, etc. The recipients slowly go from being "blobs" to fully formed human beings. Repeat, switching roles.

Discuss. How did this exercise teach appreciation for your body? In what ways do you show appreciation for your body in your day-to-day life? Why is gratitude for our bodies an important part of *Shmirat HaGuf*?

Movement

 1 (a few minutes, periodically) Our bodies are meant to move. Thus, it is necessary as part of taking care of our bodies not to sit motionless for hours on end. For this reason, it is important to include movement exercises as a part of class sessions. Commit to including movement every 15 minutes for three class sessions in a row. Doing so will help make the *Middah* of *Shmirat HaGuf* more real. The breaks can be guided by the teacher or by a student.

a. Get everyone up for a stretch. Add some deep breaths.

b. Do a few simple aerobic exercises (jumping jacks, running in place, marching in place, making large circle rotations with your arms, etc.).

c. Take a brisk walk inside or outside the building.

d. Dance freely for a minute or two to some lively Jewish music.

e. Do an Israeli folk dance.

f. Play learning games that require movement. (Examples: Run to the board and write the answer; when I throw the ball to you, give me the answer, then throw the ball to someone else; instead of raising your hand, jump up three times, and remain standing when you have something to say.)

g. Participate in a more structured creative movement activity.

After a session or two of including movement, take a poll. How did you like including movement as part of your learning? In what ways did doing so help you to take better care of your body? How does regular movement affect your ability to learn? What might be some good ways to include movement (exercising your body) throughout the course of a day?

 2 (5-10 minutes) This exercise explores the way people look who practice *Shmirat HaGuf* and take good care of their bodies.

The group makes a circle. One person is asked to go to the center and make a pose that reflects someone who does *not* take care of his/her body, who is not good about following *Shmirat HaGuf*. Someone else is chosen to gently reshape the body of the person in the middle. The one doing the reshaping is to make the person in the middle look more like someone who *does* take care of his/her body, who *is* good about following *Shmirat HaGuf*. Repeat several times with different participants.

Discuss. What makes a person look as if he/she does take care of his/her body? Can we always see whether or not someone takes care of his/her body?

3 (20 minutes) In Drama #5, "*shmirah*" is defined as "watching closely" all that our bodies can do, and appreciating this amazing gift from God. Do a movement activity based on this, in which participants are encouraged to use movement more freely and expressively. They are asked to go further physically, to "elaborate" more as they receive and explore each body part gift.

4 (5-10 minutes) The prayer in Text Study, Tefilah #A thanks God for the wondrous gift of our bodies — in particular, the intricacy of all of the body's "openings and closings." Take a few minutes to appreciate all the "openings and closings" through movement.

Everyone spreads out through the space. The leader guides participants by calling out the following. (Give enough time for each body part to be explored fully — all the ways it can open and close.)

a. Eyes
b. Ears
c. Nose and mouth (breathing)
d. Neck — the spaces between the vertebrae
e. Spine
f. Joints (i.e., shoulders, arms, hands)
g. Torso, rib cage (opens and closes with the breath), hips
h. Legs and feet
i. The whole body (visualize what is happening inside your body — organs, veins, arteries — and show how these internal openings and closings influence your movement)

Discuss. Did this improvisation capture the sense of the prayer from our *tefilah*? Will you look at this prayer any differently as a result of this experience? Explain. Why would openings and closings, rather than other body parts, have been chosen as most worthy to include in a prayer?

5 (10-15 minutes) Text Study, Tanach #E and Rabbinic #F stress moderation in caring for our bodies. In the following exercise, a more abstract exploration of moderation happens on a physical level. What does moving too much, too little, or just the right amount teach about the best way to care for our bodies?

In a large space, indicate three big circles for movement. Define for each circle what movement will take place there.

Circle 1: "Too much" movement — movement that is too fast, too busy, frantic, sloppy, hyper, chaotic, etc.

Circle 2: "Too little" movement — movement that is lethargic, apathetic, directionless, dull, monotonous, emotionless, imprecise, etc.

Circle 3: "Just right" movement — movement which is thoughtful and lively, and which is expressive of a controlled range of speeds, rhythms, emotions, and dynamics.

Participants improvise for several minutes, moving freely between circles and exploring the appropriate style of movement. When they feel they have a good sense of each of the circles, they quietly retreat to the side of the space and wait for the others to finish.

Describe your experience in each of the circles. Was it hard to go between them? Did you learn anything about moderation that can be applied to other realms of life, in particular to areas having to do with taking care of your body?

Music

1 (10-15 minutes) Do #5 above through music. Using simple percussion instruments (drums, cymbals, triangles, sticks, etc.), explore three types of music — "too much," "too little," and "just right." (See definitions for the "Circles" described above.) One

person serves as "Director," indicating which style of music the participants should play. The Director calls out "Too much," "Too little," "Just right," and "Your choice," going back and forth between the various instructions. When the Director's hand goes up, all the instrumentalists stop playing so that he/she can be heard.

Describe the experience of playing each style of music. Was it hard to go from one style to another? Through this experience of extremes and moderation in music, what did you learn about moderation that can be applied to other realms of life?

 2 (short intervals of time over a set period) Music may change our pulse. It may influence our emotions, and thus our mental health. It may inspire us to get up and move, which is exercise for our bodies. It may even help our brain to function better.

Over the course of a week or so, pay extra attention to music. Besides your regular musical fare, tune in to music you ordinarily don't listen to. As you listen, notice what happens in your body. How are you affected physically, emotionally, spiritually?

At the end of the given period of time, reflect back (on your own or with a group). What role does listening to music play in *Shmirat HaGuf*? How can music help us to take better care of our bodies?

Miscellaneous

 1 (20 minutes or more) Take a 20-minute walk "for the sake of Heaven" (see Text Study, Post-Rabbinic #B). As you walk, keep your mind focused on the gist of that text:

a. Know that your efforts to be healthy are a way of serving God.

b. Be mentally "relaxed and vigorous."

c. Reflect on your actions, committing yourself to righteous behavior.

2 (a one or two day retreat) Create and attend the retreat, the "Jewish spa getaway" that you designed in Language Arts #5.

CHAPTER TWENTY

SIMCHAH: JOY AND HAPPINESS

שִׂמְחָה

OVERVIEW

Simchah can mean exuberant rejoicing, which is a temporary condition. Exuberant rejoicing can be expressed by such words as joy, gladness, merriment, a ringing cry, leaping, exulting, a shrill cry, jubilation, a resounding cry, shouting (see Text Study, Rabbinic #A). It is most often experienced in the company of other people; it is a temporary elation fostered by a social or religious occasion, or by winning a game, a contest, or by a business success.

Simchah can also mean happiness, which is a general state of being. Happiness can include contentment, satisfaction, trust and faith, confidence, peacefulness, a positive attitude, optimism, hopefulness. Such a mind-set can influence a social event, and can transcend it. Happiness is internal and integral to one's being.

There is an essential difference between these two aspects of Simchah. Exuberant celebration cannot be sustained. Such high feelings are usually associated with a special occasion, a specific circumstance. When the occasion passes, the mood goes with it. On the other hand, happiness is a consistent emotion. A happy, satisfied, content person enjoys and appreciates life, and lives with a sense of joy. While such joy does not mean leaping and shouting with glee all the time, it may include singing, dancing, and creating merriment some of the time, and at other times, not.

To complicate matters a bit, these two understandings of Simchah can overlap, or one can lead to the other. Our Text Study sources, for instance, aren't always clear as to which definition is being highlighted. The Simchah of feeling essentially grounded or content can lead to, or serve as, the foundation for jubilant expressions of joy, say, in celebrating Shabbat or the festivals.

Another example which combines the two categories is the Simchah associated with beauty, enjoyment, or an appreciation of small pleasures. One Rabbi says that the words "I forgot what happiness was" refer "to a beautiful bed and the beautiful spread on it" (see Text Study, Rabbinic #B). A bed and bedspread are thus very special and very ordinary at the same time. When appreciation of beauty and awareness of small pleasures are added to everyday things, this increases general feelings of happiness.

Love, too, can be an important part of a general sense of happiness. A wedding celebration might give vent to exuberant expressions of joy, but a good marriage can nurture inner happiness. Likewise, love among family members and love between friends may rarely reach levels of elation, but this steady, more level experience certainly contributes to feelings of contentment.

Righteousness and ethical living also have something to do with happiness. A righteous and ethical way of life adds to a sense of our own well-being. When we treat others with dignity, we ourselves are bound to be happier. We feel good when we bring food to someone who is housebound, bring an abandoned animal to a shelter, volunteer at a soup kitchen. These good feelings are an infusion of Simchah into our lives.

What are we supposed to strive for, to work on, to practice insofar as this Middah is concerned? Are we actually supposed to strive to be happy,

or do we wait around for the next holiday or Bar/Bat Mitzvah, and then turn on the joy? The answer to both is yes. Turn on the joy full volume for special occasions — celebrate, rejoice, sing and dance. Explore the highest highs of joy. Experience enthusiasm. Honor those special moments — times for laughing, and for dancing. But strive for contentment, too. Try to become one who is *Samayach B'Chelko*, being content with one's lot/portion in life (see Chapter 15). Increase your awareness of what that means on a day-to-day basis. Ask yourself if you are content. Make efforts to be more so, to be righteous, to treat others with dignity. Nurture love. Try to grow in your ability to be optimistic, positive, hopeful, and trusting. As part of our daily prayers, we say, "Happy are those who dwell in [God's] house." Such happiness truly reflects an overall perspective on life . . . the why and how, the meaning and purpose of our existence in the world.

The following summarizes the *Simchah* that develops from our relationships to others, the internal happiness we seek for ourselves, and the idea of *Simchah* that derives in relationship with God.

 BAYN ADAM L'CHAVERO, BETWEEN PEOPLE. Joyful celebrations usually involve ourselves in relationship with other people. Love among family and friends is a source of happiness. Righteous living, acting ethically toward others, leads to a sense of contentment.

BAYN ADAM L'ATZMO, BETWEEN YOU AND YOURSELF. Your inner nature is reflected in how you process what happens around you, how you react to events and circumstances. Is it your basic nature to be happy? Is it possible to direct feelings of happiness toward yourself, to practice being or becoming

more content with your portion in life? Perhaps doing righteous acts for others and mastering *Middot* as a lifestyle lends meaning and significance to life and leads to inner happiness.

 BAYN ADAM L'MAKOM, BETWEEN YOU AND GOD. Trusting God, living with an awareness of God, serving God, being connected intimately with God, all of these attitudes promote happiness. Make efforts to fulfill commandments and to celebrate holidays and certain life events with a sense of joy.

TEXT STUDY

Tanach

A Sarah responds with laughter when messengers of God bring the news that she will bear a child, even though she is 90 years old. Sarah and Abraham had given up hope that they would be able to have a child. The laughter may have been an expression both of disbelief and of joy, as well as shock, fear, and confusion. Still, Sarah's laughter is the first indication in Torah of what clearly can be interpreted as a happy feeling.

And Sarah laughed . . . (Genesis 18:12)

➤ Why does Sarah laugh? What is Sarah feeling beneath the laughter? Sometimes joy is mixed with other emotions. When it is, do you still call it "joy"?

B The Israelites escape from slavery in Egypt. The waters of the Reed Sea miraculously part, and the Israelites cross safely on dry land. Led by Miriam, the Israelites dance and sing praises to God for this most amazing miracle.

Then Miriam the prophetess, Aaron's sister, took a timbrel in her hand, and

all the women went out after her with timbrels and in dance. (Exodus 15:20)

➤ Why were Miriam and the women celebrating? How do song and dance contribute to the expression of joy?

C Feelings of happiness can be boosted by a relationship with God. Trusting in God can help us feel more satisfied and confident about the lives we lead.

Eternal God of hosts, happy is the one who trusts in You! (Psalms 84:13)

➤ Why might someone who trusts in God feel happy? Do you clearly trust in God at all times? Or, is trust more clear sometimes and less clear at other times? How does trust in God affect your mood, your spirit?

D Joy is something we usually ascribe to human beings. But when joy is at its height, it seems to burst forth from all of creation. What brings about such bursting joy? The expectation that God's presence will be apparent, firmly grounded, and embraced by all peoples. Such is the sentiment of the Psalmist:

**Let the heavens rejoice, let the earth be glad.
Let the sea and all it contains roar in praise,
the fields and everything in them exult;
then shall all the trees of the forest shout for joy;
at the presence of the Eternal, who is coming,
who is coming to rule the earth,
to rule the world justly,
and its peoples in faithfulness.
(Psalms 96:11-13)**

➤ Why do all varieties of creation exult and shout for joy? Why does the Psalmist give a human quality — the expression of emotion — to inanimate things? Have you ever felt a surge of joy when in the midst of natural surroundings? Explain.

E Happiness can come from being a righteous and just person. Behaving in ethical ways is the path for a life of *Simchah*.

Light is sown for the righteous, and for the just of heart, happiness. (Psalms 97:11)

➤ How might behaving righteously and justly make you a happy person? How do you feel when you do the right thing? Does it make you happy? Should it make you happy?

F Happiness certainly reflects our emotions. But emotions don't take place in a vacuum. They take place in a human body, which reflects and responds to our emotions.

**A joyful heart makes for good health;
Despondency dries up the bones.
(Proverbs 17:22)**

➤ Do you think our emotions affect us physically? How so? How does joy (as opposed to other emotions) affect your body?

G The idea that love is a source of joy is an underlying theme throughout the biblical book Song of Songs. And, of course, the connection between love and joy has existed for centuries, perhaps since the beginning of time.

**Oh, give me the kisses of your mouth,
For your love is more delightful than wine. (Song of Songs 1:2)**

➤ Song of Songs is, on the surface, a kind of love song between a man and a woman. Some religious commentators view the book as a metaphor: the love between two people is a metaphor for the love between people and God. Can you feel as much joy in your love for God as you can for another person?

H Our underlying sense of confidence in God can be a source of contentment, of happiness of a sort. Nevertheless, in the course of day-to-day living, we experience a full range of human emotions — some more uplifting, some less so. We honor God by being willing to explore the meaning of all that exists "under heaven."

A season is set for everything, a time for every experience under heaven . . .
A time for weeping and a time for laughing,
A time for wailing and a time for dancing . . . (Ecclesiastes 3:1, 4)

A Rabbinic version of the same idea says:

Let there be rejoicing at the time of rejoicing, and mourning at the time of mourning. (Genesis Rabbah 27:4)

➤ Do you agree that there is a time for everything? Explain. How is trust in God like happiness? How is it possible to weep at times and laugh at times, but still feel trust in God?

Tefilah

Note: Prayers that have references to joy often have their roots in the Tanach.

A These verses of prayer underscore the positive experience of living a spiritual life. Dwelling in God's house" is a metaphor for happiness.

Happy are those who dwell in Your house, who sing Your praise.
Happy the people who have it so;
Happy the people whose God is the Eternal. (Siddur, the "Ashray"; from Psalms)

➤ What is the meaning of "dwelling in God's house"? Why do those who dwell in God's house sing praises to God? Why are they happy?

B To make Torah a central part of your life means living according to Torah laws and values. This way of life is happy, pleasant, and peaceful. The following verses are sung at services, at the end of the Torah reading, as the Torah is being returned to the Ark.

[The Torah] is a tree of life to those who grasp it, and all who uphold it are happy.
Its ways are ways of pleasantness, and all its paths are peace. (Siddur, from Proverbs 3:18 and 17)

➤ How can Torah be a source of happiness? What is pleasant about the ways of Torah? How are its paths peaceful? Why are these verses sung as the Torah is being returned to the Ark?

C This reassuring and optimistic verse comes from the Psalm that is included in the "Birkat HaMazon" (Grace after Meals) on Shabbat and holidays.

Those who sow in tears shall reap in joy. ("Shir HaMa'alot" from Psalm 126)

➤ In your own words, explain what this line from "Shir HaMa'alot" means. Do you find this agricultural image effective? Explain.

D Celebrating Shabbat brings about happiness and enjoyment.

Those who celebrate Shabbat rejoice in Your Sovereignty, hallowing the seventh day, calling it a delight. All of them truly enjoy Your goodness. (*Siddur, Musaf Amidah, "Yismechu"*)

➤ In what ways is Shabbat a happy time? What are the things you most enjoy about this day?

E In our Torah we learn that rejoicing should be part of our festival celebrations. About Sukkot it says, "You shall rejoice in your festival . . . you shall have nothing but joy" (Deuteronomy 16:14-15). This sentiment is brought into our holiday services in the special prayers we add for festivals.

Lovingly, Eternal our God, You have given us festivals for joy and holidays for happiness, among them this Festival of Matzot, season of our liberation . . . Festival of Shavuot, season of the giving of our Torah . . . Festival of Sukkot, season of our joy . . . Festival of Shemini Atzeret, season of our joy . . . [Each festival] a day for sacred assembly, recalling the Exodus from Egypt. (*Siddur*)

➤ Why are these three festivals singled out as being festivals of joy? How might "sacred assembly" contribute to joy? Why should recalling the Exodus from Egypt be cause for joy?

F In the following wedding blessing, God is praised as Source of joy. A wedding is a time for love, when the whole community is happy.

We praise You, Eternal our God, Ruler of the universe who created joy and gladness, bride and groom, pleasure,

song, delight, and happiness, love and harmony, peace and companionship. Eternal our God, may there always be heard in the cities of Judah and in the streets of Jerusalem voices of joy and gladness, voices of bride and groom, the jubilant voices of those joined in marriage under the bridal canopy, the voices of your people feasting and singing. We praise You, Eternal, who causes the groom and the bride to rejoice together. (From the seven wedding blessings)

Rabbinic

A There are all kinds of ways to rejoice and many words which flesh out nuances in expressions of happiness.

Rejoicing is designated by ten different terms: joy, gladness, merriment, a ringing cry, leaping, exulting, a shrill cry, jubilation, a resounding cry, shouting. (*Avot de Rabbi Natan 34; Song of Songs Rabbah 1:4, 1*)

➤ Why do you think there are so many terms for rejoicing? Which is your favorite — the term which expresses how you would like most to rejoice? Explain. If you are a happy person, does it mean you are constantly rejoicing?

B Beauty can inspire happiness. Enjoyment of beautiful sounds, sights, and scents can lift a person's spirit, as can appreciation for some of the things we take for granted.

Three things restore a person's spirit: [beautiful] sounds, sights, and scents. Three things increase a person's self-esteem: a beautiful home, a beautiful spouse, and beautiful clothes. (*Brachot 57b*)

"I forgot what happiness [literally, good-ness] was . . . " (Lamentations 3:17) Rabbi Isaac Nappaha said this refers to "a beautiful bed and the beautiful spread on it." (Shabbat 25b)

➤ What can nourish happiness according to the two passages above? What simple pleasures do you appreciate in life that give your personal happiness a boost?

C This passage is a good follow-up to the two quotes in Rabbinic #B above. There are many pleasures in this world. Without greed, we definitely can and should enjoy the pleasures in our midst. We are encouraged to "taste" the wonderful delights of God's creation.

Who is a pious fool? A person who sees a ripe fig and says, "[Instead of enjoying it myself], I will give it to the first person I meet." (Palestinian Talmud, *Sotah* 3:4, 19a)

➤ What is an example of a pious fool? Why would such a person be considered foolish? To what extent should we enjoy the pleasures of this world? Are there any limits that should be imposed? If so, what are they?

D Being self-sufficient is related to feeling happy. When we are capable of self-sufficiency, but rely on the hand-outs of others, our self-esteem likely will be affected. Low self-esteem means not feeling good about yourself. And when you don't feel good about yourself, it is very hard to experience happiness.

I call heaven and earth to witness that all scholars who eat of their own, and who enjoy the fruits of [their] own labor, and who [are] not supported by the

community, belong to the class who are called happy, as it says, "If you eat the fruit of your hands, you are happy" (Psalms 128:2). (*Tanna de Be Eliyahu*, ed. M. Friedmann, Vienna, 1902, p. 91)

➤ How are self-sufficiency and happiness related? Some people who are able to take care of themselves depend instead on the community to support them. Do you think such people are less happy than they could be? Are they less happy than those who are self-sufficient and who *do* take care of themselves.

Post-Rabbinic

A Fulfilling the commandments and loving God aren't enough. Rather, joy is part of the obligation.

Joy in the fulfillment of the commandment, and in love for God who prescribed the commandment, is a supreme act of divine worship. One who refrains from participation in such rejoicing deserves to be punished, as it is said, "Because you did not serve the Eternal your God with joyfulness, and with gladness of heart . . . " (Deuteronomy 28:47). (Maimonides, *Mishnah Torah*, Seasons/*Hilchot Lulav* 8:15)

➤ Maimonides says there should be joy in our fulfillment of commandments and in our love for God. What is the proof text (the biblical reason) he gives? What other reasons could be given for making efforts to incorporate joy into spiritual practices and religious duties? In what ways is your religious life a reflection of joy?

B Our first record of Jews expressing joy through song and dance may have come from Miriam and the women at the shores of the Reed Sea.

The tradition they began has continued through the centuries. In Hasidism's special approach to Jewish practice, song and dance take on a particularly significant role.

> **Hasidism sees the *niggun* [melody] as one of the branches of Divine service — as a way to show love of God, and to bind oneself to [God] with cords of love and joy. (*Ish ha-Pele,* p. 69, as quoted in *Jewish Spiritual Practices* by Yitzchak Buxbaum, p. 481)**

> **Rabbi Nachman of Bratzlav said: "Through dancing and the movements you make with your body, you awaken joy within yourself." (*Sefer ha-Middot, Simha,* #8, as quoted in *Jewish Spiritual Practices* by Yitzchak Buxbaum, p. 483)**

➤ What role should song and dance play in religious life? In general, what is your favorite way to express joy? What is your favorite way to express joy as a part of worship — in prayer, on Shabbat and holidays, at life cycle events (at birth, Bar/Bat Mitzvah, and/or wedding celebrations)?

ACTIVITIES

Language Arts

 1 (15 minutes) What is happiness? A good place to begin responding to this question is with brainstorming words and ideas that come to mind. In Text Study, Rabbinic #A, there is a list of synonyms for expressing joy. Also, in the Overview for this chapter, there is a list of words related to general happiness. Come up with some lists of your own:

a. List all the synonyms and short phrases for *Simchah* — happiness and joy — that you can.

b. List what you need in order to have *Simchah* (love, friendship, safety, inner peace, relationship with God, etc.).

Put a check mark next to all those things you can/should strive to have most (or all) of the time. Put an "X" next to those things which are associated more with a special occasion. Now write a dictionary-style definition for *Simchah.* Compare your definition to those in actual dictionaries.

A variation: Write the dictionary-style definition for *Simchah* twice, once *before* studying this *Middah*, and once *after* in-depth study and activity. Then reflect on how the definition changed.

 2 (15 minutes or more) We love the stories that end "and they lived happily ever after"! If you were writing an abridged version of the Bible, is there any story within it that you would end with those same words? What goes into "living happily ever after" (love, friendship, wealth, peace)?

Write your own "happily ever after" story. Think hard about what circumstances really deserve such an ending. What must happen in order to have enduring happiness? Illustrate your stories if you like.

In a group share your stories. Are there themes that most people touched on? If so, why do you think that is? Would you like to live the story you wrote about? Why or why not?

 3 (15 minutes) Love, friendship, doing good, being responsible and self-sufficient, feeling connected with God all contribute to our happiness. But small pleasures, too, are important. Our Rabbis mention that beautiful sounds, sights, and scents can lift a person's spirit. One Rabbi mentions a beautiful bed with a beautiful bedspread on it (see Text Study, Rabbinic #B and #C).

Discuss or write about small pleasures, things you enjoy. You can either list things or write more in an essay style.

A variation: Write a prayer thanking God for small pleasures, the things you enjoy. (This variation is in the category of *Bayn Adam L'Makom.*)

How important are small pleasures and enjoyment for overall happiness? What would it mean to become overly concerned with pleasure and enjoyment? Do you think we are "supposed to" enjoy ourselves in this life — is pursuing pleasure part of the *Middah* of *Simchah*? Explain.

 4 (15 minutes at least) When Sarah is told she finally will have a child, even though she is 90 years old, she laughs. Review this story in context in Genesis 18 and go over the questions in Text Study, Tanach #A.

Now imagine you are Sarah. It is the evening of the day in which you were told you will bear a son. Go back to your tent. Light several candles. Take out your journal (yes, somehow you have an ancient version of paper and pen), and describe your feelings. What did you feel when God spoke to you? What is going through your mind now? Are you happy, overjoyed, nervous, doubtful? Confide and explain your laughter. Do you know already what you will name your son when he is born?

In a group, you may wish to share what you wrote. Was Sarah happy? Can happiness mean different things to different people? How so? Is happiness defined differently for people at various times and stages in their lives?

 5 (15 minutes) Scholars and artists have tried for centuries to imagine the jubilant celebration following the miraculous crossing of the Reed Sea. What was the sound of the song? How did they look as they played their instruments and danced? Were they completely absorbed in joy, or did their joy have tinges of sadness or fear? (See Text Study, Tanach #B; also, you may want to look up the larger context in Exodus 15-20.)

Now, imagine you were there, hiding somewhere nearby among the reeds. You are a reporter watching the aftermath of the crossing of the Reed Sea, a historian plunged back in time. Take out your notepad. You are most interested in Miriam and the women. Describe their actions and give details about their singing and dancing.

Members of a group may wish to share their writing. Did this exercise help you to visualize the song and dance of Miriam and the women? What new discoveries did you make? What can Miriam and the women, as you understand them, teach us about *Simchah*?

 6 (20-30 minutes) Does happiness begin with yourself (how you feel about yourself, whether or not you are content inside), or with others (how you treat others, how others treat you, how much love and friendship you have in your life), or with God (whether or not you have a strong sense of faith and trust in God, whether or not you live your life according to beliefs about what God wants of you)?

Assign position papers to three groups. Each group writes a short essay, or simply outlines essential points and arguments along the lines of their given topic. These are the topics:

a. Happiness begins with yourself.

b. Happiness begins with others.

c. Happiness begins with God (or your relationship with God).

When all the small groups are finished, each presents its position. Then discuss and debate which position is the strongest. Why? See if after discussion and debate, the group can come up with a consensus concerning where happiness begins. By figuring this out, you can shed light on the meaning of happiness in general.

7 (10-15 minutes) Text Study, Tanach #C cites trust as an important factor in happiness.

Spend a few minutes writing about trust. Who do you trust? What do you trust? Why do you trust? List all the things you trust. Once you have some thoughts recorded, evaluate the relationship between trust and happiness. Does trust make you a happier person? What role does trust in God play in your life? What role would you *like* it to play?

8 (10-15 minutes) Our tradition reminds us not to despair when times are bad, when we are feeling sad, because things will improve. We can trust and have faith that there's a time and a place for everything. Begin this activity with a "trust walk." In pairs, one of the pair leads his/her partner (who has closed eyes) on a walk inside the building or outside. After a few minutes, the partners switch roles.

Look up the passages in Text Study, Tanach #H and Tefilah #C. Then write some of your own verses of reassurance. Try basing your efforts on a pattern similar to the one in Psalms 126: "Those who [something sad or bad] will [something better]." You can also draw on the pattern of the Ecclesiastes passage: "There's a time for _____ and a time for _____ ."

How did you feel during the trust walk? Do you believe what you wrote? Where is your belief strongest/weakest? In what ways did you draw from your own experience in your writing? In what ways is happiness temporary? In what ways permanent?

Visual Art

1 (15 minutes or more) Judaism provides many occasions for rejoicing — a wedding, a Bar/Bat Mitzvah celebration, building and sitting in your *sukkah*, marching around with the Torah on Simchat Torah, a Chanukah party, a Purim parade, visiting Israel for the first time.

Do a short visualization exercise. The leader asks everyone to close their eyes, then calls out one joyous occasion at a time. Participants imagine the scene for 15-30 seconds. Then they choose and illustrate a scene of rejoicing that most captures their imagination.

Share and discuss artwork. Why did you choose to illustrate the scene you did? There are times, such as rejoicing with bride and groom, when we are *supposed* to be happy and joyful, when rejoicing is mandated. In what ways is it reasonable to expect rejoicing at such times? In what ways is rejoicing a value, a virtue?

2 (10 minutes) Oftentimes, music can inspire us to feel happy. What kind of music do you find uplifting? Is there music that makes you smile, tap your toes, get up and dance? Or, perhaps the music you find "happiest" is serene, peaceful, calming.

Listen to some of that happy music. Klezmer music can be a good choice. Take out some drawing materials, and draw (or paint) freely. Allow yourself to be inspired by the sounds. Don't necessarily draw recognizable objects and figures — just let the images flow. Change colors whenever you fancy. Scribbles, doodles, long and swirling lines, percussion-like dashes, tiny shapes, large shapes — get them all down on paper.

What do you like best about your work? What gives it the "feel" of happiness? Sometimes you may want to keep a happy feeling inside. At other times, you may want to express it. Under what conditions/in what circumstances do you feel the urge to express happiness "out loud" (or on paper or in dance)?

3 (15 minutes or more) Beautiful sounds, sights, and scents contribute to happiness, according to the Talmud. One Rabbi even says that a beautiful bed with a

beautiful bedspread can give a boost to happiness (see Text Study, Rabbinic #B and #C).

What small pleasures do you find uplifting? Using magazines, newspapers, cards, photos, make a collage of small pleasures. Cut out your own shapes and drawings to add to the collage. The end product should activate a sense of happiness in you and should capture your interpretation of the small things that can bring about a more positive day-to-day outlook.

Share your collages. Display them if you like. Consider: Why did you include the items you did? Did you feel conflicted about including certain things? If so, why? In attaining a general, overall sense of happiness, how necessary is it to pay attention and enjoy small pleasures?

 4 (15 minutes or more) Instead of making a whole collage of small things as in #4 above, focus on just one. Recall how one Rabbi specifically mentioned a beautiful bed and a beautiful bedspread (see Text Study, Rabbinic #B). Design your own beautiful something (perhaps an actual bed or a bedspread). Or, will it be a beautiful car, a set of beautiful marbles and marble bag, a fish tank for beautiful fish, a terrarium or garden for beautiful plants, a beautiful piece of clothing?

 5 (15 minutes or more) The Jewish concept of *Hiddur Mitzvah* (beautifying a commandment) stresses the value of elevating the performance of a ritual by making any necessary "tools" as aesthetically pleasing as possible. As in #4 above, design something beautiful, this time a ritual object that can add an extra measure of joy to performing a *Mitzvah*. For example, design a *tallit* and *tallit* bag, Torah cover, *etrog* holder, Shabbat candlesticks, a *menorah* or *chanukiah*, *Kiddush* cup, *challah* plate, *kipah*, *mezuzah* case, Pesach plate, a basket for holding Purim treats

(*Mishloach Manot*), etc. You can be as fanciful and elaborate as you wish. If you are very motivated and skilled enough, go ahead and give your design concrete form!

 6 (15 minutes or more) Illustrate the last scene of a "happily ever after" story (see Language Arts #2). Add some appropriate words under the illustration, too, if you like.

7 (time for taking photographs over a given period) Happiness radiates from scenes such as a neighborhood basketball game, squirrels playfully chasing each other, two friends enjoying ice cream cones on a park bench.

Over a week or two, photograph happy scenes. Develop the film and arrange the photos in a mini-album or make a photo collage. For a collage, obtain and use special photo adhesive from an art supply store (regular glue doesn't work as well). The collage can also include other materials you glue in, or original drawings. Post the collages around the room.

How did you decide what to photograph? Was it hard to find appropriate subjects? What is your favorite photo, and why? During this exercise, did you change your mind about what you considered "happy" to be?

 8 (10 minutes at least) In Text Study, Tefilah #A, those who dwell in God's house are labeled happy. What do such happy people look like? What do we understand "God's house" to be?

Come up with your own interpretation of the above passage. Then translate your interpretation artistically by drawing or painting someone dwelling in God's house.

Post the artwork around the room. On a walk-through, each participant explains how

he/she came up with their interpretation. What other ideas did people consider? What would you draw if you were the model for that happy person?

 9 (10 minutes at least) Text Study, Rabbinic #D claims that if you eat the fruit of your hands, you are happy. This suggests that self-sufficiency and responsibility can contribute to your sense of well-being.

Come up with an interpretation of the verse from Psalms. Then express your interpretation through art. Draw or paint someone who is happy as a result of "eating the fruit of his/her hands." Choose to be literal or abstract. A picture might be of someone who sits in the entrance of a shop he/she owns, a farmer working the land, a teacher teaching students, a chef tasting his/her "product," etc.

How did you come up with your understanding of what it means to be happy as a result of "eating the fruit of your hands"? Are there other ideas that crossed your mind? What would you draw if *you* were the model for the happy person eating the fruit of your hands?

 10 (an art museum excursion; plus time to create your own drawing/ painting) Sometimes it's helpful to tap into our intuition to shed light on underlying beliefs and attitudes we might hold. When something we see triggers a gut reaction that says, "That's happiness," that's when we recognize it and we know it!

To help bring what we "know" to the surface, make a visit to an art museum. In each room find the painting, drawing, sculpture, or other piece of art you think most expresses *Simchah* — happiness or joy. Which piece of art does so the least? Go through a few rooms before focusing on the questions. Take notes of your observations and insights, focusing on what and why something struck you as happy or joyful.

Now, back in the studio or classroom, create your own piece of art that expresses happiness. Incorporate the notes you made at the museum. (Remember, what you "learned" is, to a large degree, a bringing to the surface ideas and beliefs you previously held, that you "knew" already.

Show your artistic creations to others. Share reactions and comments. Are there common elements in the artwork (images, themes, shapes, colors)? Do we naturally sense the meaning of happiness (we just have to uncover our intuitive knowledge), or is happiness learned?

 11 (15 minutes or more) There are powerful verses of reassurance in our Scriptures. These words can help us deal with despair, get through hard times, knowing that things will improve (see Text Study, Tefilah #C).

In Language Arts #8, participants come up with their own "verses of reassurance." Here, you will either illustrate the line from Psalms, "Those who sow in tears will reap in joy," and/or illustrate your own "verse of reassurance."

Tell another person in the group how you tried to capture a sense of reassurance. How are reassurance and happiness related? Do you feel reassured by what you created? In what ways is happiness temporary? in what ways permanent?

Drama

 1 (time for planning, plus 30 minutes) One of the most joyous occasions we celebrate is a wedding. Children hear about weddings, but often aren't fully included in such festivities until they are young adults. This activity will give them an opportunity to experience the joy in a wedding celebration. (Or, if you can find a couple willing to have the group in attendance, attend an actual wedding.)

Several weeks beforehand, begin planning a wedding celebration. If it is a mock wedding, here are some ways to give it more of an authentic feel:

a. Find a couple celebrating their silver (25th) or gold (50th) anniversary. Make the wedding celebration a renewal and reenactment of their original commitment.

b. Find two adults who were of different religions when they married in a civil ceremony. Since that time, one of them has converted. Have a Jewish wedding for the couple. Involve a Rabbi in the ceremony so that it "counts" as a real Jewish wedding.

c. Have a wedding celebration of two biblical characters, such as Abraham and Sarah, Isaac and Rebecca, Moses and Tzipporah, or Boaz and Ruth, etc.

The involvement with the wedding planning can be elaborate or simple. Minimally, you can plan the reception — music and refreshments. Or, you can get involved with details of the ceremony, too — designing the *chupah* (wedding canopy), creating an artistic border for the *ketubah* (wedding contract), writing/choosing a few creative readings to include (love poems, reflections on the joy of marriage), and so on. Be sure at some point, even in an abridged wedding ceremony, to include the blessing that highlights the association between marriage and joyous celebration (see Text Study, Tefilah #F).

 2 (10-20 minutes) There are numerous words for *Simchah* (see Text Study, Rabbinic #A). Add some of your own words to the lists of words in that Text Study. These might include laughter, enjoyment, smiling, amusement, delight, pleasure, etc. (See also Language Arts, #1.)

Divide the group into two. One group takes the list of rejoicing words. The other takes the list of happiness-as-a-state of being words. Add your own words to either list, or give the new words to a third group. Each group decides on a word they will act out. The other group(s) tries to guess what

the word is. Each group should have several turns performing different *Simchah* words.

Discuss the experience. Was it hard to distinguish between different kinds of *Simchah*? Which *Simchah* words do you think are most important for lasting happiness? Why?

 3 (20 minutes or more) In Language Arts #2, participants reflect on what it means to "live happily ever after" and then write their own stories. Complete that activity first. Then make your story into a script for a play. Small groups may act out the plays for each other.

What themes came up in the plays? Why will the characters "live happily ever after"? What might you learn about happiness from the characters in the plays?

 4 (15 minutes) Fulfilling commandments in a grudging way is not ideal. The *Mitzvot* should be lived with joy! Maimonides makes this point explicitly (see Text Study, Post-Rabbinic #A).

Choose a few active *Mitzvot*. Create a sequence of three or four (the leader or participants can decide which ones). Participants will perform the sequence of *Mitzvot* twice — the first time grudgingly, without joy, and the second time, according to the Maimonides ideal, "with joyfulness and gladness of heart." Here's one example of a sequence of *Mitzvot*: blessing food, visiting a sick person, studying Torah, and returning a lost object. Participants can either act in pantomime or include speech. Also, the acting can consist of solos (with other roles imagined) or several actors can be given parts.

Discuss. What did actors experience? What did audience members observe? How did actors distinguish between doing *Mitzvot* without joy versus with joy? Include the Text Study, Post-Rabbinic #A questions as part of your discussion.

Movement

1 (20 minutes at least) Dance can be a spontaneous, improvised expression of joy. Or, one can specifically choreograph a dance that communicates a message of joy. Rabbi Nachman of Bratzlav said that dancing awakens joy (see Text Study, Post-Rabbinic #B). Choreograph some of this joy by creating one of the following:

 a. A wedding dance

 b. A dance with the Torah (see Text Study, Tefilah #B)

 c. A *Kabbalat Shabbat* (welcoming the Sabbath) dance: The Shabbat "Queen" (or "Bride") is greeted; a time for rest and renewal is celebrated.

 d. The dance of Miriam and the women, following the crossing of the Reed Sea (see Text Study, Tanach #B).

Learn the choreographed dances well enough so that they can be repeated and performed at an assembly, before parents or friends, at a worship service, during a wedding or other celebration, etc.

 2 (20 minutes at least) In this activity, dance inspiration is taken from creatures and inanimate things of nature. In verses of Psalm 96, all different elements of creation exclaim in praise and joy (see Text Study, Tanach #D).

Experiment with the material for your dance. Do this by isolating each image in the Psalm and improvising movement phrases inspired by the words.

a. Heavens rejoicing
b. Earth exuding gladness
c. Sea roaring in praise
d. Fields exulting
e. Trees (of the forest) shouting for joy

Now that you have material, begin to string phrases of movement together to create a dance.

If you wish, add words as accompaniment (in English and/or in Hebrew, sung or spoken). Experiment with different structures for the dance, such as:

a. One person beginning, others gradually joining in

b. Repeating some phrases, maybe going back and forth between a couple of them

c. Having some dancers do the same phrase in place, while others move across the floor doing the same phrase

d. Your own ideas?

Practice the dance until it feels polished. Then find a place to perform it where you can share your joy with others!

 3 (up to 30 minutes, less if just one section of the exercise is completed) Review the story of Sarah's laughter (see Text Study, Tanach #A).

The leader asks: What was your reaction when you were the recipient of real or imagined wonderful news (got a good grade, won the lottery, a medical test came back negative, received a marriage announcement, got a promotion)? Relive the scenario, seeing yourself laughing as you hear the news.

Second, experiment with the feeling of laughter and the feeling of being 90 years old.

a. Begin by putting the rhythm and gesture of laughter in your shoulders, then in your feet, then in your legs. Continue putting the laughter in different parts of your body until laughter is expanded throughout your whole self. Make laughing turns and laughing jumps.

b. Walk as if you are 90 years old. Make arm gestures as a 90-year-old would. Improvise how it would look to be 90 years old, hearing joyful news.

c. Do a more full-out interpretation of Sarah's behavior on hearing the news by acting out or dancing a *midrash*. Everyone takes turns being Sarah, who has just heard she will have a child. "Sarah" improvises a short scene based on

laughing, keeping in mind that she is 90 years old. The different emotions behind the laughter are important to this improvisation and might include joy, confusion and shock, disbelief, fear, mocking, and fulfillment.

A variation: Half of the group improvises while the other half watches. Then they switch.

Discuss reactions and observations to the performances. As each new performer improvises the scene, he/she can incorporate performance suggestions from the group.

(Note: This activity is adapted from "Sarah Laughed" in *Torah in Motion: Creating Dance Midrash* by JoAnne Tucker and Susan Freeman, pp. 20-21.)

 4 (10-15 minutes) Ecclesiastes writes that there is a time for everything (see Text Study, Tanach #H). Explore how these times translate into movement and express those feelings with your body. How do you feel during times of weeping? during times of laughing?

Imagine two large circles in the space. Designate one of them the "circle of weeping." Designate the other the "circle of laughter."

First, participants simply go and stand in one circle for a few moments, then in the other. In each space they try to get an inner sense of what the circle is about. They may wish to close their eyes while they stand there.

Second, participants go into one circle at a time and create poses that suggest the appropriate mood. They should create one pose, hold it a few moments, release and create another pose. Repeat this five or so times (in each circle).

Third, open the improvisation up to a freer experience of movement exploration. Participants can move, at will, between the circles, trying to get a sense of the meaning of each "time."

Debrief the experience. In what ways was it difficult to go between the circles? Did you natu-

rally feel you wanted to understand and explore each circle, or did you have to "push yourself" to move from one into the other? Explain. What happened between the circles — how did you move when you were in the space that was not included in either circle? How aware were you of others as you moved? Did your awareness of others influence your own movement style? In real life, to what extent can we *choose* to enter one circle (one time) versus the other?

Music

 1 (5-10 minutes) Clapping added to singing can heighten feelings of joy. "Let the rivers burst into applause!" it says in Psalm 98. In this exercise participants create their own version of bursting applause.

Experiment with adding clapping to one or more of your (or a group's) favorite Jewish songs in order to make the song sound as joyful as possible. Try adding stomping, toe-tapping, finger snapping, hitting thighs, tongue clicking (on the roof of your mouth), etc. You may want to "set" your version of the song and perform it with all the extras at an assembly or a service.

 2 (10 minutes or more) The words of the *"Mi Chamocha"* (Who is like You, God) prayer are chanted as part of the celebration following the miraculous crossing of the Reed Sea. Over the centuries, this prayer has been set to numerous melodies.

Review (or teach) the melody used most often in your community's worship service. Then, listen to or teach other musical settings for *"Mi Chamocha."* Invite a Cantor or music specialist to work with you. (Four versions may be found in *Gates of Song*, Charles Davidson, musical editor, New York: Transcontinental Music, 1987, #37-40.)

Which melody best captures the mood the Israelites felt after crossing the sea? Should the melody be perfectly joyful and upbeat? Or, should

it reflect traces of other emotions — excitement, fear, anxiety, regret, horror at the sight of the Egyptians and horses drowning?

 3 (10 minutes or more) Review Text Study, Post-Rabbinic #B, which describes how *niggunim* (melodies) are included in divine service.

Learn some *niggunim* ("la lai lai" or "yai da dai" kinds of melodies without words). Choose some that sound particularly joyful. Also try to sing a not-so-joyful melody in a joyful way by speeding up the rhythm, singing louder, etc.

Discuss. What makes sound seem joyful? Is it the music itself, the notes? Or, is it the style in which the music is sung? Or, is the joy the result of a happy singer? Some music can be made to sound more happy (see Text Study, Tanach #H). Is it possible for us to change the way we express our moods, to "transpose" our sadness into happiness? Explain.

 4 (20 minutes or more) Read over the instructions listed in Movement #1, in which topics are given for choreographed dances of joy. Then, rather than choreographing a dance, small groups each compose a song for one of the following topics: a wedding, a Torah procession, a Kabbalat Shabbat (welcoming the Sabbath) song, a song (that could have been) sung by Miriam and the women following the crossing of the Reed Sea. Sing the songs for each other (and, if desired, for other groups as well).

Miscellaneous

1 (parts of a day) The Talmud says that beautiful sights, beautiful sounds, beautiful scents can lift our spirits (see Text Study, Rabbinic #C). A "lifted" spirit is a happy spirit. How easy it is to get caught up in the rush of life so that we don't take time "to stop and smell the roses"! We need to stop and look at the horizon, listen to children singing, slow down and really taste our food, and enjoy an extra long hug.

Put aside a day or part of a day for a recharge of appreciation of beauty. Give yourself an especially happy day. During that day, experience:

a. Beautiful sights (visit a museum or gallery, a lookout spot off a scenic road, a vantage point from a bridge, the top of skyscraper at night where you look at the city below all lit up.)

b. Beautiful sounds (go to a concert; listen to music new to you, perhaps checking out music from the library; open your ears to natural sounds — waves lapping, river water rushing, wind blowing through trees, birds singing.)

c. Beautiful scents (wander around a botanical garden; linger at the perfume counter at a department store; breathe in deeply the scents at a bakery, chocolate store, or shop that sells and grinds coffee beans; put some hot cider on your stove to simmer, adding cinnamon stick, cloves, and other sweet spices; light a scented candle.)

d. Beautiful sensations (give and receive extra hugs; wear the softest clothes you own; enjoy a massage; take a warm bath or cool swim; swing on a swing; participate in a session of stretching or yoga.)

e. Beautiful tastes (no examples are necessary, as everyone has plenty of ideas concerning these!)

If you like, you may want to buy something beautiful to remind you to stop and enjoy and appreciate loveliness all around. It can be small, like a postcard, rock, refrigerator magnet, teacup, place mat, flowerpot, or bookmark.

While this exercise lends itself nicely to a solo experience, two or three friends could take a "beautiful day" together. (That way they'd also enjoy the beauty of friendship!)

What was it like to take time out for beauty — how did you feel about doing so? Is it important to do so? Why or why not? What would be

the ideal way to build appreciation for beauty and enjoy the sense of uplift that it might provide for us?

2 (several hours) In our liturgy (and elsewhere), we are reminded that there should be a sense of joy in our celebrations of festivals and Shabbat (see Text Study, Tefilah #D and #E). Perhaps there is a holiday you haven't fully celebrated before. Or, maybe there's a new way to add an extra happy element into your typical observance routine.

Plan a joyful holiday or Shabbat experience. For Sukkot, you could host a children's Sukkot party one afternoon in your *sukkah* (or in a friend's). Include special music, dancing, games, and refreshments. For Shabbat rest and renewal (*menuchah*), arrange a late afternoon picnic with friends at a park (one with a playground, if age appropriate). Or, how about a sing-along followed by Havdalah? On one of the mid-days (*Chol HaMo'ed*) of Pesach, you could create a dramatic reenactment (including costumes and props) of the Exodus story. Do this with your own family or invite other families to join you. Whatever it is you want to do, make it joyful!

CHAPTER TWENTY-ONE

SOMAYCH NOFLIM V'ROFAY CHOLIM: SUPPORTING AND HEALING

סוֹמֵךְ נוֹפְלִים וְרוֹפֵא חוֹלִים

OVERVIEW

Somaych Noflim means "support the falling"; Rofay Cholim means "heal the sick." The words appear together in the central Jewish prayer, the "Amidah," in which the expression "Somaych Noflim V'Rofay Cholim" refers to God. That is, God supports the falling and God heals the sick. Thus, the impulse for carrying out these virtues comes from God's example which we are to emulate.

"Being supportive" conjures up concrete images. Just as a beam supports a sagging roof, hands and arms lift up someone who has fallen down. Being supportive has an intangible aspect as well. Support can be given through words or simply by one's physical presence. Even a smile or a look of understanding can provide support. The support one person offers to another usually takes a straight route. There's immediacy and directness in extending support. No intermediary is necessary. We may feel God's presence as we offer support to another; we may be influenced to be supportive as a result of God's example. But we don't need to go *through* God to give support.

The same is not true about healing. It is very clear in our tradition that God is the source of healing. We do go "through God" in order to heal. We could translate Somaych Noflim as being "supportive." There is no such equivalent word for Rofay Cholim — "healative," or "heal-i've," or "healer-ish" don't work. We ourselves can support, but when it comes to healing, we can promote it, we can be *agents* of healing, but ultimately healing happens on a level that is not directly accessible to us. The ultimate source of healing is God.

When we talk about being agents of healing, it's important that our definition of healing is expansive enough. To heal isn't simply to cure, to save someone from pain, illness, or death. Providing medical advice, or assisting someone in obtaining it, is a significant part of being an agent of healing. But healing also can involve reconciliation, coping, hope, faith, inner peace. To assist a person on those intangible levels is also a most worthy aspect of mastering the virtue of Rofay Cholim.

While people can become overly presumptuous in their role in healing — taking full responsibility for effective "cures," we should nonetheless not underestimate the human role in healing either. We need God in order to heal, but God also needs us to serve as agents, as instruments, as workers. Our hands and talents must carry out the necessary physical tasks involved, and our voices must speak healing words.

We might associate the need to offer support and healing with isolated circumstances — crises, emergencies, disasters, misfortune. But to wait until disaster falls in order to extend support is a mistake. It's important to work toward a culture of support and healing. For an individual, this effort involves developing the trait of being supportive, working toward healing on an ongoing basis. An analogy: you don't make the ladder after someone falls down a well. We need to have a supply of "ladders" available. The availability of support and the practice of support must be constant. One text talks about one "voice" lifting another's voice. To be successful in lifting and healing, we must practice "singing" together (see Text Study, Somaych Noflim, Post-Rabbinic #A).

To practice being supportive involves showing support toward others during their times of happiness and success. Similarly, we can assist others in preventive health techniques on different levels — physically, emotionally, and spiritually. Part of preventive health can come from a strengthening of identity. We can strengthen our own and help others to strengthen theirs. Knowing one's heritage, embracing it, and living by its values can be a source of comfort and support during difficult times.

The *manner* in which support is offered and healing efforts extended is significant. Our tradition urges us to honor the dignity of those who need help, to respect their modesty. We should not be dogmatic in our approach, with our suggestions. Rather, we must be flexible and creative. Medicines and medical procedures may be advised, but healers should be aware that a remedy that is right for one person may not be right for another. Certainly our tradition applauds visits to those who are ill. And guidance is offered in terms of what is and what might not be appropriate during a visit. But we can go further in our openness to ways of offering support and healing. One sage says that the shining sun brings healing (see Text Study, *Rofay Cholim*, Rabbinic #F). In other Text Study passages, we learn of additional ways to be supporters and healers, to master the virtues of *Somaych Noflim* and *Rofay Cholim*.

How these *Middot* impact our relationships with others, with ourselves, and with God is summarized below.

 BAYN ADAM L'CHAVERO, BETWEEN PEOPLE. A person can offer support to another person, and thus be a healing presence in that person's life.

 BAYN ADAM L'ATZMO, BETWEEN YOU AND YOURSELF. What does it mean to heal your own self, to be a support to yourself? First of all, it means noticing, paying attention to any problems that arise. Next, it means attending to them. Some of the attention may be given from yourself to yourself, including drawing strength from God. In addition, you may need to seek the assistance of other people to help you in your healing process. You don't have to wait for "problems" before you attend to your health. Practice preventive health by nurturing supportive relationships, taking care of your body (*Shmirat HaGuf*), embracing your identity and heritage, and cultivating a close relationship with God.

 BAYN ADAM L'MAKOM, BETWEEN YOU AND GOD. God is the exemplar for the virtues of supporting and healing. We are to try to emulate God. As God supports and heals, so, too, should we make efforts to do so. God may be the source, the provider of healing. But by being "agents of healing," we support God in bringing more people either to "cures," or to reconciliation, coping, hope, faith, and inner peace.

TEXT STUDY: SOMAYCH NOFLIM: SUPPORTING[1]

Tanach

A Moses reminds the Israelites of the support God gave them as they traveled from Egypt and through the wilderness.

You saw how the Eternal your God carried you, as a parent carries a child, all the way that you traveled until you came to this place. (Deuteronomy 1: 31)

[1] Text Study passages for Rofay *Cholim* on page 304 are also applicable for the topic of *Somaych Noflim*.

In Psalms it says:

I extol You, O Eternal, for You have lifted me up, and not let my enemies rejoice over me. (Psalms 30:2)

➤ How was God like a parent to the Israelites during their travels? Elaborate on what it might mean for God to "carry" someone or for God to "lift someone up"? Have *you* ever felt that God carried you or lifted you up? A parent may carry his/her child. What other ways might we act like God and carry each other, lift each other up?

B The image of God extending a strong hand and supportive arm is a powerful one. Though God does not *literally* reach out a hand and stretch forth an arm, the idea of God's eternal supportiveness is clear.

The Eternal freed us from Egypt with a strong hand and an outstretched arm. (Deuteronomy 26:8)

A support are the arms everlasting. (Deuteronomy 33:27)

➤ Why did the Israelites associate the experience of God's presence with the image of a strong hand and an outstretched arm? Have you ever felt God's presence to be like a strong hand and/or an outstretched arm? In what ways does the image of offering a strong hand or an outstretched arm suggest we have a responsibility to try to be like God — that we, like God, must try to reach out toward others?

C According to tradition, we can trust that God is with us during difficult times.

The Eternal is close to the brokenhearted; those crushed in spirit God delivers. (Psalms 34:19)

➤ Do you think God is especially close to those who are brokenhearted or crushed in spirit? Why or why not? How can we, like God, make an extra effort to be aware of those in our midst who are hurting?

D This verse from Psalms includes words that were incorporated into the "*Ashray*" prayer.

The Eternal supports all who are falling, lifts up all who are bowed down. (Psalms 145:14)

➤ What makes the verse from Psalms a prayer? Are we praising God? thanking God? making a plea or request before God? all three things? Is there something (or has there been something) in your own life that makes you want to pray these words? In order to support others, to feel we have the strength to do so, perhaps we need to feel God supports us. What do you think? The "*Amidah*" is a prayer that reflects a similar sentiment (see Text Study, *Royay Cholim*, Tefilah #A below).

E The value of one person supporting another person is evident in the following comment:

Two are better off than one . . . For should they fall, one can raise the other; but woe to the one who is alone and falls with no companion to raise that person up . . . (Ecclesiastes 4:9-10)

➤ Why, according to the above, are two better off than one? Do you agree? In what ways do you actively pursue mutually supportive relationships? Should you make more of an effort to do so?

Rabbinic

A Supporting and healing often go "hand-in-hand" in a visit to the sick (*Bikur Cholim*). An offer of support is not limited to verbal communication. (In fact, sometimes it's difficult to find any words that seem perfectly appropriate.) Thus, extending a hand to someone who is hurting may express our empathy in a most effective and heartfelt way.

> Rabbi Hiyya ben Abba fell ill and Rabbi Yochanan went in to visit him. He said to him: "Are your sufferings welcome to you [knowing you can expect to be rewarded for them in the World To Come]?" He replied: "Neither they nor their reward." He said to him: "Give me your hand." He gave him his hand and he raised him.
>
> Rabbi Yochanan once fell ill and Rabbi Hanina went in to visit him. He said to him: "Are your sufferings welcome to you?" He replied: "Neither they nor their reward." He said to him: "Give me your hand." He gave him his hand and he raised him. Why couldn't Rabbi Yochanan raise himself? They replied: "Prisoners cannot free themselves from jail." (*Brachot* 5b)

➤ Sometimes we may be the providers of support; at other times, we ourselves may be in need of support. Notice how Rabbi Yochanan finds himself in both roles. Is Rabbi Yochanan's experience typical? To be an effective healer, do we need to know how to receive healing ourselves? What do you believe is suggested by the words "giving a hand and raising up another"? Explain the line, "Prisoners cannot free themselves from jail."

B We can translate *Somaych Noflim* as "supporting the falling." Oftentimes, "falls" come by surprise. It is best not to wait until bad things happen to have coping strategies in mind. Whether in happy or difficult times, we must make efforts to support and sustain each other.

> It is written, "In the days of prosperity, be joyful; in the day of adversity, consider" (Ecclesiastes 7:14). Rabbi Tanchum ben Chiyya said: "In the happy days of your neighbors, be with them in their happiness; if an evil day befalls your neighbor, consider how you can show the neighbor loving kindness to deliver the neighbor from the evil. The mother of Rabbi Tanchum ben Chiyya was wont, when she wanted one pound of meat, to buy two pounds, one for him and one for the poor, because God has set the one against the other. Why indeed has God created both rich and poor? That the one might be sustained by the other." (*Pesikta Kahana* 191b)

➤ Why might it be important to be supportive of others in happy as well as difficult times? What did the mother of Rabbi Tanchum ben Chiyya do to make sure she did her part in helping to sustain others? Do you know anyone today like this mother? Is there anything you do to make sure others, among your friends and in your community, are "sustained"? Is there something you would like to start doing?

C Our heritage is a source of support. Knowing our identity — where we came from, who our ancestors were — helps keep us grounded. A feeling of being rooted in a particular tradition and

history can make it easier to restabilize ourselves when we stumble or fall.

> A proof that just as the vine that lives derives its support from dead stalks, so does living Israel find support in Patriarchs long dead — hence "Remember Your servants, Abraham, Isaac, and Israel . . . " (Exodus 32:13). (*Exodus Rabbah* 44:1)

➤ How are a live vine and Israel alike, according to this passage? How can history and heritage be a source of support? From what in your heritage do you draw support — the Patriarchs, the Matriarchs, other important Jewish figures? Do you draw support from certain stories, values, observances, and traditions that have come down to you? Explain.

Tefilah

Note: The words *Somaych Noflim* appear in both the *"Ashray"* and the *"Amidah"* prayers. (See Text Study, Tanach #D above, and also the passages in Text Study, Tefilah for *Rofay Cholim* below.)

Post-Rabbinic

A How we can lift each other up is explained using singing as an example.

> Rabbi Pinhas said: "When a person is singing and cannot lift his[/her] voice, and another comes and sings along, another who can lift his[/her] voice, then the first will be able to lift his[/her] voice, too. That is the secret of the bond between spirit and spirit." ("When Two Sing" from Martin Buber, *Tales of the Hasidim: Early Masters*, p. 126.)

➤ "Singing" in this passage conveys ideas on two levels — one more literal and one more metaphorical. Explain what these two levels are.

B We can seek help from another person, But God's presence is within and behind any person who assists us.

> [Said] Rabbi Tzvi Elimelech of Dinov: "It is permitted to seek help from someone if you have the need in some matter, but you should, at the same time, put your trust in God to save you through this particular person, who serves, so to speak, to make it all look as if it is a natural thing in the regular course of events." (*Agra d'Pirka*, Sh'lach, in *Derech HaTovah VeHayasharah*, p. 20, Bitachon #7, as quoted in *Jewish Spiritual Practices* by Yitzchak Buxbaum, p. 211)

➤ Have you ever felt that a friend's help was "God-sent"? What does the above passage suggest in terms of God's involvement in the support another person may give you?

C When we are at our lowest, there is a "hand" available to help pull us out. Being willing to be drawn out of the darkness is likened to opening ourselves to redemption.

> One Hasidic master spoke of "the hours in the lowest depths when our soul hovers over the frail trap door which, at the very next instant, may send us down into destruction, madness, and 'suicide' at our own verdict. Indeed, we are astonished that it has not opened up until now. But suddenly we feel a touch as of a hand. It reaches down to us, it wishes to be grasped — and yet what incredible courage is needed to take

the hand, to let it draw us up out of the darkness! This is redemption." (Martin Buber, "The Man of Today and the Jewish Bible," in *Israel and the World: Essays in a Time of Crisis*, New York: Schocken Books, 1948, p. 102)

➤ Why might it take courage to grasp the hand that reaches toward us in the darkness? What do *Somaych Noflim* and redemption have in common?

D The following contains an underlying message similar to the one above: God can help "pull us up."

The Ladder
The souls descended from the realm of heaven to earth on a long ladder. Then it was taken away. Now, up there, they are calling home the souls. Some do not budge from the spot, for how can one get to heaven without a ladder? Others leap and fall and leap again, and give up. But there are those who know very well that they cannot achieve it, but try and try over and over again until God catches hold of them and pulls them up. (Martin Buber, *Ten Rungs: Hasidic Sayings*, p. 40)

➤ How does God provide assistance according to this passage? Can we learn from God's example and "catch hold" of others and "pull them up"?

TEXT STUDY: ROFAY CHOLIM: HEALING[2]

Tanach

A God is the exemplar of appropriate behavior toward the sick. Visiting those who are ill

(*Bikur Cholim*) is one example. The *Middah/Mitzvah* of visiting the sick is derived from an instance in which God visits Abraham, presumably as the Patriarch is recovering from circumcision (*Sotah* 14a).

The Eternal appeared to [Abraham] by the terebinths of Mamre; he was sitting at the entrance of the tent as the day grew hot. (Genesis 18:1)

➤ Emulating God as a healer is the underlying principle for the virtue of *Rofay Cholim*. In what ways can a visit to the sick be "healing"?

B God may be the source of all healing, but we can be like God and participate in the healing process as well.

I the Eternal am your healer. (Exodus 15:26)

➤ What do you think of the concept of God being the source of all healing? To what extent can and should people participate in the healing process?

C No matter how brief a prayer for the sick may be, God is addressed.

So Moses cried out to the Eternal, saying, "O God, pray heal her!" (Numbers 12:13)

➤ In what ways do you believe effective healing involves prayer? To be a healer, should you pray to God when you are sick? Should you pray for others when they are sick? Should you offer to pray with those who are sick?

D We have learned that, on some level, God visits the sick. Here is a more abstract way of describing a "visit" from God.

[2]Many of the passages in the Text Study for *Somaych Noflim* are also applicable to the topic of *Rofay Cholim*.

The Eternal will sustain those on their sickbed; You shall wholly transform their bed of suffering. (Psalms 41:4)

➤ What does it mean that God will *sustain* those on their sickbed? In what ways can sensing God's presence help transform a person's "bed of suffering"? If we are to be healers, what must we do in terms of sustaining the sick and helping them to transform their suffering?

E In the following passage, God's role in healing is acknowledged through prayer. Yet, it is a human healer — Elisha — who brings about the actual "cure."

[Elisha] went in, shut the door behind the two of them and prayed to the Eternal. Then he mounted [the bed] and placed himself over the [seemingly dead] child. He put his mouth on its mouth, his eyes on its eyes, and his hand on its hands, as he bent over. And the body of the child became warm. He stepped down, walked once up and down the room, then mounted and bent over him. Thereupon, the boy sneezed seven times, and the boy opened his eyes. (II Kings 4:33-35)

➤ How did Elisha help heal the child? To become a master of the virtue of *Rofay Cholim* means becoming an "agent" of healing (God's "agent"). Is such a statement a fair summary of the requirements of mastering *Rofay Cholim*?

Rabbinic

Note: Be sure to refer especially to Text Study, Rabbinic #A in the *Somaych Noflim* section above for the significant message about healing.

A Among other verses, the Rabbis rely upon Exodus 21:19 to support the permission to heal.

The sages in the school of Rabbi Ishmael taught: "And to heal he shall heal" (Exodus 21:19). From this verse we infer that permission has been given [by God] to the physician to heal. (*Brachot* 60a)

➤ God may be the ultimate source of healing, but people are "agents" of God in the healing process. What "powers" do agents of healing have that are beyond the ordinary?

B This statement makes it clear that the human role in healing is of utmost importance.

The sages said in the name of Rav: "It is forbidden to live in a city where there is no physician." (Palestinian Talmud, *Kiddushin* 4:12)

➤ Why would it be *forbidden* to live in a city without a physician? What other agents and instruments of healing do you think every community should have (ambulance service, 911, hospital, 24-hour pharmacy, mental health professional, community chaplain, etc.)?

C Healing involves some give and take. We need always to consider the input of the one who is suffering. Our efforts to heal should reflect flexibility and compassion for the one in pain.

Samuel Yarhin'ah was Rabbi's [healer]. Now, Rabbi having contracted an eye disease, Samuel offered to bathe it with a lotion, but [Rabbi] said, "I cannot bear it." "Then I will apply an ointment to it," he said. "This too I cannot bear,"

he objected. So [Samuel] placed a vial of chemicals under [Rabbi's] pillow, and he was healed. (*Baba Metzia* 85b)

➤ How did Samuel Yarhin'ah react to Rabbi's resistance to the remedies he offered? Do you think Samuel Yarhin'ah's responses to Rabbi were appropriate? Have you ever resisted a healing treatment or remedy recommended to you? Have others ever resisted a remedy you recommended to them? How did you deal with such situations? What is the *best* way to deal with such situations?

D Abba is an exemplary healer. He respects the modesty of his patients and honors their dignity.

What was the special merit of Abba? When he performed his operations, he would separate men from women. In addition, he had a cloak which held a cup [for receiving] blood and which was slit at the shoulder, and whenever a woman patient came to him, he would put the garment on her shoulder in order not to see her [exposed body]. He also had a place out of public gaze where patients deposited their fees. Those who could afford it put their fees there, and thus those who could not pay were not put to shame. (*Ta'anit* 21b)

➤ It is not just *what* remedies and procedures a healer offers that's important. *How* healing is carried out is also significant. What is praiseworthy about Abba's healing methods? What can we learn from Abba concerning our own efforts to provide healing to others?

E *Bikur Cholim* (visiting the sick) enables us to participate in the healing process. Such participation is an esteemed component of the virtue of *Rofay Cholim*.

It was taught: There is no measure for visiting the sick . . . Abaye explained [the teaching]: "Even a great person must visit a person of low status." Raba said: "[One must visit] even a hundred times a day." Rabbi Abba son of Rabbi Hanina said: "Those who visit a sick person take away a sixtieth of that person's pain." . . . Rabbi Akiba went forth and lectured: "Those who do not visit the sick are like shedders of blood." . . . Rabbi Dimi said: "Those who visit the sick cause the person to live, while those who do not, cause the person to die." (Nedarim 39b-40a; Maimonides reiterates these same ideas in *Mishnah Torah*, Book Fourteen, Judges 14:4)

➤ Why do the Rabbis express in such dramatic (and perhaps exaggerated) ways the importance of visiting the sick? Is it because they want to attract attention to this value, as people tend not to visit the sick often enough? Is it because the Rabbis know that making visits to the sick can be difficult, and, therefore, we need the extra "shove" of their forceful words in order to get us to do what we should?

F Prayer, study, self-reflection, and visits with others can all contribute to the healing process. But healing can also be aided in other sorts of ways — including exposure to sunshine.

The saving sun with healing in its wings (Malachi 3:20). Abaye said: "This proves that the shining sun brings healing." (*Nedarim* 8b)

➤ How does the shining sun aid in healing? Are there other things you can think of that may help a person to heal (spending time with pets, art therapy, dance therapy, writing in a journal, lis-

tening to music, humor, travel, being in a natural setting — near the ocean, in the mountains, by a stream or lake, in the woods, at the base of a waterfall, in the shadows of soaring rock formations)?

Tefilah

A In the *"Amidah"* prayer is a section that begins, *"Mechalkayl Chayim B'Chesed"* (Your lovingkindness sustains the living). The section includes mention of God's role in supporting the falling and healing the sick. (See also Text Study, *Somaych Noflim*, Tanach #D.)

> *Somaych Noflim V'Rofay Cholim . . .*
> **You support the falling and heal the sick . . .**

➤ We say that God is ultimately responsible for supporting and healing. Perhaps one goal of reciting those words on a regular basis is to absorb the directive provided by God's example — make the virtues your own. To what degree do such words of prayer penetrate you, inspire you to act?

B Included in the weekday *"Amidah"* is a prayer for healing.

> **Heal us, O Eternal, and we shall be healed. Help us and save us, for You are our glory. Grant perfect healing for all our afflictions.**
> **[On behalf of someone ill, you may add:]**
> **May it be Your will, Eternal our God and God of our ancestors, to send perfect healing, of body and of soul, to _____, along with all others who are stricken.**
> **For you are the faithful and merciful God of healing. Praised are You, Eternal, Healer of Your people Israel.**

➤ How might regular recitation of these words assist in the healing process?

Post-Rabbinic

A The following comes from a Rabbinic idea (*Nedarim* 39b). Maimonides draws on a Talmudic text, interprets it, and captures in a succinct way one of the text's essential messages.

> **One who visits a sick person shall not sit upon the bed, or in a chair or on a bench or any elevated place, or above the head side of the patient, but should wrap him/ herself up and sit below the head side, pray for the sick person's recovery, and depart. (Maimonides, *Mishnah Torah*, Book Fourteen: Judges 14:6)**

➤ Why do you think Maimonides instructs visitors to the sick on where to sit? Do his instructions sound too businesslike? Maimonides may be sensitive to the fact that some visitors can overstay their welcome. Is that a fair concern?

B This instruction for visiting the sick by Maimonides is less "businesslike" than that in #A above.

> **To boost the essential strength [of people who are ill] you should use musical instruments, and tell patients happy tales that will cause their heart to fill with joy and descriptions of events that will distract the mind and cause them and those around them to laugh.**
>
> **Attendants and caretakers should be selected who have the ability to cheer up the patient. This is a must in every illness . . . (Maimonides, *Mishnah Torah*, *The Preservation of Youth*)**

➤ How do the Text Study passages in #A and #B complement each other? As healers, our mission may vary. To master the virtue of being a healing person, we need to be sensitive to the best manner in which to aid healing for each individual situation. Do *you* have a usual style for attending to those who are sick? In what areas of healing (being a healer) would you like to grow?

ACTIVITIES

Language Arts

 1 (10 minutes) There are many ways to provide support and to assist in healing. There can be very practical assistance, such as bandaging a wound or providing C.P.R. (cardio-pulmonary resuscitation). And there can be healing support that is of a more intangible nature — for instance, telling someone who is ill funny stories to help lift that person's spirits.

List all the things you can do to assist in supporting and healing. What things do you usually do? Which things have you never done? Are there any you never have done that you would like to try?

 2 (10 minutes) You might say, "May you have a *refuah shlaymah*" (a complete healing) to someone who is ill. What else might you say? A review of the above Text Study passages may give you some ideas.

Brainstorm ways of wishing others well. Then write Jewish messages of healing on someone's imaginary cast (a large piece of butcher paper). If the group is ambitious, they can create a cast out of plaster of paris, let it dry, and actually write on it.

Now write one or more actual get well cards to people participants know. Or, the leader may suggest someone in the congregation or community who would appreciate a boost. When the cards are completed, send them! (If desired, cards can be created on a computer or send a card without charge through http://www.bluemountain.com.)

 3 (10-15 minutes) Review Text Study, *Tefilah* #2 for *Rofay Cholim*. This traditional Jewish prayer for healing is part of our daily liturgy.

Have everyone write his/her own prayers for healing.

For more resources on healing, contact the National Center for Jewish Healing (NCJH), c/o Jewish Board of Family and Children Services, 120 West 57th Street, New York, NY 10019; 212-632-4705.

 4 (15 minutes or so for each interview) While everyone has healing capacities, there are those who devote their professional lives to healing. Some volunteer on a regular basis in hospitals or other arenas of healing. We can expect that such professionals (and experienced volunteers) spend more time than most of us do thinking about healing. What might we learn from them? What can they teach us that we might incorporate into our own efforts to be agents of healing?

Invite to class one or more healing professionals (or experienced volunteers) to interview — a doctor, nurse, health aide, psychologist, hospice volunteer, Rabbi, chaplain, social worker, chairperson of the synagogue *Bikur Cholim* (visiting the sick) committee, etc. Some possible interview questions:

a. What exactly are the healing services you provide?

b. Why did you go into the healing profession?

c. (For medical professionals) Besides medical knowledge or skill, what do you think is the most important thing you offer as a healer?

d. What do you believe is God's role in healing?

e. Some people don't respond (with improved health) to medications, therapies, remedies. How do you feel when that happens? What do you do?

f. Have you ever come across someone whose physical health was deteriorating while their spiritual health became stronger? Please comment on your observations.

g. What advice do you have for people who want to visit the sick (or who want to give support to someone who is in pain)?

h. Your ideas

Ideally, interview more than one healer. Compare the similarities and differences in their statements. Were any of the answers unexpected? Explain. Did they say anything which might help you refine your own efforts to carry out *Somaych Noflim* and *Rofay Cholim*?

5 (30 minutes or more) Judaism teaches the importance of visiting the sick. Even so, many of us find that doing so is not always easy. We may find ourselves plagued with questions: When should I visit? How long should I stay? What should I say? Should I bring anything? What if I arrive and the person is sleeping? What if I arrive and someone else is already there? Should I visit if I barely know the person? Should I visit if the person is recovering from an injury that the person may feel is private (like an instance of domestic abuse or drug abuse)? In order to feel comfortable about our responses to the sick, it can be helpful to think through these issues before they arise. Hearing what others in a group have to say can expand our ways of thinking and acting and help us to feel good about our efforts to carry out *Somaych Noflim* and *Rofay Cholim*.

Begin by discussing some of the questions mentioned above. Bring in Jewish texts and other books (from both the Jewish world and the secular world) that discuss caring for the sick.[3] Then write an instruction booklet for visiting the sick. Some possibilities of what to include:

a. Various Jewish texts and contemporary readings that can be shared with the sick person

b. Suggestions of conversation openers, plus words and phrases to use when conversation stalls, and a note about when silence might be most appropriate

c. A list of good books the patient might enjoy reading, including novels and stories that are engrossing, engaging, entertaining (the visitor may want to read some of the books on the list so that he/she can talk about them in a more informed way with the patient).

d. A list of good videos the patient might enjoy watching

e. Ideas of small gifts to bring

f. Recipes of healing foods that can be prepared and offered to the patient (e.g., soup)

The booklet writers may want to ask hospital nurses and/or someone who recently has recovered from a long illness what others can do for patients that is most helpful for their healing.

Consider photocopying the booklet for distribution through the synagogue information table or shelf. Perhaps a Jewish Chaplain, Jewish Family Service, and/or local hospital would like to make the booklets available to those who visit Jewish patients.

 6 (10 minutes) In some places, it is required at a certain grade level to learn First Aid and C.P.R. (cardio-pulmonary resuscitation). We usually associate such learning with secular studies. But should teaching First Aid and C.P.R. also be required from a Jewish standpoint?

[3]For Jewish texts, see Text Study sections in this chapter. Books of interest on the subject include: *The Healing Visit: Insights into the Mitzvah of Bikur Cholim* by Chana Shosnos Otr and Bat Tova Zwebener, Southfield, MI: Targum Press, 1989; *I Don't Know What to Say: How to Support Someone Who Is Dying* by Robert Buckman, New York: Vintage Books, 1988; *Is There Anything I Can Do?* by Sol Gordon, New York, Delacorte Press, 1994.

Stage a debate. Everyone imagines they are members of the School Committee of the local Jewish Day School discussing what should be included in the curriculum. In a Jewish Day School, both secular studies and Jewish studies must be thoroughly covered. First Aid and C.P.R. require about 20 hours the first year the topic is introduced, plus ten hours each year thereafter for a refresher.

The debate can be conducted informally as a discussion or as a more formal debate. For a formal debate, assign sides. One side is for the addition of First Aid and C.P.R. classes, the other side is against. Debaters should draw on Jewish values and texts as much as they can to support their positions. They may also want to see texts and ideas related to the virtue of *Shmirat HaGuf,* (taking care of your body), which is covered in Chapter 19. Another important Jewish value worth taking into consideration is *Pikuach Nefesh* (saving a life).

 7 (15 minutes) If we tap into our "gut" (or intuitive) understandings of words related to healing, we may gain insights about what healing can mean for us.

Brainstorm words you associate with healing (e.g., hope, peace, harmony, wholeness, energy, love, reconciliation, mending, transformation, serenity, grace, comfort). List one word per line down one side of a piece of paper. Write a short phrase, image, or thought that comes to mind about each. Put down the first thing you think of without worrying about being profound or making logical sense. The object is to capture an intuitive sense of the words. Here are a couple of examples:
Hope – a butterfly alighting on the heart of a daffodil
Serenity – a goose down pillow
Reconciliation – mended fractures
Transformation – slums become the Garden of Eden

Use the imagery you came up with to compose a poem on the subject of healing.

In a group share your poems and comment on the images. If you like, collect the poems and make copies of them to create booklets. Make the booklets available for members of the community. Your words may provide support and comfort for others.

 8 (15-20 minutes) *Somaych Noflim* is a virtue, and we should strive to live by it — to be supportive. Such support, however, is rather abstract and cannot necessarily be seen. But if we focus on tangible associations with support (beams, pillars, walls, and the like), it can help us to expand our thinking and give us insights into the less tangible aspects of supporting.

Spend some time studying Jewish sources on *Somaych Noflim* (such as Text Study, Tanach #B, Rabbinic #A and #C, Post-Rabbinic #C and #D). Then name and make a list of supports — things that can hold, lift, carry. Examples include, in addition to those mentioned above, poles, stakes, arms, elevators, shovels, escalators, ladders, ropes, buoys, strollers, wheel chairs, crutches, cars and other vehicles (that can "give you a lift" to where you need to go). Using these tangible supports, create a poem on the virtue of *Somaych Noflim.* How many ways can you say, "I want to support and heal"?

In a group share your poems. Were there any Jewish texts you had in mind as you composed your poems? How does your poem reflect the Jewish virtue of *Somaych Noflim*?

 9 (15 minutes or more) In Text Study, Rabbinic #F on *Rofay Cholim,* the sun is cited as a source of healing. In Ezekiel it says that trees, growing on the banks of a stream by the Temple, will flourish with fruit for food and *leaves for healing* (Ezekiel 47:12).

Draw on nature imagery. What else in nature might nurture the healing process? Create a story or a description of someone who, by spending time in nature, experiences some healing. What does the sun provide? What does the stream teach? How do the ocean waves soothe? What do trees contribute? What can be learned from animals? Etc.

In a group share your stories. What parts of nature do you see as aiding in healing? What other ways can you think of to support others with the help of nature? Some examples might be: taking walks (pushing the person in a wheel chair if necessary); bringing a plant, a terrarium, flowers; beautifying the garden of someone too ill to care for it; taking the person to the zoo or bringing a pet to visit (making sure the pet would be a welcome visitor!); decorating a sick person's room with nature photographs; bringing a tape recording of ocean, jungle, rainstorm sounds. Other ideas?

Visual Art

 1 (10 minutes or more) Complete Language Arts #1 above. Illustrate one (or more) items on your list of things that can be done to assist in supporting and healing.

 2 (10 minutes) We should visit the sick as often as possible, says a Jewish source. If a visit is not possible, or as a supplement to visiting, sending a card can be a supportive thing to do.

Design a card to send to someone who is ill. Refer to Language Arts #2 for a more detailed exercise.

An extension or alternative: You may wish to make something that a sick person might enjoy. Some possibilities: an origami or tissue paper bouquet of flowers, knitted slipper socks or lap

blanket, a tea mug, a neck pillow, a small decorated box filled with potpourri.

 3 (15 minutes) Text Study, Tanach #4, *Rofay Cholim* speaks of God sustaining the sick and transforming their bed of suffering. We, too, can help transform another's "bed of suffering."

Divide a piece of paper in half. One side will show a bed "pre-transformation" and the other side will show a bed "post-transformation." The transformation should reflect those things under human control. For example, the "pre-transformation bed" may be a simple wood frame with a thin and sagging mattress. The bed is in a room with one bare light bulb hanging from the ceiling. There's a tiny window way high up — too high for anyone to see out of without a ladder. Etc. The "post-transformation bed" is in a bright, airy, cheerful room. The bed has a thick, soft mattress with lots of pillows. There's a dresser with plants and get well cards. A sliding glass door opens out to a rose garden. Etc.

Share your artwork with others and discuss: How did you transform the "bed of suffering"? Do you think your transformations are realistic — can they be done? In your own experience, what was the worst place (the worst "bed") you ever saw for someone trying to heal? (This might be something you didn't see directly, such as something you saw on TV or in a news magazine). What was the best place (the best "bed")?

 4 (15 minutes minimum) God's healing energy can be likened to water for a parched garden. As it says in the Bible, "The Eternal will guide you always . . . slake your thirst in parched places and give strength to your bones. You shall be like a watered garden, like a spring whose waters do not fail" (Isaiah 58:11).

As a preliminary, do a short visualization exercise. The leader asks everyone to close their

eyes, and then says: Picture weakness in your body, as if your insides are parched, your bones thirsty . . . Next, visualize a parched, withered garden . . . In the middle of this garden is a spring from which a stream flows . . . Go through the garden to the stream, and with cupped hands scoop water from the stream . . . Drink deeply . . . As you do so, your body is revitalized, strengthened . . . The garden around you is also revitalized, becoming green and full of flowering color.

Now, to the canvas! Use the image of a withered garden coming back to life as the basis for a drawing or painting. The garden in the process of revitalizing is a metaphor for the healing process. God is like the water. One way to tackle this challenge is to paint a garden that stretches across the canvas. The garden goes from being withered looking to gradually looking revitalized, bursting with color. This transformation to renewal takes place at the point in which water is introduced into the picture. The water might be in the form of a spring (as in the Isaiah passage), a stream, waterfall, rainfall, water from a watering can, etc.

Share and discuss the drawings or paintings. What do you like best about yours? Why did you depict the garden the way you did? What did you introduce as the water source, and why that particular source? Do you think water is a good image (metaphor) for God's contribution to the healing process?

 5 (15 minutes minimum) In this variation of #4 above, draw or paint, creating a more abstract exploration of water imagery as it suggests healing. Use one or more of the following verses for inspiration: "Arid earth shall become a pool; parched land, fountains of water." (Isaiah 35:7) "My drink is abundant, overflowing." (Psalms 23:5) "My soul thirsts for You, my body yearns for You, as in a dry and weary land, where there is no water." (Psalms 63:2)

"Drink water from your own cistern, running water from your own well. Your springs will gush forth . . . Let your fountain be blessed . . . " (Proverbs 5:15-18)

 6 (15 minutes or more) Psalms 104:1-2 provides a wondrous image of God as "clothed in glory and majesty, wrapped in a robe of light." Psalm 145 says that God is close to all those who cry out to God. Perhaps when we are in pain, God draws us close, enveloping us within God's "robe of light."

Being wrapped in a robe of light can be a healing image. What would that robe look like if we were to give it substance? Draw or paint this robe of light. You can depict the robe on its own or show a person wrapped within its folds. Share your artwork with others, offering comments and observations.

7 (15 minutes minimum) In Language Arts #7 above, participants brainstorm a list of words associated with healing. Here, you will come up with visual images — quick doodles or sketches for each word. Divide a piece of paper into eight or so squares. Write one of the healing words at the top of each square. Then go back and make a quick doodle which captures the essence of the word. You can do the sketches in black and white (with charcoal) or in color (crayons, pastels, watercolor). If something concrete comes to mind and you want to put that down, fine, but don't feel wed to creating recognizable objects. Doodles that are more abstract can be expressive and powerful, too. These might emphasize color, a dynamic (sharp and chaotic lines, for example), a shape, or a pattern.

Develop one or more of the images in your small doodle sketches into a whole picture/painting. Share by having each participant state one positive thing about the creations of other group members.

Drama

1 (10-15 minutes for each skit) Several of the Text Study passages lend themselves well to dramatic interpretation in small groups. After practicing, groups can perform the skits for each other or for another group (another class, assembly, their families and/or friends). Here are some suggested texts with suggested numbers of actors. (More actors can be added as narrators.)

a. Two or three actors. Text Study, Tanach #E, *Somaych Noflim*.

b. Four actors (Rabbi Hiyya ben Abba, Rabbi Yochanan, Rabbi Hanina, and Rabbi Eleazar). Text Study, Rabbinic #A, *Somaych Noflim*.

c. Two actors (Samuel Yarhin'ah and Rabbi). Text Study, Rabbinic #C, *Rofay Cholim*.

d. Three or more actors (Abba and at least two patients, preferably more — both male and female). Text Study, Rabbinic #D, *Rofay Cholim*.

Discuss, using the questions provided for each of those Text Study passages.

2 (15 minutes) There are issues which may be challenging to those who plan to visit the sick.

Divide the group into pairs or trios. Give each section a question (from the first paragraph of Language Arts #3). Have them discuss it among themselves, and then create a short skit in which their response to their question is shaped.

Perform the skits for the group.

3 (15 minutes) Have participants imagine they are the models for a "slide show" that teaches the virtue *Somaych Noflim*. They will provide the "visuals." The particular lesson of the day covers different ways of reaching out toward one another. For each of the following, participants are to come up with a tableau, a "slide," that illustrates the meaning of the teaching:

a. Carrying or lifting another as a parent carries a child (Text Study, Tanach #A, *Somaych Noflim*)

b. Reaching out to others with strong hands and outstretched arms (Text Study, Tanach #B, *Somaych Noflim*)

c. Supporting others with arms that seem to stretch out forever (Text Study, Tanach #B, *Somaych Noflim*)

d. Supporting the falling and lifting up those who are bowed down (Text Study, Tanach #D, *Somaych Noflim*)

e. Reaching out a hand toward another to raise that person up (Text Study, Rabbinic #A, *Somaych Noflim*)

f. Supporting another as a dead stalk can support a live vine (Text Study, Rabbinic #C, *Somaych Noflim*)

g. Grasping another's hand in the darkness (Text Study, Post-Rabbinic #C, *Somaych Noflim*)

h. Your own ideas

As the actors hold their positions in the "slides," the leader gives comments and elaborates on the meaning of *Somaych Noflim*. If desired, take pictures of each slide and compile them into a visual exhibit.

Note: For more activities along these lines, see also Movement #1 and #6 below.

Movement

1 (10 minutes) Arms can communicate a great deal. We use our arms all the time when we talk to others. But even more — reaching out to others with arms (and hands) can suggest an offer of emotional and spiritual support.

Review the verses in Text Study, Tanach #B, *Somaych Noflim*. Then do a simple hand and arm warm-up. The leader says: Move your hands and arms in every which way you can. Stretch with your arms, reach out with your arms, open and

close your hands, make gestures, be expressive of emotions with your hands and arms, etc.

In pairs, participants communicate with their hands and arms only. They converse back and forth, one person at a time. They communicate support to each other, taking inspiration from the images of the "outstretched arm" and "arms everlasting."

A variation: Begin with pairs facing each other, palms touching. They "converse" as above, communicating support for each other. The difference is that they communicate while maintaining physical contact the whole time. While the pairs begin with just their palms touching, they can slowly involve more of the arm surface in their "conversation."

After a few minutes, the pairs bring their "conversation" to a close. Discuss the experience. How did you communicate support for each other using your hands and arms only? How was communicating with your hands and arms different from communicating verbally? How did the variation (maintaining contact with each other) differ from the first thing you did in pairs (communicating with hands and arms, but not touching each other)? Did this exercise expand your thinking concerning ways you might offer support to another person?

2 (10 minutes) *Somaych Noflim* is about supporting others, especially during troubled times. Often this support is on an emotional or spiritual level. But sometimes it's physical support that is most needed. If, for instance, someone is beginning to fall, you need to catch them/lift them up before doing anything else.

In pairs or trios, explore all the different ways you can think of to support another's weight. Begin simply, with pinky fingers, and gradually try more complicated things, such as giving support by leaning against each other back to back. Experiment taking (supporting) a small *part*

of another's weight, then *most* of it, and, finally, *all* of it.

Describe how you felt when you were the one providing support/receiving support. Which was more difficult? Were there things you had to be careful about? Is it important to know your own strength? Did you discover that giving support in some ways was more successful than in other ways — that you had to try various approaches before "getting it right"? Explain. Do different individuals need to be supported in different ways? Anything else? What lessons did you learn from this physical support exercise that could be applied to the task of giving support on an emotional or spiritual level?

3 (10 minutes) As in #2 above, this exercise explores giving physical support to one another. It is very specific in the type of physical support it asks participants to explore — the physical side of Text Study, Tanach #B, *Somaych Noflim*. This is about being supported/offering support with arms that seem to go on forever.

The group divides into smaller groups of four or five people each. Groups form circles, with one of the members of the group standing in the middle. Those who are forming the circle hold hands. Their hands joined together represent "arms everlasting." The circular band of arms makes it seem as if the arms go on forever (that is, there's no beginning and no end to this circle). The person in the middle (the one supported) moves within the circle of arms everlasting (the supporters' arms). The one who is supported "tests" these arms — leaning part of his/her weight on them, then all of his/her weight. He/she might lean gently into the arms, then practically fall onto them. And so on. Give everyone a chance to be in the middle, to experience being supported by the "arms everlasting."

Continue with discussion, as presented at the end of #2 above.

4 (10 minutes) Psalm 104:1-2 speaks of God as wrapped in a "robe of light." In Psalm 145 it says God is close to all those who cry out to God. Thus, when we are in pain, God will be near us. God will draw us close, enveloping us within God's robe of light.

Through movement, explore the healing image of being wrapped in a robe of light. Do a warm-up exercise that simply explores wrapping. Imagine wrapping various parts of your body with an endless bolt of fabri. Then imagine wrapping other things like a ball or a box — use your hands to wrap, use your feet, use other body parts. Wrap small things, large things, oblong things, etc.

Now turn your attention to the image of being wrapped in a robe of light. Everyone can move in the space at the same time, but does his/her own solo. With your own imaginary robe of light, begin moving. You might start by holding the robe away from you — looking at it, studying it, admiring it. You might wrap yourself in the robe and stand still for a few moments. Perhaps you will glide around the space with the robe, then lie down and roll around in it. You may swirl the robe around you, turn into and out of it, surrender to its enveloping folds.

Next improvise with the group. Rather than everyone having his/her own robe, there will be one robe to share. Imagine the robe is lying in the center of the space. Experience as a group the image of being encompassed in God's robe of light. Individuals might trade off being wrapped in the robe of light. Two or more people might wrap themselves together in the robe. The group might experience the robe growing in size, growing in light, gathering in more and more people. Remember, you can also choose to be still at times and watch while one or more others have the robe.

What did you experience in the improvisation? What did you observe others doing? In what ways did you feel as if a robe of light was actually in your midst? On a day-to-day basis, what can it mean to be "wrapped in God's robe of light"? If you yourself feel you are enveloped in God's robe of light, how will that make you a more effective "agent" for healing others?

 5 (10 minutes) In helping each other heal, we can offer bandages of gauze and tape. Or, compassion and empathy may be the "bandages" we need to pull from our "healing kits." We can draw inspiration for our bandaging efforts from God, for "God heals their broken hearts, and binds up their wounds" (Psalms 147:3).

In Text Study, Tanach #E, *Rofay Cholim*, Elisha breathed life into a seemingly lifeless child. Perhaps our "binding and bandaging" efforts can revitalize one another, too. The following improvisation explores lifelessness as it becomes transformed through another's "binding and bandaging."

Divide into pairs. One person is the "binder"; the other receives the bandaging. The bandage recipient begins in a lifeless, collapsed position. The binder does a short bandaging-type movement around one part of the recipient's body. The binder then steps away. The recipient allows that part of the body to become enlivened, before becoming still again. It might be that just the one part of the recipient's body becomes reenergized. Or, the one body part's renewal might provide a domino effect in "awakening" other parts of the body. Repeat with the binder and the recipient switching roles.

An extension or variation: Allow the pair to improvise more freely. They need not stay rigidly in their roles as binder and recipient. Rather they can move fluidly between giving aid and receiving it.

Discuss. How did you feel about your role as the binder? What did you experience as the recipient of bandaging? Which role did you prefer,

and why? What lessons did you learn that might be applied to "bandaging" other people in "real life"?

 6 (10-15 minutes) "My soul thirsts for You, my body yearns for You, as in a dry and weary land, where there is no water" (Psalms 63:2). When your body or soul "thirsts" to an extreme degree, you may need to put yourself on a regimen of healing. How can you slake your thirst? Use water imagery as a basis for exploring aspects of the experience of healing.

Have everyone imagine they are extremely thirsty. On the other side of the space is a tall glass of water. Have them walk across the space in their very thirsty state of being. They arrive to the glass of water (it can be real or imaginary). They drink the water, showing its effect in terms of rehydrating them.

Take the idea one step further. Rather than just one glass of water, you will reap the replenishing benefits of a whole fountain. Consider the verse: "Arid earth shall become a pool; parched land, fountains of water" (Isaiah 35:7). As before, have everyone imagine their whole bodies, their whole beings to be extremely thirsty, this time like arid earth, like parched land. On the other side of the space is a fountain of water. Have them walk across the space in their arid and parched state of being. They arrive at fountains of water. They "drink" not only with their mouths, but with their whole bodies, their whole selves. They show the effect of this healing replenishment.

Now have participants imagine what exactly they are "thirsting" for in terms of spiritual healing, in terms of God. Perhaps they thirst for love or protection or strength. Ask them to come up with an image that embodies that quality. For love, for instance, they might imagine enveloping arms; for protection, a large leafy tree; for strength, a pillar. Ask them to picture that image/object as

existing on the other side of the space. They are to walk gradually across the space in their spiritually "thirsty" state of being. They are moving toward something they associate with God's healing energy. They are walking as if their life depends on being infused (not with water, but with a kind of divine sustenance). Once they "arrive," have them show the effect of this infusion of divine sustenance. This spiritual renewal is captured by their encounter with the object they imagined previously (the open arms, the large leafy tree, the pillar, etc.). This encounter has an effect similar to a "drink being abundant, overflowing" (Psalms 23:5).

Discuss and share reactions. What challenges did you face at the three stages of this exercise: encountering the glass of water, encountering fountains of water, and experiencing spiritual renewal? What did you enjoy most/least about this exercise? What did you learn? In what ways does the imagery of quenching thirst as a metaphor for healing make sense to you?

Note: See also Drama activities #2, #3, and #4.

Music

 1 Learn and sing the Debbie Friedman song "*Mi Shebeirach*." This may be found on the tape/CD *And You Shall Be a Blessing* (available from A.R.E. Publishing, Inc.).

 2 (5-10 minutes) Refer to Text Study, Post-Rabbinic #A, *Somaych Noflim*, about one person's voice lifting up another's. Then, in a circle, choose a familiar song, an uplifting one that has a spiritual message. The leader asks one person to volunteer to begin the singing. After that person has sung for a few moments, the leader signals the next person in the circle to join him/her. Continue in this manner until everyone is singing. If you like, start with everyone singing, then the leader goes around

the circle and indicates that participants stop singing, one at a time.

Discuss. How did the sound of the singing change as it traveled around the circle? How did this singing experience reflect the message in Text Study, Post-Rabbinic #A, *Somaych Noflim*?

 3 (time on your own, plus time for sharing and time for listening) When we are not feeling well (physically or emotionally), music can have a healing, soothing effect.

Make your own compilation of music that you find most healing, that gives you a lift when you're tired of feeling down. Choose songs and pieces of music that elevate your spirits, that you find comforting and reassuring. In a group share parts of the tapes. Listen to your tape (or others' tapes) when you are down or sick. If desired, make a copy of your tape to bring to someone who is ill.

TOCHECHAH: REBUKING

תוכחה

OVERVIEW

When we witness something we believe to be wrong, should we say something or not? Rebuking may involve alerting someone to an erroneous assumption; it can mean scolding a person for wrong behavior. When to rebuke? Why rebuke? How to rebuke? All sorts of considerations go into such a decision. Here are some:

Is the offender wronging only him/herself; or do others stand to be hurt by his/her actions as well? Might my saying something now help change the person's behavior in the future? Will a rebuke so embarrass the person that it is not worth bringing up the problem? Why is it *my* responsibility to say something? If the person whom I rebuke is offended, will he/she try to take revenge on me? What happens if I do say something, and the person ignores me? How hard do I have to try to get the person to listen to me? If I don't say anything, will my relationship with the other person suffer — will we begin to feel we can't be honest with each other? Who am *I* to criticize? I'm not perfect.

Rebuking is mentioned in the Bible in Leviticus 19:17: "*Hochayach tochiach et amitecha,*" (You shall surely rebuke your neighbor). The next phrase says, " . . . *v'lo tissa alav chayt*" (and incur no sin because of this person). We should rebuke so as not to become complicitous in another's sin.

In later sources, we get the message that rebuking is essential, that it leads to change, that it removes us from sin, that it diminishes evil in the world. But we are also advised to be extremely

cautious in rebuking. There are even prescribed methods for delivering a rebuke. And there are circumstances in which rebuking is discouraged altogether. One reason *not* to rebuke is if the offender is likely to ignore your words. Another reason *not* to rebuke is if the offender will be overwhelmed with shame because of your rebuke. There's another important point to consider as well. Before rebuking others, take a look at yourself. In other words, worry about your own ethical behavior before you speak out about that of others.

The issue of rebuking is complex, yet important. We need to explore and reflect on our own beliefs and experiences concerning rebuke. Ideally, our efforts will serve us when we confront puzzling situations. Mastering the art of *Tochechah* is a virtue. It requires sensitivity to the feelings of others, conviction in our beliefs, and awareness of our own failings.

The following summarizes how this virtue applies in relationships between one another, within our own selves, and between us and God.

 BAYN ADAM L'CHAVERO, BETWEEN PEOPLE: As outlined in the Overview, the questions to consider when deciding who, how, and when to rebuke another are daunting. It's often difficult to know the right thing to do.

Knowing how to *receive* rebuke is not easy either. Does the way we *receive* rebuke reflect "wickedness" or "wisdom" (see Proverbs 9:7-8 under Text Study, Tanach #C)?

BAYN ADAM L'ATZMO, BETWEEN YOU AND YOURSELF. Surely, a certain amount of self-rebuke is necessary in order for us to change and grow. But when does self-rebuke go too far? Does self-criticism help us to become better, wiser people? Or, do we tear ourselves down so much as to cause more harm than good (becoming paralyzed with fear, feeling low self-esteem, sinking into depression)?

One way to sort out attitudes about self-rebuke is to look at it hand-in-hand with the *Middah* of *Din V'Rachamim,* justice and mercy (see Chapter 5). We must ask how to rebuke ourselves and do we deserve rebuke? In our response it is necessary to keep justice and mercy in mind, and in balance. Yes, take a hard, critical look at yourself, but also be kind and compassionate, fair and reasonable, just and merciful.

BAYN ADAM L'MAKOM, BETWEEN YOU AND GOD. Even though Abraham rebuked God concerning the plan to destroy the city of Sodom, it seems presumptuous for us to express (give) rebuke toward the One we call All-Knowing, Ever-Present, and All-Powerful. Who are we to be rebuking God? Is such a practice something we should engage in? If so, under what circumstances?

Receiving rebuke from God causes us to examine our deeds in light of what we believe God wants and requires of us. We can assume that God doesn't have ulterior motives (vengeance or self-aggrandizement) when rebuking us. Rather, rebuke from God is a gift of instruction, a gift of love. God's loving energy guides us to perfect ourselves — to become the best people we can be. Building on such guidance, we gain the strength to help reshape and perfect flaws in the world around us.

TEXT STUDY

Tanach

A Rebuking another is included in the "Holiness Code," that section of Torah that is full of moral imperatives — making fair decisions, not hating your kinsfolk in your heart, not taking vengeance or bearing a grudge, and loving your fellow person as yourself. This statement from Leviticus is the foundation of discussions on rebuke throughout Jewish literature. Generations of scholars have explored the implications of these words.

> **You shall surely rebuke your neighbor, and incur no sin because of this person. (Leviticus 19:17)**

➤ The requirement to rebuke is stated strongly, but what is the meaning of "and incur no sin"? How might offering rebuke prevent someone from sinning? What concerns would you expect the Rabbis and other commentators to raise concerning the carrying out of this virtue?

B These statements from Proverbs encourage the practice of rebuke and imply that the one who rebukes benefits through rebuking.

> **They that rebuke find favor, and a good blessing falls upon them. (Proverbs 24:25)**

> **One who rebukes another will in the end find more favor than one who flatters the person. (Proverbs 28:23)**

➤ What reasons are suggested here for a person to rebuke? Why might it be better to favor rebuke over flattery? Based on your experience, do these two statements reflect reality?

C Unlike the statements from #B above, this passage distinguishes between worthwhile and non-worthwhile circumstances for rebuke. Not every instance calling for rebuke should be addressed; the nature of the potential recipient of the rebuke must be considered.

> To correct a scoffer, or rebuke a wicked person for that person's blemish, is to call down abuse on oneself. Do not rebuke a scoffer, for that person will hate you. Reprove a wise person, and that person will love you. (Proverbs 9:7-8)

➤ In contrast to the practice of other *Middot*, rebuking seems to suggest that a person decide how carrying it out may affect him/her before doing it! Why might that be? How much should a person consider protecting him/herself before rebuking?

The last line of the Proverbs citation above, about a wise person loving the one who offers rebuke, is given an interpretation by two Rabbis.

> Rabbi Jose ben Chanina said: "A love without reproof is no love." Resh Lakish said: "Reproof leads to peace; a peace where there has been no reproof is no peace." (*Genesis Rabbah* 54:3)

➤ Why should true love require reproof? Why can there be no peace without reproof? Does Rabbi Chanina's comment apply in relation to God? That is, for God to truly love us, God must rebuke us? And we should welcome such rebuke?!

D The outcome of an instance of rebuke between Abraham and Abimelech was an oath of peace. This interchange underscores Resh Lakish's notion that true peace needs to be accompanied by reproof to be true peace (see #C above).

> Then Abraham rebuked Abimelech for the well of water which the servants of Abimelech had seized. But Abimelech said, "I do not know who did this; you did not tell me, nor have I heard of it until today." (Genesis 21:25-26)

Abraham then seeks to prove to Abimelech that he [Abraham] indeed did dig the well (meaning the servants had no right to seize it). Afterward, Abraham and Abimelech conclude a pact which allows for peaceful coexistence in the land of the Philistines.

➤ Why did Abraham rebuke Abimelech? Why was the rebuke necessary as a prerequisite for the ensuing peace between the two? What is the relationship between honesty and willingness to rebuke? Does honesty always entail willingness to rebuke?

E Saul rebukes his son Jonathan for his loyalty toward David, Saul's rival. The rebuke, accompanied by a "flying into a rage," has a threatening edge to it.

> Saul flew into a rage against Jonathan. "You son of a perverse rebellious woman!" he shouted. "I know that you side with the son of Jesse [David] to your own shame, and to the shame of your mother's nakedness! For as long as the son of Jesse lives on earth, neither you nor your kingship will be secure. Now then, have him brought to me, for he is marked for death." But Jonathan spoke up and said to his father, "Why should he be put to death? What has he done?" At that, Saul threw his spear at [Jonathan] to strike him down. and Jonathan realized that his father [Saul] was determined to do away with David. (I Samuel 20:30-33)

➤ What is the tone of Saul's rebuke of his son Jonathan? Does this type of rebuke fall within the parameters of an acceptable, desirable kind of rebuke? Should there be different standards for the appropriateness of rebuke between family members versus between non-related people? (For further discussion of this passage, see *Arachin* 16b.)

F Abraham rebukes God for God's plans to destroy the people of Sodom because of their sins. As a result of Abraham's rebuke (and some additional negotiation), God agrees not to destroy the city if ten innocent people are found there.

Abraham came forward and said [to God], "Will You sweep away the innocent along with the guilty?" (Genesis 18:23)

➤ Was it proper for Abraham to rebuke God? Was he obliged to? At what times, if any, might it be appropriate to express rebuke toward God?

Rabbinic

A Building on a verse from Proverbs, the Rabbis elaborate on the potential benefits of rebuking. One Rabbi (Jonathan) emphasizes the religious implications.

Rabbi [Judah HaNasi] says: "Which is the right way a person should choose? Let [that person] love rebuke since as long as there is rebuke in the world, ease of mind comes to the world, good and blessing come to the world, and evil departs from it, as it says, 'They that rebuke find favor, and a good blessing falls upon them'" (Proverbs 24:25) . . . Rabbi Jonathan said: "Whoever reproves their neighbors for a purely religious motive [literally, 'in the name of Heaven'], is worthy of a portion of the

Holy Blessed One [i.e., is in the inner circle of the righteous in Heaven], as it says — 'one that rebukes another finds favor with Me.' And not only that, God draws over [that person] a thread of love" (Proverbs 28:23). (*Tamid* 28a)

➤ How is the Proverbs 24:25 verse extended by the Rabbis? Do you think the Rabbis really believe that all those benefits can come from rebuke? If the Rabbis are using hyperbole (exaggerating), why are they doing so? What is Rabbi Jonathan's angle on rebuke? Do you believe people are rewarded by God for rebuking?

B Rebuke may have its place, but there are some things a rebuker must consider.

"You shall surely rebuke your neighbor and not incur guilt as a result" (Leviticus 19:17). How do we know that if a person has rebuked a neighbor four and five times [without succeeding in turning the neighbor from sin], that person should continue to rebuke [the neighbor]? Because it says: "You shall surely rebuke the other." One might infer that the reproof should be carried so far as to change a person's face with shame. But it says, "You shall not bring guilt upon the other." Rabbi Tarfon said: "In this generation there is no one capable of rebuking [because everyone is a sinner]." Rabbi Elazar ben Azariah said: "In this generation there is no one capable of receiving rebuke." Rabbi Akiba said: "In this generation there is no one who knows how rebuke ought to be worded." (*Sifra* 89a-89b)

➤ In Rabbinic #A, the results of rebuke are ease of mind, good blessing, departing evil. And here

it says that no one is truly capable of giving rebuke. How can these two statements be reconciled, or can they? Why might it be important to preserve conflicting texts in our tradition, embracing them both?

Post-Rabbinic

A Maimonides tries to give coherence to the sometimes conflicting opinions regarding rebuke. His approach reflects more of a code of behavior. That is, he gives one cohesive presentation on the topic.

When a person sins against another, the injured party should not hate the offender in deep silence . . . But it is that person's duty to inform the offender and say, "Why did you do this to me? Why did you sin against me in this matter?" Therefore it is said, "You shall surely rebuke your neighbor" (Leviticus 19:17). If the offender repents and pleads for forgiveness, the offender should be forgiven. The forgiver should not be unyielding, as it is said, "And Abraham prayed unto God (for Abimelech)" (Genesis 20:17).

If one observes that another committed a sin or walks in a way that is not good, it is the person's duty to bring the erring one back to the right path and point out that he/she is wronging him/herself by this evil course, as it is said, "You shall surely rebuke your neighbor" (Leviticus 19:17). One who rebukes another, whether for offenses against the one who rebukes him/herself or for sins against God, should administer the rebuke in private, speak to the offender gently and tenderly, and point out that the rebuke is offered for the wrongdoer's

own good, to secure for the other life in the World To Come. If the person accepts the rebuke, well and good. If not, the person should be rebuked a second, and a third time. And so one is bound to continue the admonitions, until the sinner assaults the admonisher and says, "I refuse to listen." Whoever is in a position to prevent wrongdoing and does not do so is responsible for the iniquity of all the wrongdoers whom that person might have restrained. (Maimonides, *Mishnah Torah, Book One: Knowledge,* Chapter 6: 6,7)

➤ How does this style of presenting a value differ from the biblical and Rabbinic approaches included in this chapter's Text Study? Would a reader have a clearer notion of what is required of him/her concerning *Tochechah* after studying Maimonides? What more do you think a learner might need to know or experience in order to be effective and appropriate in the realm of rebuke?

B Elsewhere it has been mentioned that there are very few, if any, people capable of validly giving rebuke. Here, Luzzato seems to discourage the practice of rebuke, saying that it can make matters worse.

How often does a person rebuke sinners at the wrong time, or in the wrong place, so that they pay no attention to what is said! The rebuker is thus the cause of their becoming more confirmed in their wickedness, and of their desecrating the name of God by adding rebellion to sin. In a case of this kind, it is the part of saintliness to remain silent. "As it is our duty to reprove when we are likely to be heeded," say our sages, "so is it our duty to withhold from reproof when we are not likely to be heeded" (*Yebamot*

65). (Adapted from *Mesilat Yesharim: The Path of the Upright,* published in 1740 by Moses Hayyim Luzzatto; translated and edited by Mordecai Kaplan, Philadelphia: Jewish Publication Society, 1966, p. 370)

➤ What are Luzzato's chief concerns about rebuking? If you were to follow Luzzato's advice, what process would you go through in deciding whether or not to rebuke another person?

C The Baal Shem Tov offers a different approach concerning what to do if you see another involved in wrongdoing. Rather than weighing the faults of other people, look more closely at *your own self.*

> [The] great root teaching which the Besht [Baal Shem Tov], his memory for a blessing, planted for us, [is that] if you see another person doing something ugly, meditate on the presence of that same ugliness in yourself. And know that it is one of God's mercies that God brought this sight before your eyes in order to remind you of that fault in you, so as to bring you back in repentance, and to save you from hell. For if you saw someone desecrating the Sabbath, or desecrating God's name some other way, you should examine your own deeds and you will certainly find among them desecration of the Sabbath and *hillul ha-Shem* [cursing God's name]. Or if you heard some profanity or obscene language, you should consider your own impudence, and when you failed to conduct yourself modestly. If you heard some skeptical or atheistic talk from someone, then you should work to strengthen your faith and trust in God. (*Seder ha-Dorot ha-Hadash,* p. 59, as

quoted in *Jewish Spiritual Practices* by Yitzchak Buxbaum, p. 305)

➤ How does the Baal Shem Tov's approach differ from those of the previously cited texts? What style of rebuke might be acceptable to the Baal Shem Tov? What do you think brings a person closer to God — a willingness to rebuke a wrongdoer, or a focus and willingness to engage in self-examination? Explain.

ACTIVITIES

Language Arts

1 (10 minutes) Note: This exercise works well as an introduction to this *Middah.* The issue of rebuke is complex and involves many sensitive considerations as outlined in a list of questions presented in the second paragraph of the Overview. The leader should encourage the group to examine the challenge of this *Middah* by brainstorming their own questions. List these on the blackboard or have individuals write them down. Hopefully, as a result of doing so, participants will think twice (at least!) about rebuke as it comes up in their own lives.

2 (10 minutes) Maimonides tells us that a rebuke should be administered privately, spoken gently and tenderly, and given for the wrongdoer's own good (see Text Study, Post-Rabbinic #A). Keeping his ideas (and perhaps those of other scholars) in mind, create definitions for what could be considered a successful and worthy rebuke versus an unsuccessful and unworthy rebuke.

As a whole group, in small groups, or individually, complete this exercise either orally or in writing. Make two columns. Label one side "Successful and Worthy Rebukes" (e.g., gentle, private, direct, clear, honest, fair, kind, forgiving, responsible, given for the other's own good, etc.), and the

other side "Unsuccessful and Unworthy Rebukes" (harsh, public, loud, angry, condescending, ambiguous, self-serving, resentful, etc.).

Do you now have a clearer idea about what is permissible and favorable in *Tochechah*? What questions still remain? Does the subject make you uncomfortable? Why?

 3 (10-15 minutes) Text Study, Rabbinic #A says that a person should love rebuke because it results in ease of mind, and good and blessing for the world. Furthermore, a rebuker is deserving of God's favor.

Compose a prayer for rebuke that makes sense to you. You might ask God to give you rebuke, or ask for the insight and sensitivity to make you a compassionate rebuker. Or, you might ask for the ability to see your own wrongs and improve (see the Baal Shem Tov's attitude under Text Study, Post-Rabbinic #C). Will you thank or praise God concerning rebuke?

Share the prayers and discuss. If desired, include any of the prayers in an actual worship service. Which one would be appropriate? How often should it be included?

 4 (15 minutes) In order to become more aware of some of our subconscious attitudes about *Tochechah*, it is worth examining the media for messages. Look for examples of rebuke in newspapers. For younger groups the leader will need to select articles in advance of the class; older groups can look for themselves. Types of articles might include:

a. Articles which describe a rebuke someone has received

b. Articles which use a rebuking tone (usually more prevalent in some magazines)

c. Editorials

d. Letters to the editor

e. Opinion pieces

Is the media fair when it rebukes? Are the rebukes helpful to the one at whom they are directed? Will the rebukes make the offender "wiser"?

 5 (15-20 minutes) Stage a debate on one or both of the following statements:

a. No one is capable of offering or receiving rebuke. (Review Text Study, Rabbinic #B as preparation. Other Text Study passages may be helpful as well.)

b. In order for love and peace to exist, there must be rebuke. (See *Genesis Rabbah* comment on Text Study, Tanach #C.)

What arguments were most convincing? Why? Did the debate change your view? Will this experience change the way you handle rebuke in your day-to-day life?"

 6 (5 minutes) For what qualities are human beings deserving of rebuke from God? List ideas on a board (e.g., greed, cruelty, disrespect of parents, non-observance of Jewish holy days).

Does everyone agree that all the listed ideas are equally deserving of rebuke? Should God actually engage in rebuke? What alternatives are there? Might God, instead of actively rebuking, set standards for good conduct?

 7 (10-20 minutes) This activity is closely related to #6 above. Consider doing the two activities together. Do you think you ever received a rebuke from God? Write down your thoughts, addressing some or all of the following questions:

a. What happened that deserved a rebuke?

b. Why do you think what happened was unacceptable to God?

c. What did you experience that made you think you were receiving a rebuke from God?

d. How did you respond to this rebuke? How did you feel?

e. Did anything change as a result of this experience?

8 (5-15 minutes each evening for a week or so) How does self-rebuke factor into your life on a day-to-day basis? Spend a week or so reflecting each evening on this question through writing. Begin by reviewing your day, noting down each and every instance of self-rebuke. Include anything that possibly could be seen as rebuke. You can spend a few minutes each time commenting on what you wrote, or do so at the end of the week.

In your comments, consider: Is there a pattern in my self-rebuking? Are my feelings of self-rebuke manifested physically (through posture, muscle tension, teeth clenching, accelerated heart rate, etc.)? Or, is my self-rebuke more part of my inner dialogue? If the latter, what percentage of it? What effect do others' words or actions have on my likelihood to engage in self-rebuke? How do my self-rebuking "moods" affect my interactions with other people?

Will your attitude toward self-rebuke change in any way as a result of completing this writing exercise?

9 (10 minutes) This exercise helps participants think through the potential ramifications of self-rebuke so as to determine which path is the best.

With a group, use a blackboard. If completing the exercise individually, use sheets of paper. Write the word "Self-Rebuke" at the top of the board (or paper). The leader asks what self-rebuke might lead to (e.g., anger, self-pity, resolve, inspiration, self-examination). Put this word underneath "Self-Rebuke." Then add a third word describing what the second word might lead to. Continue in this pattern a few more times until you feel you've come to a significant "result." One example: self-rebuke leads to anger, leads to stubbornness, leads to refusal to change, leads to a diminished life. Another example: self-rebuke leads to values clarification, leads to renewed commitments, leads to

sense of purpose. Try this exercise several times to see the different results you obtain.

What possibilities are there in dealing with self-rebuke? How much power do we have in making the choices that will best lead us to personal growth?

10 (20 minutes) Refer to Visual Art #4, in which participants come up with ideas as to what rebuke is like (e.g., rebuke is like putting out a fire). For this exercise, elaborate on one or more comparisons (a rebuke is like putting out a fire because . . .). Here you're trying to articulate why you chose a particular metaphor for rebuke.

In a group you may want to share parts of your writing. Did you uncover any new insights as a result of thinking abstractly?

 11 (10-15 minutes) As part of our confession of wrongdoing on Yom Kippur, during the "*Al Chayt*" prayer, we say, "For the sin we have committed in [doing such and such] . . . " As we say this prayer, we take our fists and beat lightly across our chests, over our hearts. We make a similar gesture during the "*Vidui*" (Confession) prayer. Is this a gesture of self-rebuke? What other gestures might people make when they are rebuking themselves? List ideas on the board. What about verbal rebukes people say to themselves? List examples of these as well.

Next, review some styles of rebuke represented in our tradition:

a. Harsh, similar in tone to Saul's rebuke of his son Jonathan (see Text Study, Tanach #E).

b. Private, spoken gently and tenderly; for the wrongdoer's own good; to secure life in the World To Come (see Text Study, Post-Rabbinic #A).

c. Shaming, such as you are *not* supposed to do (see Text Study, Rabbinic #B).

d. Silence — not bothering to rebuke at all. Luzzato asserts in Text Study, Post-Rabbinic #B that silence is often most appropriate.

Now, go back to the lists of rebuke gestures and verbal rebukes on the board. How should we communicate rebuke toward ourselves? Take a few of the verbal examples and discuss how each might sound if said in each of the four styles above. Is one approach preferable above the others? Why and how? Is there a better approach that is not included above? Does the *type* of wrongdoing affect what would be most appropriate in terms of self-rebuke? Are there styles of self-rebuke that are never acceptable?

Visual Art

 1 (10-15 minutes) Review Text Study, Tanach #F, Abraham's rebuke of God for God's intention to destroy Sodom. Then draw pictures of Abraham in this moment of rebuke. Consider his facial expression, the position of his body, any physical gestures he might be making, the place in the landscape where he would be standing, etc.

Share and comment on the illustrations. Discuss the range of interpretations of Abraham in this significant moment of confrontation with God. What similarities/differences are there in the drawings?

 2 (30 minutes) Put an artistic spin on the exercise in Drama #3 below. Divide a piece of paper into four sections. Each section will reflect one of four styles of rebuke as described in that Drama activity. The task is to make four portraits of a person, each one showing the face of someone who has just received a rebuke in the given style — a harsh rebuke, a gentle and tender rebuke, a shaming rebuke, and a rebuke of disapproving silence. Quickly rendered charcoal drawings can work well.

A variation: Use pipe cleaners or clay to create the four "portraits."

Which drawing was the most difficult to render? Why? Which image do you think reflects a person most likely to heed an admonition?

3 (20 minutes minimum) Read through Language Arts #3, in which participants are asked to write a prayer on rebuke. Reflect on the questions posed in that activity. Then, rather than writing a prayer, draw or paint "A Prayer of [or for] Rebuke."

Is your picture of an individual praying? If so, what is the motivation for the prayer and how is that depicted? Is the picture of a community so embroiled in wrongdoing that it is "begging for" rebuke? Did you use other ideas? Share and discuss your creations.

4 (20 minutes minimum) According to Maimonides, one of the conditions for giving rebuke is that it be done for the wrongdoer's own good. In this way, *Tochechah*, rebuke, is similar to *Tikkun*, fixing or repairing something that is broken or flawed. *Tikkun* is fixing that goes beyond our immediate circumstances. It implies that our actions in this world can have cosmic implications. Make the comparison between the two ideas — *Tochechah* and *Tikkun*. Come up with similes along the lines of this comparison. For example, a rebuke can be like:

a. Reattaching a handle to someone's favorite (but broken) teacup.

b. Putting socks on another's cold feet.

c. Patching the punctured tire of a person stranded far from home.

d. Putting out a fire.

What does an abstract exploration of the idea add to your grasping of the significance of this *Middah*? Which similes work the best? Choose one that captures your imagination. Depict the simile artistically. (For example, create a teacup

with handle reattached; a pair of feet/legs with someone putting a sock on one of the feet.) This activity would work well as homework, perhaps with found objects.

 5 (15- 45 minutes) Rendering ideas in the abstract can point us to beliefs we might hold, but hadn't recognized before and can influence us in how we choose to act. There are two steps to this activity.

First, draw or paint a series of shapes that represent rebukes, such as an angry shape, a gentle and caring shape, a shaming shape, and a silent/invisible or barely visible shape. (These references are included in Text Study, and are mentioned under Language Arts #11.) But improvise, and freely draw other shapes as well.

Now, choose a sample shape from your shape page. Draw a person receiving, experiencing the essence of this shape's rebuke. Does the "person" voluntarily take the "rebuke" (shape) in his/her hands? Do you place the shape in the middle of the figure's gut, with one spike protruding out from his/her skin? Does the shape weigh heavily on the figure's head, compressing him/her down? First draw the figure's outline with the shape. Then fill in the facial expression. Try to make at least four figures with shapes.

In a group share your drawings. Which picture most captures your attention? Why do you think that is? Why did you place the shapes where you did? How did you decide to fill in the facial expressions? How do your renditions reflect real-life experience?

Drama

 1 (5 minutes) Review Text Study, Tanach #F, in which Abraham rebukes God for God's plans to destroy the wayward city of Sodom. How did this rebuke sound — i.e., what tone of voice and volume did

Abraham use in this rebuke? What was his demeanor?

Go around the room, allowing each person in the group to give a vocal interpretation of Abraham's rebuke, "Will You sweep away the innocent along with the guilty?" Each person also should choose a deliberate body position for delivering the rebuke. After Abraham "came forward," did he sit, kneel, prostrate, stand with/without arms in the air, etc? How many possibilities are there?

Compare the various renditions of Abraham's rebuke. Which do you and the other participants think is most realistic? Why? Under what, if any, circumstances might you express rebuke toward God? What voice and posture would you use?

 2 (10-15 minutes) Complete Language Arts #2, in which "successful" and "unsuccessful" rebukes are defined. Then recall and review Saul's rebuke of his son Jonathan, one of the most powerful, and perhaps disturbing, records of rebuke in our ancient literature (see Text Study, Tanach #E).

Reenact this scene as you imagine it happened according to what you read in the text. Next, repeat the scene, revising the action and the words in ways that reflect the positive values gleaned from the column of "successful" rebukes in the preparatory exercise (from Language Arts #2 above). Several pairs can give the scene a try.

Which scene was harder to act out — the traditional one or the improvised, new version? Those in the audience describe what was most effective in the presentations.

3 (30 minutes) This exercise is similar to, but much more elaborate than, #2 above. Here participants are given the opportunity to give and receive rebukes in a variety of styles reflected in our tradition. They then can evaluate which style is most effective

and why. Study the actors' roles beforehand (as gleaned from the relevant texts as noted).

Five people are needed for each rendition. One actor, "The Rebuked," stands in the middle of the room. Actors who play "The Rebukers" stand in the four corners of the room.

"Rebuker" #1 – Style of rebuke is harsh, similar in tone to Saul's rebuke of his son, Jonathan (see Text Study, Tanach #E).

"Rebuker" #2 – Style of rebuke is inspired by Maimonides. The rebuke should be administered in private, spoken gently and tenderly, and it should be pointed out that the rebuke is offered for the wrongdoer's own good, to secure life in the World To Come (see Text Study, Post-Rabbinic #A).

"Rebuker" #3 – Style of rebuke is shaming (see Text Study, Rabbinic #B).

"Rebuker" #4 – Style of rebuke is nonverbal (e.g., silently shaking the head, sighing, grunting, shrugging shoulders, throwing hands into the air, etc.). While Luzzato says in Text Study, Post-Rabbinic #B that silence is often most appropriate, we allow here for expressive, even disapproving "silence." Non-expressive silence can be experimented with as well.

After you have clarified the roles of the actors, you will need to come up with some sample rebukes, preferably not too "loaded." Some examples:

a. Shoes constantly being untied

b. Forgetfulness concerning turning off the oven before leaving the house

c. Allowing a baby to ride in the car without a car seat

d. Smoking in a crowded restaurant

e. Repeatedly using grammar incorrectly

f. Your own ideas

Choose a rebuke for the scene, and have the actors take their places. (Decide beforehand if the "Rebuked" person will be allowed to respond verbally to the "Rebukers.") Each "Rebuker"

improvises his/her version of the rebuke in turn, remaining true to his/her assigned style. Allow several groups to improvise scenes.

Discuss which rebukes were most successful and why. Were any of the rebukes completely unacceptable? What was the experience of the "Rebuked" person standing in the center of the room?

 4 (20-30 minutes) How does a rebuke feel to its recipient? We can reflect on our own experience, making an effort to empathize with those receiving rebukes. In this way, we can make better judgments about whom, when, and how to rebuke. To begin our empathizing, we can make comparisons with other feelings we know about. Write down (individually or as a group) some metaphors along the lines of the following examples. A rebuke is like:

a. a slap in the face

b. a boost, lifting you up to help you be your best

c. an icy wind

d. a warm shower, washing you clean

e. a frightening intruder

f. a roof caving in over your head

g. other ideas?

Organize the group so that everyone stands on one side of the space. One to three people at a time walk across the space as if they are meeting their rebuke. Define the rebuke beforehand, using one of the previously generated metaphors. Repeat with several to all of the metaphors.

Some coaching may be helpful. For (a rebuke like) an icy wind, a leader might say: This is not a warm, soft summer breeze you're encountering — we're talking about an icy wind. Icy! Freezing! Below zero! Wind-chill factors! The kind of wind that slaps you around, that shocks you, throws you off-balance, that leaves you shivering, chattering, shaking uncontrollably.

 5 (15 minutes) Complete Language Arts #11, which is about styles of self-rebuke. Keep the discussion short and move into a game of *Charades*. One person goes out of the room and pretends he/she has given him/herself a rebuke. The person is to enter the room, cross to his/her seat, and sit down. As the person does so, he/she should communicate, through facial expression and the way he/she completes the entrance, what type of self-rebuke he/she has just experienced. The others in the room try to guess correctly.

 6 (15 minutes) This activity can be done on a drama or on a creative movement level. How do we give and how do we respond to rebukes? Explore the nuances of this *Middah* by trying to experience the power of *Tochechah*.

One person says the following phrases (experimenting with different intonations and volumes); the other person(s) responds. For drama, focus on "acting" out a response. For movement, the response should use the whole body in a freer, more abstract manner.

a. You were wrong.

b. I'm disappointed in what you did.

c. You don't believe what you did was a good thing. Why did you do it?

d. You need to change.

e. You owe me an apology.

f. You hurt others when you behave that way.

g. Is this what God wants of you?

h. Is this the kind of person you ideally want to be?

i. Your ideas

How did the rebuker feel about speaking the given phrases? What did the responder(s) experience? In what ways will you be more conscious and conscientious about *Tochechah* as a result of doing this activity?

 7 (10-20 minutes) Sometimes a rebuke from God might come as a sense that God wants us to give up an offending behavior or trait, to let go. Can we be open and not threatened by such a rebuke?

A small group will act out this scenario: One person is given a flaw to become. He/she improvises words and physical action to communicate the offending behavior (e.g., uncontrollable anger, stinginess, dishonesty, disrespect, etc.). To begin, the person expresses a full range of familiarity with the flaw, even reveling in what it "provides" for him/her.

Gradually, others enter the scene. They represent supportive, coaxing, loving energy. They improvise, trying to communicate a message that says, "Let go . . . Give it up . . ." The offender slowly allows him/herself to be convinced and changed by the interaction.

Discuss: How was the person with the "flaw" affected by the "let go" message? Was it threatening/helpful? Does it ring true that God's loving energy seeks to reshape and perfect flaws in the universe? How best can we heighten awareness concerning God's wishes for us?

A variation: Rather than acting, use movement more freely with or without the addition of words.

Movement

 1 (5 minutes) Rebuking another can be like a wake-up call; such a call can bring to the surface motivation and energy needed for change.

Partners (of the same sex) give each other "wake-up calls." One person remains still, in a relaxed position (standing, sitting, or lying down). The partner gently taps/pats the other's body, beginning at the top of the head and going down to the feet. Continue by repeating the pattern with "brushes." Again, begin at your partner's head.

Using brushing and sweeping motions across his/her body surface, "clean" and "clear" the partner, making way for new energy to come to the surface. Switch roles and repeat.

For an advanced version of this activity, do Movement #2 below.

 2 (5-10 minutes) To extend Movement #1 above, freely use taps, pats, brushing and sweeping motions to improvise or choreograph a more elaborate study on the nature and energy of rebuke. This can be done with individuals (solos), duets, or small groups performing.

 3 (5-10 minutes) Get a sense of why a rebuke over a flawed way of doing something can be positive. This light, kinesthetic experience can make an impression that will challenge cognitive thinking on the matter. Participants are instructed to move in ways that are not quite "right." The leader will "rebuke" the participants to "improved" movement.

Ask participants to do the following:

a. Use flowing movement to travel around the space, but keep your fingers tense and claw-like. After a minute or so of this kind of movement, the leader gives a rebuke: Release and relax your fingers.

b. Angry movement with happy hips

c. Travel in large movements, covering lots of space without ever taking your feet off the ground.

d. Dance bent over, never taking your eyes off the ground (or ceiling).

e. Leader's or participants' own ideas.

Discuss. What was the effect of the "rebuke"? Did you welcome the rebuke? Why or why not? In what instances from real life would you welcome rebuke? When would you not? Why?

 4 (5-10 minutes) Our tradition acknowledges that nobody is perfect, and that rebukes give us opportunities to improve.

In this movement exercise, we experience going toward and going away from perfection as a natural process. Experiment with statues:

Statue #1: Person A makes a statue that expresses "perfection" (perhaps, symmetrical, well-grounded, in balance, or other intuitive ideas). Person B distorts Person A's perfection, gently shaping A's body in such a way that a "flaw" is introduced into the pose (perhaps by hunching up the other's shoulder and dangling the arm from the elbow down). Person C responds to the perfection distorted, and "fixes" it.

Statue #2: Person A begins as a statue that is perfection with a flaw. Person B responds to what he/she sees, and fixes the flaw (through reshaping the body).

Statue #3: Person A begins in a shape that says perfection. Person B shapes and reshapes the other's body several times, moving it into and out of perfection.

Share reactions to the experience of shaping bodies into and out of perfection. Did it feel threatening for the person being shaped? Did it feel presumptuous for the shaper? How so or how not? What new thing about *Tochechah* did the physical exploration of moving in and out of perfection teach you?

 5 (5-10 minutes) The "*Tachanun*" (a confession of wrongdoing for which we hold ourselves in a special posture) is included during certain weekly morning services. A typical posture for this prayer is cradling your forehead in your arm, leaning forward, resting your head on a chair or pew in front of you, leaving your eyes unshielded so as to be able to read the words in the prayer book. Have everyone try this position, imagining they are confessing, or reading the real words from the prayer. Recall also the "*Al Chayt*" prayer ("For the sin we have committed in [doing such and such] . . . ") and the "*Vidui*," which we say as

part of our confession of wrongdoing on Yom Kippur. As we say these prayers, we beat our right fists lightly across our chests, over our hearts. Have everyone try this as well.

Choreograph a prayer of confession or regret incorporating the traditional postures and gestures mentioned above.

Note: See also Drama #4 for an exercise that can be completed using movement more freely.

Music

 1 (30 minutes) Read through Drama #3 above. Then, in a variation of that activity, create musical phrases based on the four styles of rebuke. That is, compose a harsh and angry phrase, a gentle and caring phrase, a shaming phrase, and a barely audible phrase. You can create your own styles of musical rebuke phrases as well. Discuss.

 2 (on your own, intermittently) Be extra aware of self-rebukes over the course of several days. Each time you catch yourself in one, improvise aloud (or in your head) a short melody that captures the sense of it.

How does this technique help give perspective and insight into self-rebukes? Does the "distancing" through music allow you to evaluate the rebuke's worthiness more clearly? Explain.

YIRAH:
AWE AND REVERENCE

יִרְאָה

OVERVIEW

The word *Yirah* has many shades of meaning. Two definitions are "awe" and "reverence," but it would take a whole list of English words to elucidate all its subtleties of meaning. *Yirah* is often translated as "fear" of God — and can include wonder, amazement, appreciation, surprise, gratitude, humility, standing in mystery. With these words, we begin to have a working definition of *Yirah*.

In our sacred literature, there are two other terms we may come across — *Yirat Shamayim* and *Yirat HaShem*. While these terms mean "Awe of Heaven" and "Reverence for God," if one added an emotive aspect to those expressions, they might be translated as: "Wow! This universe is amazing!" Perhaps a huge sigh best captures the feeling, or maybe "Ah!" and "Aha!" and "Wow" all mixed together.

Another way to clarify the meaning of *Yirah* is to see it in comparison to *D'vaykut* — a mystical term describing a loving and constant attachment to God. *D'vaykut* suggests that you begin to know God through becoming close — "stepping up" to God. If *D'vaykut* is taking a step up, *Yirah* is taking a step back. *Yirah* is getting a sense of the "big picture." You feel grateful to God for the wonder of life. Even the small things — tiny ants, chips of quartz, bubbling brooks — are echoes of something much greater. (For more on *D'vaykut,* see Chapter 4, "Dibuk Chaverim: Cleaving To Friends.")

With *Yirah,* we acknowledge that God is wondrous, yet mysterious. The universe is vast, and our understanding is minimal. That can be scary. Perhaps this is the reason why *Yirah* is often translated as "fear." Sometimes the word "trembling" is attached, too — we say "fear and trembling before God."

A book from the 1500s, *Orchot Tzaddikim,* has a chapter on *Yirat Shamayim* — fear or awe of heaven. The author writes that there are three kinds, or levels, of *Yirah:*

The first kind may look like *Yirah,* but it is defective. People at this level do good deeds not out of reverence for God, but out of fear of people. They worry that if certain deeds are not done, others will scorn and distrust them.

The second kind of *Yirah,* while having to do with fearing God, focuses on the self. At this level, people are doing good deeds, but mainly out of concern that God may punish them (in this world or in the World To Come) if they don't. Such acts are done more out of concern for one's self, and are less about honoring and serving God.

The third kind of *Yirah* is the highest level. It is reverence for God, pure and simple — wondrous appreciation and amazement. At this level, *Yirah* means that one's whole being is filled with an awareness of God's greatness.

What about "fear" — are there times when the plain, straightforward definition of *Yirah* actually should be fear, as in being afraid? Might being afraid of God have its place, too? Such a concept is consistent with certain Jewish religious messages, particularly biblical ones. For one, fear of God can help us overcome fear of other people. In the first chapter of Exodus, the midwives Shifra and Puah

are under orders by Pharaoh to drown all newborn Jewish males. They disobey, refusing to be intimidated by Pharaoh's edict. Rather, as Torah states, "They feared God." The midwives knew that they should not fear a person, even a Pharaoh, over God. Their example teaches a worthy lesson for anyone in any era who wishes to live in accord with *Middot* values.

Another point about fear as being *afraid* of God: this notion protects people who are in a weak or disadvantageous position. Take, for example, the wording of several commandments in Leviticus: Do (or do not do) such and such, *"and you shall fear God."* More specifically — do not insult the deaf or place a stumbling block before the blind, [do] honor the old, do not take interest from someone who has become impoverished, do not rule over servants ruthlessly . . . *But you should fear God.* (See Text Study, Tanach #C.) The idea is that there are people who are not able to stand up to others who seek to take advantage of them. Those who may seek to take advantage should beware, however. While people they harm may not be able to "get back" at such wrongdoers, God surely will. Potential wrongdoers should fear God, as in "be afraid." God will punish them for any harm they do.

Now, back to *Yirah*, as in awe and reverence. Where does such *Yirah* happen? A sense of awe and reverence isn't limited to a particular time and place. *Yirah* suggests a general attitude. This attitude can be present in you all the time — at least when you are open to it. When you pray, you may make extra effort to fill yourself with *Yirah*. But it goes beyond that. When you look at the sky, when you gaze at the stars at night, when you notice the order and intricacy involved in any and all of God's creation — you may also experience *Yirah*.

In addition to being part of our experience of nature, *Yirah* can also be a factor in our relationships with people. According to Proverbs (8:13),

those who revere God, hate evil. How you act toward others is an opportunity for reverence. For example, when you give your seat to an elderly person on a crowded bus, you are showing reverence for God. (You also may be afraid of the results of not doing so!) When you keep others from harm, you are showing reverence for God.

As you master *Yirah*, you can expect to grow in wisdom in your relationships with others, with yourself, and with God.

 BAYN ADAM L'CHAVERO, BETWEEN PEOPLE. *Yirah* is essentially between human beings and God. However, such awe and reverence can and should affect how you treat people. We are reminded of this in the Tanach when it teaches: "Behave [in such and such right way], do [such and such good thing] . . . You shall revere God. I am the Eternal your God . . . "

Just from our own observations, we should see that ethical behavior, doing good, is important. But our tradition adds emphasis by teaching that ethical behavior is demanded by God. Through righteousness toward people, you honor and serve God. Treating people well is a part of *Yirah*.

 BAYN ADAM L'ATZMO, BETWEEN YOU AND YOURSELF. Taking care of yourself and treating your own self well, can be an aspect of *Yirah*.

Appreciating the miracle of life can be an expression of *Yirah*. You know your own body, your heart, and your soul. The fact that you exist at all is amazing, a miracle of no little importance. "I praise You, for I am awesomely, wondrously made; Your work is wonderful; I know it very well." (Psalms 139:14)

 BAYN ADAM L'MAKOM, BETWEEN YOU AND GOD. Awe and reverence for God is the normative understanding of this *Middah*. *Yirah* as in *Yirat Shamayim* and *Yirat*

HaShem (awe of heaven and reverence for God) evoke thoughts of wonder, surprise, awareness, amazement, mystery, and appreciation. *Yirah* implies that we step back and appreciate the Creator, the universe, and all that is therein.

TEXT STUDY

Tanach

A In a dream Jacob sees a ladder stretching to the sky, with angels going up and down. God appears beside it and promises Jacob and his offspring a prosperous future, blessing Jacob and assuring him of protection. When Jacob awakes, he feels sure God is present.

> **How awesome is this place! This is none other than the abode of God, and that is the gateway to heaven. (Genesis 28:17)**

➤ Why does Jacob call the place awesome? Have *you* ever been in a place that seemed filled with awe? Advanced questions: Imagine someone feels reverence for God. Is sensing God's presence something which happens directly between a person and God — a private, intimate relationship? Or, can such feelings actually transform a *place*, spill over, flood the environment? That is, can a sense of God's presence actually change the surroundings, making it so that it seems to be filled with awe?

B Moses pleads with Pharaoh to let the Israelite people go. Each time Pharaoh refuses, various plagues are brought upon Egypt. And with each plague, Pharaoh asks Moses to tell God to put a stop to the horrors. During the plague of thunder and hail, Moses again agrees to do what he can to stop the plague, adding the following:

> **But I know that you and your courtiers do not yet fear God. (Exodus 9:30)**

➤ Do you agree or disagree that God sends the plagues so that Pharaoh will fear God? Why *should* Pharaoh fear God? What about awe — does God send plagues so that Pharaoh and crew will be in awe of God? Does good leadership depend on awe and reverence for God?

C The book of Leviticus includes ethical instructions on how to be righteous and holy. Even though certain ethics seem to be about how people should treat others, God is mentioned. Some commandments are given, each followed by the statement that "you shall fear God," that God is the Eternal One.

> **You shall not insult the deaf, or place a stumbling block before the blind. *You shall fear your God:* I am the Eternal One . . . You shall rise before the aged and show deference to the old; *you shall fear your God:* I am the Eternal One . . . Do not take interest [from one who has become impoverished], *but fear your God* . . . You shall not rule over [your servant] ruthlessly; *you shall fear your God* . . . (Leviticus 19:14, 32; 25:36, 43)**

➤ Why do you think fear of God is mentioned alongside certain ethical instructions? Do you think reverence for God motivates you to be more ethical, too? Can you be ethical if you do not revere God? Are you *more likely* to be ethical if you do? Explain. Is there a *Mitzvah* or ethical instruction which makes you feel that, by doing it, you are revering God? Is there one which you do out of *fear* of God?

D Moses speaks to the Israelite people, reminding them of their obligations.

> **And now, O Israel, what does the Eternal your God demand of you? Only this: to**

revere the Eternal your God, to walk only in God's paths, to love God, and to serve the Eternal your God with all your heart and soul, keeping the Eternal's commandments and laws, which I enjoin upon you today, for your good. (Deuteronomy 10:12-13)

➤ Is there a particular reason that reverence is mentioned first in this list of what God requires. If so, what is it? How much does reverence for God influence *you*, in terms of your day-to-day life?

E While the doers of evil shall be doomed, the prophet forecasts a much brighter future for those who revere God.

But for you who revere My name, the sun of victory shall rise with healing in its wings. (Malachi 3:20)

➤ In our own times, can those who revere God expect anything special for their efforts? If so, what?

F Isaiah poetically expresses wonder at the night sky. Each night, every shining star appears in its place.

Lift high your eyes and see;
Who created these?
The One Who brings out their host by number, calling them each by name.
Because of God's great might and vast power,
Not one fails to appear. (Isaiah 40:26)

The Psalmist also expresses similar wonder for God's amazing works.

Say to God, "How awesome are Your deeds . . . " (Psalms 66:3)

➤ What impresses Isaiah so much about the sky? How is the world around us a reflection of God's "awesome deeds"? In a later source, a Hasidic master points out that looking at the sky helps develop awe. (See Post-Rabbinic #A for related discussion material.)

G *Yirah*, awe and reverence, is a foundation for wisdom.

The beginning of wisdom is reverence of God. (Psalms 111:10)

➤ How can reverence for God make you wise? What have you learned as a result of reverence, awe, or wonder?

H Proverbs describes reverence for God in this way.

Reverence for God is a stronghold, a refuge for one's children. Reverence of God is a fountain of life, enabling one to avoid deadly snares. (Proverbs 14:26-27)

➤ In what ways is reverence a stronghold? a refuge for one's children? a fountain of life? a means by which to avoid deadly snares? Is there anything you would add?

I In Ecclesiastes there's another side to reverence. Kohelet's frustration presents a challenging contrast to what is usually said about this virtue.

Although I am aware that "it will be well with those who revere God since they revere God, and it will not be well with the scoundrel, and the scoundrel will not live long, because that one does not revere God" — here is a frustration that occurs in the world: Sometimes those who are upright are punished as if their conduct was like that of scoundrels. And

sometimes scoundrels receive benefits no different from those who are upright. I say all that is frustration. (Ecclesiastes 8:12-14)

➤ In your own words, what is Kohelet saying? Do you think his frustration is justified? If no apparent good comes from revering God, should you abandon reverence? How would you respond if Kohelet expressed his frustration to you? Despite his frustrations, in the end Kohelet affirms reverence. Do you agree with this affirmation?

The sum of the matter, when all is said and done: Revere God and observe God's commandments! For this applies to all humankind: that God will call every creature to account for all their conduct, be it good or bad. (Ecclesiastes 12:13)

➤ What is Kohelet's "last word" on reverence? Is it normal for a person to have mixed feelings about reverence for God? How so? What are some ways to sustain reverence — to keep those awesome feelings strong?

Rabbinic

A In Psalms it says that the beginning of wisdom is reverence for God. This statement goes a step further.

The peak of wisdom is the feeling of awe. (Derech Eretz Zuta, chapter 5)

➤ Do you agree that the peak of wisdom is the feeling of awe? Why or why not? Can awe be both the beginning of wisdom and the peak of it? How so?

B God's realm is eternal, extending everywhere throughout all time. But God can't

make you feel *Yirah*. God doesn't force you to be amazed, appreciative, and full of wonder. If you are reverent, a certain lifestyle will follow; if not, another lifestyle will follow. Thus, reverence is your choice to make.

Rabbi Hanina said further: "Everything is in the hand of heaven except the awe of heaven, as it is written, 'And now, O Israel, what [mah] does the Eternal your God demand of you? Only this: to be in awe of the Eternal your God'" (Deuteronomy 10:12). (Brachot 33b)

➤ Do you agree or disagree that reverence or "awe of heaven" is in your hands? If we are responsible for our own reverence, does that mean we're responsible for other things as well? What might those things be? The rest of the verse, the "proof text" from Deuteronomy, gives some clues (see Text Study, Tanach #D).

C In #B above, we learned of one interpretation of Deuteronomy 10:12. Here's another: The word "what" (*mah*) in the verse is interpreted as "one hundred" (*may-ah*). Saying one hundred blessings a day will help you master awe and reverence.

It was taught: Rabbi Meir used to say: "A person should say one hundred blessings daily, as it is written, 'And now, O Israel, one hundred things does the Eternal your God demand of you'" (Deuteronomy 10:12). (Menachot 43b)

➤ What would Rabbi Meir say is the way to master *Yirah*? In what ways might doing what he prescribes help you be a more reverent person? Are there blessings that you now say on a daily basis? Are there others you would like to add?

D The Rabbis emphasize the importance of reverence of God.

> As to the one who reveres God, the whole world was created for that person's sake. That person is equal in worth to the whole world. (*Brachot* 6b)

➤ Are the Rabbis exaggerating to make a point? What do they say that could be considered hyperbole, an overstatement? Why do you think the Rabbis put such emphasis on reverence?

E There's a relationship between reverence for God and humility, modesty. When you revere God, fulfilling the commandments and being a virtuous person are the logical next steps. Reverence for God provides a strong and secure foundation for a righteous life. No special rewards are necessary.

> Rabbi Judah ben Tema used to say: "Love and revere God; tremble and rejoice when you perform the commandments. If you have done a little wrong to your neighbor, let it seem to you large. If you have done a big kindness, let it seem to you small. If your neighbor has done to you a big evil, let it seem to you small; if your neighbor has done to you a small kindness, let it seem to you large." (*Avot d'Rabbi Natan* 41, 67a)

➤ Why, when you revere God, are you less in need of getting "credit" for every single thing you do? Is it true that when you revere God, you're less likely to feel resentment if someone wrongs you? Explain.

Post-Rabbinic

A Developing awe of God doesn't have to be some grandiose effort, such as hours of prayer and study or the most strict ritual observance. While those things may have their place, simple approaches should not be overlooked.

> It is good to look at the sky often, as this helps to develop [awe] of God. (Rabbi Hayim Yosef David Azulai, *Hanhagot Tzaddikim*, p. 66, #7; in *Jewish Spiritual Practices* by Yitzchak Buxbaum, p. 501)

➤ How can looking at the sky often help to develop awe? What else in the world around us can help inspire awe? Can you go through the motions of ritual without ever "mastering" *Yirah*? Can going through the motions of ritual help to develop awe? Explain.

B Abraham Joshua Heschel takes the statement in #A above a bit further.

> Awe enables us to perceive in the world intimations of the divine, to sense in small things the beginning of infinite significance, to sense the ultimate in the common and the simple; to feel in the rush of the passing, the stillness of the eternal. (Abraham Joshua Heschel, *The Wisdom of Heschel*, selected by Ruth Marcus Goodhill, New York, Farrar, Straus, and Giroux, 1970, p. 135)

➤ What are your reactions to Heschel's comment? Can you really live with such an awareness of the divine? Is a constant, underlying sense of reverence possible? What can we do to help increase our sense of awe?

C While reverence has the potential to bring you to your highest level, to help you live life at its richest, it is misunderstood by some as a sign of weakness or as a crutch. Rav Kook disagrees with these doubters.

> **The concept of the [reverence] of God lends strength to the person who understands it in its purity. It endows life with interest and great aspirations, and with a high level of spirituality, which refine the potentialities of the soul with the light of holiness. But for fools it appears as a symbol of the confusion that engenders weakness and despair . . .** (*Abraham Isaac Kook, The Lights of Penitence, Lights of Holiness, The Moral Principles, Essays, Letters, Poems,* **p. 163**)

➤ Do you agree with Rav Kook that reverence can be a genuine source of strength? Explain. Why might someone say that reverence reflects weakness and despair? How can reverence become more of a source of strength for you?

ACTIVITIES

Language Arts

 1 (10 minutes) This exercise is a good warm-up or beginners' activity. Individually or in a group, make two lists. On one list include "Things I Wonder About." On the second list, put "Things That Amaze Me."

How do the lists reflect *Yirah* — awe and reverence of God? Do you think a sense of *Yirah* is part of your life now? Explain. Why might mastering *Yirah* be considered a virtue?

 2 (15 minutes or more) Awe and reverence play key roles in our formal religious experiences. Spend time dis-cussing how *Yirah* is part of various holidays and life events. Here are a few examples related to holidays:

a. Pesach: We remember the wonder of the plagues, the miracle of the crossing of the Reed Sea.

b. Shavuot: We recall the awe of thunder, lightning, blare of the horn, and mountain smoking when the Ten Commandments were given.

c. *Yamim Nora'im* (High Holy Days): We experience fear as we stand so vulnerable before God, but also wonder at the concept that we can always return and that God will take us in.

d. Chanukah: We celebrate the miracle of the oil that was supposed to last just one day, but lasted a full eight days.

e. Tu B'Shevat: Every year we celebrate the miraculous "rebirth" of trees — bursting into blossom, regenerating with new foliage.

Here are a few examples related to life events:

a. Birth: This is a readily apparent miracle!

b. Bar/Bat Mitzvah: We celebrate the wonder of change and growth.

c. Marriage: We witness the awesome nature of love.

d. Death: We face mystery. What does it all mean? What happens after life?

Where and how does *Yirah* play a role? Before the leader shows participants the above list, allow them to come up with their own ideas for those holidays and life cycle events. Afterward, they can add to the list. Where does *Yirah* fit into other holidays — Yom HaShoah, Yom HaAtzma'ut, Tishah B'Av, Sukkot, Purim, Shabbat? Where does *Yirah* fit into other life events?

 3 (15 minutes) Our *Siddur* (prayer book) includes many prayers with exclamations of wonder. Psalms are also filled with good examples of wonder. Riffle through a *Siddur* and notice how often there are expressions of awe.

Now, make your own list of expressions of awe. Draw on familiar English words and phrases/

idioms, such as: Out of this world! Unbelievable! Astonishing! Terrific! Fantastic! Astounding! I'm at a loss for words! I'm going to burst! Takes my breath away! I can't contain myself!

Next, use some of your own modern English exclamations to write a prayer with the following structure:

Astounding is the _____.
I'm at a loss for words whenever _____.
_____ takes my breath away . . .

In a group, share your prayers. Is using exclamations an effective way to communicate religious feelings? Is it important to include expressions of wonder as part of worship? If desired, use the creative prayers in an actual worship setting. Extend the experience by illustrating the prayers.

 4 (15 minutes) In Text Study, Post-Rabbinic #A, one Hasidic master says that looking often at the sky helps develop awe of God.

Create a formula, a "recipe," for developing Yirat HaShem (awe of God) in other ways. Here's one example:
Touch the toes of a newborn baby.
Watch the trees change color in a New England fall.
Smell roses.
Sample varieties of chocolate.
Climb mountain peaks.
Count your blessings each night before you go to sleep.

Share your "recipes." How well do you follow your own recipe? How could you make *Yirah* more predominant in your life?

 5 (15 minutes) In Text Study, Rabbinic #C, Rabbi Meir says that a good way to develop *Yirah* is to say one hundred blessings a day.

Number a piece of paper from one to a hundred. Fill in the list with one hundred things for which you could say a blessing.

Discuss. Was this list hard to complete? Do you think it's realistic to say one hundred blessings in a day? Did this exercise make you more aware of areas which "deserve" blessing? Are you motivated to increase the number of blessings you offer in a day?

 6 (15 minutes) Refer to Movement #2, in which participants imagine themselves as Jacob physically exploring the "awesome place" in which he found himself.

Again, imagine you are Jacob. This time, use words rather than movement to flesh out what he experienced. Using the first person voice, give more details and descriptions of the "awesome place" than are in the Bible. What was it really like to be there?

After all the participants complete their versions of Jacob's experience, continue with discussion as suggested in Movement #2.

 7 (20 minutes or more) There are several Psalms included as part of the Kabbalat Shabbat (Friday evening, welcoming Sabbath) service. In these Psalms all different parts of Creation exclaim awe and reverence. Here are some excerpts:
Let the heavens rejoice. (Psalm 96)
Let the earth be glad. (Psalm 96)
Let the sea and all it contains roar in praise. (Psalm 96)
Let field and forest shout for joy. (Psalm 96)
Let the rivers burst into applause. (Psalm 98)
Let mountains join in acclaim with joy. (Psalm 98)
The voice of the Eternal shatters the cedars. (Psalm 29)
The hills skip like rams. (Psalm 29)
The mountains leap like lambs. (Psalm 29)

Begin by looking over some of the exclamations included in the Kabbalat Shabbat Psalms. What is the effect of bringing in nature to express wonder for God?

Now, write your own Psalm-like prayer using various parts of nature as the theme. These parts of creation express their *Yirah* in whatever ways you invent. For example: What does the moon do to exclaim its wonder of God? What do the turtles do? How about the roses? the trees bursting with cherry blossoms? the deep, red-earth canyons? the alpine wildflowers? electric eels? the neon fish of the coral reef? And so on.

When you finish your prayer, share it with others if you wish. You may want to include your prayer as part of an actual Kabbalat Shabbat service.

 8 (15-20 minutes) Abraham Joshua Heschel reminds us to appreciate the wonder in even the small things (see Text Study, Post-Rabbinic #B). It's fine and good to *say* we should appreciate the small wonders, but some focused practice, now and then, could be helpful.

Describe why doing something small is amazing. Study a task you may do automatically. Observe it closely and be open to appreciating whatever wonder is involved. Write in a detailed way about the task. Add commentary, if you like, elaborating on how the senses experience the task by including descriptions of how things look, sound, smell, taste, and feel. Perhaps the task is planting a seed, putting a fresh coat of paint on a wall, brushing a horse's mane, or putting a bandage on a child's scrape.

Discuss reactions to writing in this detailed manner. In what ways did the activity "exercise" your sense of wonder? To a large extent, creative writing is about noticing. Is spending time writing a good way for you to develop a higher sense of wonder? How about reading what others write? What is the best way for *you* to nurture wonder?

 9 (15 minutes or more) As early as the book of Leviticus, a connection is made between ethical behaviors and *Yirah*.

Review some of the biblical passages that make this connection (see Text Study, Tanach #C). Now reflect on your own life. Can you remember a time when you felt that an interaction with another person(s) had divine significance? Write about the experience. If you can't think of something that actually happened, make up a scenario you think could happen and write about that.

Share your writing. Is the potential for experiencing *Yirah* in the context of everyday interactions with people high, medium, or low? Explain. What ways might you increase opportunities for *Yirah* in everyday interactions?

Visual Art

 1 (15 minutes or more) Jacob dreams of a ladder with angels going up and down. They make promises and give blessings. In Text Study, Tanach #A, Jacob remarks on the awesomeness of the place.

Study Jacob's experience at this "awesome place" more in detail (see Genesis 28). Then do one of the following:

a. Illustrate the place, as you think Jacob saw it.

b. Using a more abstract approach, create a non-specific awesome place. Use your visual imagination and put imagery — colors and textures — into the feeling of awe. Suffuse the canvas with this feeling.

c. Do both of the above.

Discuss. How did you come up with your interpretation of an awesome place? What makes a place look or feel "awesome"?

 2 (15 minutes or more) One Hasidic master says that in order to develop awe, you should look at the sky often (see Text Study, Post-Rabbinic #A). Isaiah, who preceded the Hasidic master by many hundreds of years, also felt a great sense of wonder when he looked out at the sky, especially at night (see Text Study, Tanach #F). Think of the majesty

people can feel as they gaze up at the sky, and out on the horizon at various times of the day and night.

Begin by brainstorming various skies and horizons we see. Some examples:

a. A bright, sunny blue sky at midday

b. A sky with billowing dark gray thunder clouds

c. A pale blue sky with thin strips of white cloud across the horizon

d. Sunrise over mountain tops

e. Sunset over the ocean horizon

f. A clear blue-black night sky, dotted with endless numbers of shining stars

g. Your ideas!

Now, try to recreate some of these skies, and try to capture why these skies might inspire awe. With watercolors, special watercolor paper, and plenty of water, create "washes" which can reflect subtle shades of sky.

Are the skies you painted "awesome"? What reactions do you have when you look at unusual skies? Will you now be inspired to look at the sky more often?

Note: A similar activity can be found in Chapter 17: "Sh'lom Bayit: Peace in the Home/Peace in the Family, Visual Art #7.

3 (15 minutes or more) There are many wonderful images associated with reverence in our sacred literature (see Text Study, Tanach #E and #H).

Choose one of these images and illustrate it. Share your illustrations with others, inviting comments and making your own.

4 (time varies, depending on how preparation is done; plus 20 minutes at least to finish the project) Opportunities for nurturing a sense of awe and reverence are all around us. Keep your eyes open and notice!

Over the course of a week or so, photograph or sketch anything that seems wondrous to you. Assemble the developed photos or sketches into a collage of wonder — a collage of *Yirah*. A practical note: For assembling photos in a collage, obtain special photograph adhesive (a specific product for gluing photos) from an art supply store.

For a group, there's another, simpler and more focused way of doing the preparation. Give everyone a sketch pad. Then, allow them to take whatever amount of time seems appropriate— a half hour to an hour — to wander around. During that time, they draw sketches of whatever seems wondrous to them. Access to outdoor grounds will help make this approach more successful. Continue with putting together the collages as above.

Share and/or exhibit the collages. Discuss: During the time you were collecting images, in what ways did you feel you had a heightened sense of awe and reverence? Would you like to have these feelings more often? If so, what can you do to make this happen? Does such a feeling make you a more virtuous or religious person? How did you choose your images to photograph or sketch? And what was going through your mind as you assembled the collage itself?

5 (20 minutes or more) In Text Study, Tanach #G and Rabbinic #A, we learn that *Yirah* is the *beginning* and the *peak* of wisdom. This activity explores that notion.

A couple of images in Jewish tradition suggest "peaks": Mt. Sinai and the Temple Mount in Jerusalem. Using one of those images to represent your peak or high point of wisdom, draw an outline of the shape. A mountain peak will be like a huge triangle; the Temple can be symbolized by one wall (such as the Western Wall).

Begin to fill the shape in with small things, remembering that appreciation and wonder of the small things are how you build toward the

peaks. Fill the shape with small wonders, such as lady bugs, spiders, worms, chips of quartz, nuggets of gold and silver, almonds, cherries, grapes, vines, flower petals, fish, grass, or whatever!

Try looking at your picture from a fresh angle, as if you didn't know what the assignment was. How would you interpret what you see? In what ways does your picture capture the goal of the assignment? Do you agree or disagree with the following statement: If you trample over the small things, without really seeing them, you will never truly understand awe.

 6 (20 minutes at least) Do a Visual Art version of Movement #5 below. Read through the guidelines in that exercise, then make the following changes:

For the warm up: Divide a piece of paper in two, making a line down the middle. The leader calls out "awe and reverence." Make a quick sketch, a simple shape in response to these words on one side of the paper. The leader then calls out "weakness and despair." Again, respond with a quick drawing, this time on the other half of the paper. The leader repeats this several times. After a few rounds, each side of the paper should have a number of shapes reflecting different kinds of "fear."

Using a fresh sheet of paper, make two figures (more or less realistic) that are imagined to be standing before God. One is to reflect the first kind of fear — fear that derives from awe and reverence. The other is to reflect the second kind of fear — fear that is prompted by weakness and despair.

Share your art and discuss. Was it difficult to express different kinds of fear through art? What is notably different between the two types of shapes, the two figures you drew? How are your interpretations of fear similar to/different from those of others in the group? Do you agree that there are two kinds of fear — one which "refines the soul" (as Rav Kook says in Text Study, Post-Rabbinic #C), the other which is confused, born of weakness and despair? How can you embrace the first type and avoid the second?

Drama

 1 (3 minutes) Oftentimes, words just can't express our feelings of awe and reverence. We may become so overwhelmed by our feelings that words escape us.

As a warm-up, spend a couple of minutes exploring sounds of awe — exclamations, sighs, and hums, uhms, ahs, and ohs. Fill the room with these awesome sounds. Share reactions to the sounds. When do you actually make these sounds? When do you hear these sounds from others?

 2 (10 minutes) First, complete #1 above. This activity builds on that one. Then, in pairs, improvise a conversation consisting mainly of exclamations such as those described in #1. A few recognizable words are okay, too, such as, "really, my oh my, wow, hot tamale, mind boggling," and so on. Converse about something amazing (the fireworks show, the whale swimming just 50 yards from your boat, the comet streaking across the sky, the massive beehive, the tiny birds breaking forth from their eggs, etc.). You and your partner don't have to specify what it is, but can if that is helpful. In either case, the exclamations should reflect wonder, feelings of *Yirah*.

Pairs may perform these improvisations in front of the rest of a group. Both the actors and the audience may comment on the performances. What did they hear? What did they see? In what ways were the performances convincing/ unconvincing?

 3 (10 minutes) "How awesome are Your deeds," it says in Psalms 66:3. How you look at

things can reflect a sense of reverence for God. How you touch and handle things can also do so.

All of God's works are worthy of awe. For this exercise, choose a few of these "works" — a few small ones. The leader gives pairs one item at a time to pass back and forth between themselves — a stone, a branch, a flower, a piece of fruit, a stuffed animal (and/or doll) representing a live one, a pot of earth, a glass of water, etc. (The leader could also suggest some imaginary items, such as a chunk from a meteor, or a large dinosaur bone.) Pairs begin by passing the item in a nonchalant and uncaring way. Very gradually, they discover *Yirah*. They slowly become more reverent toward the item, more in awe of its specialness, more appreciative of the item's unique place in God's Creation. The way they touch and look at the object should reflect this growing sense of *Yirah*. Pairs should wait for a signal from the leader before beginning with a new item.

After several items have been offered, react to the exercise. Is it possible to feel awe for any and all things in God's Creation? In what ways did you enjoy the process of intentionally trying to develop a sense of awe? Was it easy/hard? Is there anything you learned that you can bring into your everyday way of looking at things?

 4 (5-10 minutes) Instead of focusing on things you can hold, as in #3 above, the focus here is on the bigger picture. As stated in the Overview, sometimes we have to take a step back to get perspective, to appreciate just how awesome the world around us is. Astronauts report that when they get far enough away from earth to see it as a whole, the experience is awe-inspiring, truly beautiful and amazing.

Imagine one wall of the room is a "wall of wonder." There is something awesome and amazing about the wall. But if you are standing with your nose touching the wall, there's only so

much you can see.

The leader says: Go to the wall now. Stand so that your nose is touching the wall. Very slowly, step back from the wall. And take another step back . . . and another step back . . . and another step back . . . and so on. With each step back, imagine you are able to take in more of the wonder. Your walk backwards from the wall is a journey from not seeing much to seeing more and more, to feeling awe and amazement about what you see. Perhaps you can imagine the wall as the earth. Each step backward is like backing into space. Eventually, you see the whole picture — the amazing full sphere of the world of creation. Your job as an actor is to show the transition from no sense of *Yirah* to indeed being filled with this powerful emotion.

Discuss. What did you experience as you backed away from the "wall of wonder"? Describe any sense of awe you felt growing.

 5 (10-15 minutes) In the Exodus story, Moses tells Pharaoh that the plagues will keep coming and coming as long as Pharaoh is not in awe of God.

Read the Exodus account (Exodus 1:1-15:21). Then focus on the comment Moses makes following the plague of thunder and hail (see Text Study, Tanach #B). Moses knows that Pharaoh and his courtiers do not yet fear God.

Extend the above scene by choosing two actors, one to play Moses and one to play Pharaoh. Moses will try to press Pharaoh further concerning *Yirah*. The actors improvise the dialogue that could have taken place. It might start something like this:

Pharaoh: Moses, really, is there anything you can do to stop this horrible thunder and hail?!

Moses: I'll do what I can. Perhaps God will let up on this plague, too. But I know you and your gang don't appreciate God's power. You have no sense of how awesome God is.

Pharaoh: Why should we see God as awesome? We have our own gods.

Moses: Pharaoh, you just don't get it. Let me tell you a thing or two. Let me explain to you why these plagues keep coming and coming.

Pharaoh: Be my guest. But don't count on me buying into what you have to say . . .

Audience members may be invited to question Moses and Pharaoh, while the two remain in character. When one pair of actors finishes improvising, a few others can improvise the scene. After a few rounds, discuss why awe and reverence for God play such an important role in the Exodus story. Do we relive the Exodus story each year so as to renew a sense of awe and reverence and thus reinvigorate *Yirah*? Can *Yirah* grow dull without an extra boost? Explain.

Movement

 1 (5 minutes) Not having *Yirah* is like "going around with your eyes closed" — going around "half-asleep." Having *Yirah* is like "going around with your eyes open."

Everyone starts on the floor, imagining they are asleep. Gradually, they wake up. They move their bodies in ways that reflect the waking up process. Then repeat the waking up experience, starting once again on the floor. This time, however, the waking up is happening on a spiritual level. Participants go from not being aware to being aware, from being "spiritually asleep" to being spiritually awake, from being unseeing to being full of reverence and awe, from "going around with their eyes closed" to "going around with their eyes open."

Discuss. What was the difference between the two waking-up experiences? Are the two similar? Think of other images and experiences besides sleeping and waking-up. Are there any that bring to mind the idea of growing in *Yirah* (a seed in the ground, finally sprouting; a rose bud opening to full bloom; a baby kangaroo beginning to peek

out from its mother's pouch; the sun breaking through a sky of gray clouds)? If you like, take some of these new images for waking up to *Yirah*, and set them to creative movement.

 2 (10 minutes) Review Genesis 28, Jacob's encounters with God's presence in an "awesome place" (see also Text Study, Tanach #A).

After the group is very familiar with the Jacob story, they imagine they are standing in the "awesome place." They are each Jacob moving about and exploring this amazing site. Turn on some music if you like, and allow participants to improvise for a few minutes.

Discuss. Do you think you got a sense of what Jacob experienced in the "awesome place"? What makes a place awesome, seemingly filled with God's presence? Is your answer different from what it would have been before you did this activity?

 3 (15-20 minutes) The Israelites are standing at the foot of Mount Sinai following the giving of the Ten Commandments. They witness thunder and lightning, the blare of a horn, and the mountain smoking. When the people see this amazing sight, they "fall back and stand at a distance." This "falling back" doesn't come from being afraid, but rather from the awe and reverence they feel. They ask Moses to speak to them, and Moses answers them, saying: "Be not afraid; for God has come only in order to test you, and in order that awe and reverence for God [*Yirah*] may be ever with you, so that you do not go astray." (Exodus 20:17)

Begin by practicing falls. Explore all kinds of ways of falling — forward, sideways, backward. Try raising just one body part at a time and allowing it to fall — an arm, a leg, the torso. Use one body part at a time to lead you to a full fall (for example, an arm pulls you down until you are completely flat out on the floor). Fall down fast. Fall down

slow. Fall down in jerky movements. Fall down smoothly. Fall as if you meant to fall. Fall as if by accident. What other ways can you fall?

Now imagine you are one of the Israelites standing at Sinai. You have just witnessed the giving of the Ten Commandments. You have seen the lightning, heard the thunder and the horn blaring, smelled the mountain smoking. Are you afraid? Are you in awe? Explore your reactions to this scene in movement. Use falling as a recurring movement theme. Your falls at the beginning of the improvisation should reflect being afraid — fright, trembling, agitation, anxiety. Then, as you imagine hearing and absorbing the words of Moses, the nature of your falls should begin to change. Your falls should come out of awe; they should be motivated from a sense of reverence. If you like, choose some dramatic music as accompaniment for the improvisation.

Share reactions. What did you do, what did you see, how did you feel? Did you notice what other participants were doing, or were you more focused on your own experience? What is the difference between "fear" as in being afraid and "fear" as in feeling awe and reverence? Do you think you were successful in making that distinction in the improvisation?

 4 (5-10 minutes) In Drama #4, participants "step back" to get more perspective, to take in the "big picture," to feel awe and reverence.

Complete the Drama activity, but use movement more freely. Also, you can go back and forth toward wonder and away from wonder. Explore the nuances between various degrees of *Yirah*.

Following a few minutes of improvisation, discuss the experience. What did you experience as you moved back and forth, away and toward and away from the "wall of wonder"? In what ways did you sense different degrees of wonder?

How does "stepping back" contribute to "seeing the big picture?"

 5 (10-15 minutes) In Text Study, Post-Rabbinic #C, Rav Kook points out that true *Yirah* is a source of strength. Unfortunately, people can confuse *Yirah* with weakness and despair.

Warm up by doing the following. A leader calls out "awe and reverence." Participants strike a pose in response to these words. The leader then calls out "weakness and despair." Again, participants strike a pose in response. The leader repeats these several times.

The leader then gives about ten seconds for movement after each call. Now participants don't simply strike a pose in response to the words they hear, but they move for a few moments until the leader calls out the opposite words.

For a more developed improvisation, define two large circles within the space. One will represent awe and reverence. The other circle will represent weakness and despair. Participants explore the two spaces in movement, going back and forth as they wish. They try to move in ways that reflect the circle they are in. Participants should feel free to interact with one another as seems appropriate. When they feel they have a clear sense of each circle, they can step out of the improvisation, moving to the side and waiting while everyone else finishes.

Discuss the improvisation. Was it difficult to distinguish between the two circles, between awe/reverence and weakness/despair? What was different in the movement in each of the circles? Should we be concerned about confusing *Yirah* which "refines the soul" (as Rav Kook says in Text Study, Post-Rabbinic #C) with weakness and despair? How can we avoid such confusion?

Note: For an art version of this activity, see Visual Art #6.

Music

 1 (time on your own; for a group, add 5-10 minutes for discussion.) Awe and reverence are frequently expressed in our prayer books. Our liturgical music also inspires a sense of *Yirah*, reinforcing the meaning of the words.

Next time you are at a worship service, pay close attention to the music. Listen for *Yirah* — music that is filled with a sense of reverence, music that inspires awe. If desired, a group can attend a service together. Afterward, share and describe the times when you heard *Yirah*. Do some musical selections suggest *Yirah* more than others? What gives some music that "*Yirah* sound"? Is there certain holiday music that sounds particularly awe inspired and reverent (such as that on Rosh HaShanah and Yom Kippur)?

 2 (3 minutes) Drama #1 and #2 explore a nonverbal approach to expressing awe and reverence. The emphasis is on the *sounds* of awe — exclamations, sighs, and hums, uhms, ahs, and ohs. Complete those exercises by improvising sounds of awe on simple percussion instruments (drums, bells, cymbals, sticks, triangles, etc.).

 3 (10 minutes) Complete Movement #5 through music. Read that exercise, then make the following changes. For the warm-up, create musical responses to the words (rather than striking poses). For the more developed improvisation, participants carry instruments between the two circles, playing sounds appropriate to each. That is, in one circle, participants play sounds which reflect awe and reverence. And in the other circle, participants play sounds of weakness and despair.

APPENDIX 1

LESSON PLAN: GRADES K-2
SH'LOM BAYIT (PEACE IN THE HOME/
PEACE IN THE FAMILY)
TIME FRAME: ONE HOUR; CAN BE
DIVIDED INTO TWO PARTS

0-5 minutes: Opening exercise. Ask: Who is in your family? Go around the room, inviting children to tell who are the members of their family.

5-10 minutes: Write on the board the words *Shalom* and *Bayit*. Ask who knows what the words mean. Add definition for each word as necessary. Next write *Sh'lom Bayit*. Ask: What do you think this means? Go over ideas from the Overview of Chapter 17, Sh'lom Bayit: Peace in the Family, a home that feels complete, a family in which members are connected with one another (interested in each other's lives), a home in which everyone works together to solve problems (simplified from Overview), family harmony.

10-15 minutes: Text Study, Tanach #E and Rabbinic #B (Write these on the board.)

15-25 minutes: Activity: Language Arts #1 — creating "recipes" for *Sh'lom Bayit*

(If desired, take a break here and continue later with rest of lesson plan.)

25-30 minutes: The leader says: Each person in each house is important in making peace at home, right? Since peace begins with each of us, let's do something that will help us get more of a sense of what feeling peace in ourselves is like.

30-35 minutes: Warm-up activity related to peace in yourself: Movement #1

35-45 minutes: Activity related to peace in yourself: Visual Art #2

45-50 minutes: Discussion of God as *Oseh Shalom* — the Source of Peace, the Maker of Peace. What does it mean to feel peace in "God's home"? (See Text Study, Tefilah #A — *Ufros alaynu sukat shlomecha*, Spread over us the shelter of your peace.)

50-60 minutes: Activity related to feeling peace and protection: Movement #3

Optional: Give homework assignment: Language Arts #2. Students do this with their families, creating a list of the family's "Ten Commandments." Hand out written instructions for children to take home.

APPENDIX 2

LESSON PLAN: GRADES 3-5
LO LEVAYESH (NOT EMBARRASSING)
TIME FRAME: ONE HOUR

This lesson plan stays with the *Bayn Adam L'Chavero* (Between People) approach to this *Middah*. That is, participants explore the meaning of not embarrassing *other people* (rather than not embarrassing oneself or God). This focus is especially appropriate for students in Grades 3-5.

0-5 minutes: Introduce topic with Text Study, Rabbinic #B. Just present the first text. Then, for the discussion, don't get into hyperbole, at least not right away. Rather, use the text as a jumping-off point for explaining the meaning of *Lo Levayesh* and why it is taken so seriously.

5-10 minutes: More introduction, drawing from the Overview:

 1. Review the comparison of *Lo Levayesh* with not stealing (see the second paragraph of the Overview of Chapter 9, Lo Levayesh: Not Embarrasing).

 2. Talk about deliberate versus non-deliberate instances of embarrassing others (see third paragraph of the Overview of Chapter 9). Even if you didn't mean to embarrass another, you still are responsible for having done so. This goes to show just how very careful you have to be not to embarrass others.

10-20 minutes: Text Study, Rabbinic #C and #D; Post-Rabbinic passage

20-40 minutes: Activity: Drama #5. Focus on skits for Rabbinic #D and the Post-Rabbinic passage. (Don't use Rabbinic #E unless there is extra time, since that text was not studied previously.)

40-55 minutes: Activity: Language Arts #3. More Text Study. Then have students create their own classroom rules, taking into account the importance of *Lo Levayesh*.

55-60 minutes: Closure. Questions to ask: What was the most important thing you learned about *Lo Levayesh* today? What specific thing(s) will you do to try to live more in accordance with this *Middah*? (Examples: Follow the new classroom rules, choose teams randomly for sports games so that no one is embarrassed by being picked last, think before teasing others, etc.)

APPENDIX 3

LESSON PLAN: GRADES 6-8
SHMIRAT HAGUF (TAKING CARE OF YOUR BODY)
TIME FRAME: ONE HOUR

Before students arrive, the teacher or leader writes on the board (or prepares hand-outs) with these texts:

1. (Tanach #A) "For in the image of God, did God make humankind." (Genesis 9:6)

2. (Tanach #C) "Take good care of yourselves . . . " (Deuteronomy 2:4)

3. (Tanach #D) "I praise You, for I am awesomely, wondrously made. Your work is wonderful; I know it very well." (Psalms 139:14)

4. (Rabbinic #B) "Don't get into the habit of taking drugs, don't leap over a sewer, don't have your teeth pulled, don't provoke serpents." (Talmud)

5. (Post-Rabbinic #A) "The body is the soul's house. Therefore, shouldn't we take care of our house so that it docs not fall into ruin?" (Philo Judaeus)

0-5 minutes: Read the above texts out loud or have students read them on their own. Ask: What theme or idea do these texts have in common? Is there any virtue you can derive out of the texts — do they point to anything you should do, a certain way you should act? Say: Keep in mind what we've discussed so far, and we'll come back to these texts later.

5-15 minutes: Introduce *Shmirat Haguf.* Go over, elaborate, explain, ask questions about the main points presented in the Overview, including:

1. The body is holy, it houses the soul.

2. The body is a gift from God — we need to take good care of it.

3. The body is a gift, but it belongs to God.

4. Jewish attitudes on: suicide, cremation, gashing (also talk about tattoos and body-piercing)

5. Traditional prayer — recognizes body is gift from God. Read: Text Study, Tefilah.

6. Ask: What do you think we are *supposed* to do to care for our bodies (eating, bathing, sleeping, exercising)? What do you think we are not supposed to do (endangering ourselves, injuring ourselves)?

7. Importance of moderation

8. Qualities which support the virtue: responsibility, appreciation, loving care

15-20 minutes: The teacher or leader says: Let's go back now and look again at a couple of the texts we read before. Reinforce some of the above ideas from the Overview to Chapter 19, Shmirat HaGuf: Taking Care of Your Body, by returning to the texts presented at the beginning of the lesson and asking questions for Tanach #A and #C.

20-25 minutes: Text Study, Post Rabbinic #B

25-40 minutes: Activity: Miscellaneous #1 — take a walk "for the sake of heaven"

40-55 minutes: Activity: Language Arts #2. Debate the topic that will seem most controversial to the group. Time permitting, debate a second topic.

55-60 minutes: Closure. Questions to ask: What was the most important thing you learned about *Shmirat HaGuf* today? What specific thing(s) will you do to try to live more in accordance with this *Middah*? (Examples: Exercise more regularly, say the prayer each day thanking God for my body, being more careful when riding my bike, never getting a tattoo, etc.)

APPENDIX 4

LESSON PLAN: GRADE 9-ADULT
OMETZ LAYV (COURAGE)
TIME FRAME: ONE HOUR

This lesson focuses on inner strength and on courage that is fortified by trust and faith in God. The lesson would be most appropriate as a second session on the topic of *Ometz Layv*. In that case, a first lesson might cover: points raised in the Overview to Chapter 14, Ometz Layv: Courage (10 minutes); Text Study, other than what appears in the lesson below (15 minutes); an activity that explores the basics of the *Middah*, such as Language Arts #1 (10 minutes); reinforcing the Language Arts activity with Drama #1 (10 minutes); and finally, an Activity that allows participants to examine how others experienced the *Middah*, as in Language Arts #7 (15 minutes). If the teacher or leader chooses to jump into the lesson below as a first session, he/ she will need to spend a few minutes introducing the virtue.

0-5 minutes: Review points made about *Ometz Layv* from the previous session. Also, ask if anyone thought about the subject or had questions about it in the interim between sessions. If this is the group's first session on *Ometz Layv*, introduce the *Middah* and give an overview of the virtue.

5-15 minutes: Text Study, related to inner strength and courage from God — Tanach #D, Rabbinic #D, Post-Rabbinic #A and #D

15-25 minutes: Activity: Language Arts #4 (stream-of-consciousness writing exercise exploring fears and sources/times of courage)

25-30 minutes: Activity: Visual Art #7 (shape exercise)

30-35 minutes: Activity: Movement #1 (parallels above art exercise, forming shapes with bodies)

35-50 minutes: Activity: Visual Art #6 (creating the very narrow bridge)

50-55 minutes: Activity: Movement #5 (parallels above art activity, physically crossing the very narrow bridge)

55-60 minutes: Activity: Music #1. Close with singing "*Gesher Tzar Me-od*" (All the World Is a Very Narrow Bridge). Invite each participant to make one brief comment (just a sentence or two) regarding the aspect of the lesson that made the most vivid impression upon him/her.

APPENDIX 5

LESSON PLAN: FAMILY EDUCATION SAYVER PANIM YAFOT (A PLEASANT DEMEANOR)
TIME FRAME: ONE HOUR

0-5 minutes: Introducing the topic and introducing ourselves. Make the following change to Drama #2: Simply have everyone go around the room and say their names. (Having everyone get up in front of the whole group may be too lengthy a process for a big family education group.) Instruct the group to clap and cheer and yell out words of greeting after each person says his/her name. The teacher or leader should have a signal (such as raising a hand) that shows the group when to "cut" their greetings, so that the introduction process remains in control.

5-10 minutes: The teacher or leader comments on the activity just completed, saying that what we just did actually reflected a Jewish virtue — the *Middah* called *Sayver Panim Yafot*. Give a brief introduction to and information about the *Middah*, drawing from the Overview.

10-15 minutes: Activity: Movement #1, third variation. Rather than dividing the group into pairs (a likely unwieldy process), do the following. Ask everyone to get up, leave the room, and prepare to reenter it and take the same seats. They will do this twice. The first time they should do so as if they are *not* exhibiting *Sayver Panim Yafot* — that is, they will just sit down, not look at or greet those sitting near them, etc. The second time they reenter and take their seats,

they will try to practice *Sayver Panim Yafot*, giving warm and gracious greetings to those they encounter.

15-30 minutes: Text Study. The teacher or leader prepares hand-outs ahead of time with several texts he/she thinks the group would enjoy studying. Then divide into small groups. Adults can study together and children can study together (with just one adult leader for each children's group). Or, the larger group can be divided into smaller mixed-aged groups.

30-50 minutes: Activity: Drama #4. Divide into groups for skits. The teacher or leader decides beforehand how to divide the groups. Also, he/she decides what skit topics to assign, or each group will be allowed to choose what they want to do. (Remember that it will take a good bit of time if groups are asked to choose a topic on their own.) Give groups ten minutes for creating the skits, then ten minutes to perform the skits for each other.

50-60 minutes: Final Discussion. Discuss the skits, as completed above, using the questions provided in Drama #4. Then close by raising the idea that *Sayver Panim Yafot* is a family value. The teacher or leader asks: How might the virtue of a pleasant demeanor apply to families and to family interactions? Is this a *Middah* that comes naturally to family interactions? In what ways would it be worthwhile for family members to make a concerted, intentional effort to master *Sayver Panim Yafot?*

APPENDIX 6

LESSON PLAN: INDEPENDENT STUDY
SAMAYACH B'CHELKO (CONTENTMENT WITH YOUR LOT)
MAKIR ET MEKOMO (KNOWING YOUR PLACE)
LO TACHMOD (NOT COVETING)
TIME FRAME: ONE HOUR

This lesson plan focuses on study, with creative writing as the means to delve into and "invest" in the *Middah* more intently.

0-5 minutes: Read the Overview to Chapter 15, Samayach B'Chelko: Contentment with Your Lot. Some questions to think about or respond to in writing: What is the relationship between the three terms *Samayach B'Chelko, Makir et Mekomo,* and *Lo Tachmod*? What is the relationship of the tenth commandment to the nine preceding?

Describe the tension between coveting and legitimate desires for improvement in one's lot. How might that tension be resolved?

5-25 minutes: Text Study. Read through the texts in Text Study. Then, go back to the four or five that most interest you and respond to the questions that follow each. Which text gets closest to the essence of these *Middot*? If you were to choose one text to memorize as a kind of mantra to help you stay on the contentment tract, which would it be, and why?

25-30 minutes: Activity: Language Arts #3, filling in the blanks

30-60 minutes: Additional Activities: Language Arts #8, #9, and/or #10

APPENDIX 7

SHABBATON/RETREAT PLAN:
GRADES 7 AND UP
OHEV ZEH ET ZEH, MECHABAYD ZEH ET ZEH (LOVING AND HONORING OTHERS)
TIME FRAME: WEEKEND

FRIDAY, EREV SHABBAT

4 to 5 P.M.:
Serve informal refreshments in a central meeting place — juice, soft drinks, fruit, chips. When everyone has gathered (having received room assignments, "freshened up," snacked a bit on the refreshments, etc.), make a circle. The teacher or leader introduces the theme of the *Shabbaton: Ohev Zeh et Zeh, Mechaybed Zeh et Zeh* (loving and honoring others). Adapt parts of Language Arts #8 for an ice breaker. First, go over Text Study, Post-Rabbinic #D, about appreciating and honoring the uniqueness of each individual. At that point, go around the circle asking everyone to say something unique about themselves (such as a special talent or knowledge, their unusual home, a unique pet they care for, etc.). Do this activity as a memory game — each person must repeat the unique aspect of the previous individuals before stating his/her own unique quality. Finish by reading and discussing Text Study, Rabbinic #F.

5 to 6 P.M.:
Kabbalat Shabbat Service. Instead of a *D'var Torah* or sermon, hand out copies of texts from *Pirke Avot* (see Text Study, Rabbinic #B and #C) to study in pairs (*chevruta* style). After 5 to 10 minutes, have the small groups report back to the larger group on what they learned and talked about.

6 to 7 P.M.:
Shabbat dinner, *Birkat HaMazon* (Grace after the Meal), singing

7:30 to 9 P.M.:
Focus on loving and honoring others on the level of *Bayn Adam L'Chavero* (Between People). Do Drama activities #1, #2, and (if time) #6.

9 P.M to ?:
Storytelling, singing, other informal activities. Create an *Oneg Shabbat* atmosphere with dessert snacks available.

SATURDAY

Early morning:
Informal movement or meditation opportunities — yoga or stretching, outdoor walk, etc. Have juice available.

8:30 A.M.: Breakfast

9:30 A.M.:
Shacharit services. Include a *D'var Tefilah* (commentary about prayer) and discussion on "Ahavah Rabbah," "Shema," and the "V'Ahavta" (see Text Study, Tanach #B). Also, see #H on p. 48, #10 on p. 50, and #29 on p. 52 in *Teaching Tefilah: Insights and Activities on Prayer* by Bruce Kadden and Barbara Binder Kadden (A.R.E. Publishing, Inc.) for ideas.

12 noon to 1 P.M.:
Birkat HaMazon, singing

1 P.M. to 2:30 P.M.; 3 P.M. to 4:30 P.M.:
Choices (reading, storytelling, walking, music, drama, etc.) for two activity periods

4:30 P.M. to 6 P.M.:
Focus on the topic "Getting Rid of Hatred." Learn using Text Study, Tanach #A and Rabbinic #D and #E. Do Movement #3 — getting rid of an

imagined, almost tangible presence of hatred. Follow with the given discussion questions.

Then everyone finds his/her own space. The leader calms the group by asking them to get into a comfortable position, relax, close their eyes, focus on their breath, breathe deeply in and out ten or so times, etc. Begin a guided meditation with Text Study, Rabbinic #G, a prayer in which God is asked to help us remove any hatred and jealousy we hold in our hearts. Expand on the ideas as desired. Give participants some silent time to focus on the ideas in the prayer. End this contemplative time by reading the prayer again. Have everyone slowly open eyes, stretch, move around a bit, and return attention to the group and the next activity.

For the last part of this session, pair off and do a variation on Language Arts #6. Each person takes a turn naming someone (orally, rather than in writing), then "practices" saying something loving and honoring to that person. The pair goes back and forth until they each have had five to ten turns. They then report back to the group about this experience.

6 P.M. to 7 P.M.:
Tefilah, dinner, *Birkat HaMazon,* singing, *Havdalah*

7:30 P.M. to 9 P.M.:
Hold a "Sing Down" using terms relevant to the retreat's theme (see Music #2). Then, adapt Visual

Art #2 by making a group mural of unique faces in a crowd (rather than individual pictures).

9 P.M.. to ?:
Storytelling, movie, dancing, etc.

SUNDAY

8 A.M.:
Tefilah, breakfast

9 A.M. to 9:30 A.M.:
Clean up, pack bags and bring them to central place.

9:30 A.M. to 11 A.M.:
Visual Art #4: Design anti-hate buttons, or use fabric paints and create T-shirts to take home. Afterward, in a closing circle, everyone says the most important thing they learned during the *Shabbaton.* Do some singing, especially songs related to the weekend's topic. End by chanting the "*V'Ahavta*" prayer in Hebrew, followed by reciting in unison in English. The poem "S'hema" is a particularly inspiring translation/interpretation of the prayer (see *The Art of Blessing The Day* by Marge Piercy, New York, Alfred A. Knopf, 1999, p. 132).

11 A.M.:
Departure for home

APPENDIX 8

A LISTING OF MIDDOT

The earliest *Middot* are listed in the Book of Exodus, where they are seen as descriptors of God. "The Eternal, the Eternal God, is *Rachum* (gracious) and *Chanun* (compassionate), *Erech Apayim* (slow to anger), *Rav Chesed V'Emet* (abounding in kindness and truth), *Notzer Chesed L'Alafim* (assuring love for a thousand generations), *Nosay Avon VaFesha V'Chata'ah V'Nakay* (forgiving iniquity, transgression, and sin, and granting pardon)." (Exodus 34:6-7)

Middot can be found scattered throughout Jewish texts from all eras. For this book two main sources are drawn upon which actually list Jewish virtues per se. These are a passage in *Pirke Avot* (a tractate of the Mishnah) and *Orchot Tzaddikim* (an anonymous Hebrew work probably written in Germany in the fifteenth century).

From *Pirke Avot* 6:6 comes this statement and list of virtues:

Torah is greater than Priesthood and Royalty.
Royalty is acquired through 30 virtues,
Priesthood through 24.
Torah, however, is acquired through 48 virtues:

Talmud (study)
Shmiat HaOzen (attentiveness)
Arichat Sefatayim (orderly speech)
Binat HaLev (an understanding heart)
Sichlut HaLev (a perceptive heart)
Aymah (fear)
Yirah (awe)
Anavah (humility)
Simchah (joy)
Shimush Chachamim (ministering to the sages)
Dibuk Chaverim (cleaving to colleagues/friends)
Pilpul HaTalmidim (acute discussion with pupils)

Yishuv BeMikra (calmness in study)
Mishnah (study of Scripture and Mishnah)
Miyut Sechorah (moderation in business)
Miyut Shaynah (a minimum of sleep)
Miyut Sichah (a minimum of small talk)
Miyut Ta'anug (a minimum of worldly pleasure)
Miyut Sechok (a minimum of frivolity)
Miyut Derech Eretz (a minimum of worldly pursuits)
Erech Apayim (slowness to anger)
Lev Tov (a generous heart)
Emunat Chachamim (trust in the sages)
Kabbalat HaYisurin (acceptance of suffering)
Makir et Mekomo (knowing one's place)
Samayach B'Chelko (contentment with one's lot)
Seyag LiD'varav (guarding one's speech)
Eino Machazik Tova L'Atzmo (taking no personal credit)
Ahuv (being beloved)
Ohev et HaMakom (loving God)
Ohev et HaBriyot (loving all creatures)
Ohev et HaTz'dakot (loving charitable deeds)
Ohev et HaMaysharim (loving rectitude)
Ohev et HaTochachot (loving rebuke)
Mitrachayk Min HaKavod (shunning honor)
Lo Maygis Libo B'Talmudo (not boasting of one's learning)
Eino Samayach BeHora'ah (not delighting in rendering decisions)
Nosay V'Ol Im Chavayro (sharing the burden with one's fellow)
Machrio L'Chaf Zechut (influencing one's fellow to virtue)
Ma'amido al HaEmet (setting others on the path of truth)
Ma'amido al HaShalom (setting others on the path of peace)
Miyashev BeTalmudo (concentrating on one's studies)
Shoayl U'Mayshiv (asking and answering questions)

Shomaya U'Mosif (absorbing knowledge and adding to it)
Lomed al Manat Lelamed (studying in order to teach)
Lomed al Manat La'asot (studying in order to perform Mitzvot)
Machkim et Rabo (sharpening the wisdom of one's teacher)
Mechavayn et Sh'muato (being precise in transmitting what one has learned)
Omer Davar BeShem Omro (quoting one's source)

In the book *Orchot Tzaddikim/The Ways of the Tzaddikim,* numerous traits are discussed. We are instructed there to examine them all, the good and the bad, and to strive to improve ourselves. The benefits and dangers of the following traits are included in that book:

Ga'avah (pride)
Anavah (humility)
Bushah (shame)
Azut (arrogance)

Ahavah (love)
Sinah (hatred)
Rachamim (mercy)
Ach'zariyut (cruelty)
Simchah (joy)
Da'agah (worry)
Charatah (regret)
Ka'as (anger)
Ratzon (willingness)
Keenah (envy)
Zrizut (zeal)
Atzlut (laziness)
Nedivut (generosity/magnanimity)
Tzayekanut (miserliness)
Zechirah (rememberance),
Shichechah (forgetfulness)
Shetikah (silence)
Sheker (falseness)
Emet (truth)
Chanifut (flattery)
Lashon HaRa (slander)
Teshuvah (repentance)
Torah (learning)
Yirat Shamayim (fear of heaven)

BIBLIOGRAPHY

JEWISH RESOURCES

Ben Shea, Noah. *The Word: A Spiritual Sourcebook.* New York: Villard, 1995.

Bialik, Hayyim Nahman, ed. *Book of Legends (SeferHaAggadah).* Translated by William Braude. New York: Schocken Books, 1992.

Birnbaum, Philip. *Maimonides' Mishneh Torah: Yad HaHazakah.* New York: Hebrew Publishing Company, 1944, o.p.

Bokser, Ben Zion, trans. *Abraham Isaac Kook, The Lights of Penitence, Lights of Holiness, The Moral Principles, Essays, Letters, and Poems.* Ramsey, NJ: Paulist Press, 1978.

Borowitz, Eugene B., and Frances W. Schwartz. "The Rabbi and Personal Virtues." *CCAR Journal: A Reform Jewish Quarterly* (Winter, 1999): 40-49.

Buber, Martin. *Tales of the Hasidim: Book One: The Early Masters* and *Book Two: The Later Masters/ Two Books in One.* Edited by Bonnie V. Fetterman. New York: Schocken Books, 1991.

———. *Ten Rungs: Hasidic Sayings.* New York: Schocken Books, 1947.

Buxbaum, Yitzchak. *Jewish Spiritual Practices.* Northvale, NJ: Jason Aronson Inc., 1990.

Freeman, Susan. "Creative, Artistic Responses to Jewish Tradition." In *CCAR Journal: A Reform Jewish Quarterly* (Summer, 1997): 129-135.

Goldstein, Niles E., and Steven S. Mason. *Judaism and Spiritual Ethics.* New York: UAHC Press, 1996.

Klagsbrun, Francine. *Voices of Wisdom: Jewish Ideals and Ethics for Everyday Living.* New York: Pantheon Books, 1980.

Luzzatto, Moses Hayyim. *The Path of the Upright (Mesillat Yesharim).* Edited and translated by Mordecai Kaplan. Philadelphia: Jewish Publication Society, 1966.

Montefiore, C.G., and Herbert Martin James Loewe. *A Rabbinic Anthology.* Cleveland, OH: World Publishing Company, 1963. o.p.

Olitzky, Kerry M. *Striving Toward Virtue: A Contemporary Guide for Jewish Ethical Behavior.* Hoboken, NJ: KTAV Publishing House, Inc., 1996.

Raz, Simcha. *A Tzaddik in Our Time.* Jerusalem: Feldheim Publishers, 1976.

Rosten, Leo. *Treasury of Jewish Quotations.* New York: Bantam Books, 1972, o.p.

Schwartz, Earl. *Moral Development: A Practical Guide for Jewish Teachers.* Denver, CO: A.R.E. Publishing, Inc., 1983. o.p.

Zaloshinsky, Gavriel, ed. *The Ways of the Tzaddikim (Orchot Tzaddikim).* Translated by Shraga Silverstein. New York and Jerusalem: Feldheim Publishers, 1995.

RESOURCES RELATED TO THE CREATIVE ARTS
Language Arts

Baldwin, Christina. *Life's Companion: Journal Writing as a Spiritual Quest.* New York: Bantam Books, 1990.

Rico, Gabriele L. *Writing the Natural Way: Using Right-Brain Techniques to Release Your Expressive Powers.* Los Angeles, CA: Putnam Publishing Group, 1983.

Schneider, Myra, and John Killick. *Writing for Self-Discovery: A Personal Approach To Creative Writing.* Rockport, MA: Element Books Limited, 1998.

Sweeney, Jacqueline. *Teaching Poetry: Yes You Can!* New York: Scholastic, Inc., 1993. (Grades 4-8)

Tucker, Shelley. *Painting the Sky: Writing Poetry with Children.* Glenview, IL: Good Year Publishing Co., 1995. (Grades 3-6)

Visual Arts

Brookes, Mona. *Drawing with Children: A Creative Method for Adult Beginners, Too.* New York: Putnam Publishing Group, 1996.

Hurd, Thacher, and John Cassidy. *Watercolor for the Artistically Undiscovered.* Palo Alto, CA: Klutz Press, 1992.

Topal, Cathy Weisman. *Children and Painting.* Worcester, MA: Davis Publications, Inc., 1992.

Drama

Bany-Winters, Lisa. *On Stage: Theater Games and Activities for Kids.* Chicago, IL: Chicago Review Press, 1997.

Belt, Lynda, and Rebecca Stockley. *Acting through Improv: Improv through Theatresports.* Seattle: Thespis Productions, 1995.

Bernardi, Philip. *Improvisation Starters: A Collection of 900 Improvisation Situations for the Theater.* Cincinnati, OH: Betterway Books, 1992.

Clark, Larry, and Charles McGaw. *Acting Is Believing: A Basic Method.* New York: Holt, Rinehart, and Winston, 1992.

Peterson, Lenka, and Dan O'Connor. *Kids Take the Stage: Helping Young People Discover the Creative Outlet of Theater.* New York: Back Stage Books, 1997.

Pitzele, Peter. *Scripture Windows.* Los Angeles, CA: Alef Design Group, 1997.

Spolin, Viola. *Theater Games for the Classroom: A Teacher's Handbook.* Evanston, IL: Northwestern University Press, 1986.

Movement

Gilbert, Anne Green. *Creative Dance for All Ages.* Reston, VA: The American Alliance for Health, Physical Education, and Dance, 1992.

Hawkins, Alma. *Moving from Within: A New Method for Dance Making.* Chicago, IL: Cappella Books, 1991.

Minton, Sandra Cerny. *Choreography: A Basic Approach Using Improvisation.* Champaign, IL: Human Kinetics, 1997.

Morgenroth, Joyce. *Dance Improvisations.* Pittsburgh, PA: University of Pittsburgh Press, 1987.

Tucker, JoAnne, and Susan Freeman. "Creative Movement Activities." In *The New Jewish Teachers Handbook.* Denver, CO: A.R.E. Publishing, Inc., 1994.

———. *Torah in Motion: Creating Dance Midrash.* Denver, CO: A.R.E. Publishing, Inc., 1990.

Turner, Margery J. *New Dance: Approaches To Nonliteral Choreography.* Pittsburgh, PA: University of Pittsburgh Press, 1976.

Music

Miles, Elizabeth. *Tune Your Brain: Using Music To Manage Your Mind, Body, and Mood.* New York: Berkely Publishing Group, 1997.

MISCELLANEOUS (GENERAL CREATIVITY DEVELOPMENT)

Cameron, Julia. *The Artist's Way.* New York: Putnam Publishing Group, 1995.

———. *The Vein of Gold: A Journey To Your Creative Heart.* New York: Putnam Publishing Group, 1996.

Freeman, Susan. "Creative, Artistic Responses to Jewish Tradition." In *CCAR Journal: A Reform Jewish Quarterly* (Summer, 1997): 129-135.